100 YEARS OF

LONDON

100 YEARS OF

LONDON

First Published 2018 by
Ammonite Press
an imprint of Guild of Master Craftsman Publications Ltd
Castle Place, 166 High Street, Lewes, East Sussex,
BN7 IXU, United Kingdom
www.ammonitepress.com

Text © GMC Publications Ltd, 2018 Images © Press Association Images, 2018 Copyright in the Work © GMC Publications Ltd, 2018

ISBN 978-1-78145-358-2

All rights reserved.

No part of this publication may be reproduced, stored in a retrieval system or transmitted in any form or by any means without the prior permission of the publishers and copyright owners.

While every effort has been made to obtain permission from the copyright holders for all material used in this book, the publishers will be pleased to hear from anyone who has not been appropriately acknowledged, and to make a correction in future reprints.

A catalogue record of this book is available from the British Library.

Publisher: Jason Hook
Design Manager: Robin Shields
Editor: Huw Pryce
Series Editor: Paul Richardson
Picture Research: Press Association Images

Colour reproduction by GMC Reprographics Printed and bound in China Page 2: Royal Navy 12-oared cutters taking part in the River Thames Peace Pageant.

4 August 1919

Page 5: A huge crowd outside the Stock Exchange and the Bank of England after the announcement of the Armistice, which heralded the end of the First World War.

Page 6: A Beefeater surveys some of the 888,246 ceramic poppies on display in the dry moat at the Tower of London.

16 October 2014

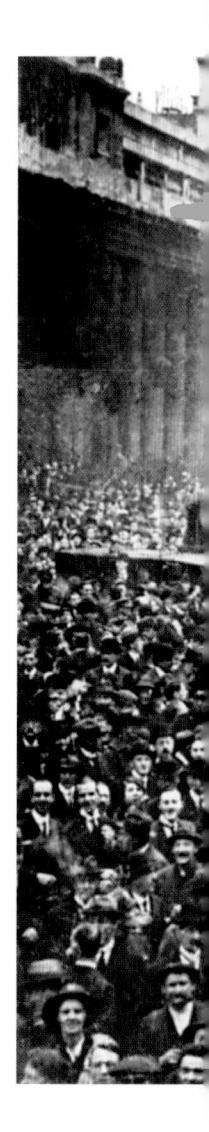

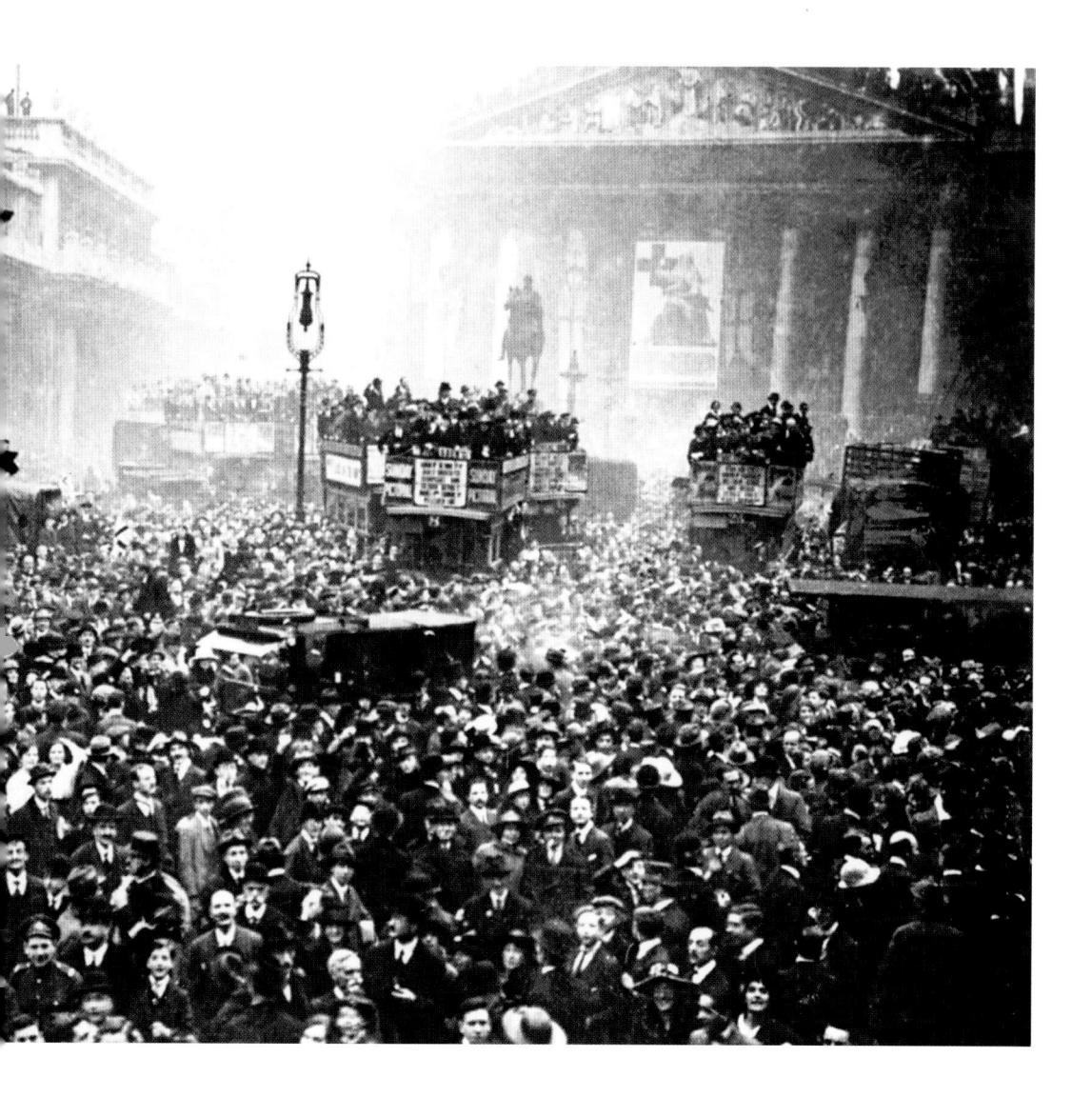

Introduction

One of the world's great capitals, London is steeped in history while being the home and workplace of some eight million people. When this book's first picture was taken the city was the hub of a great empire; now it is a cosmopolitan city in Western Europe. During that tumultuous century the city has hosted three Olympic games; it suffered the bombs of two world wars and endured – endures still – generations of terrorism. London has ever been a stage on which great events unfold.

Yet amid the pageantry, demonstrations, sporting events, disasters, publicity stunts, riots and carnivals, booms and crashes, London's everyday life rolls on. And at every turn, a photographer of the Press Association has been there with a camera to make a record. Newspapers gained the ability to reproduce large numbers of half-tone images in 1897. However, the nature of photographic equipment of the time – bulky wooden cameras, flash powder and glass plates – meant that images were still difficult to obtain, requiring bright daylight or complete stillness for a clear picture.

It is a tribute to the early photographers whose work features here that their images display a spontaneity that belies the preparation behind them. Who are those children playing in the slums of the East End? What equipment was used to capture commuters clambering onto a moving tram in 1919? Themes emerge from these pictures and weave through the lives of the city's generations. How Londoners travel and work, how they buy food, celebrate, survive and mourn, how newcomers arrive and assimilate, how civilians and royalty fight wars, all remain burned onto glass plates, celluloid negatives and hard drives, waiting to be called back into existence here, each image as fresh as the day it was captured.

Although Britain's influence waned with the passing of its empire, London remains a world city and financial centre, a capital of the arts and home of the music industry. It swung in the 1960s, marched and demonstrated in the 1970s, gave in to rampant greed in the 1980s then re-emerged as a cultural powerhouse with Cool Britannia in the 1990s. As the old Roman river crossing moves into her third millennium, the cameras of the PA's photographers are there to bear witness to what comes next.

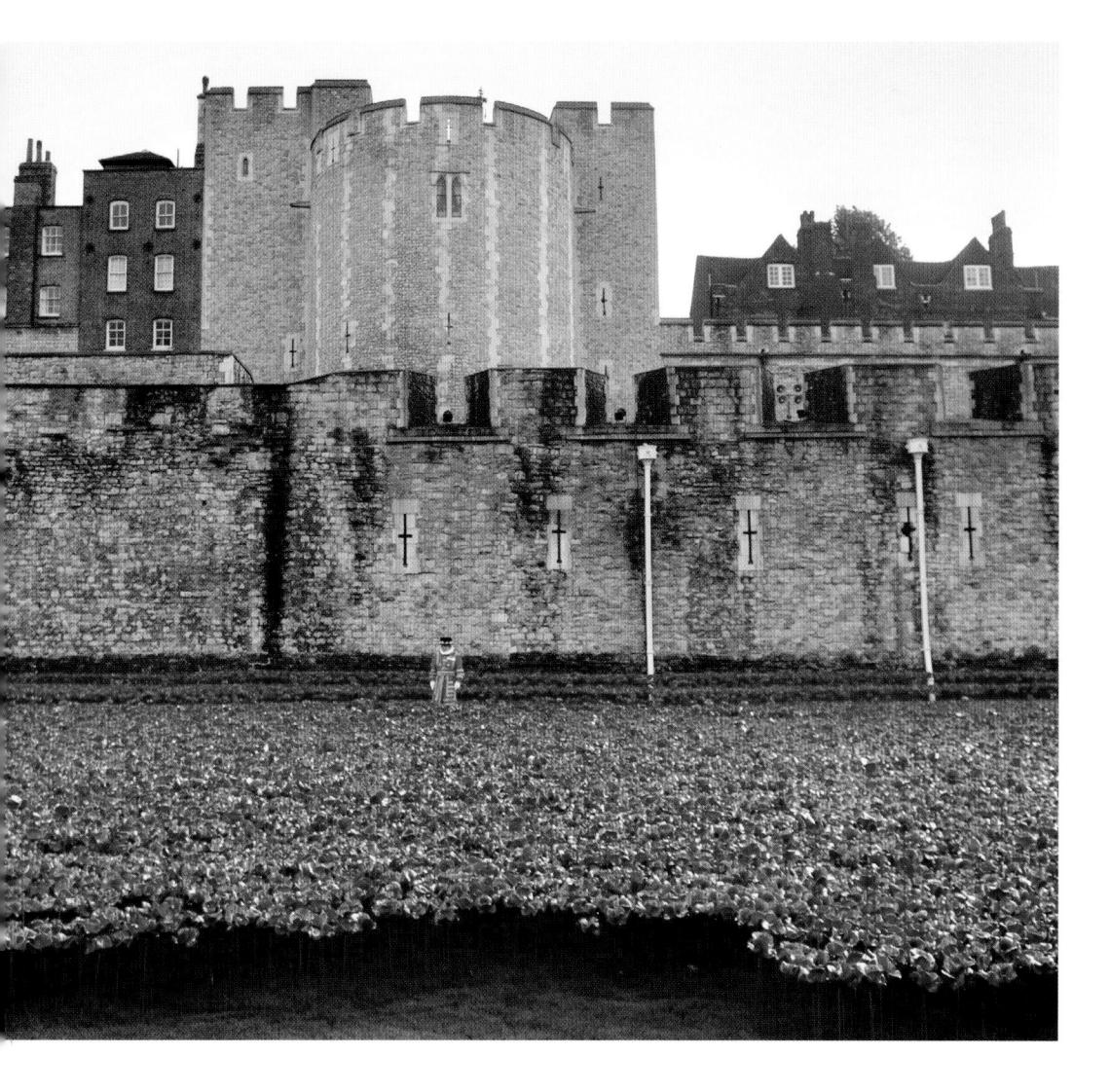

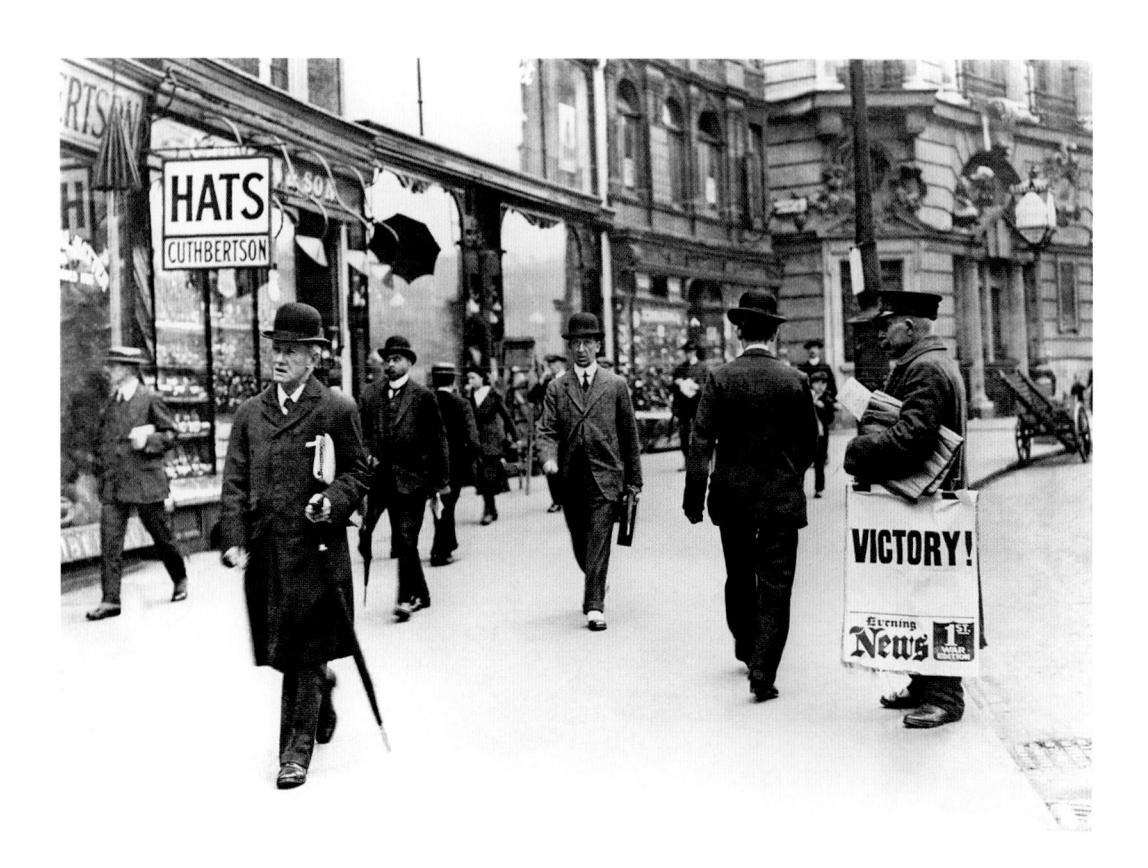

News of the Allied victory reaches the Aldwych.

11 November 1918

Former Suffragette Christabel Pankhurst casts her vote in the 1918 General Election, the first in which women – albeit only those over 30 years of age – were permitted to vote. 14 December 1918

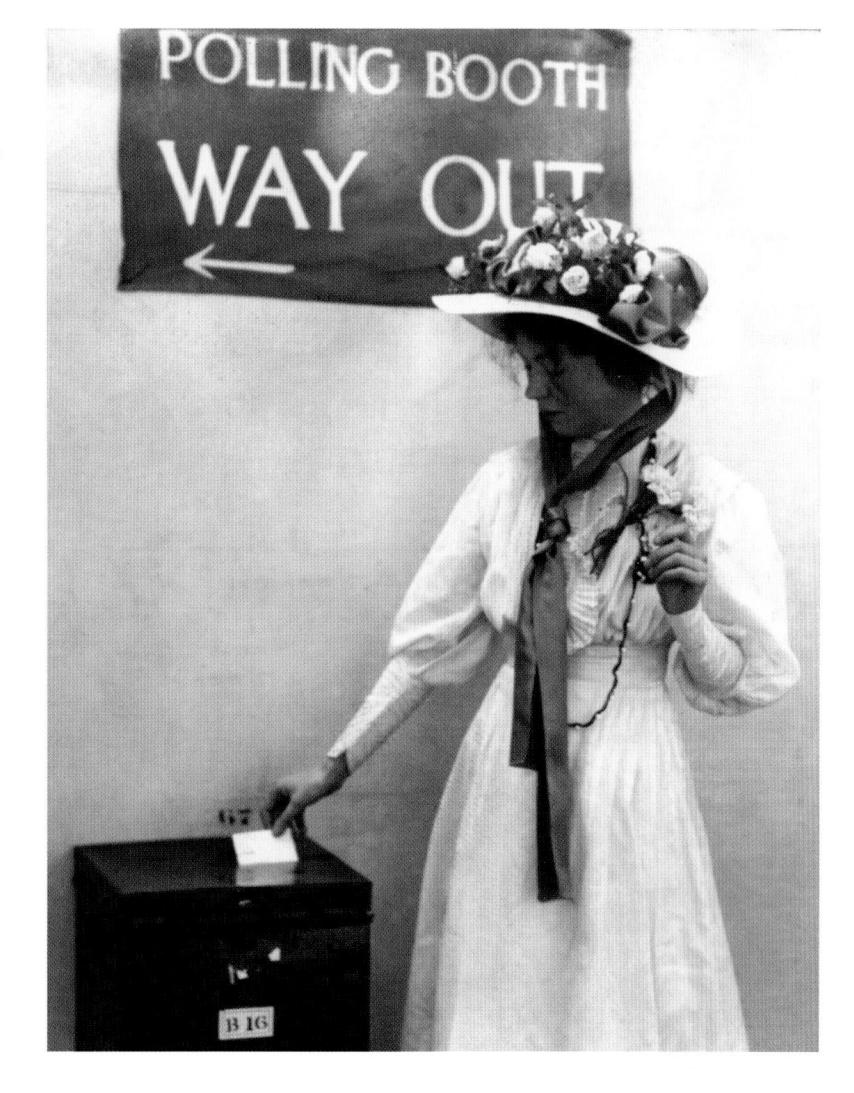

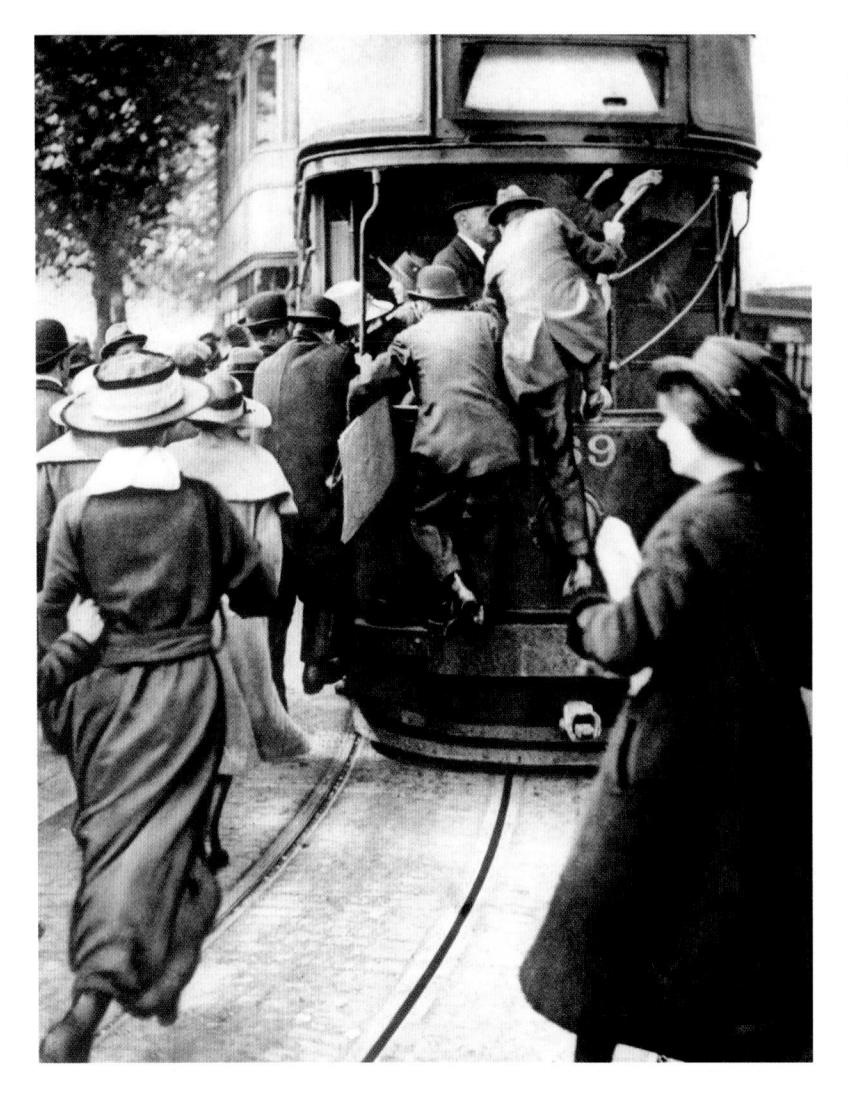

A rush for trams on the Victoria Embankment during a railway strike.

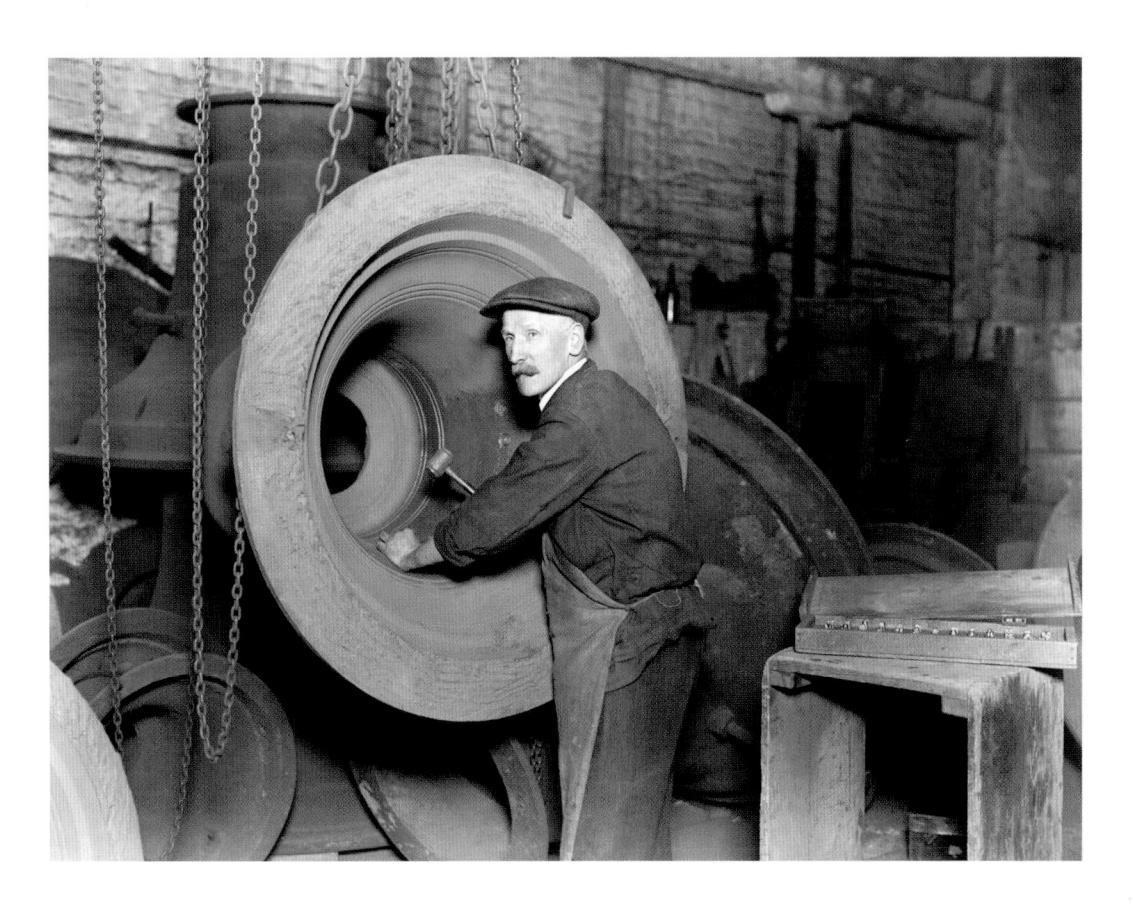

The Whitechapel Bell Foundry – the oldest manufacturing company in the world. Big Ben – the hour bell of the Great Clock of Westminster – and Philadelphia's Liberty Bell were both cast here.

1919

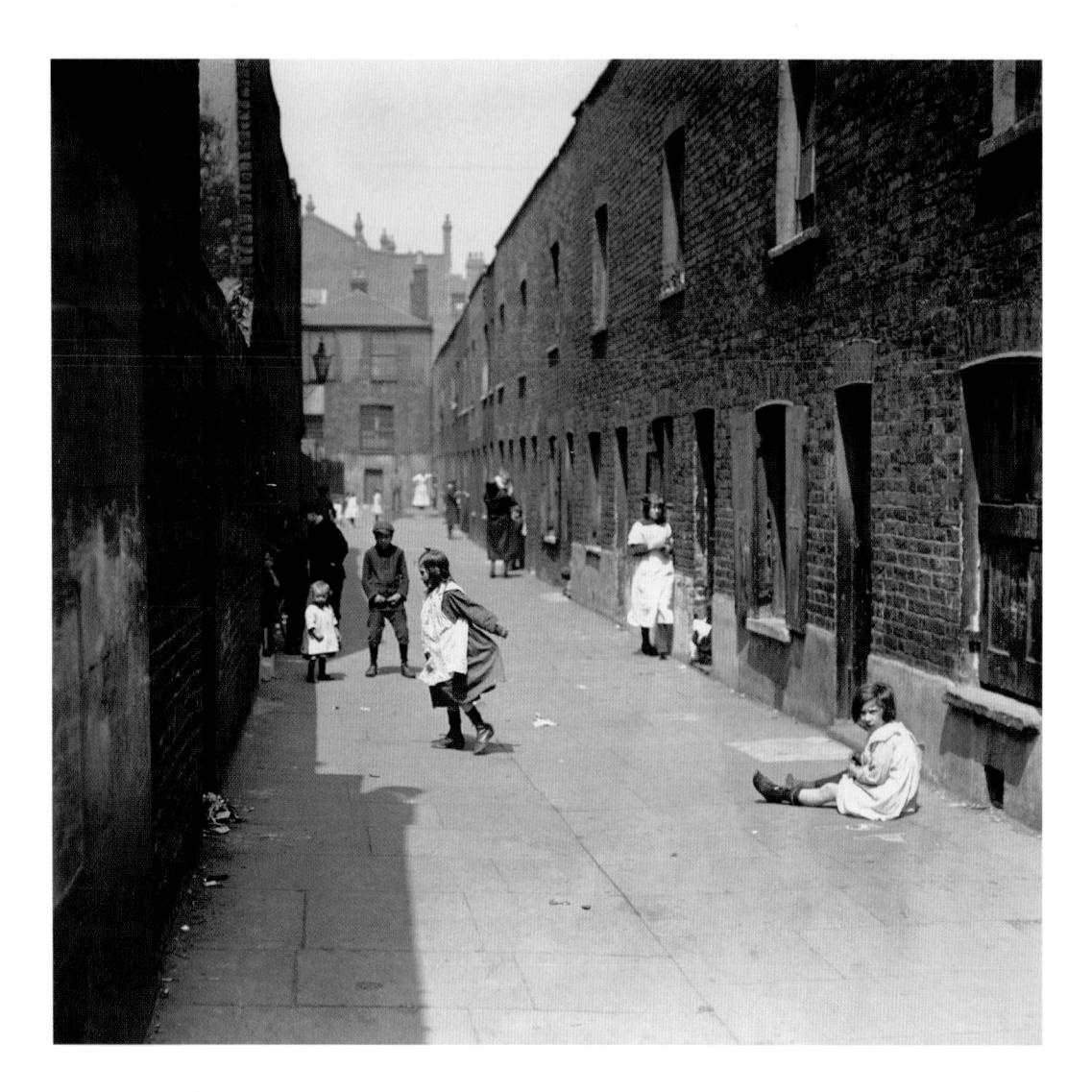

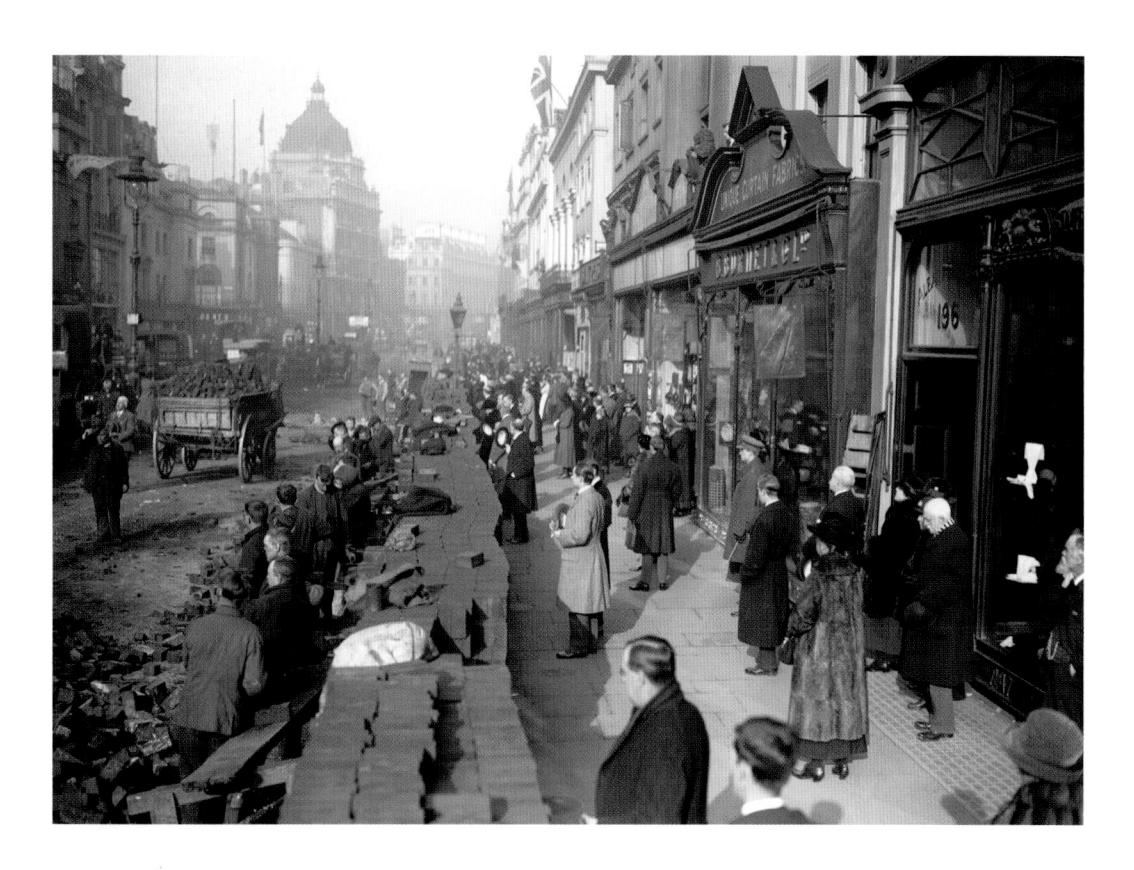

Facing page: Slum dwellings in the East End.
May 1919

Road workers and pedestrians observe the two-minute silence on the first anniversary of the end of the First World War.

II November 1919

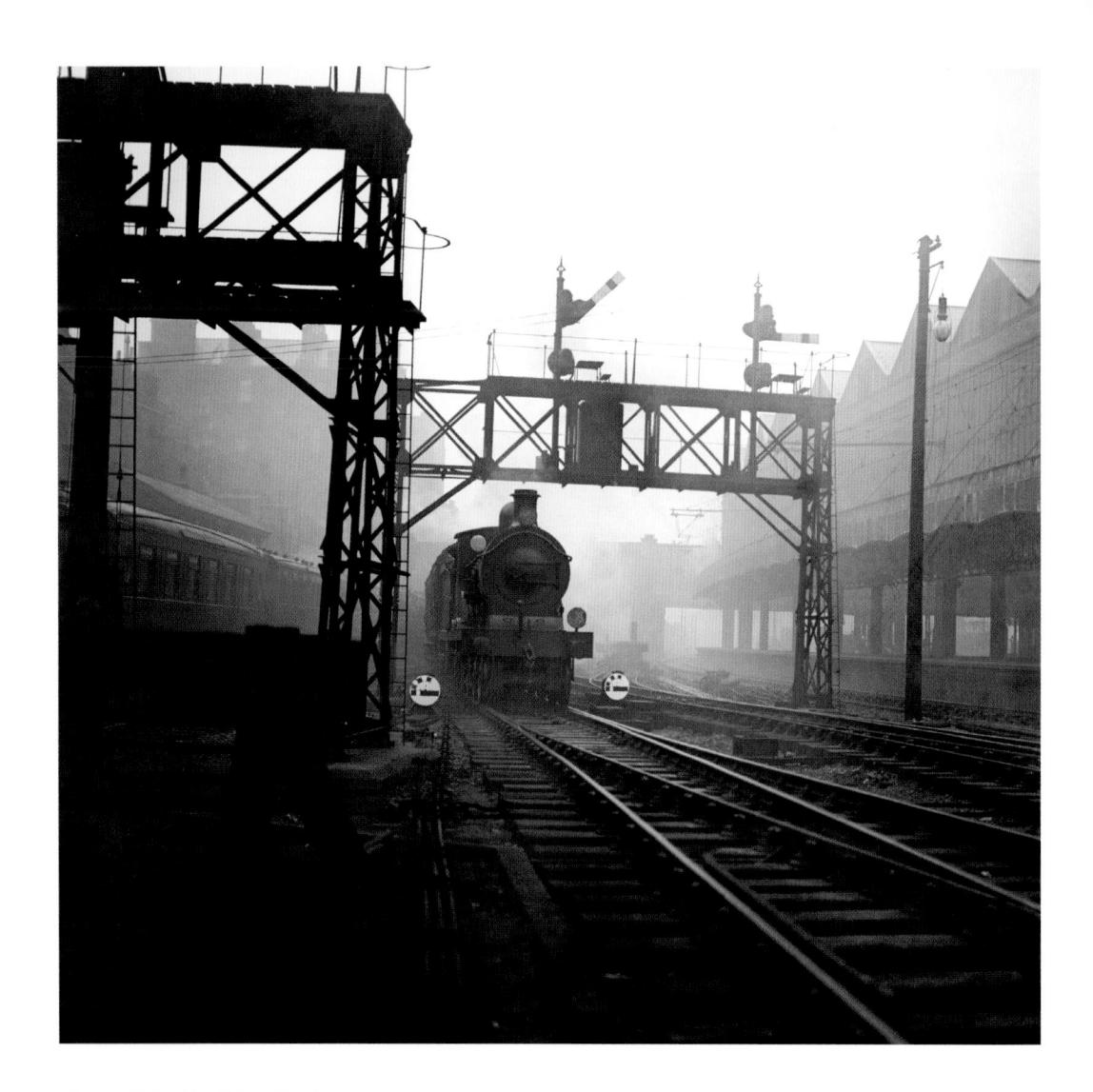

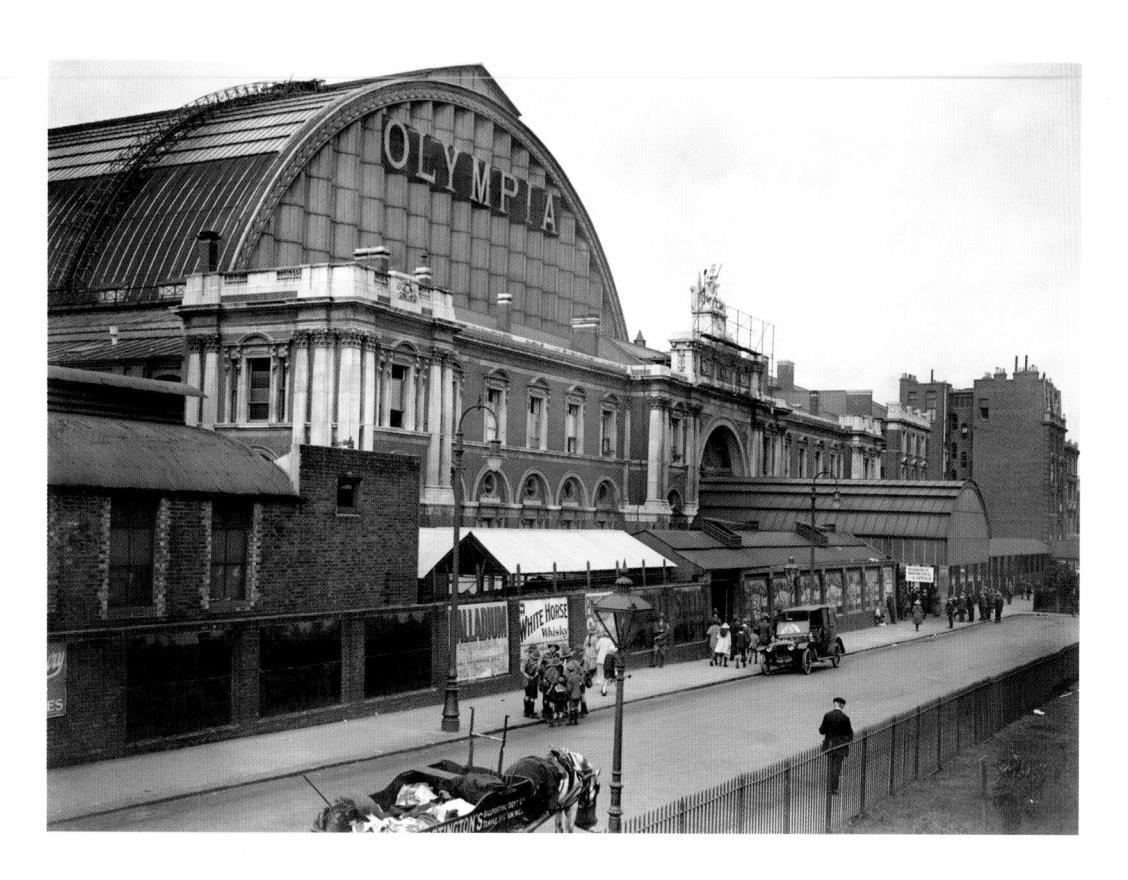

Facing page: The Chatham express leaves Victoria station with the new signalling apparatus in the raised position, indicating 'all clear'.

5 January 1920

Scouts arrive at Olympia Exhibition Centre for the world's first Boy Scouts' Jamboree. August 1920

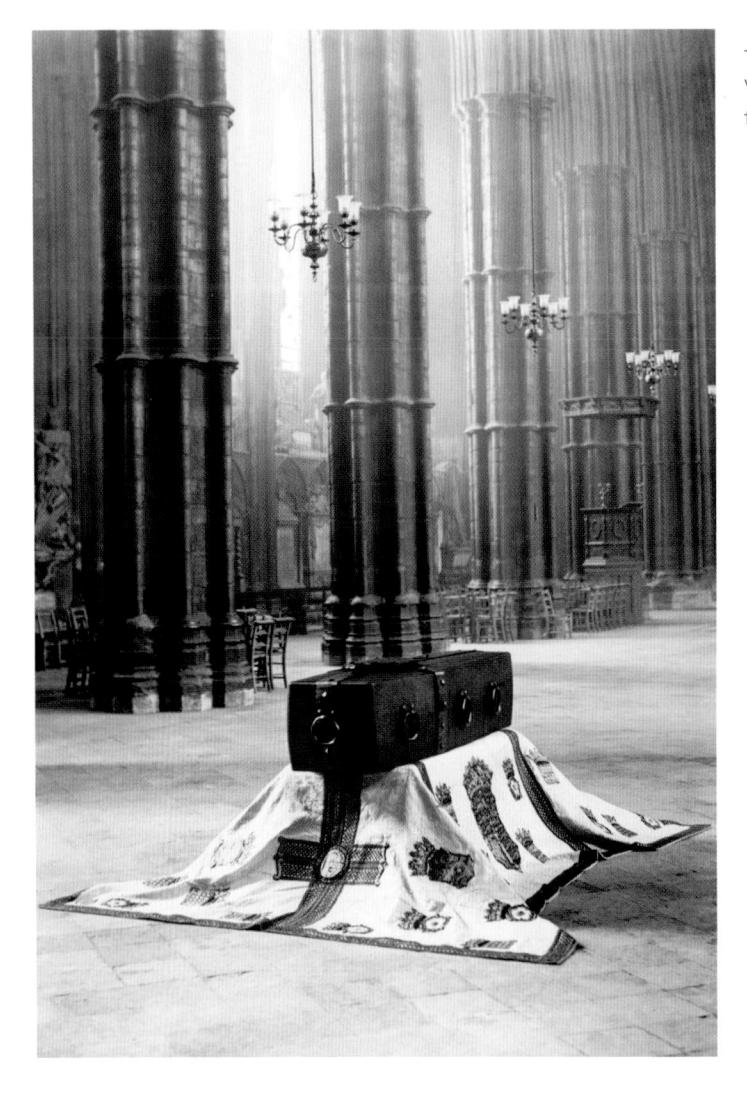

The coffin of the Unknown Warrior rests in the west end of the nave of Westminster Abbey. II November 1920

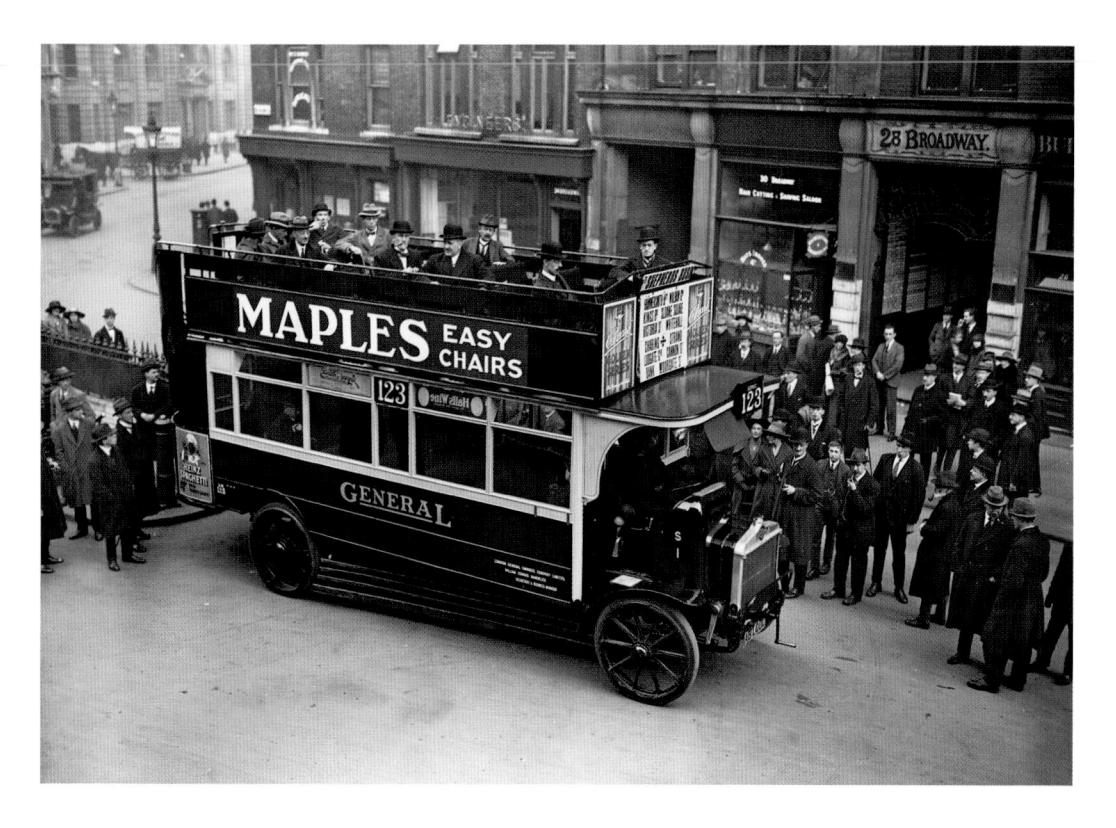

A K type motorbus, in The Broadway, Westminster. 16 November 1920

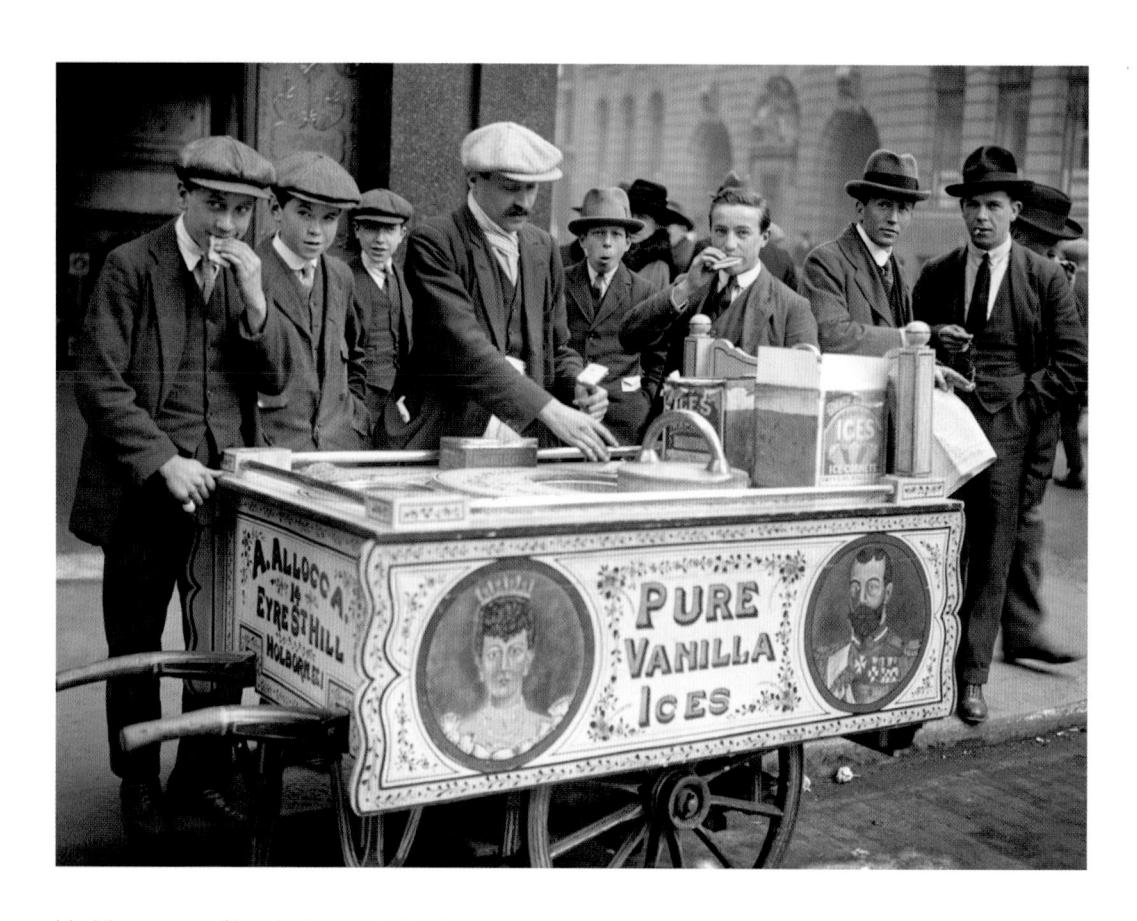

Mr Allocca, one of London's many Italian ice-cream sellers, and his patriotically decorated cart. 3 January 1921

A Defence Force sentry at Somerset House, during the strike crisis of 1921. Defence Force members were taken from the Territorial Army but did not wear uniform, as the TA cannot be used to suppress civil disturbances.

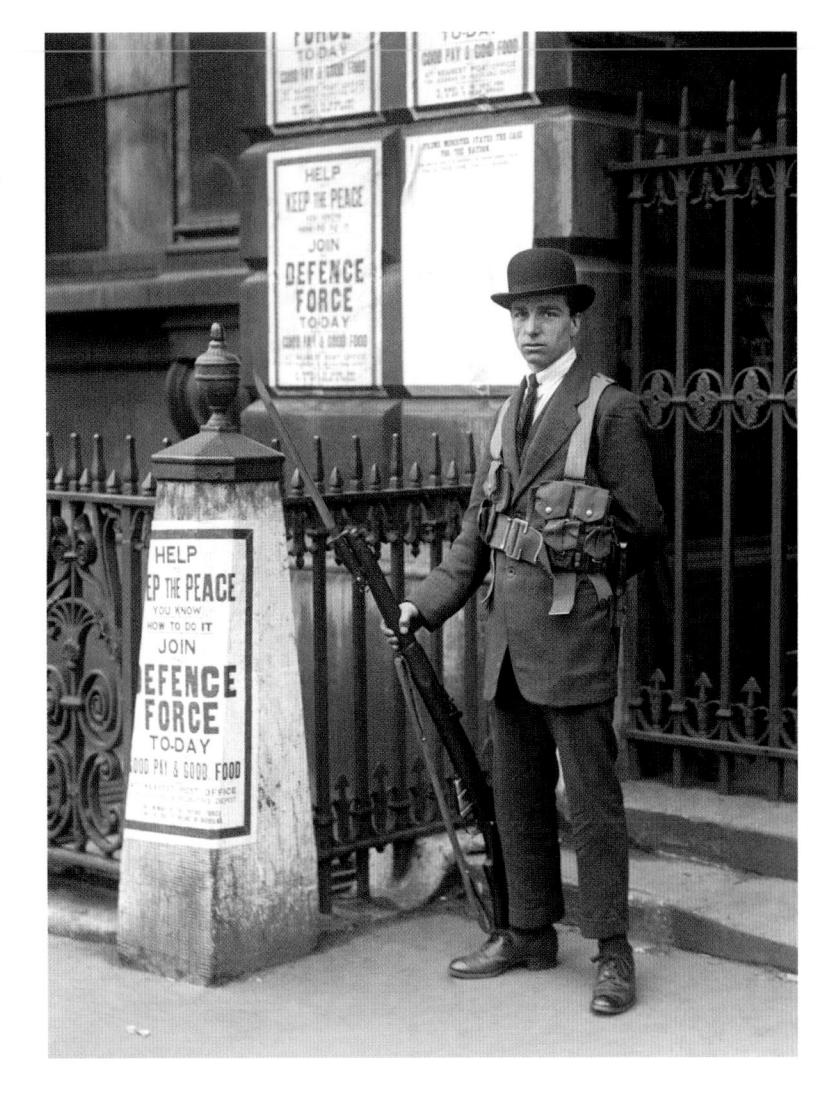

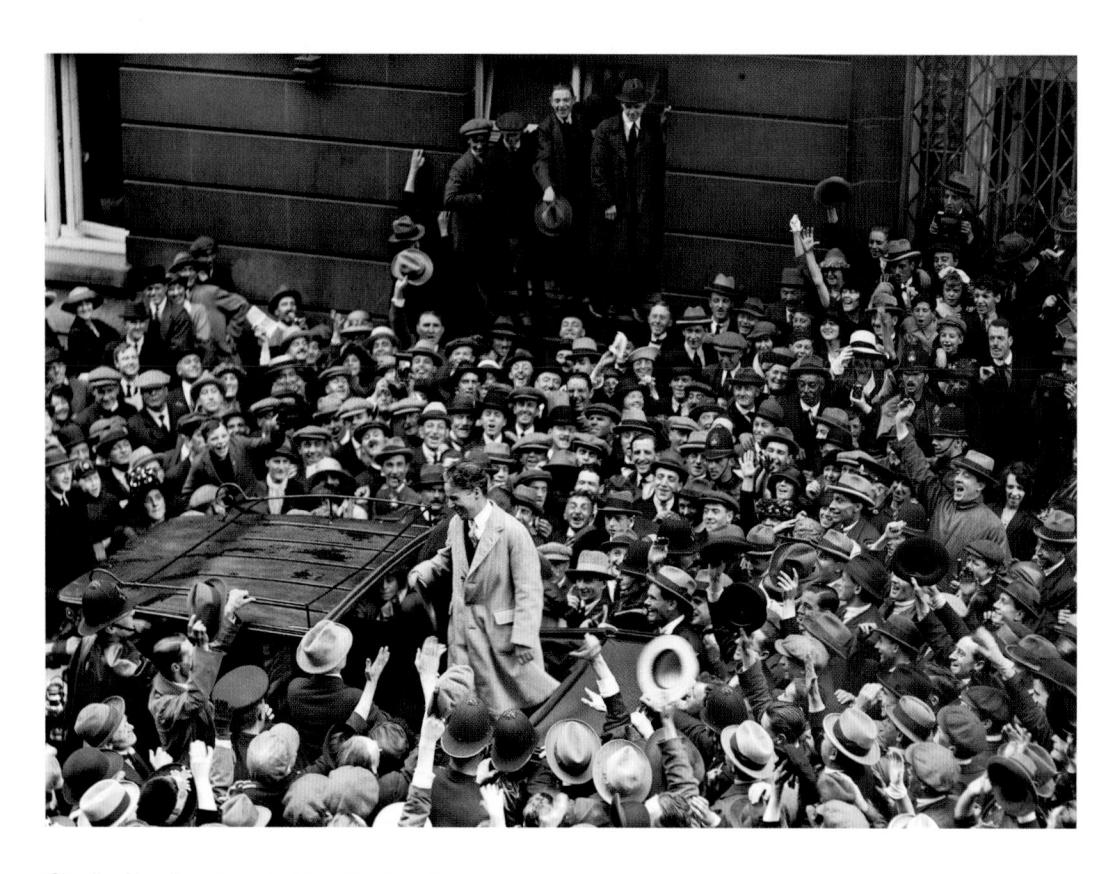

Charlie Chaplin returns to his native London to promote his new film *The Kid*.

10 September 1921

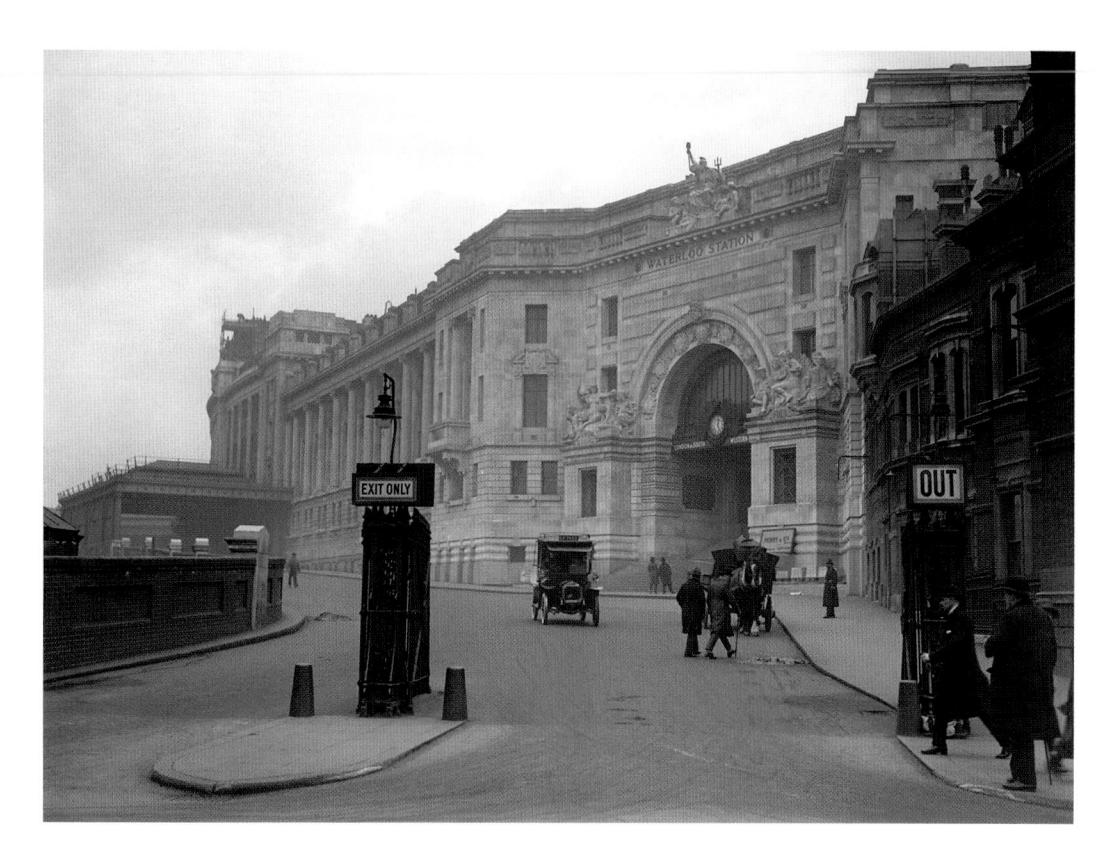

Waterloo station. 25 April 1922

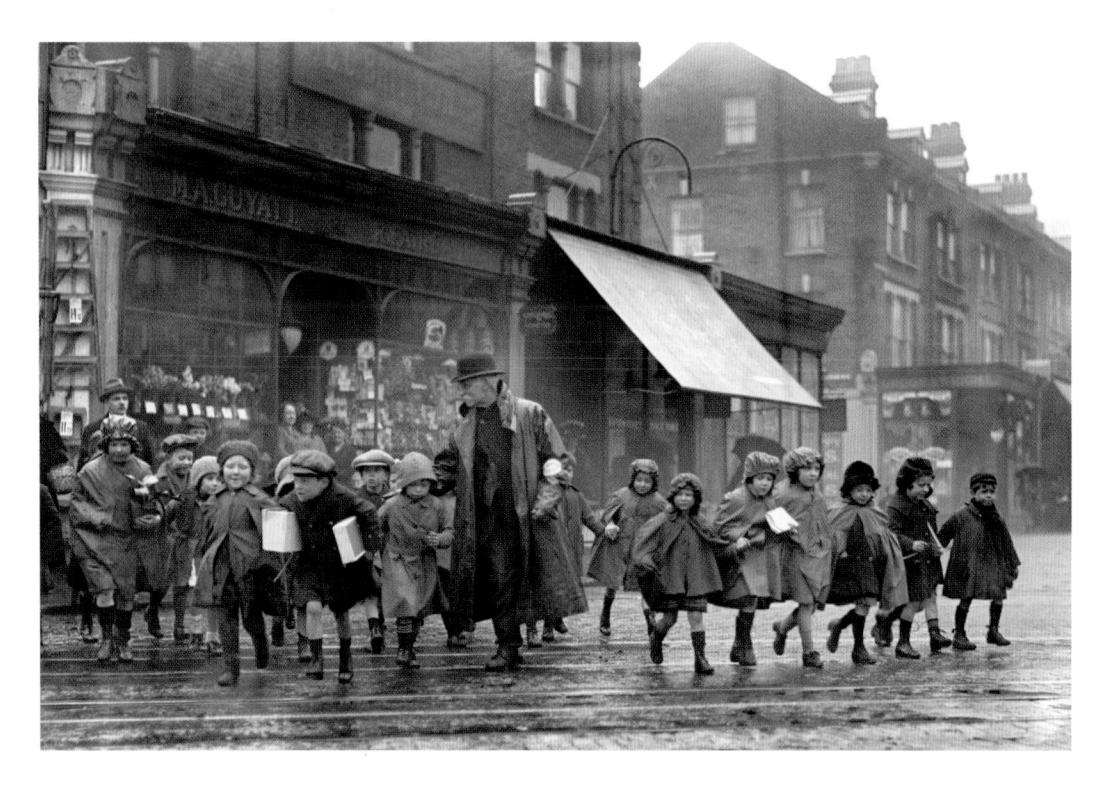

Volunteer crossing guard Mr Cannell shepherds children across the road at Tufnell Park. Many such volunteer guards were old soldiers.

6 November 1922

Facing page: A dustman in Kentish Town. Motorised dustcarts first appeared on the streets of the capital in the 1920s.

13 July 1925

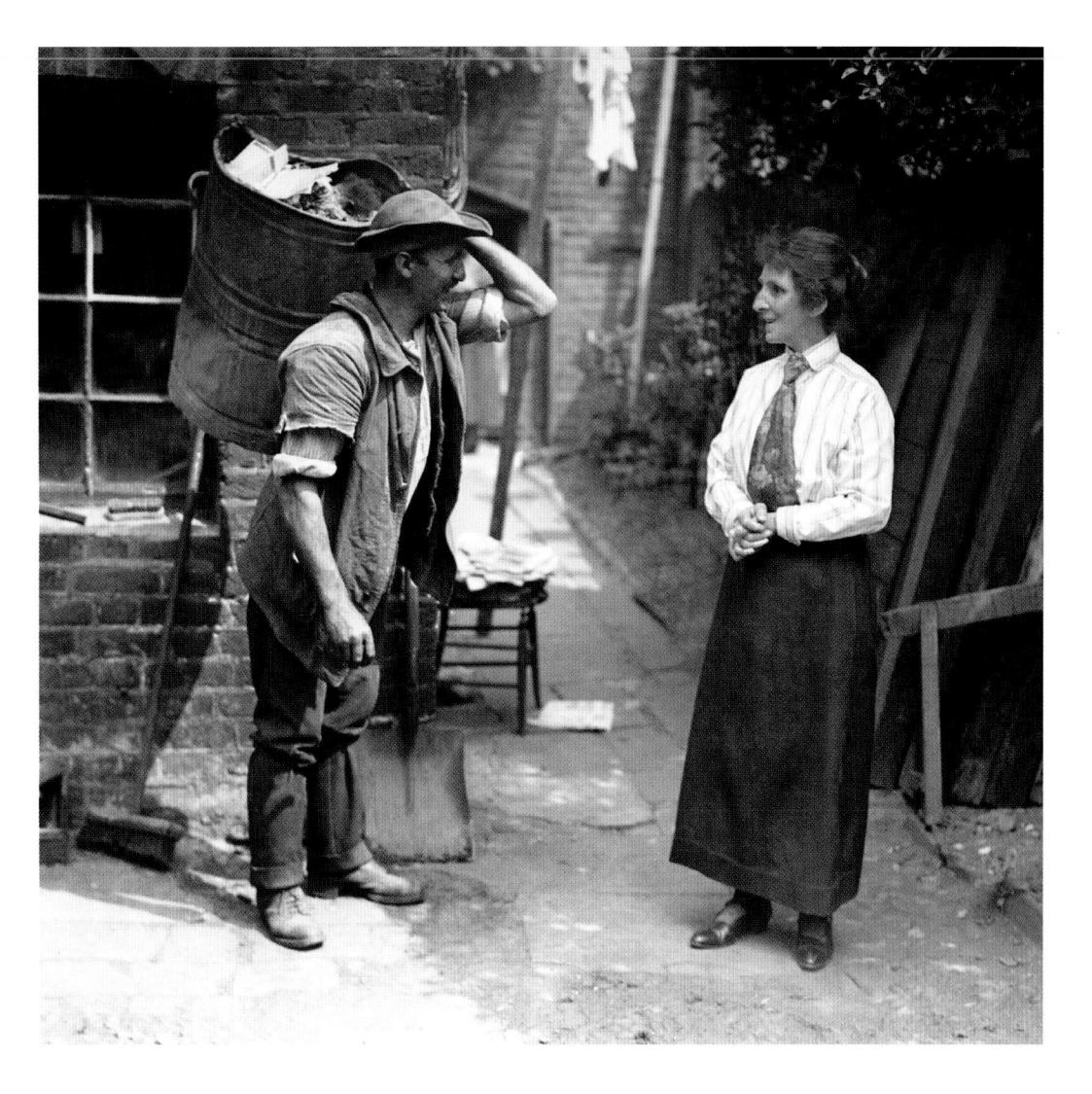

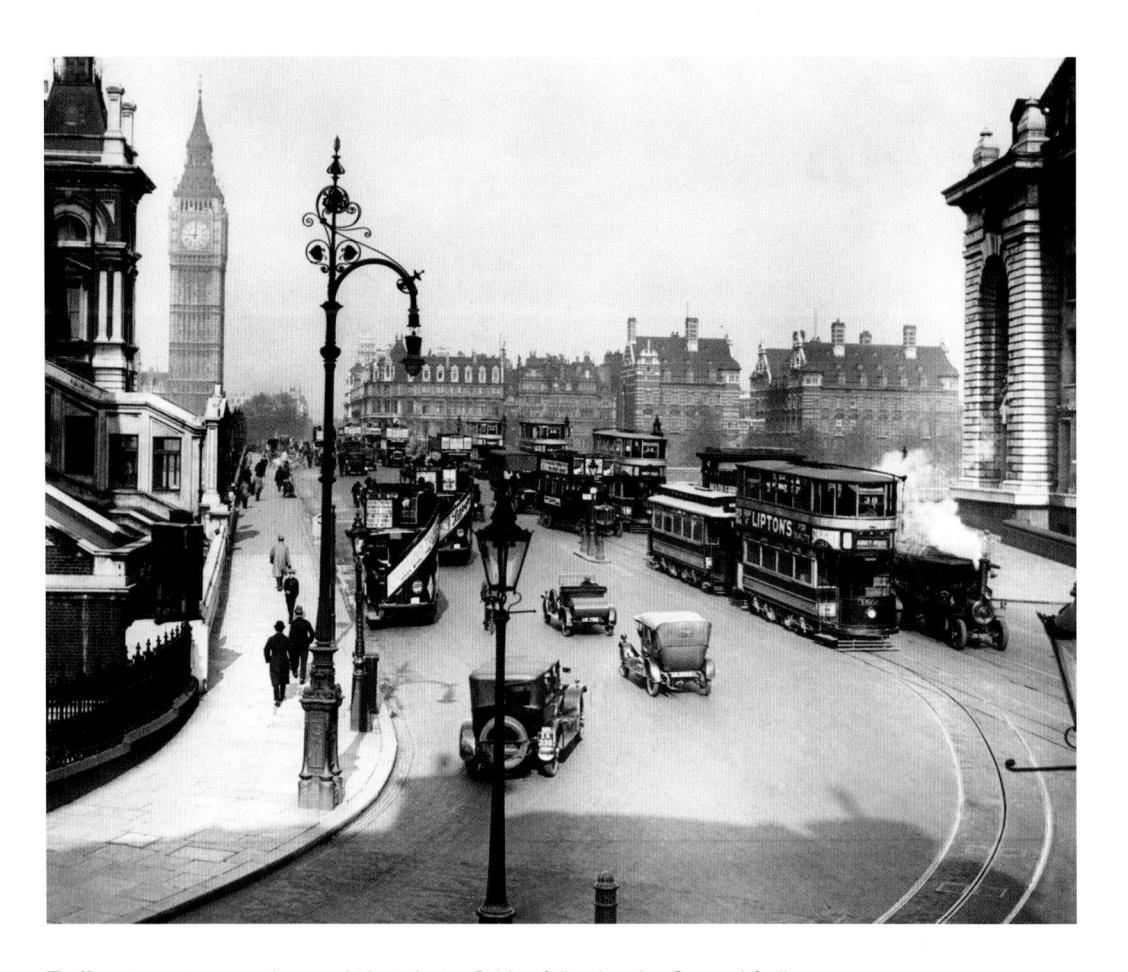

Traffic returns to normal across Westminster Bridge following the General Strike. ${\bf 18~May~1926}$

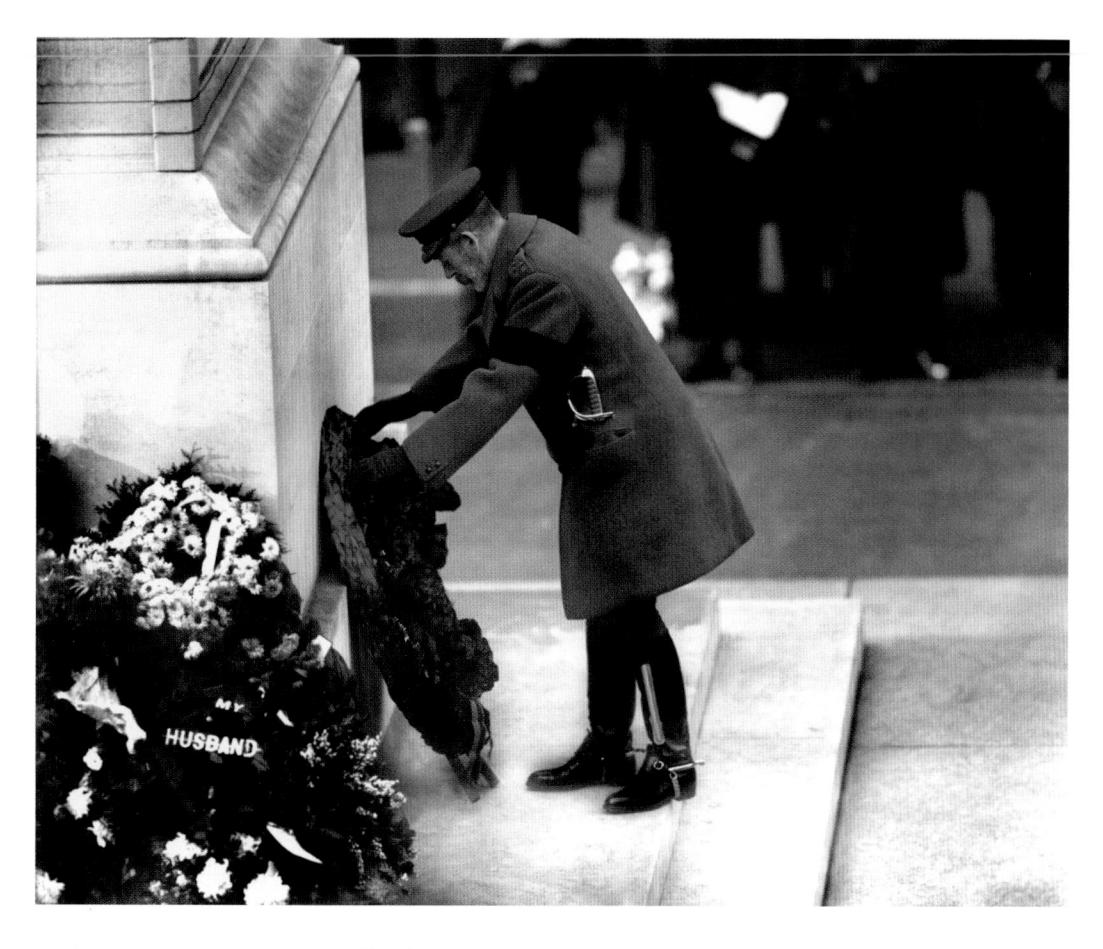

King George V places his wreath at the Cenotaph on Armistice Day. II November 1927

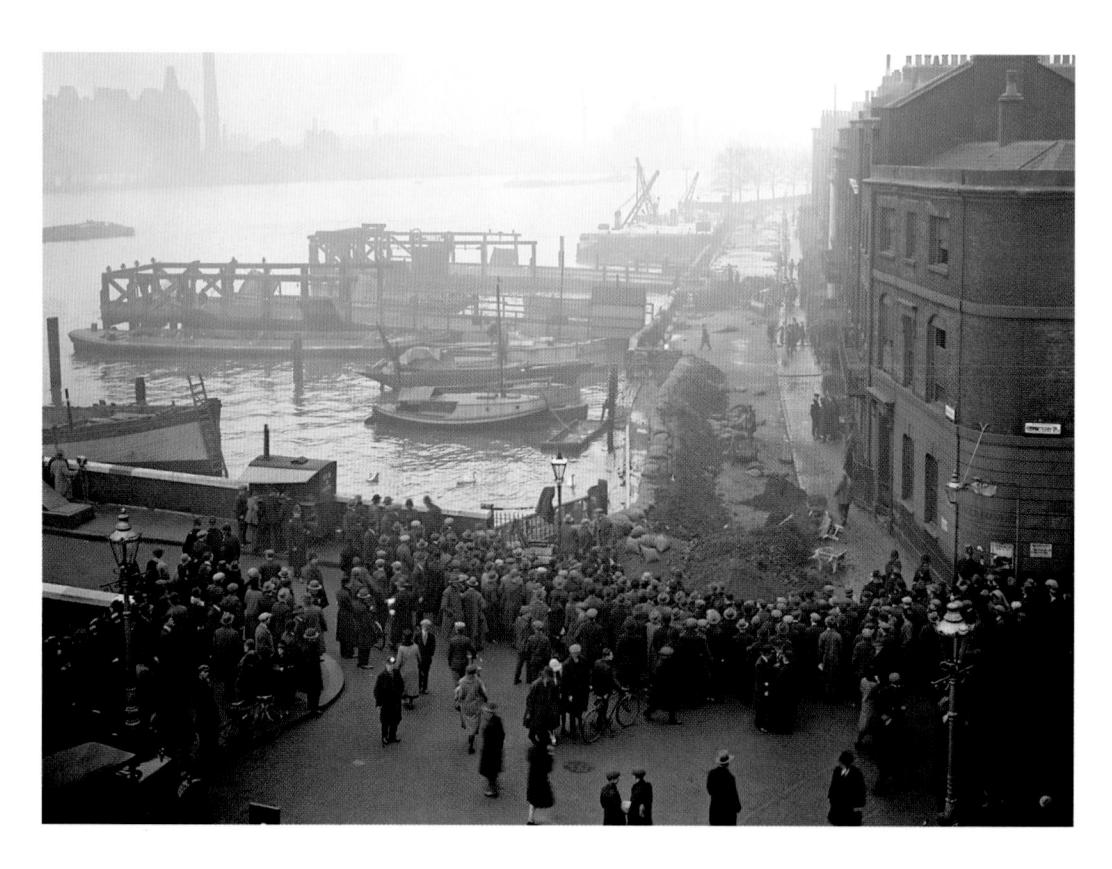

Floods at Grosvenor Road, Westminster. On 6 January 1928, the flood tide on the Thames turned out to be six feet above the predicted level. Many low-lying areas on the river flooded, including Battersea, Pimlico (where the first breach occurred, flooding the Tate Gallery) and Westminster. Further up the river, at Lambeth, the defences gave way and drowned 14 people in their basement flats.

7 January 1928

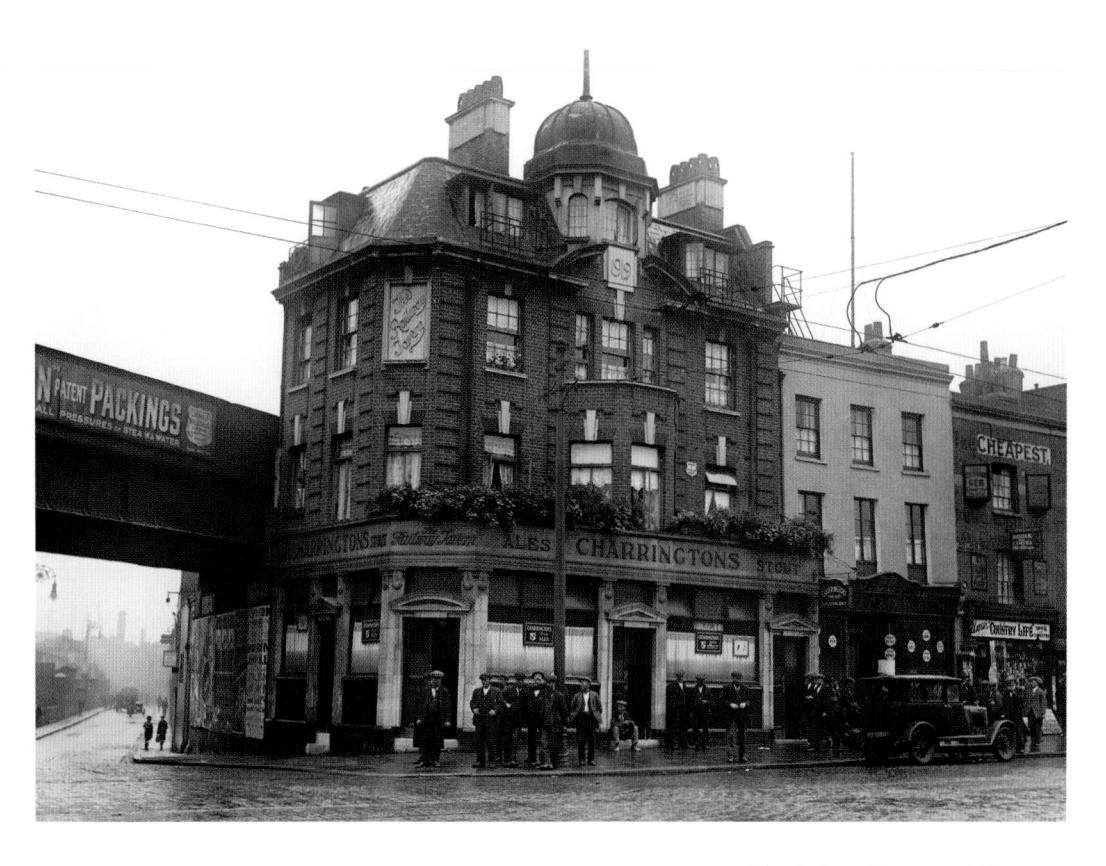

The Railway Tavern on West India Dock Road, Limehouse. August 1928

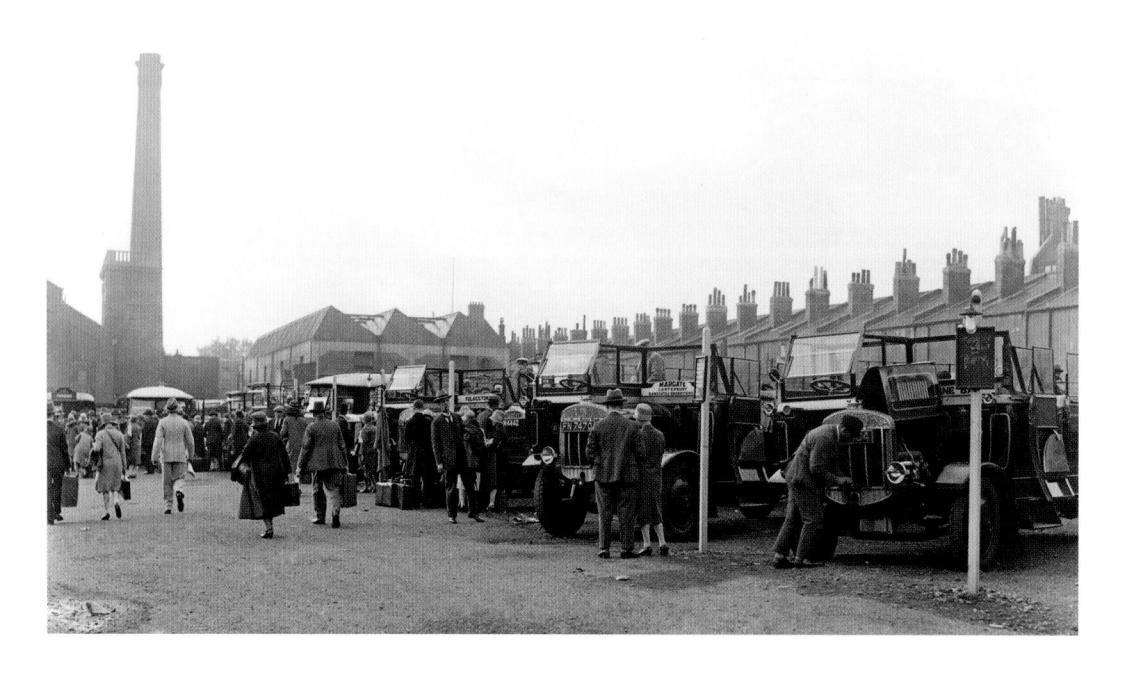

London Coastal Coaches' charabancs at the coach station on Lupus Road, Westminster, prepare for day trips to the coast.

August 1928

Facing page: Upgrading work at Piccadilly Circus station.

September 1928

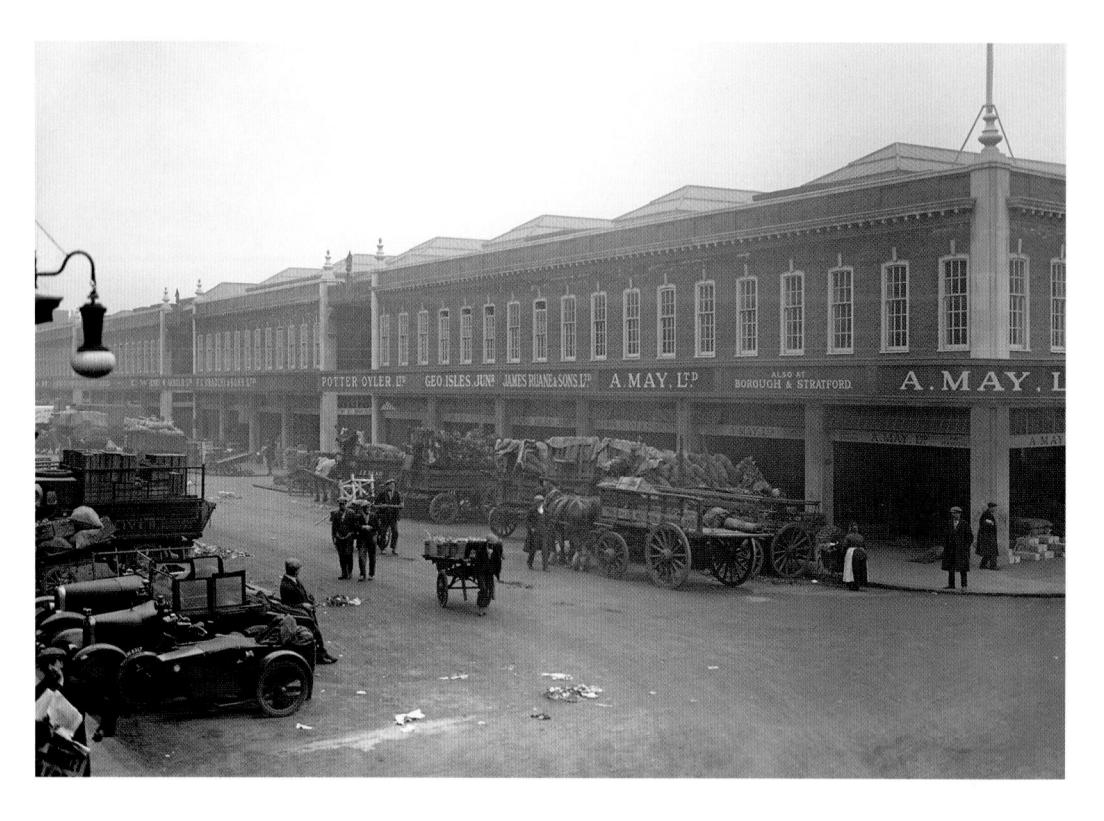

The new £2m Spitalfields Market stands ready to open. Claimed, at the time, to be Europe's finest market, the new development on the site of the original market took nine years to build.

2 October 1928

Facing page: A mobile greengrocer demonstrates an economical way to deliver.
February 1929

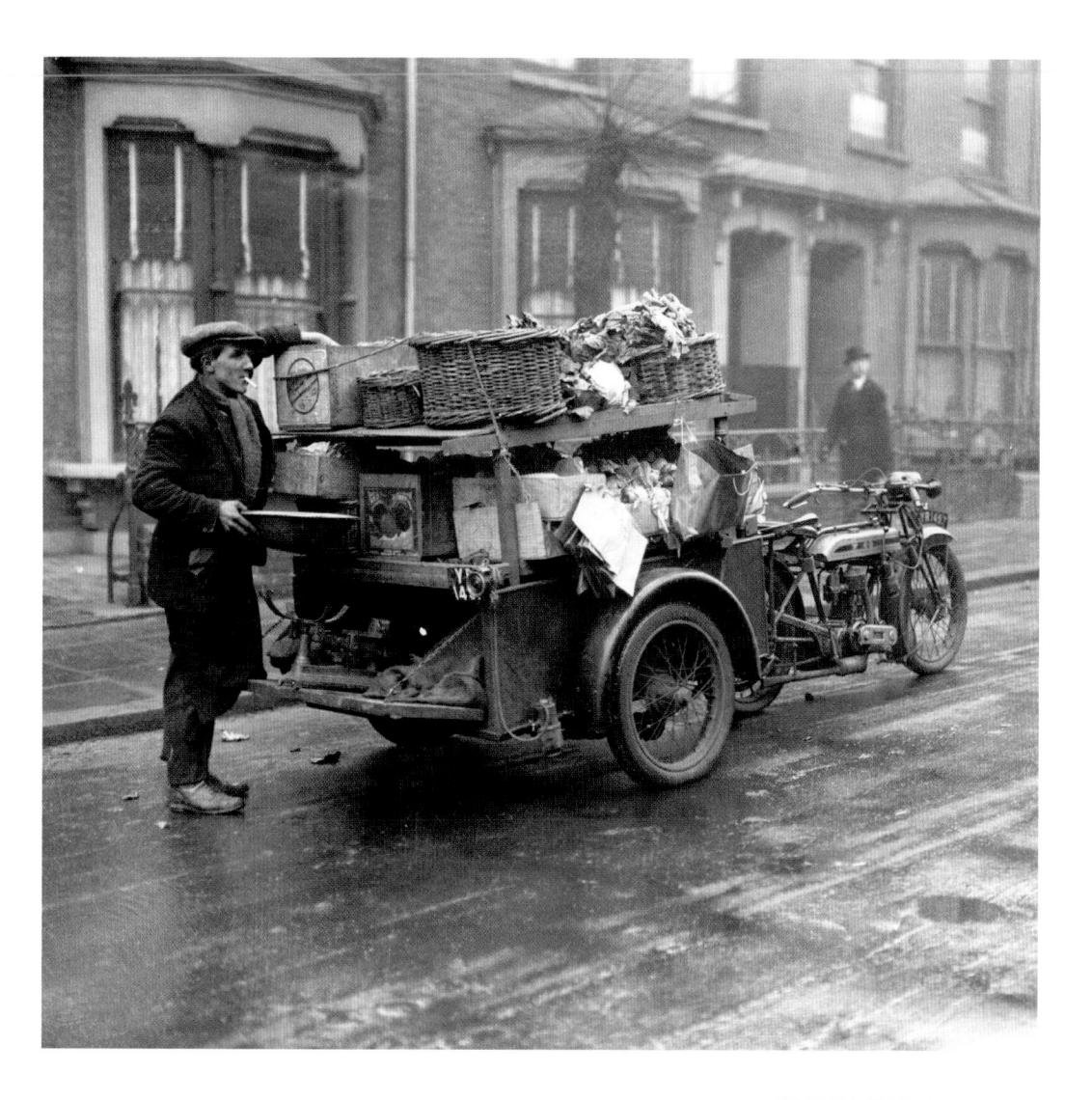

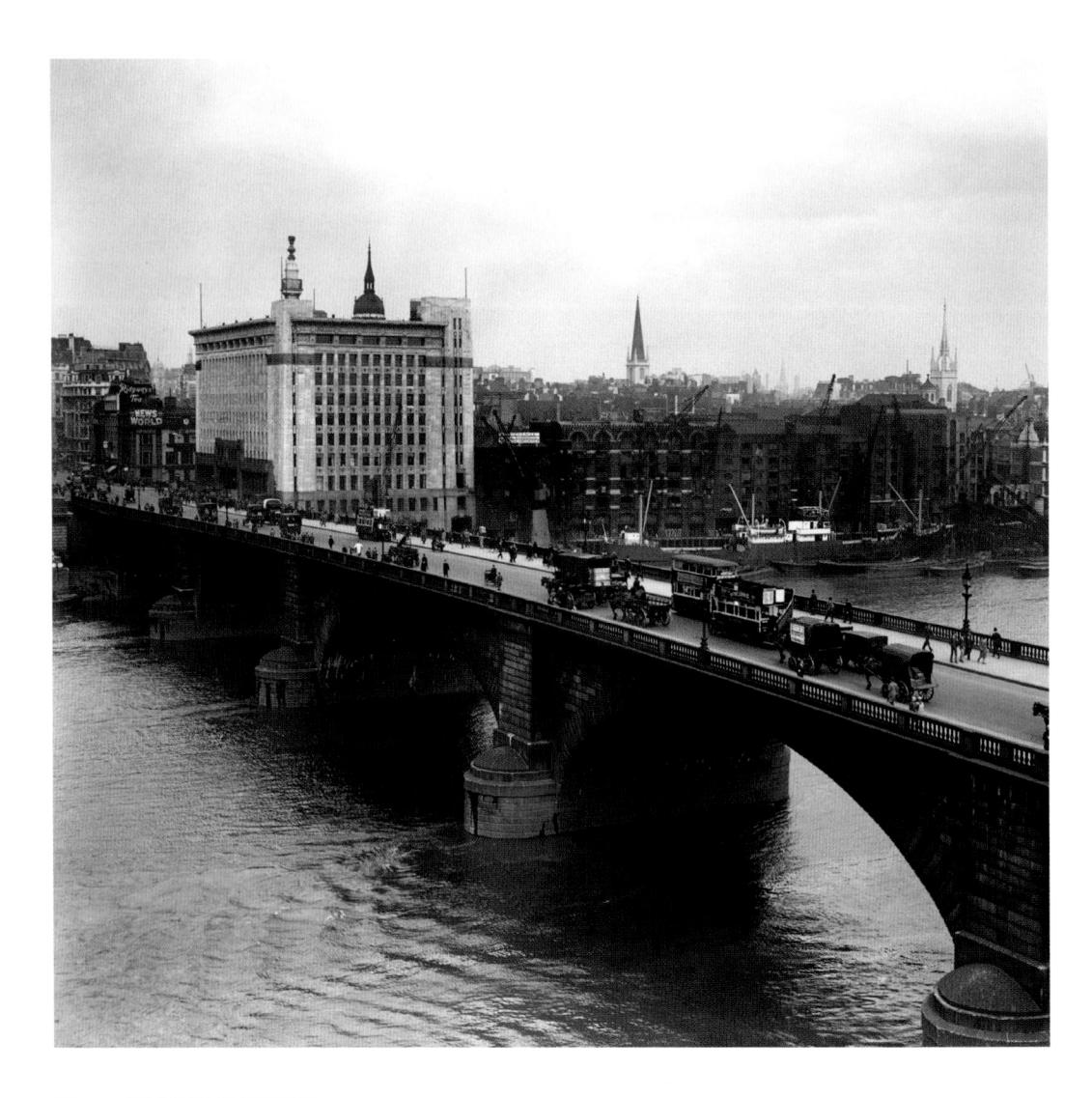

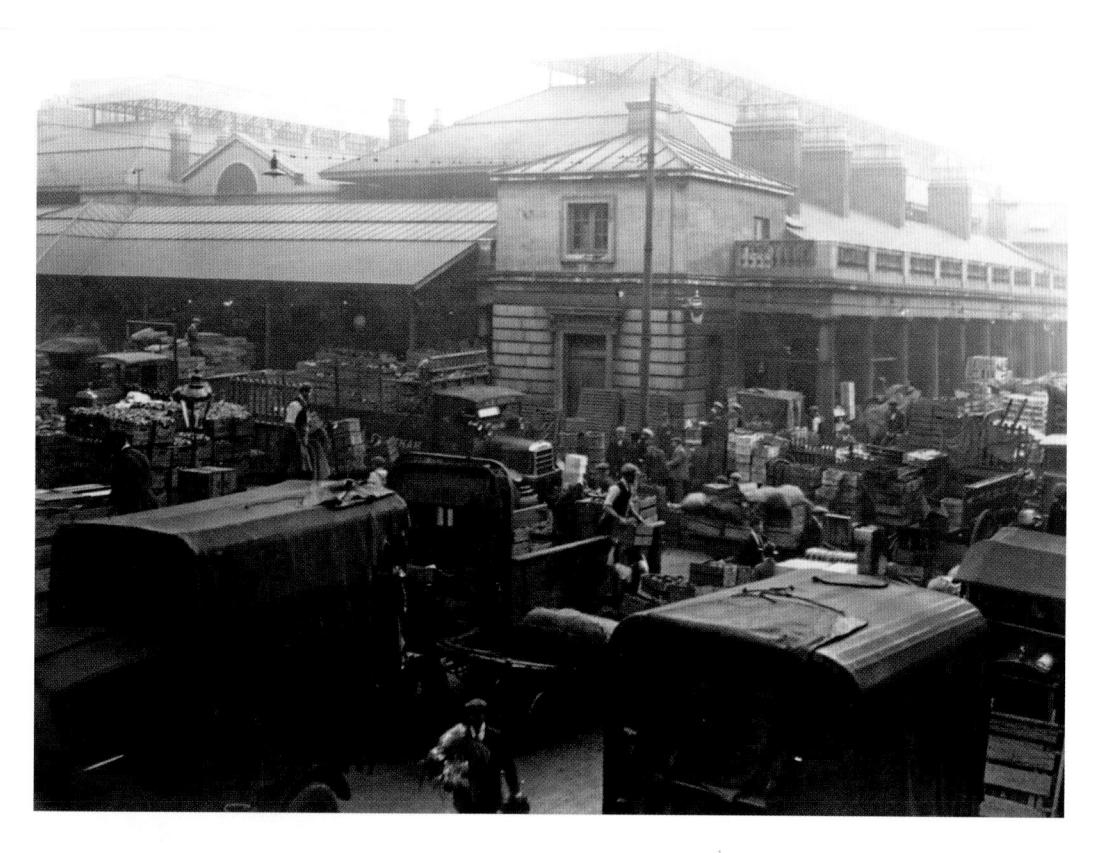

Facing page: John Rennie's London Bridge, dismantled in 1972 and now a tourist attraction in Lake Havasu City, Arizona. Claims that the buyer, Robert P McCulloch, was expecting Tower Bridge were later denied by the Arizona businessman. May 1929

Covent Garden. The famous market was moved to Nine Elms in the 1960s. 10 May 1929

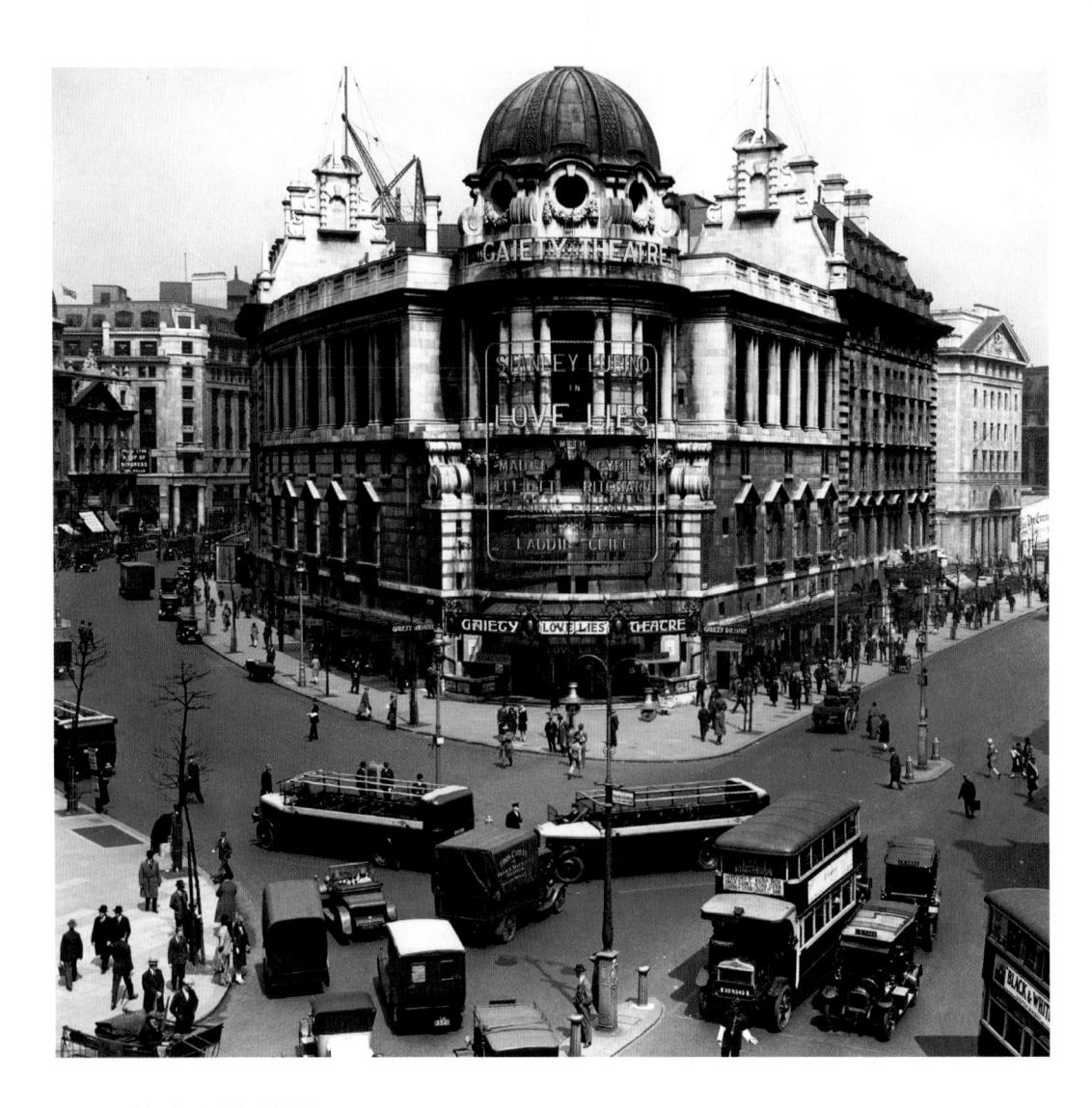

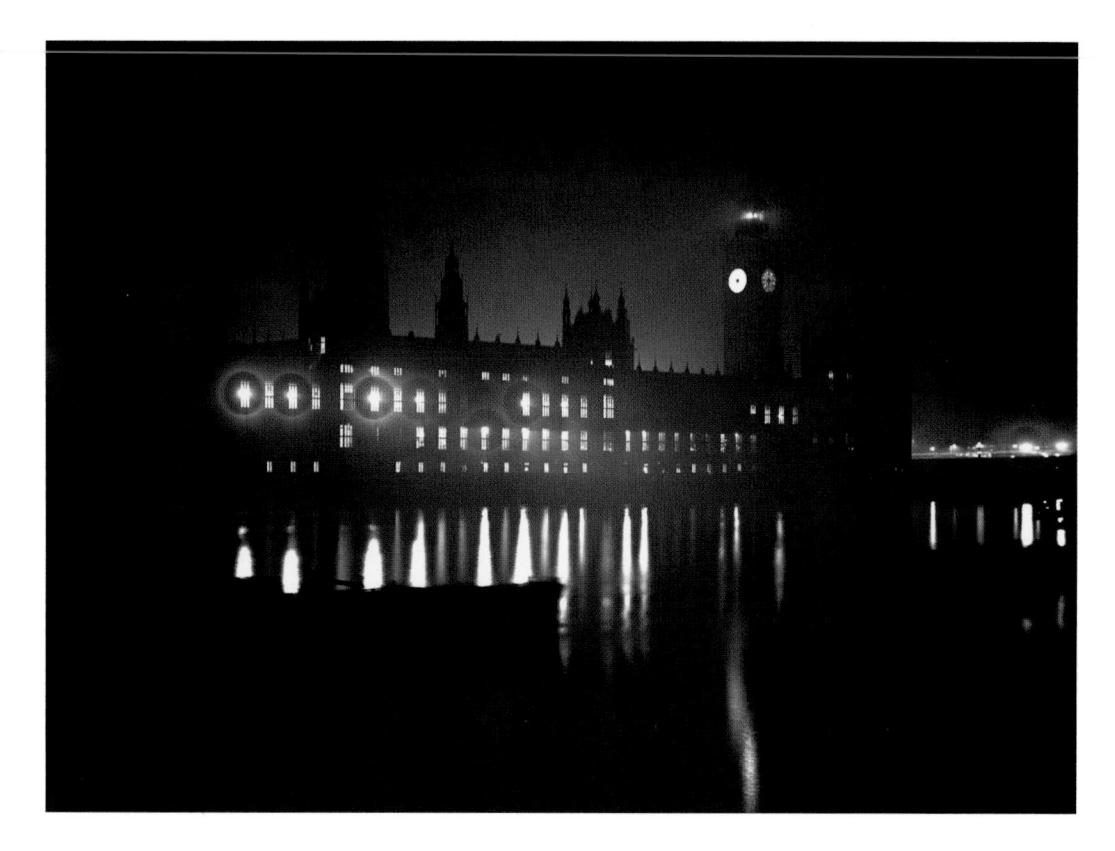

Facing page: The Gaiety Theatre on the corner of The Strand and Aldwych.

and Aldwych. Was
11 October 1929 24 N

Power returns to the Houses of Parliament after a lengthy failure during which government business was conducted by candlelight.

24 November 1929

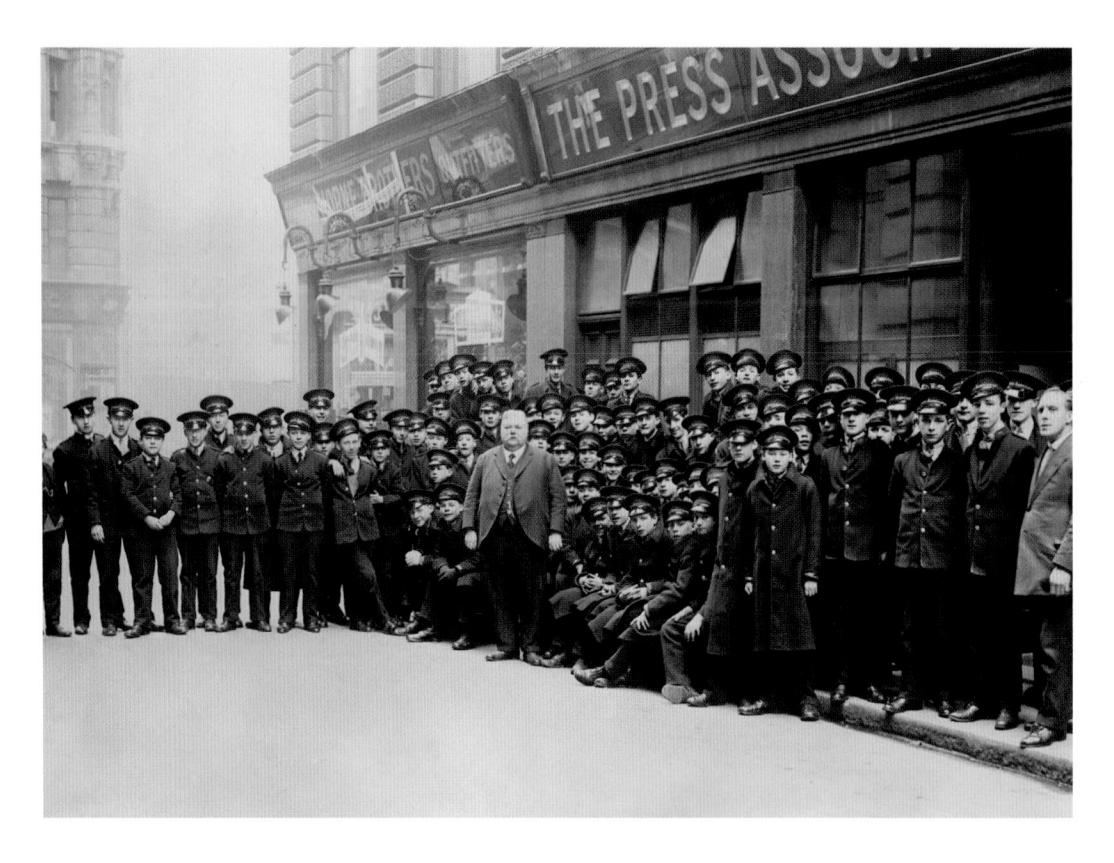

Dispatch Superintendent Walter Cattermole with Press Association messenger boys outside the PA in Fleet Street. Cattermole's small army, many of whom came from the poorest parts of London, were inspected daily. Their blue uniforms were often followed by cries of 'pick-a-narny' (pig in harness), an old Cockney term for soldiers in the regular army. Although a disciplinarian, it would take a great deal for Cattermole to fire a messenger. A big man with a big heart.

1930
Building work in the City opens up a new view of The Royal Exchange on Threadneedle Street.

18 June 1931

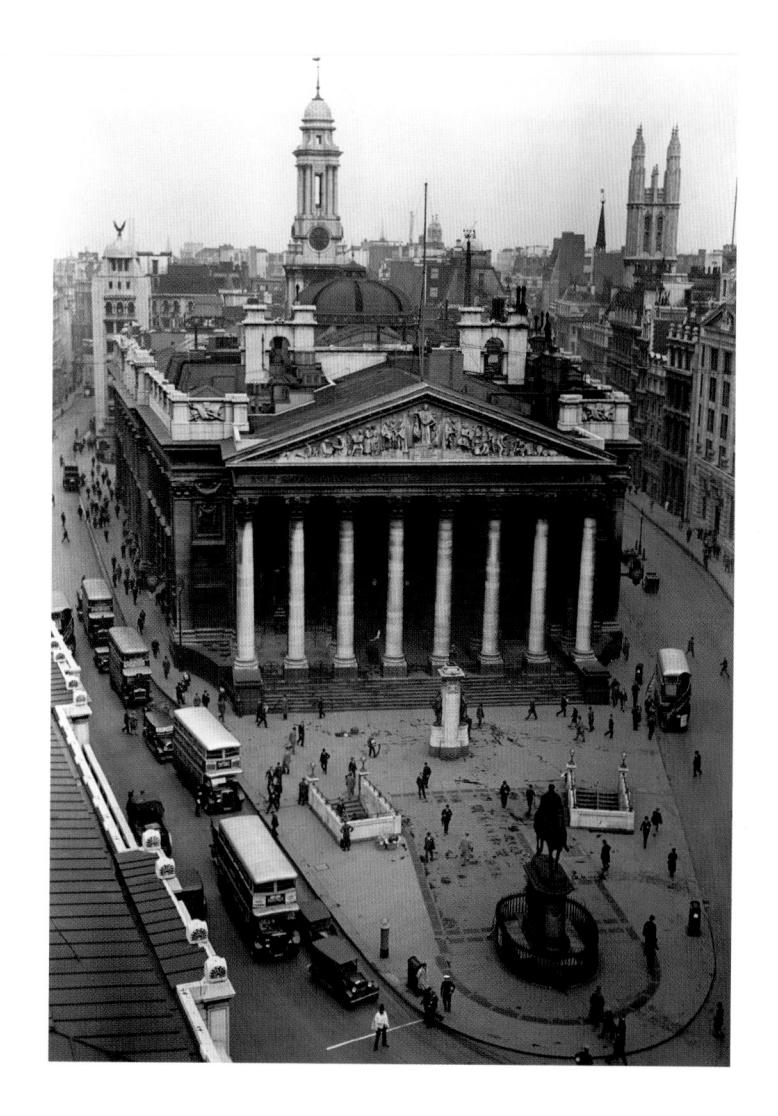

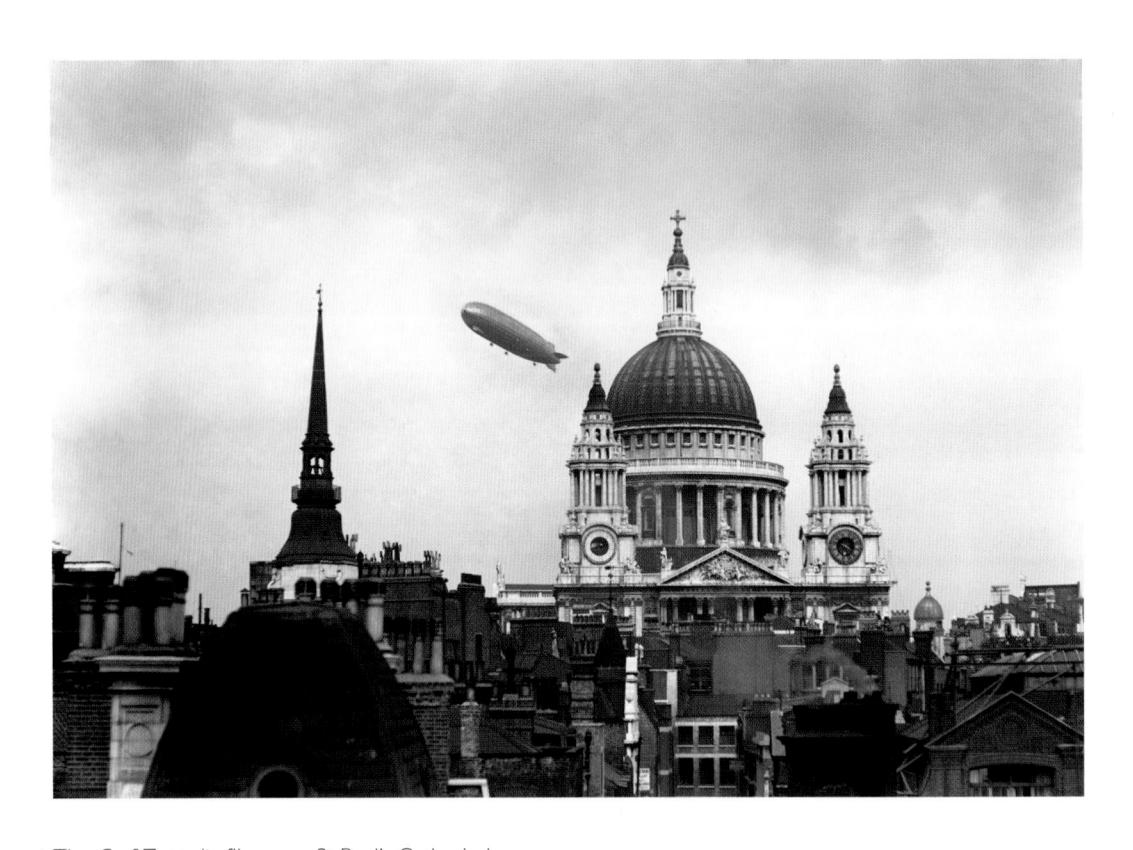

The *Graf Zeppelin* flies over St Paul's Cathedral on its 24-hour cruise around the British Isles.

18 August 1931

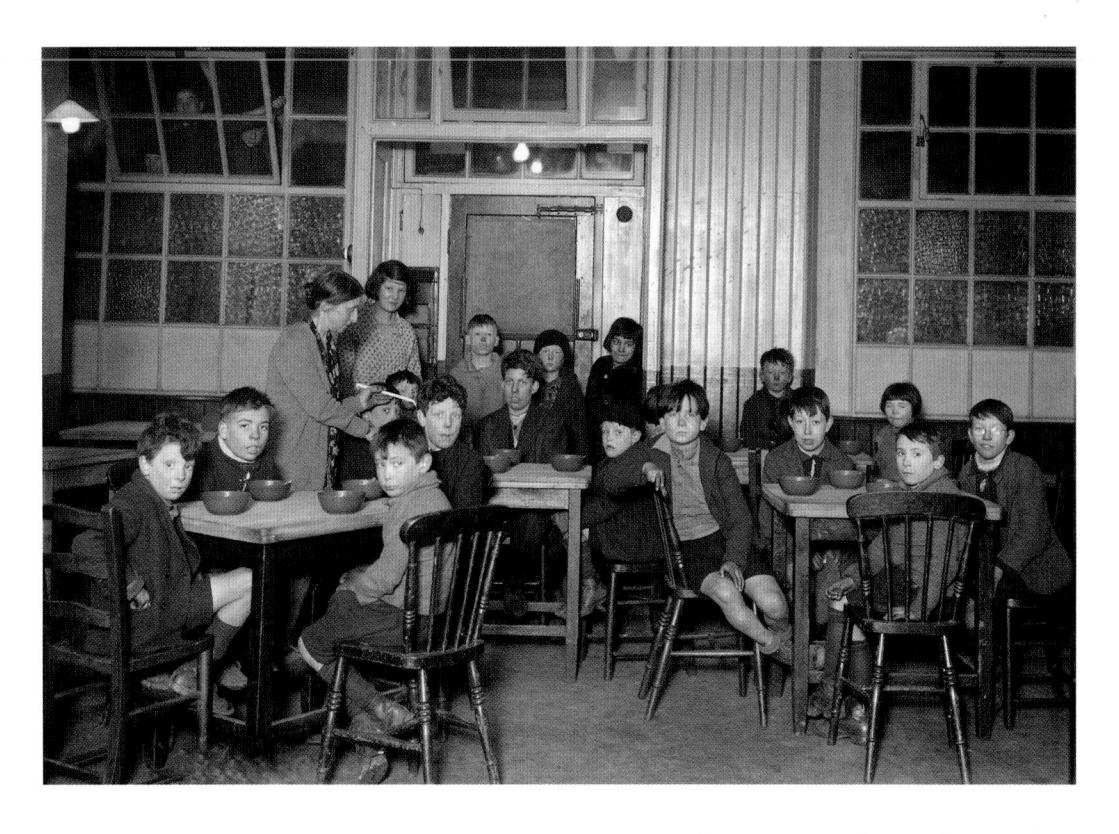

Poor children in Canning Town are fed soup to supplement their meagre diets.

25 November 1931

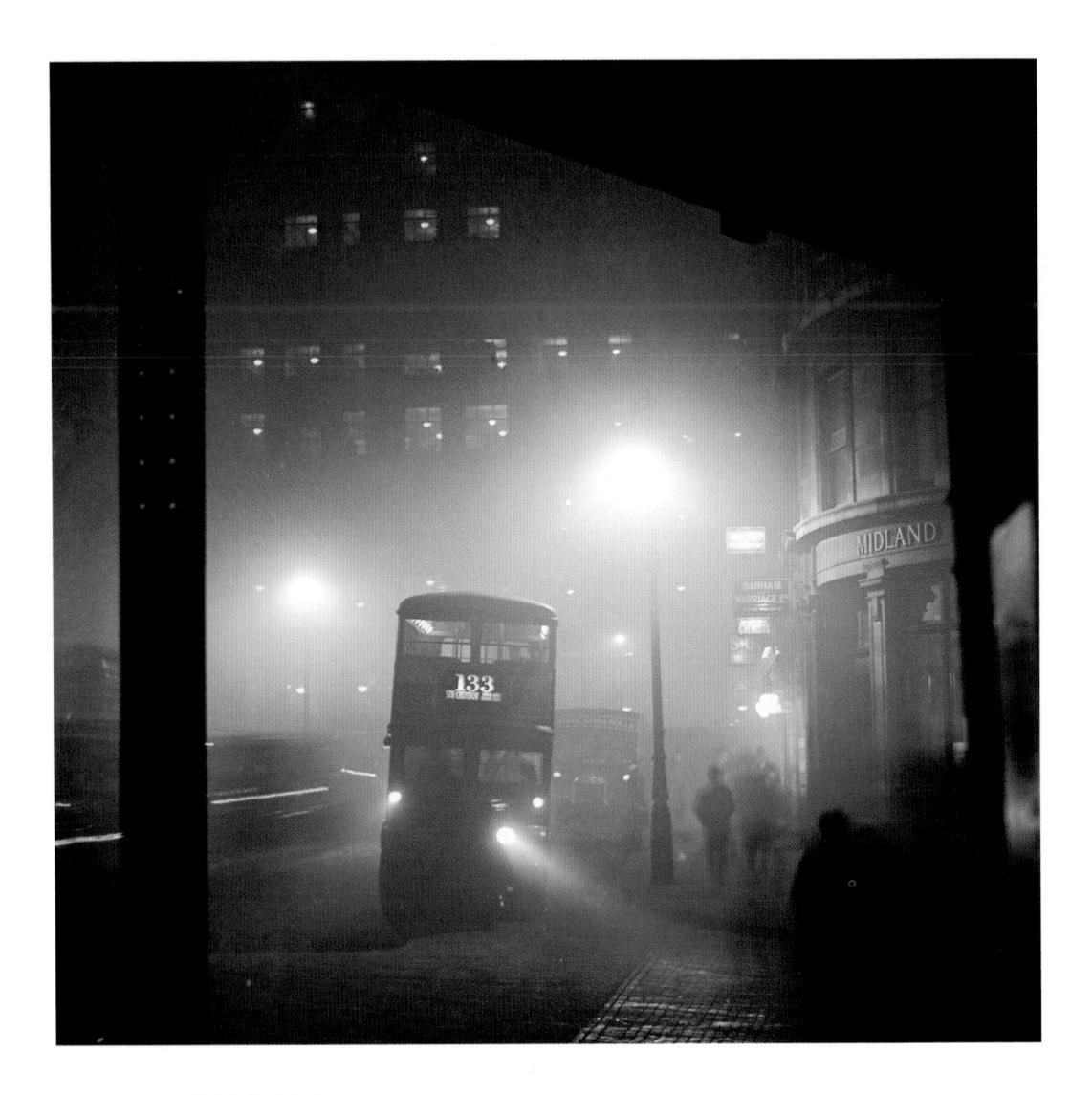

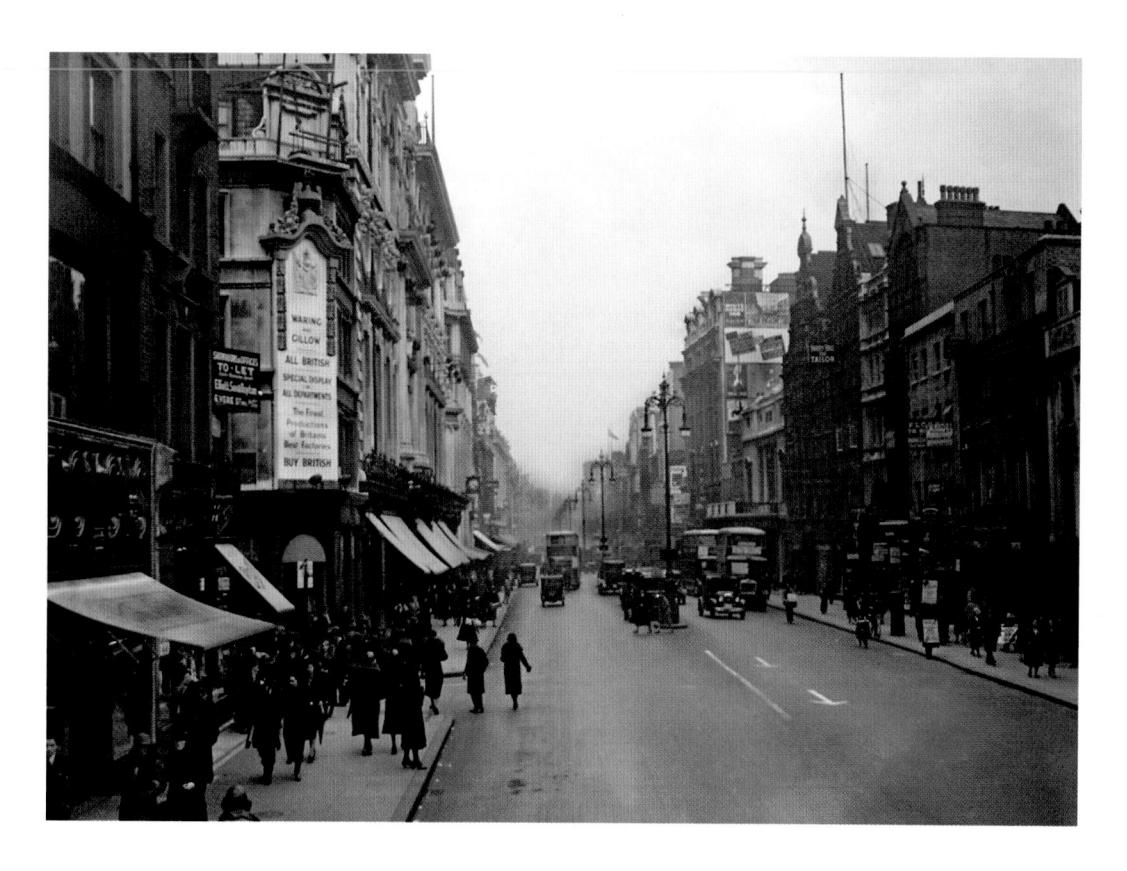

Facing page: Industrial activity and the use of coal fires to heat homes caused long bouts of thick fog known as 'pea-soupers'. These fog-bound days saw increases in road accidents, crime rates and in respiratory ailments in the poor, the old and the very young. March 1932

Oxford Street.

April 1932

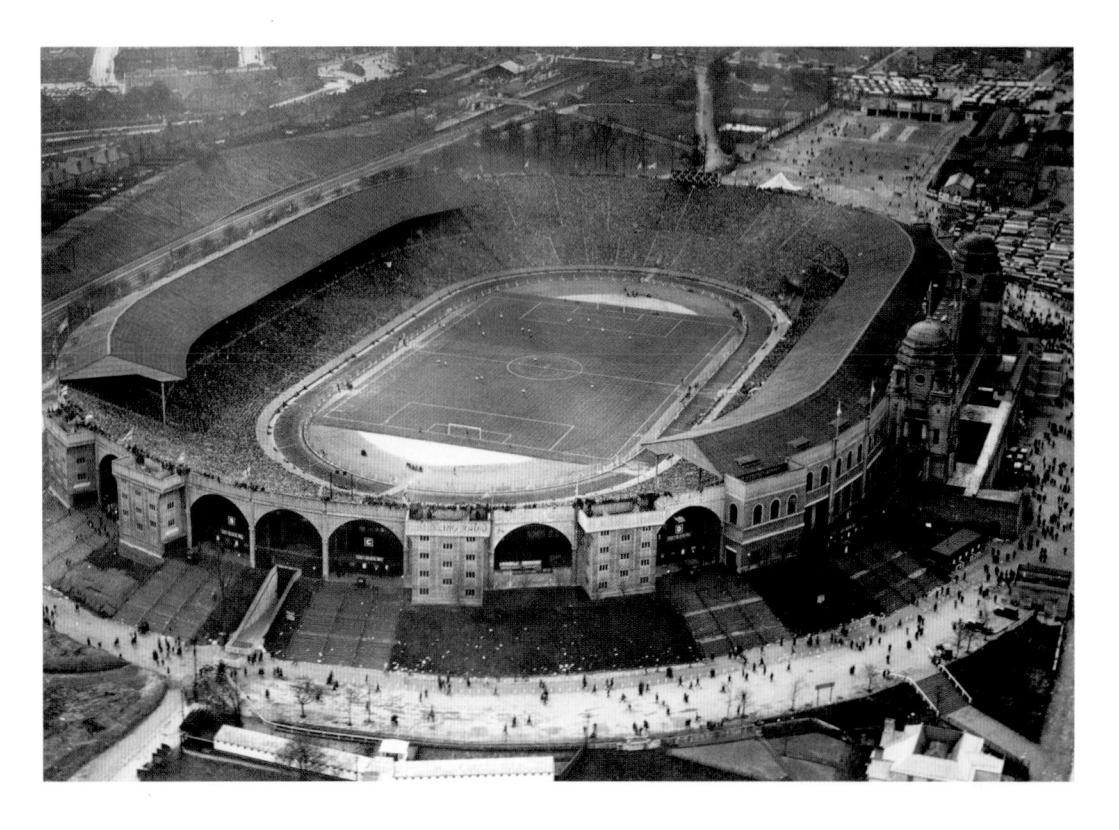

The FA Cup Final at Wembley Stadium. Arsenal v Newcastle United. 23 April 1932

Facing page: Britain's first modern traffic lights, at Ludgate Circus.

19 May 1932

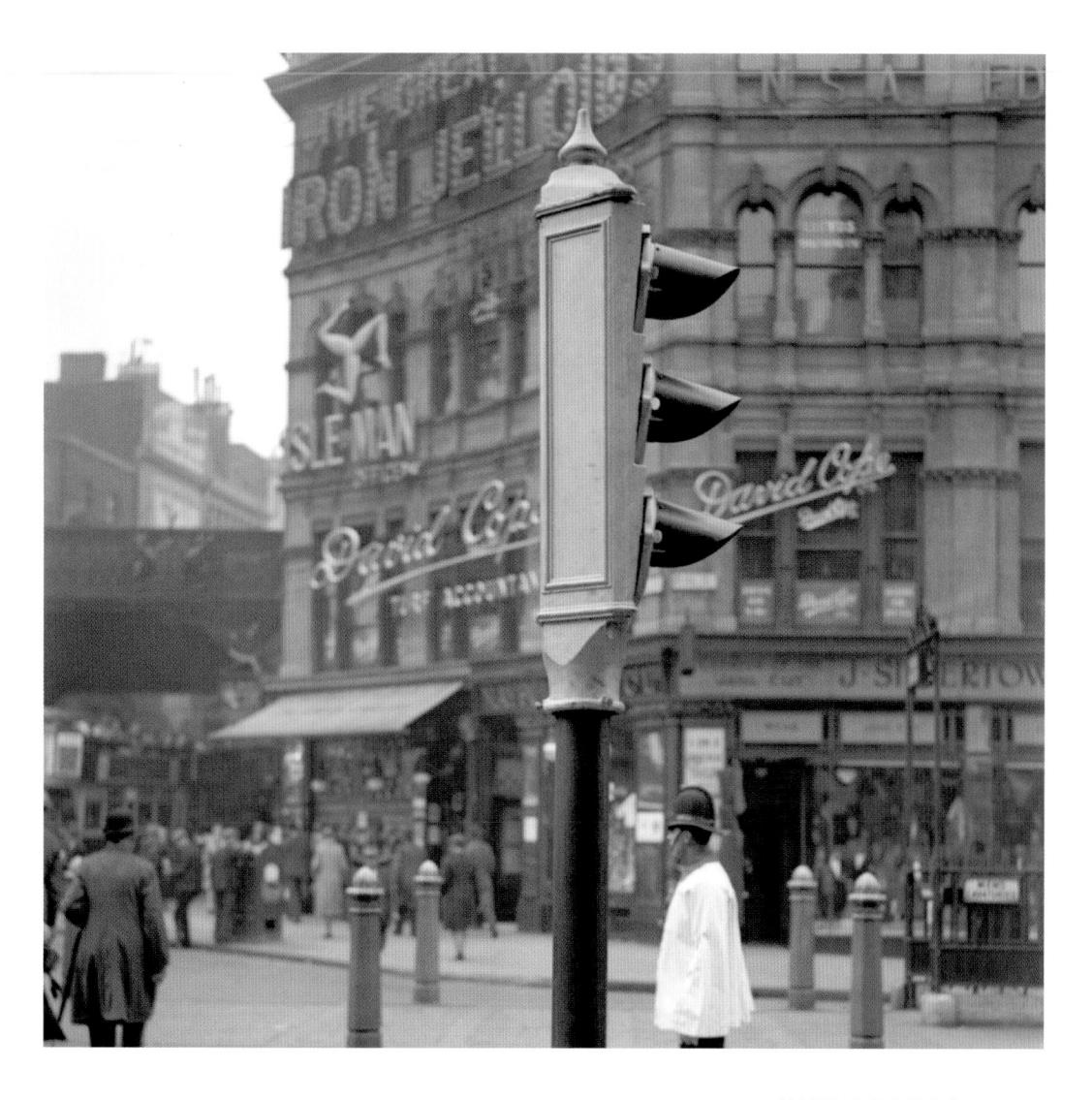

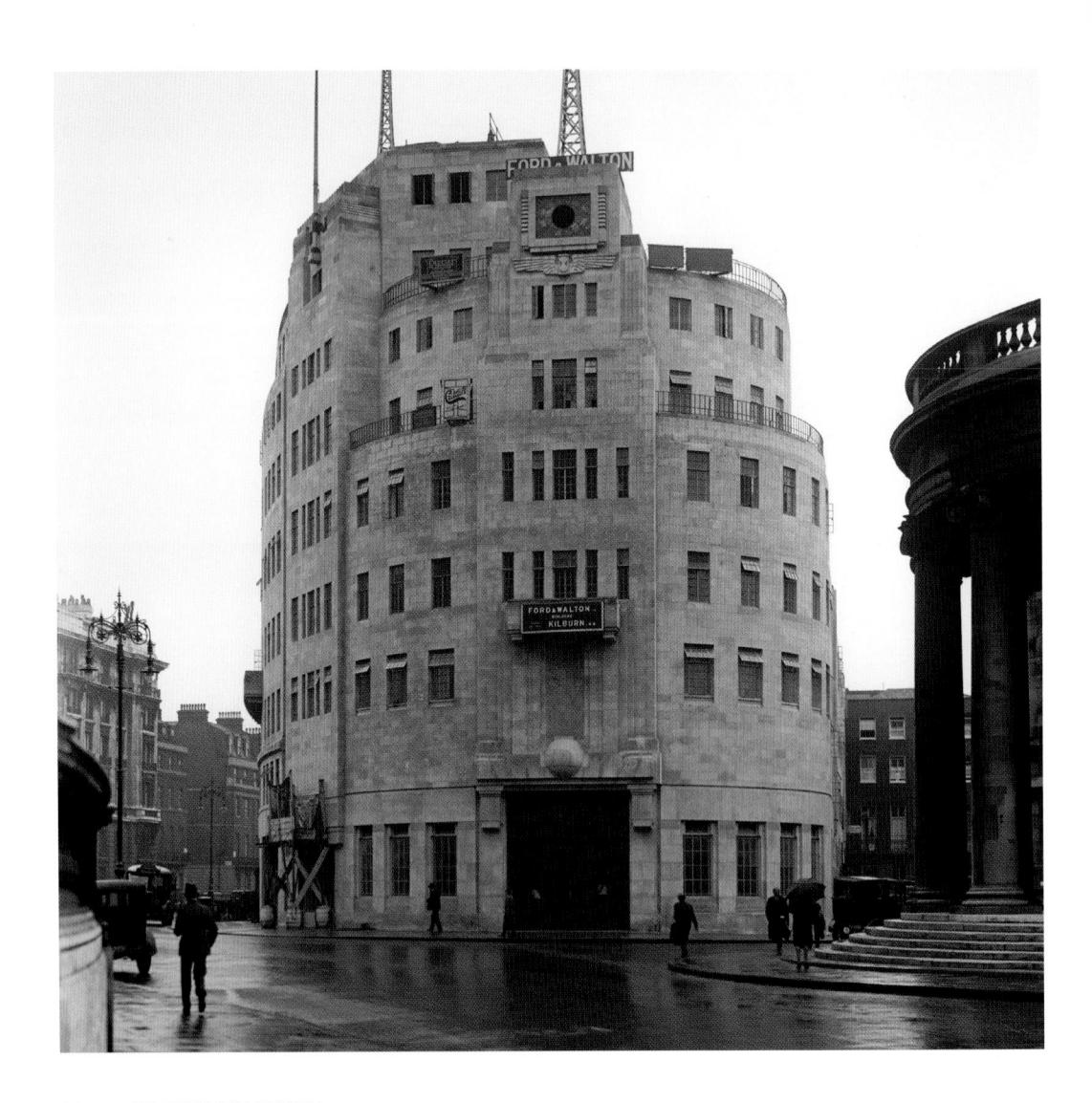

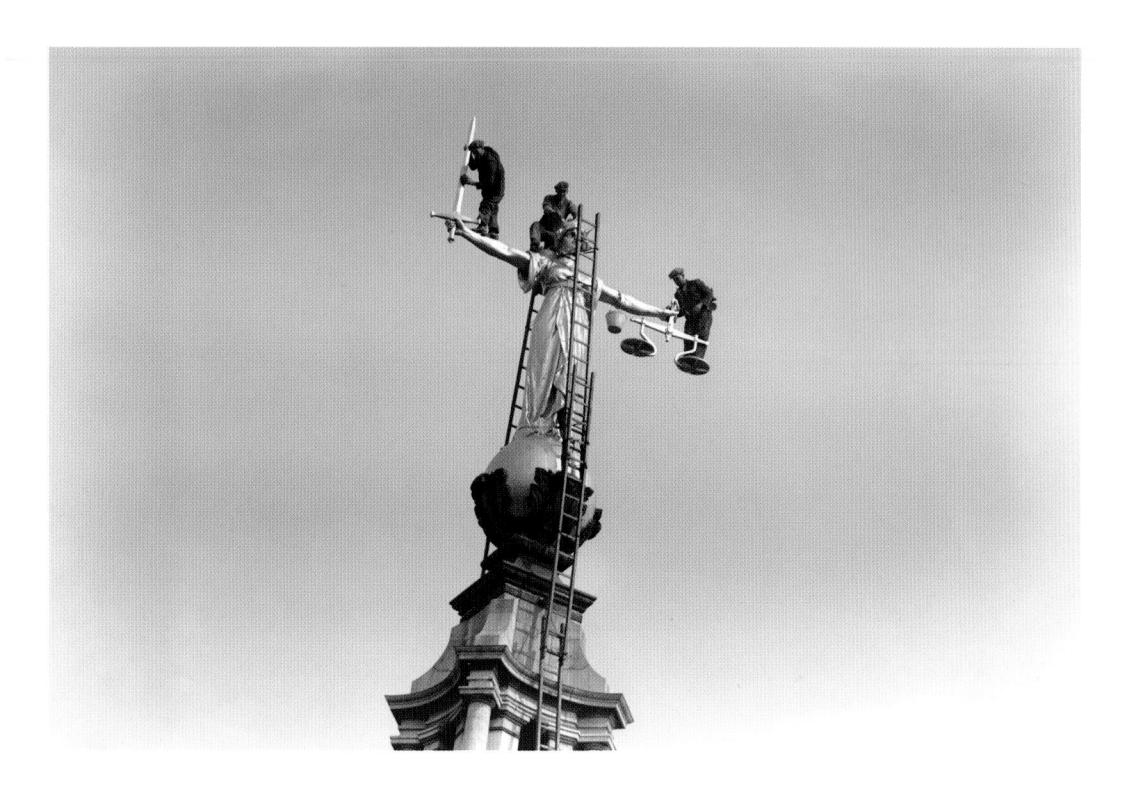

Facing page: The newly built BBC Broadcasting House. Eric Gill's controversial statuary is still a work in progress; the major pieces, Prospero and Ariel, are absent from above the front door. Gill's scaffolding is set up to work on a smaller bas-relief (L).

13 August 1932

Cleaning the Lady of Justice atop the Old Bailey.

6 January 1933

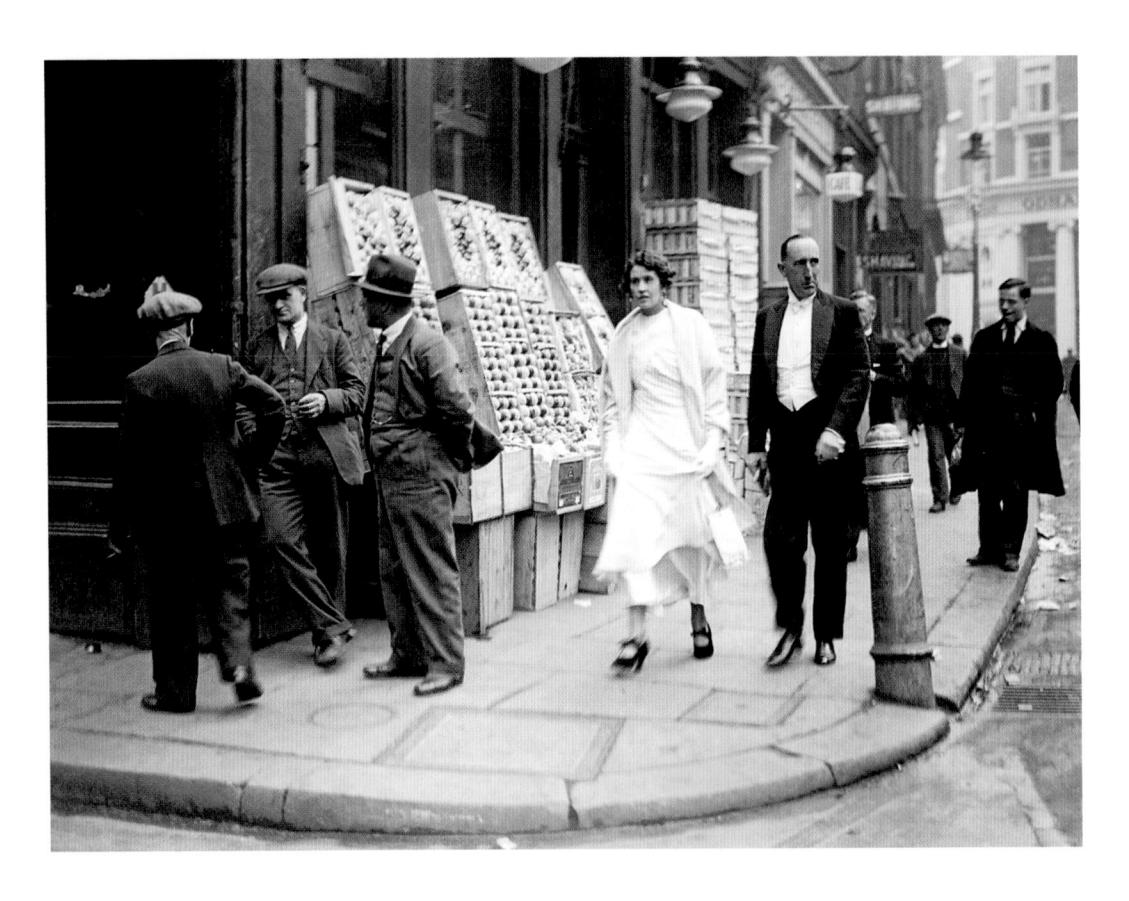

The proximity of many of London's theatres to Covent Garden market brought 'toffs' and the 'costers' into close proximity with each other. A situation used by George Bernard Shaw to set the scene for his play *Pygmalion*, an adaptation of which became the 1964 film *My Fair Lady*.

May 1933

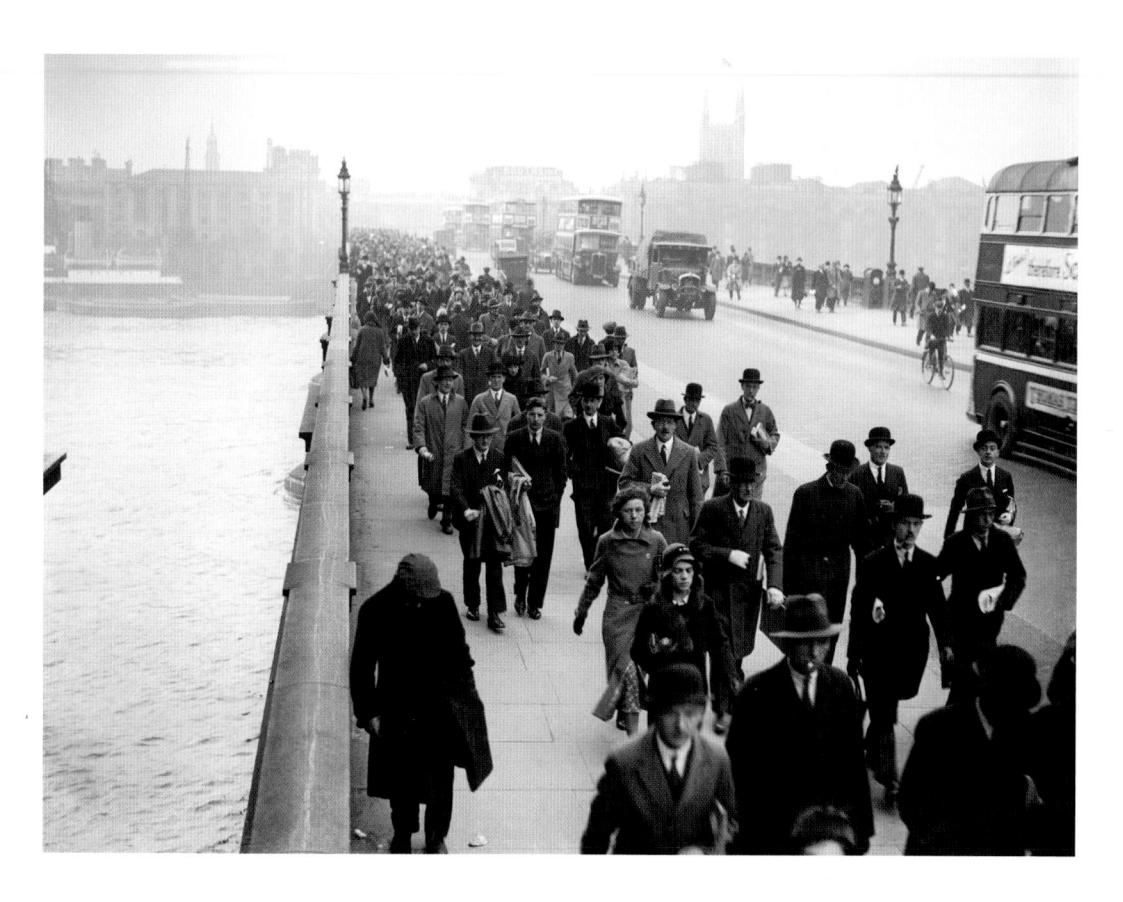

Morning rush hour on London Bridge. May 1933

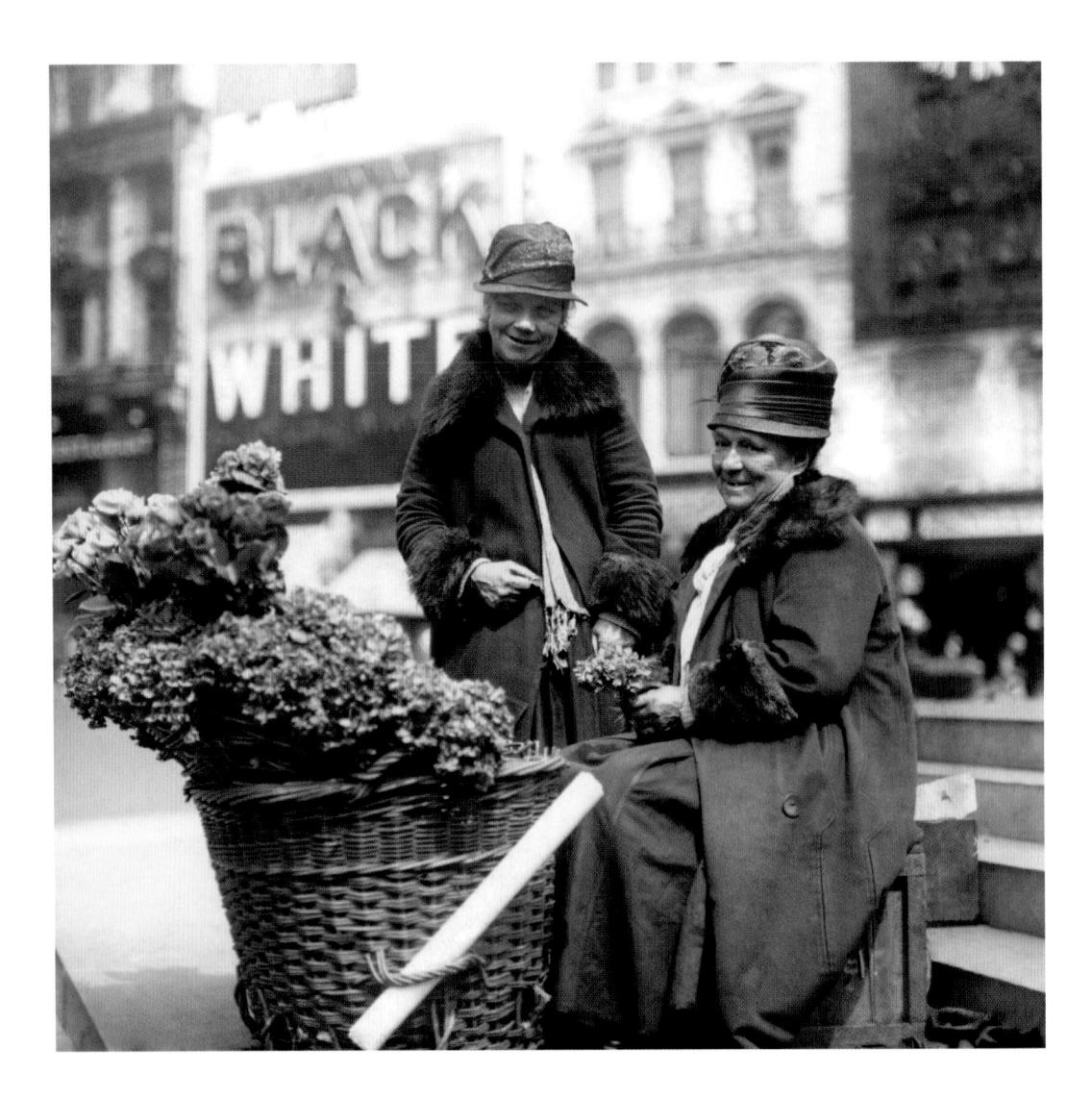

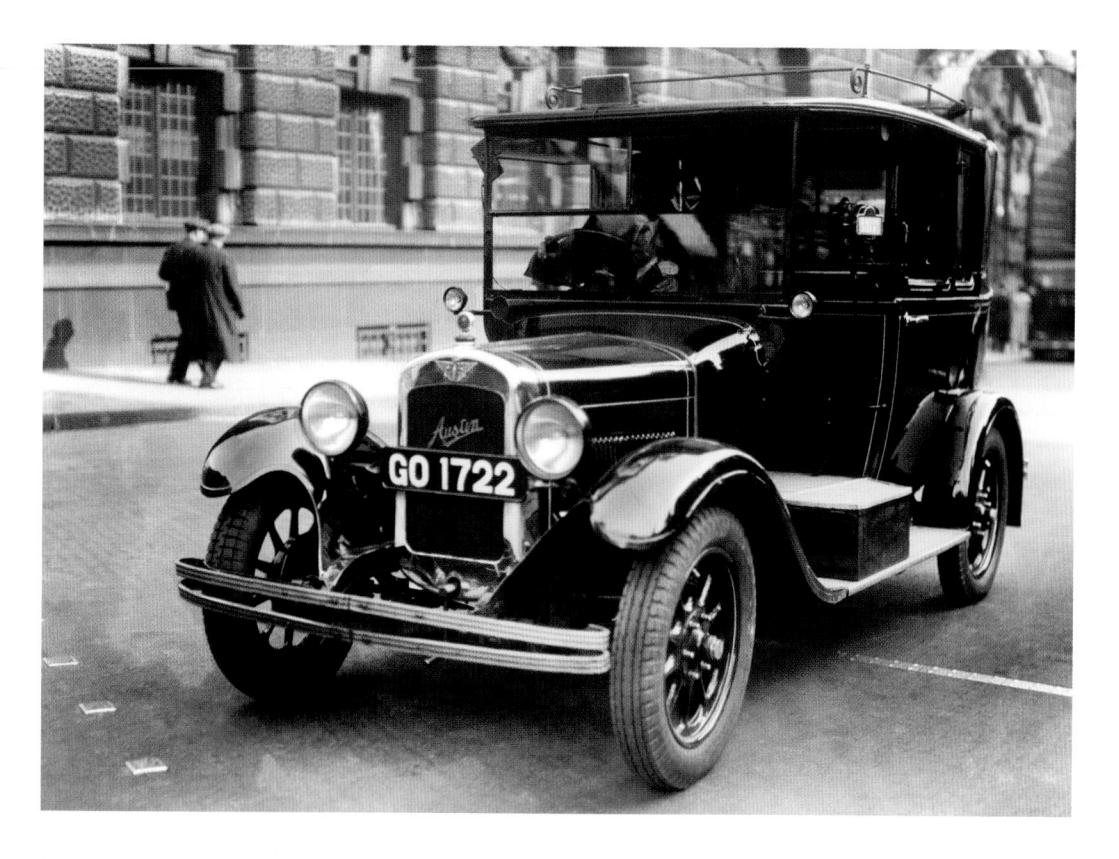

Facing page: Real life Eliza Doolittles. Lizzie Sanger and Polly Beecham (R), Piccadilly flower sellers.

12 May 1933

An Austin 7 taxi cab. May 1935

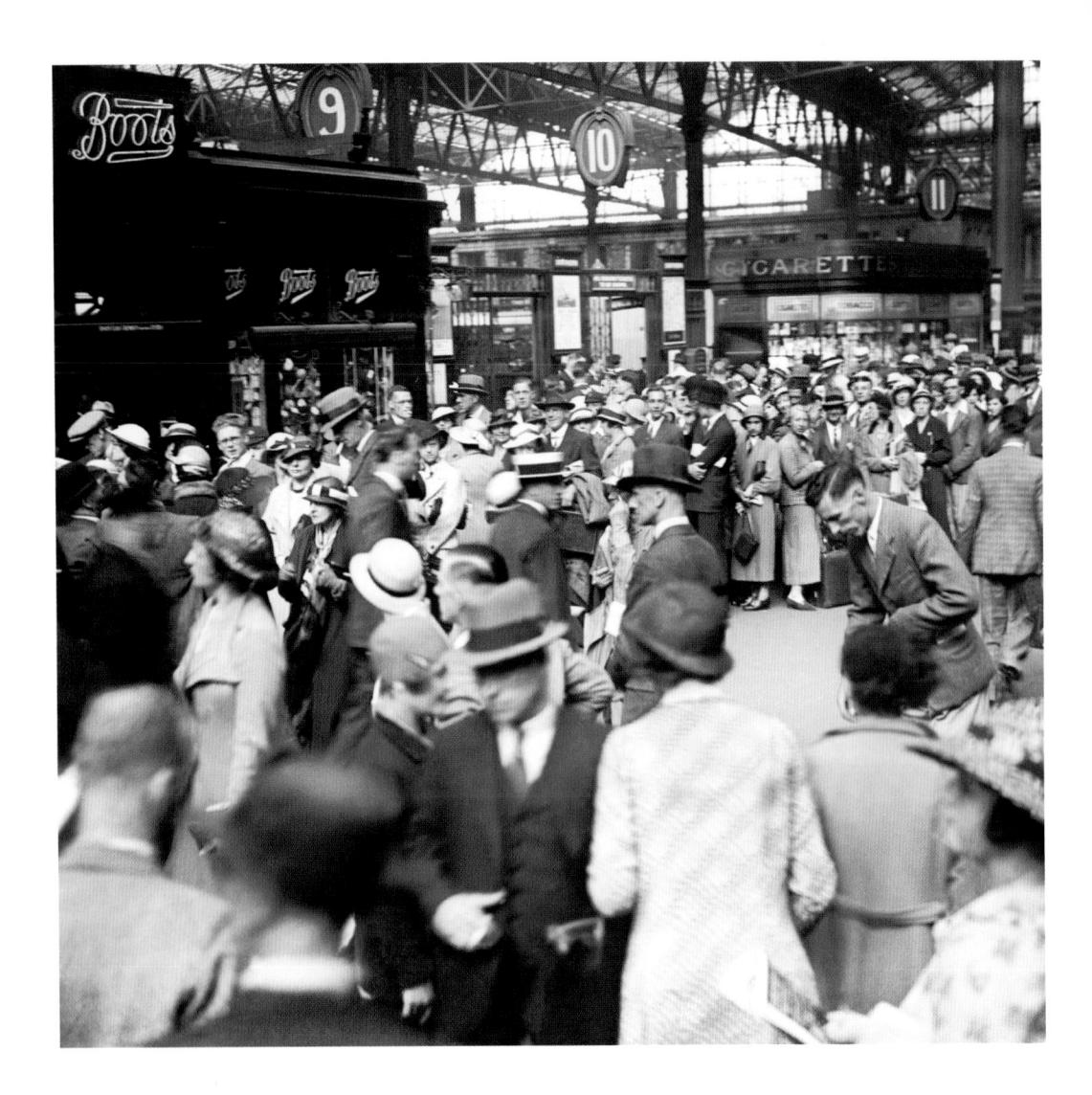

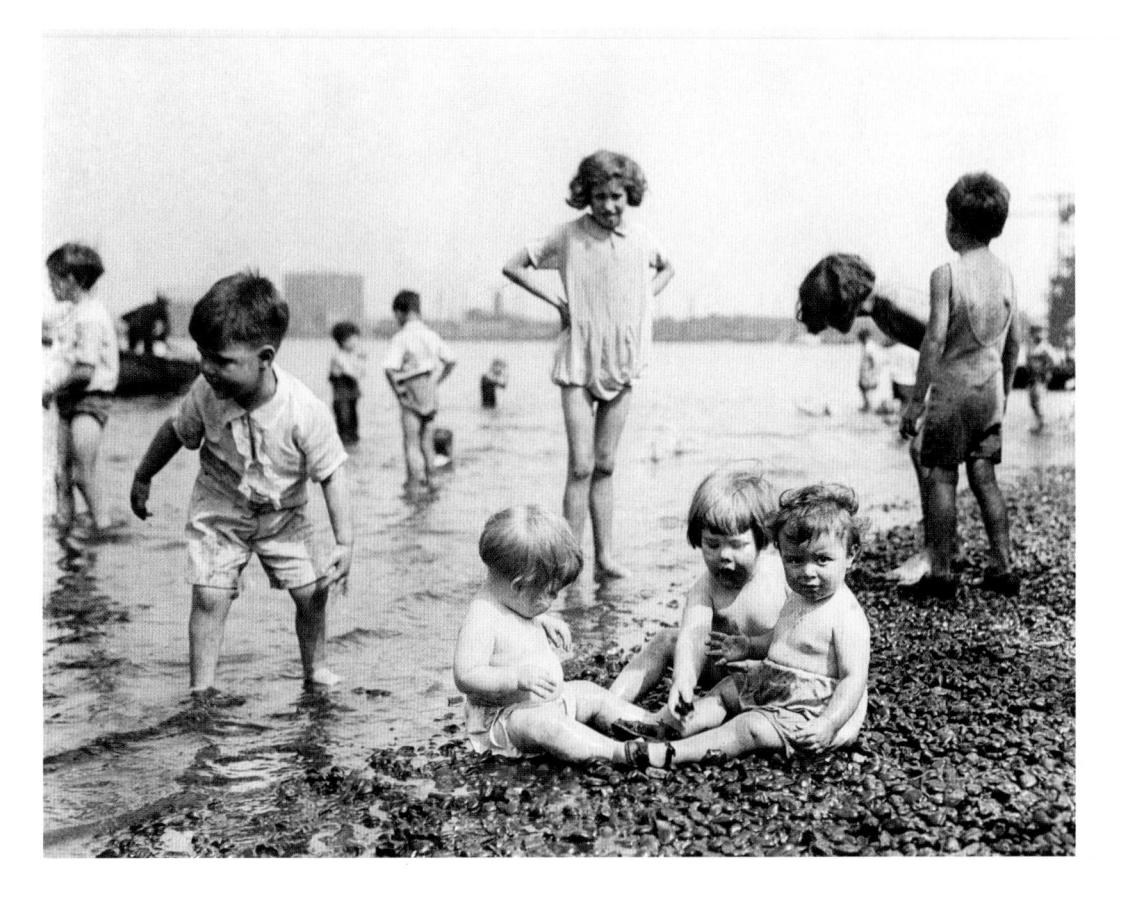

Facing page: Holiday crowds at Waterloo station. 23 July 1935

Paddling at Greenwich riverside. 26 September 1935

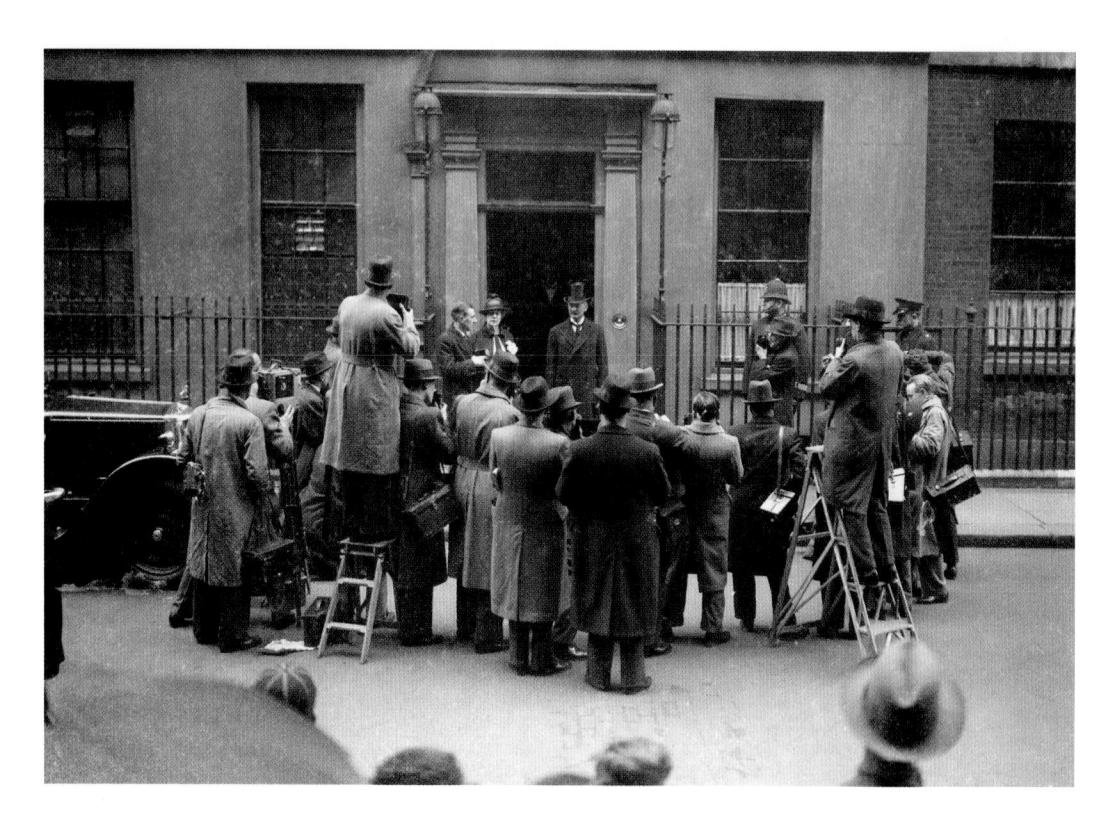

The Chancellor of the Exchequer, Neville Chamberlain, leaves II Downing Street on Budget Day. 10 April 1936

Facing page: Shelves full of umbrellas in the Lost Property Department at Waterloo station.

April 1936

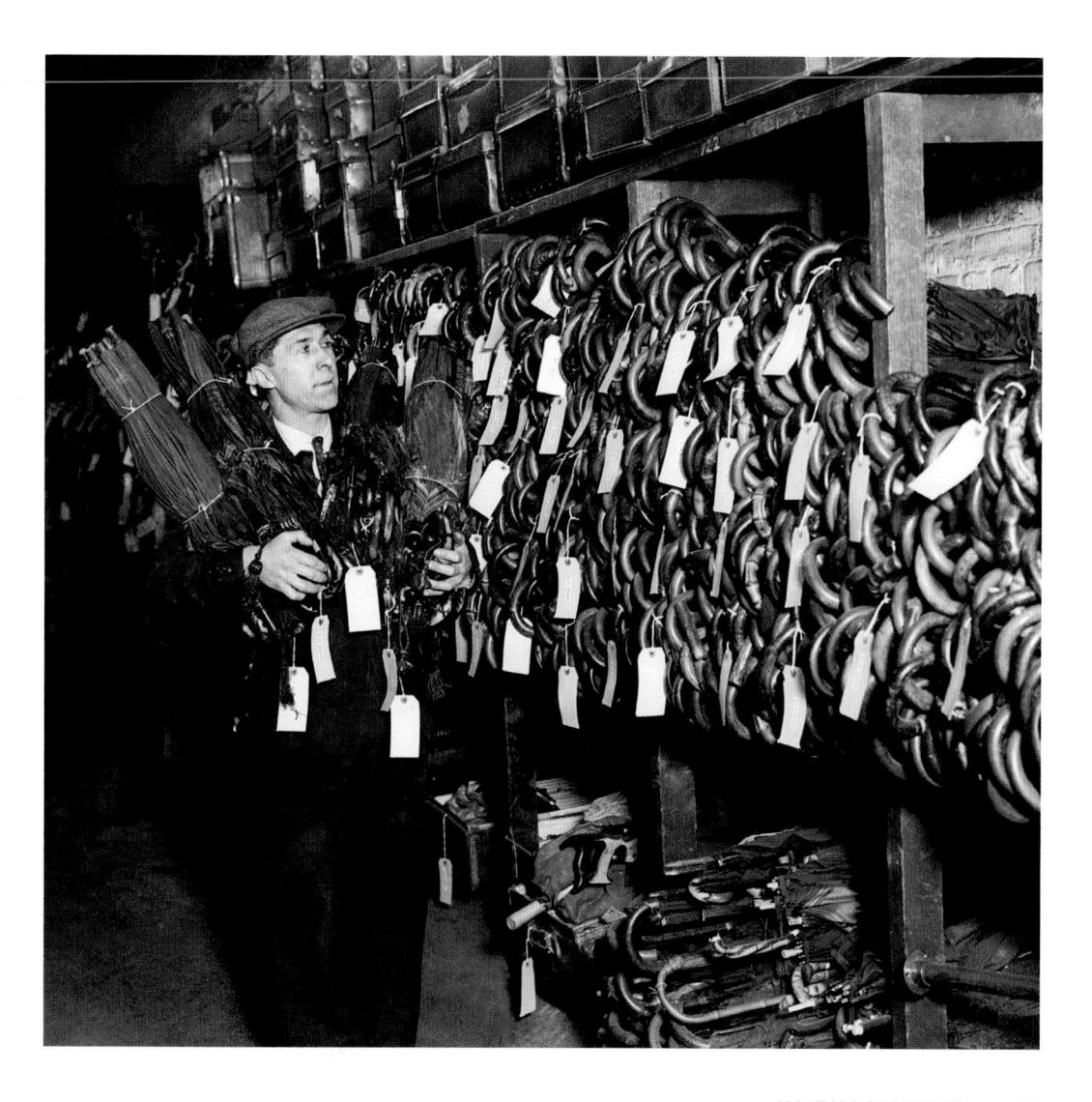

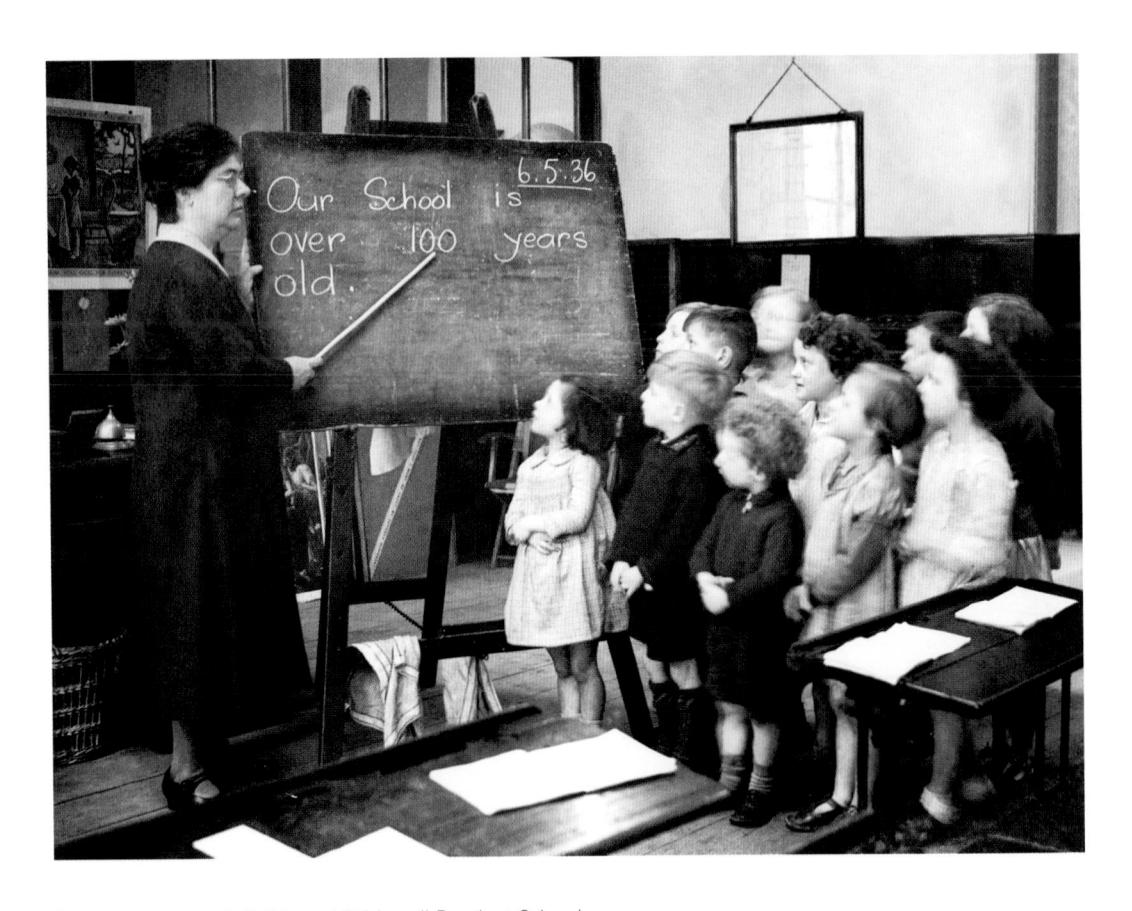

Fun and games at St Bride and Bridewell Precinct School. 6 May 1936

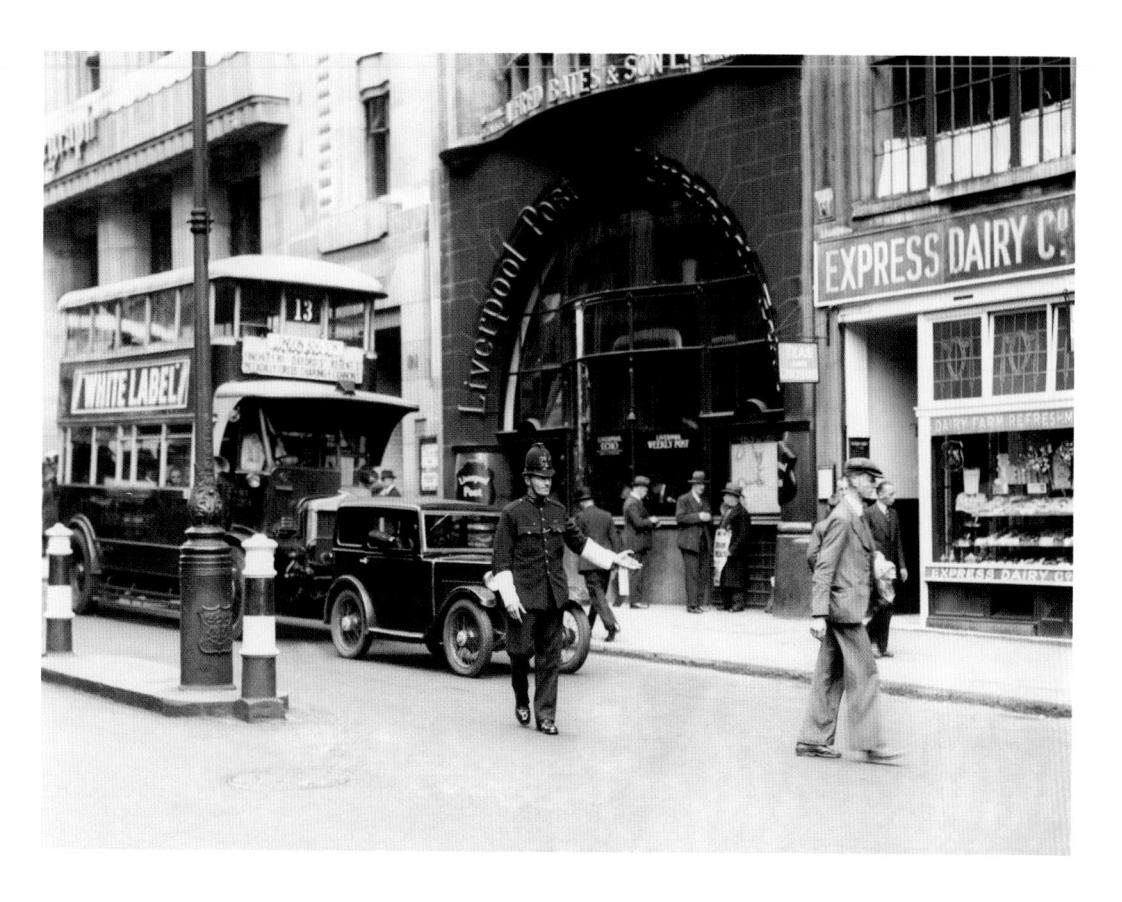

A policeman holds up traffic in Fleet Street. 24 July 1936

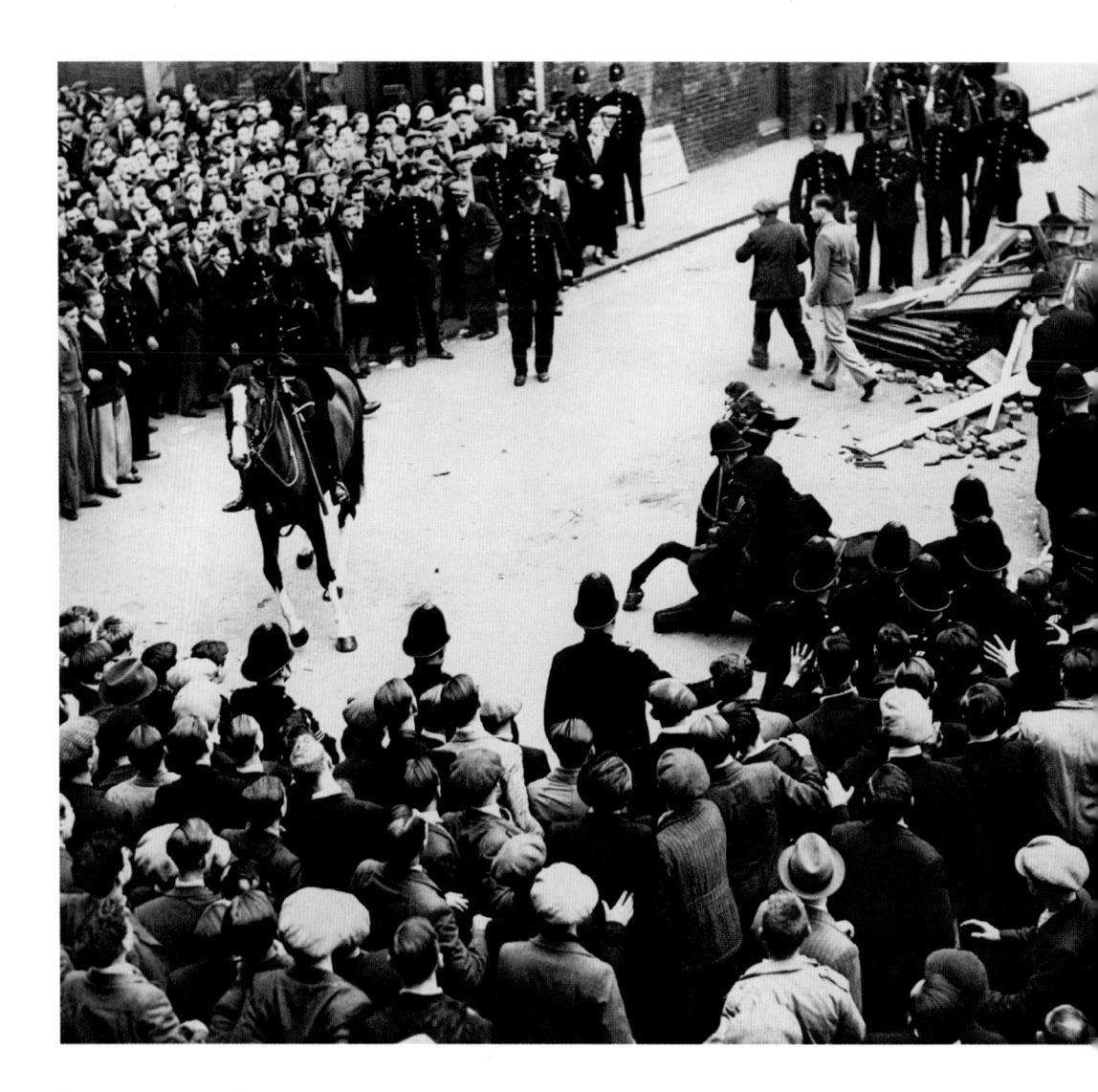

Facing page: A police horse falls during the Great Fascist March through East London to Bermondsey. Residents of the East End fought pitched battles with police and Moseley's Blackshirts, forcing the fascists to use a different route, in what became known as The Battle of Cable Street.

4 October 1936

One of the two water towers, built by Isambard Kingdom Brunel, which were left standing after the first Crystal Palace fire in 1936. War Department occupation of the site during the Second World War, and a second fire in 1950, completed the destruction of the great landmark.

December 1936

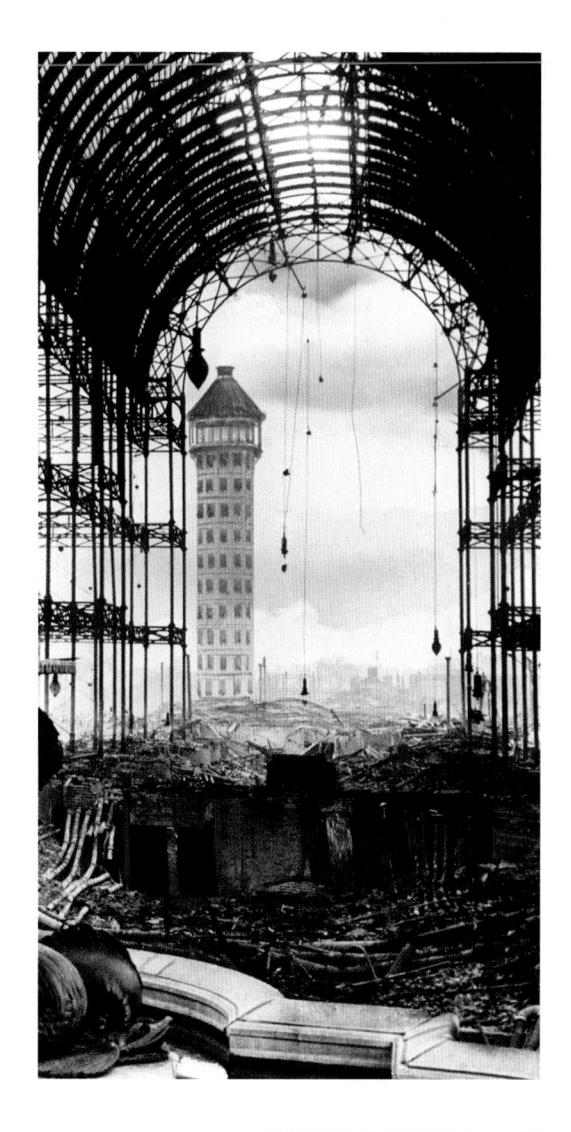

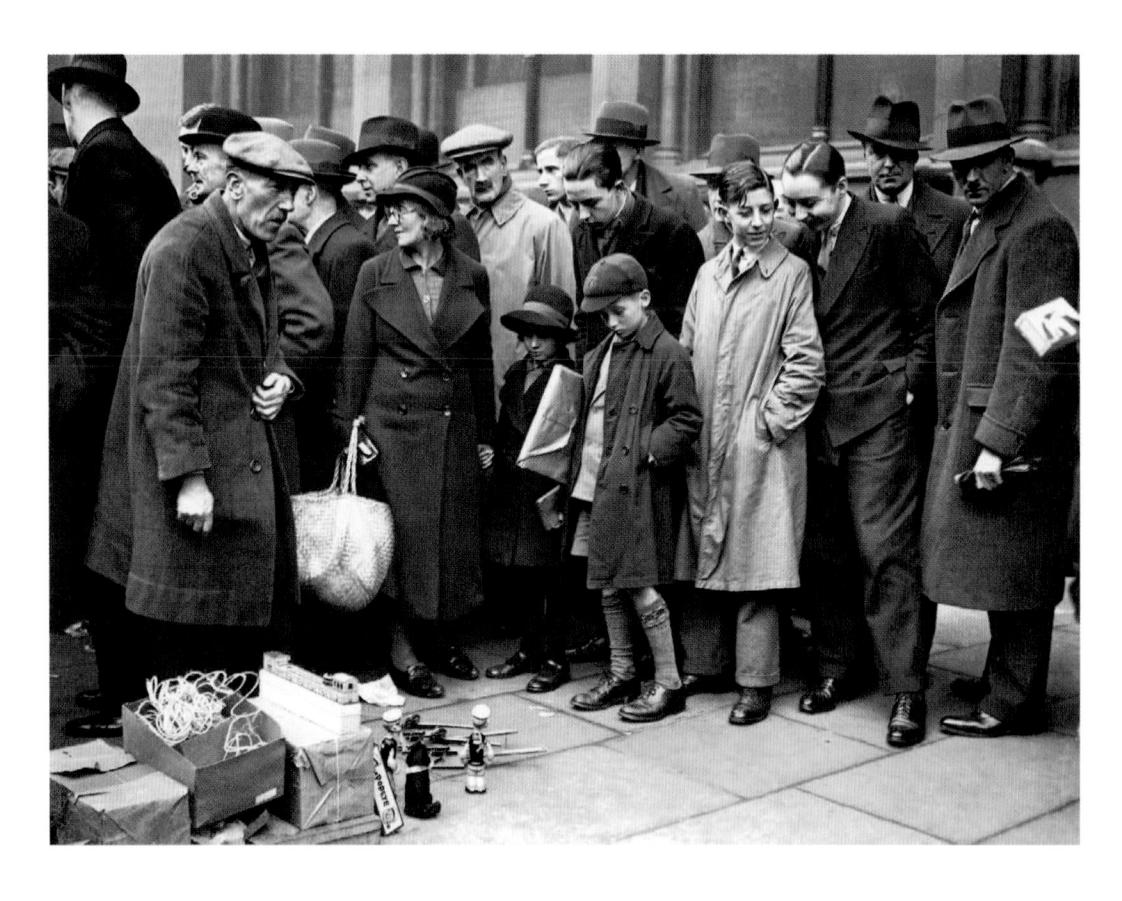

A hawker sells toys at Holborn. 14 January 1937

Facing page: Victoria Embankment from Hungerford Bridge. February 1937

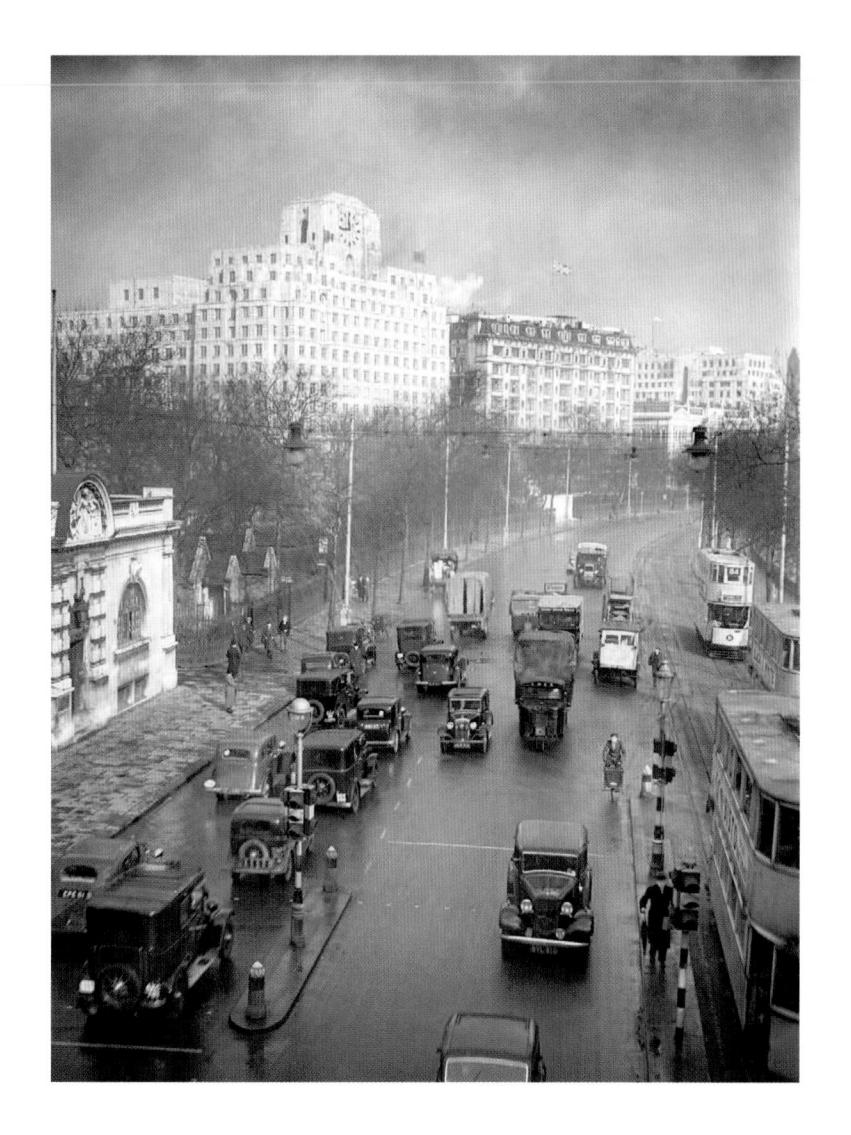

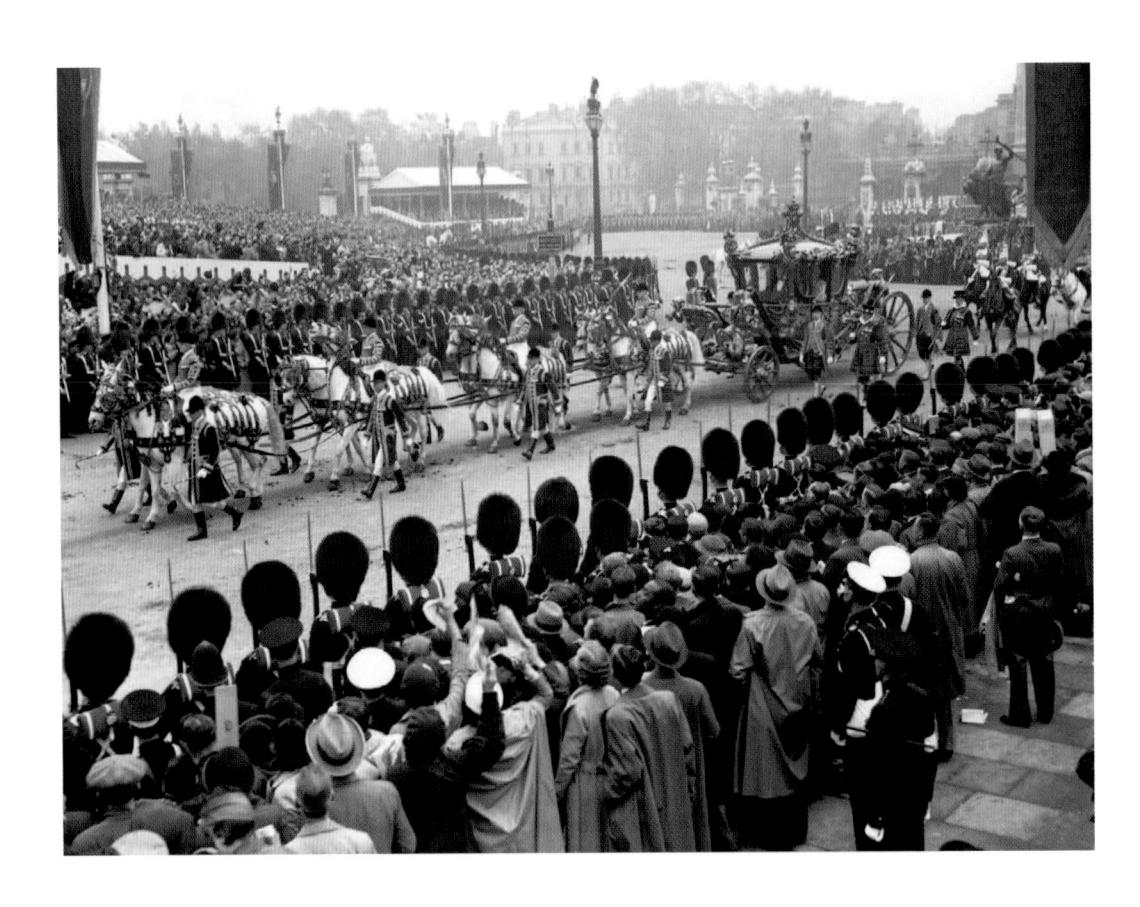

The Duke and Duchess of York leave Buckingham Palace for the Coronation at Westminster Abbey, after which they will be King George VI and Queen Elizabeth. The new Queen left her bouquet on the Tomb of the Unknown Warrior in honour of her brother Fergus, who was killed at Loos.

12 May 1937

Demolishing the rear of the Palace of Whitehall. It was redeveloped to house the Ministry of Defence.

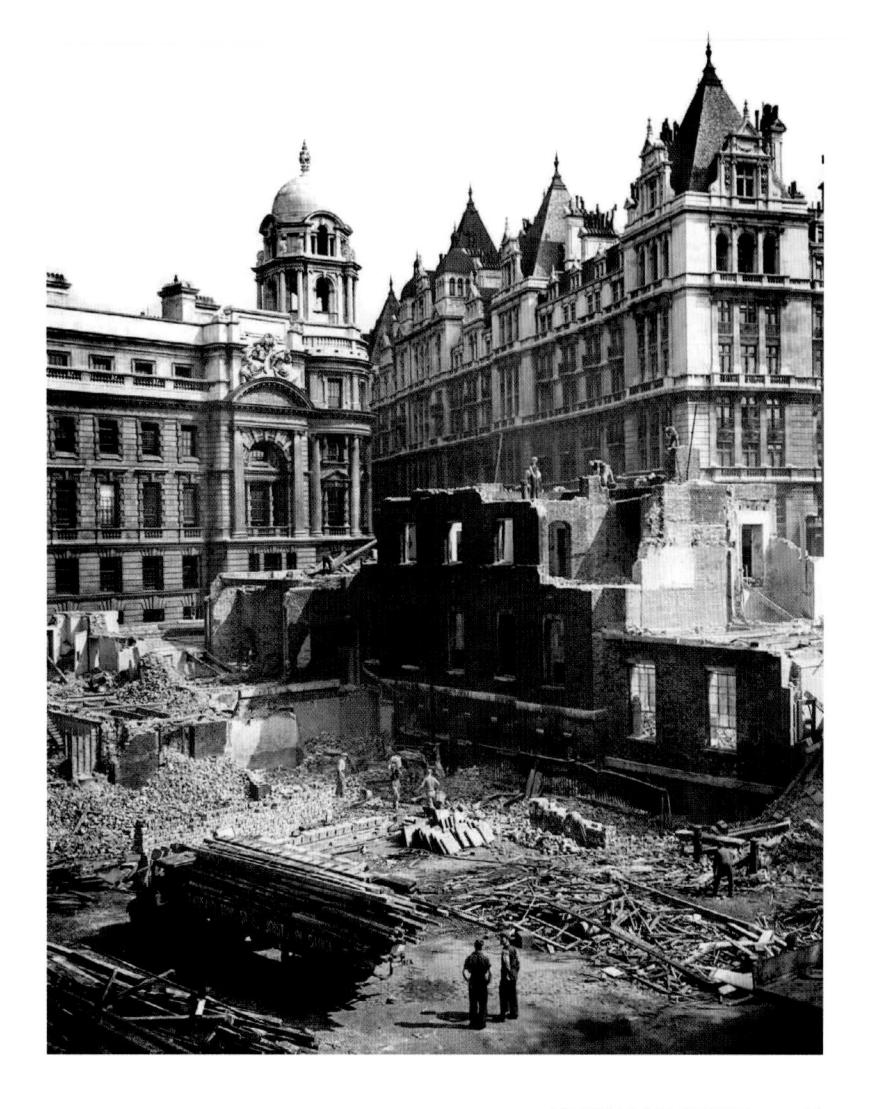

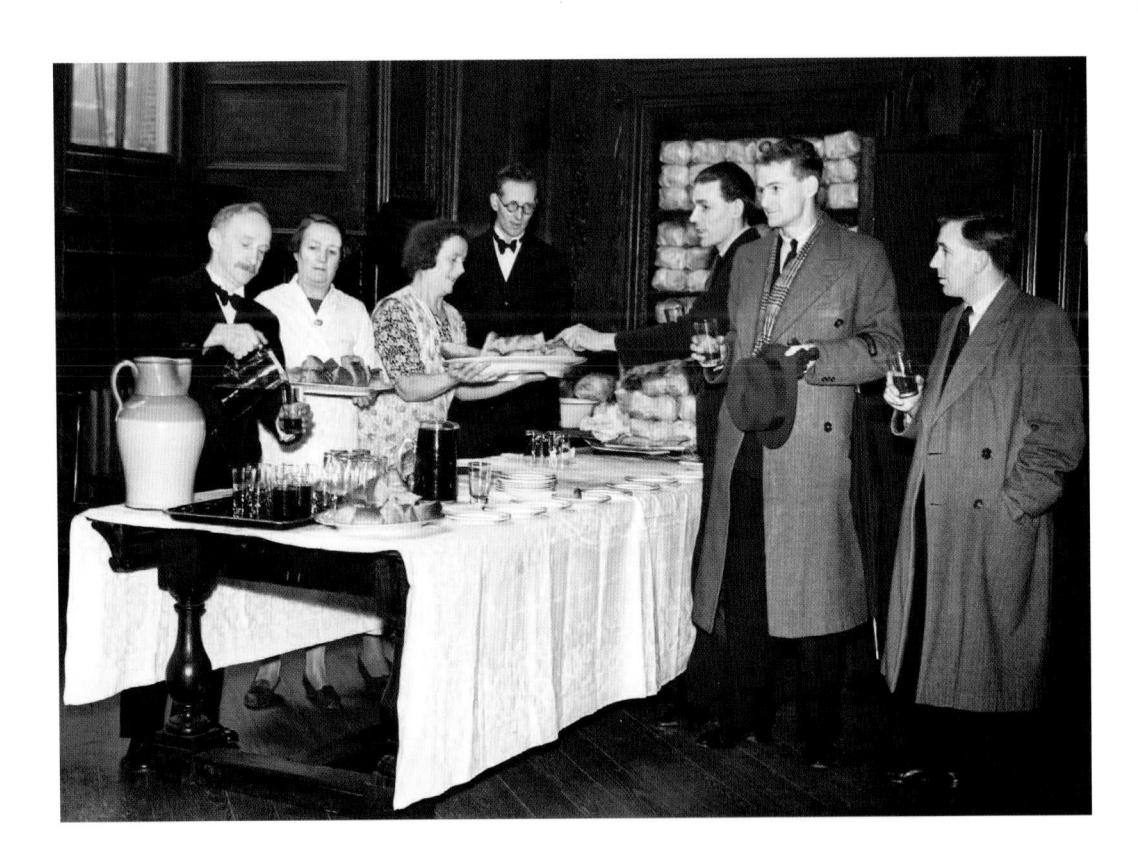

Ash Wednesday. Ale and cakes are traditionally distributed to members of the Worshipful Company of Stationers and Newspaper Makers at Stationers Hall.

4 February 1938

Facing page: Queues outside Lord's cricket ground on Saturday morning to see the continuation of the Wally Hammond/Les Ames fourth wicket partnership in the Ashes, Second Test, England v Australia.

25 June 1938

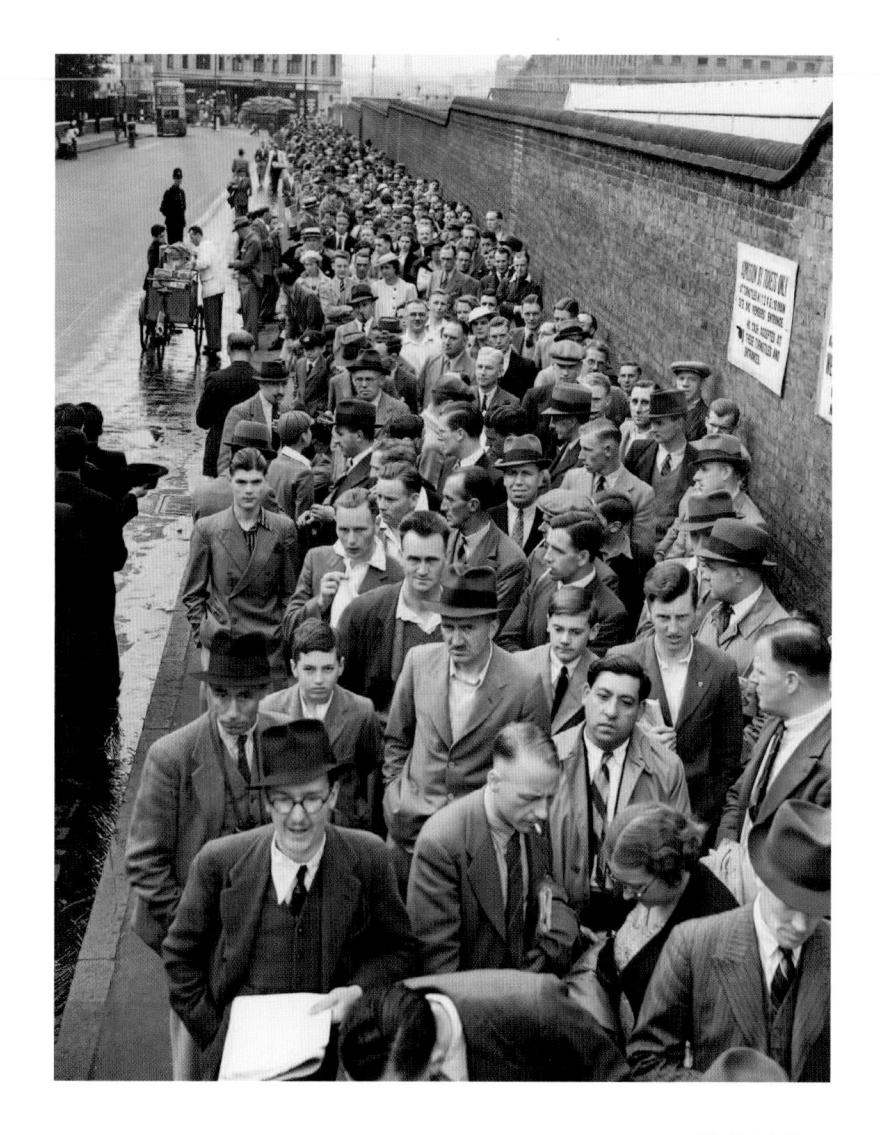

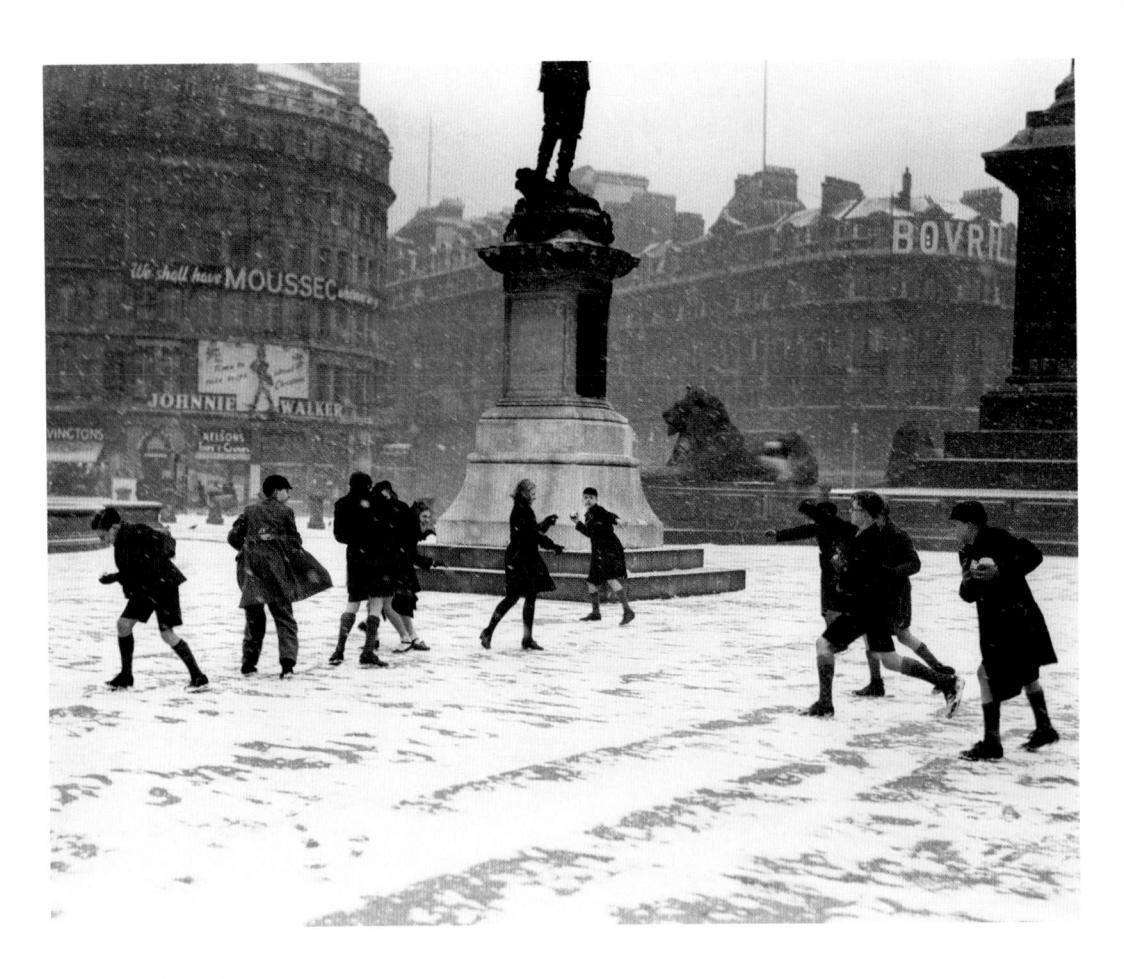

Snow in Trafalgar Square.
7 November 1938

Piccadilly Circus just before the start of the Second World War. The famous Shaftesbury Memorial with its winged statue (not actually Eros, but his brother Anteros), has been covered prior to being removed for the duration of the conflict.

May 1939

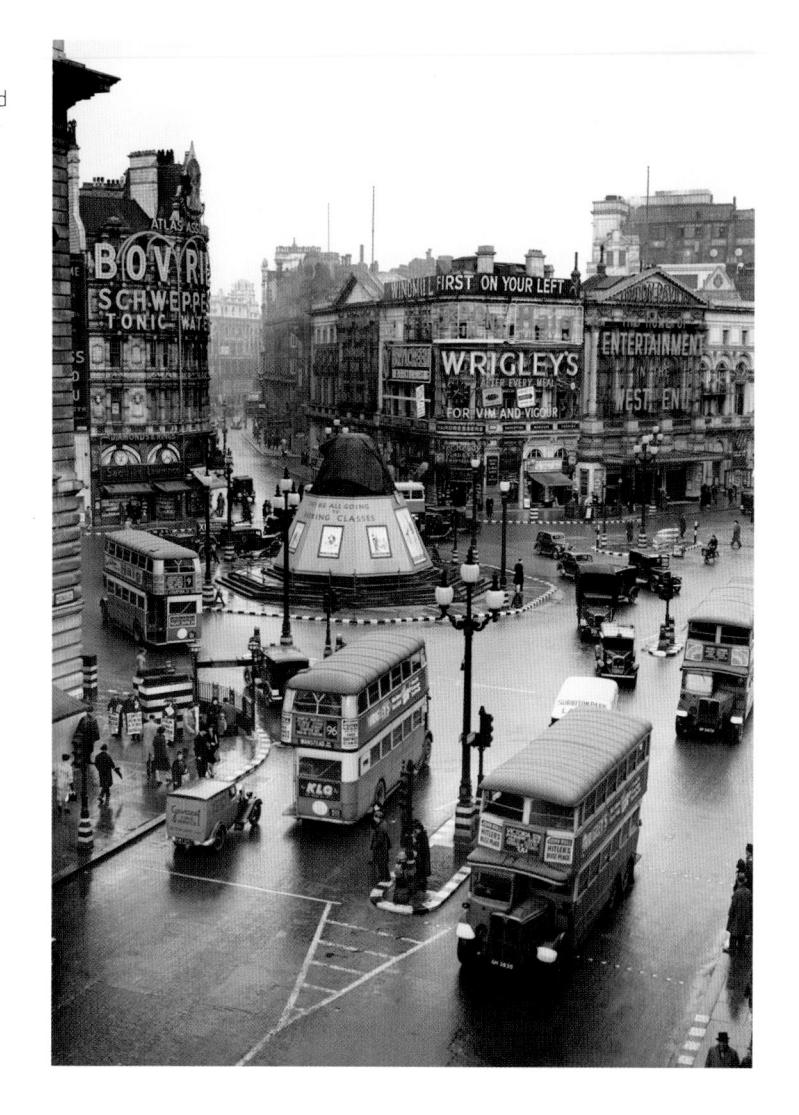

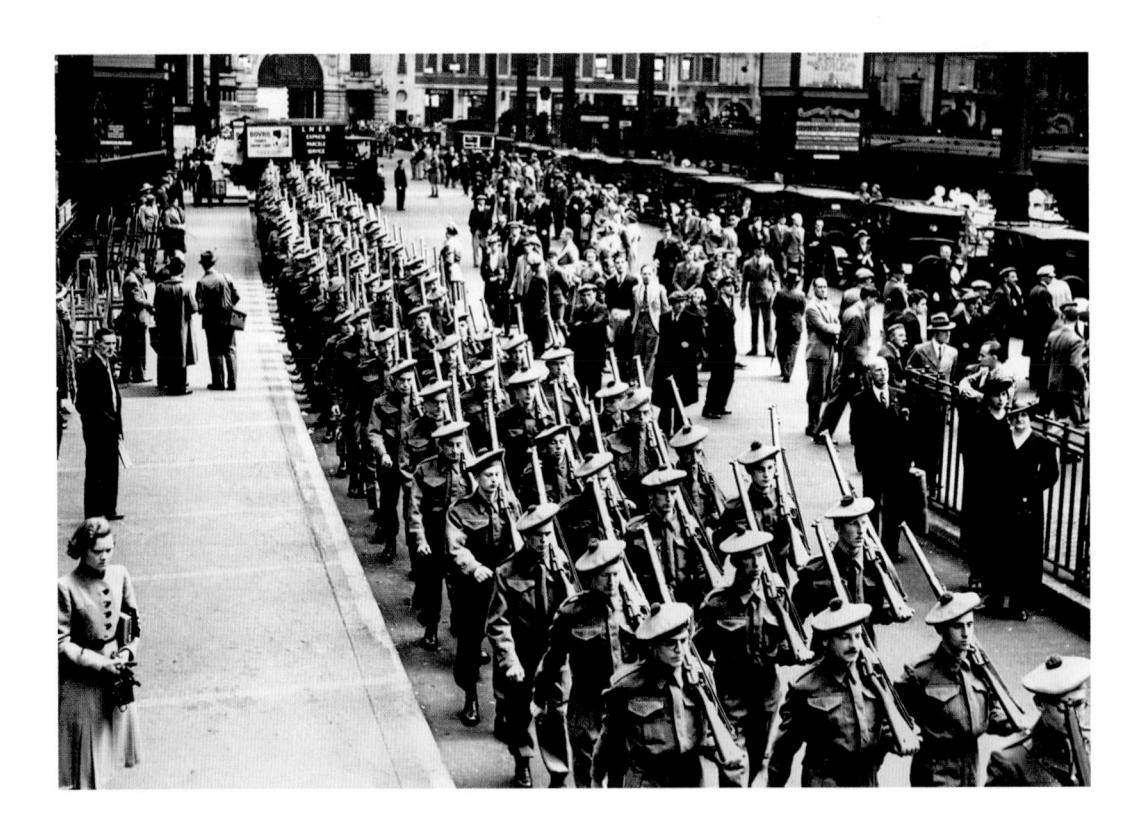

Scottish troops in transit through London. July 1939 Facing page: A four-mile-long public air raid shelter opens into a London park. Training exercises are a daily occurrence as Londoners begin to realize that, should war break out, they are living in a target area. Air raid drills, gas mask drills and evacuation drills become part of everyday life and the face of London takes on a grimmer aspect.

August 1939

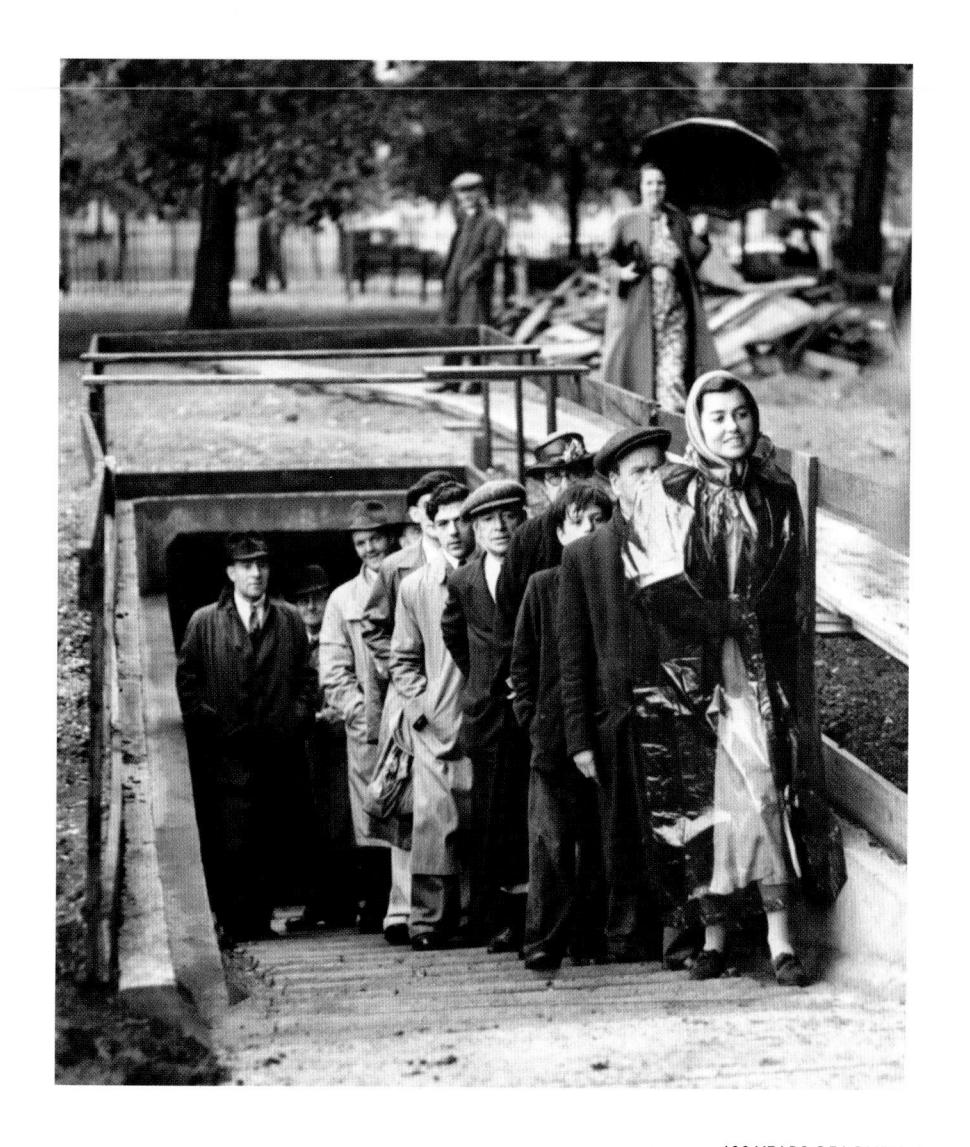

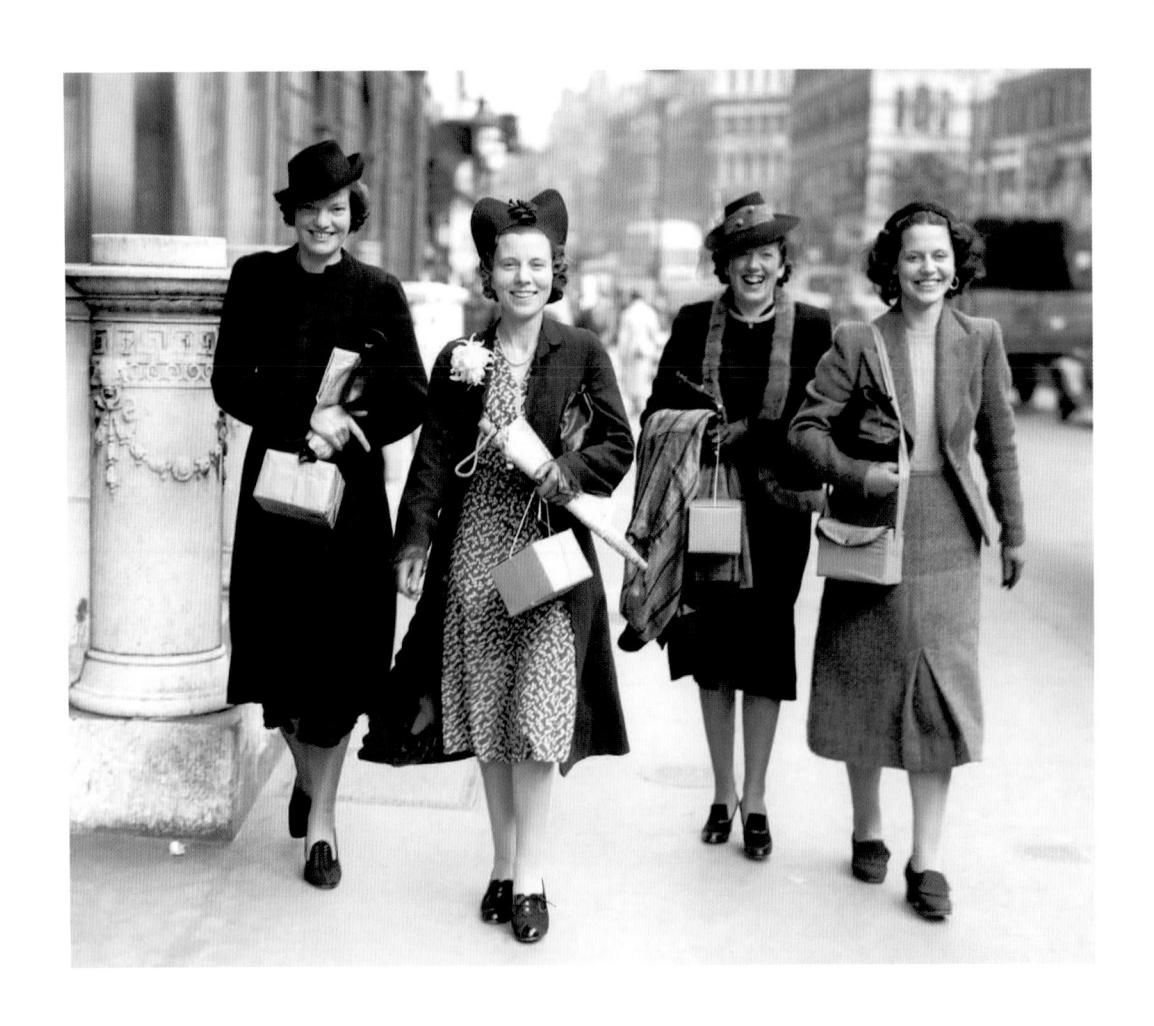

Facing page: Women on their way to work with gas masks in boxes. August 1939

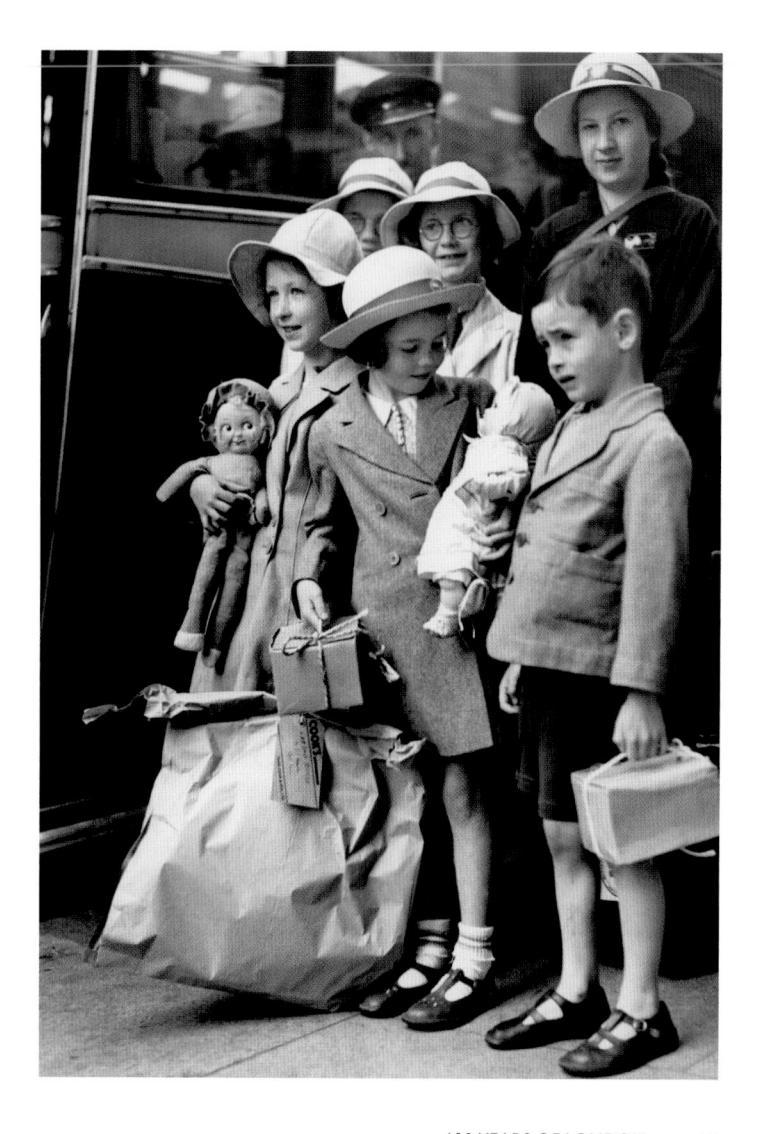

Operation Pied Piper: London evacuees with gas masks and luggage all set for evacuation to the country.

I September 1939

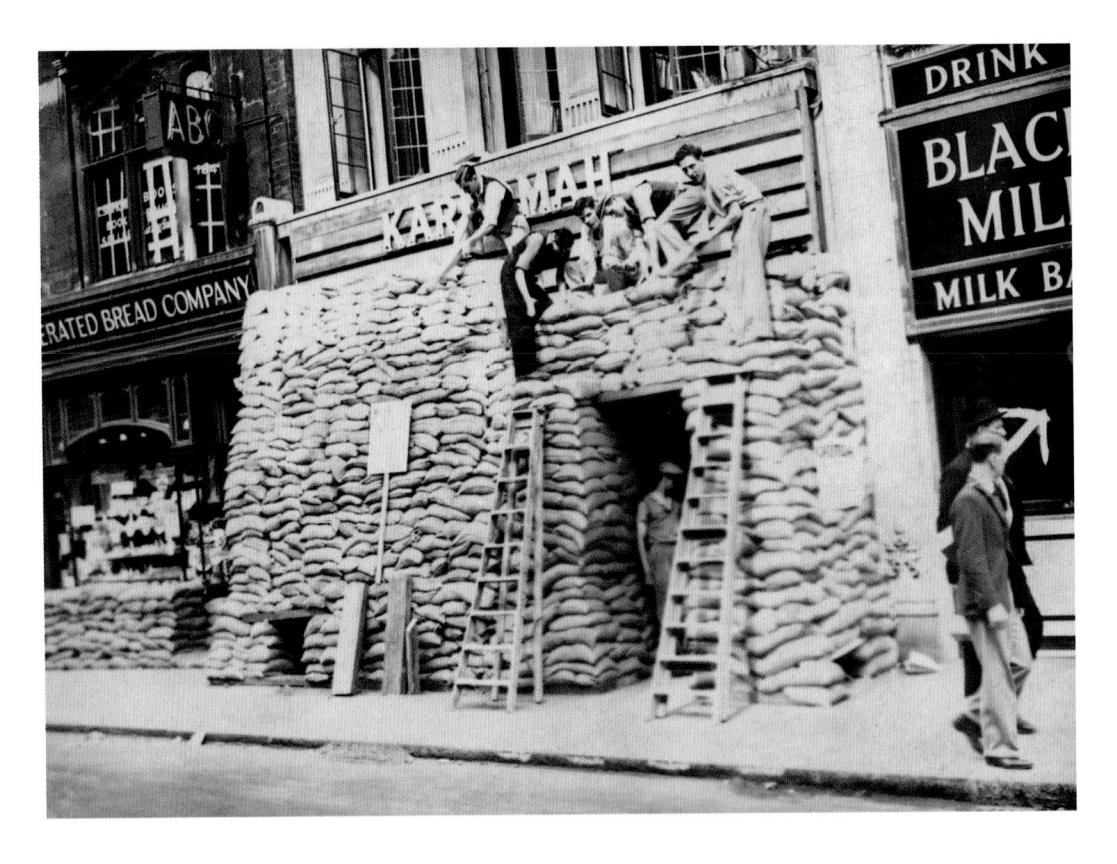

Sand bags are placed in front of shop windows for blast protection. The anticipated bombs of the Second World War wouldn't start falling on London until August the following year.

3 September 1939

Facing page: Soldiers demonstrate a Vickers machine gun and a rangefinder to onlookers in Trafalgar Square as part of a recruiting drive.

5 September 1939

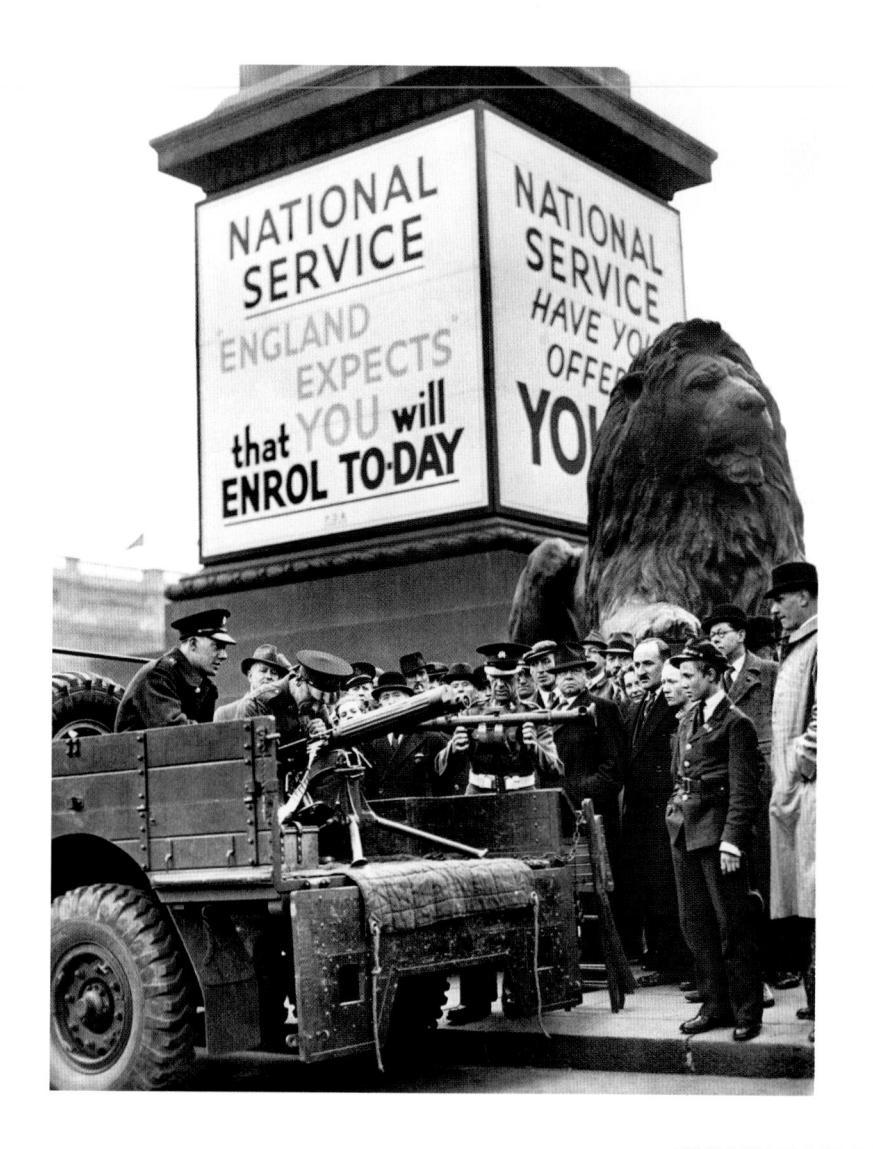

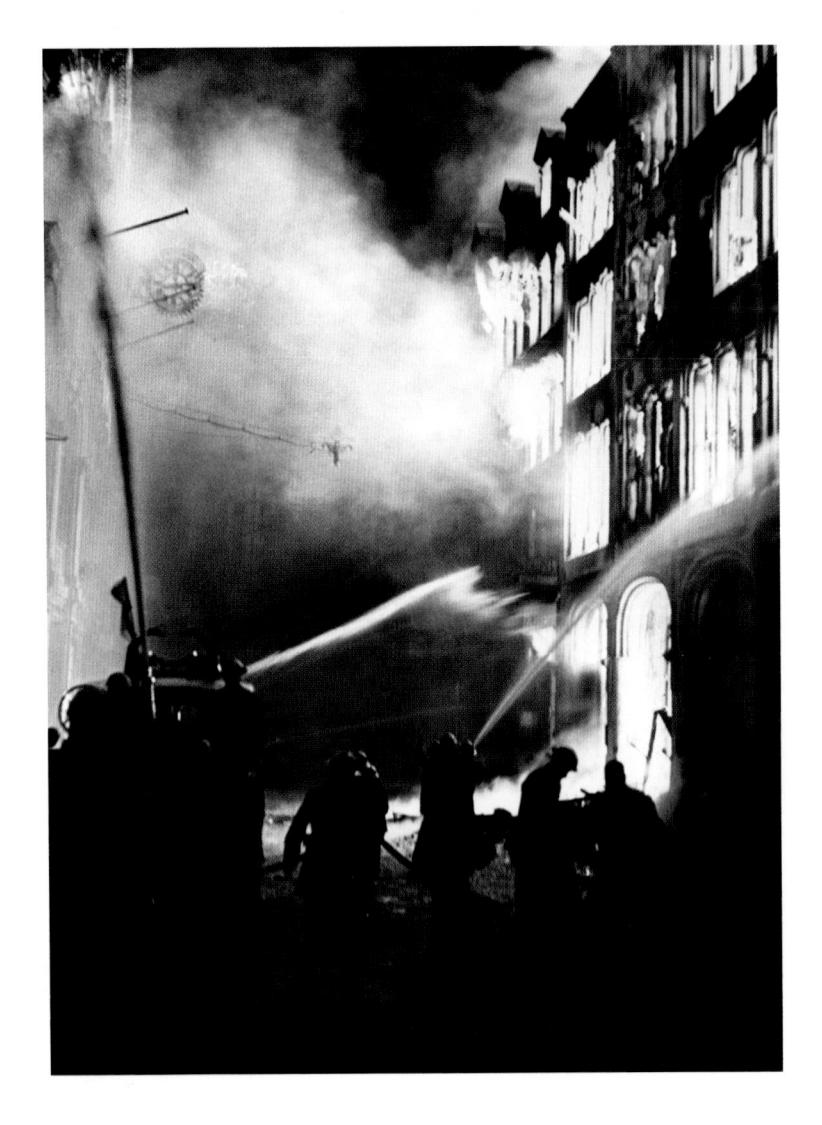

Firemen attempt to tackle a blaze caused by incendiary bombs during the Blitz. 24 August 1940
Hard hats must be worn: particularly by those who remain at their posts during air raids.

September 1940

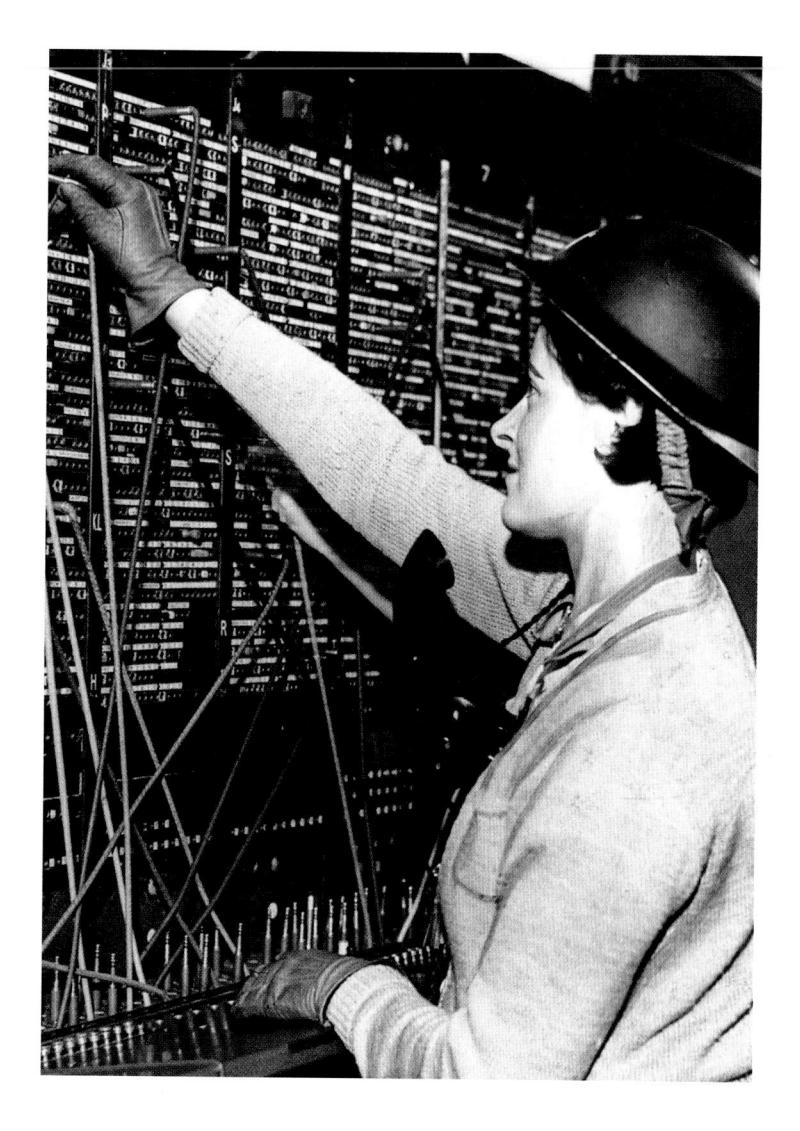

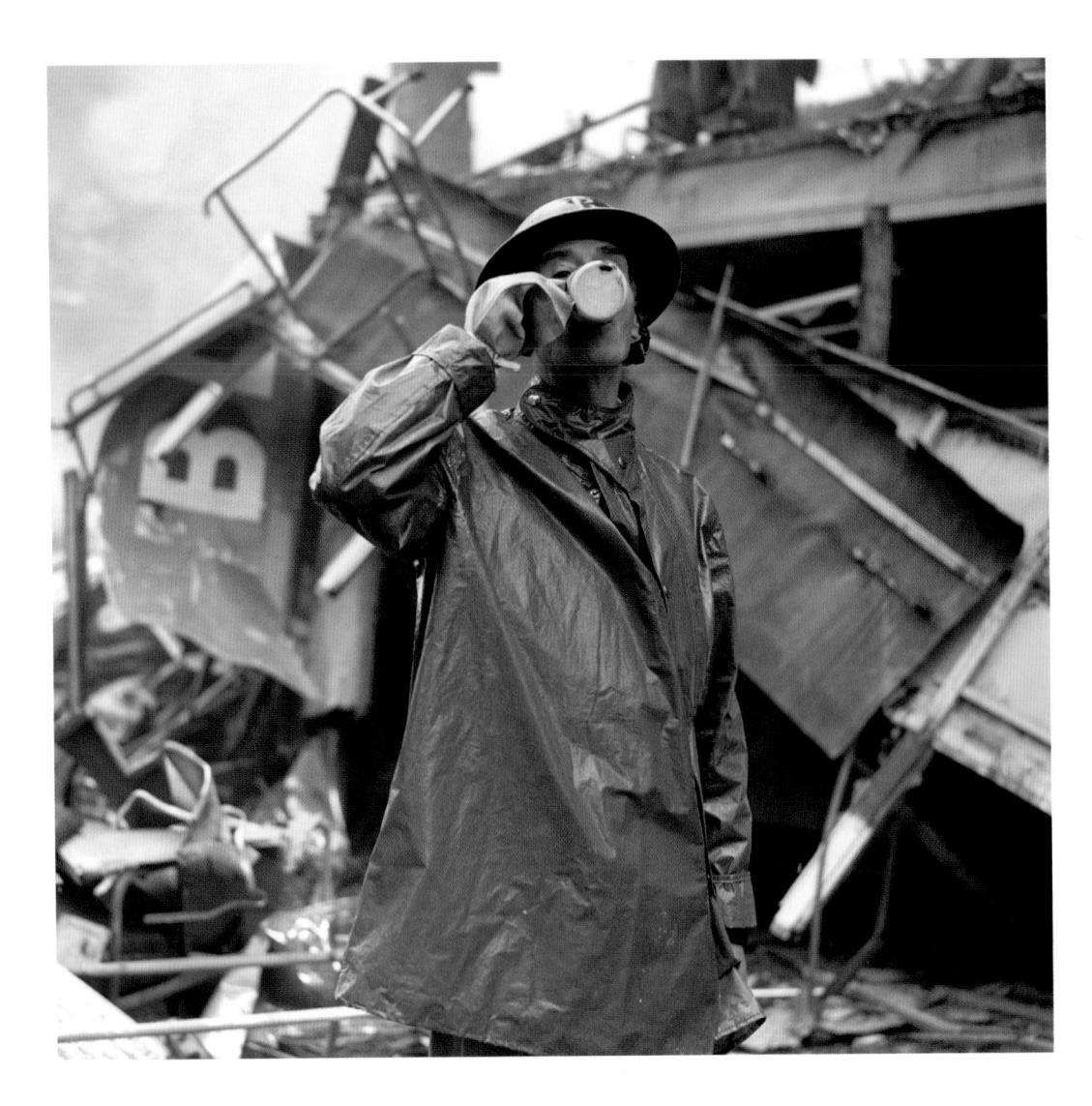

Facing page: A fireman enjoys a richly deserved cup of tea amid the destruction of the Blitz.

9 September 1940

A no.88 double-decker bus plunged into a bomb crater while travelling in blackout conditions (with reduced lighting). More than 60 people lost their lives sheltering in Balham underground station, which filled with debris and water from burst pipes when the bomb fell.

14 October 1940

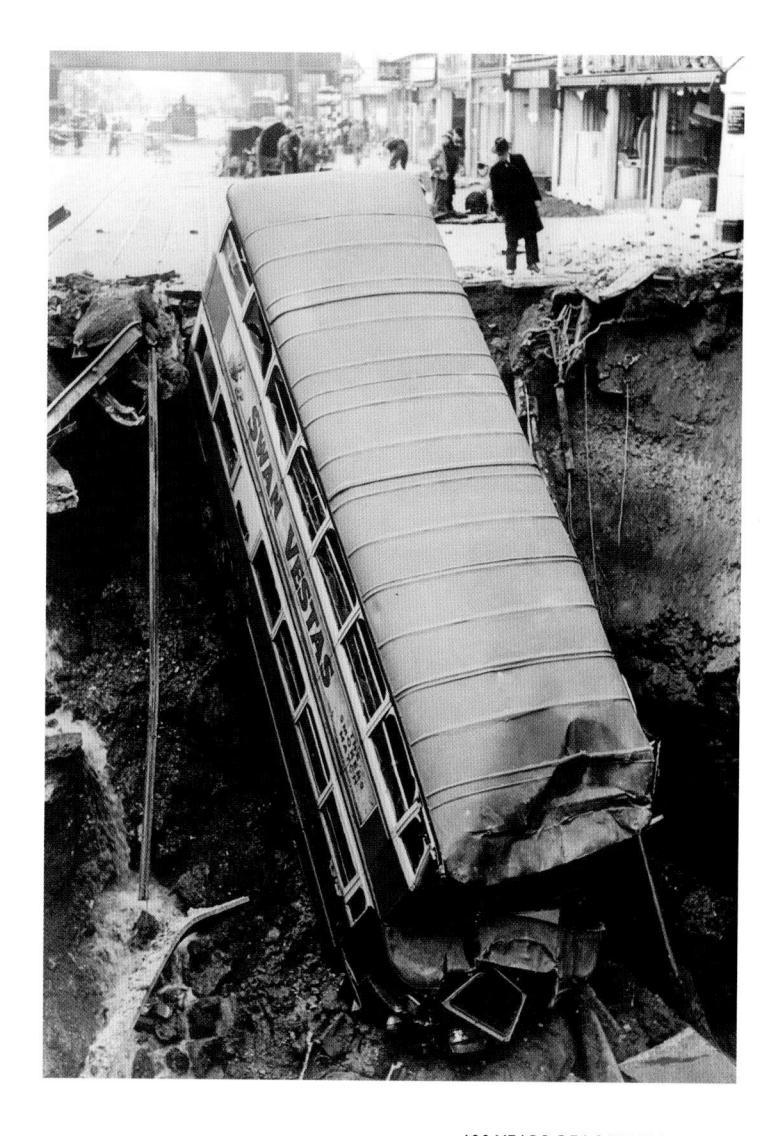

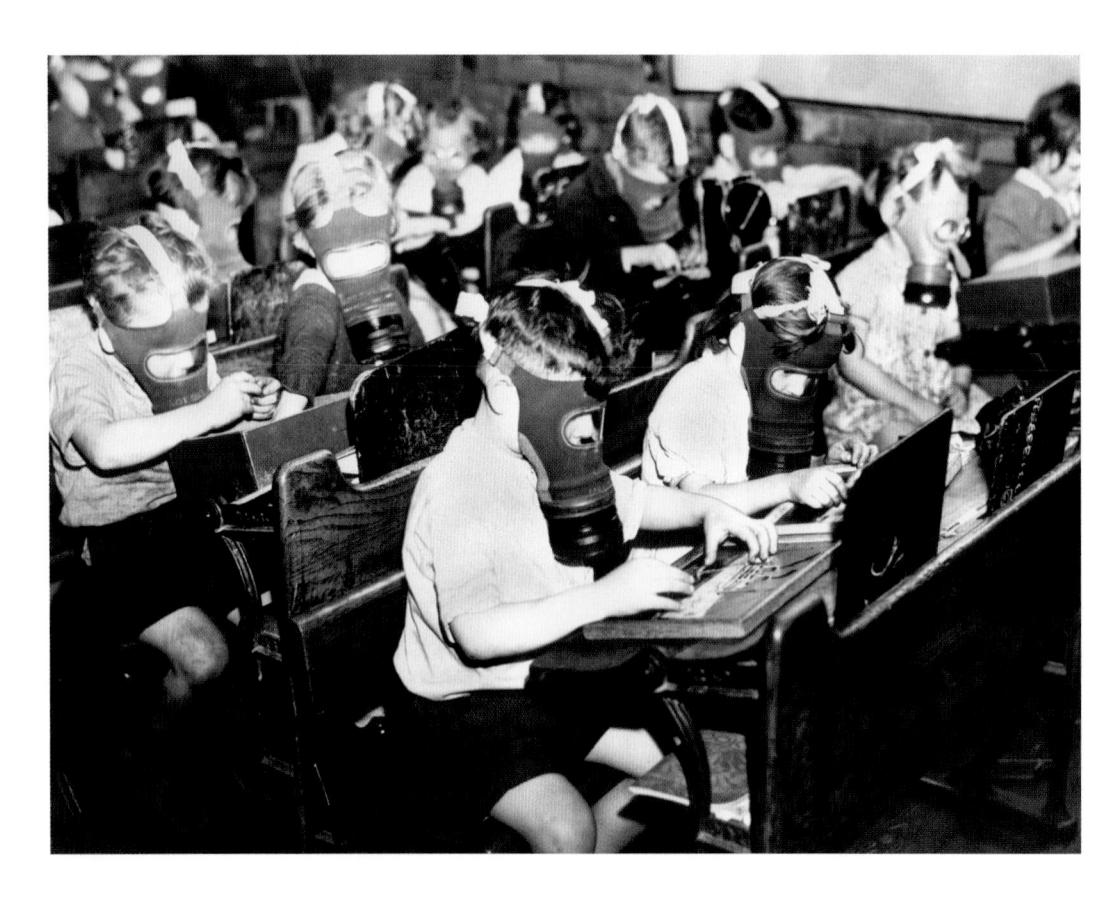

Children at a Clerkenwell school. Many of those evacuated came home before the bombing started.

1941

Facing page: Putting a brave face on it: a Londoner recovers the remains of his belongings from the rubble of his bombed home.

1941

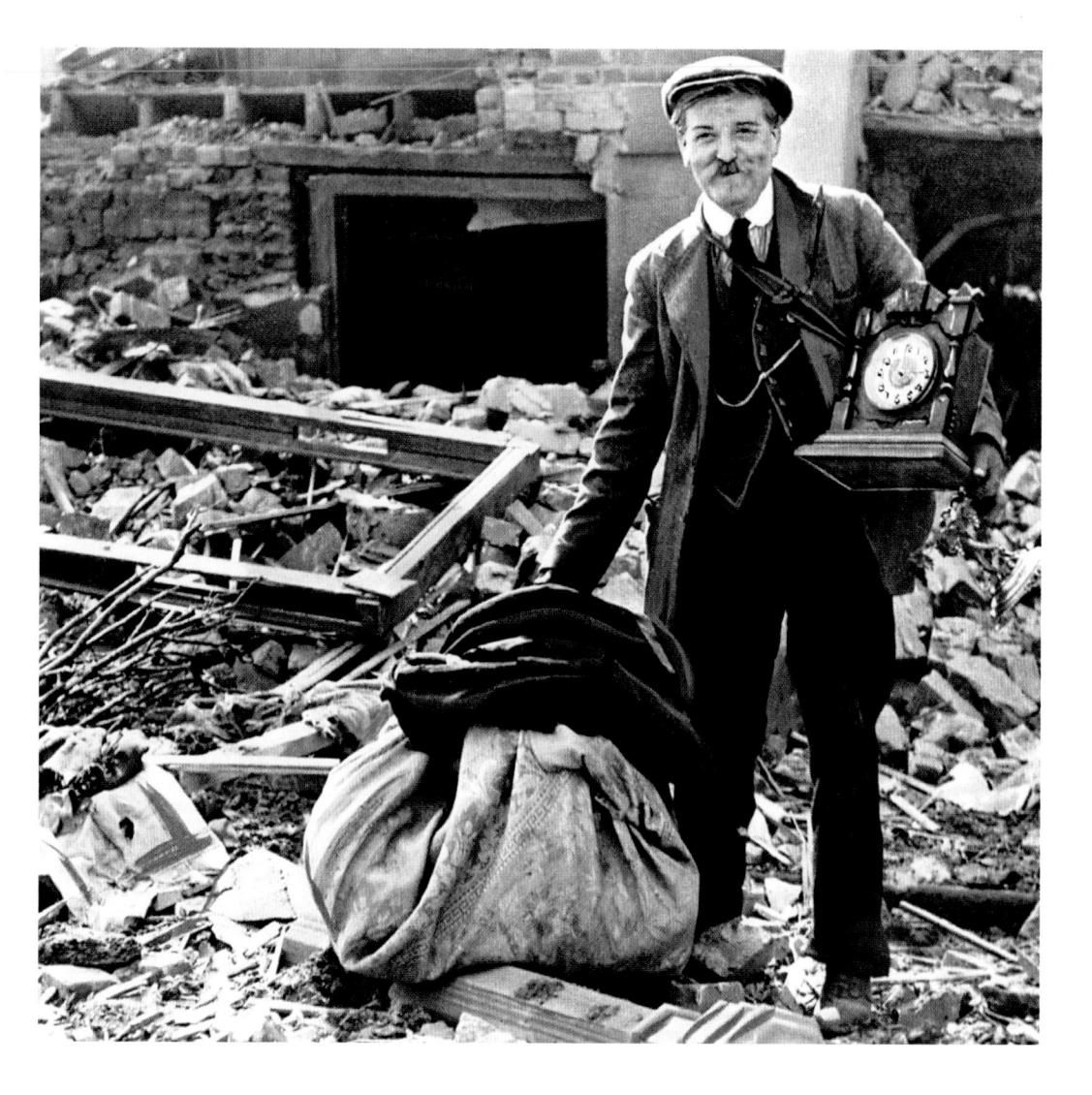

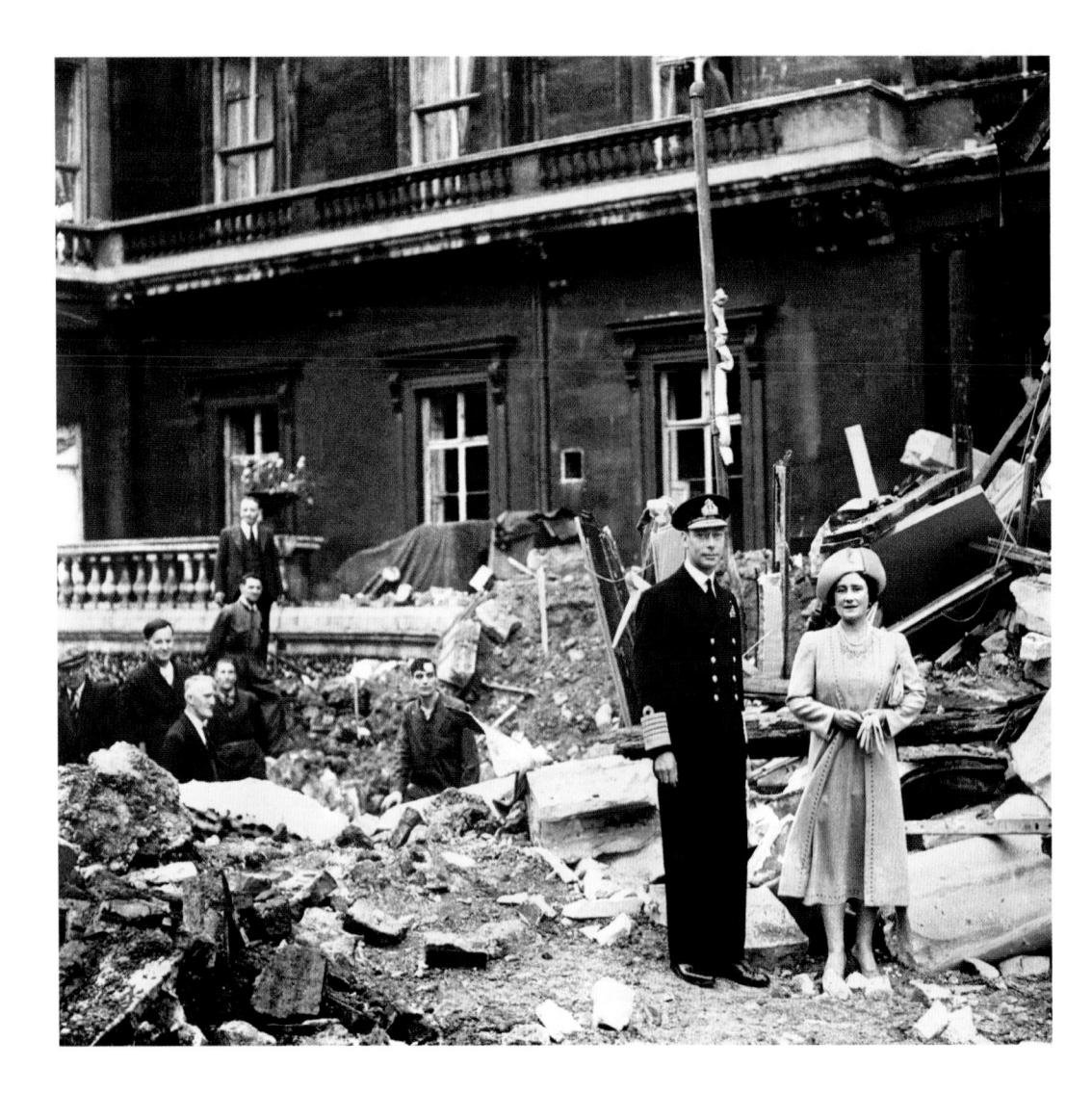

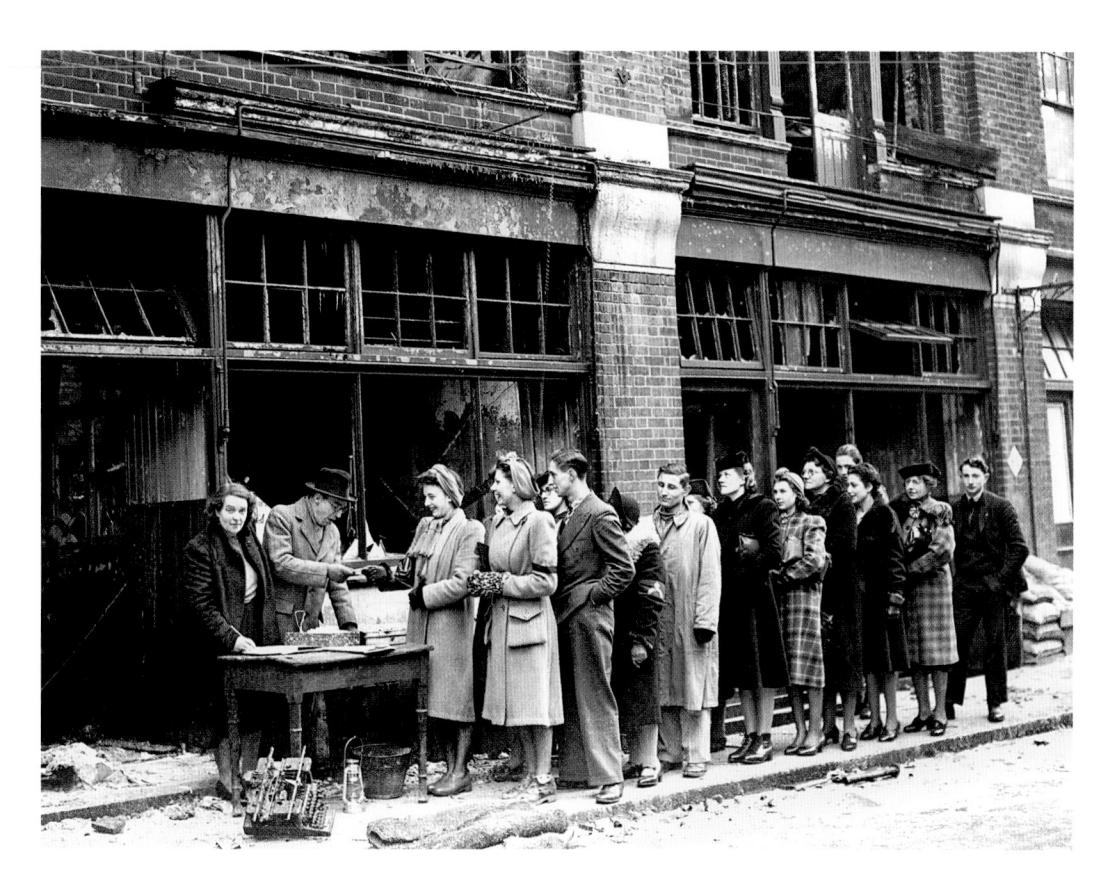

Facing page: Bomb damage at Buckingham Palace. The palace was a priority target for the Luftwaffe. "Now we can look the East End in the face" said Queen Elizabeth.

Staff of the Sport and General Press Agency are paid their wages outside their wrecked offices. 3 January 1941

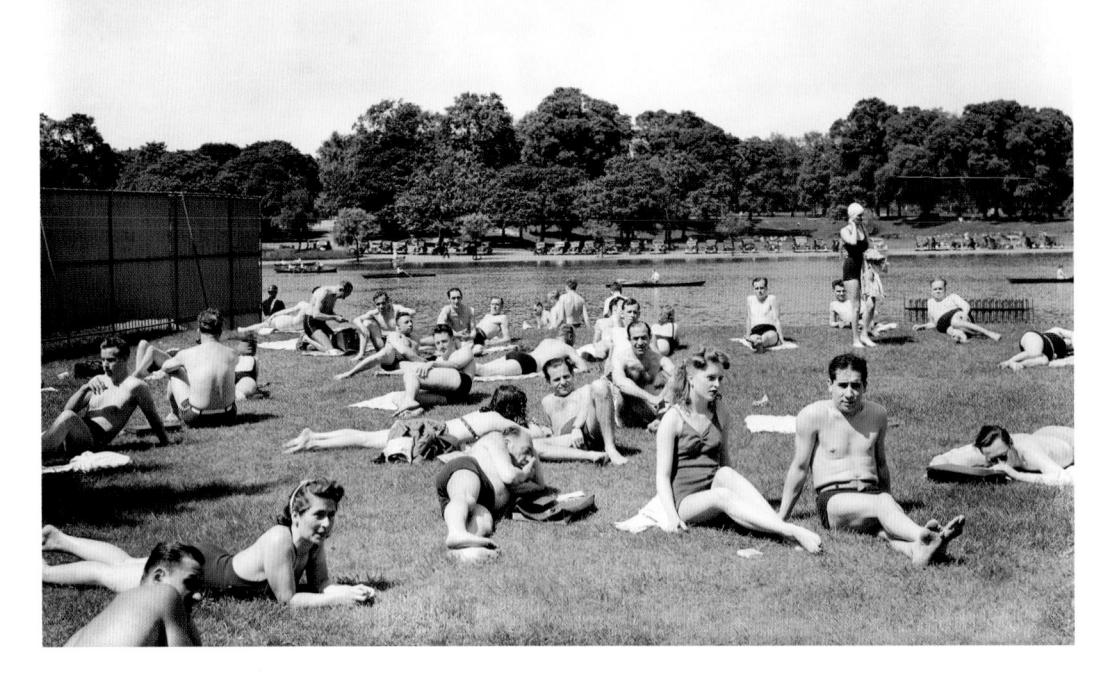

Sunbathing at the Hyde Park Lido. 16 June 1941

Facing page: Prime Minister Winston Churchill inspects the Home Guard in Hyde Park.

14 July 1941

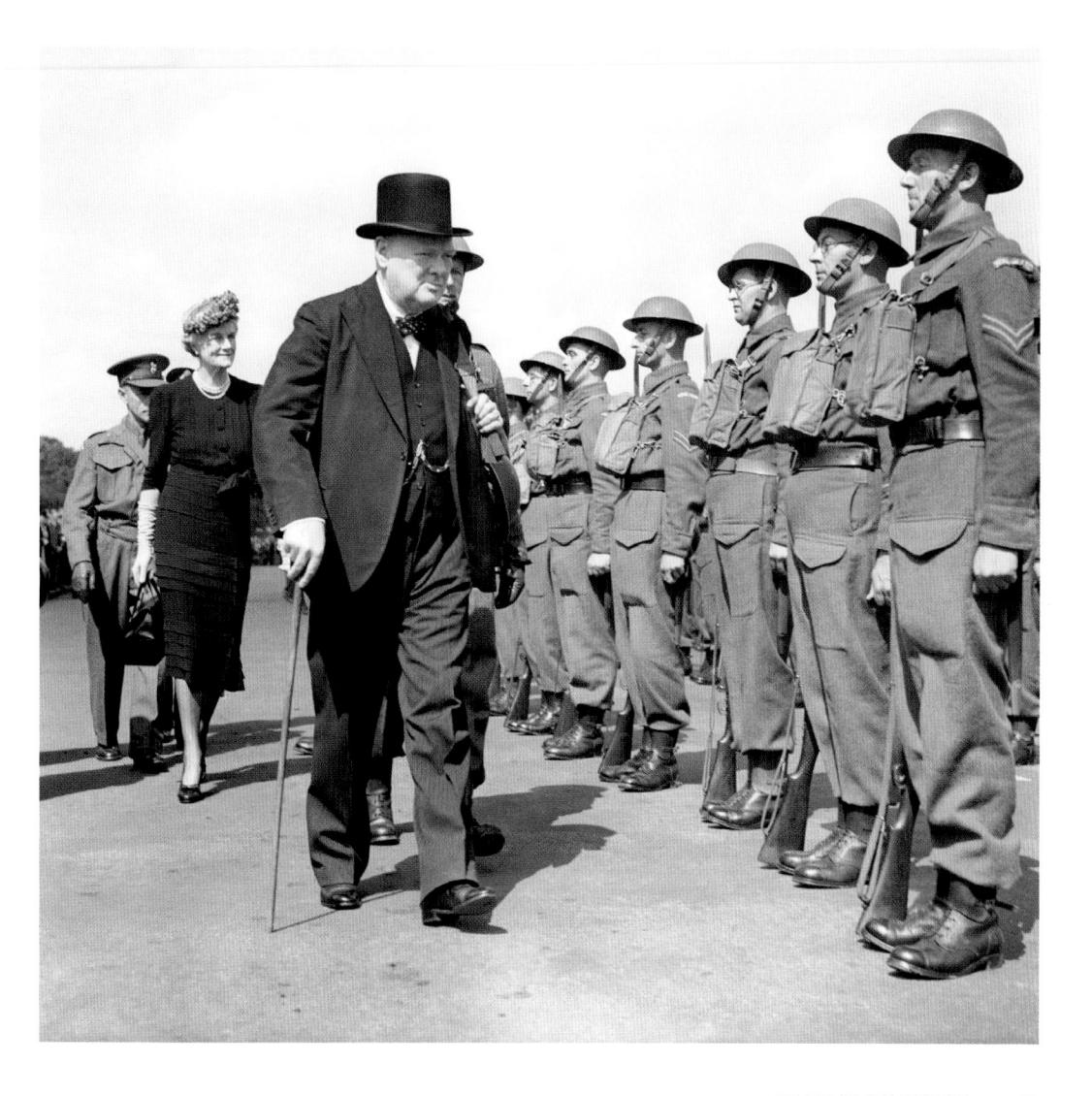

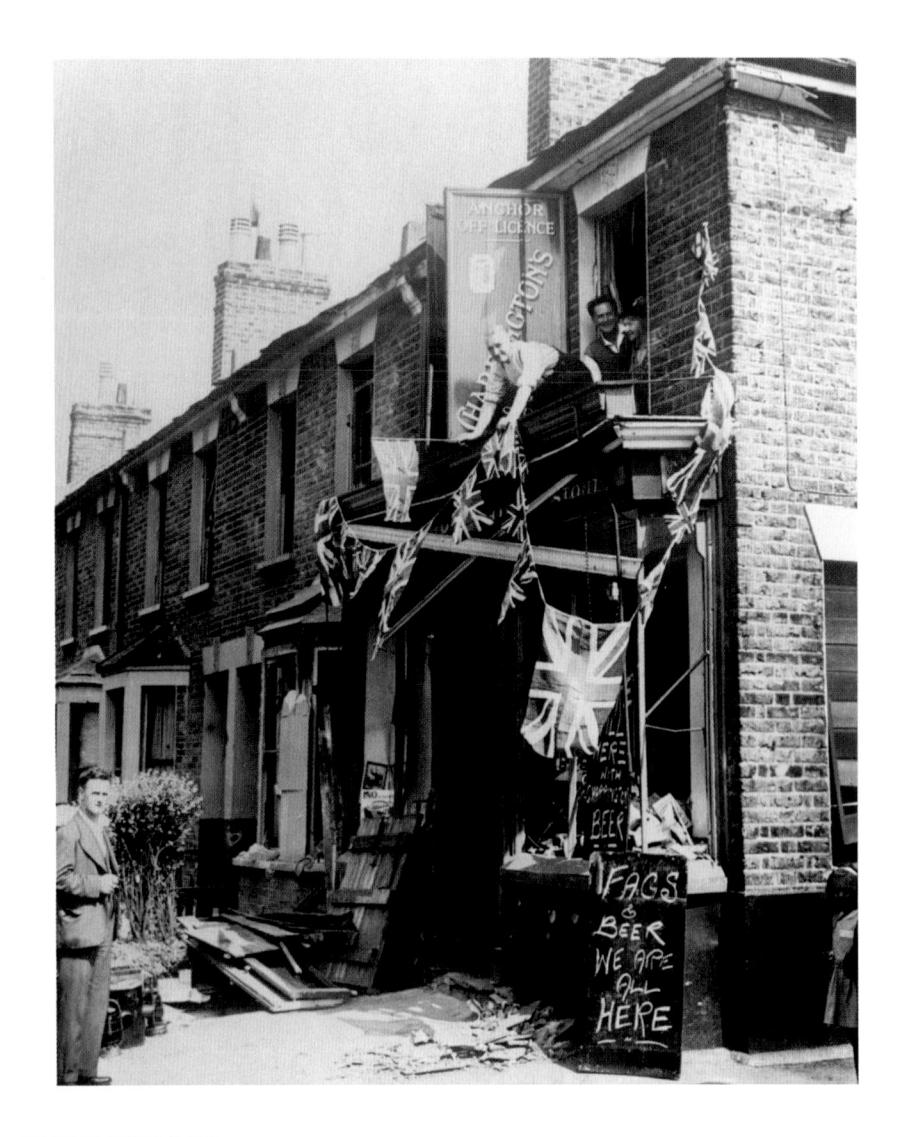

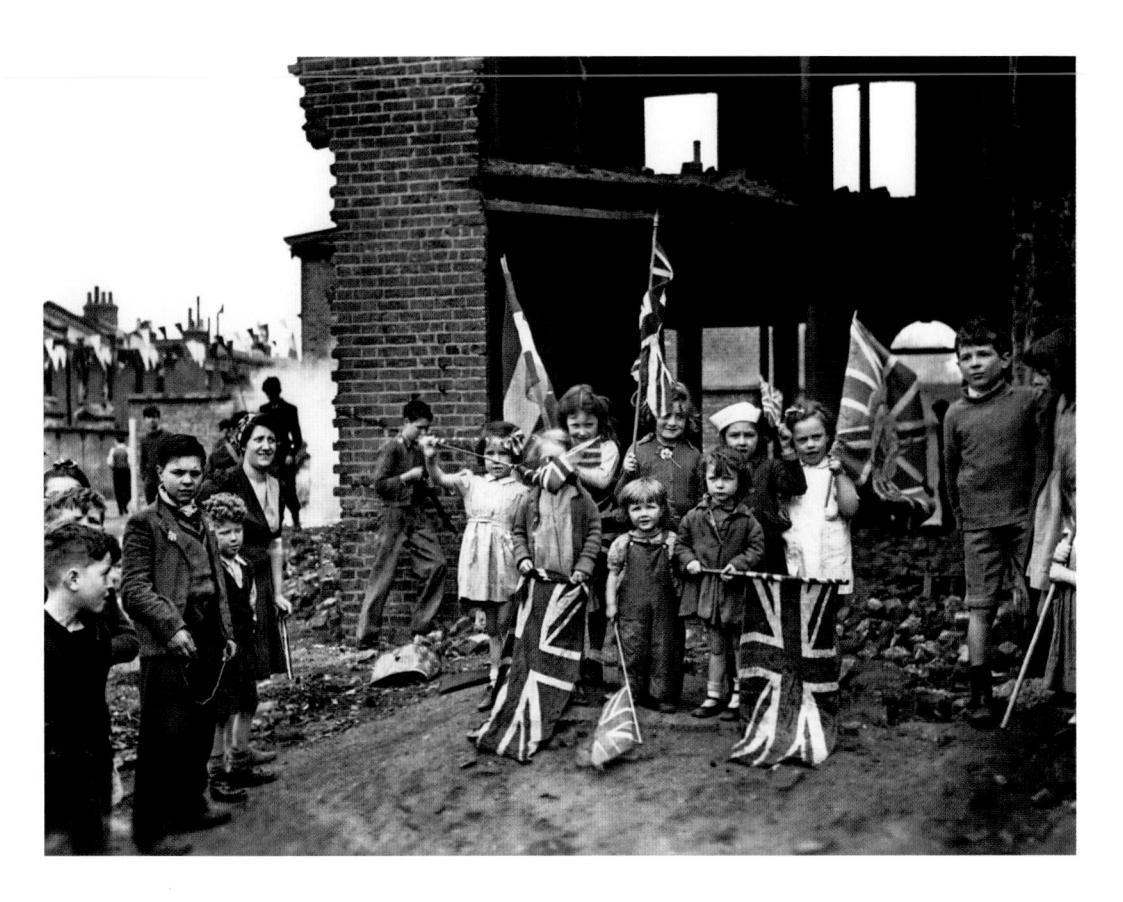

Facing page: Business as usual, even though the shop has been bombed.
28 October 1941

Young Londoners celebrate VE (Victory in Europe) Day, amidst the ruins of their homes in Battersea. 8 May 1945

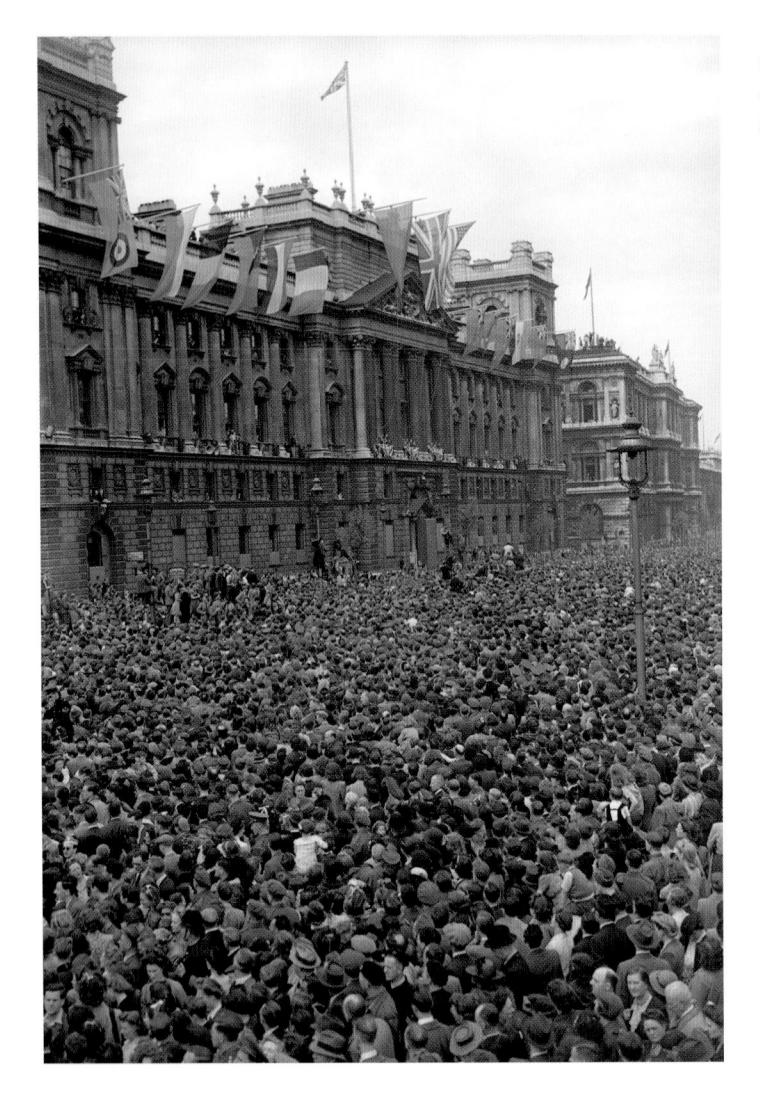

Crowds in Whitehall celebrate VE Day. 8 May 1945

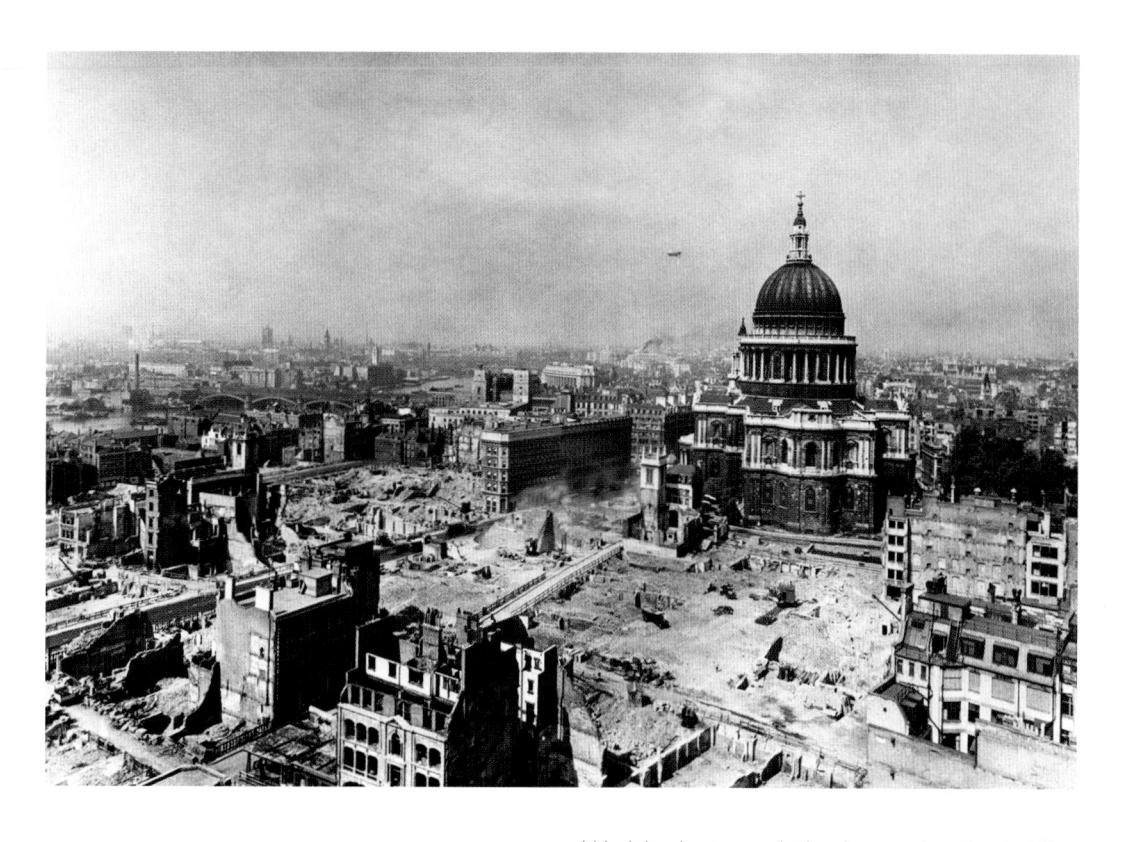

Work begins to repair the damage done by the Blitz and rocket attacks during the war.

June 1945

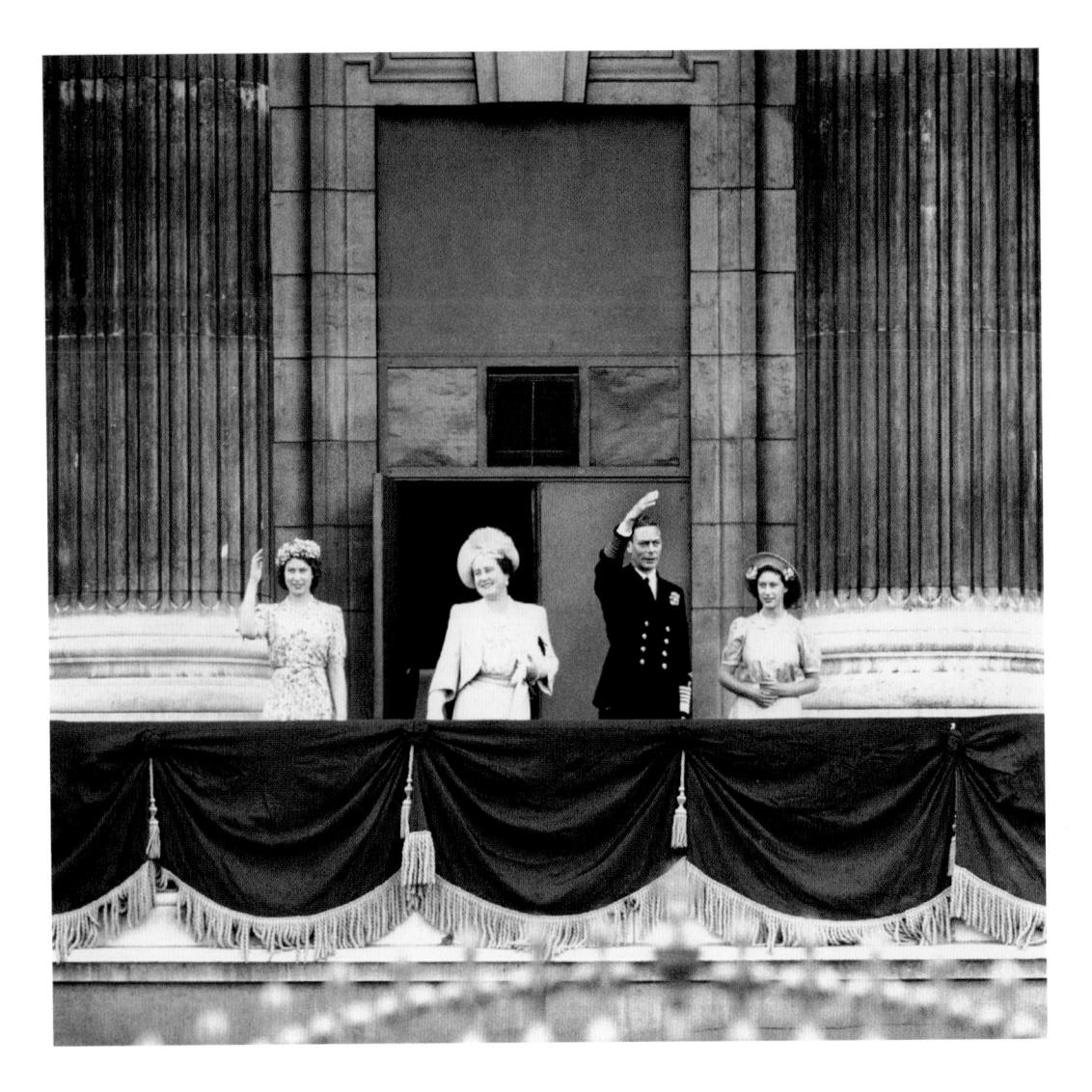

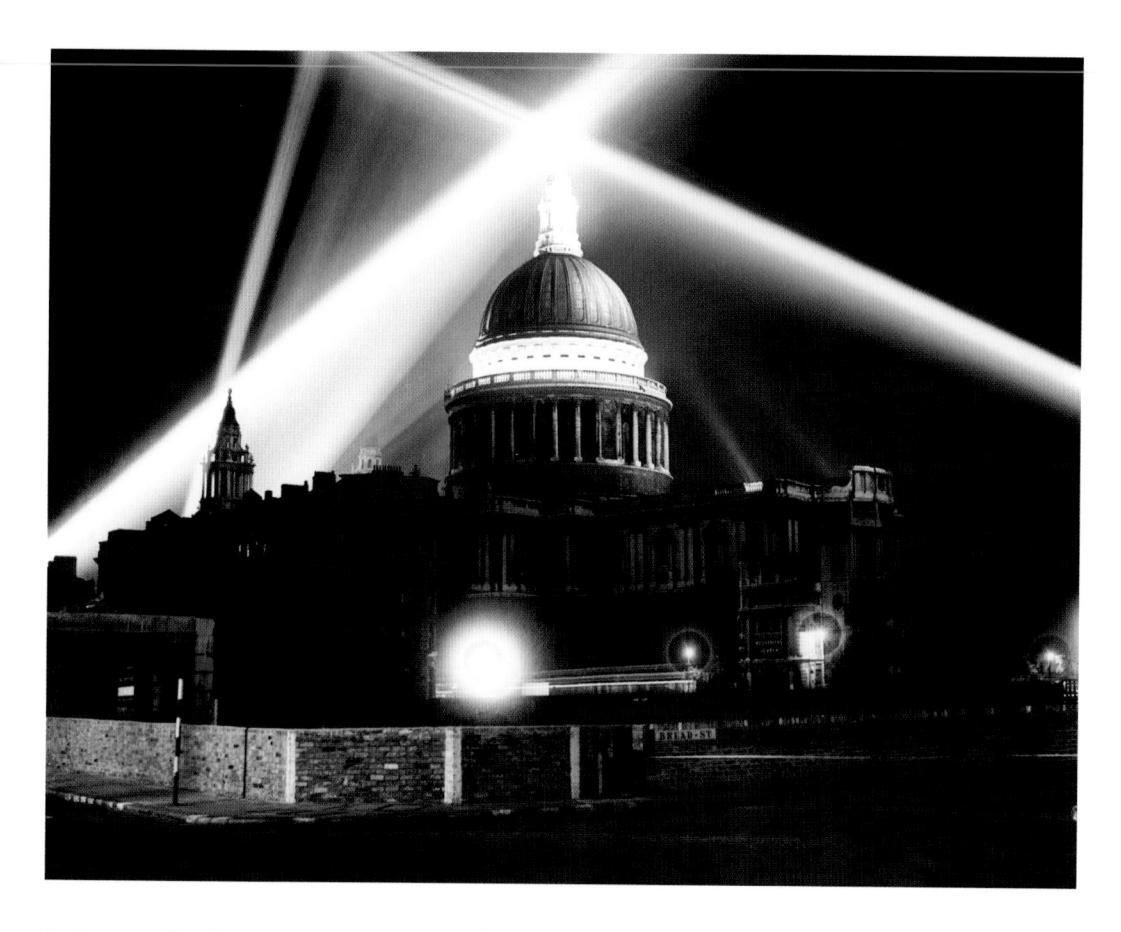

Facing page: King George VI with the Queen, Princess Elizabeth and Princess Margaret on the balcony of Buckingham Palace on VJ (Victory over Japan) Day.

15 August 1945

St. Paul's Cathedral lit by searchlights, on VJ night. 15 August 1945

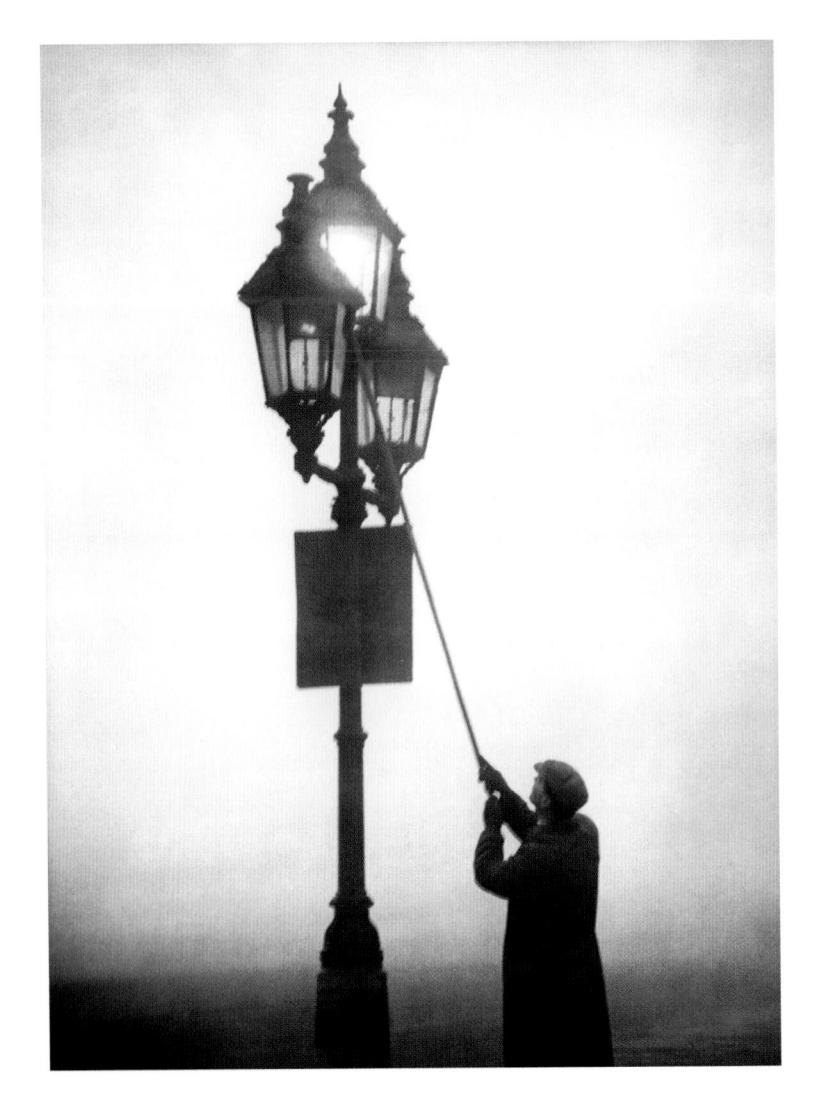

A lamplighter in a pea-souper fog.
31 December 1945

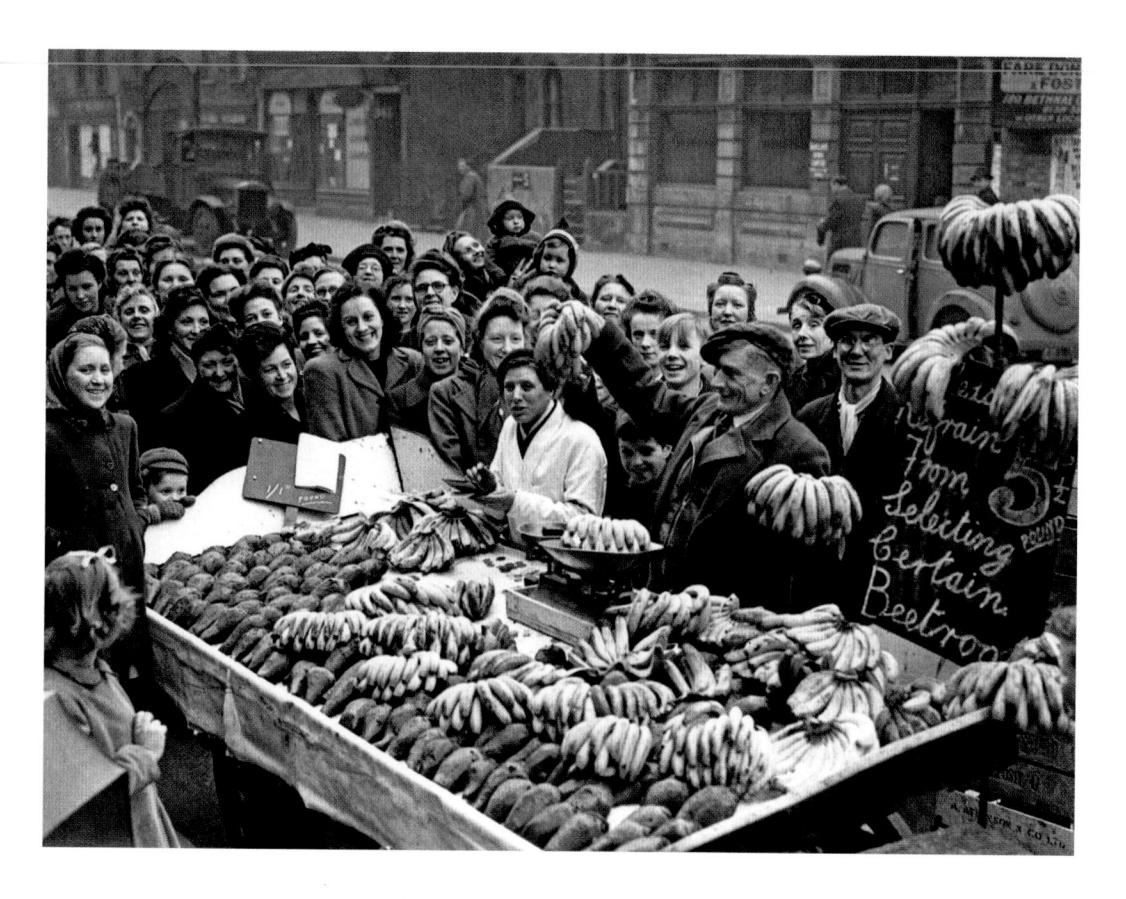

Bethnal Green women queuing for much awaited bananas that have been scarce since the beginning of the war. Rationing did not end in the United Kingdom until the 1950s.

1946

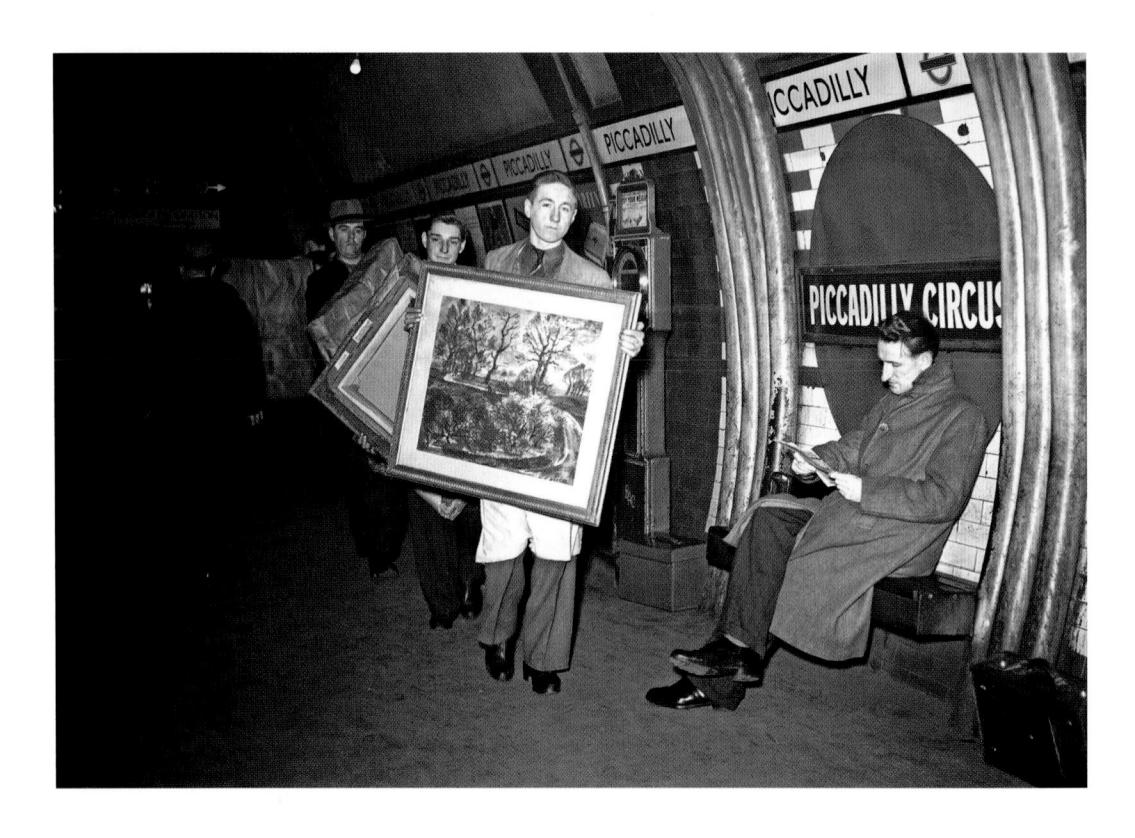

Some 25 metres below Piccadilly Circus is a part of the underground station known as Aladdin's Cave, where national art treasures from the Tate Gallery and the London Museum were stored at the outbreak of war. 4 February 1946

Facing page: Tanks and bulldozers at Admiralty Arch as part of the London Victory Celebration military parade.

8 June 1946

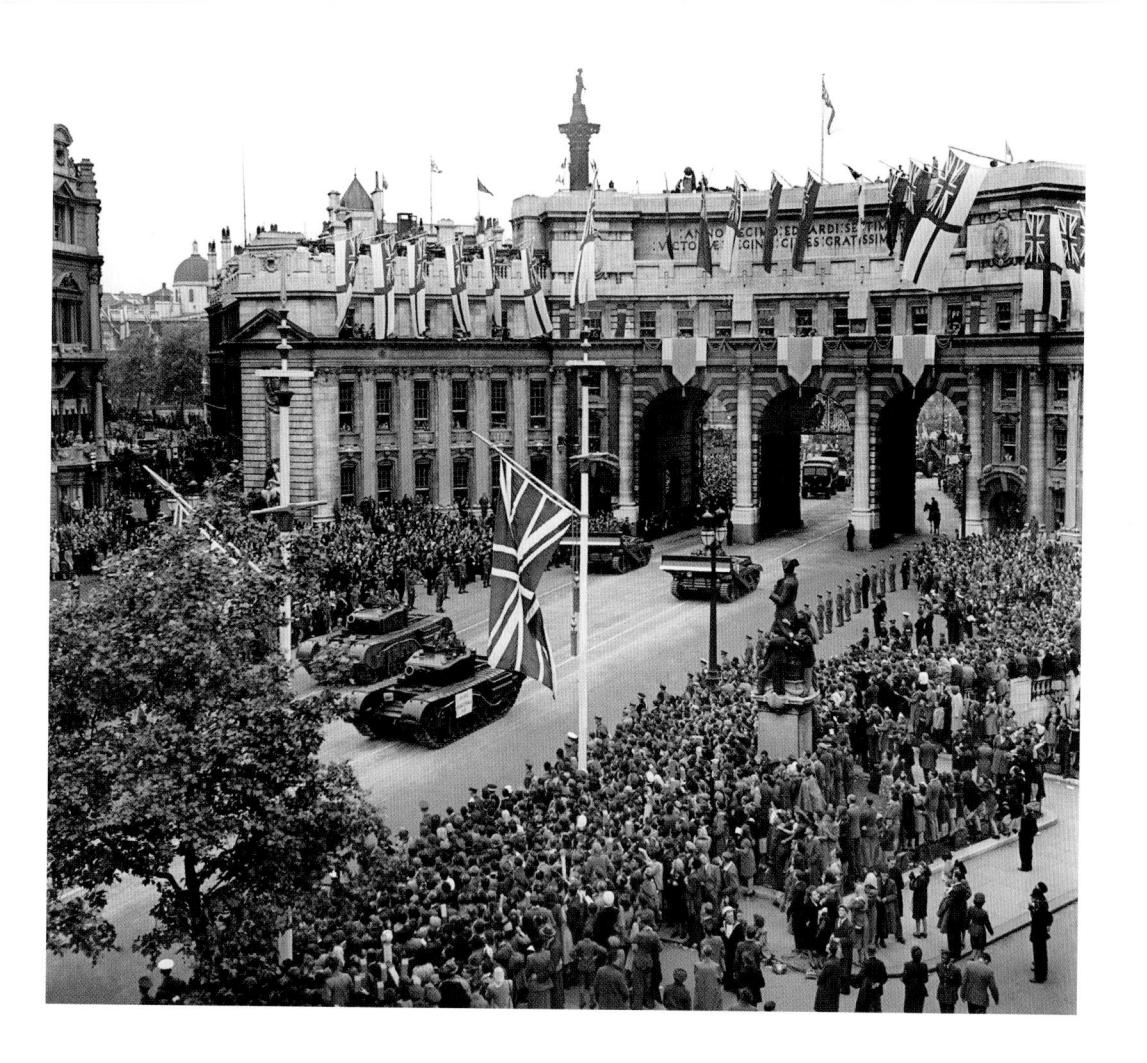

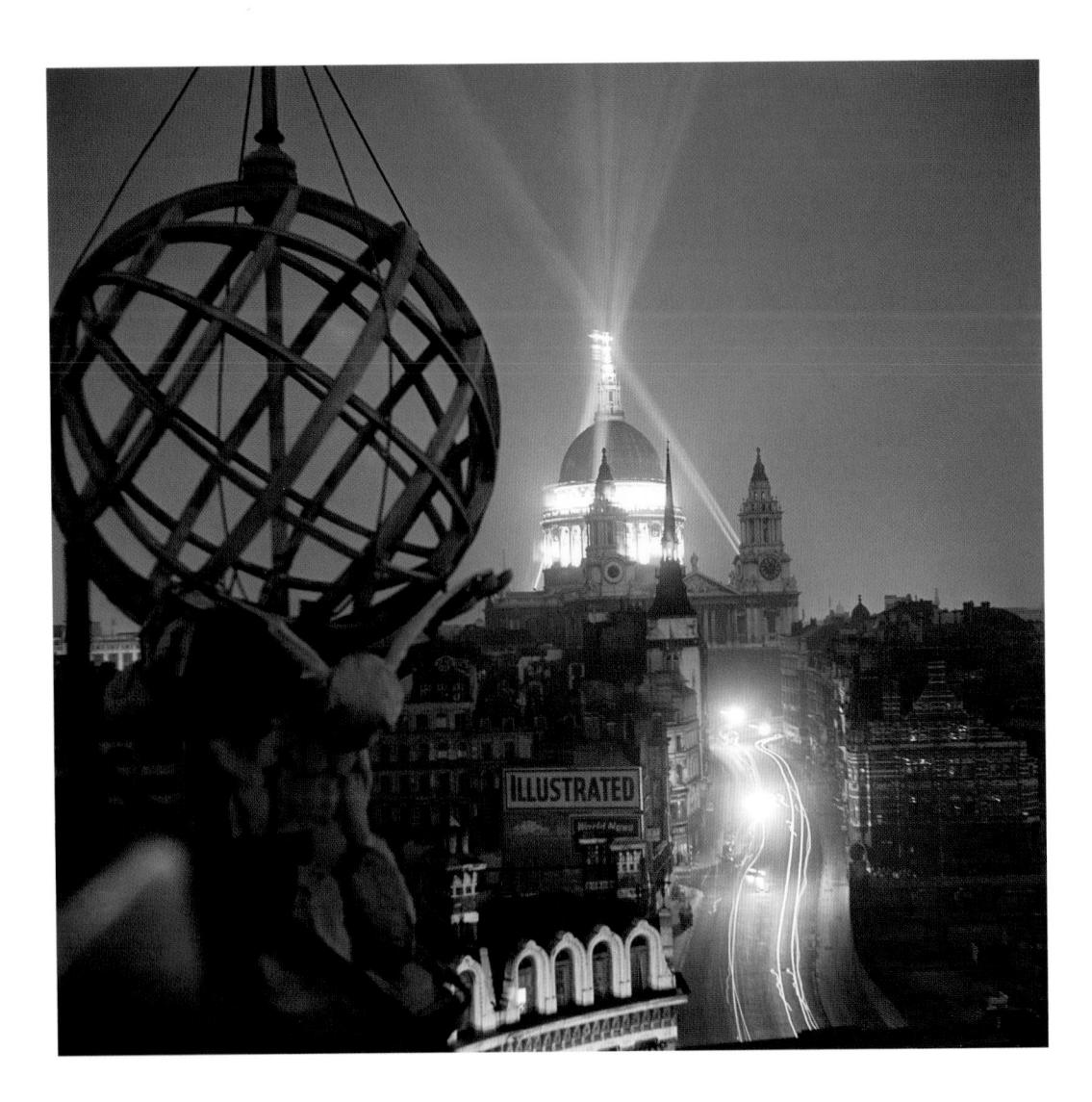

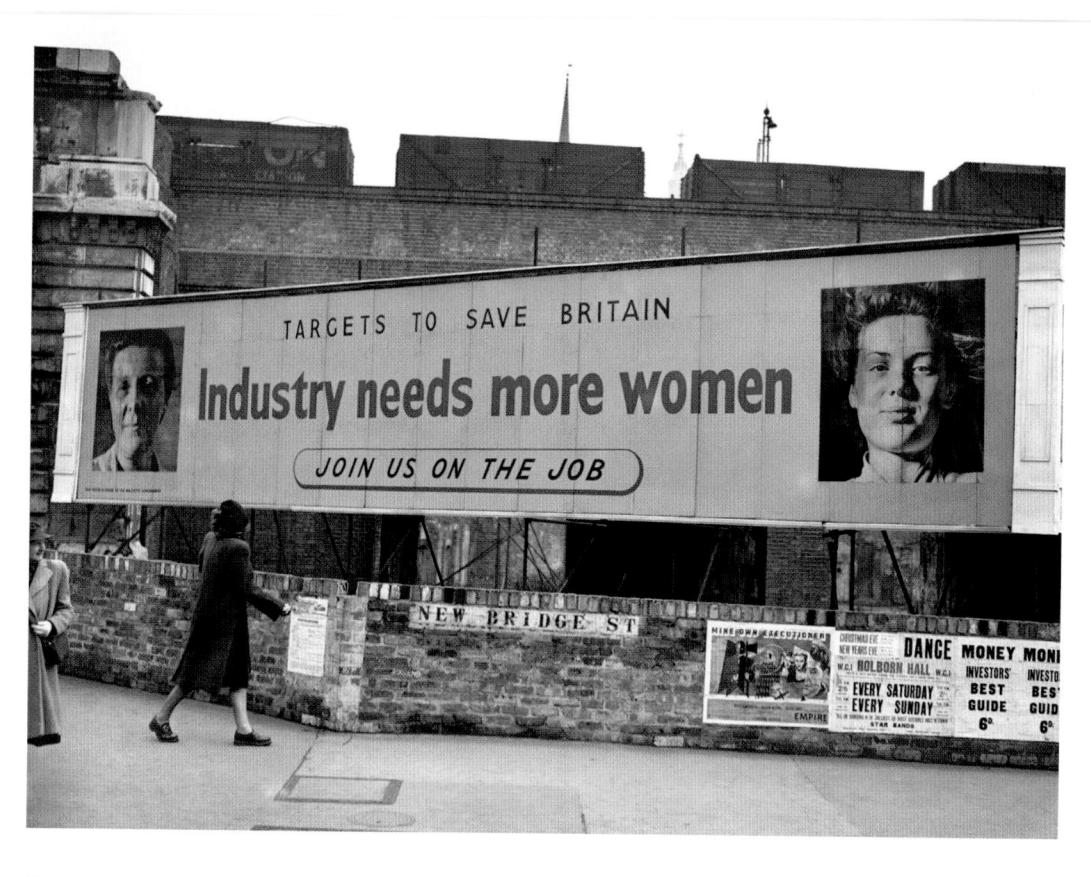

Facing page: The view of St Paul's Cathedral on Victory night from Ludgate Circus.

8 June 1946

Hoarding around a bombsite at Ludgate Circus calling for women to join the industrial workforce.

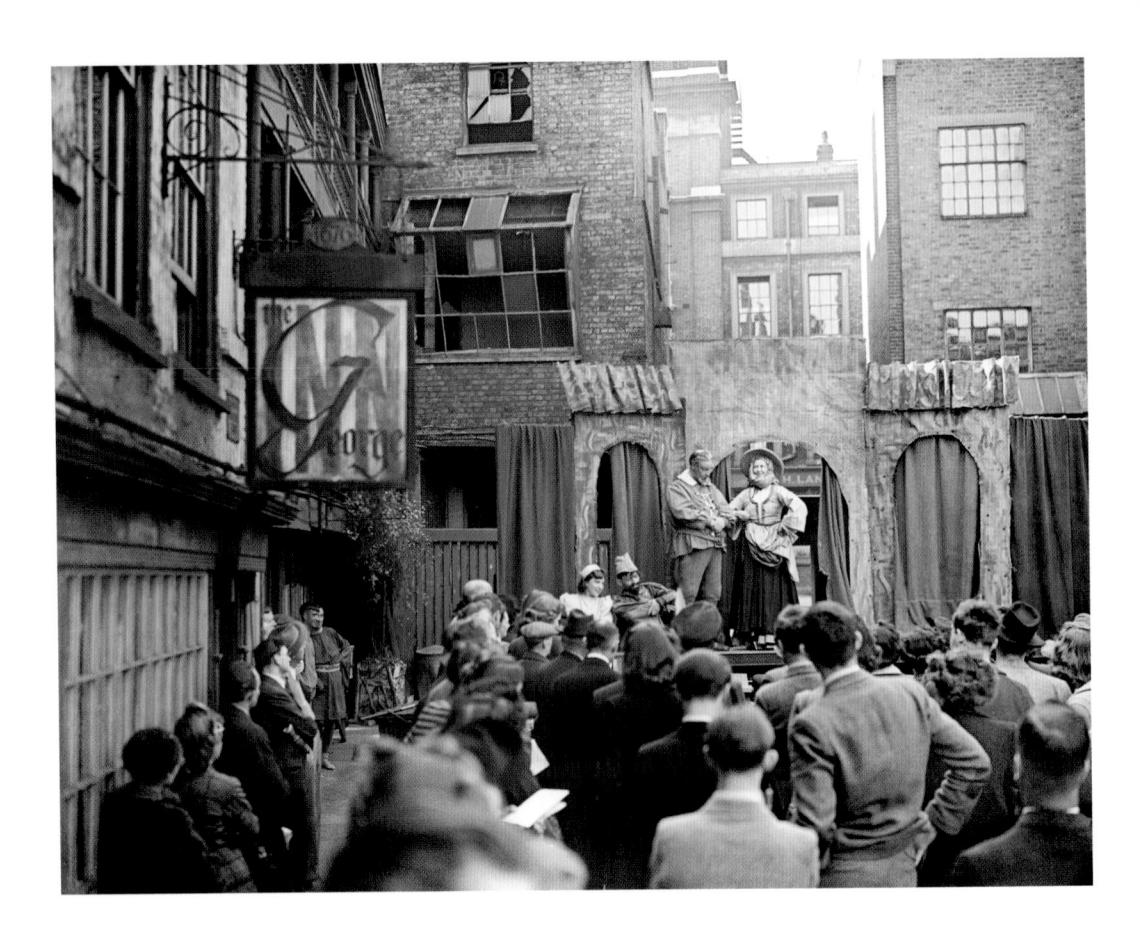

A presentation in the traditional Elizabethan manner of Shakespeare's *The Merry Wives of Windsor* in the courtyard of the George Inn, Southwark, near the site of the original Globe theatre. 26 April 1947

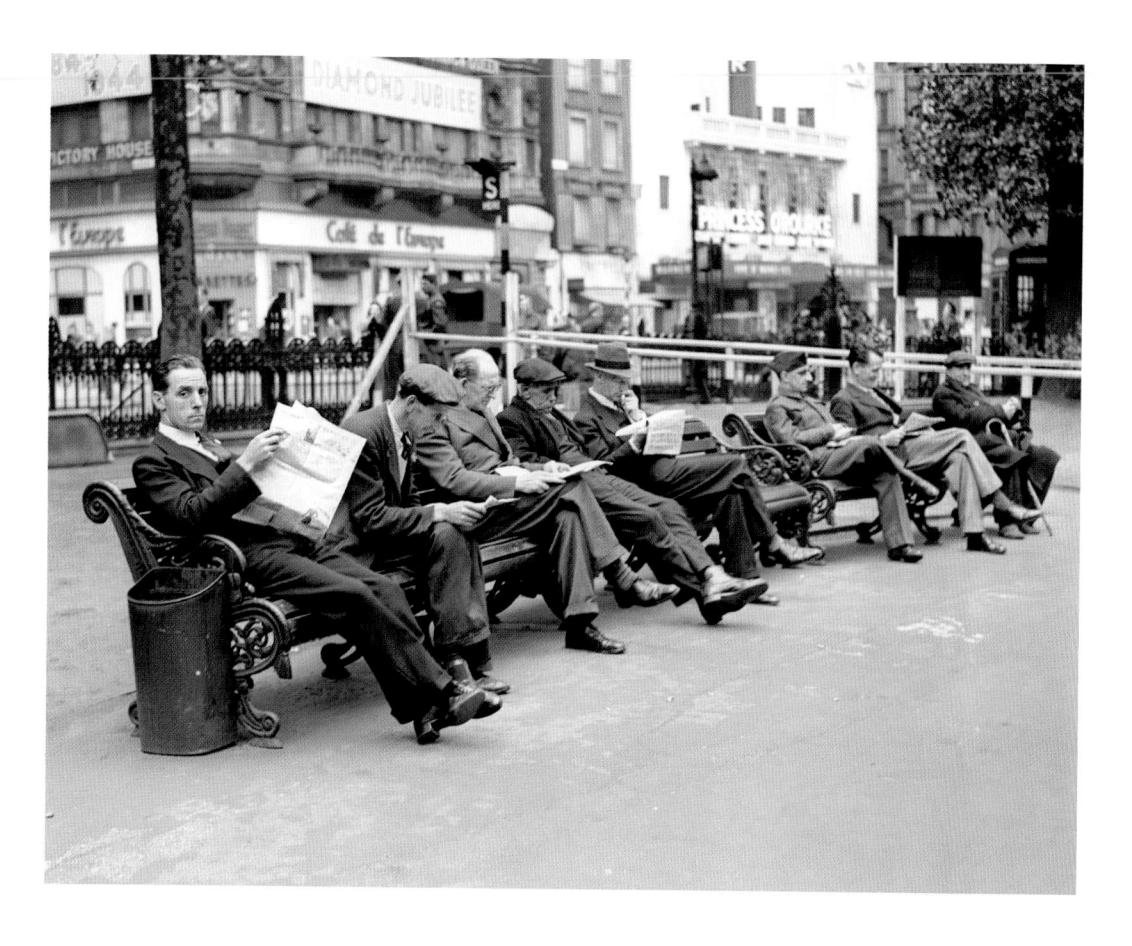

Leicester Square.
13 November 1947

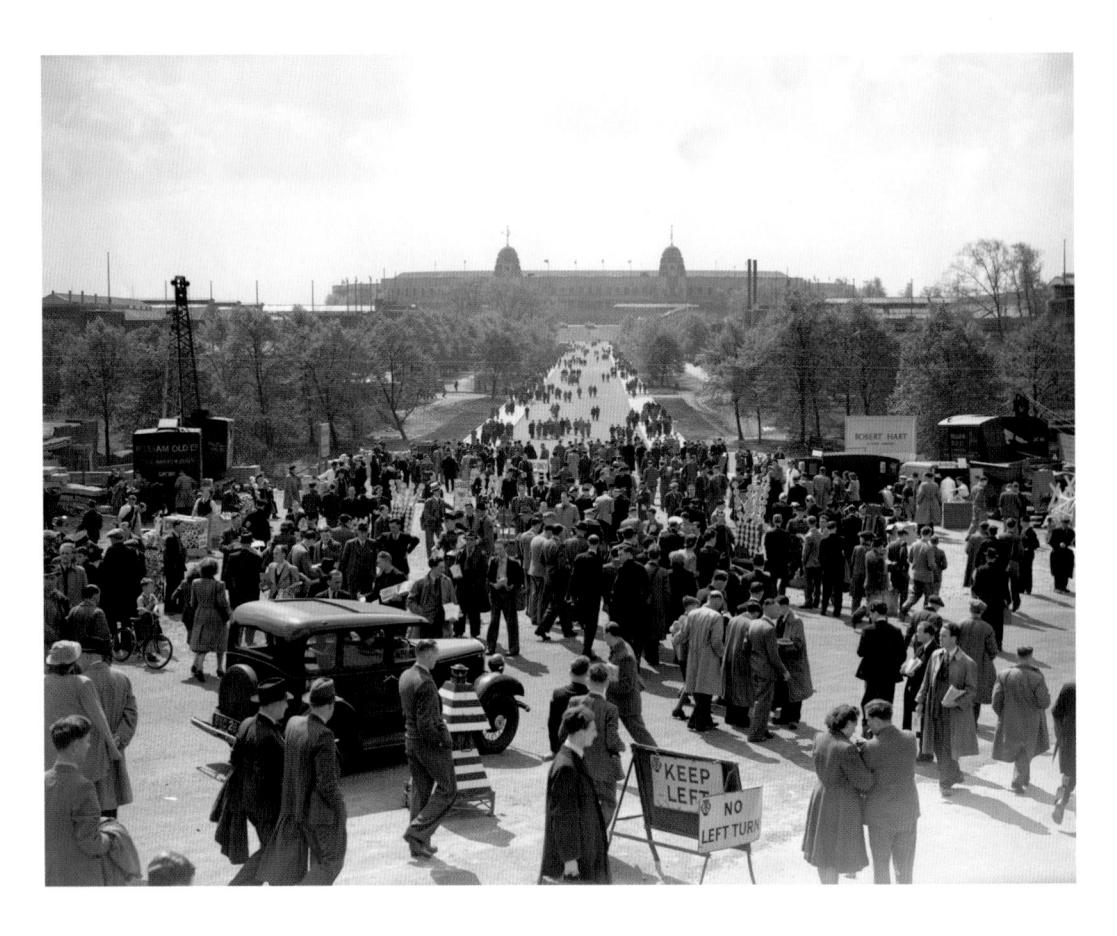

Blackpool and Manchester United supporters take the new Olympic Road on their way to Wembley Stadium for the FA Cup Final.

24 April 1948

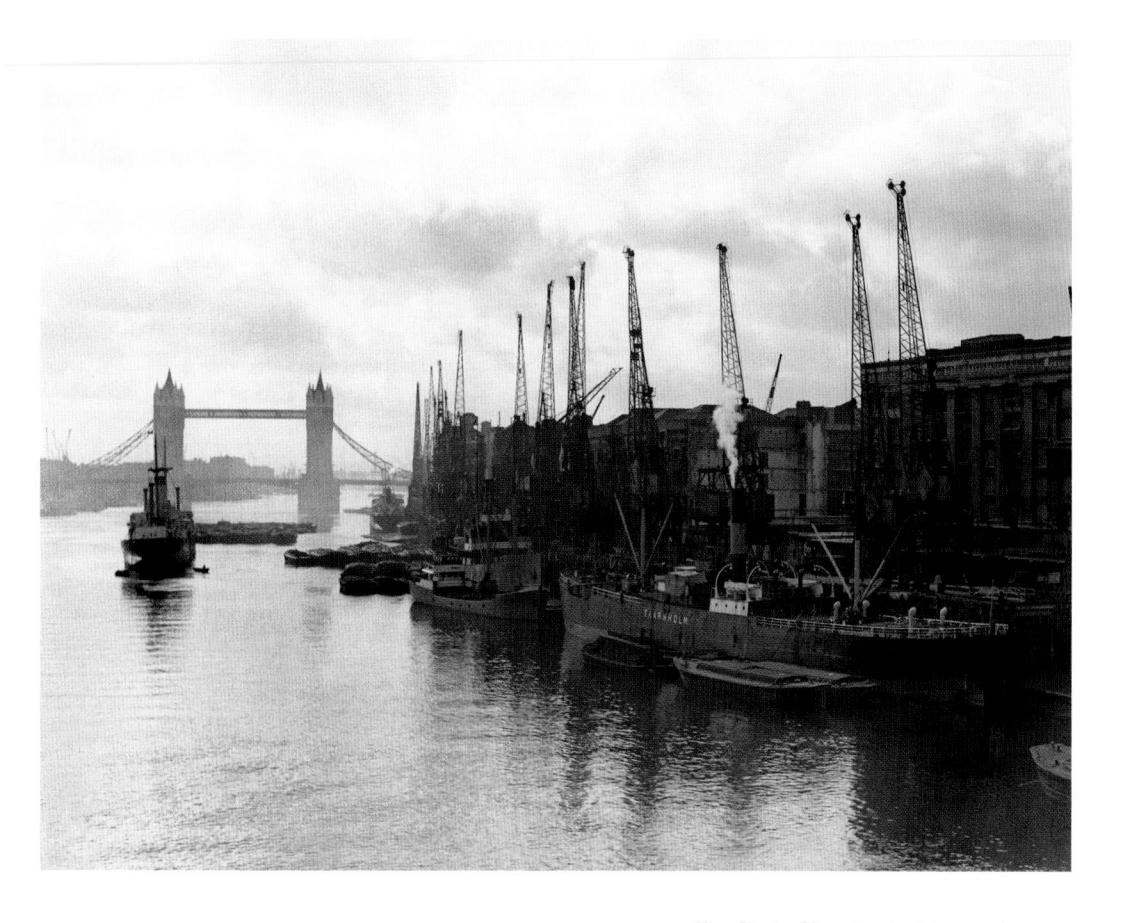

The Pool of London looking west.

June 1948

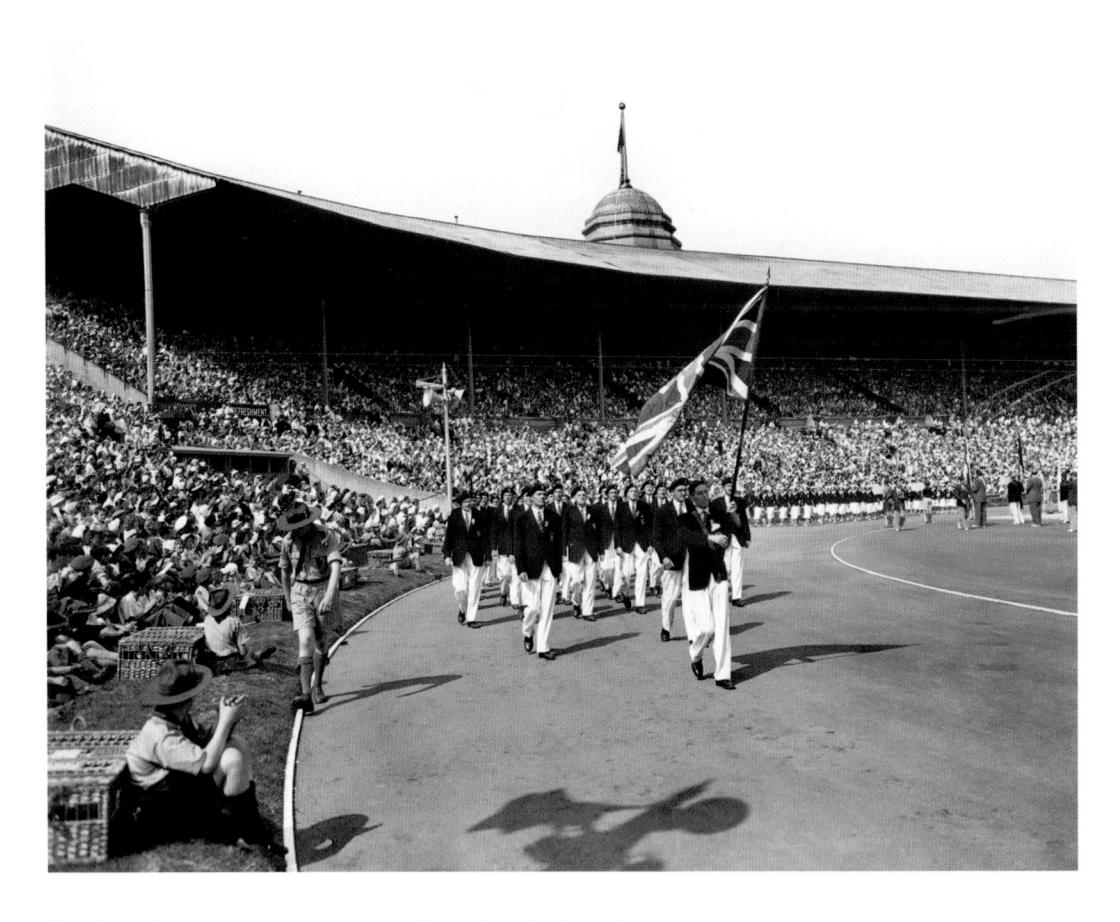

The Great Britain team marches around Wembley Stadium during the opening ceremony of the 1948 London Olympic Games. 29 July 1948

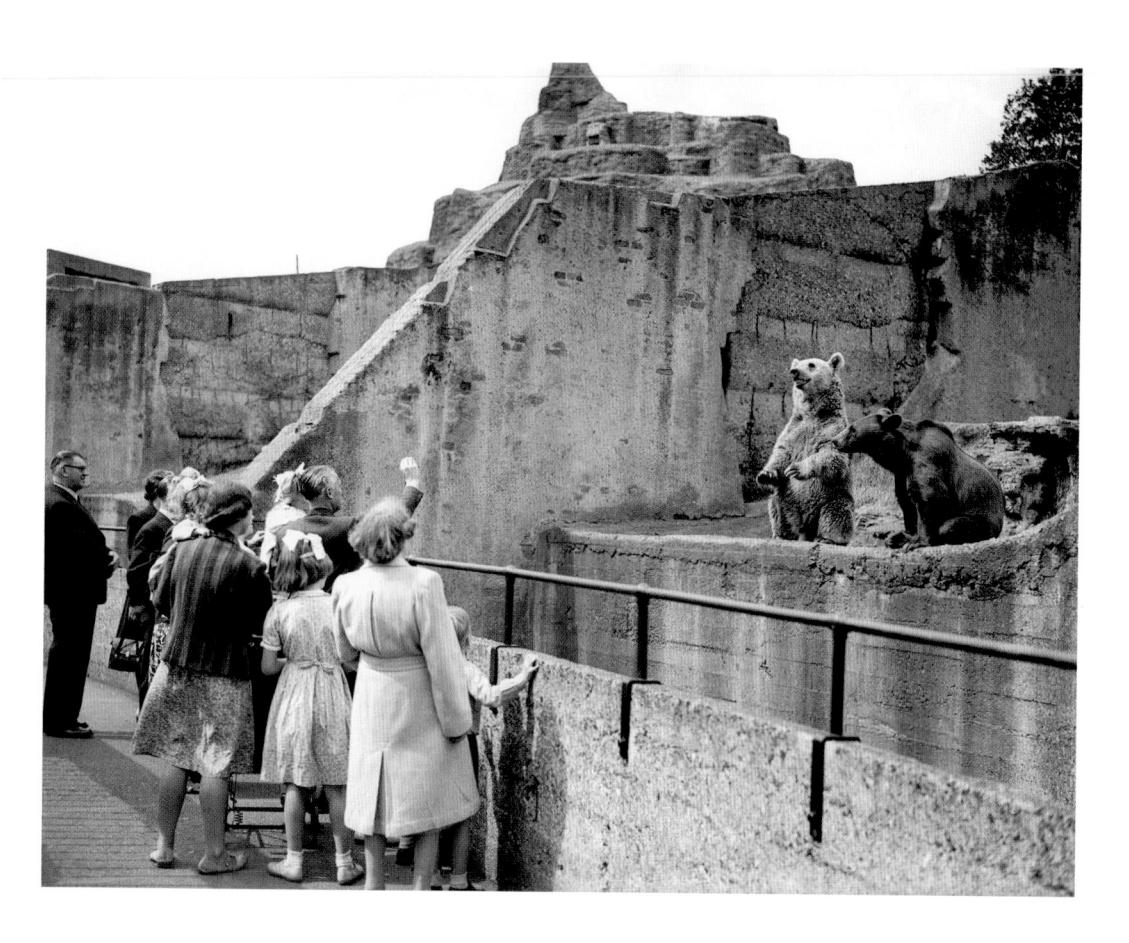

Bear Mountain, the main bear enclosure at London Zoo.

16 August 1948

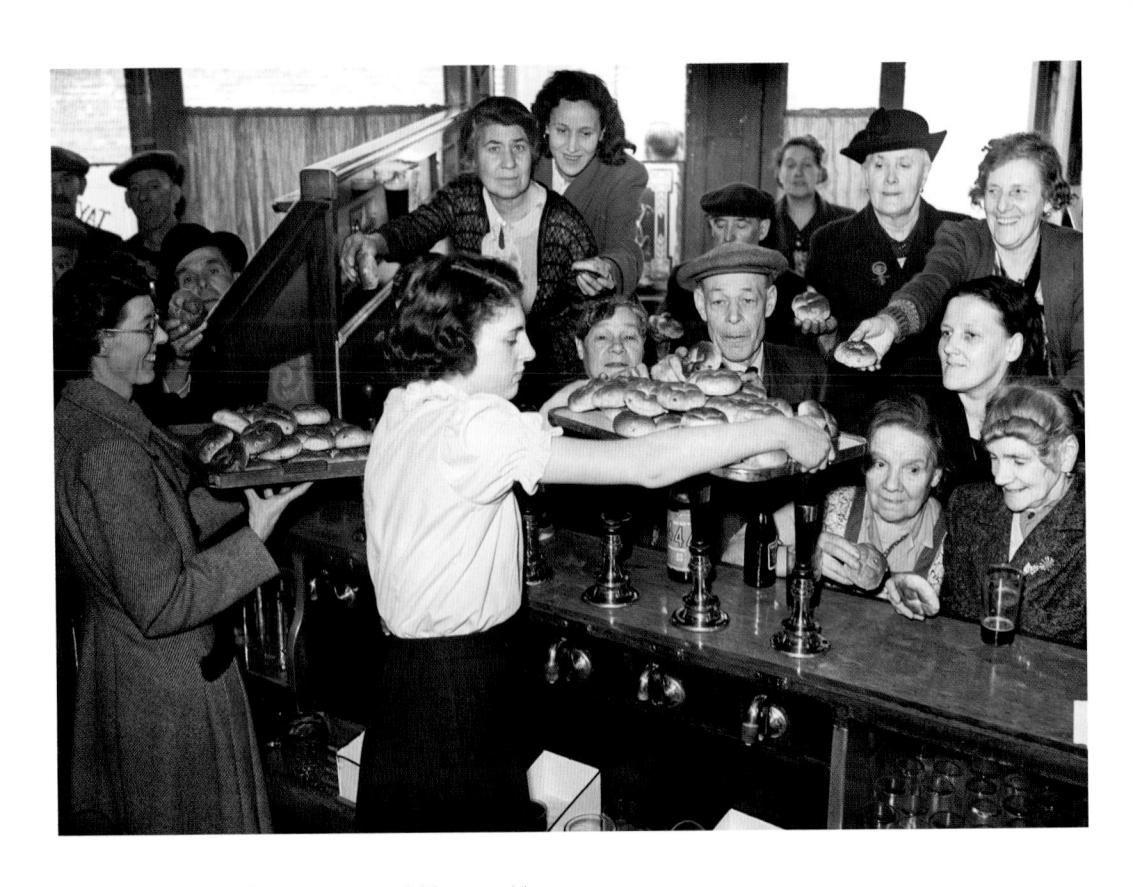

Free hot cross buns for customers, a 300-year-old custom at St Bartholomew's the Great, Smithfield. 16 April 1949

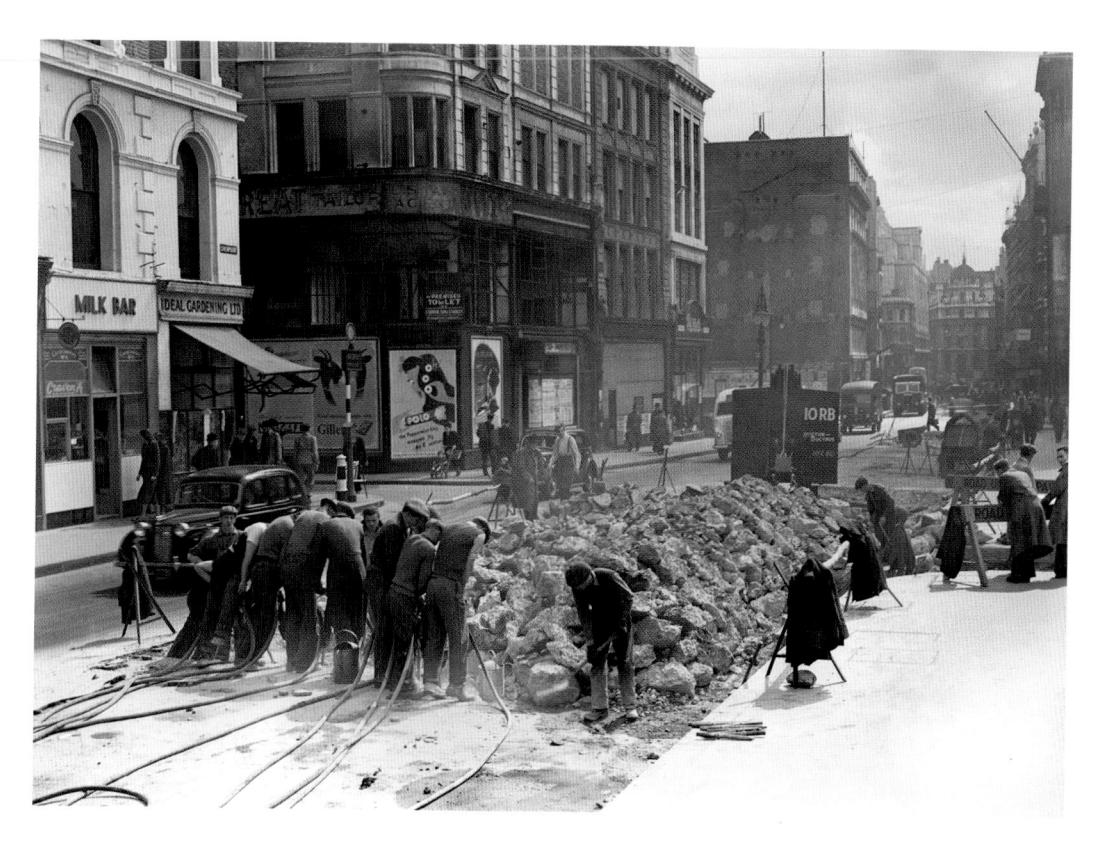

Cheapside was extensively damaged by the heat of incendiary attacks during the Blitz. Portions of the roadway had to be completely replaced.

25 May 1949

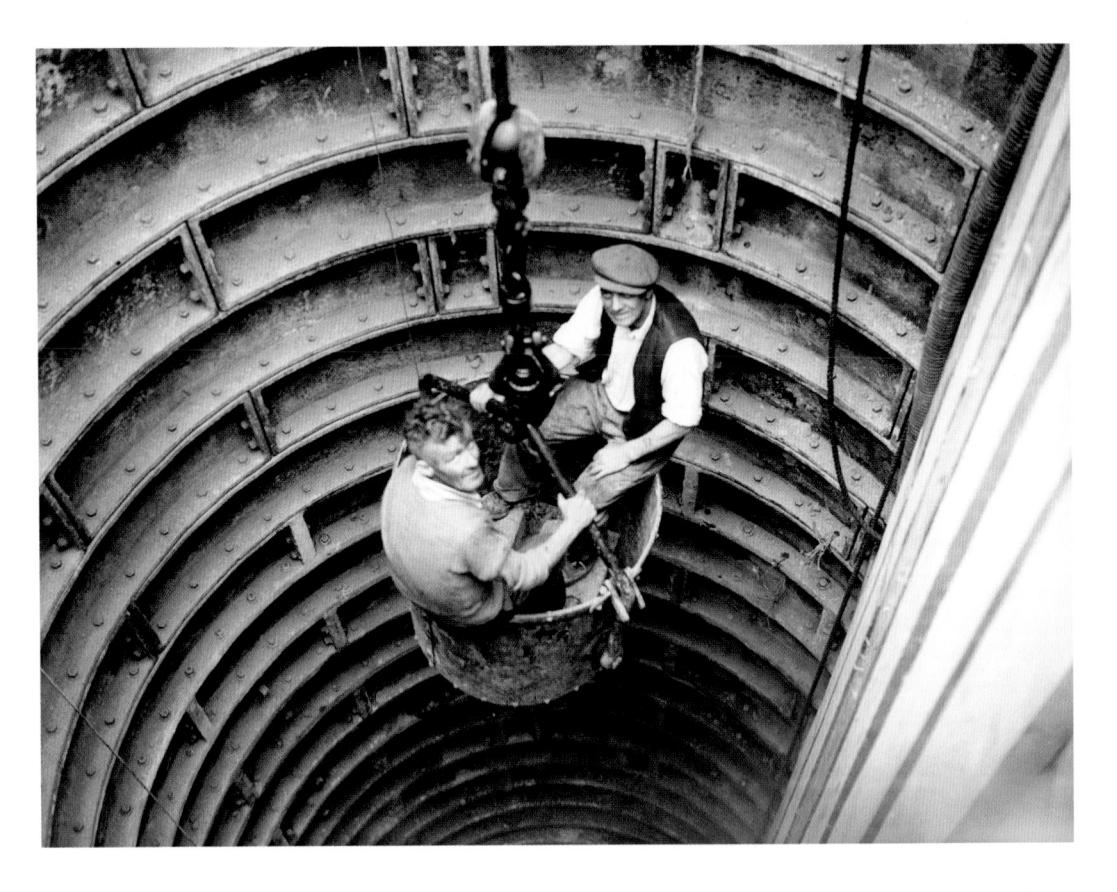

Workmen being lowered down a shaft to work on an escalator at Waterloo station. 7 July 1949

Facing page: Sweet rationing, to the horror of British children, is reintroduced and will not end until 1953. 12 August 1949

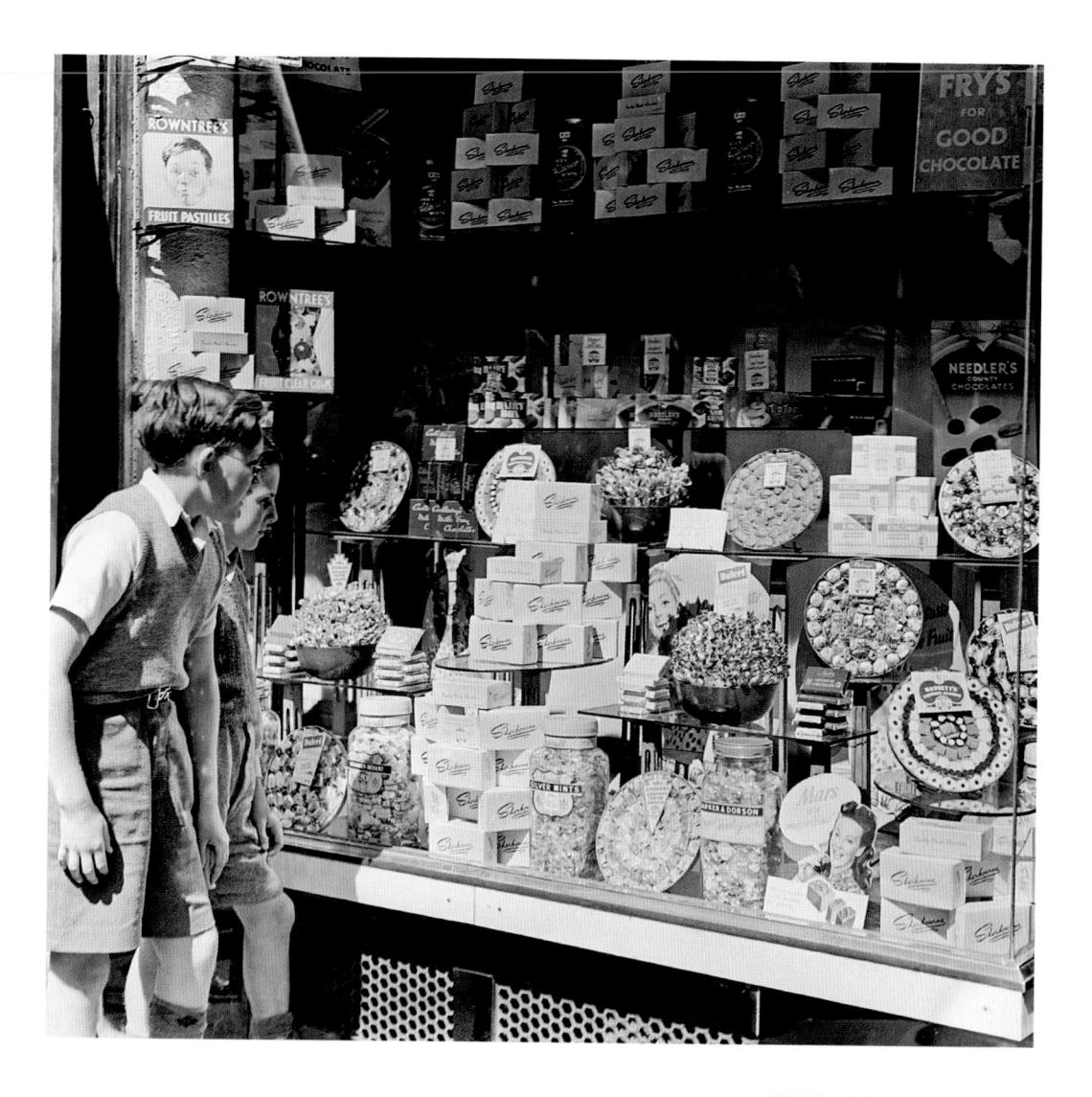

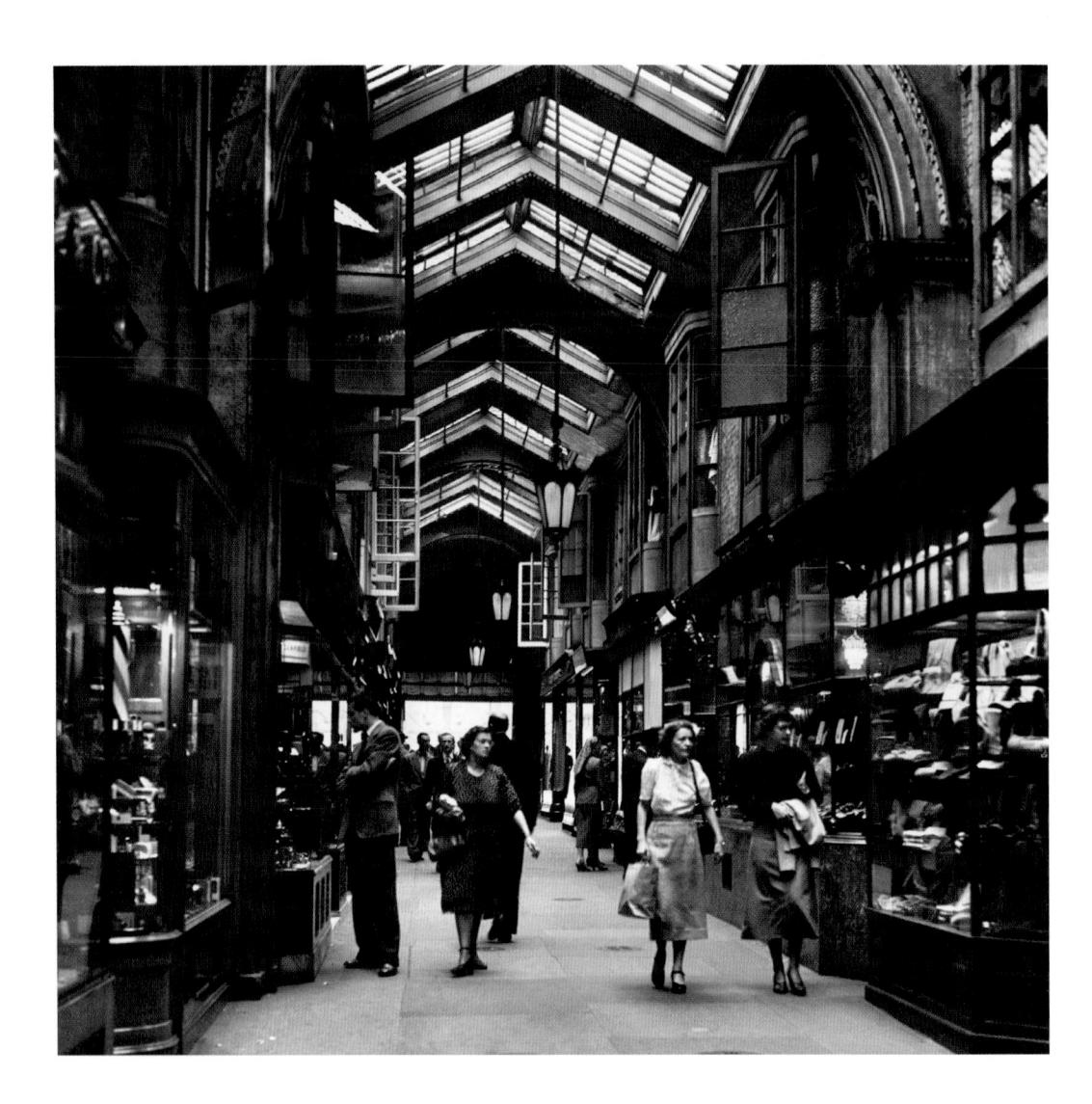

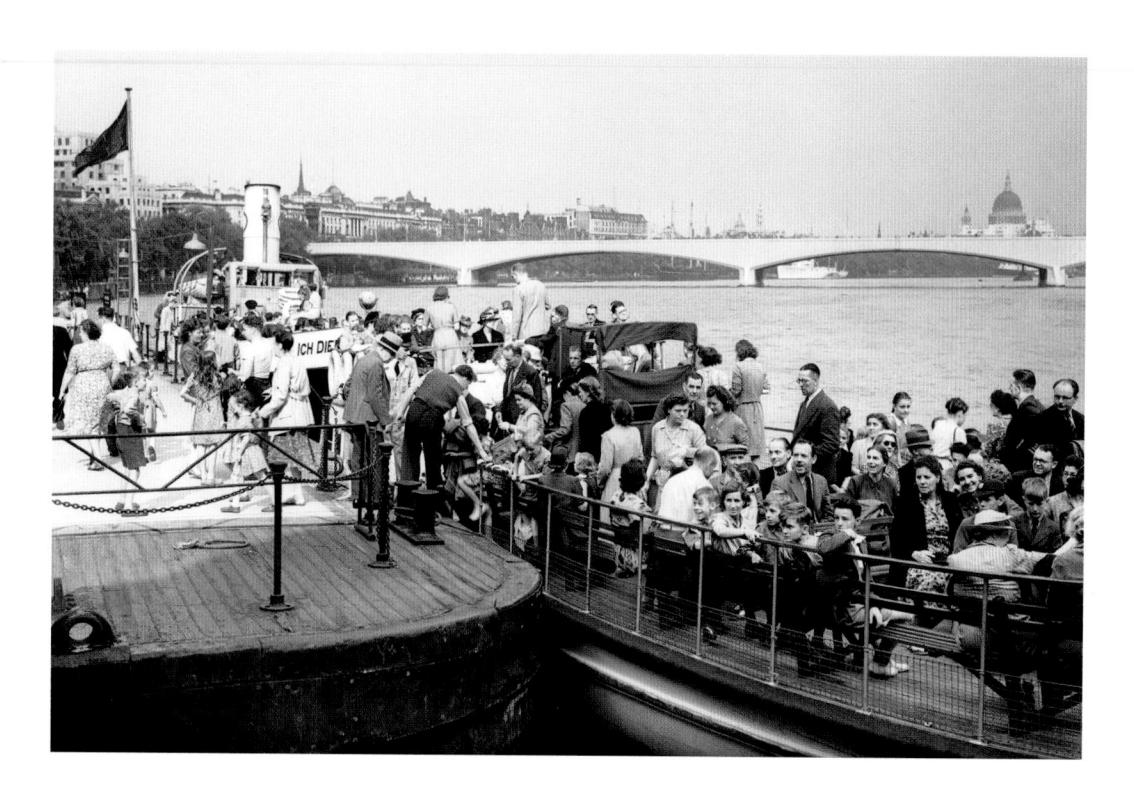

Passengers board the Thames waterbus at Charing Cross.

22 August 1949

Facing page: The Burlington Arcade, from the Piccadilly end. 22 August 1949

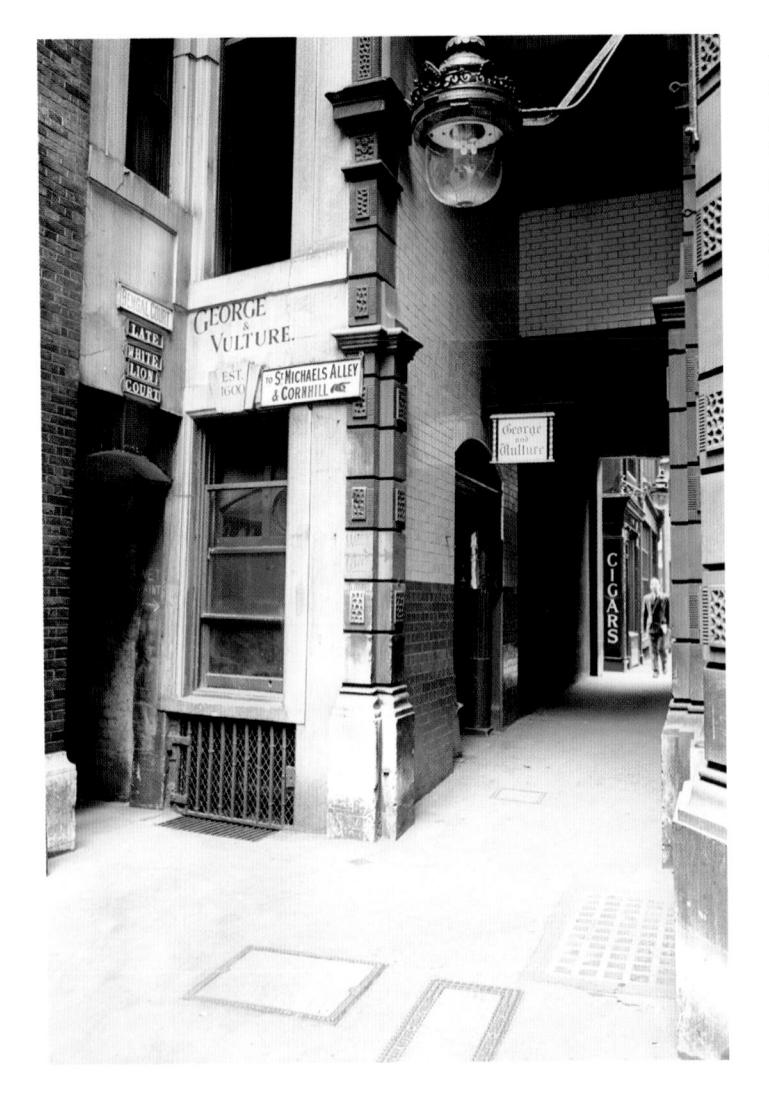

The rear of the George and Vulture Inn in Castle Court, near Lombard Street in the City. Dickens made this the base for the City Pickwick Club and the Dickens family gathered here at Christmas. 22 August 1949

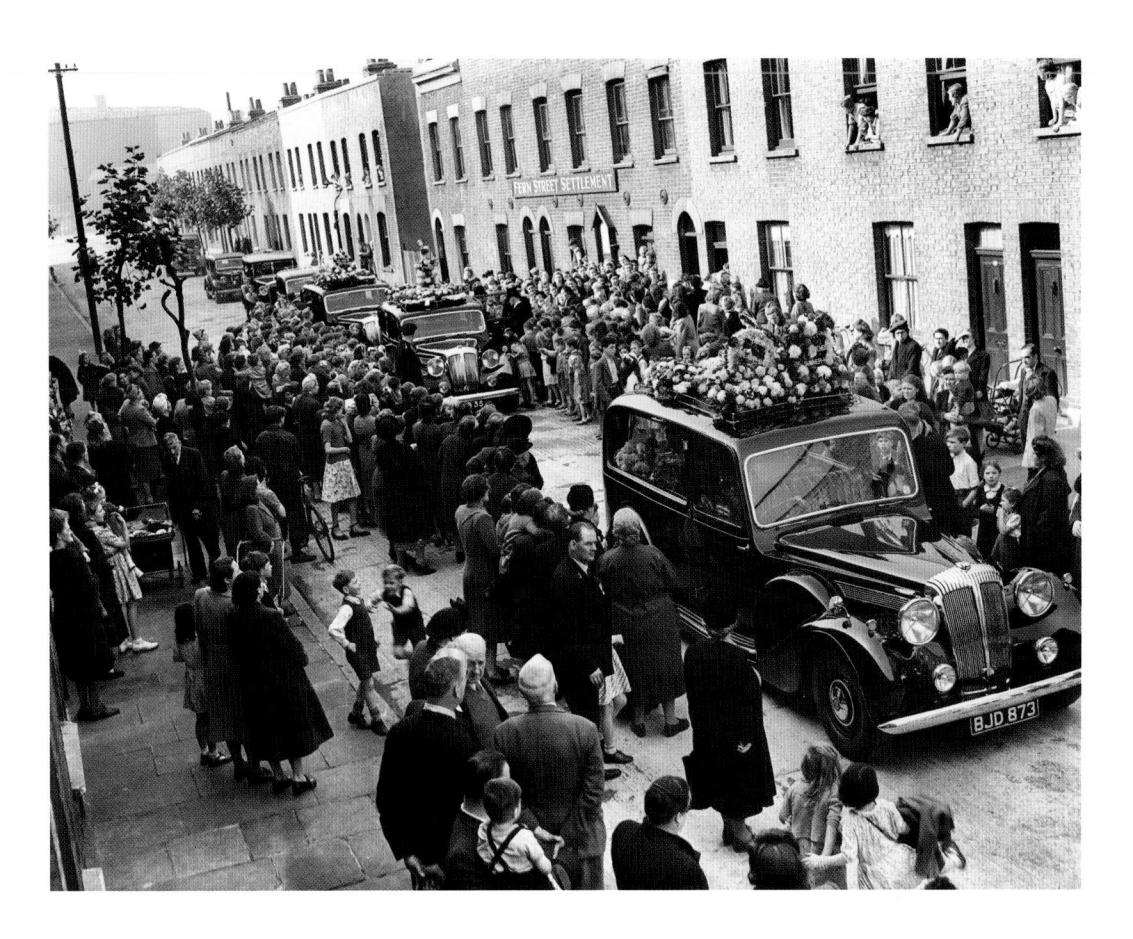

The funeral of Clara Grant, The Bundle Woman of Bow, passes the Fern Street Settlement, which she founded to give aid to deprived children.

13 October 1949

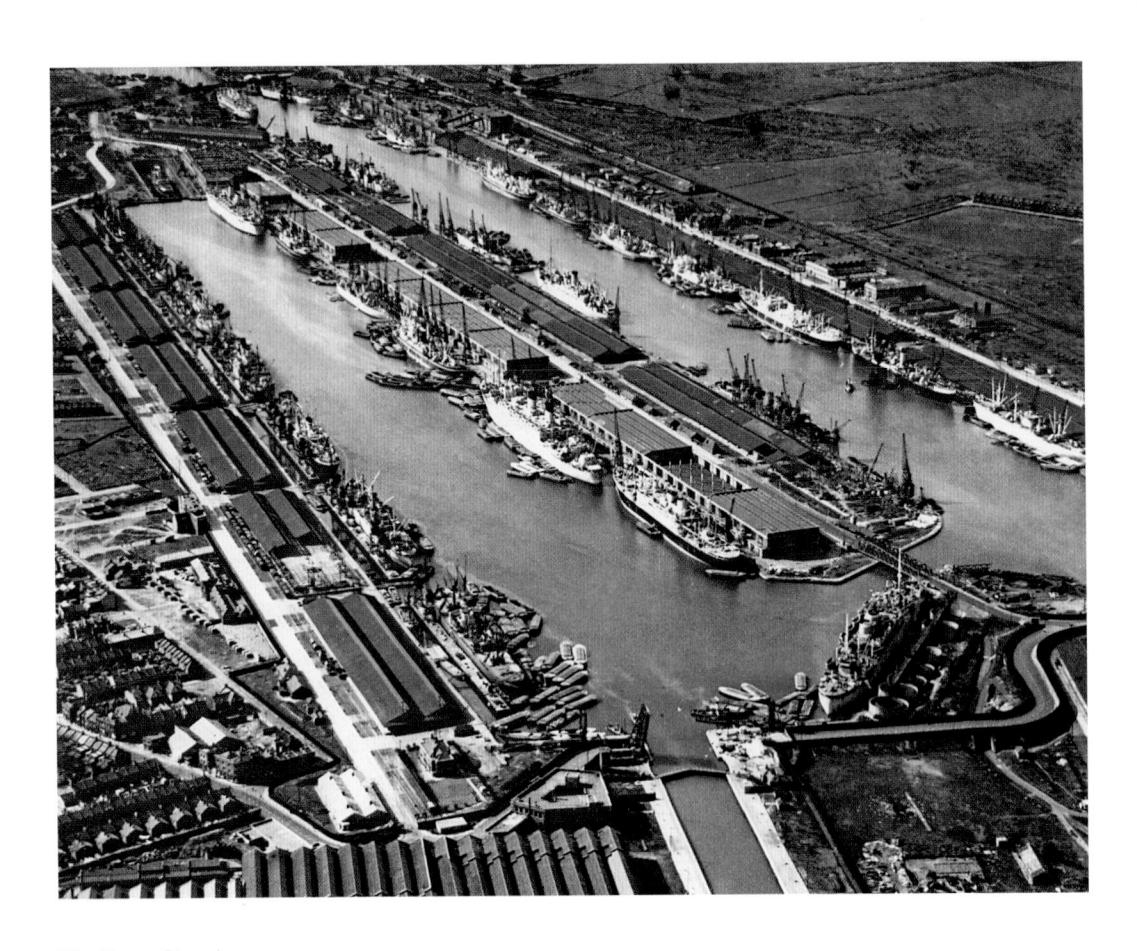

The Port of London.
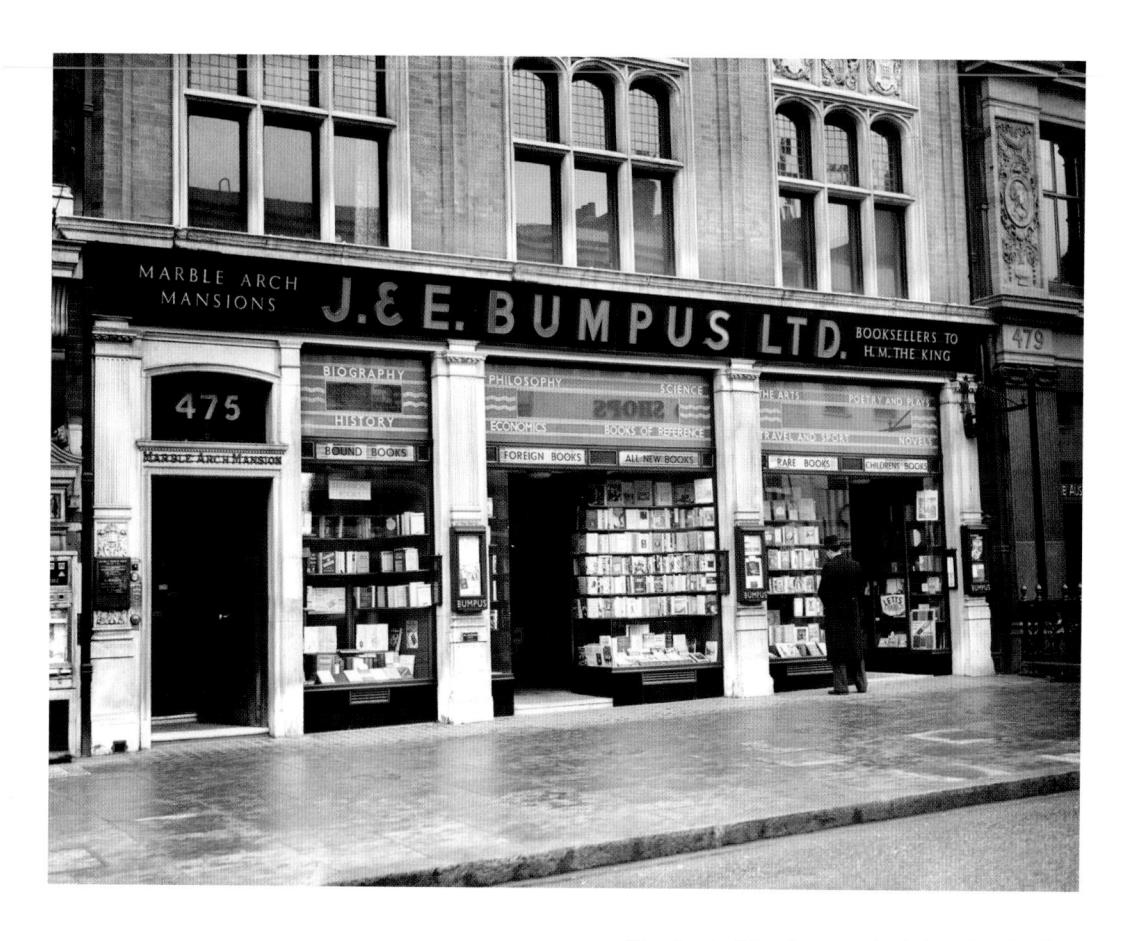

The front of the Bumpus Bookshop, bookseller to King George VI, on Oxford Street.

2 January 1950

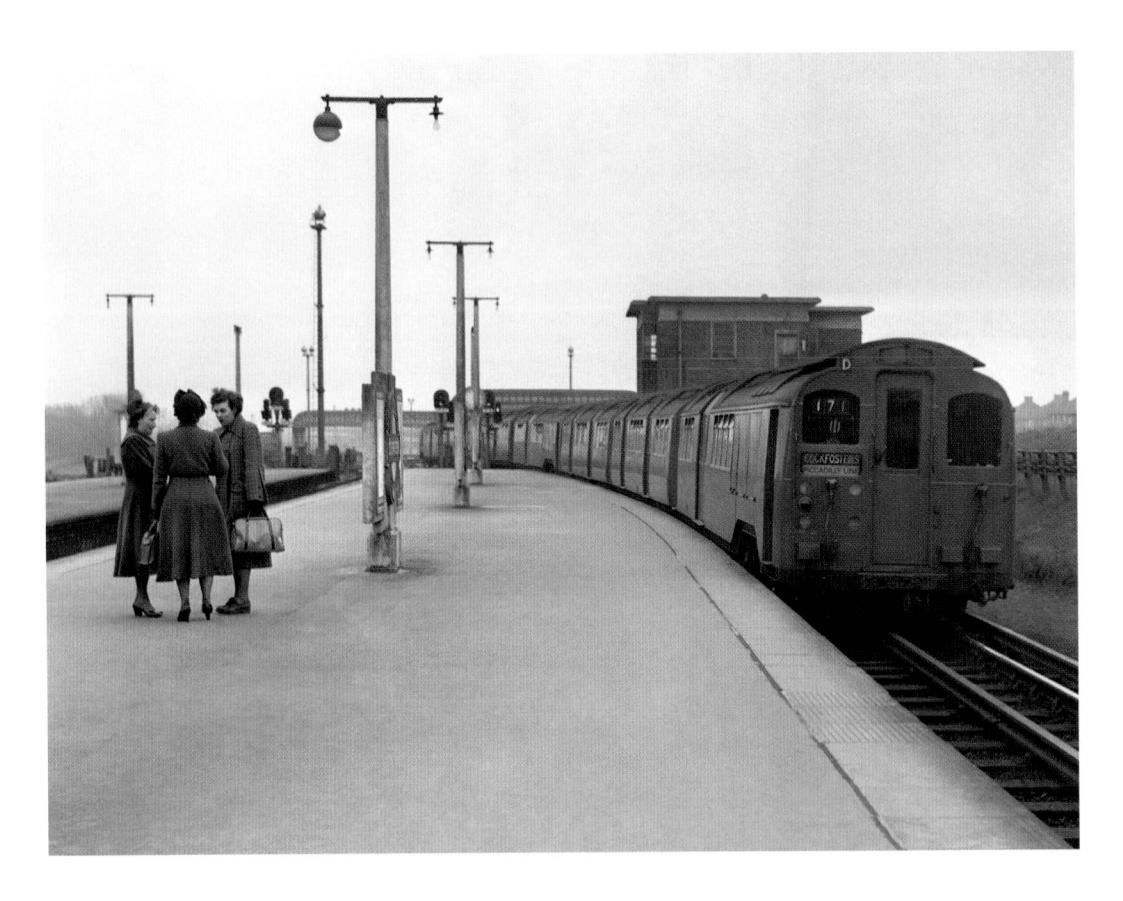

Cockfosters station, the northern end of the Piccadilly Line.

25 February 1950

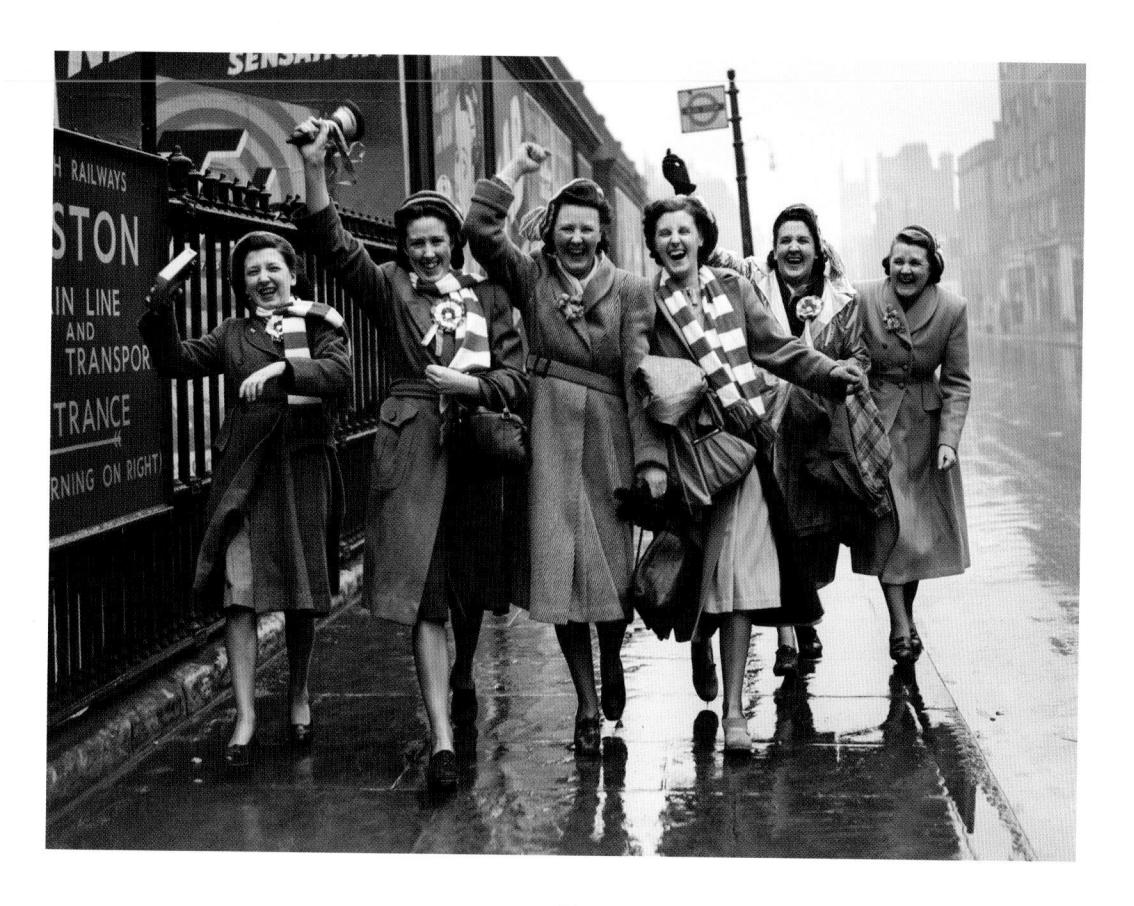

Liverpool girls head for Wembley Stadium for the FA Cup Final, Liverpool v Arsenal. 23 April 1950

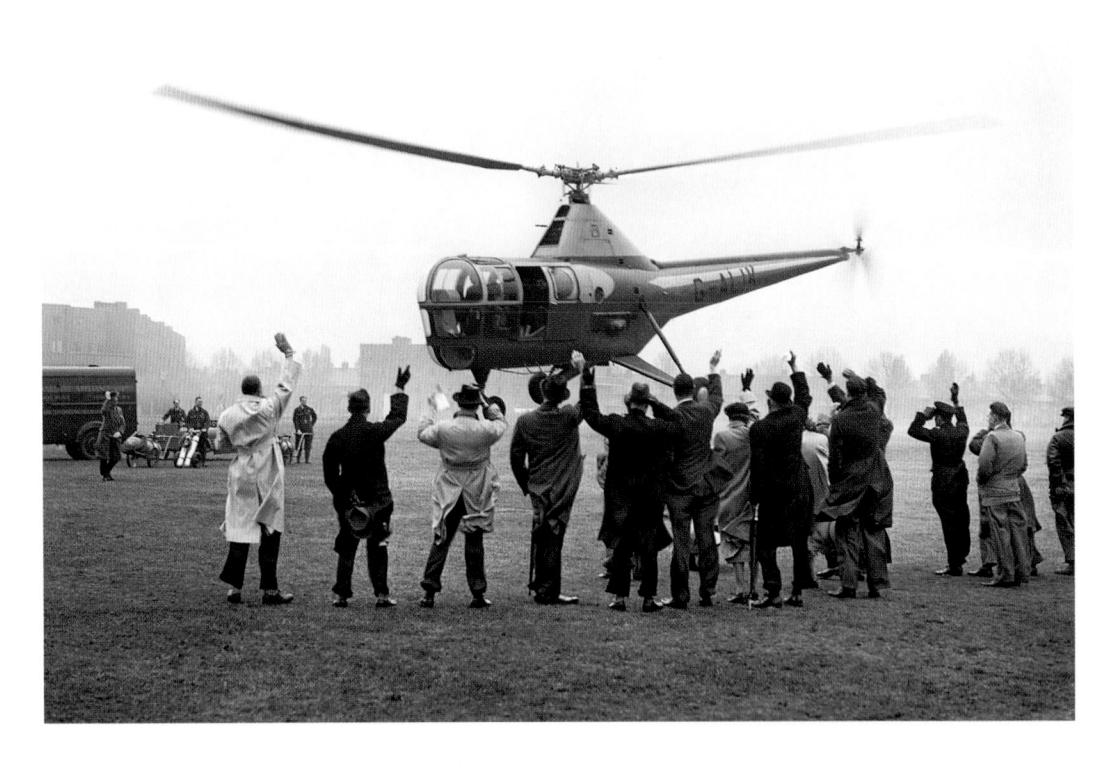

The world's first helicopter passenger service, from London to Birmingham, takes off from the Harrods' Sports Ground in Barnes.

5 May 1950

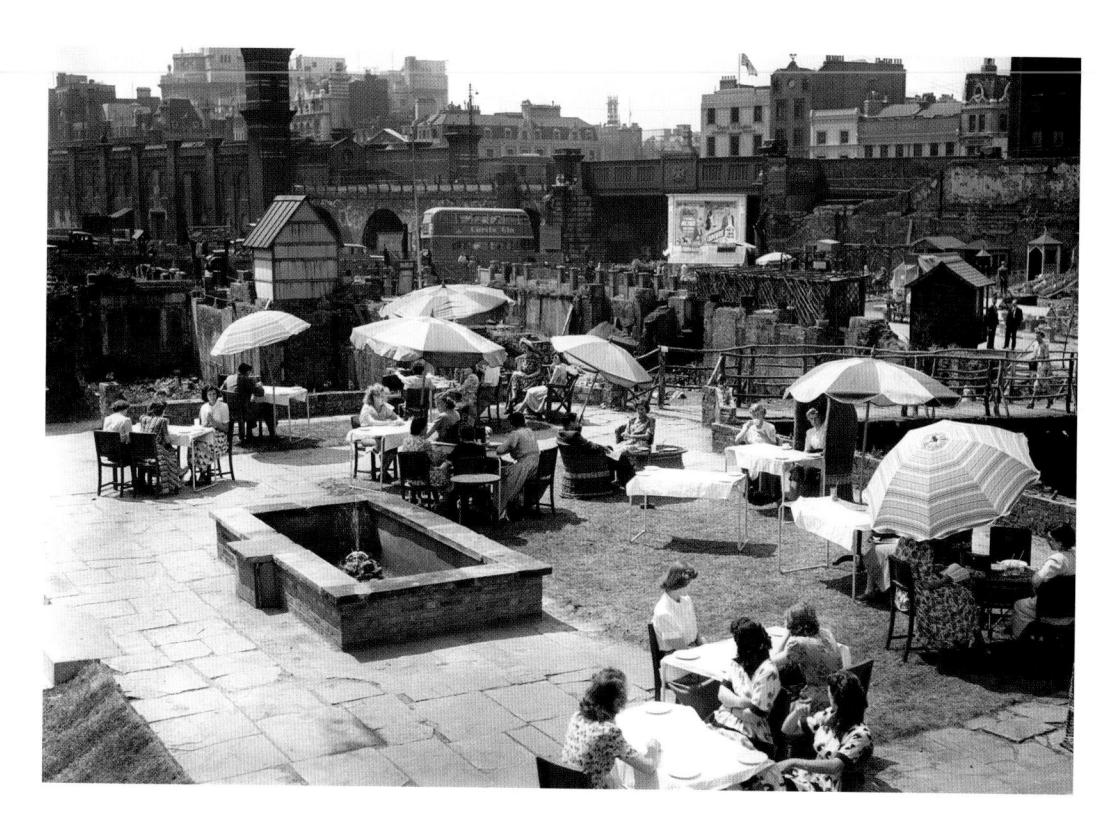

Ludgate Hill Gardens open-air cafe. 26 May 1950

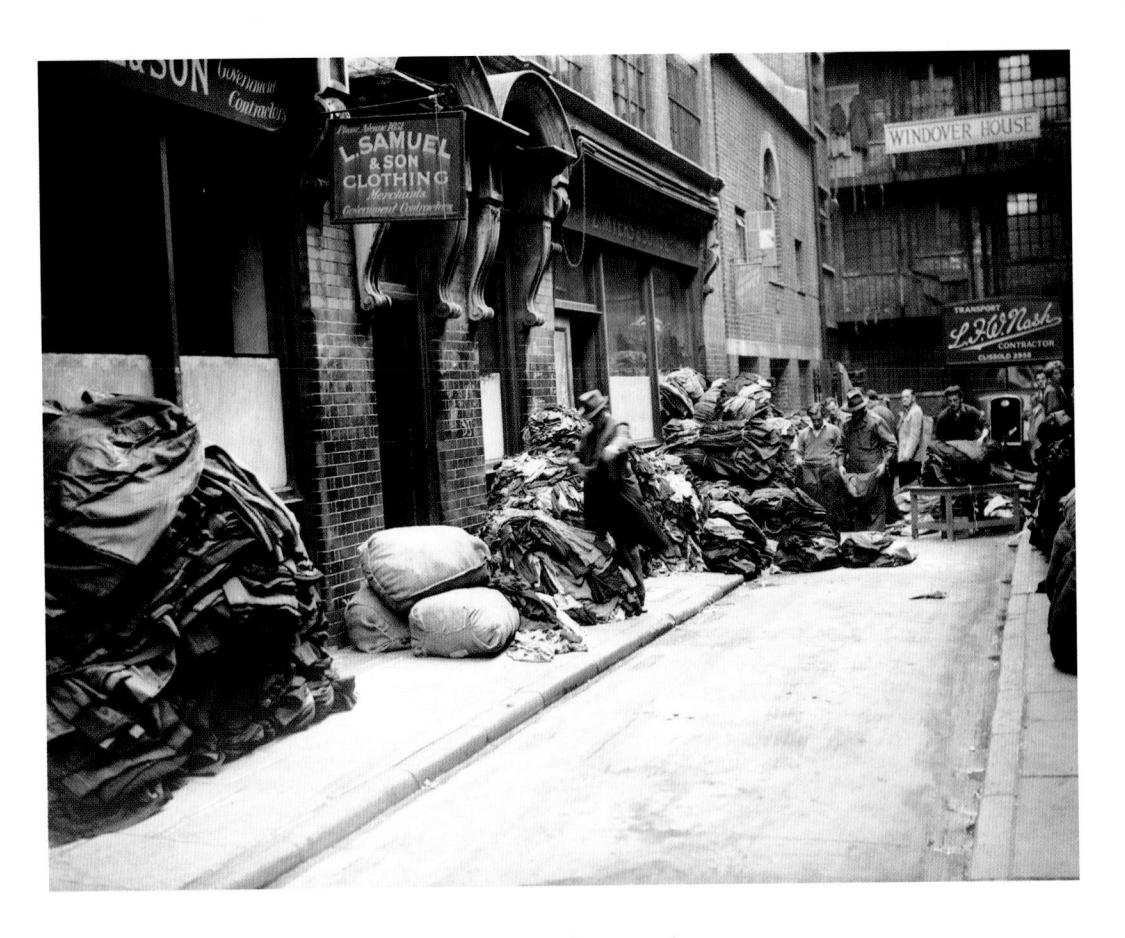

Clothier Street, Houndsditch. Old clothes are received for processing into such things as stuffing for furniture and toys, duffle for coats and rags for papermaking.

7 October 1950

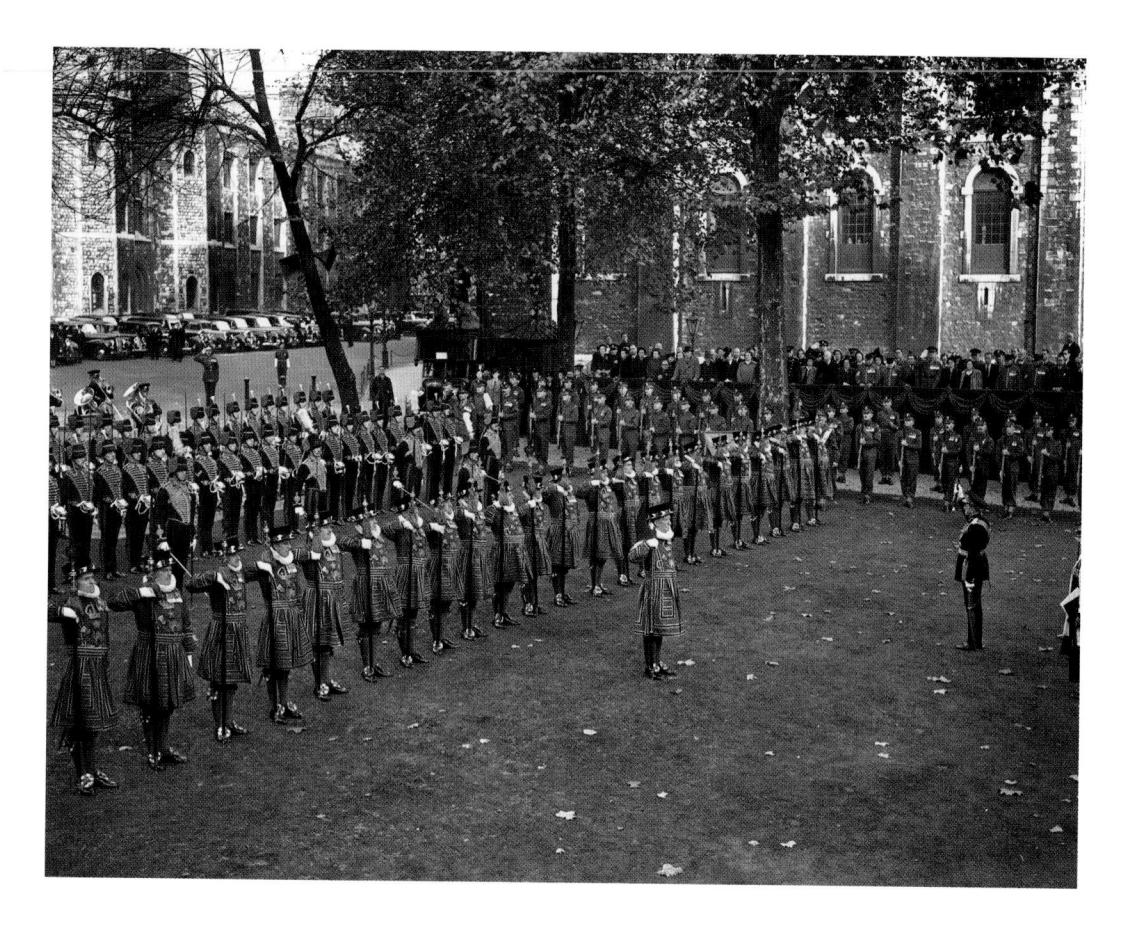

Yeoman Warders lined up for the swearing-in of the new Constable of the Tower of London.

19 October 1950

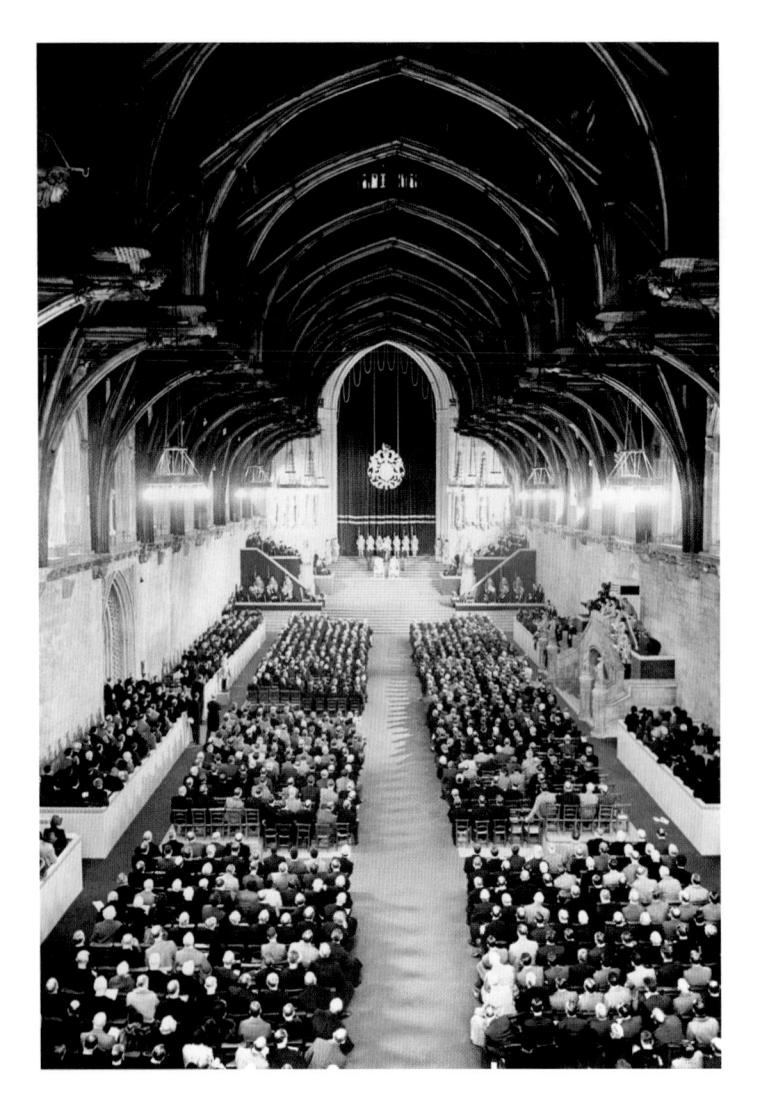

Westminster Hall during the opening of the new chamber of the House of Commons.

25 October 1950

Facing page: Tim Healey and his fruit stall in the gateway of Lincoln's Inn.

13 November 1950

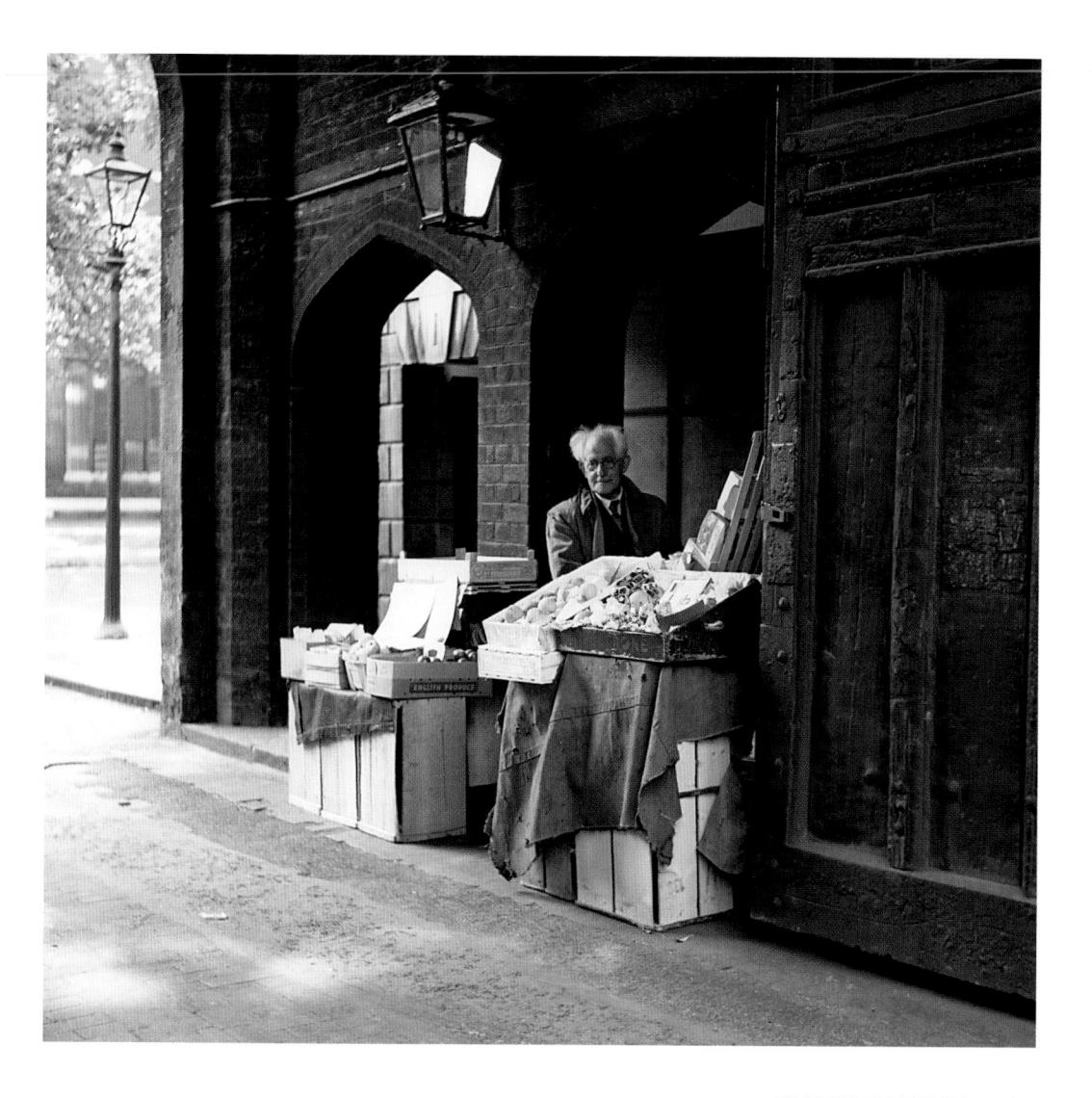

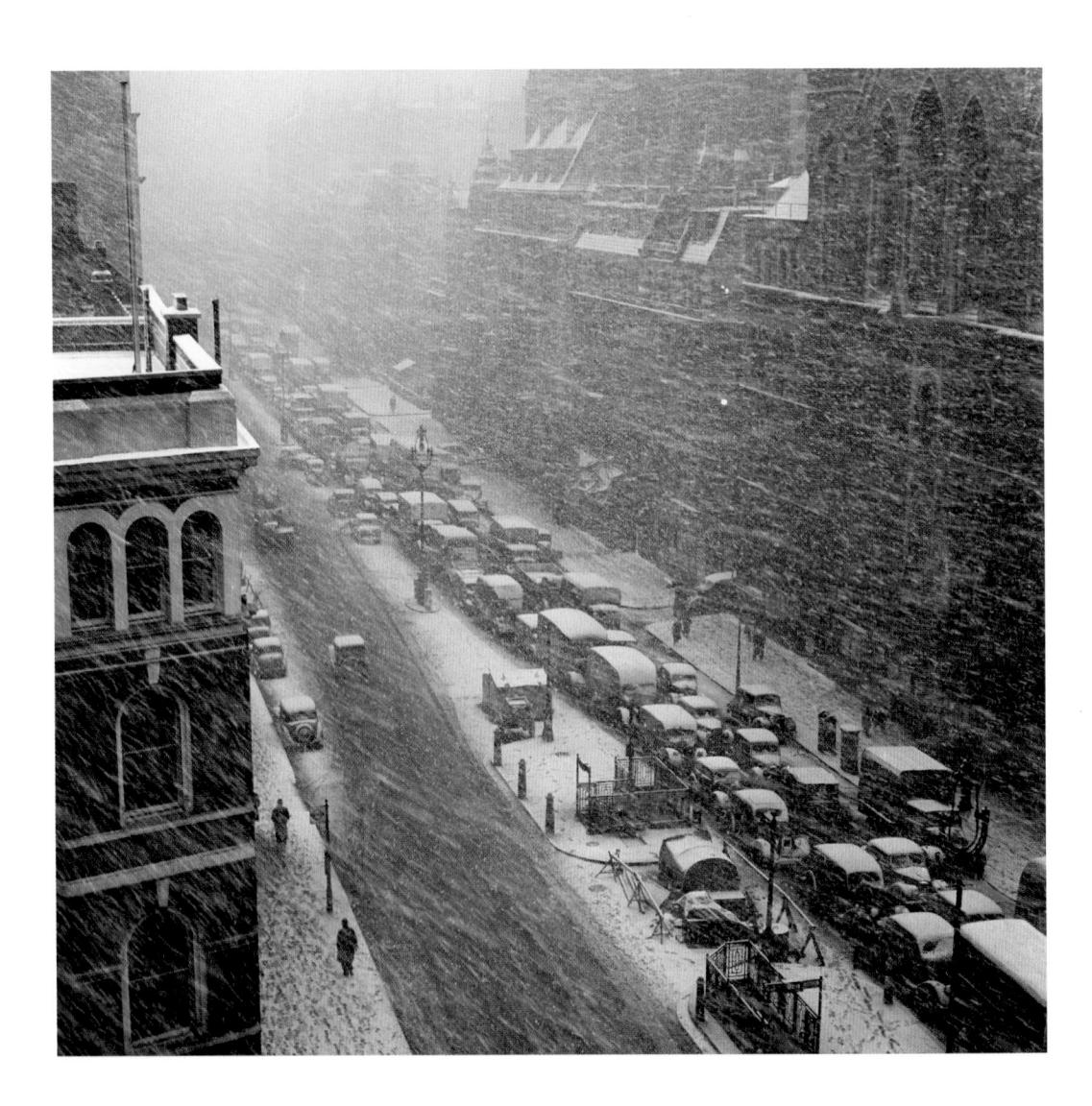

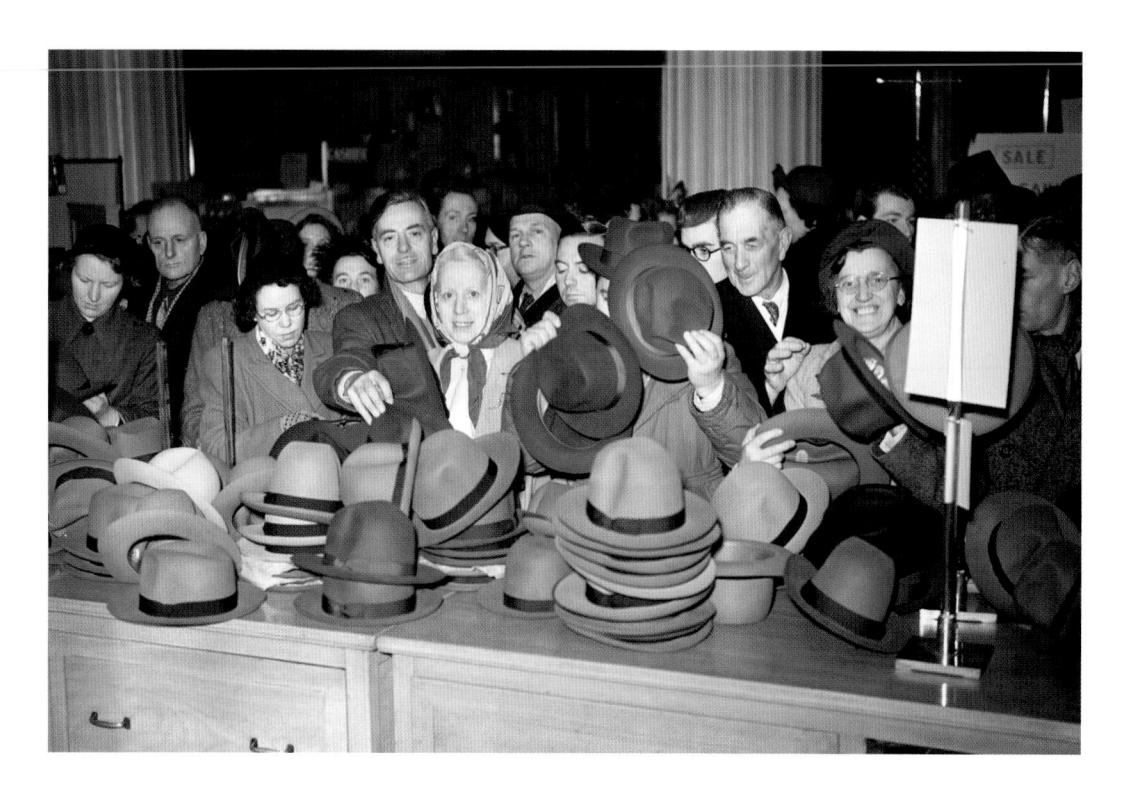

Selfridges during the winter sale.

Facing page: Snow covers vehicles on Farringdon Street during a storm.

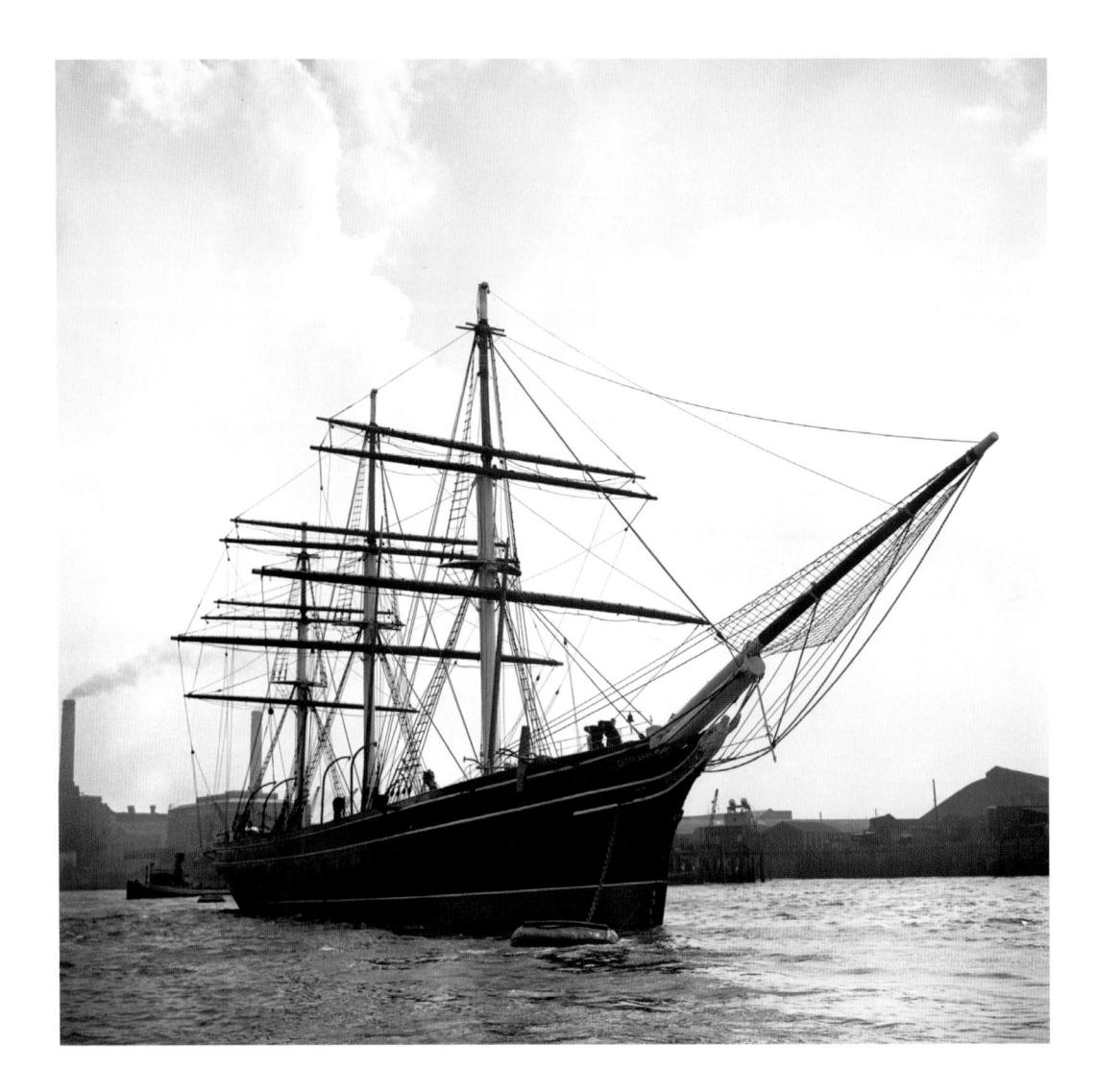

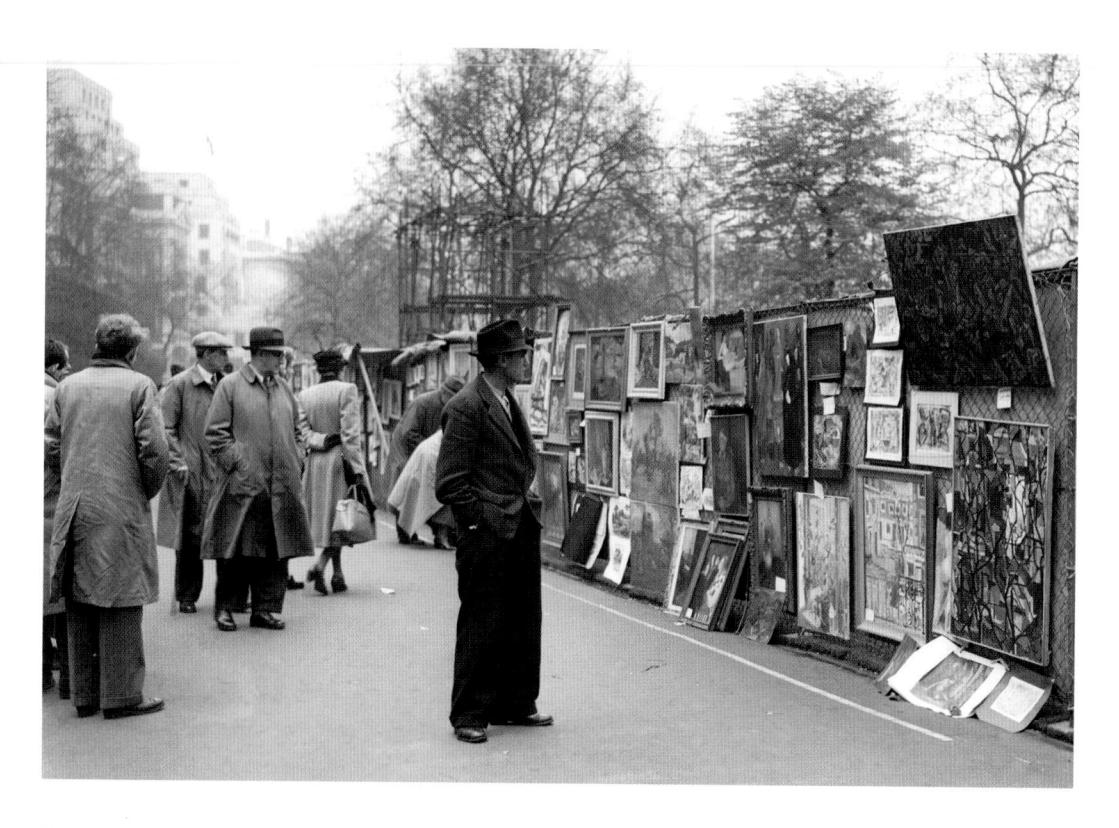

Facing page: The Cutty Sark moored off Rotherhithe in readiness for the Festival of Britain. The clipper, relic of the China tea trade and the wool races from Australia, was in regular service from 1870 to 1922. She was laid up for 16 years until being towed to the Thames in 1938 for presentation to the Thames Nautical Training College.

May 1951

An open-air art exhibition at Victoria Embankment Gardens during the Festival of Britain. 7 May 1951

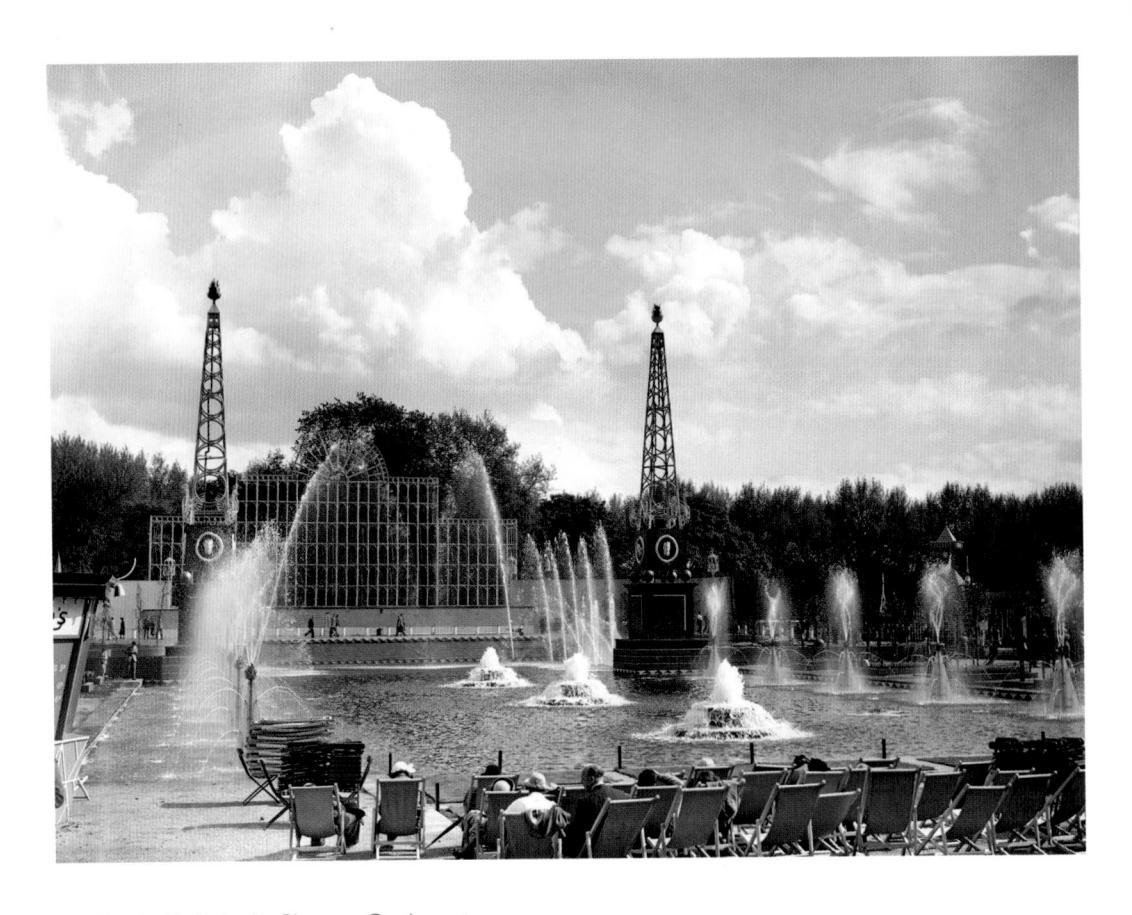

The Festival Lake in the Pleasure Gardens at Battersea Park.
25 May 1951

The world's tallest flagpole in front of the Royal Festival Hall during the Festival of Britain.
29 May 1951

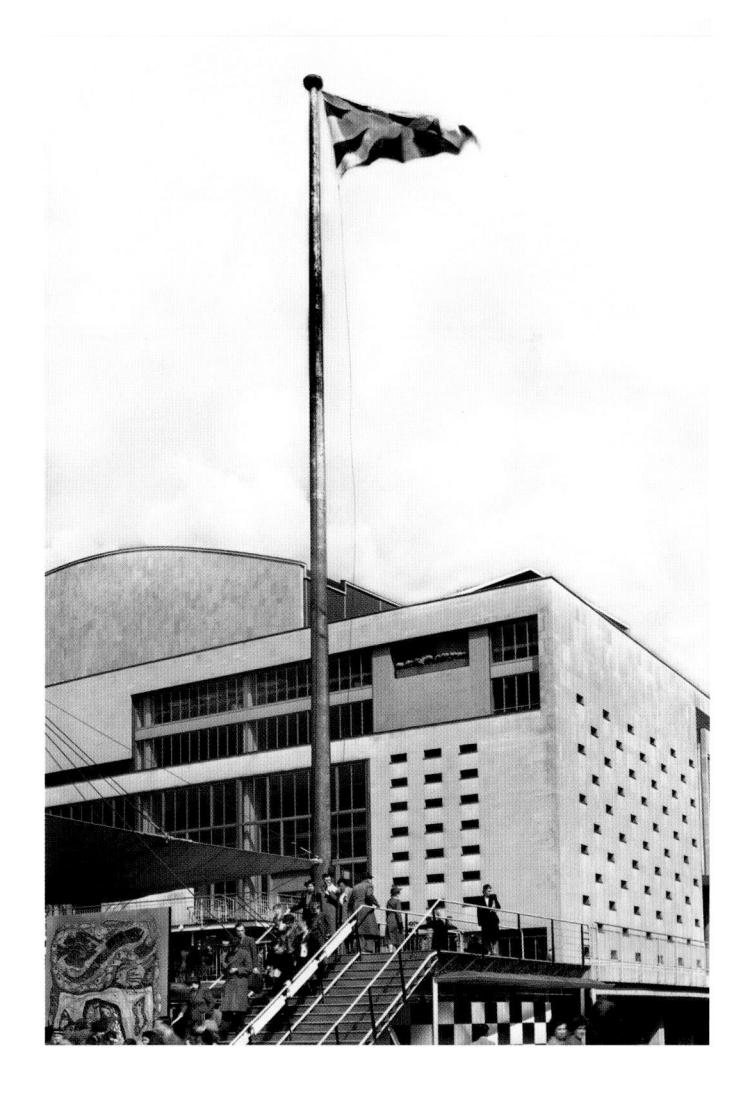

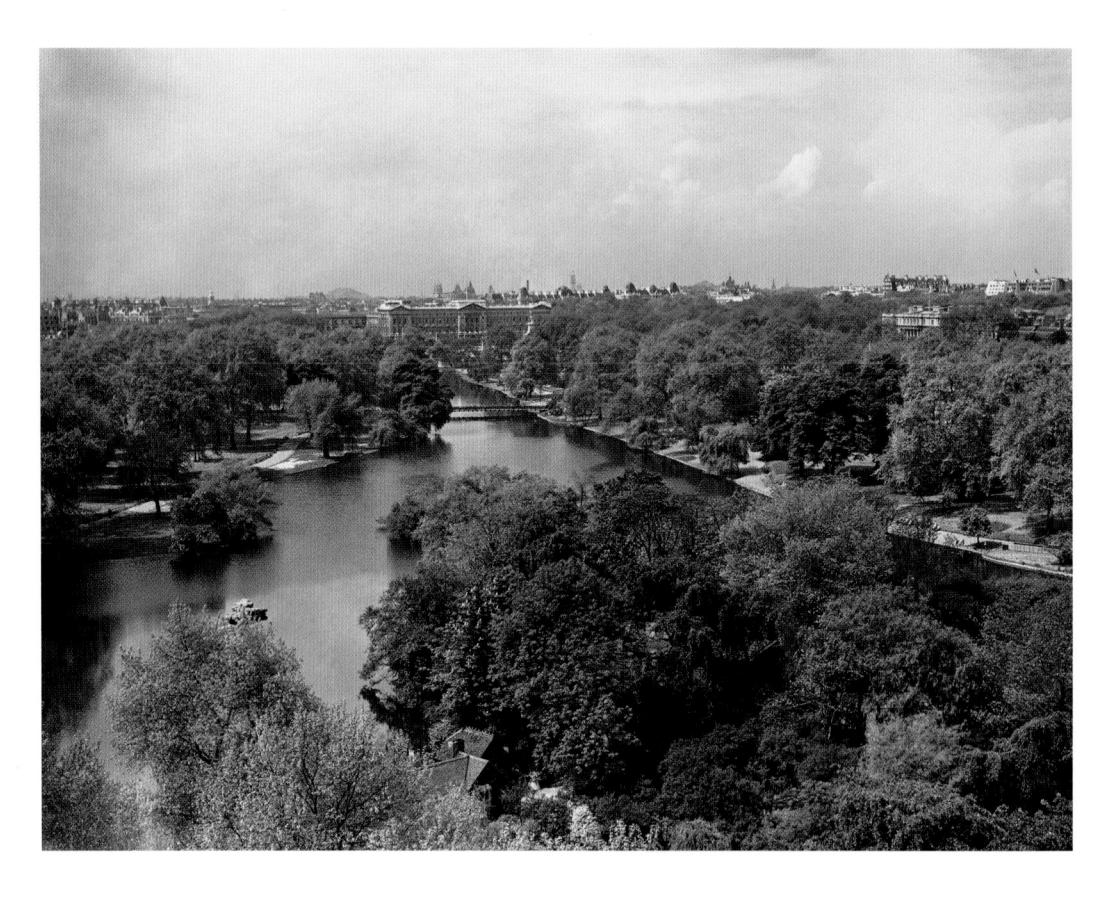

Buckingham Palace and St James' Park from the roof of the Foreign Office.

2 June 1951

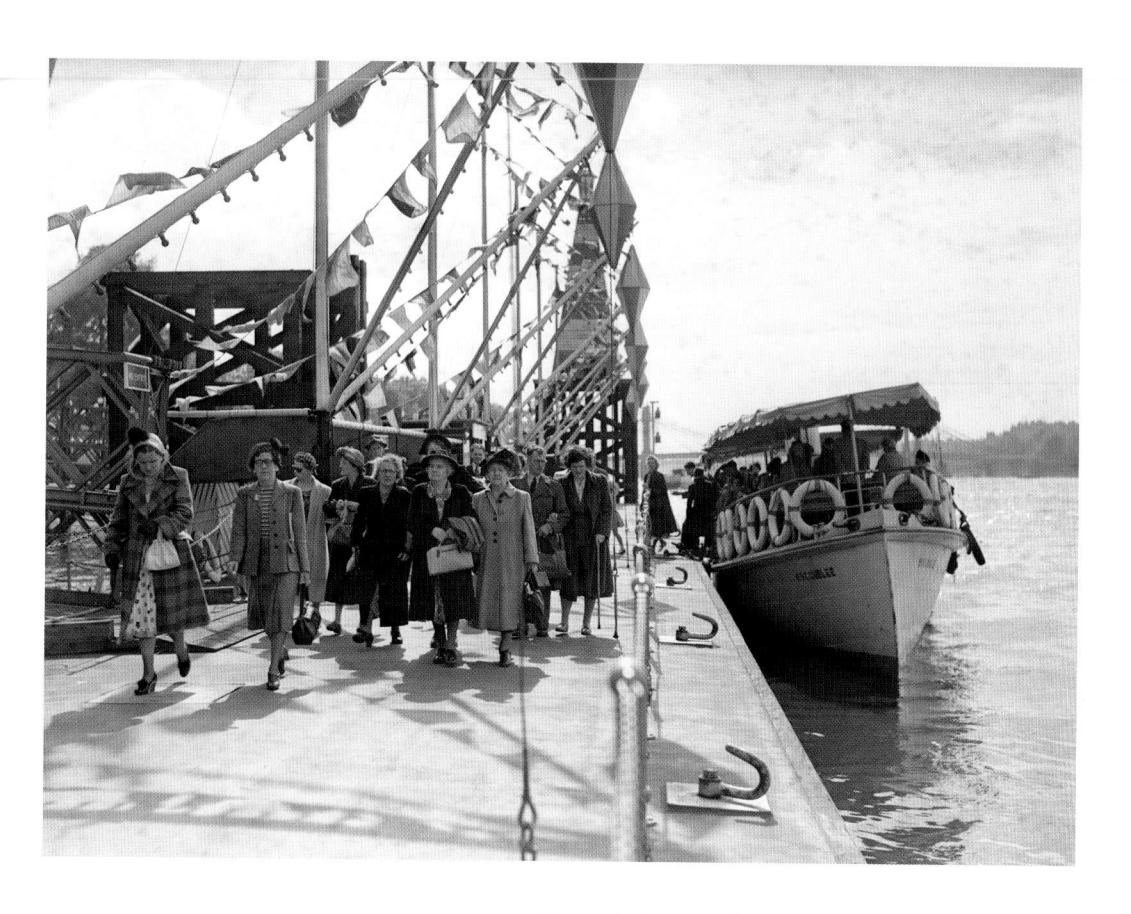

Thames Water Bus Service: passengers walk along the landing stage for the Festival of Britain in Battersea Park. 7 June 1951

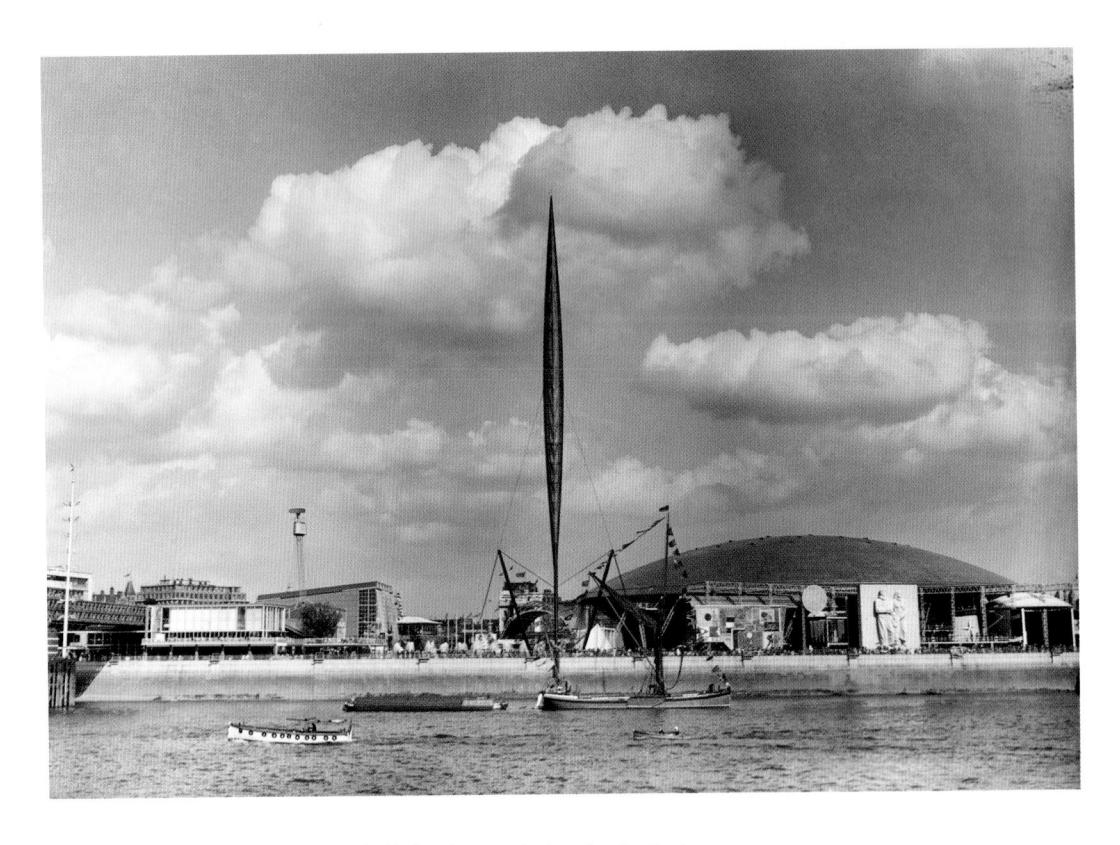

The South Bank seen from Victoria Embankment during the Festival of Britain. The Skylon sculpture (C) generated enormous interest. Controversially it and The Dome of Discovery exhibition hall (R) were demolished and sold for scrap when the festival ended.

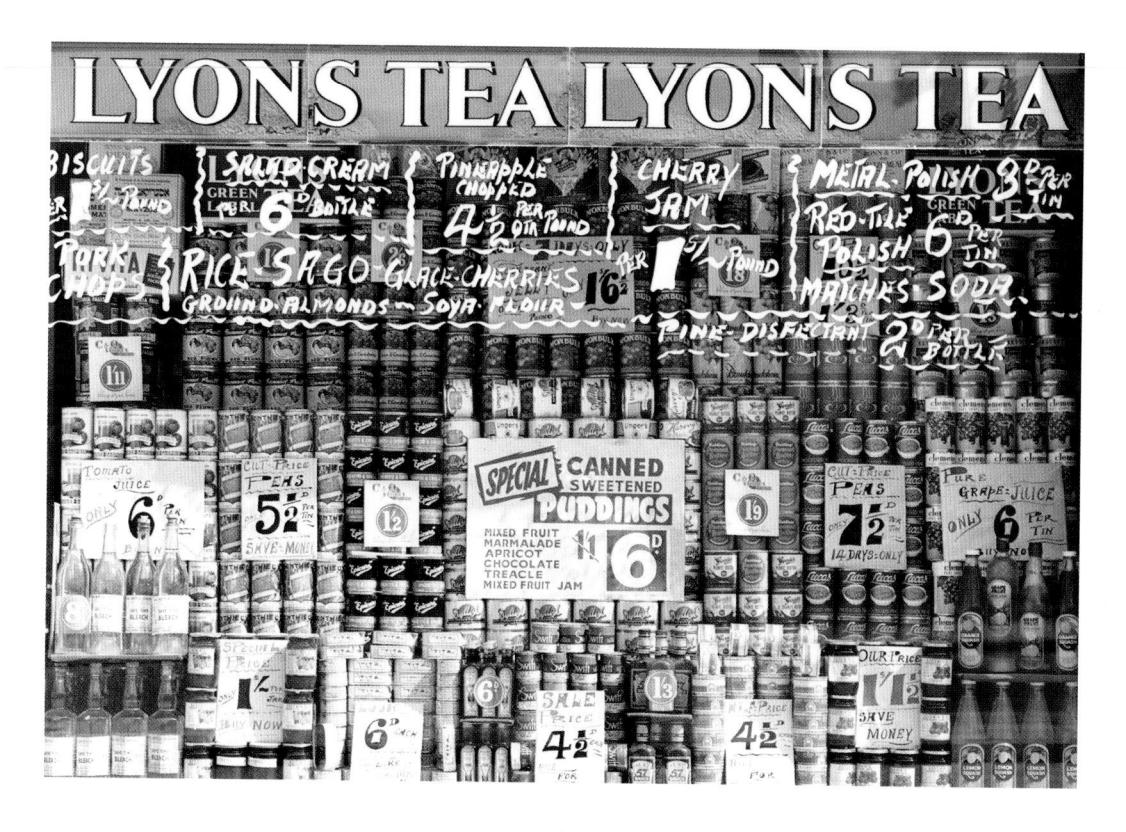

A grocer's window. Food rationing had been in place from 1940, with restrictions starting to be lifted in 1948. Rations of canned fruit were lifted in 1950 and all food rationing had ended by 1954.

11 July 1951

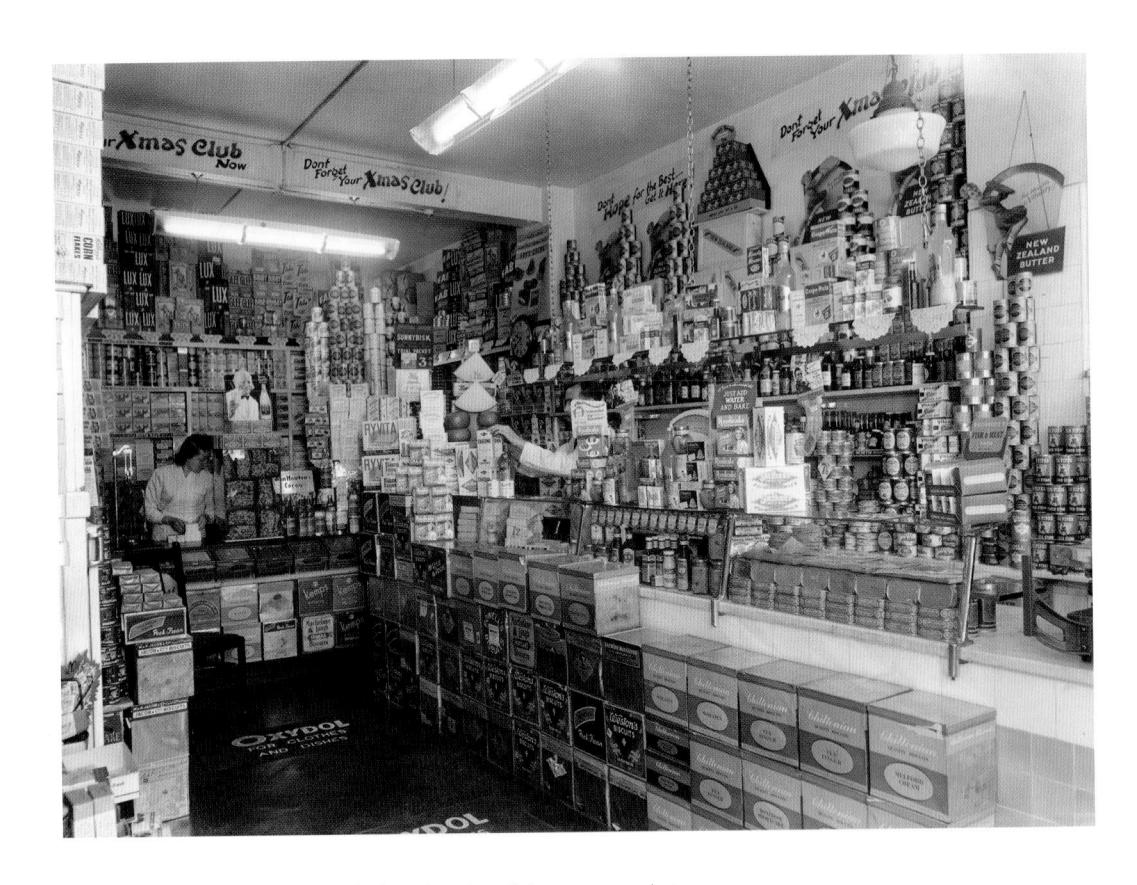

The interior of a grocer's shop before the rise of the supermarket. Marks & Spencer opened their first self-service shop in 1948, Sainsbury's and Gateway (Somerfield) followed suit in 1950. Tesco opened its first supermarket in 1954.

11 July 1951

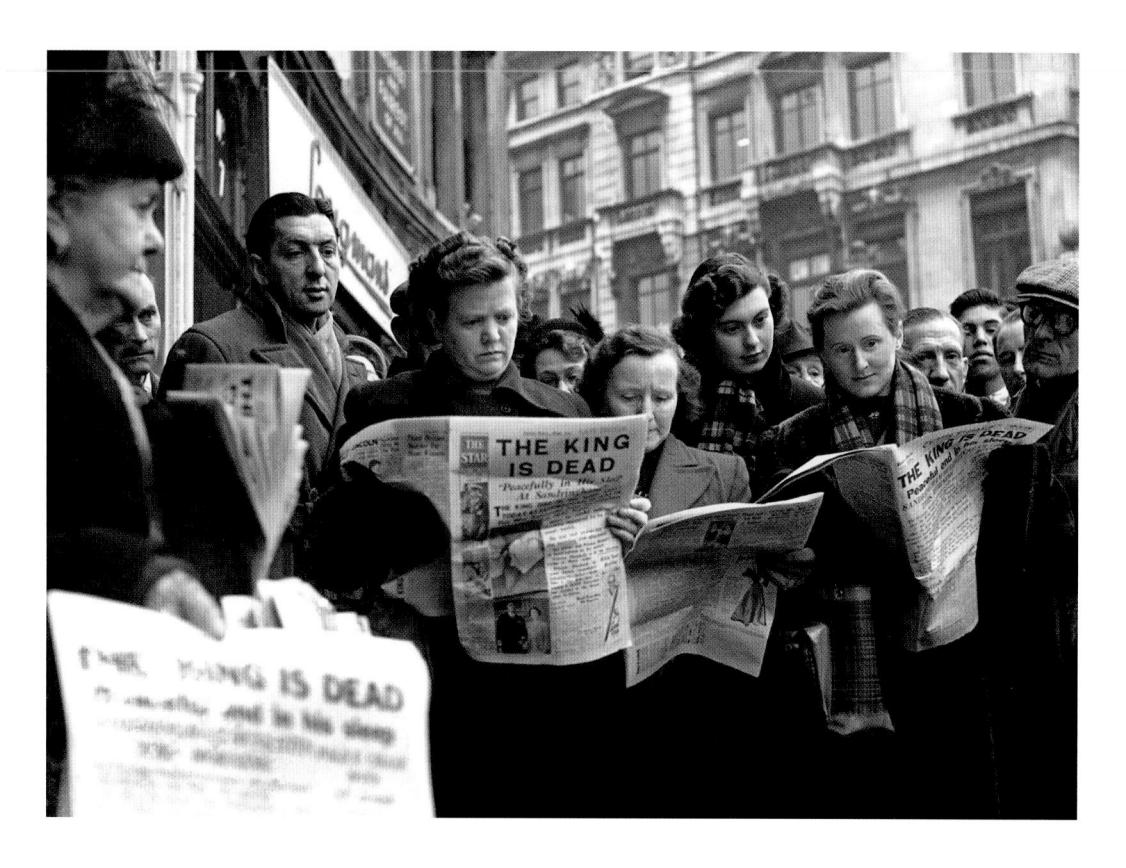

Lunchtime crowds at Ludgate Circus read news of the death of King George VI.

6 February 1952

The King's coffin lies in state at Westminster Hall. 11 February 1952

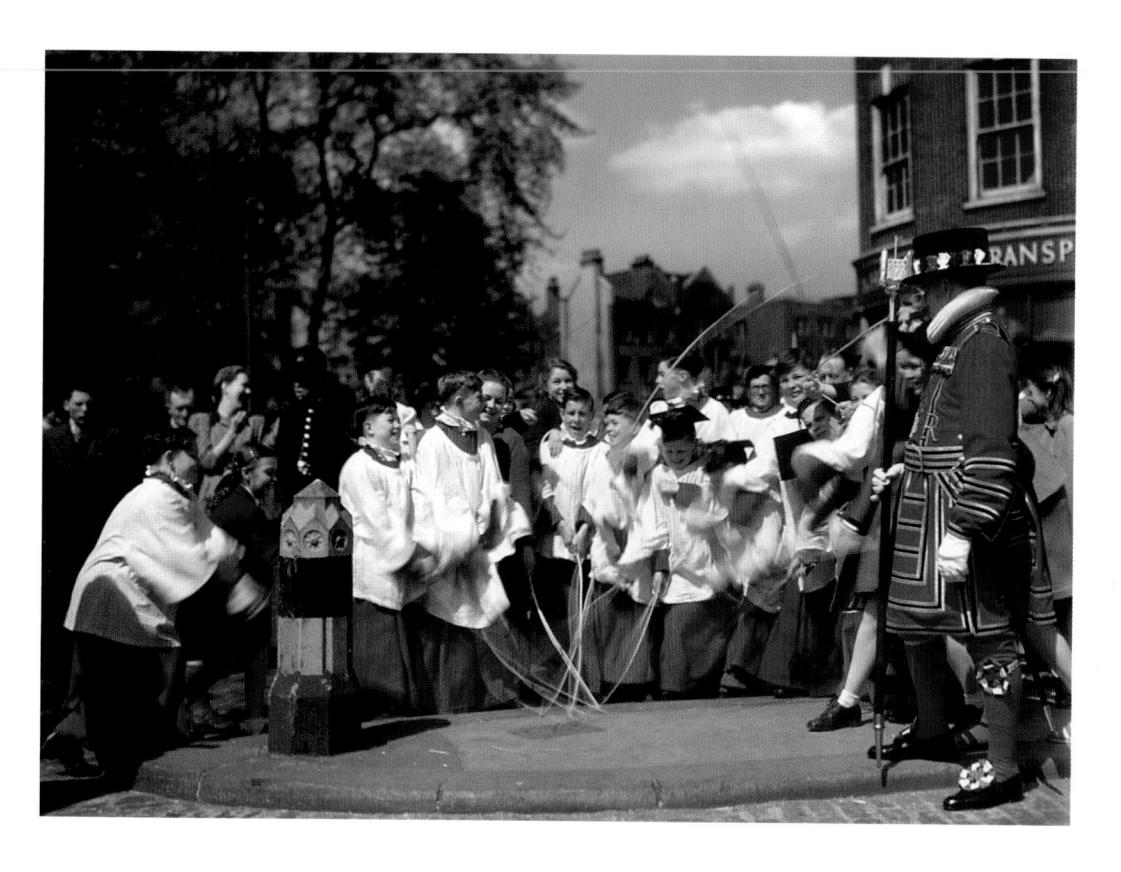

Following tradition, these choirboys are Beating the Bounds, marking the edges of the parish by hitting them with sticks of green willow.

22 February 1952

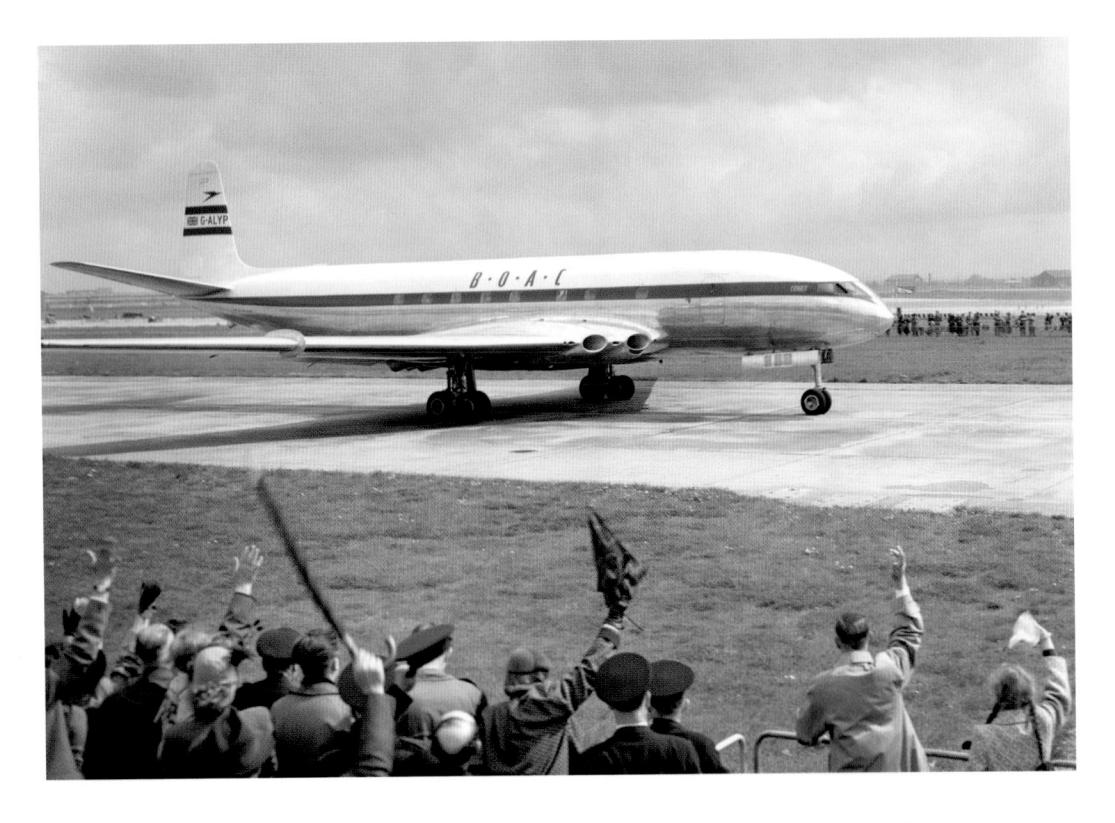

The world's first regular jetliner service. A 36-seater de Havilland Comet, G-ALYP of British Overseas Airways, takes off from London Airport on the inaugural passenger flight to Johannesburg, South Africa.

2 May 1952

Facing page: The last week of the London tram service.
30 June 1952

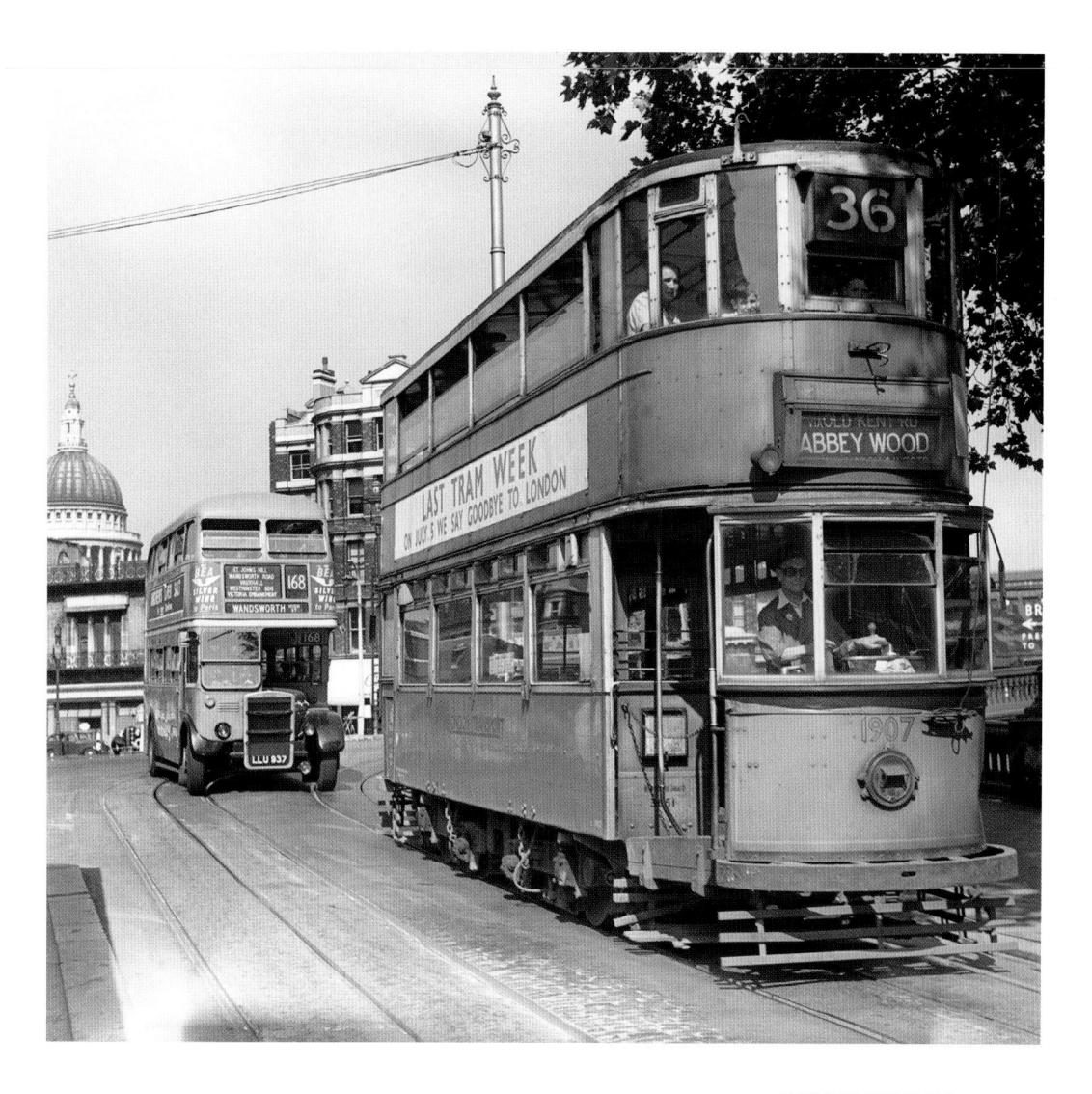

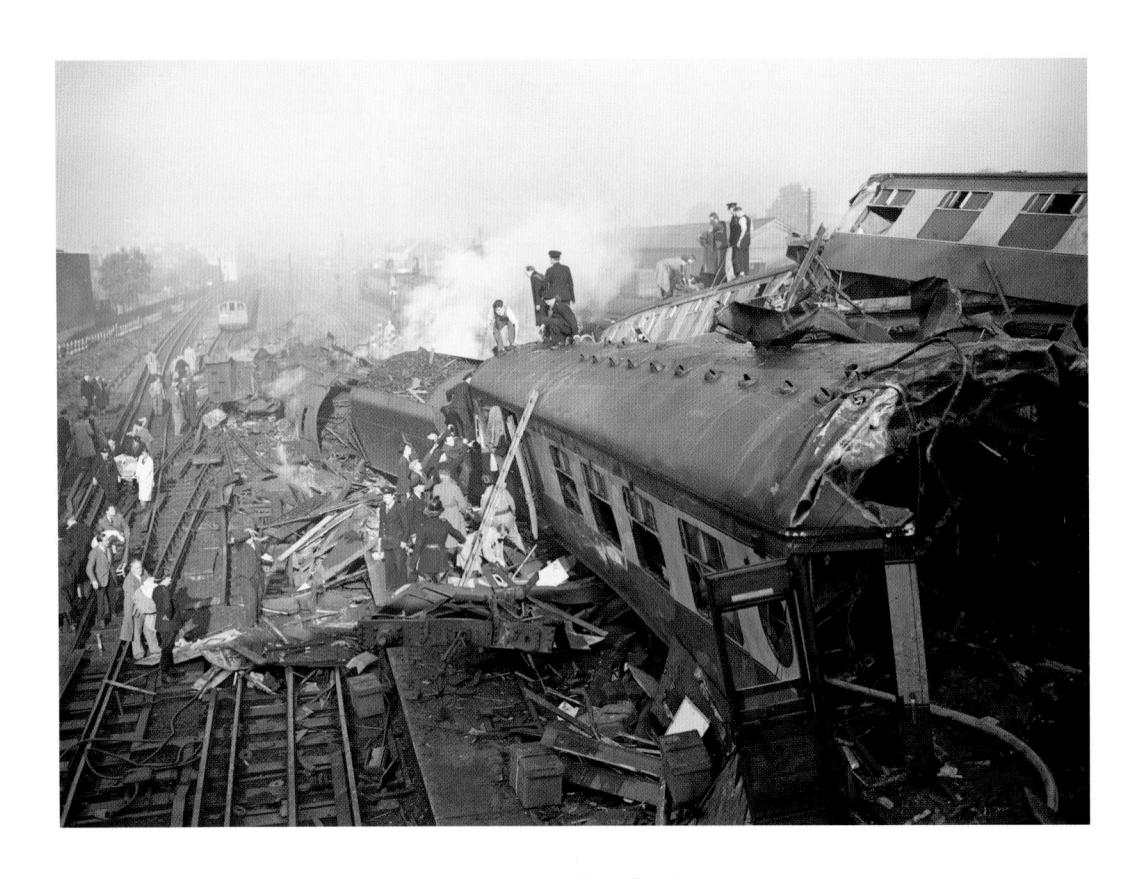

Britain's worst peacetime rail disaster. An express train from Perth struck a local train at Harrow and Wealdstone station and then an express going from Euston to Liverpool struck the derailed coaches. Altogether, 112 people were killed.

8 October 1952

Prime Minister Winston Churchill speaks at a service for a memorial dedicated to Members of Parliament in Westminster Hall.

12 November 1952

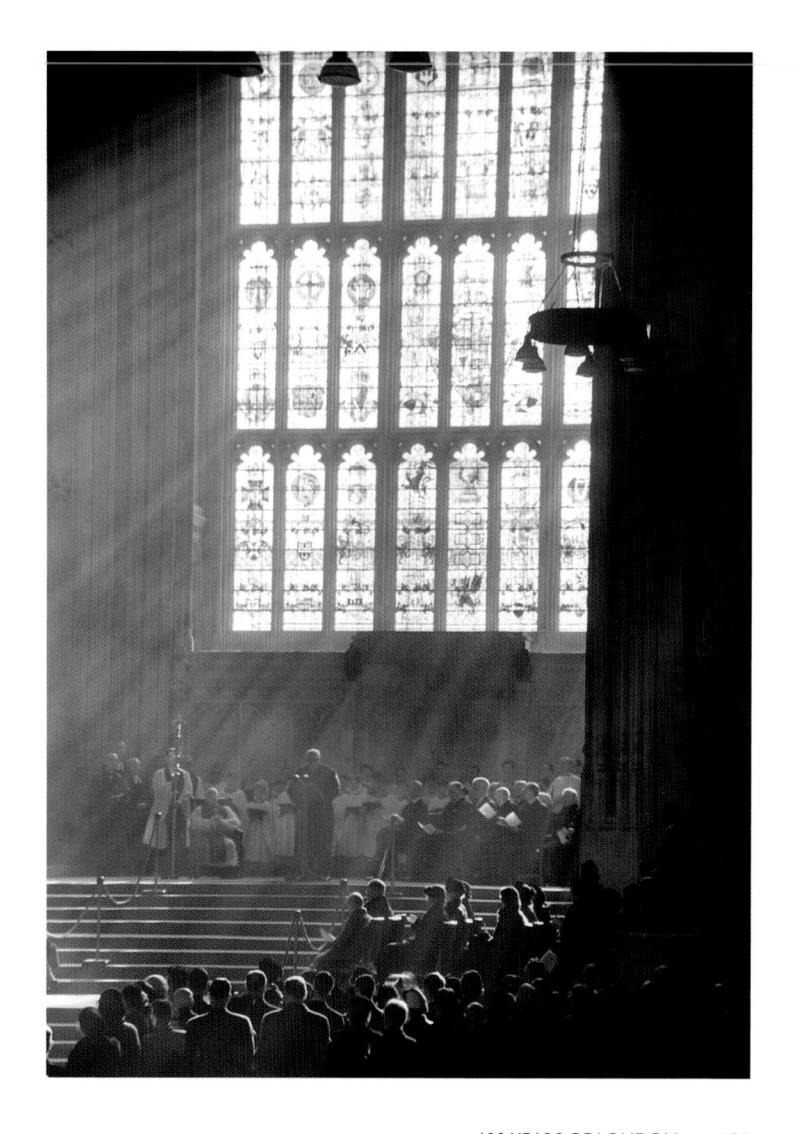

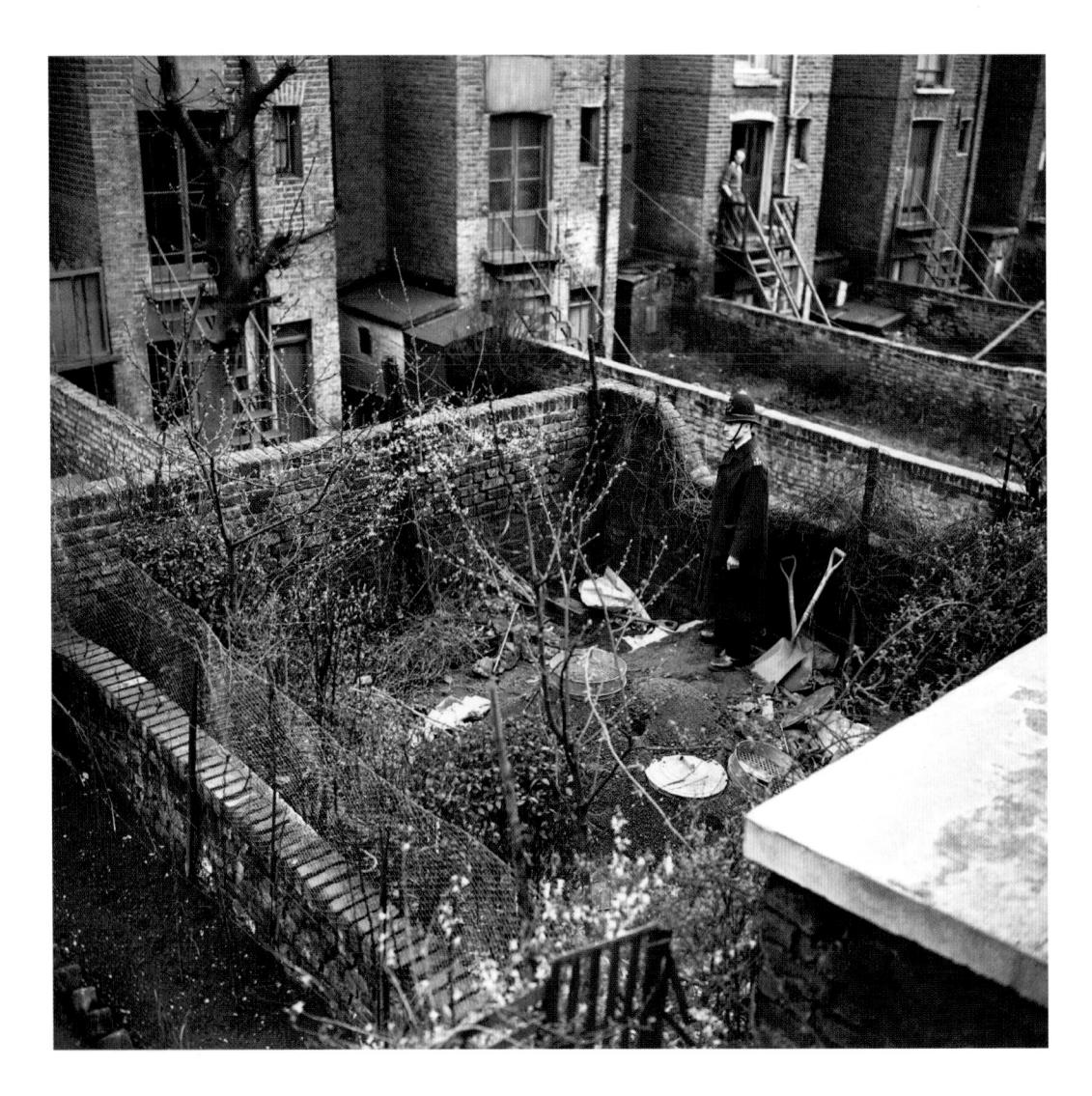

Facing page: A policeman in the garden of 10 Rillington Place in Notting Hill, where human bones were found buried a few inches under the soil. The bodies of four strangled women had already been discovered at the address and police were searching nationwide for suspect John Reginald Christie.

28 March 1953

Sweet rationing comes to an end. • 2 April 1953

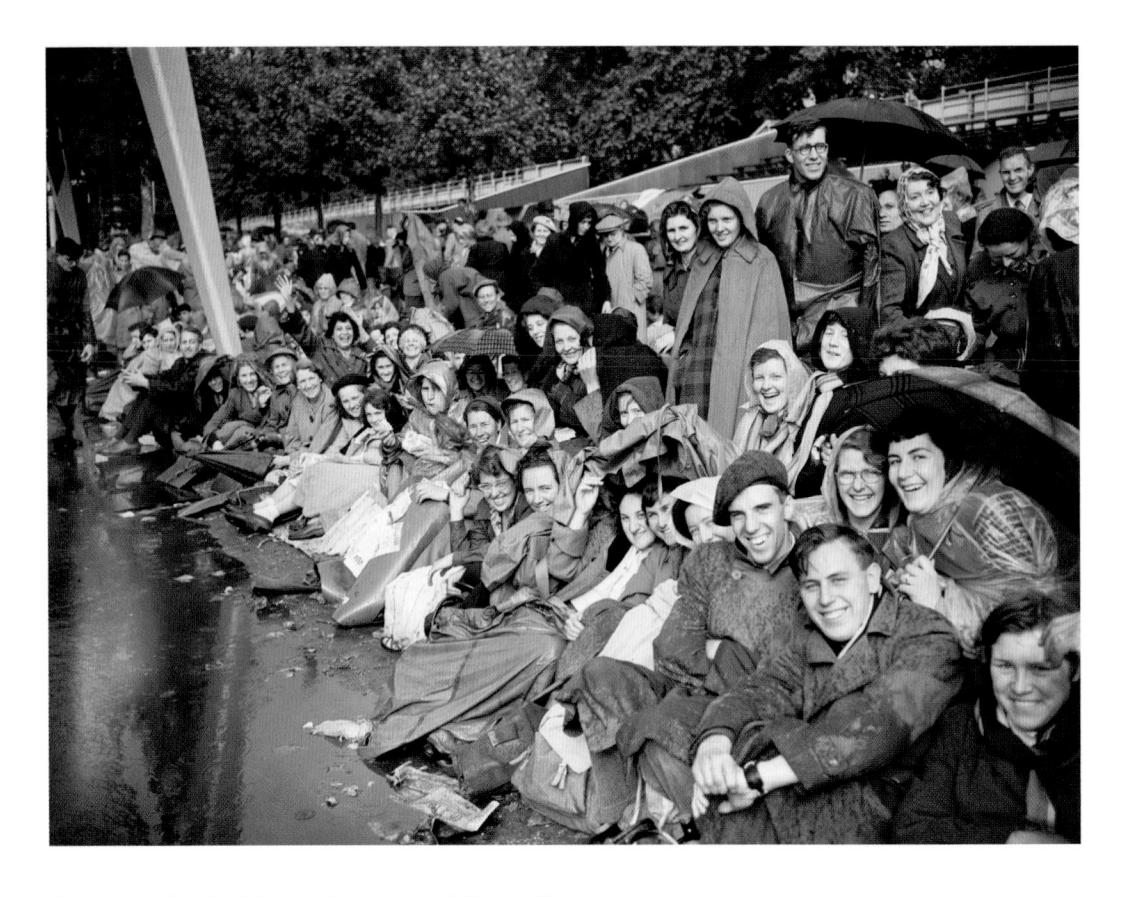

Crowds line The Mall for the Coronation of Queen Elizabeth II. ${\tt June~1953}$

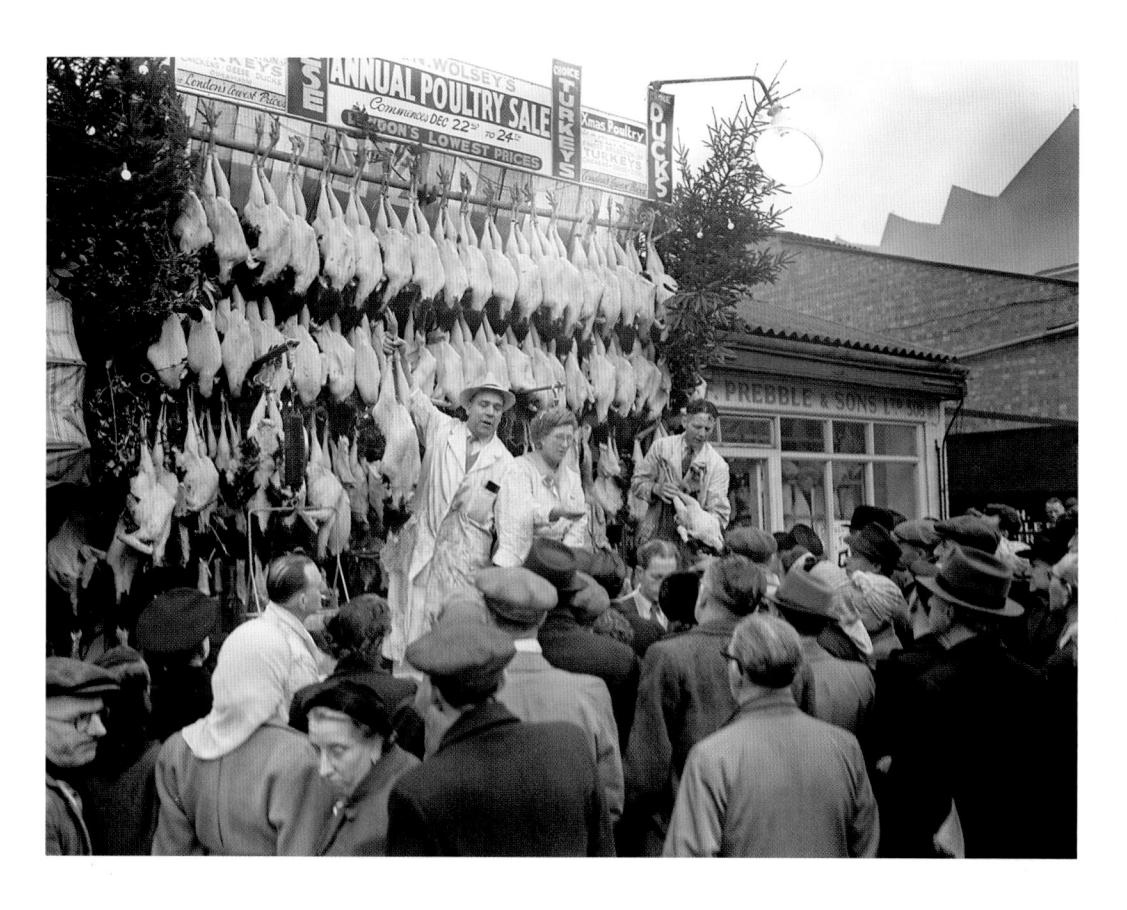

Turkey auction at Smithfield Market. 23 December 1953

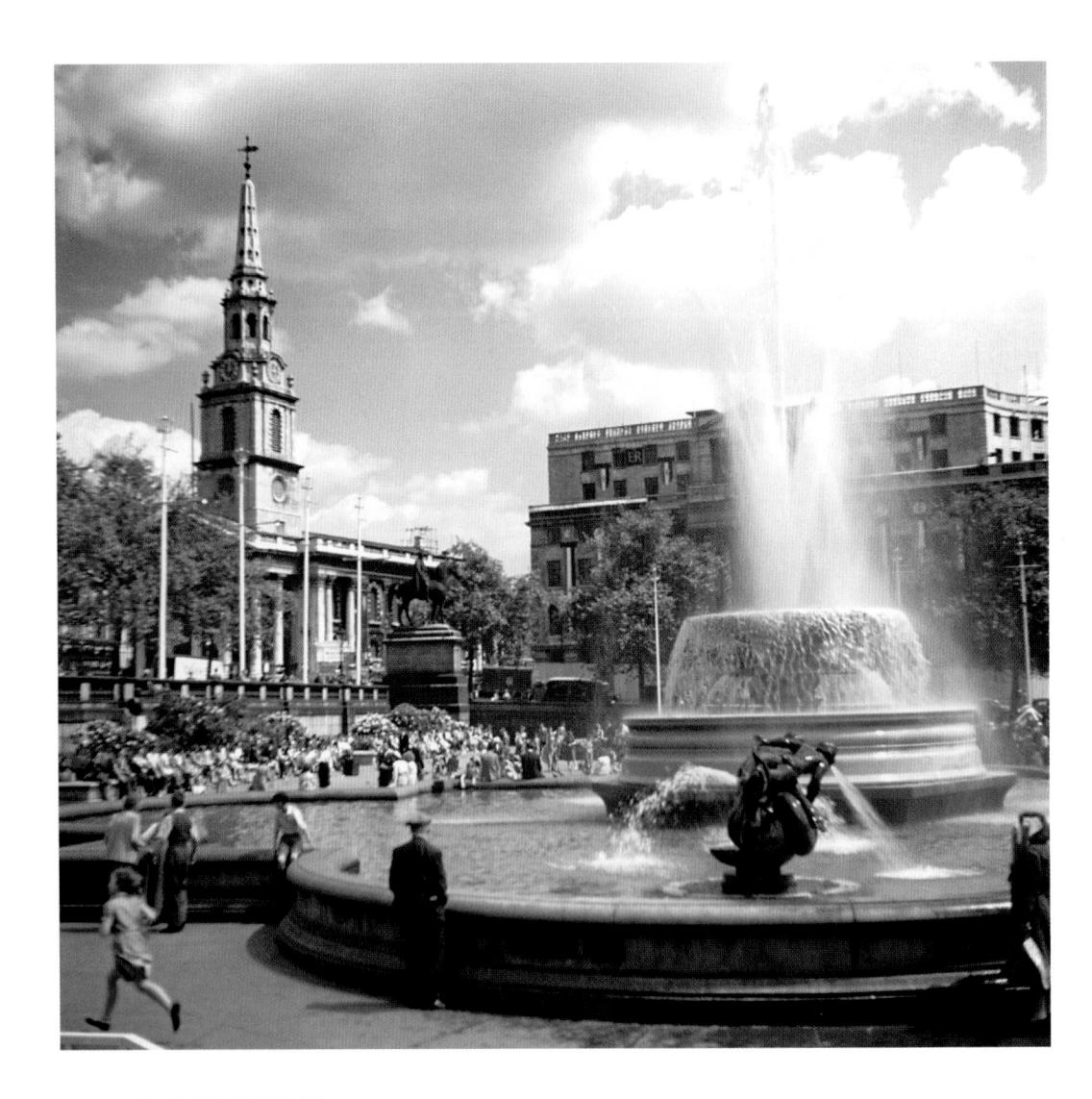

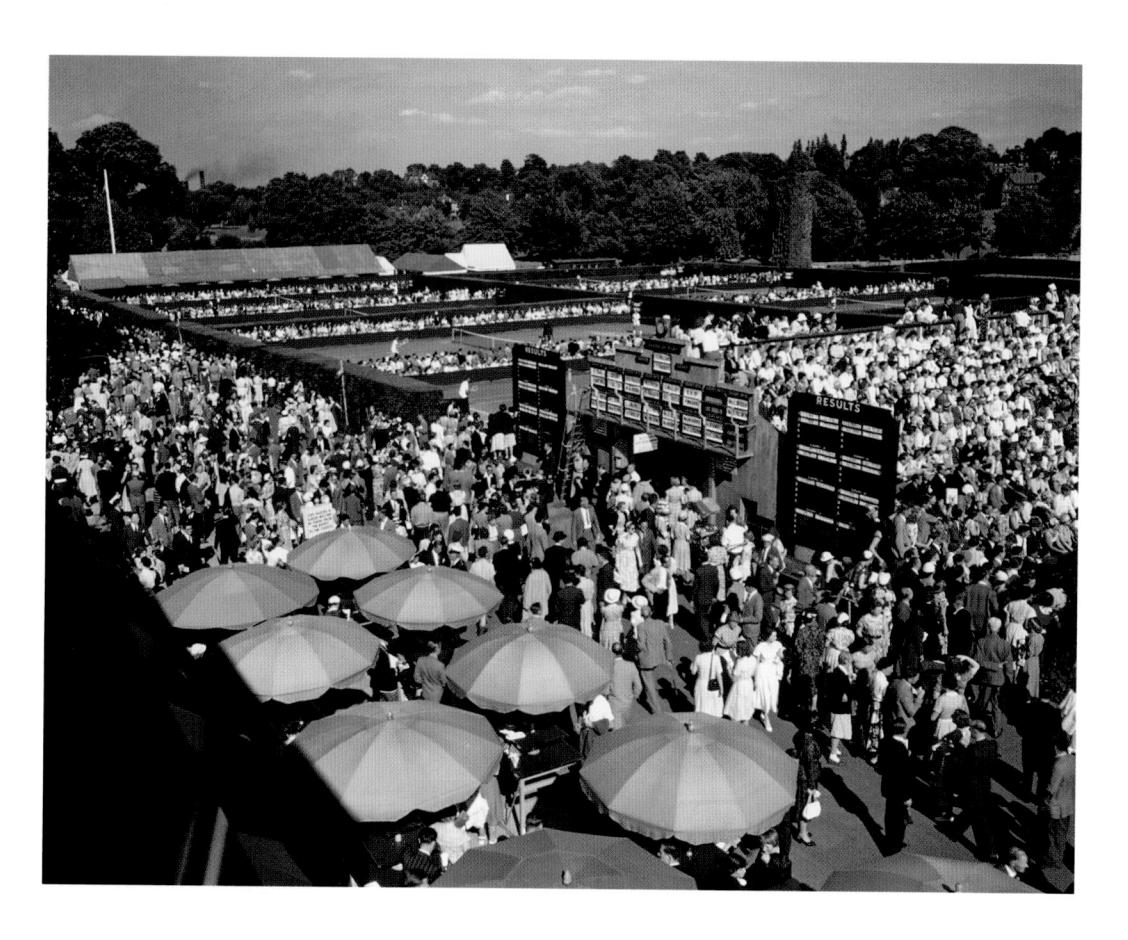

The All England Club, Wimbledon. June 1954

Facing page: Trafalgar Square in summer.

1954

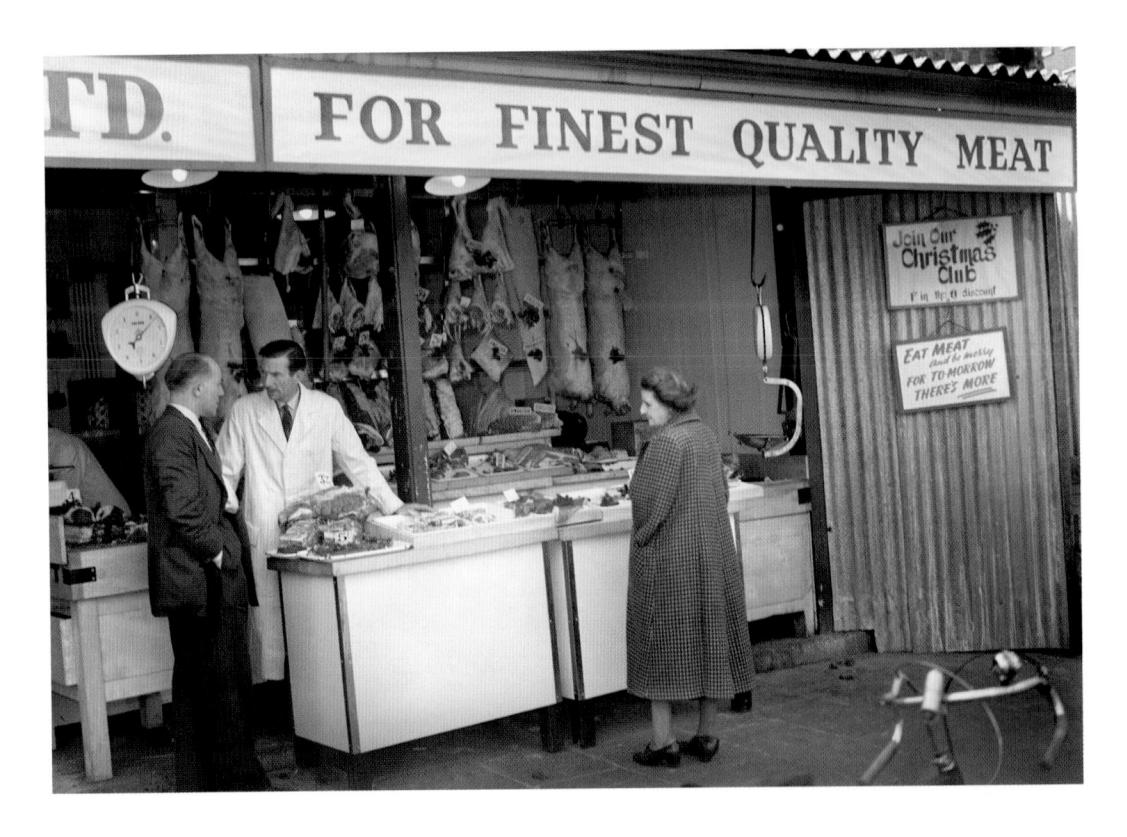

Smithfield Market, as rationing comes to an end. 7 July 1954

Facing page: Christmas illuminations on Regent Street. 2 December 1954

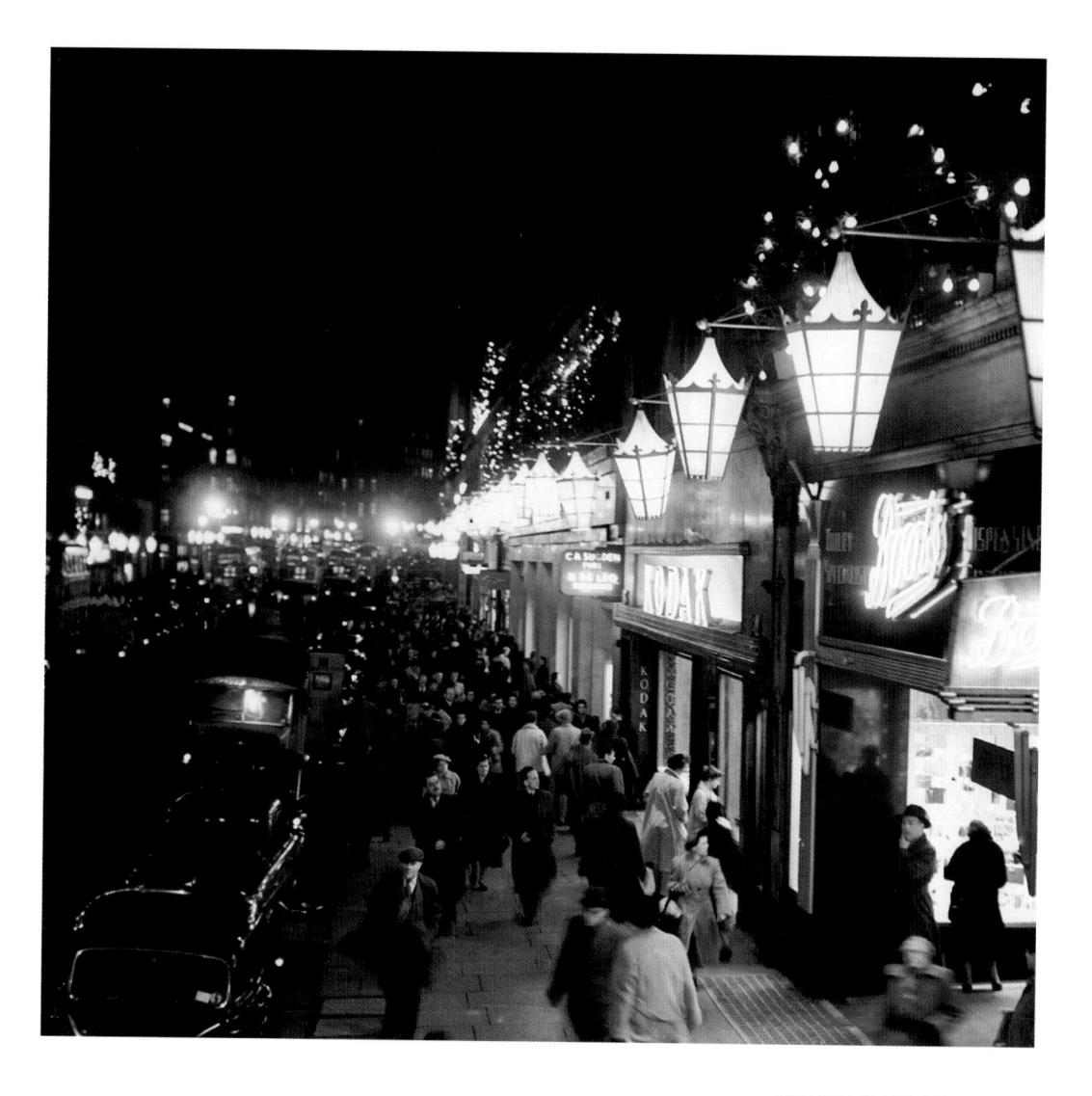

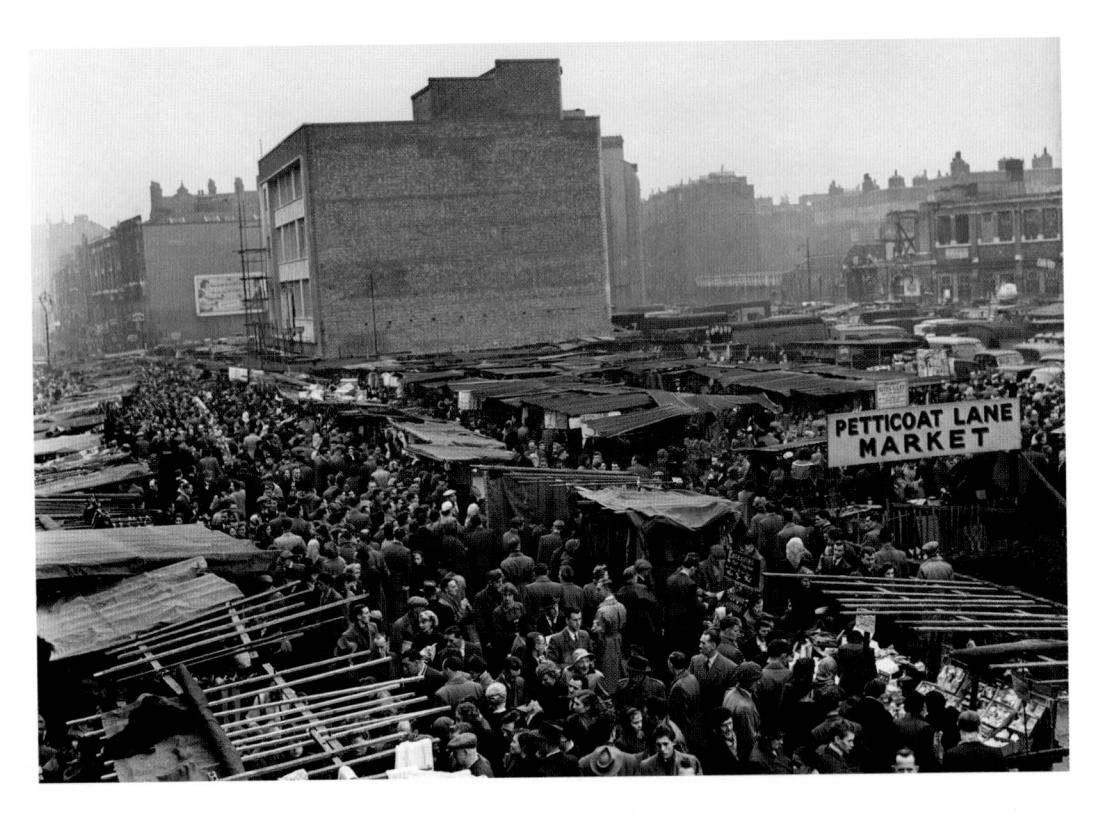

Christmas shopping at Petticoat Lane Market. 20 December 1954

Facing page: Tower Bridge. 1955
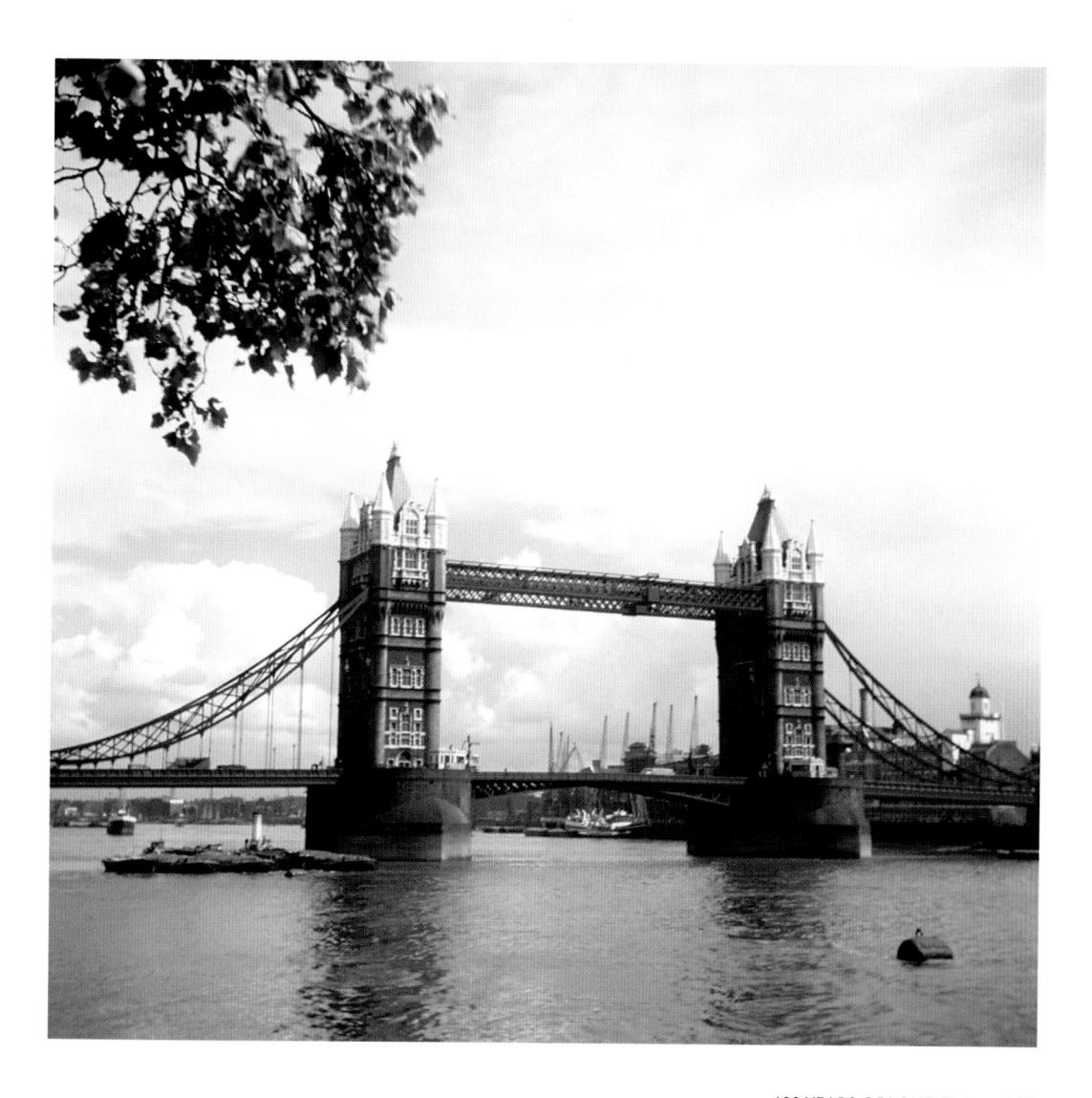

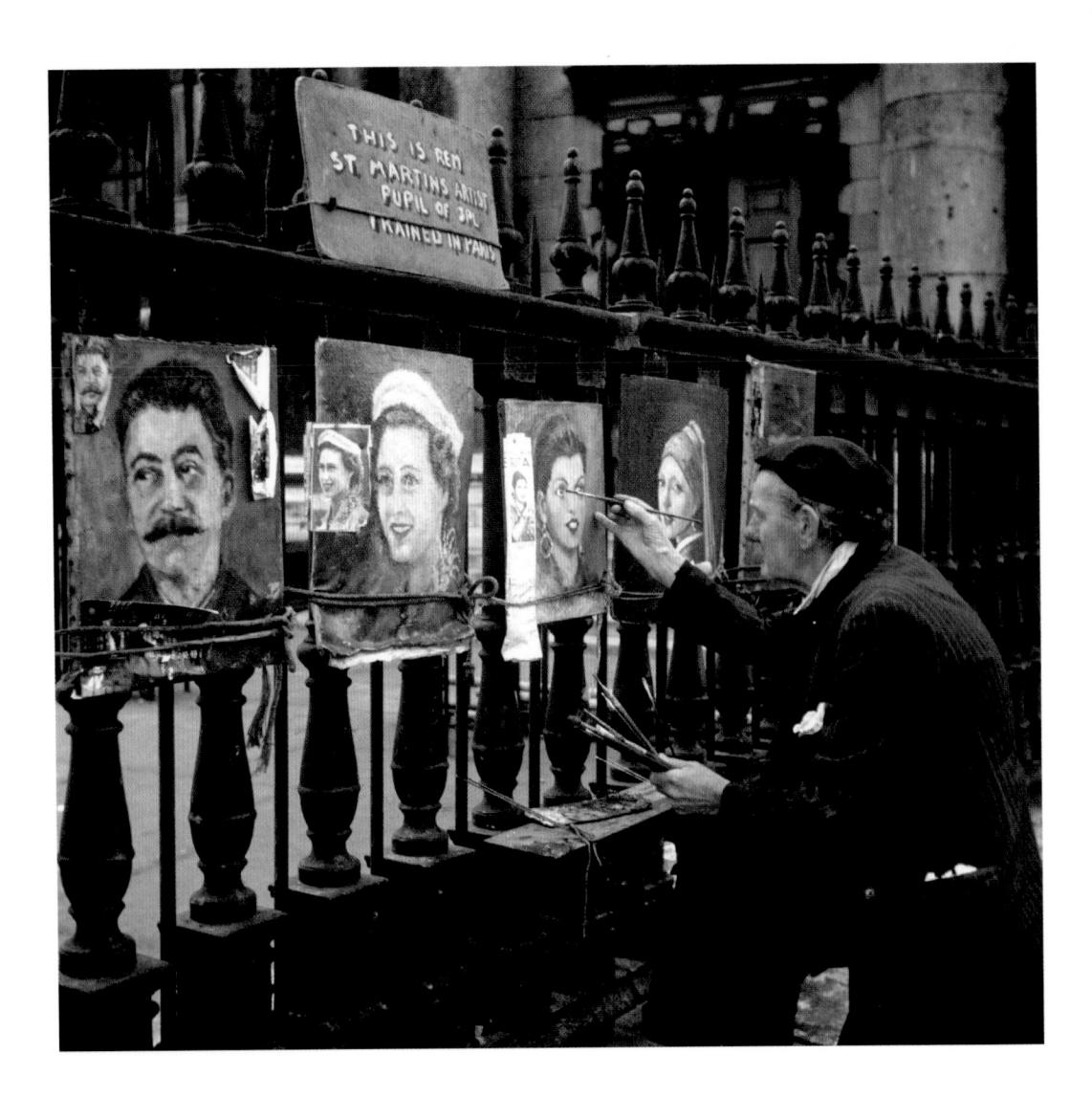

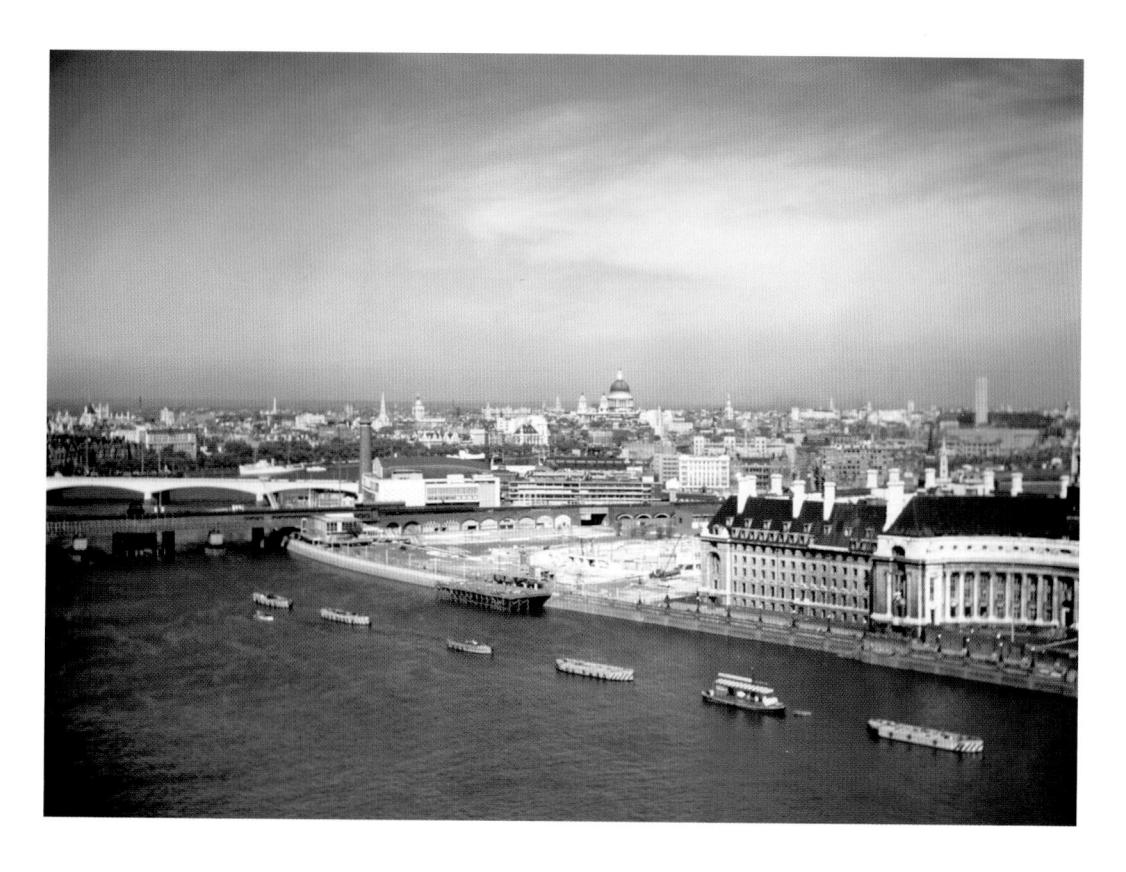

The River Thames and Festival of Britain site beside County Hall. June 1955

Facing page: A pavement artist at St Martin-in-the-Fields. May 1955

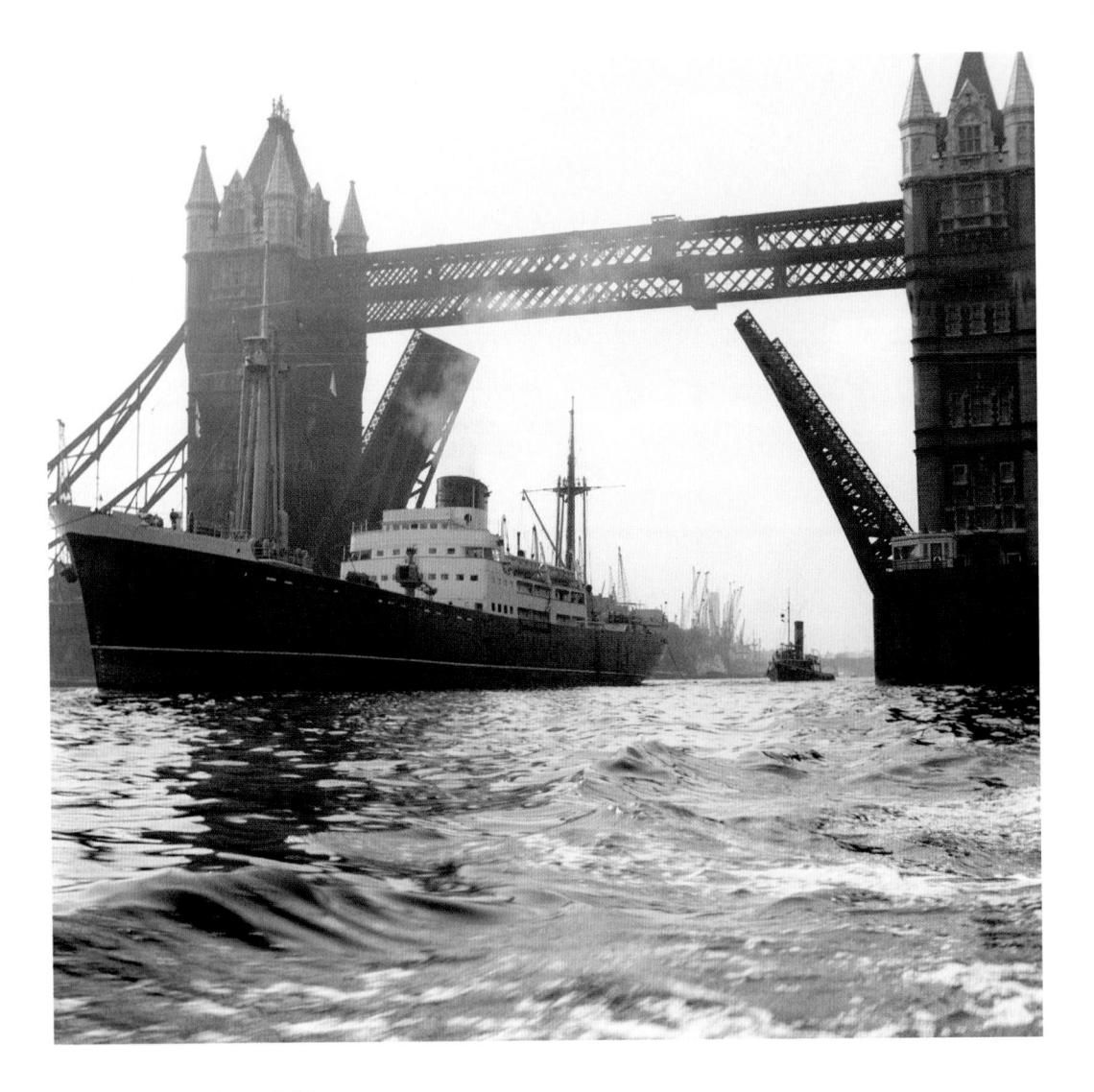

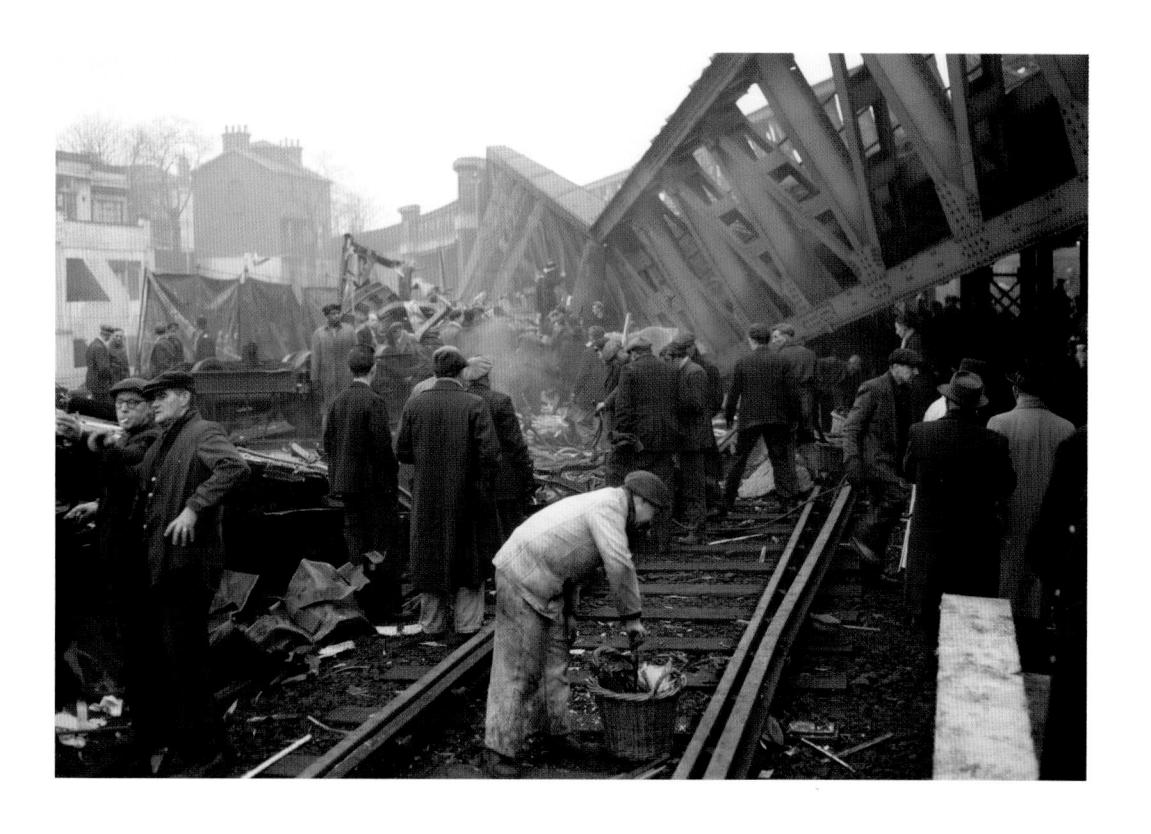

Facing page: Tower Bridge with bascules raised.
5 February 1957

Work on clearing the wreckage continues near the fallen fly-over bridge, after two passenger trains collided in fog near St John's Southern Region railway station in Lewisham.

6 December 1957

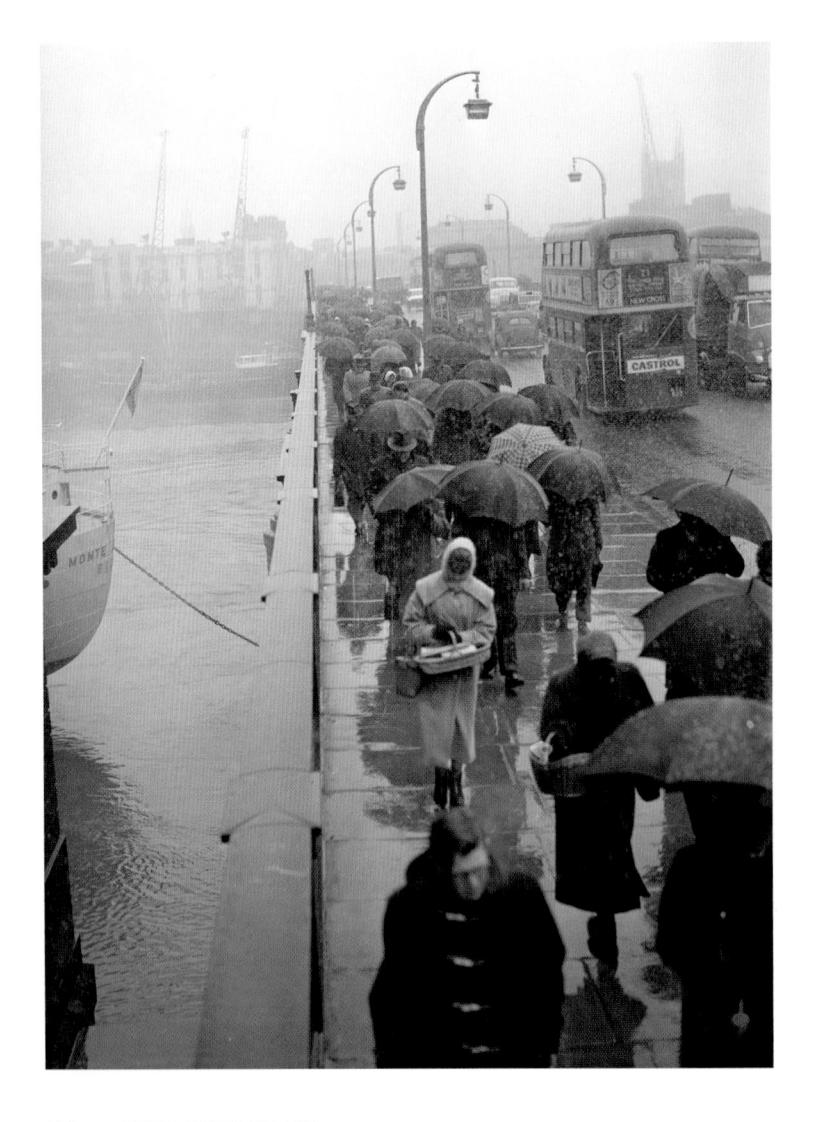

London Bridge. 25 February 1958

Facing page: Nurses watch as Princess Anne leaves the Hospital for Sick Children, Great Ormond Street, after an operation to remove her tonsils and adenoids.

16 May 1958

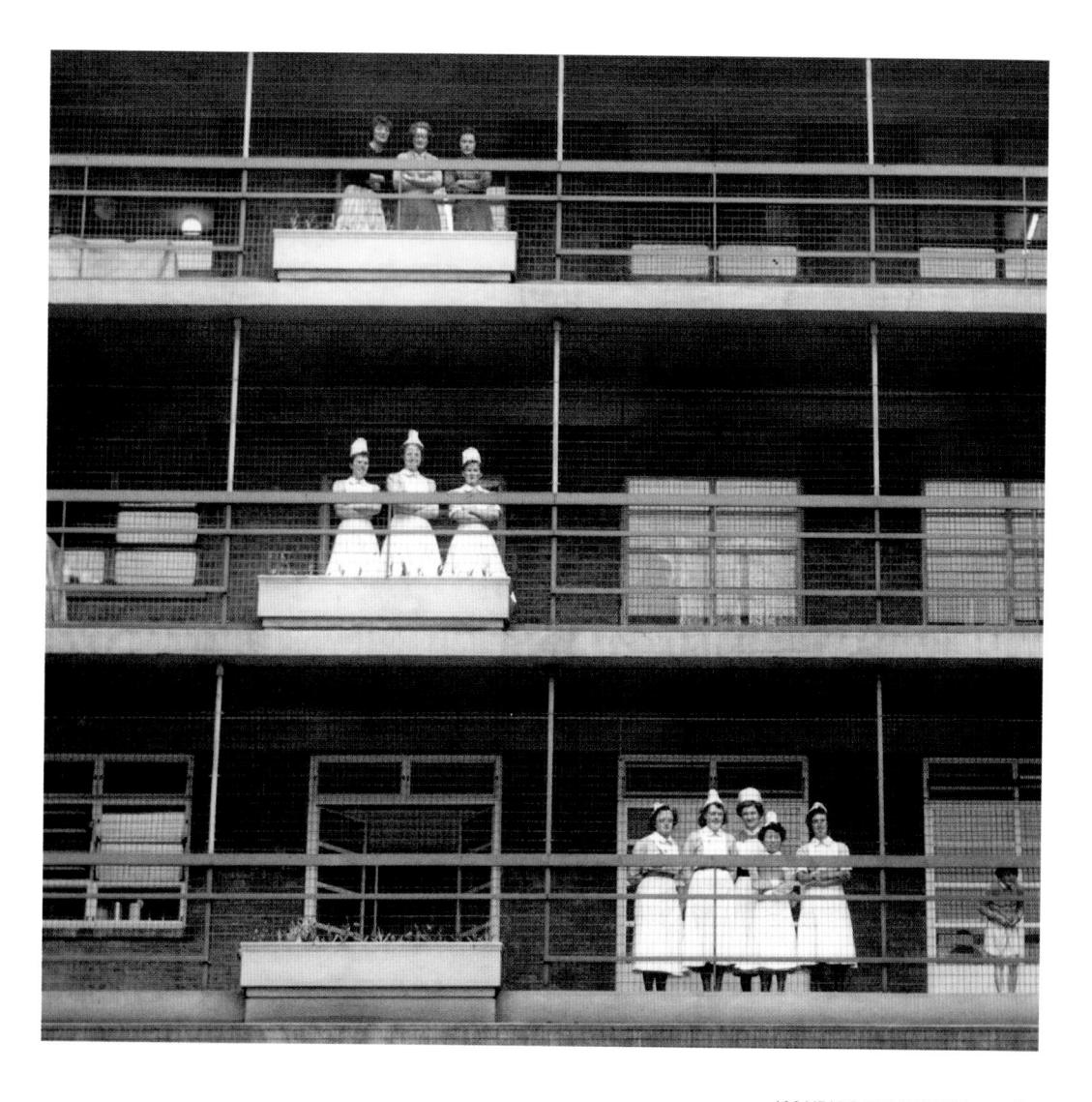

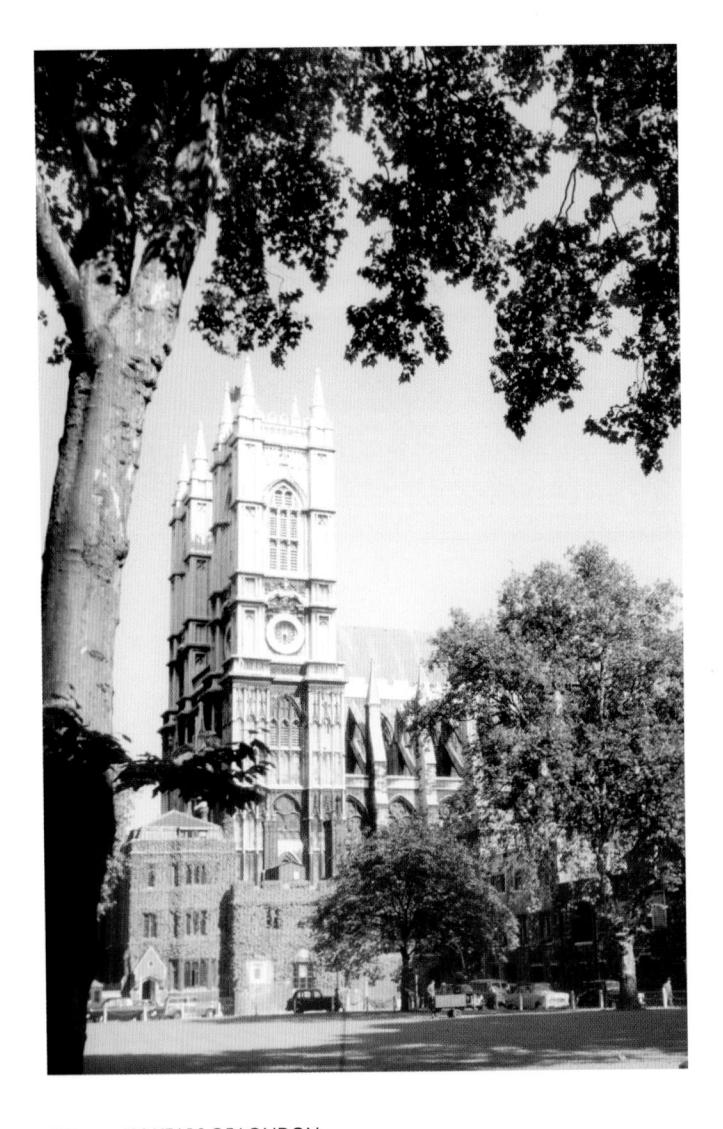

Westminster Abbey.

June 1958

Facing page: All Soul's Church and Broadcasting House.
June 1958

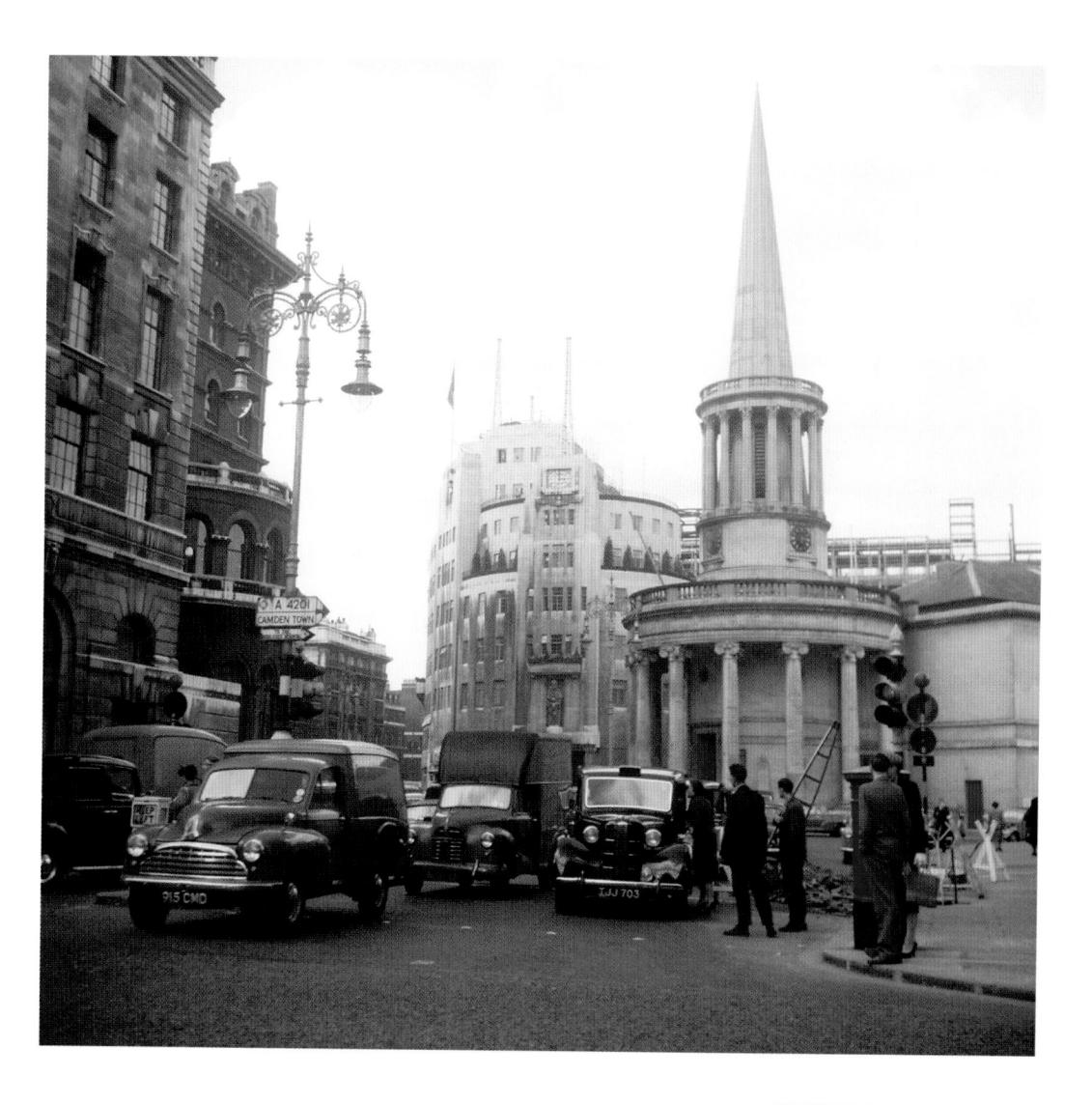

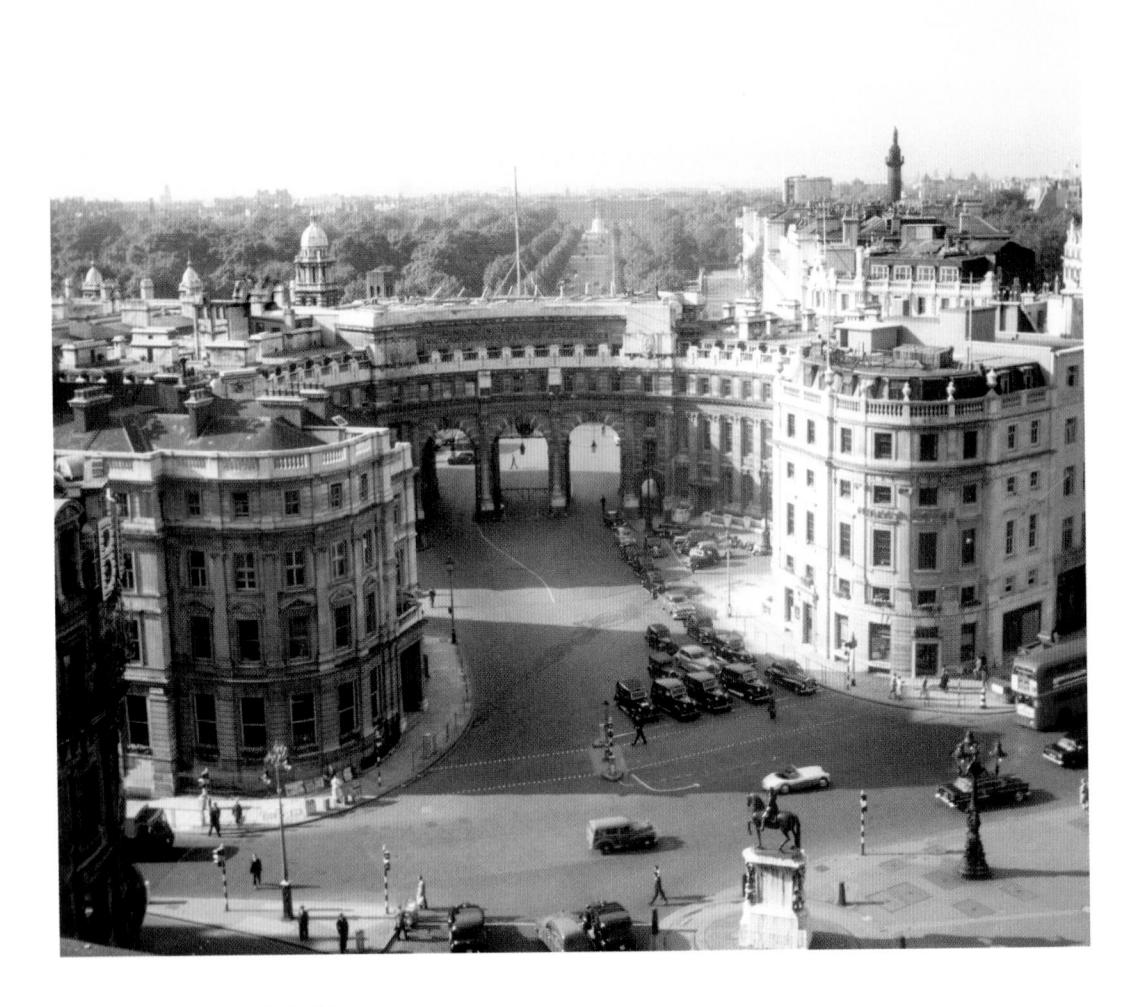

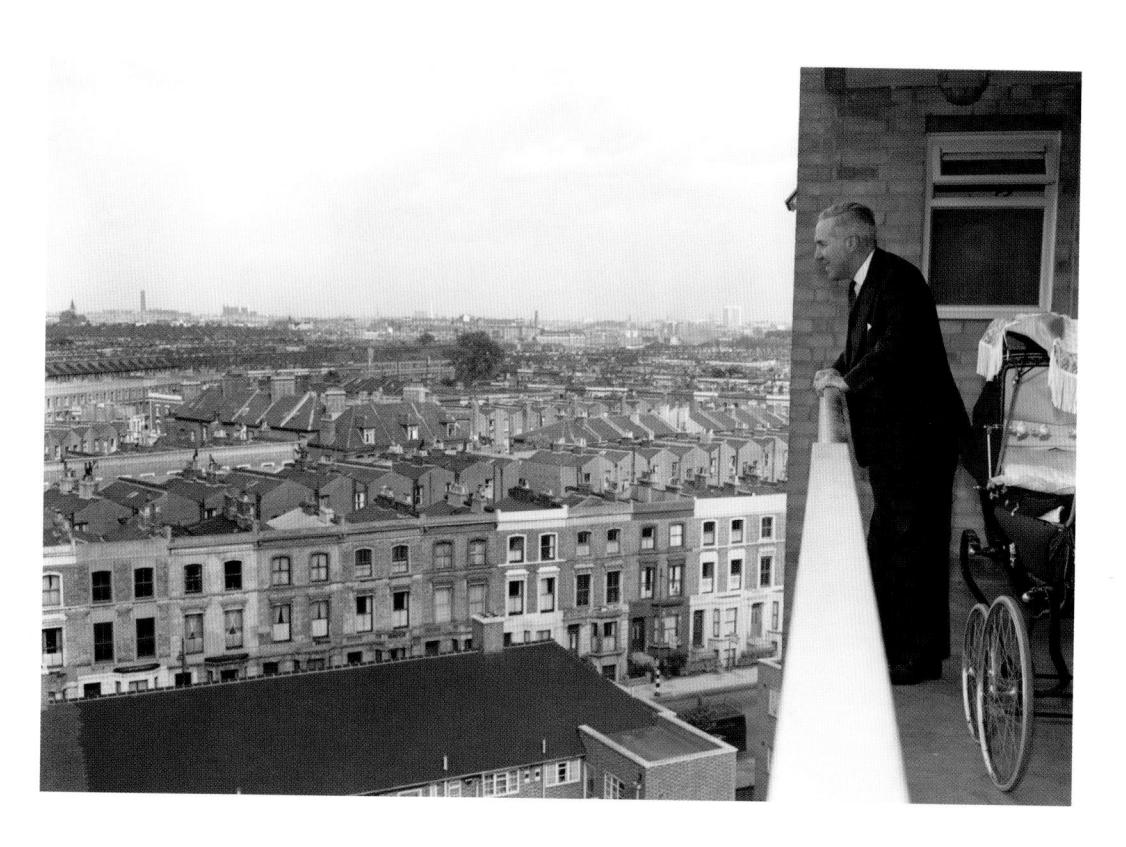

Housing Minister Henry Brooke on the 10th floor of a new block of flats in Treverton Street, Notting Hill, while inspecting rehousing and slum clearance schemes.

10 June 1959

Facing page: Admiralty Arch and The Mall, seen from South Africa House.

June 1959

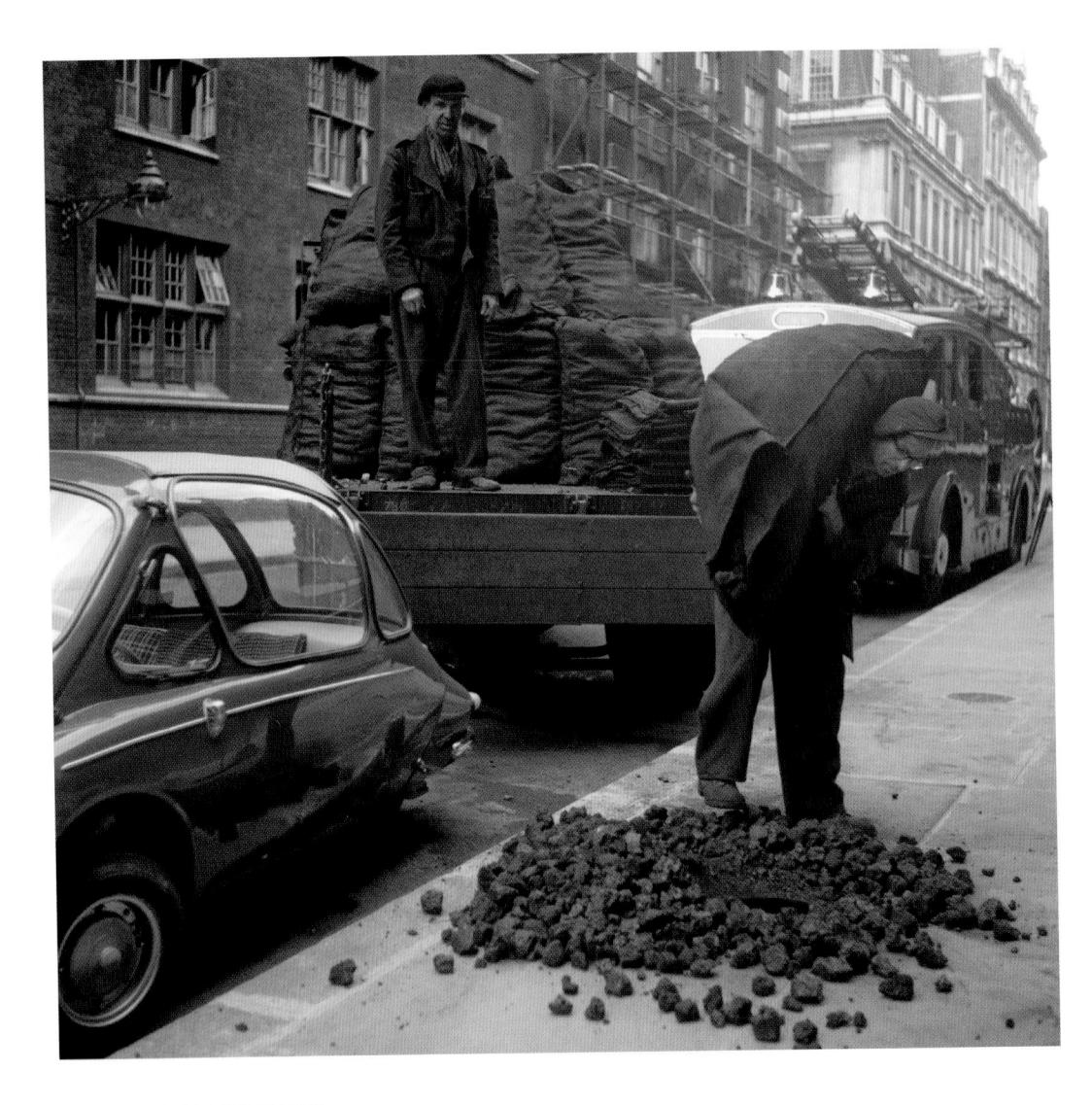

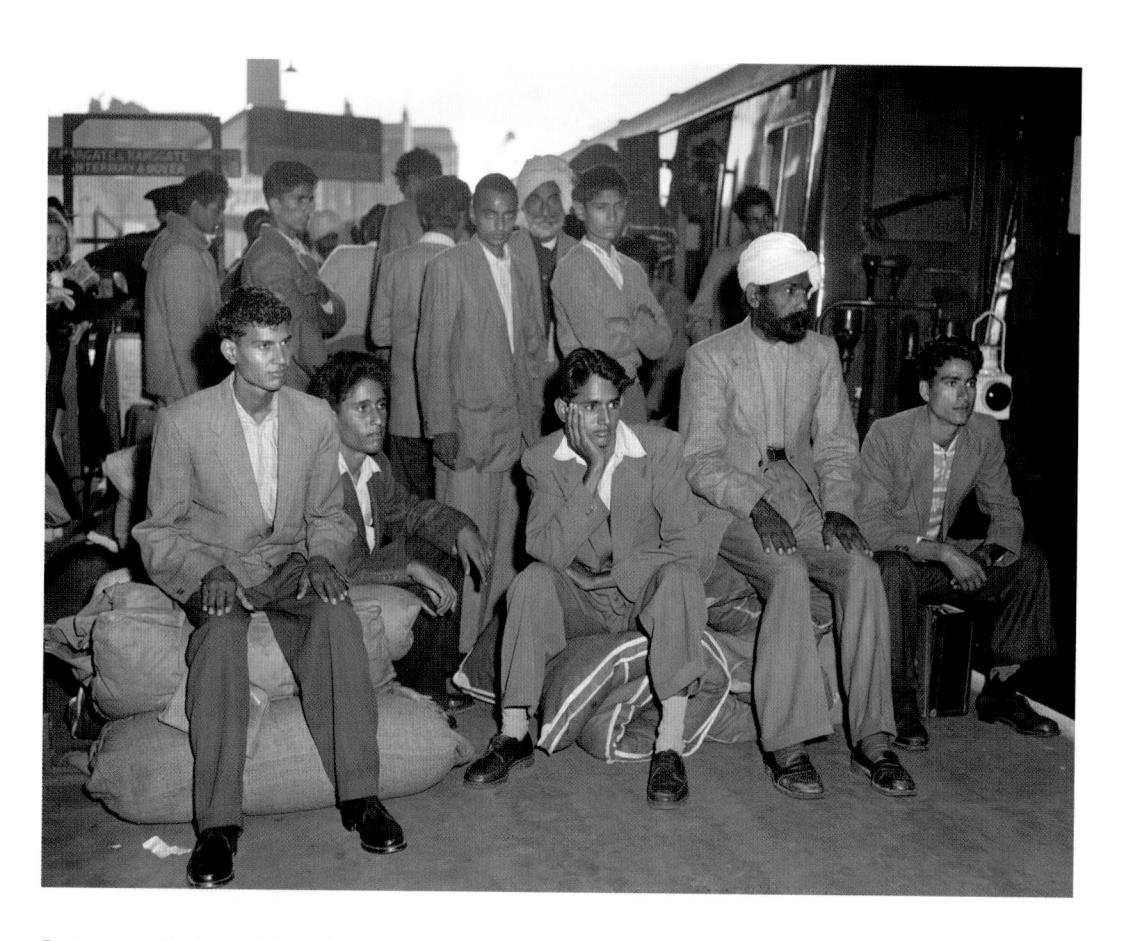

Facing page: Coalmen deliver via a coalhole in a London street.

5 September 1959

Victoria station. A group of Indians were permitted to enter Britain following inquiries about their passports. November 1959

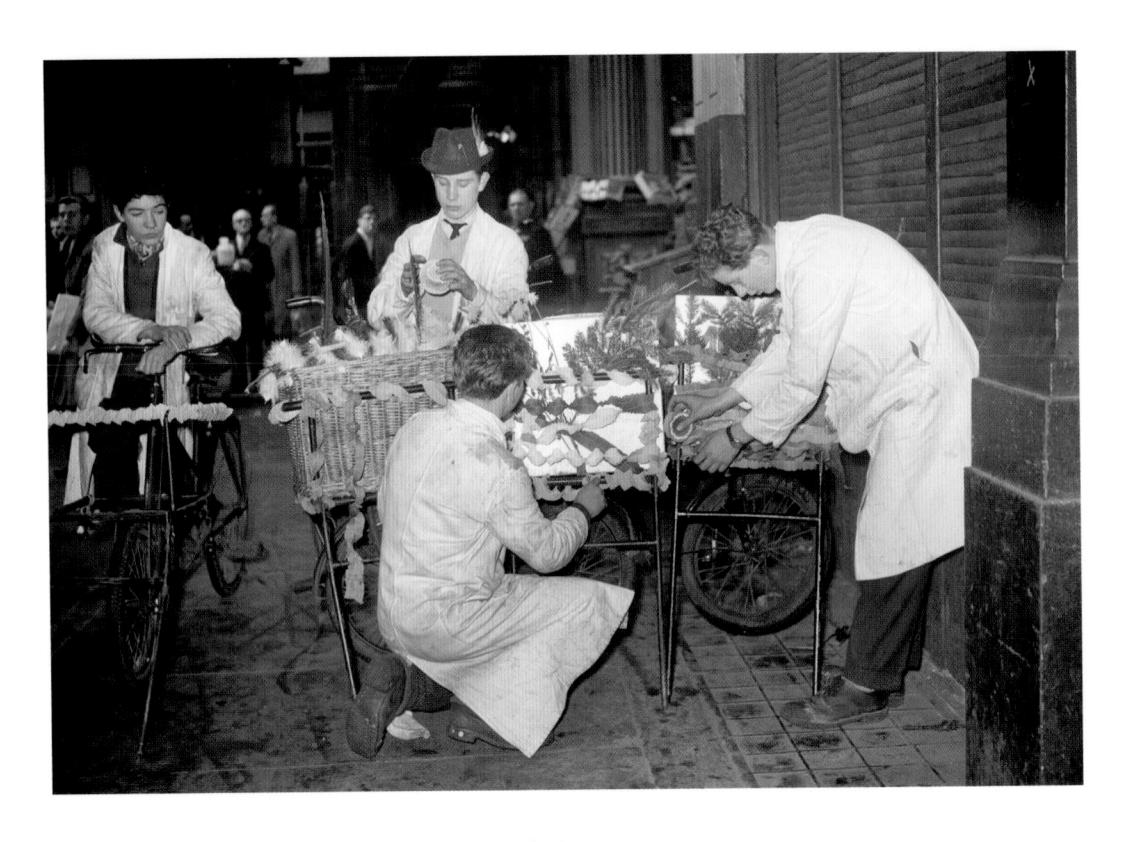

Butchers' boys decorate their delivery bicycles for Christmas. 22 December 1959

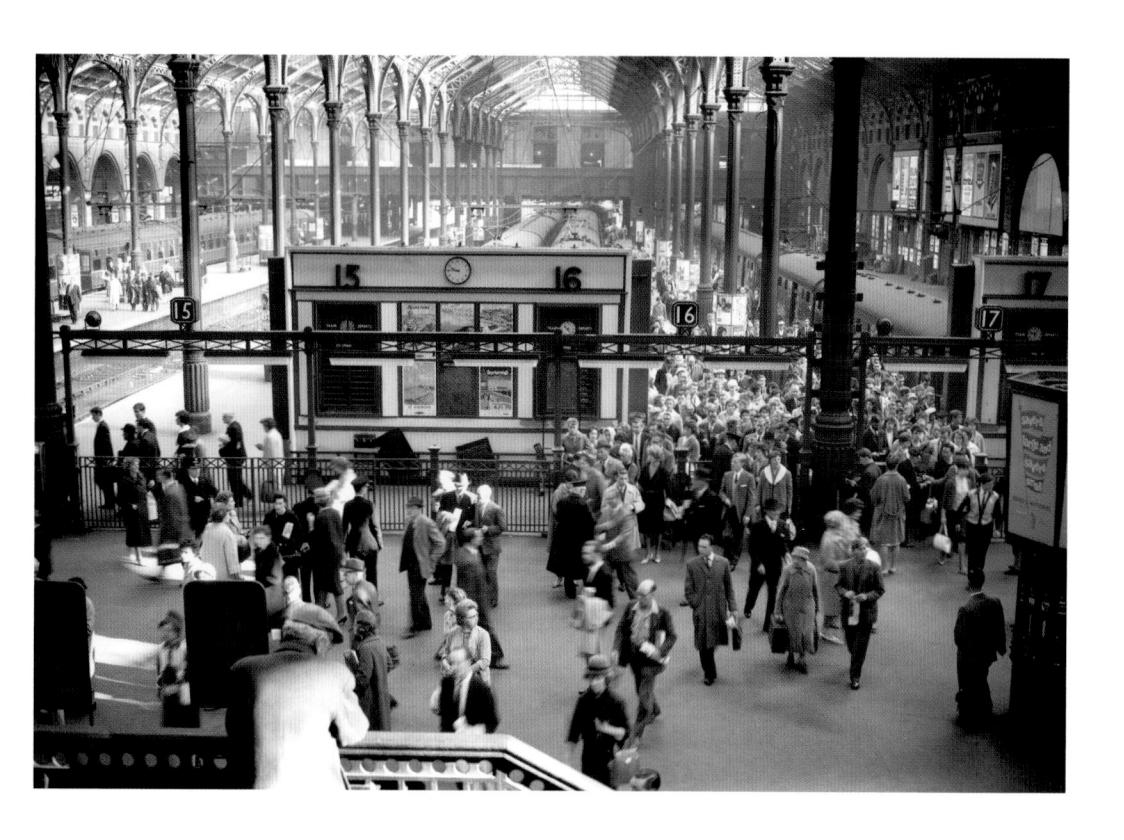

Victoria station. 2 October 1962

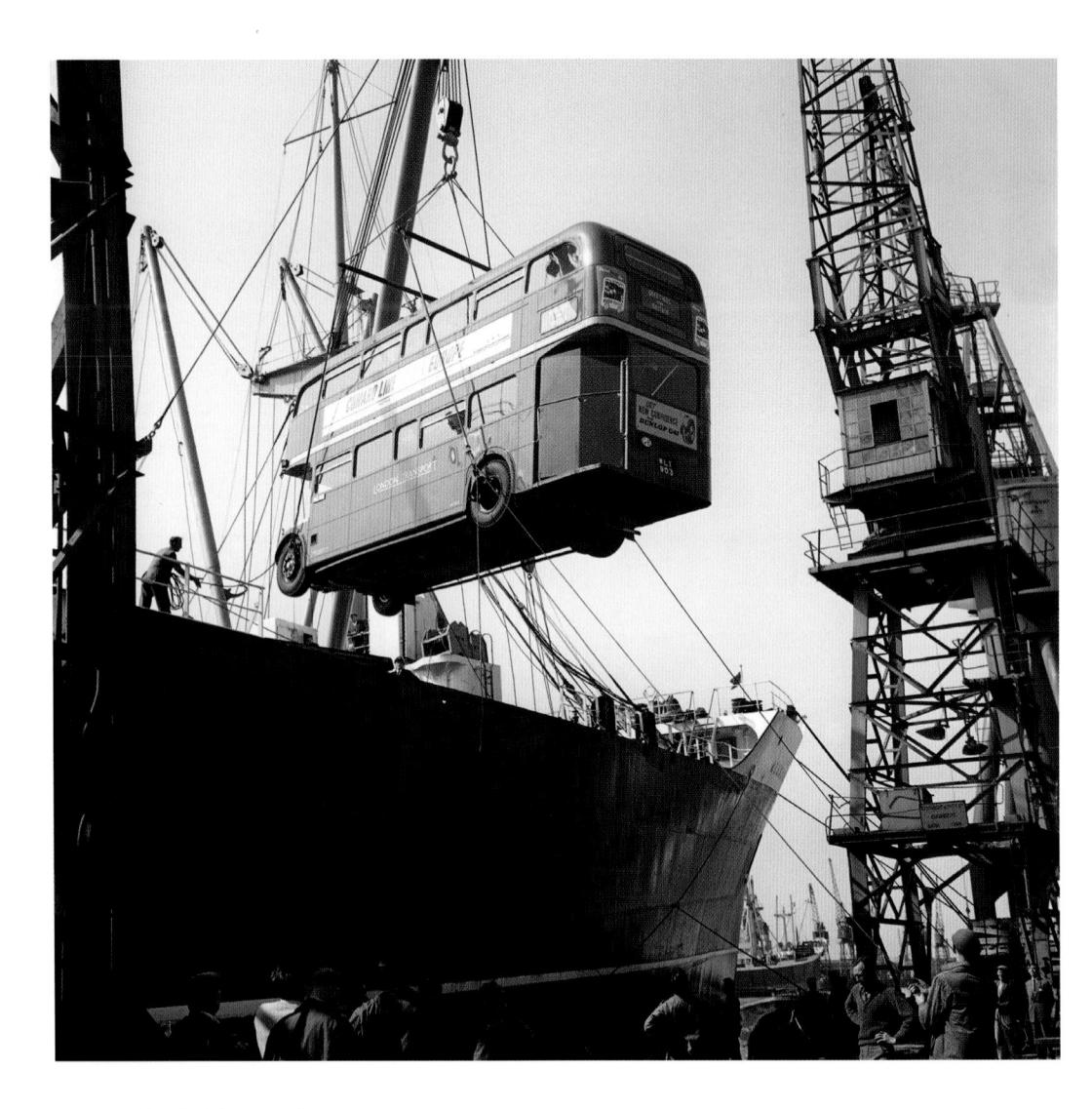

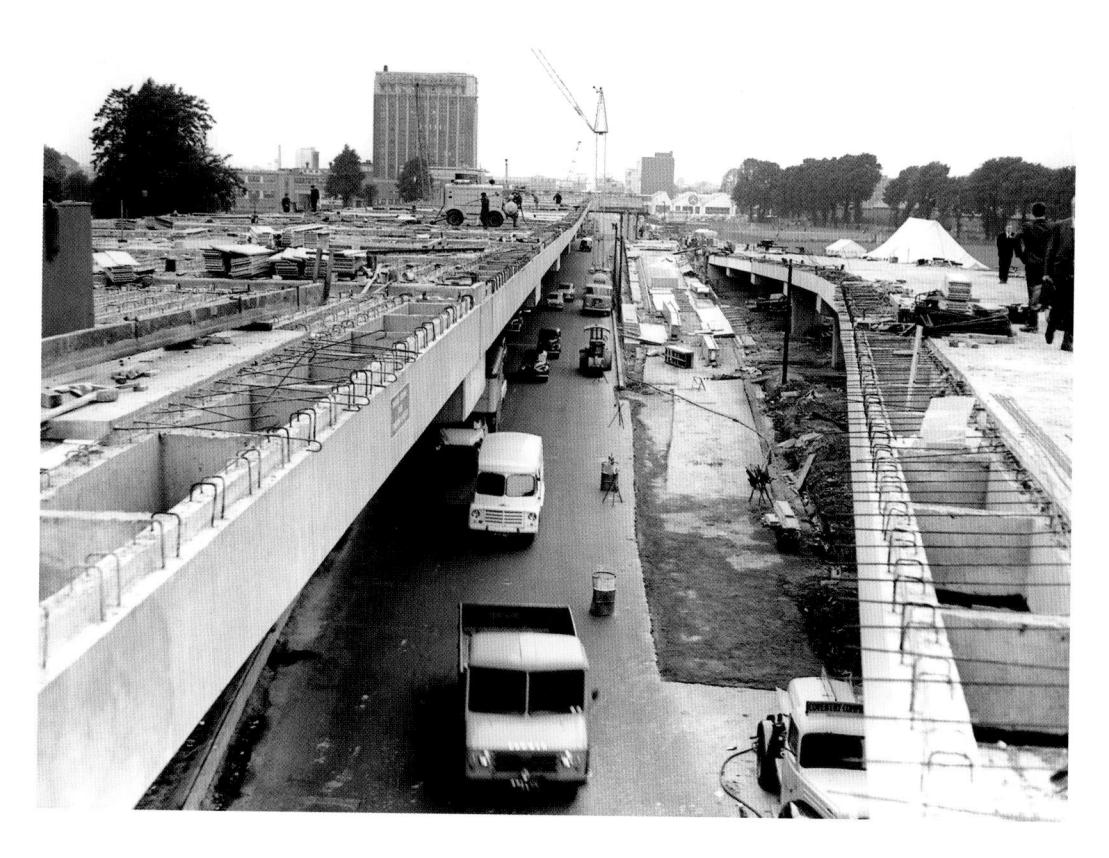

Facing page: RML 903, one of London's latest and biggest double-decker Routemaster buses, is swung aboard the Cunard cargo liner Alaunia at King George V Dock, for a month's visit to Philadelphia's Exposition Britannia.

12 September 1963

Junction 2 of the new M4 at Brentford.
4 October 1963

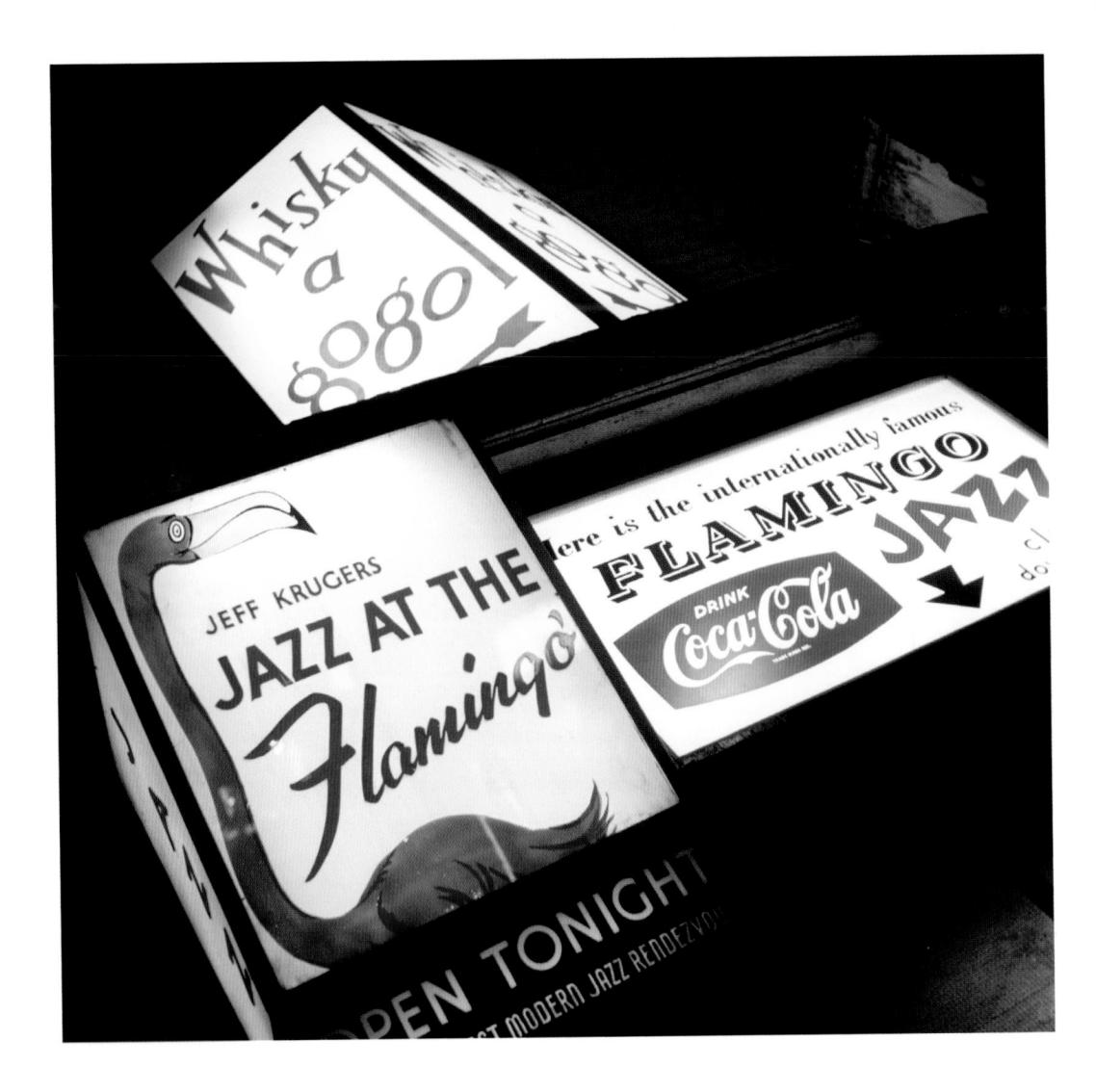

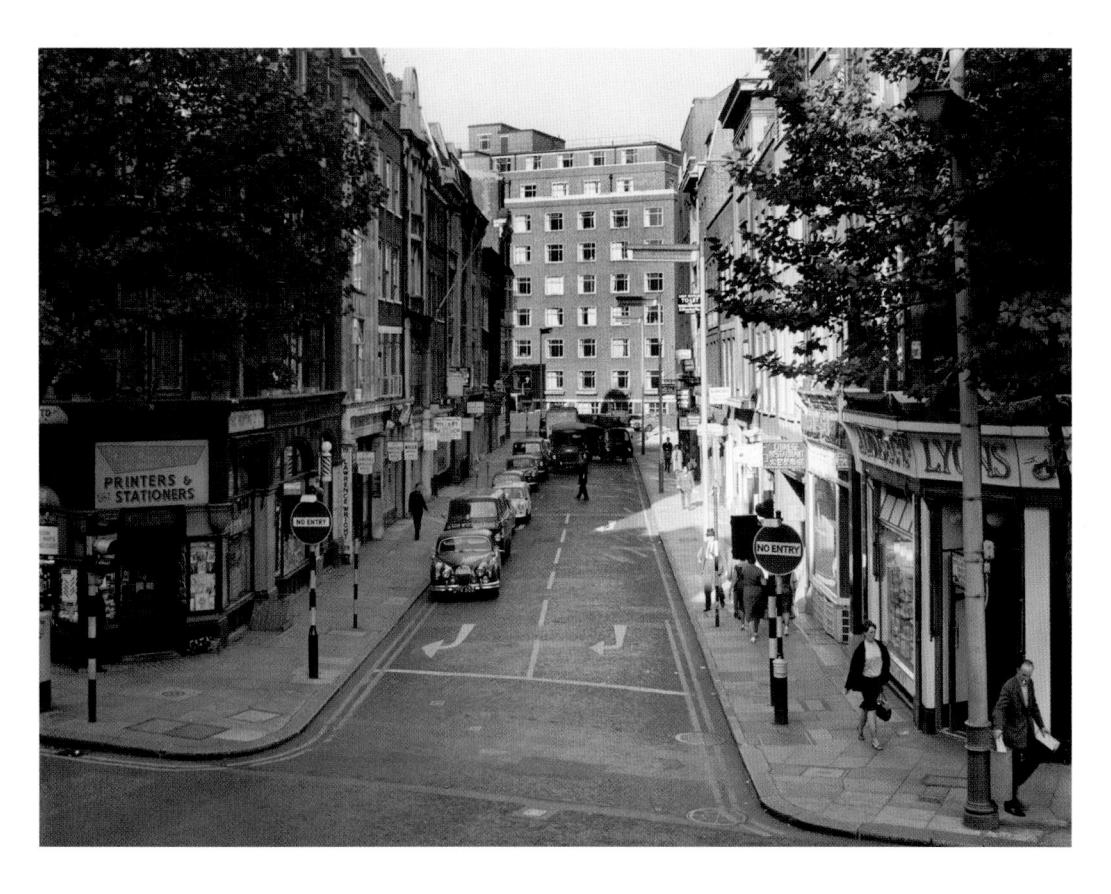

Denmark Street, home to many music publishers and an unofficial employment exchange for jobbing musicians since the 1920s.

September 1964

Facing page: Jazz at the Flamingo in Soho.

September 1964

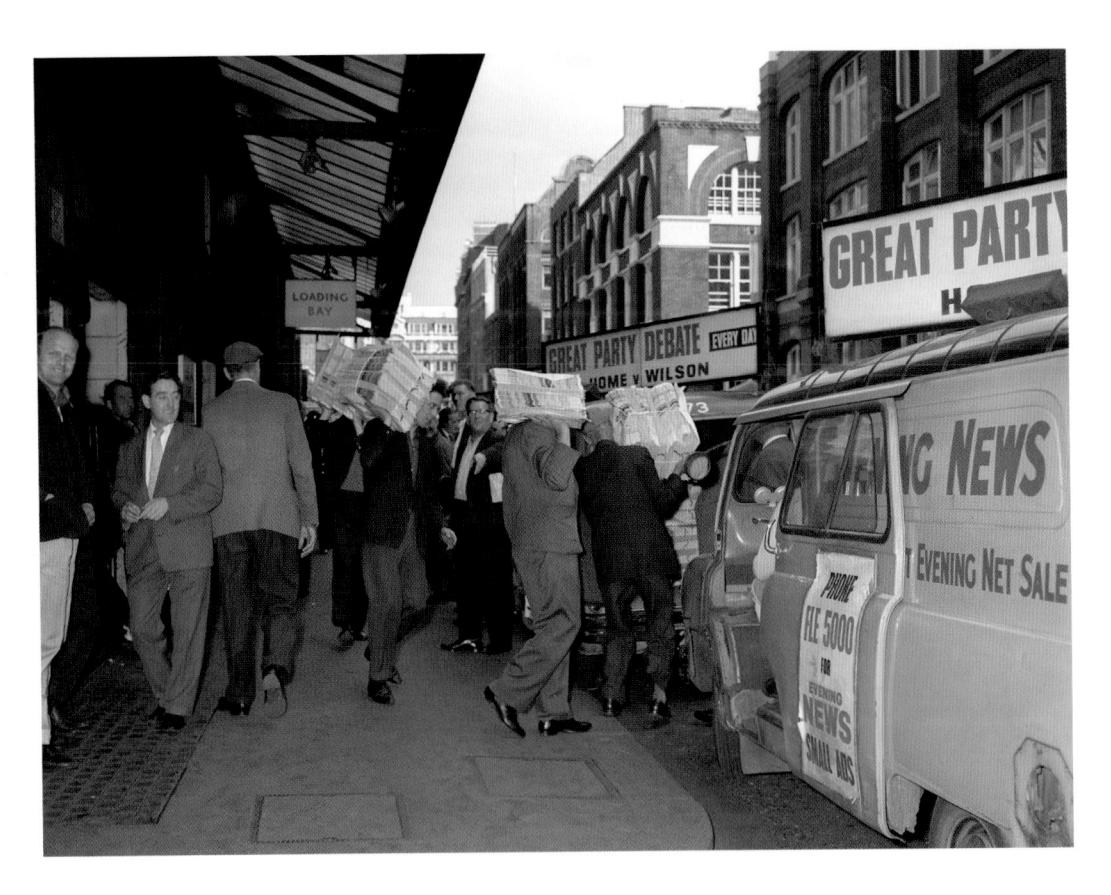

The London Evening News is loaded into delivery vans in Tudor Street.

September 1964

Facing page: In this month, groups playing at Soho's Marquee Club include The Moody Blues, The Yardbirds, Long John Baldry and Manfred Mann.

September 1964

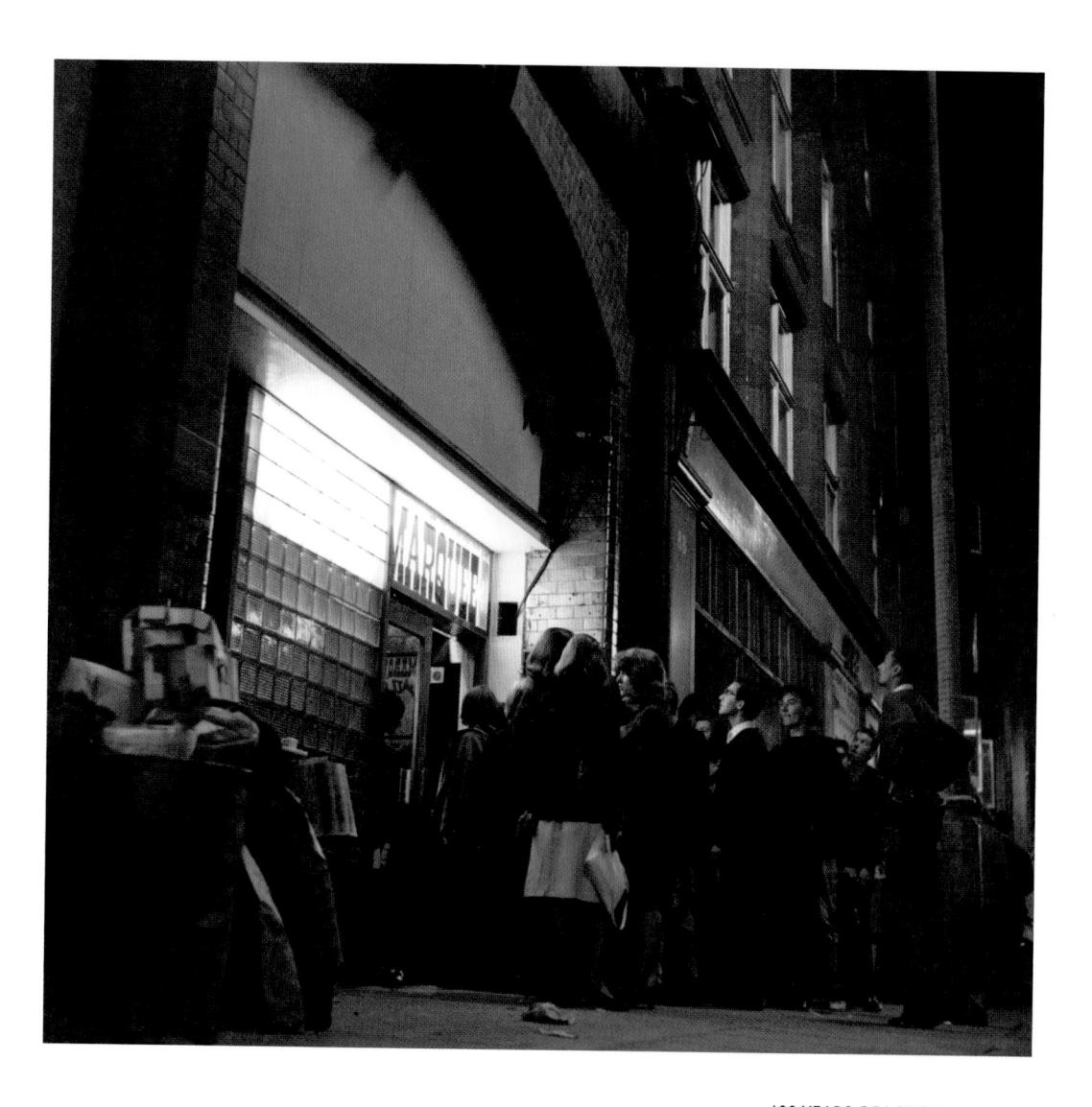

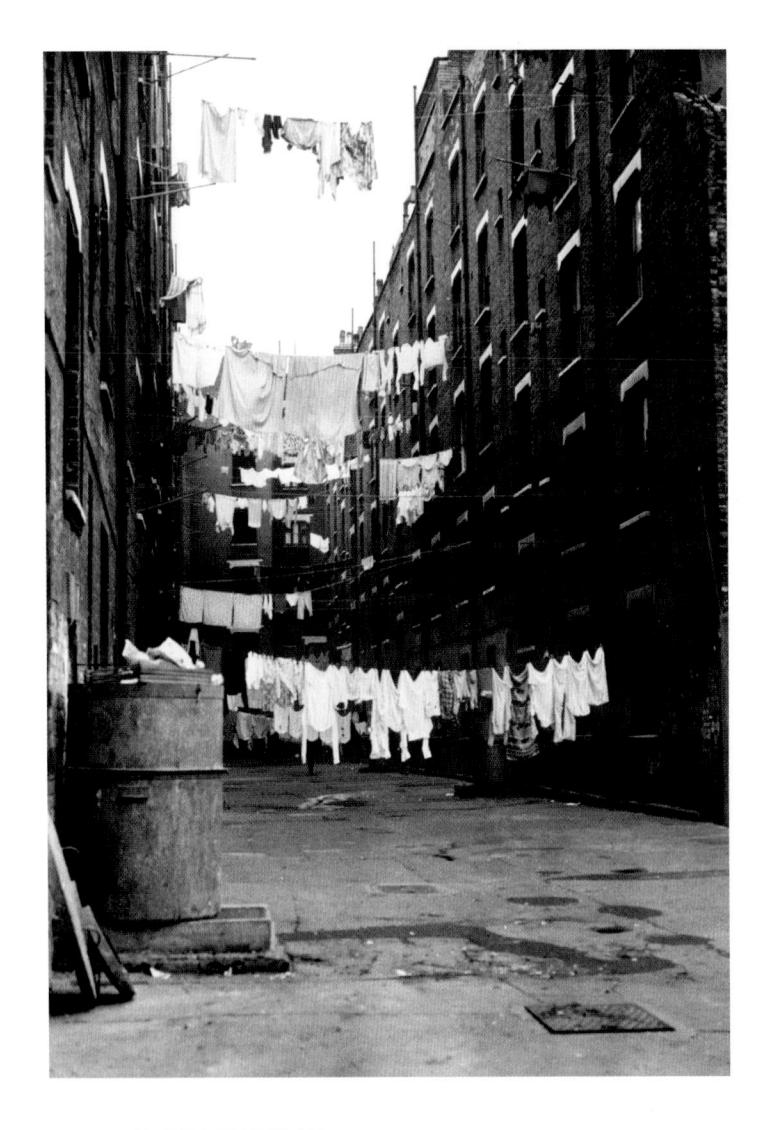

Slum tenements in Southwark.

Facing page: Life on the Underground.

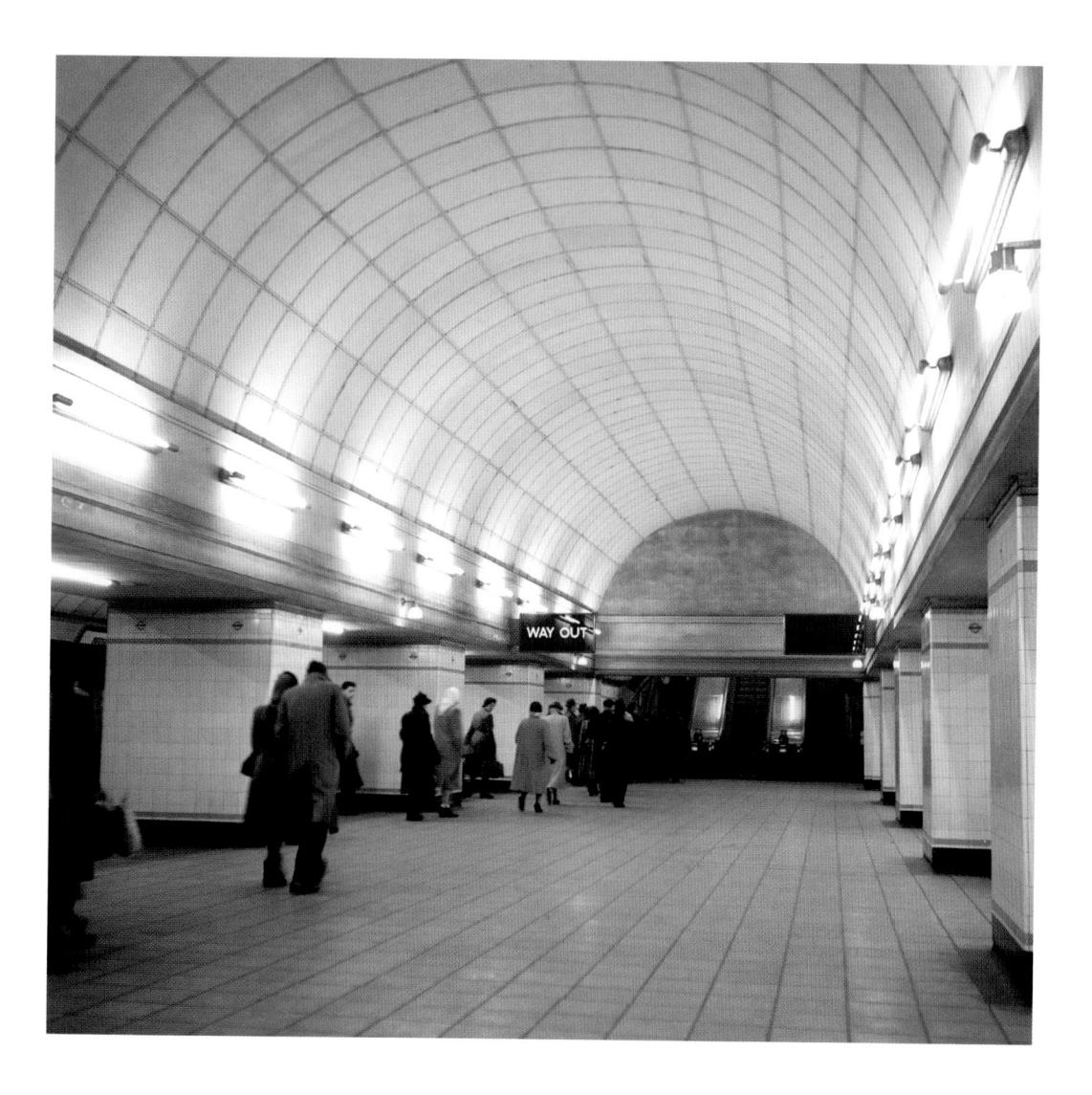

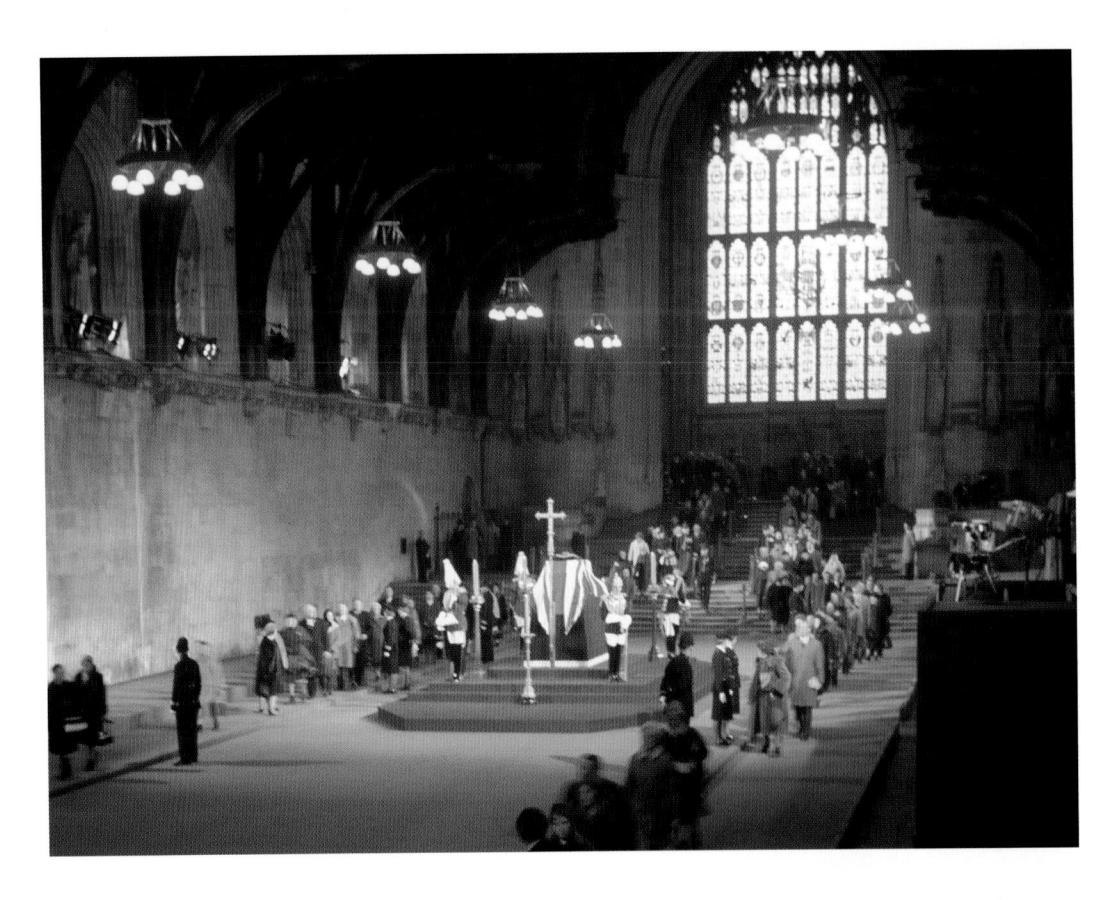

Officers of the Household Cavalry stand guard over the coffin of Sir Winston Churchill in Westminster Abbey. 27 January 1965

Facing page: Fish and chips on the Uxbridge Road.
9 September 1965

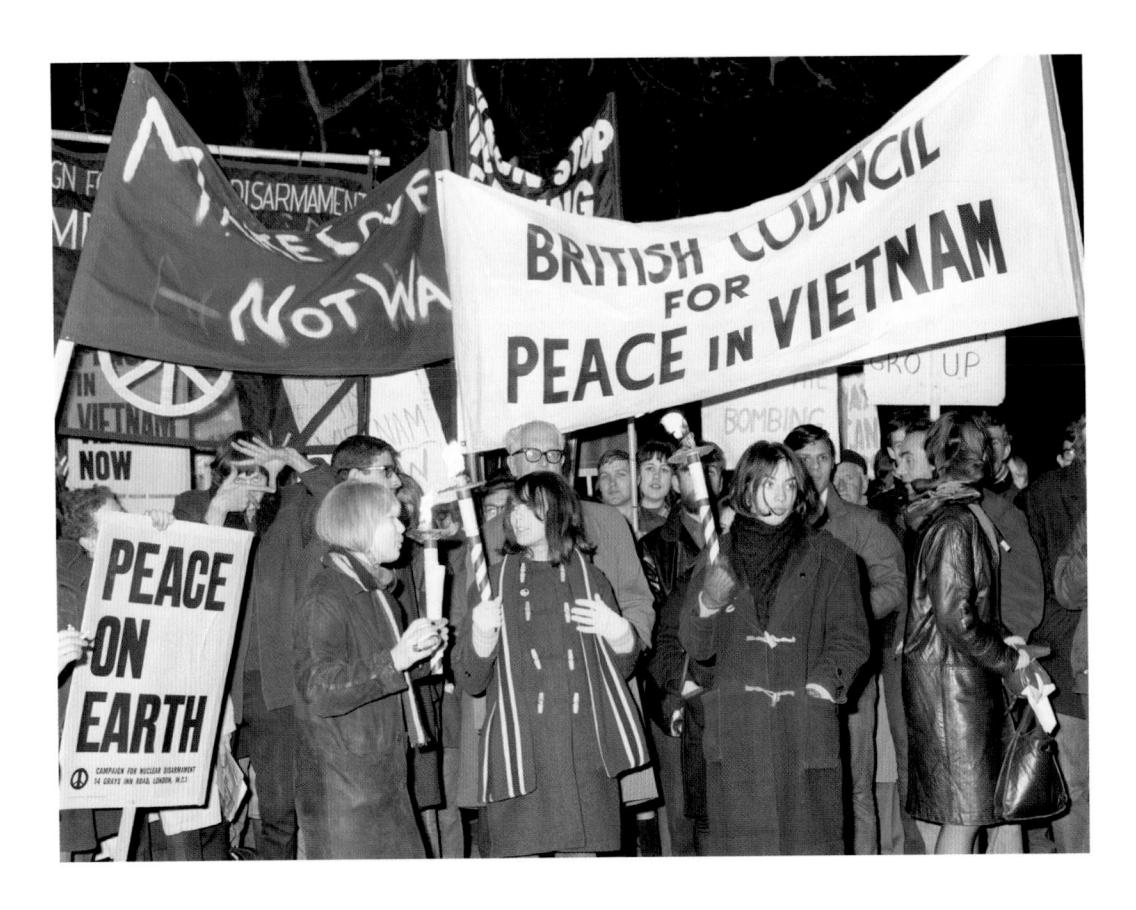

Marchers call on the US government to end the war in Vietnam. Subsequent demonstrations would be less peaceful.

27 November 1965

Facing page: The Phoenix strip club in Old Compton Street.

15 March 1966

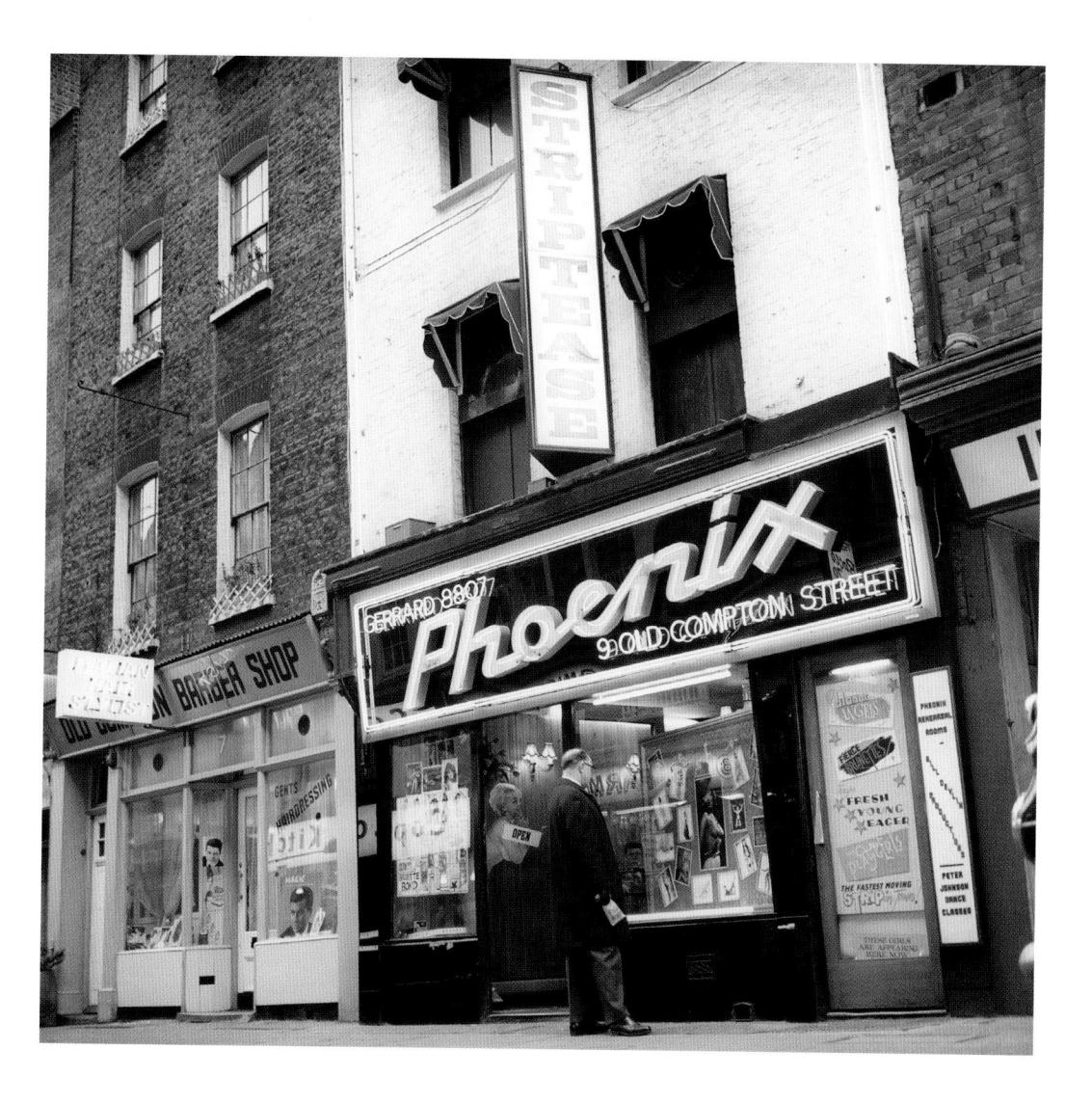

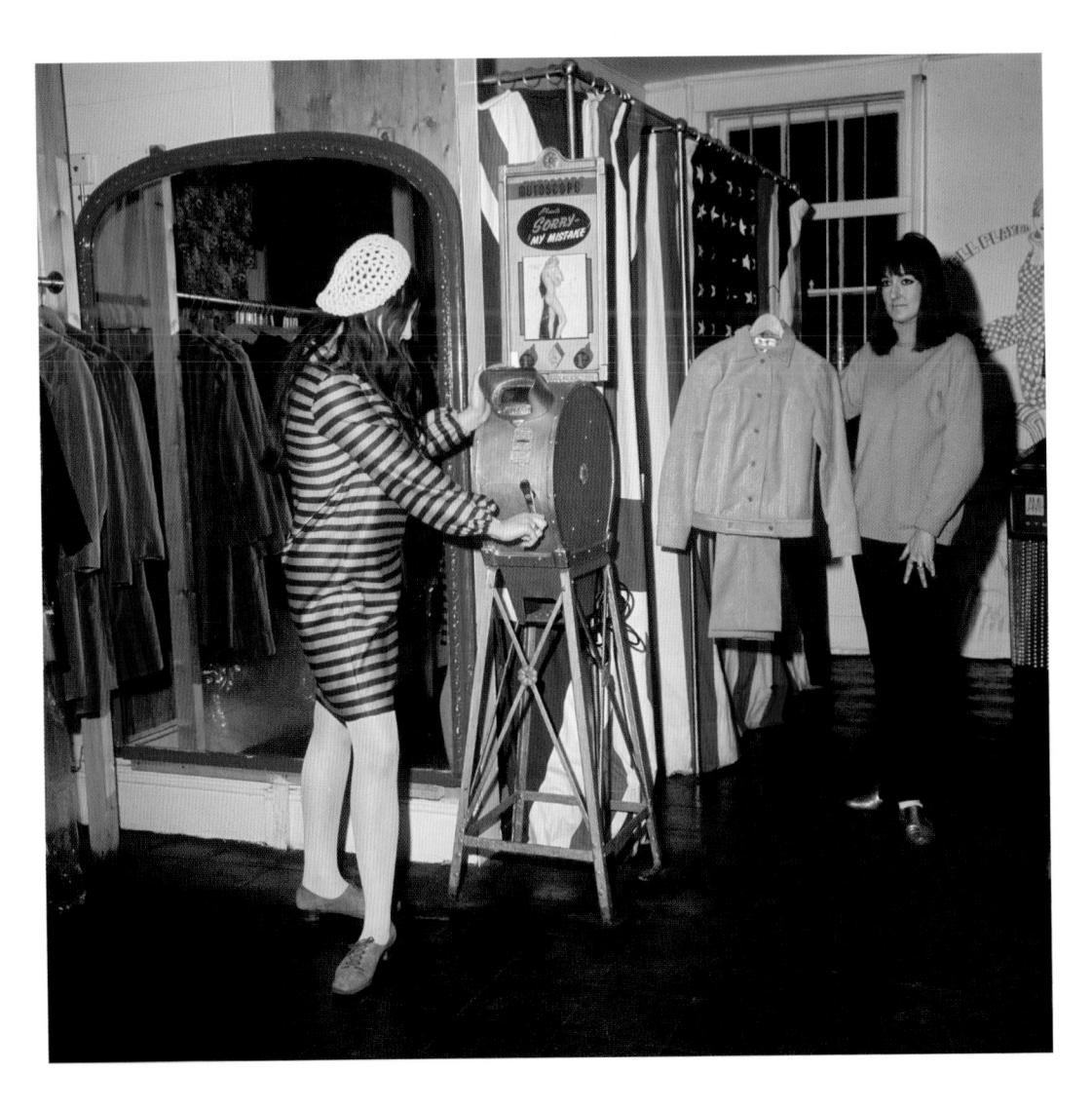

Facing page: Swinging London: Pauline Fordham's boutique in Ganton Street, off Carnaby Street. April 1966

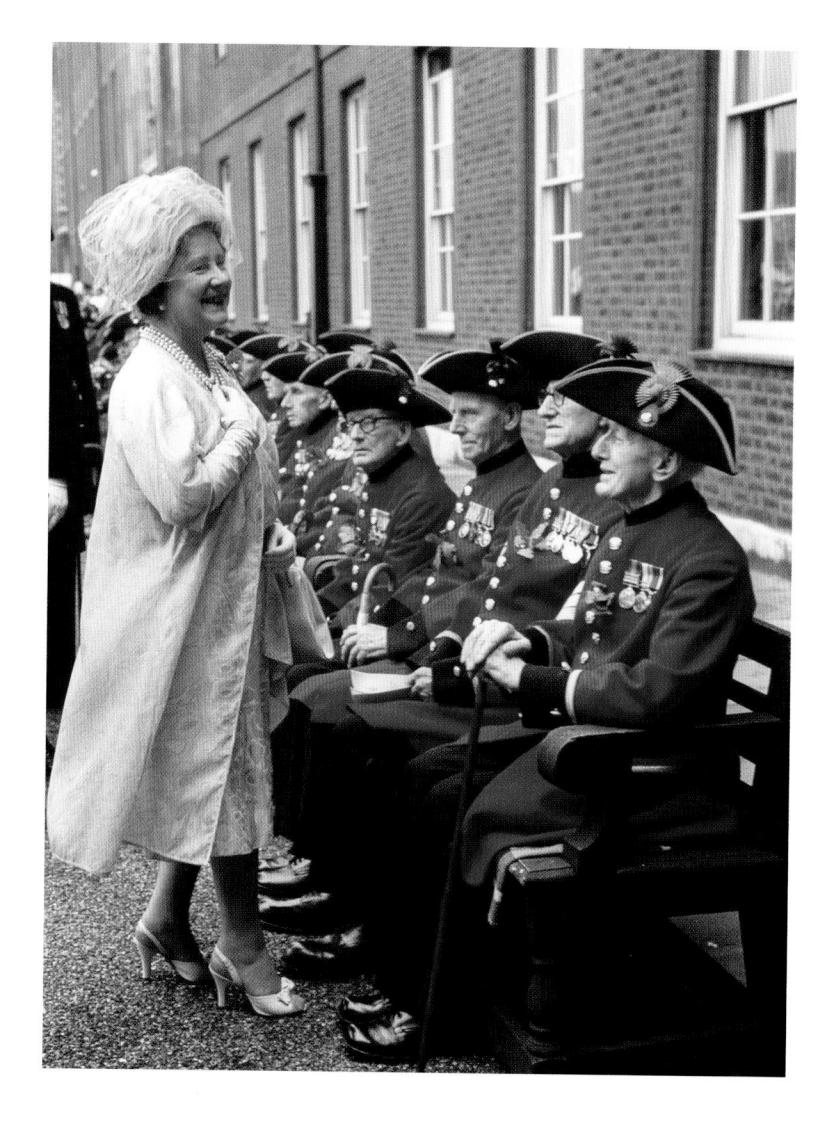

The Queen Mother talks to Boer War veterans among Chelsea pensioners at Founder's Day, Chelsea Hospital. 10 June 1966

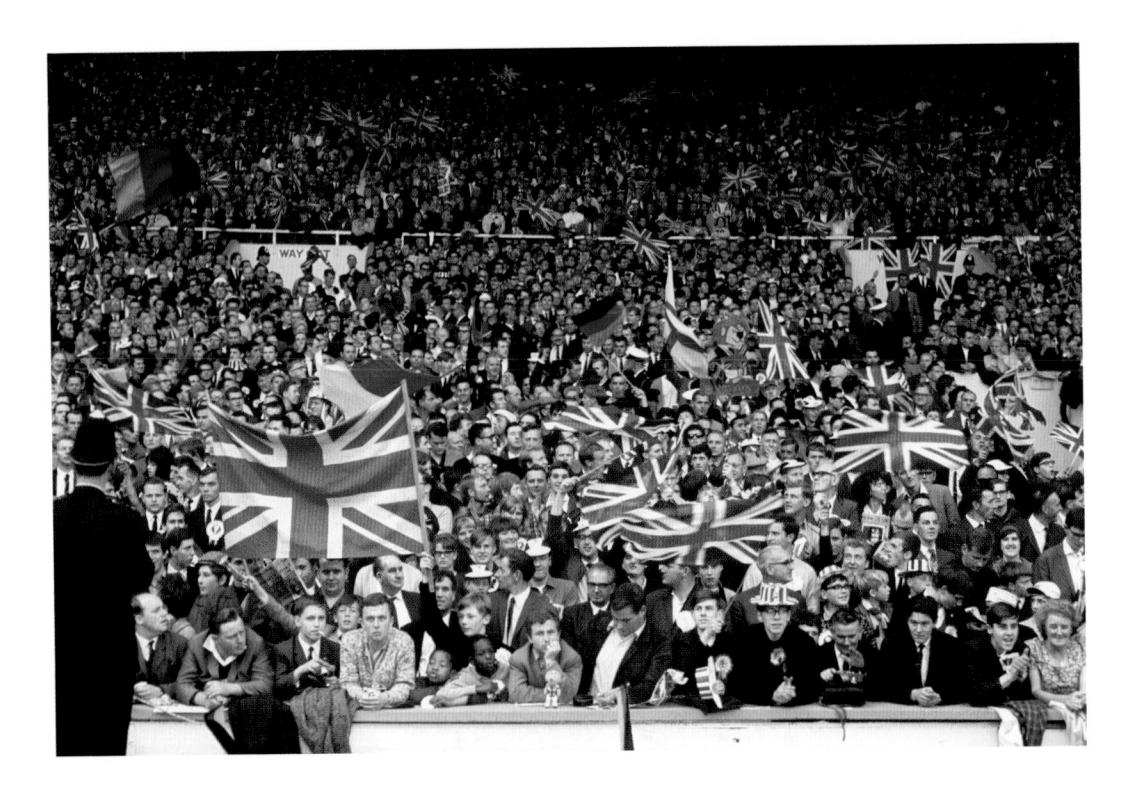

England fans waving Union Jack flags at the World Cup Final. 30 July 1966

Facing page: England captain, Bobby Moore, holds aloft the World Cup Trophy after beating West Germany 4-2 at Wembley.

30 July 1966

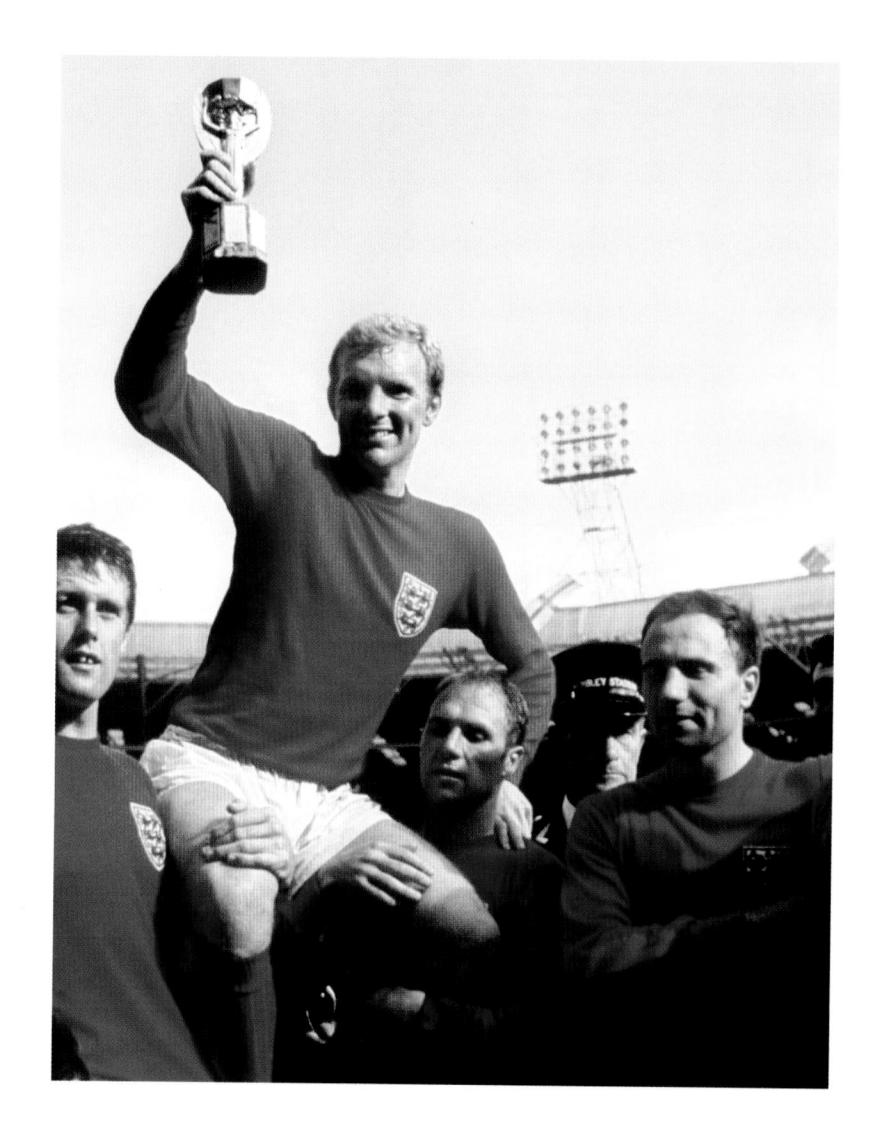

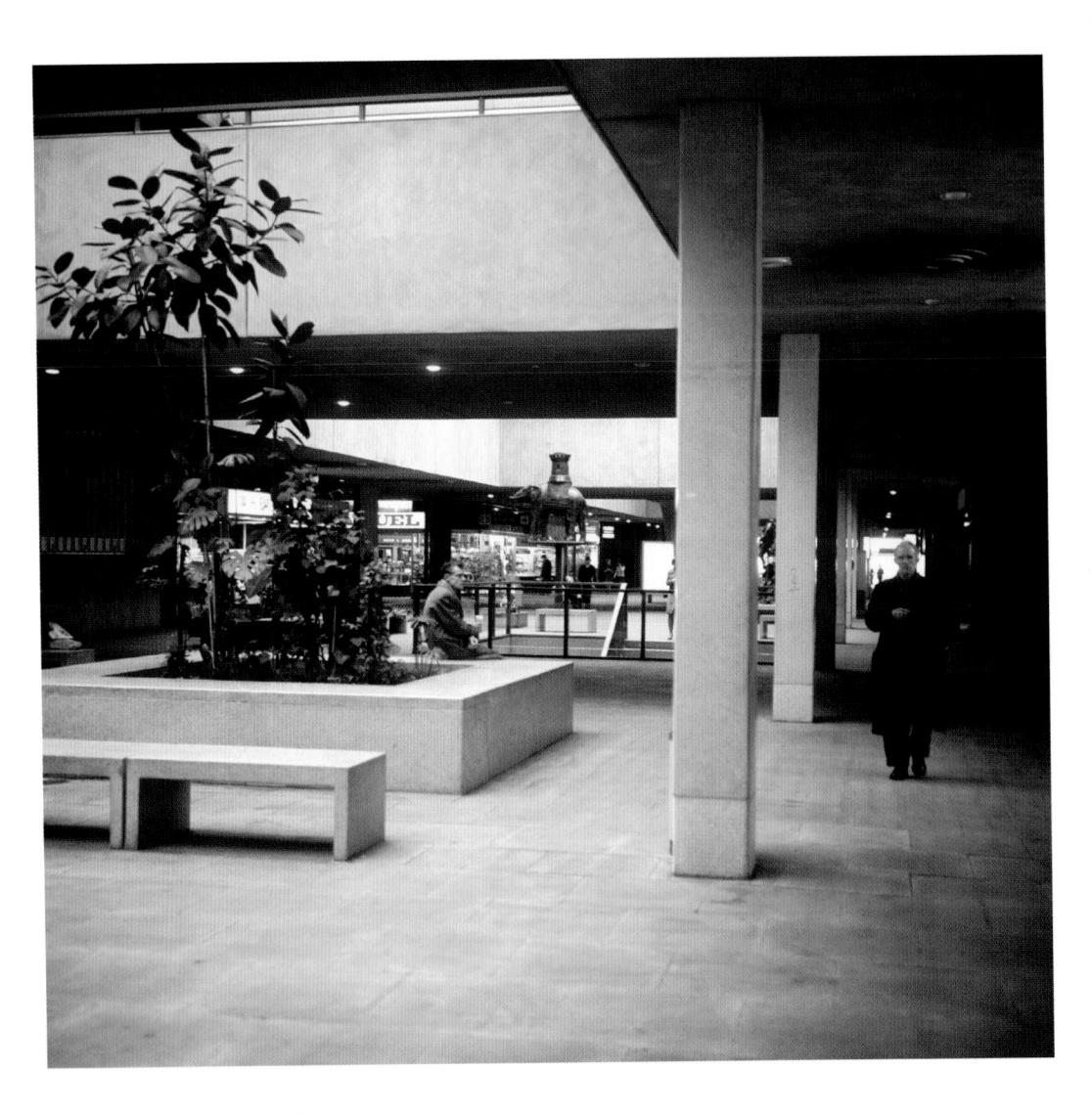

Facing page: Inside the new Elephant and Castle shopping centre. During the 1980s the building was painted shocking pink in an attempt to 'brighten it up'.

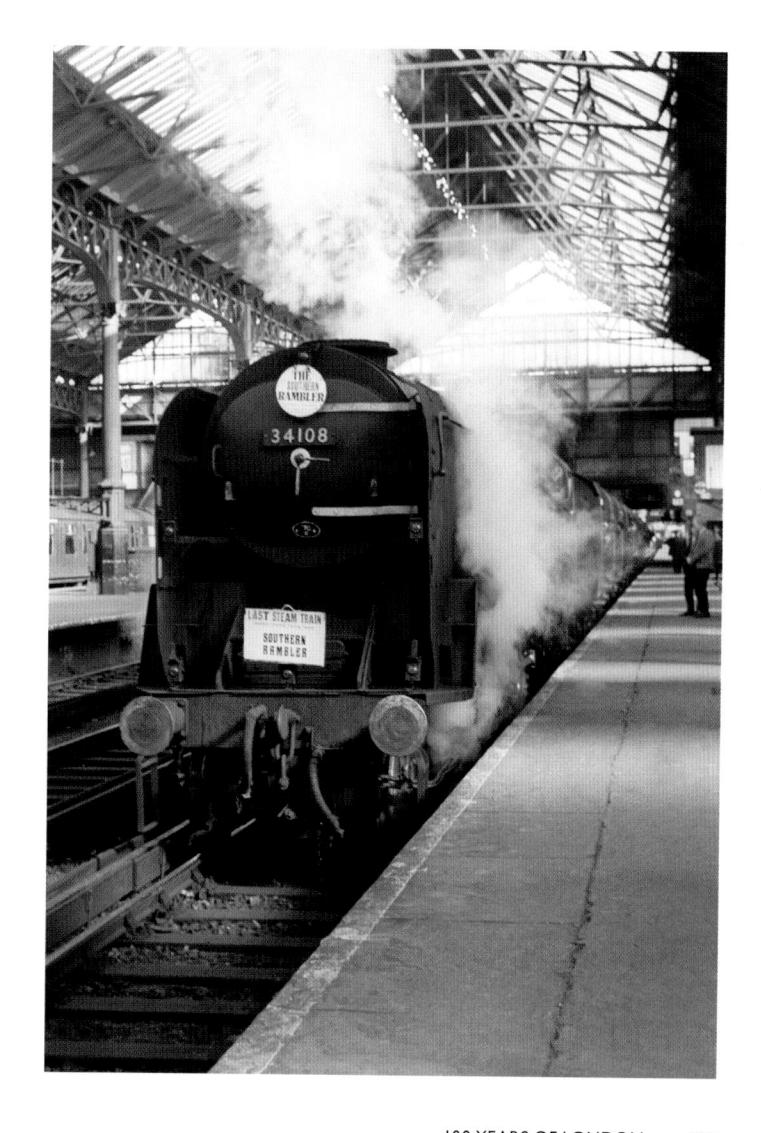

Wincanton, the last steam locomotive to leave Victoria station for Brighton and Eastbourne. 19 March 1967

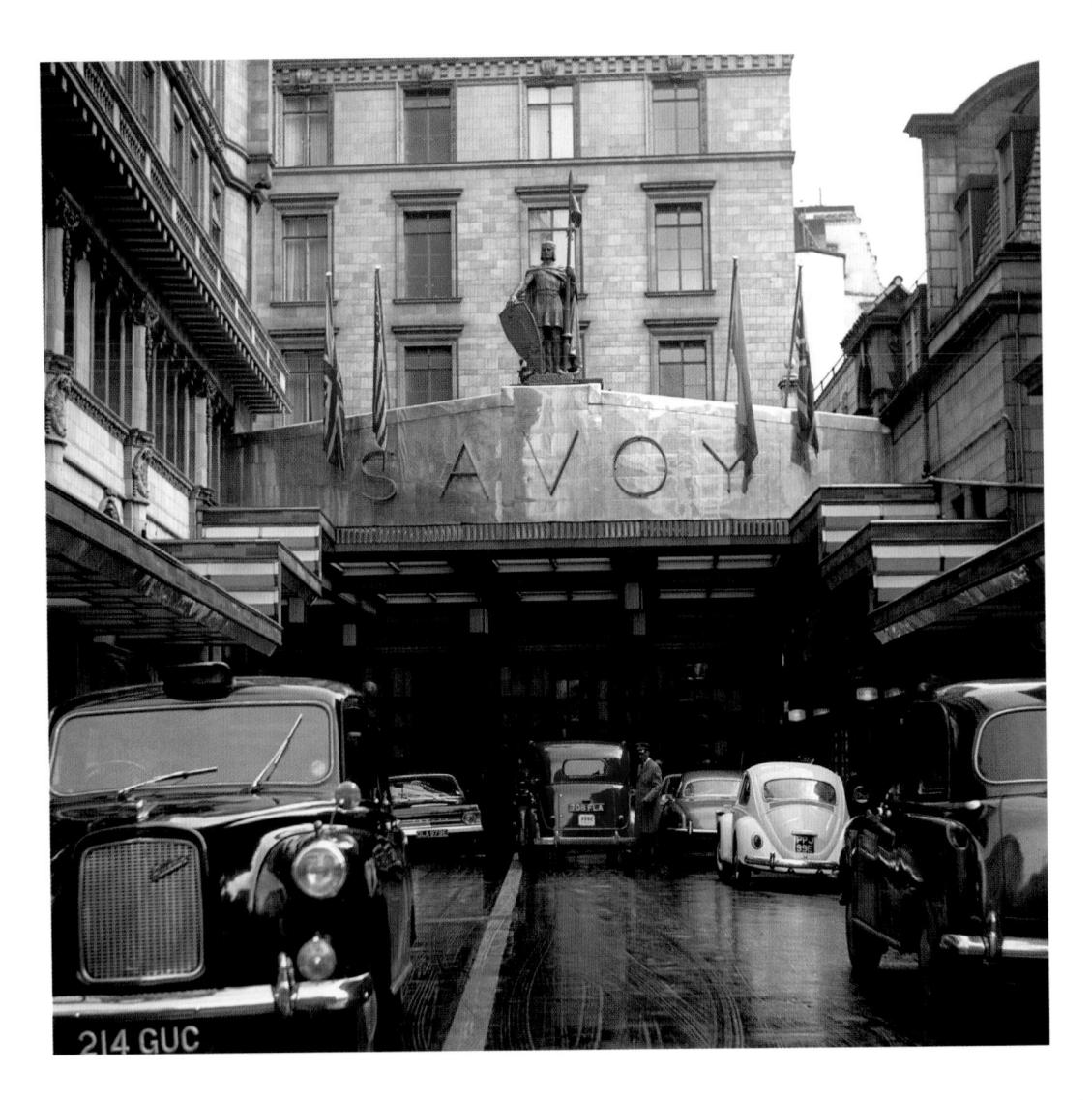

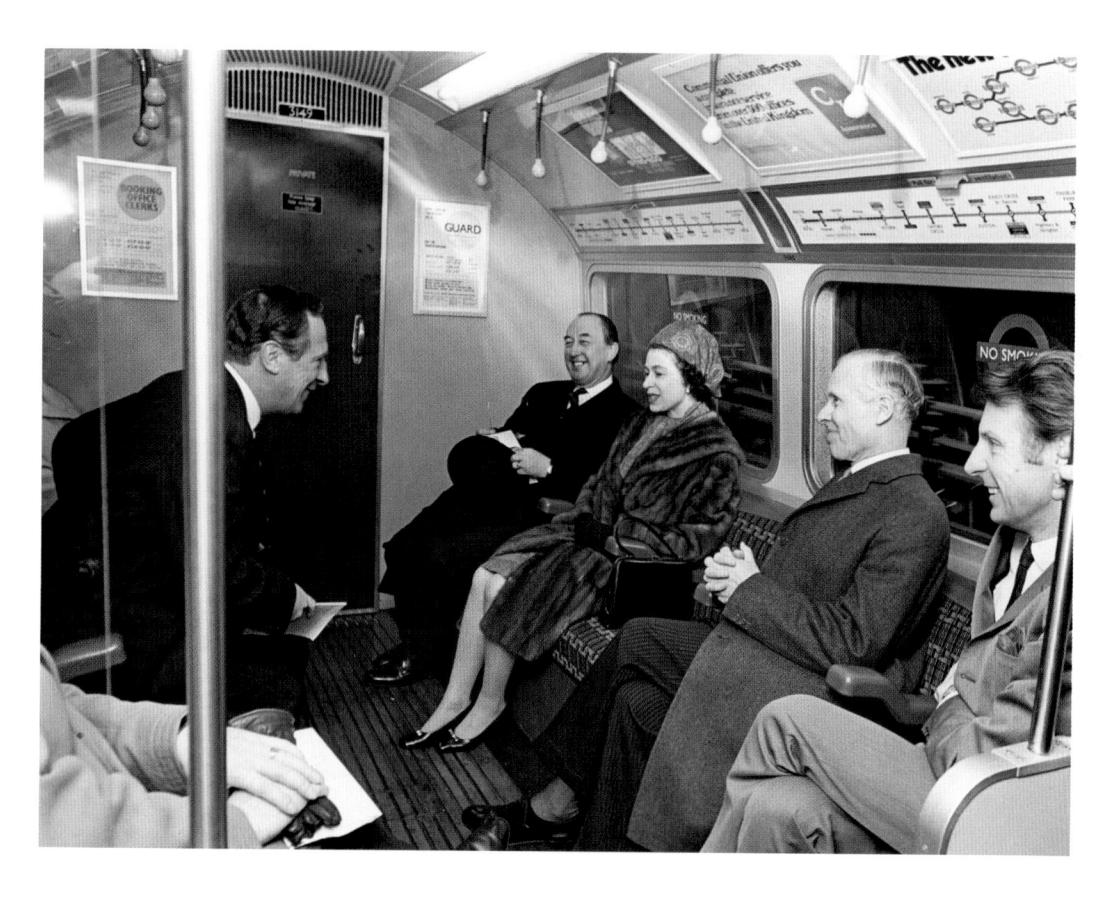

The Queen takes the Tube to the opening ceremony for the new Victoria Line. It is the first time a reigning monarch has ridden on the Underground.
7 March 1969

Facing page: The Savoy Hotel. 22 May 1967

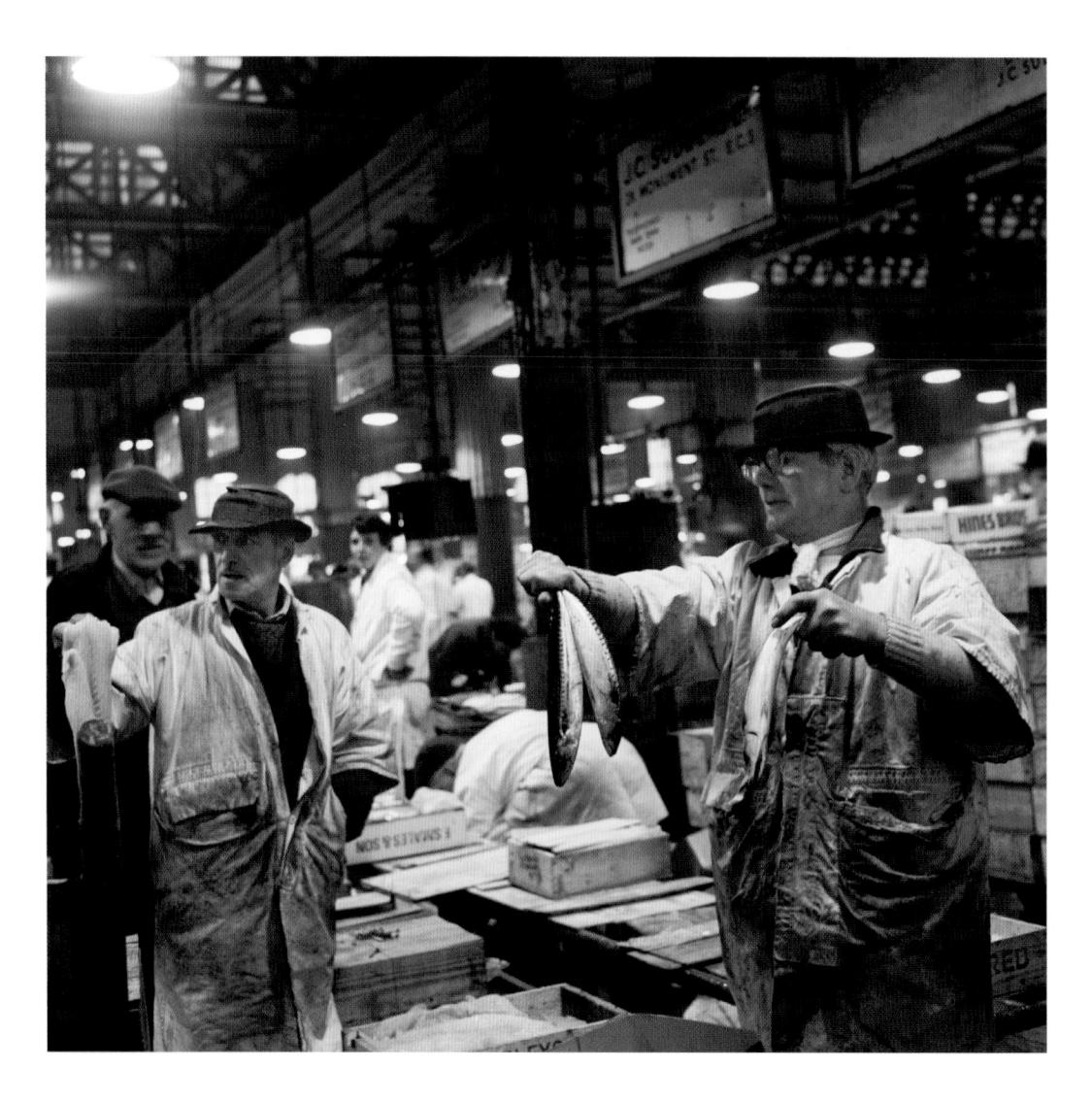
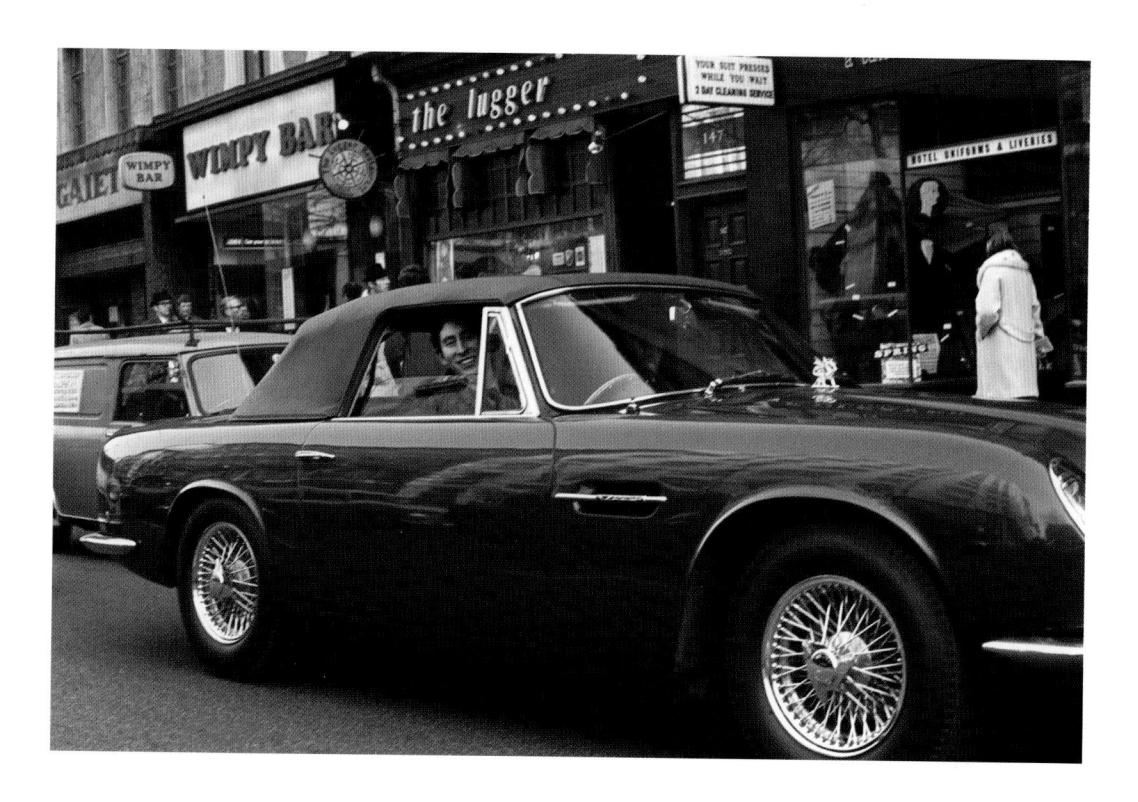

The Prince of Wales at the wheel of his Aston Martin DB6 convertible, on the Strand after visiting the Press Association in Fleet Street.

4 February 1971

Facing page: Billingsgate fish market.

8 December 1969

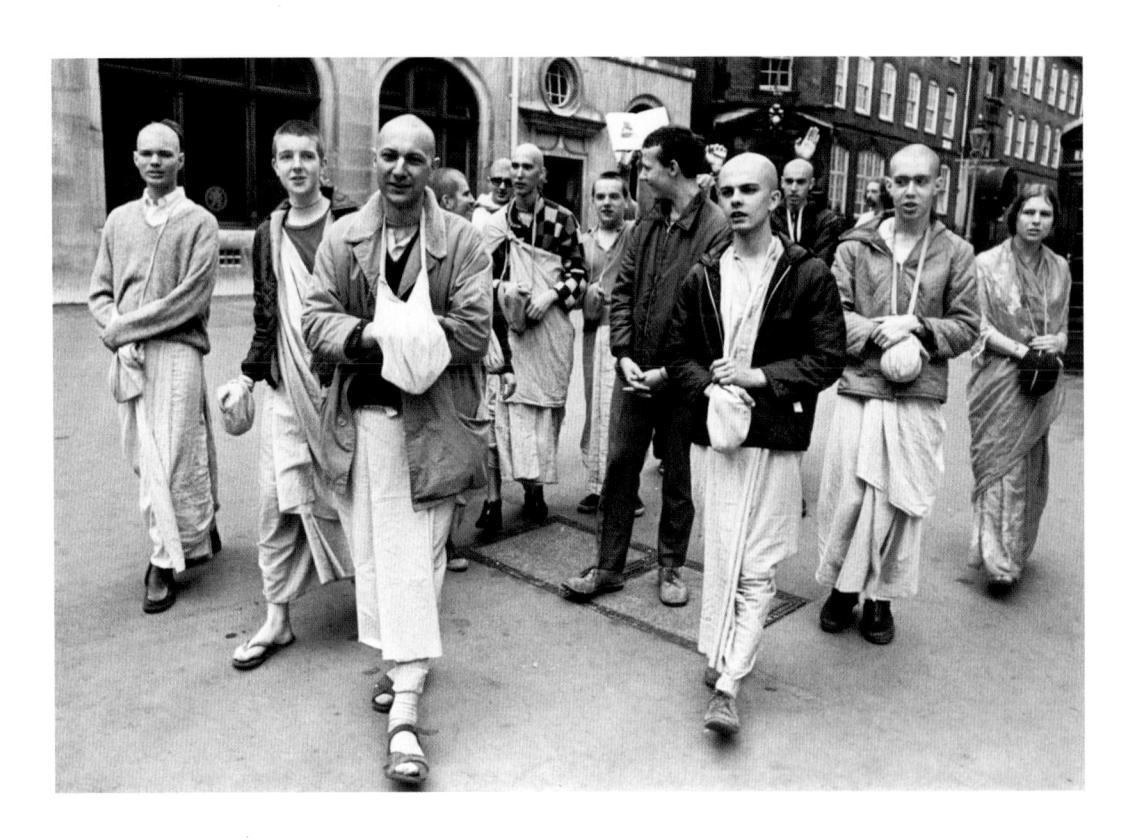

Devotees of Hare Krishna.

Facing page: The 50th Annual General Meeting of the National Federation of Women's Institutes, at the Royal Albert Hall. 8 June 1971

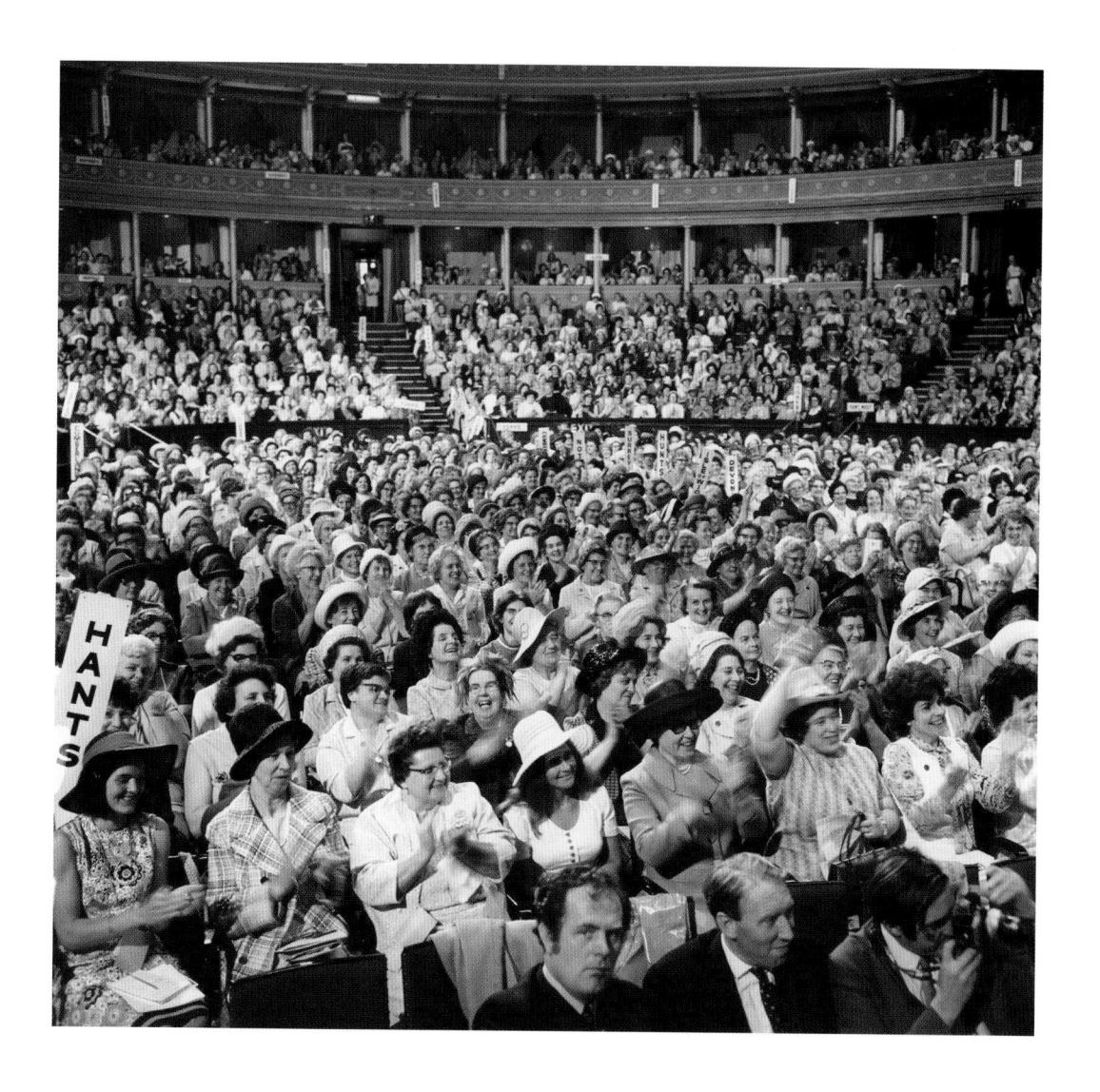

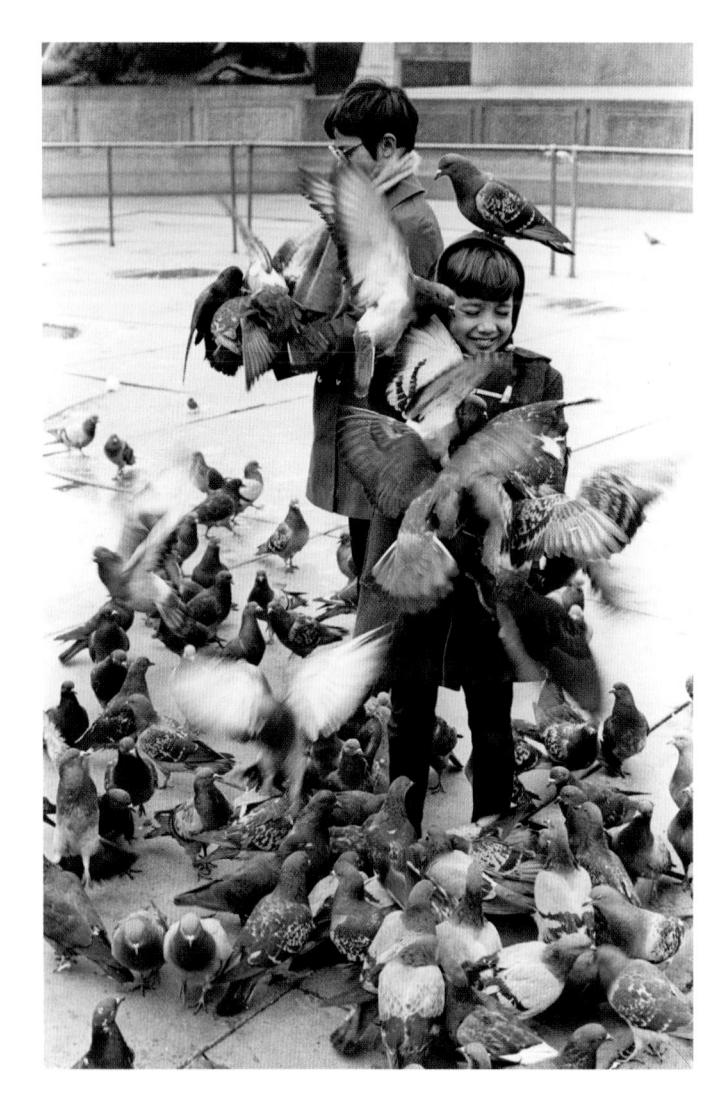

Feeding pigeons in Trafalgar Square. Cleaning the droppings from the thousands of pigeons resident in the square became costly. To discourage the birds, feeding them was made illegal in 2003.

1972

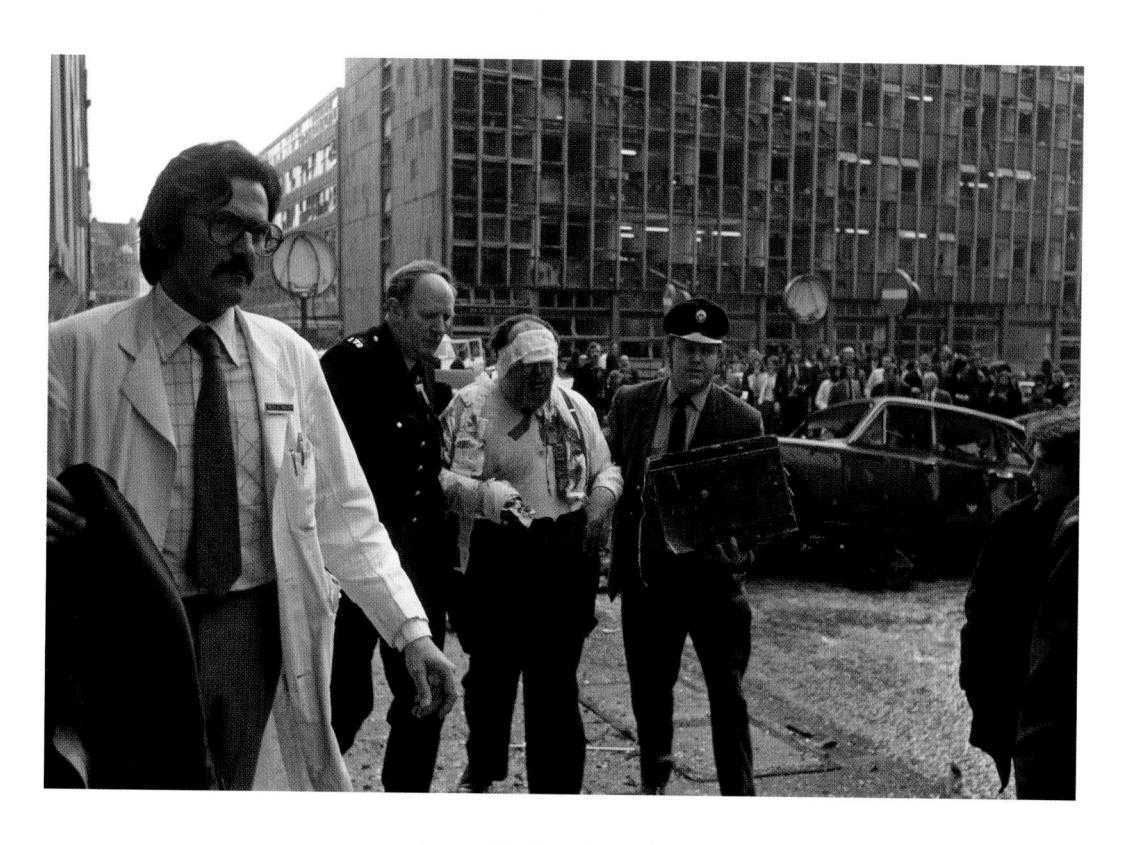

Barrister James Crespi, a casualty of an IRA car bomb attack at the Old Bailey. One of the terrorists convicted of the crime, Gerry Kelly, who received two life-sentences, went on to become law and order spokesman for Sinn Féin and a member of the Northern Irish Assembly.

8 March 1973

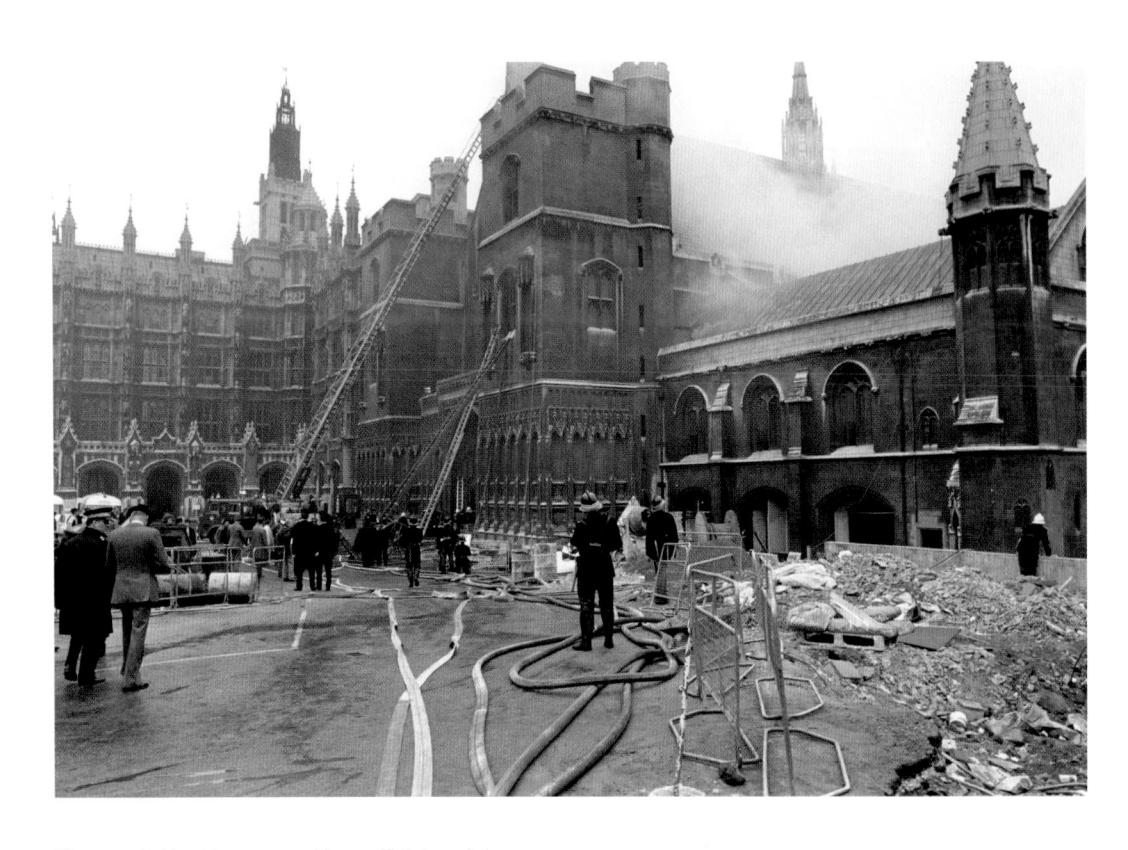

Firemen fight a blaze caused by an IRA bomb in the crypt chapel of the House of Commons.

17 June 1974

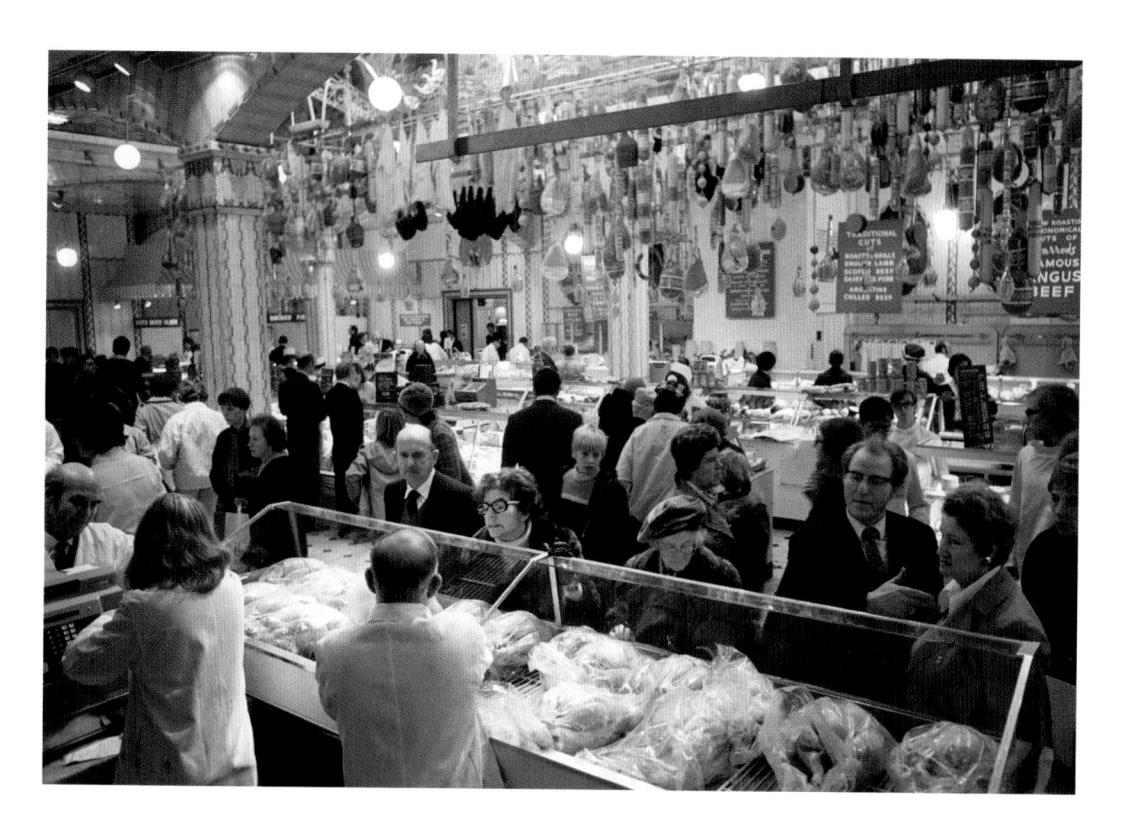

Christmas shoppers in the food hall at Harrods. Business returns to normal following a bomb blast on the second floor of the store in Knightsbridge.

23 December 1974

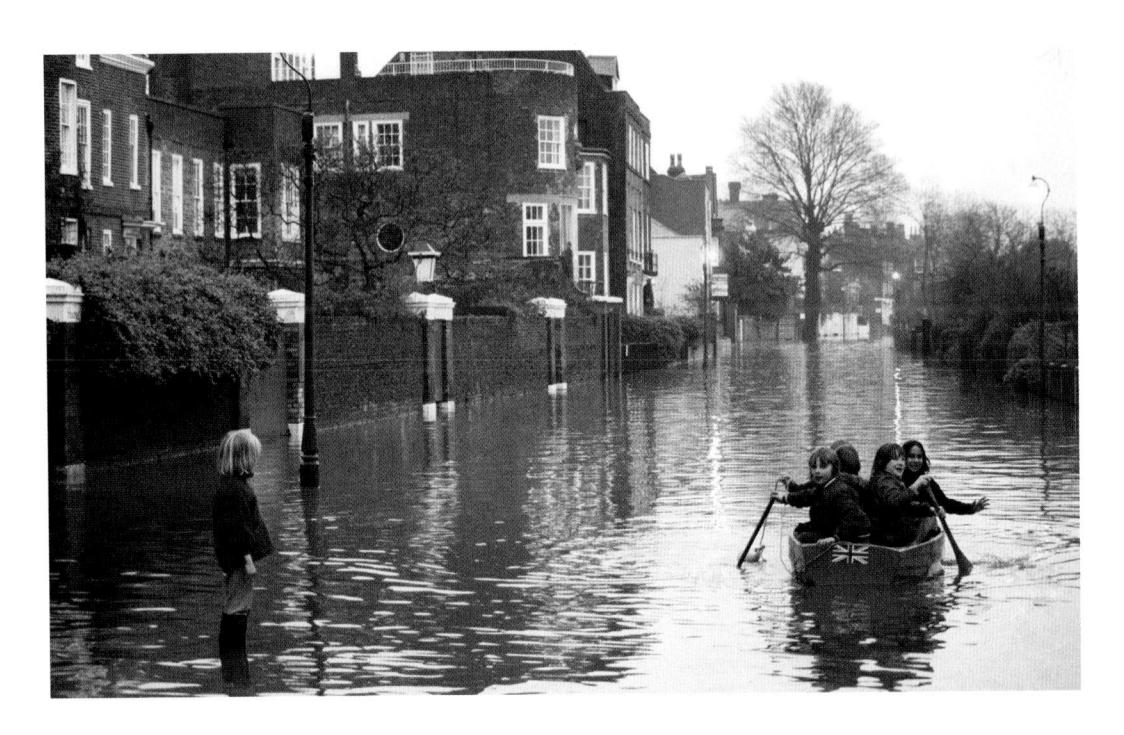

The Thames overflows its banks at Putney. An exceptional tide – over 7.5 metres at London Bridge – was further swollen by heavy rain upstream.

30 January 1975

Facing page: Fireman at work after 43 people were killed when an underground train overran the platform, crashed through buffers and into an end wall at Moorgate station.

28 February 1975

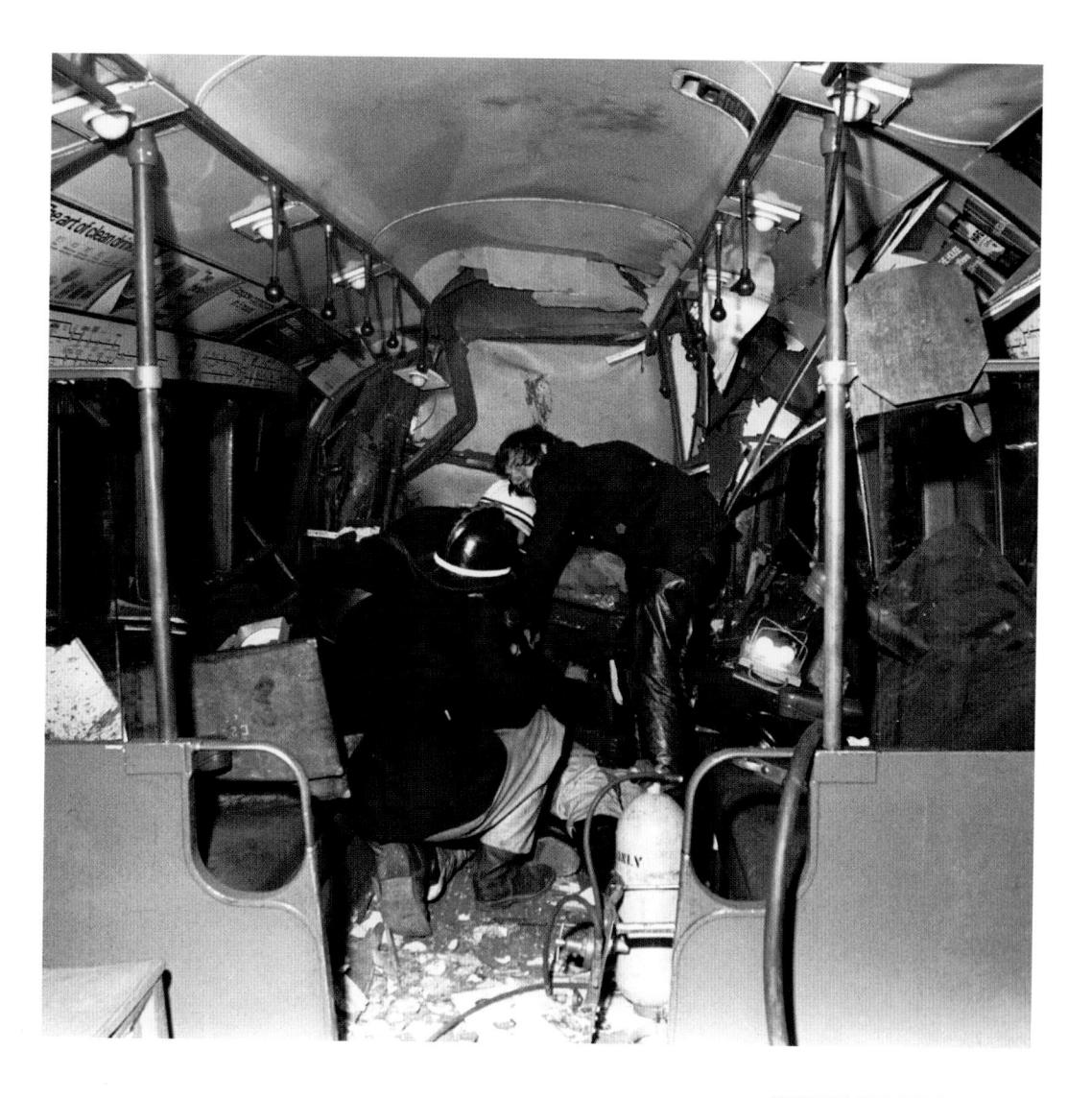

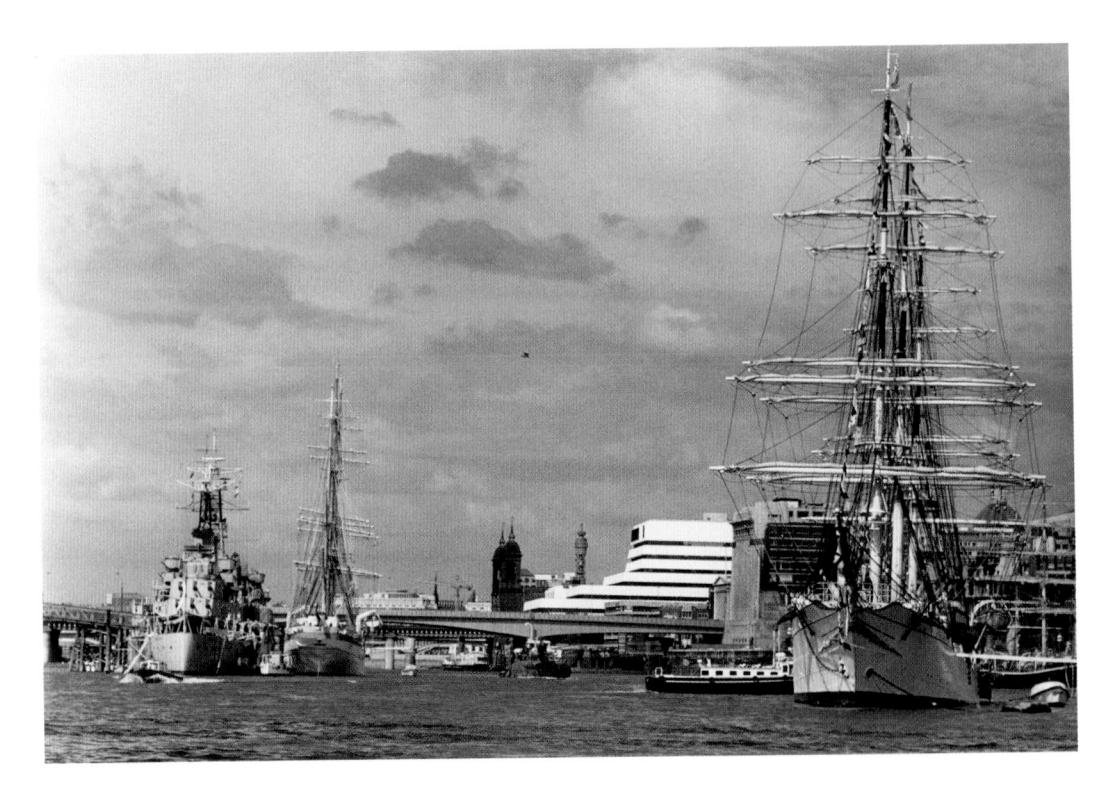

Sail training ships moored alongside HMS *Belfast*, the West German Navy's barque the *Gorch Fock* and the full-rigged Danish ship *Danmark*.

23 August 1975

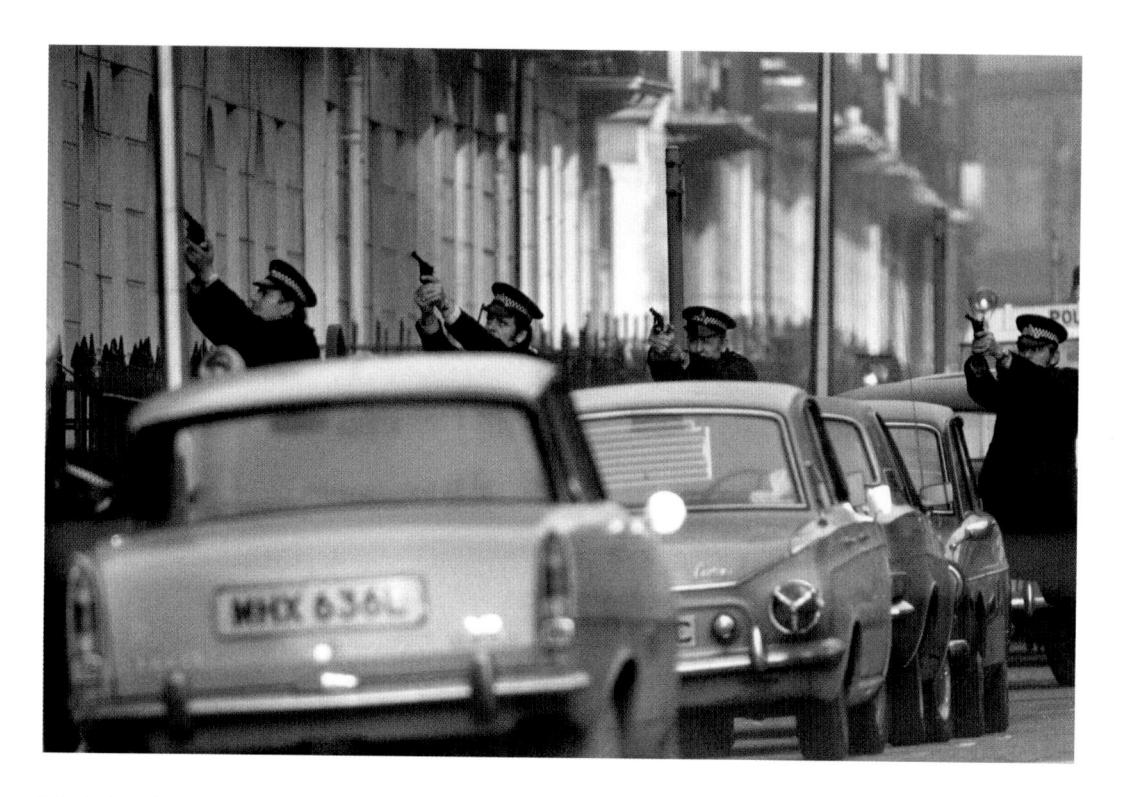

The Balcombe Street Siege saw policemen in bulletproof vests and wielding guns on Britain's streets for the first time in such a public manner. The gang, four highly trained IRA men who held a middle-aged couple hostage in their central London home, gave themselves up after a six-day stand-off when the SAS were called in with instructions to shoot to kill if they tried to escape.

8 December 1975

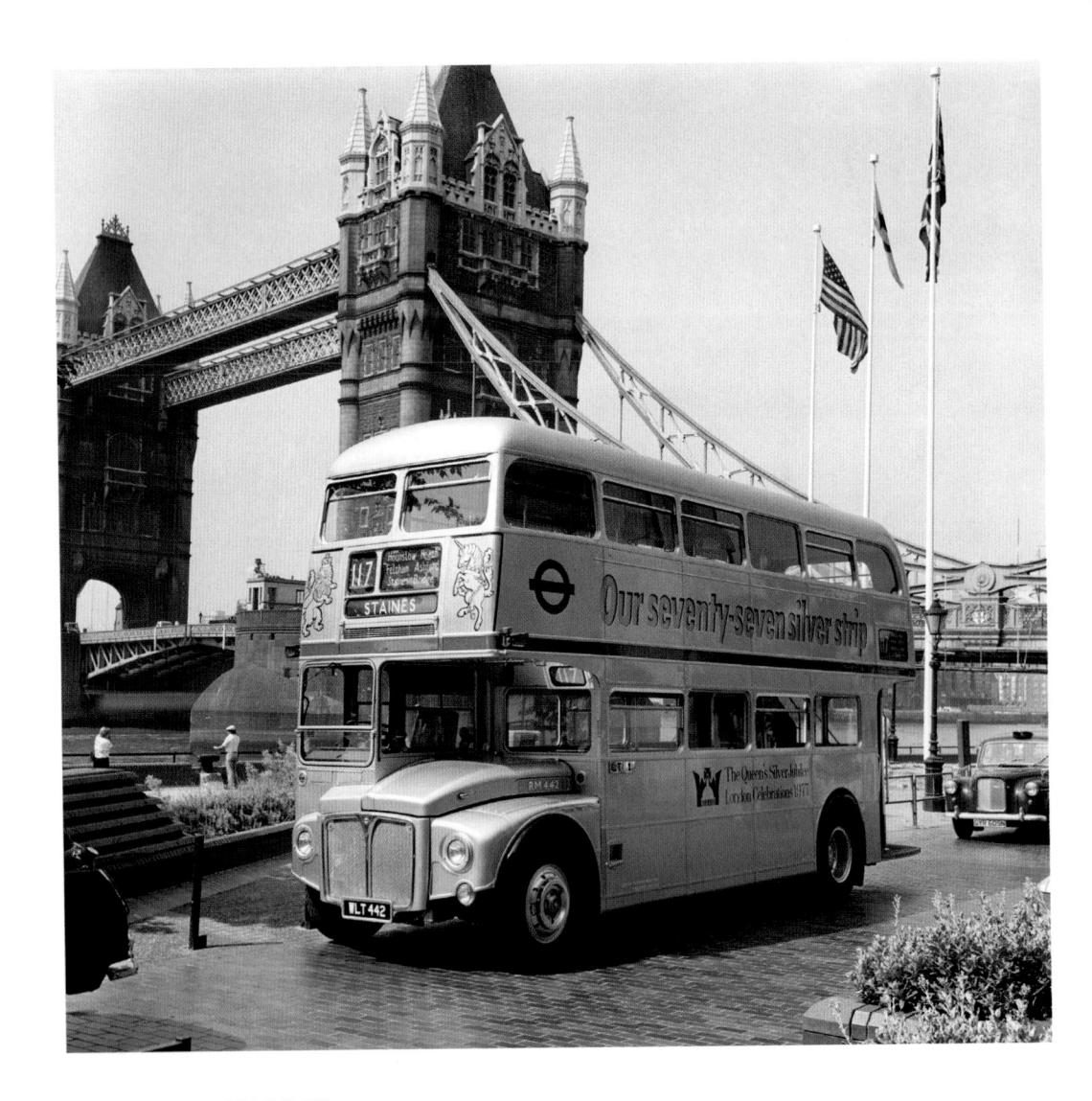

Facing page: A prototype of the 25 silver buses destined for several busy London routes as a London Transport contribution to celebrations marking the Queen's Silver Jubilee.

6 July 1976

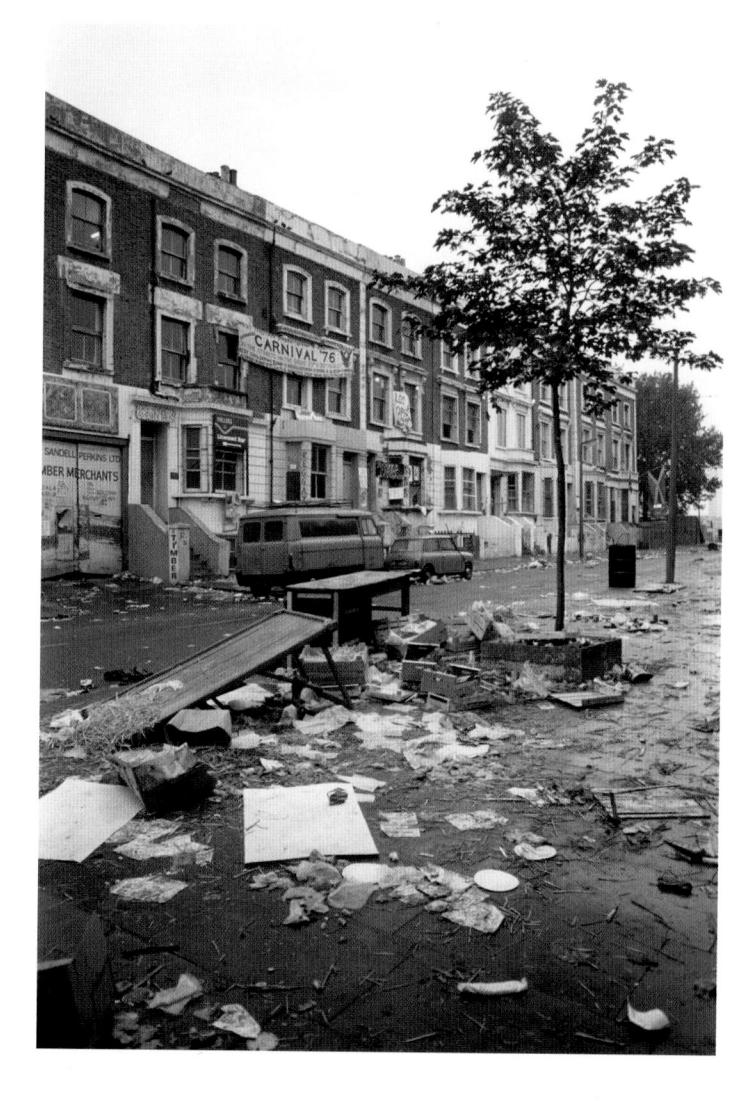

Rubbish strewn across Acklam Road, West London, following scenes of violence when the Notting Hill Carnival erupted in rioting.

31 August 1976

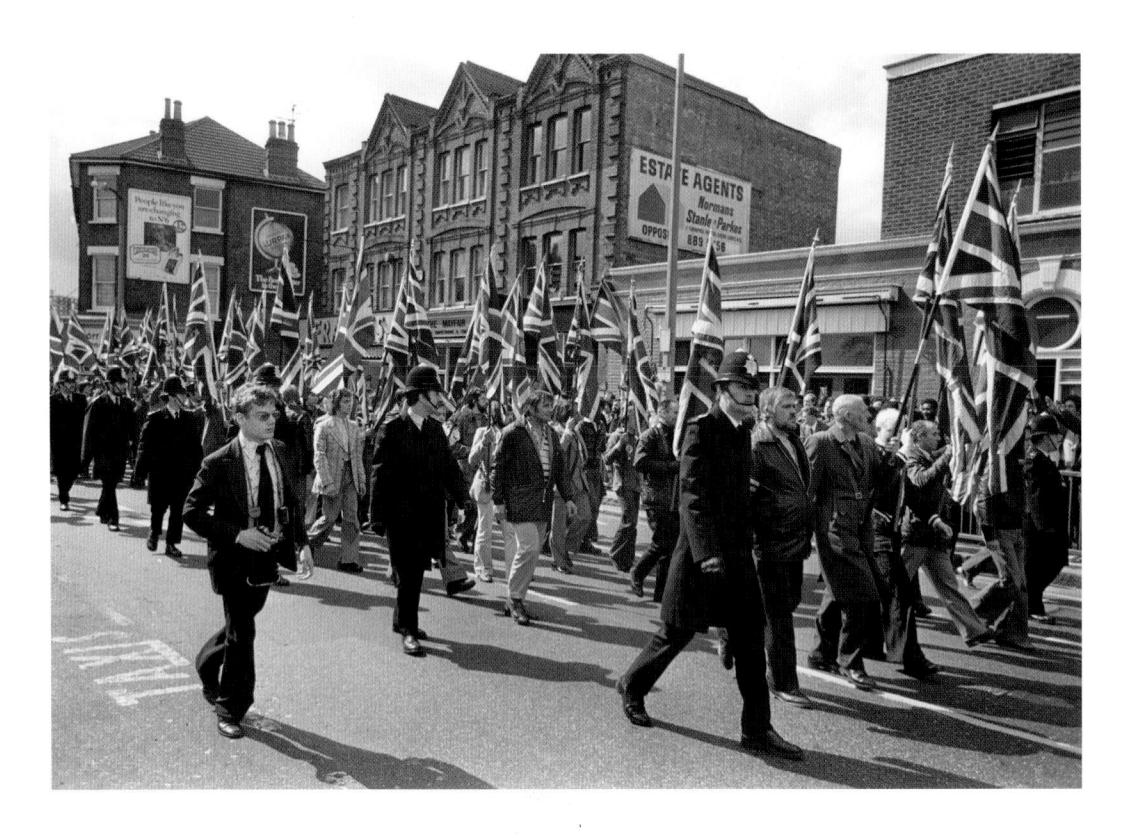

National Front supporters march through a largely immigrant area, a show of force in their campaign for the Greater London Council elections.

23 April 1977

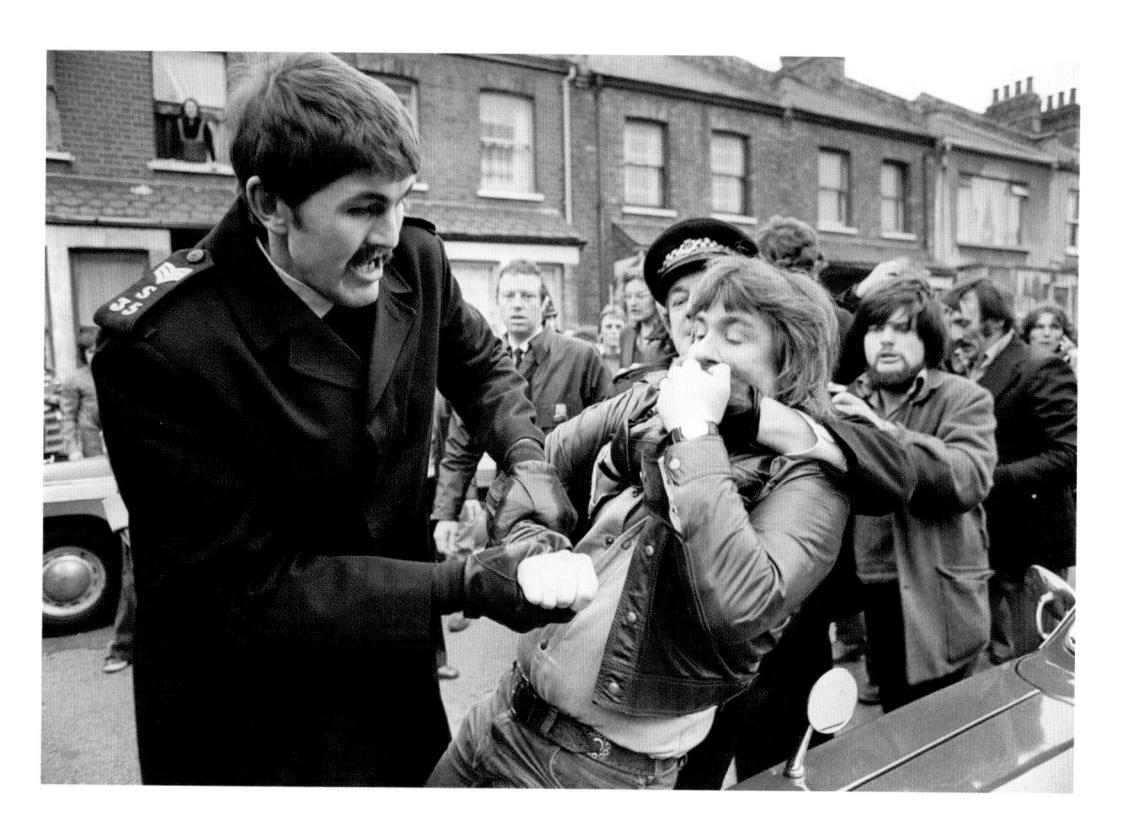

Police restraining pickets supporting an official strike by process workers outside the Grunwick film processing laboratories at Willesden.

23 June 1977

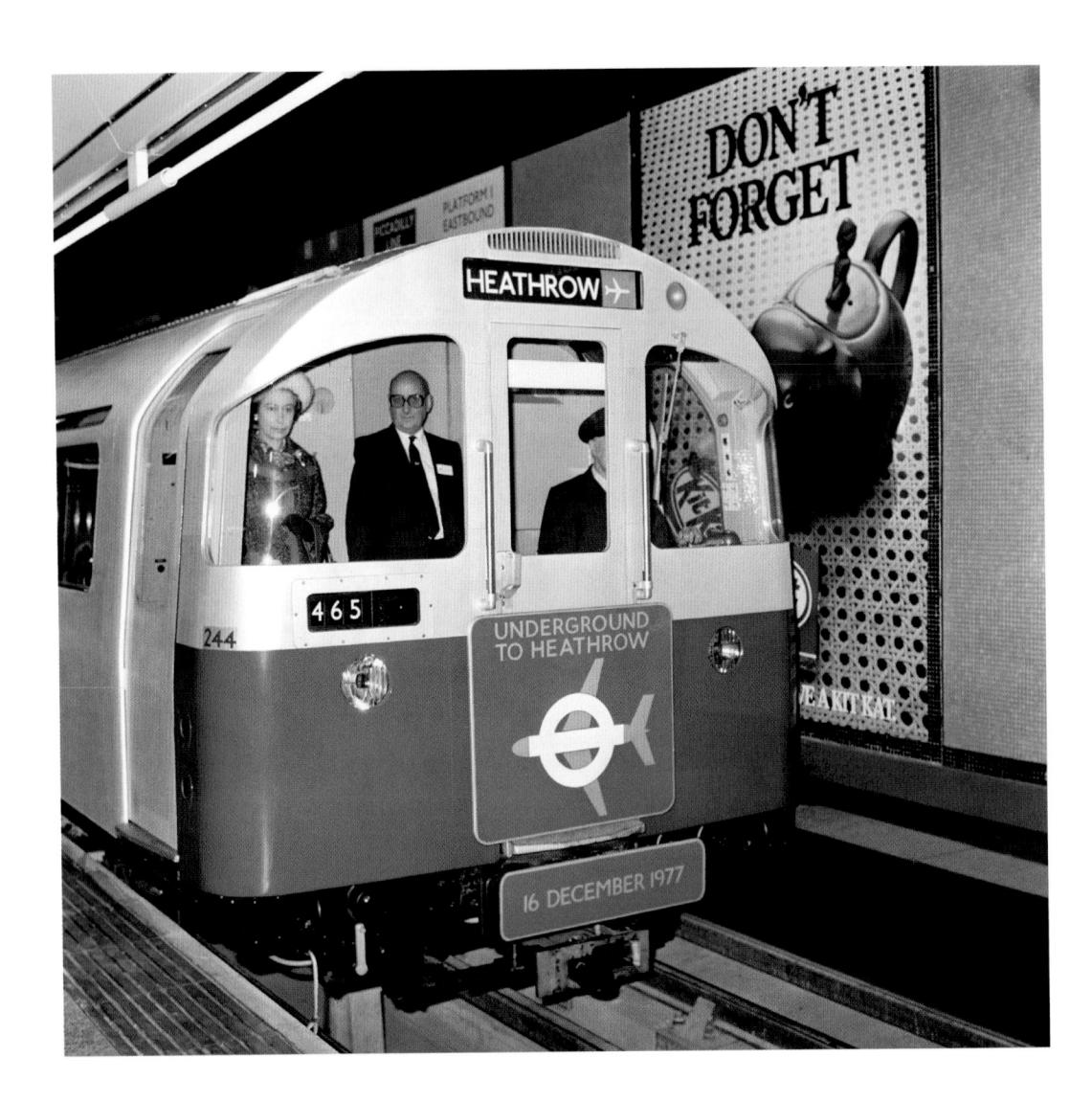

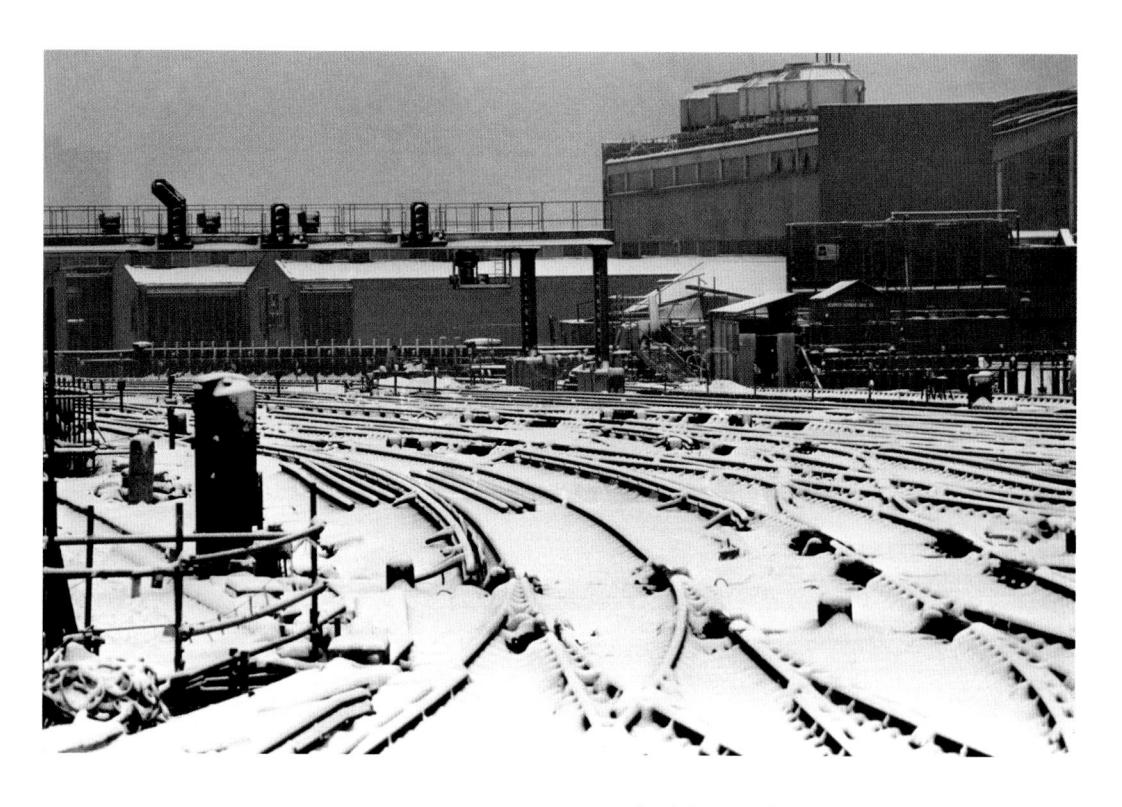

Facing page: The Queen arrives at Heathrow Central station by tube, to open the £30m Piccadilly Line extension linking Heathrow Airport with the Underground.

16 December 1977

Rush hour at Cannon Street station and not a train in sight. Commuters faced a third one-day rail strike and arctic conditions caused by blizzards throughout southern Britain.

23 January 1979

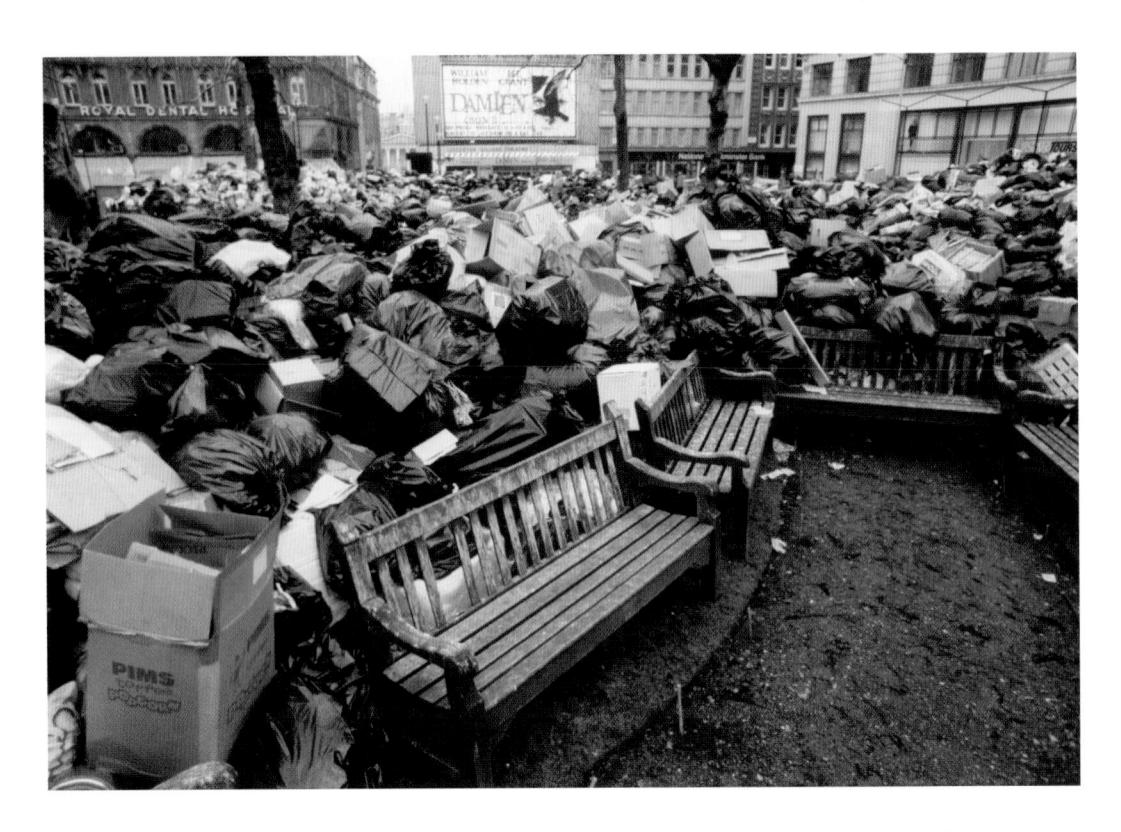

Mountains of rubbish dumped in Leicester Square. Refuse remains uncollected during a strike by City of Westminster dustmen in support of a pay claim: part of a rash of industrial unrest known as 'The Winter of Discontent'.

Facing page: BBC sound recordist Sim Harris scrambles to safety as flames billow from the Iranian Embassy. The six-day siege at the building in Princes Gate ends when SAS commandos storm the building, rescuing 19 hostages.

5 May 1980

31 January 1979

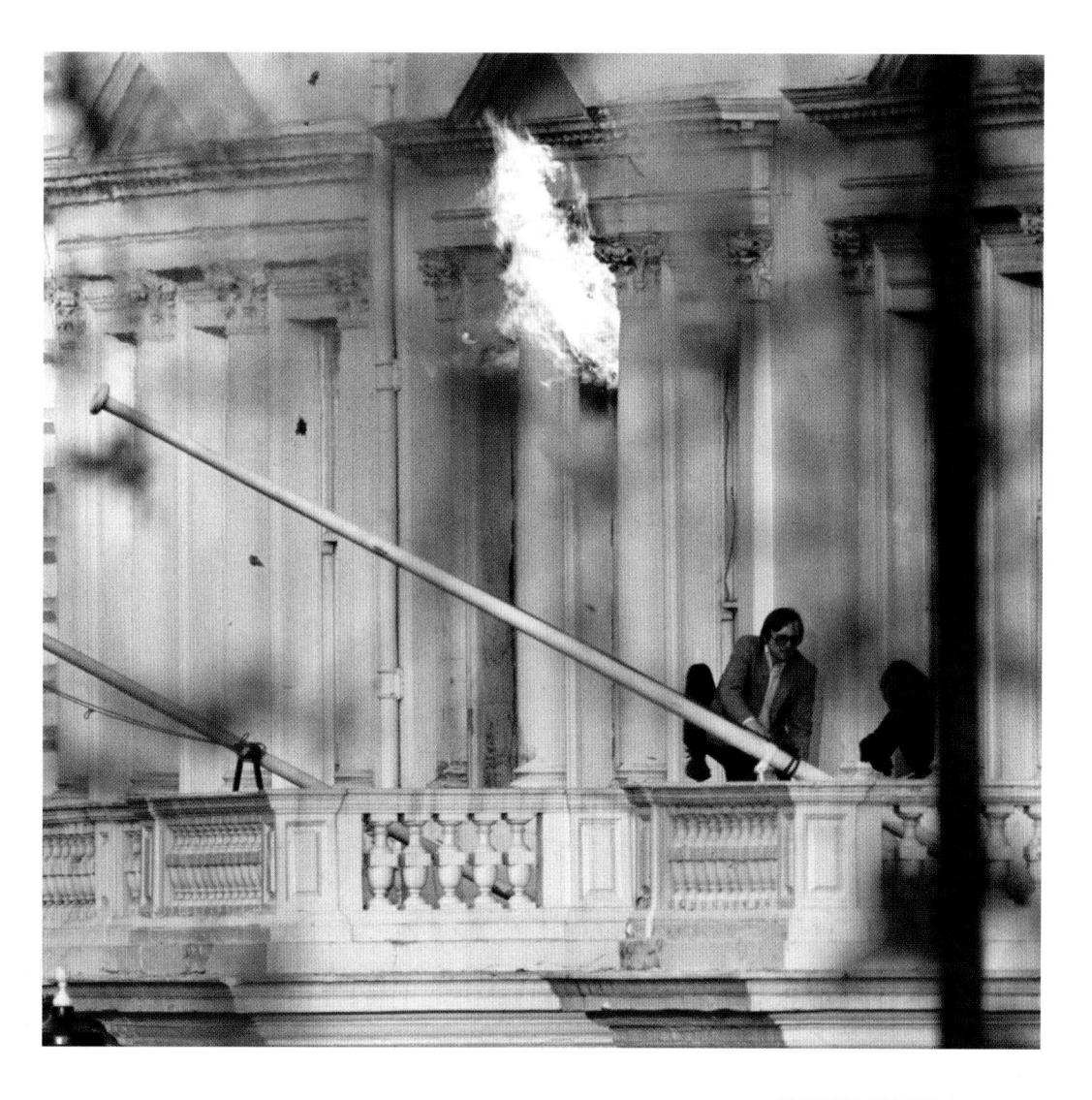

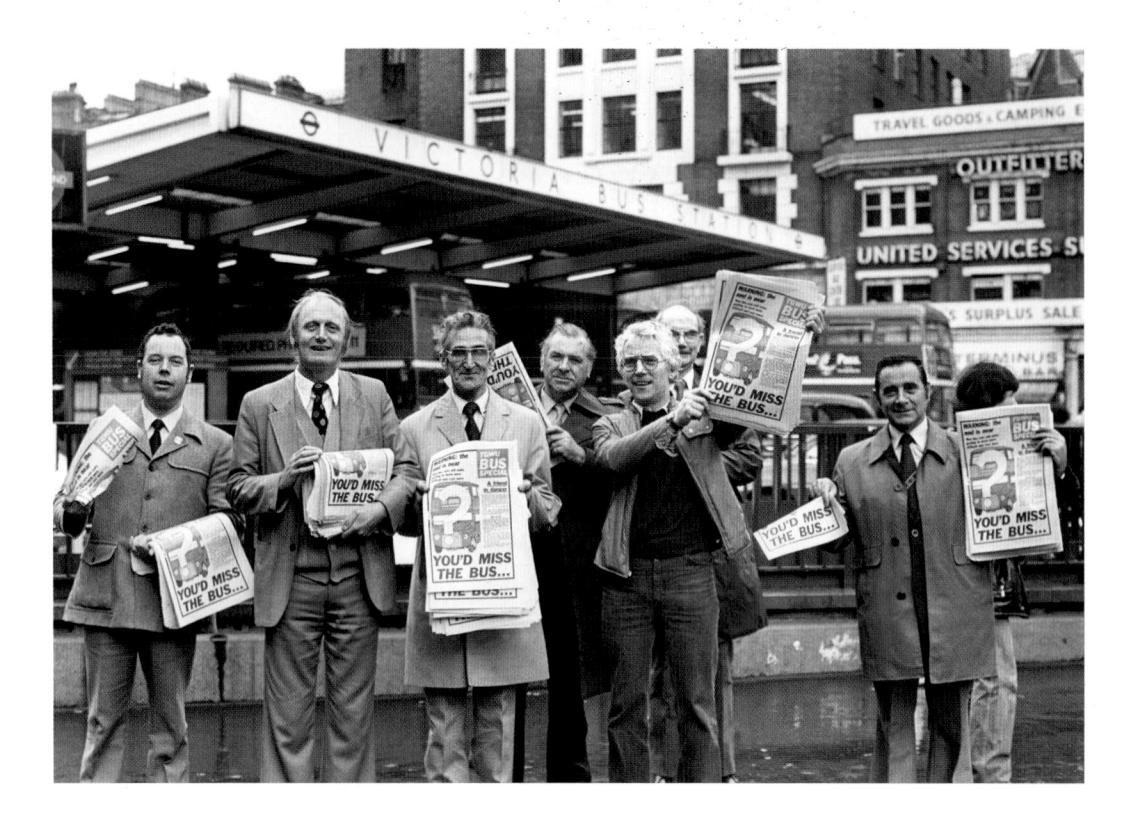

Transport and General Workers Union drivers and conductors at Victoria station, handing out leaflets calling on commuters to fight the new Transport Act. July 1980

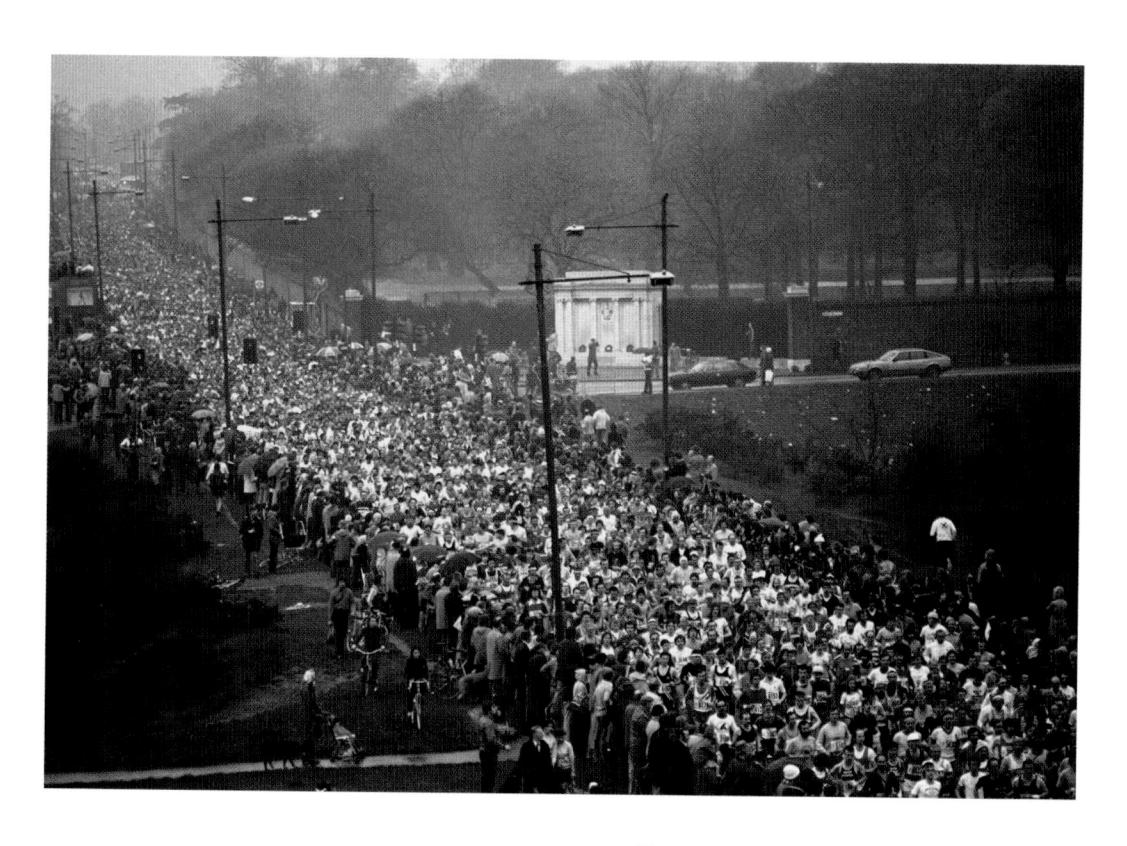

The start of the first London Marathon in Greenwich Park. Of the 6,747 entrants, 6,255 crossed the finish line on Constitution Hill. 29 March 1981

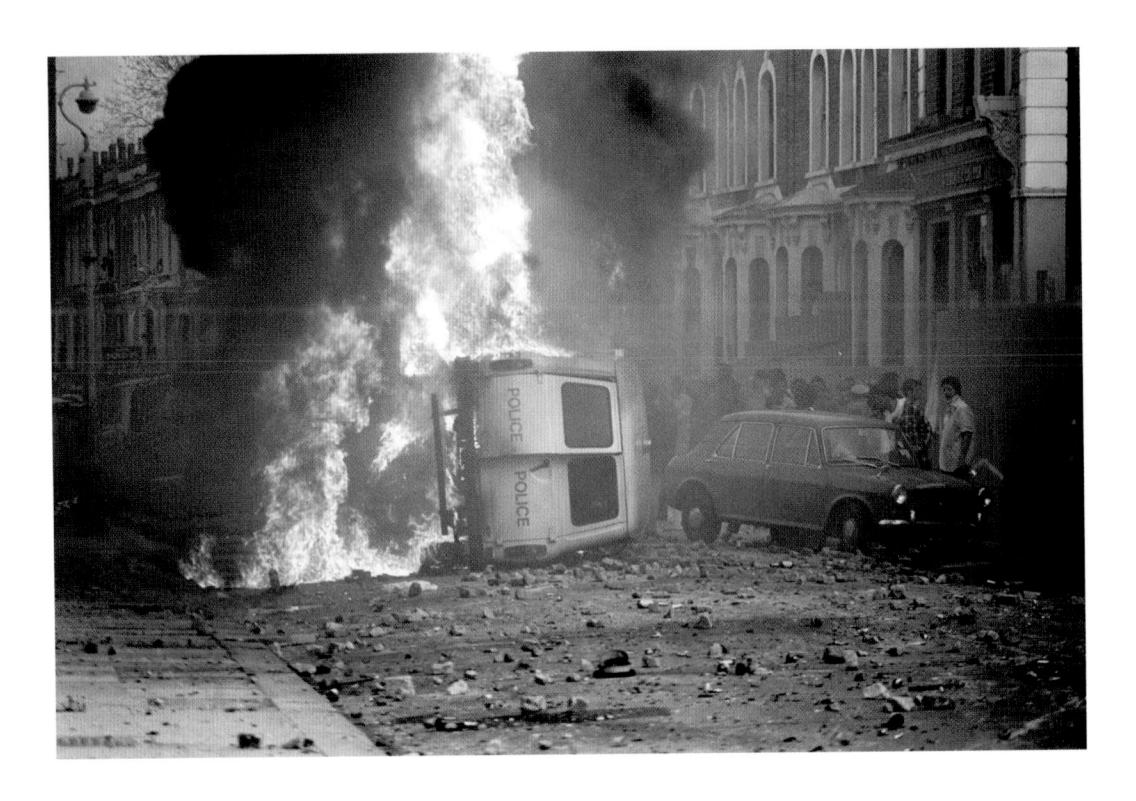

A police van on fire during a riot in Brixton. Clashes between police and rioters left 23 police officers injured. II April 1981

Waitresses rehearsing for the opening of an old-style Lyons Corner House restaurant in The Strand. 19 June 1981

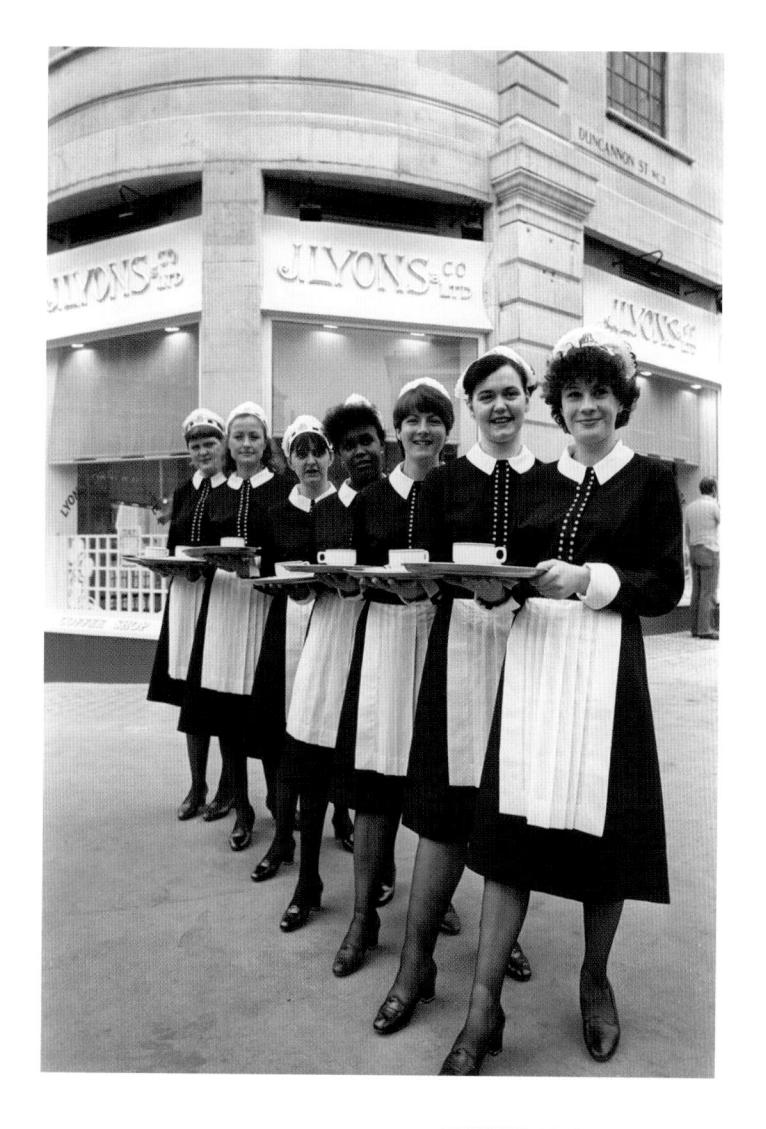

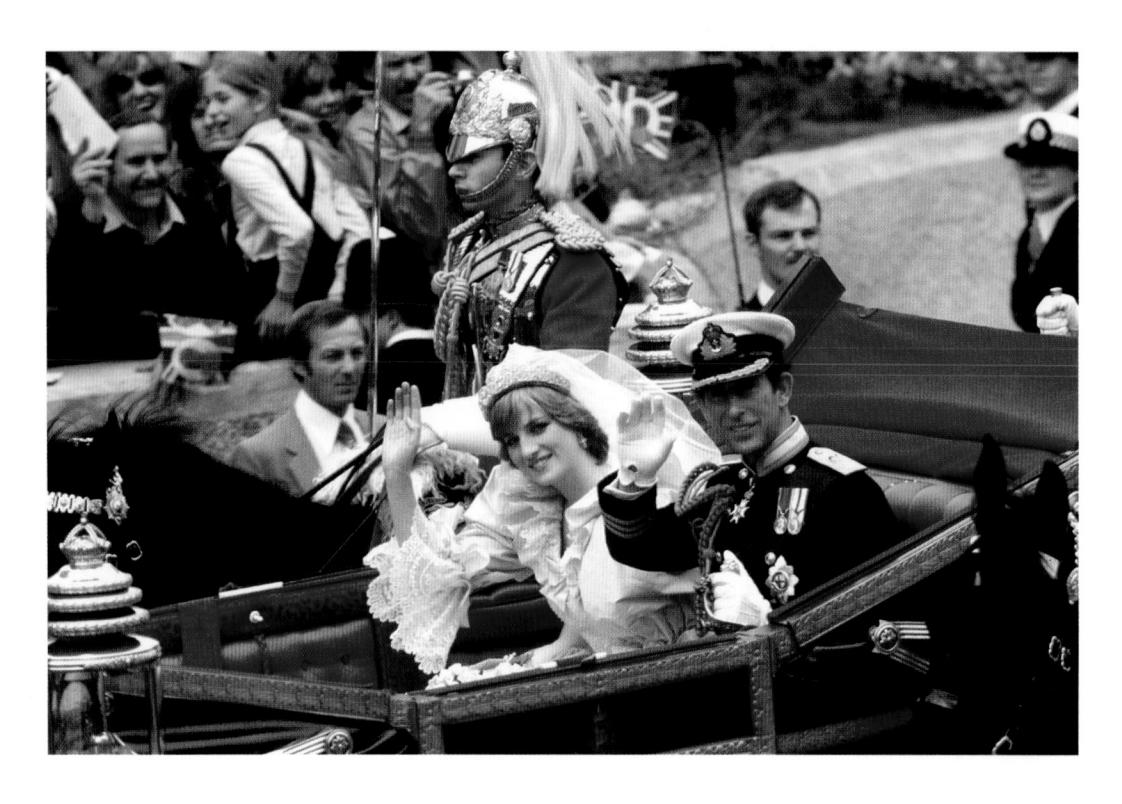

The Prince and Princess of Wales make their way to Buckingham Palace after their wedding ceremony at St Paul's Cathedral. 29 July 1981

Facing page: The El Vino wine bar and off licence in Fleet Street, an old haunt of news journalists. The last news agency left the area in 2005.

10 November 1982

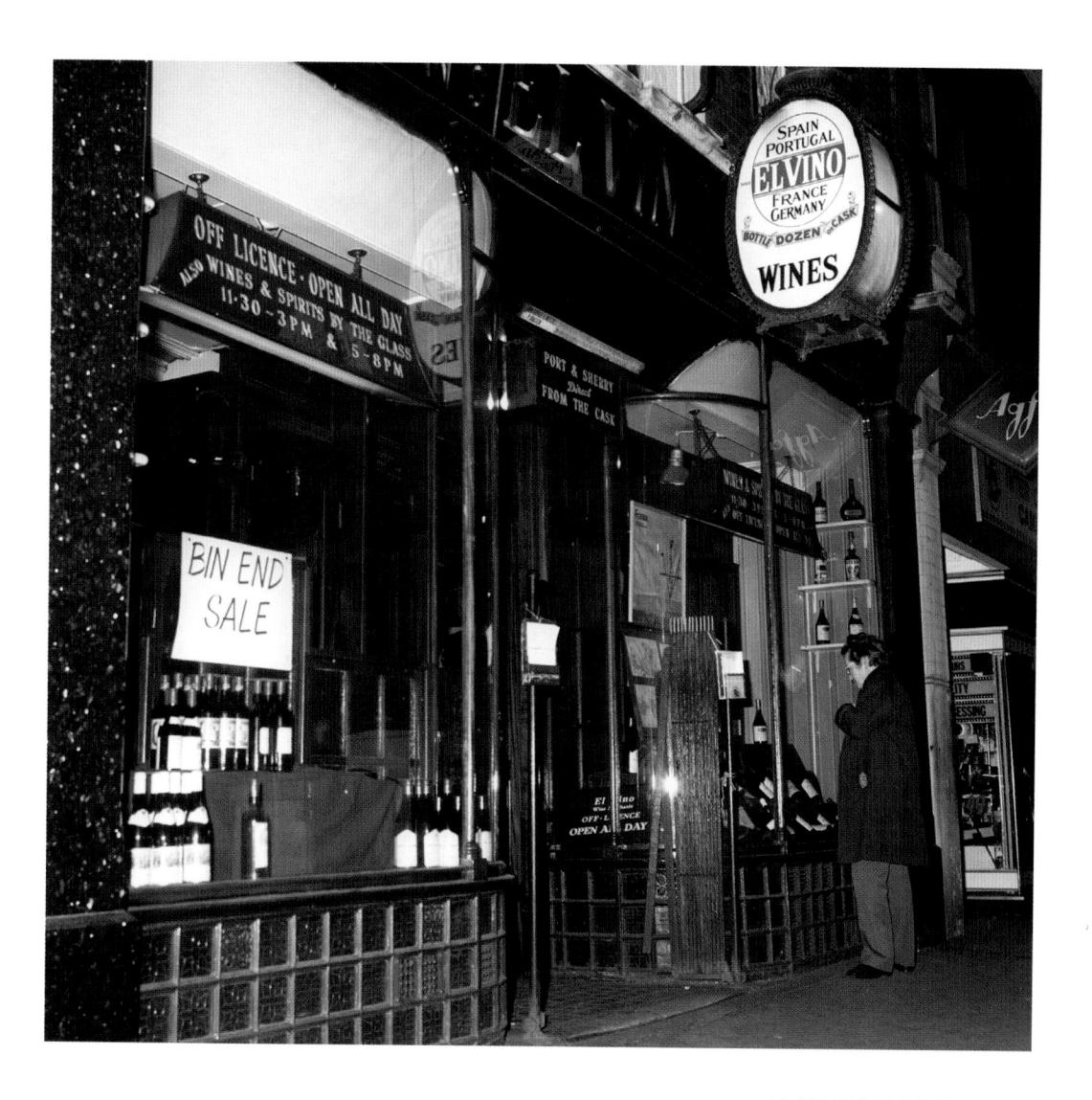

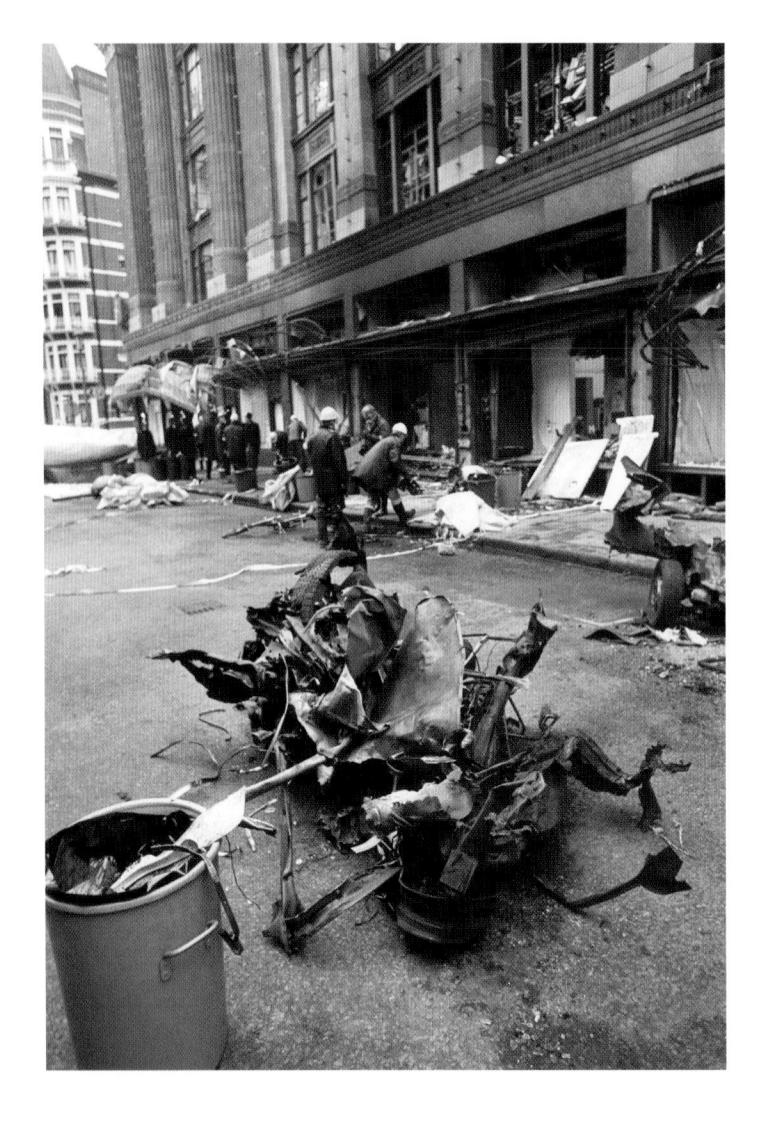

The remains of the Austin 1100 used in an IRA car bomb attack that killed five people outside Harrods.

18 December 1983

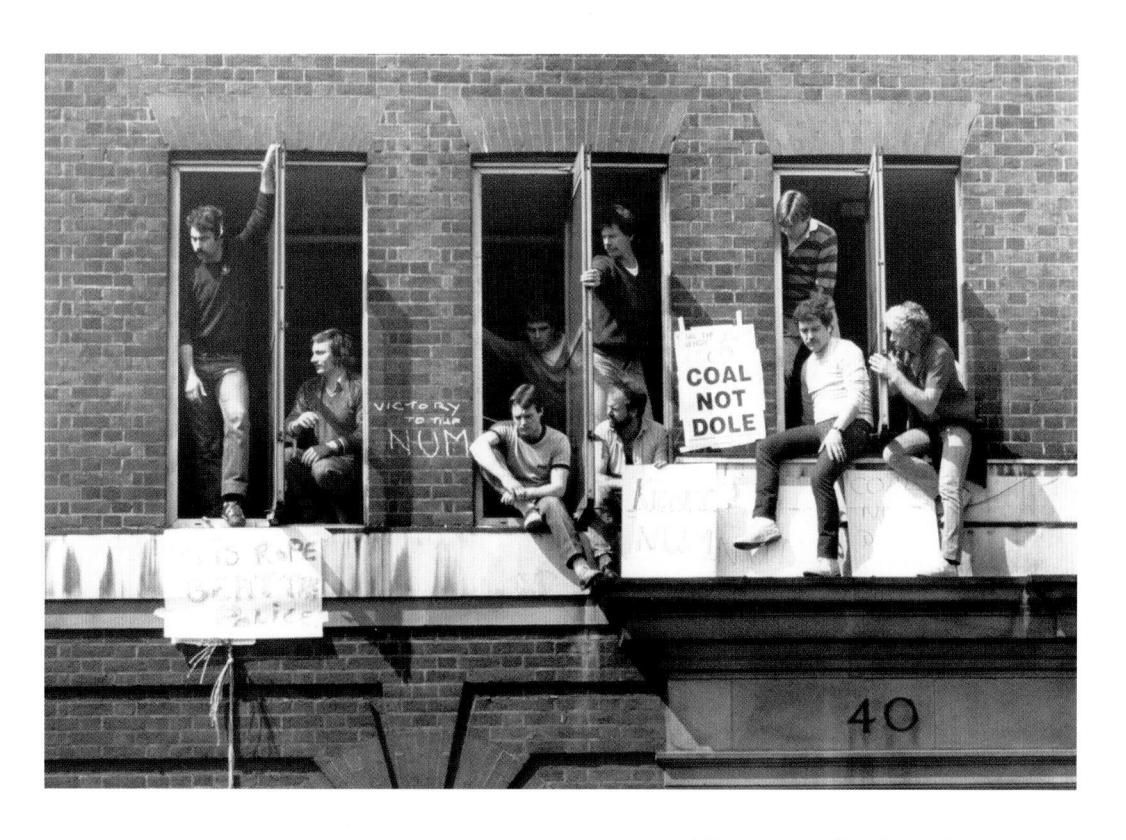

Miners occupy first floor offices of the National Coal Board in Hobart House, Grosvenor Place.

1984

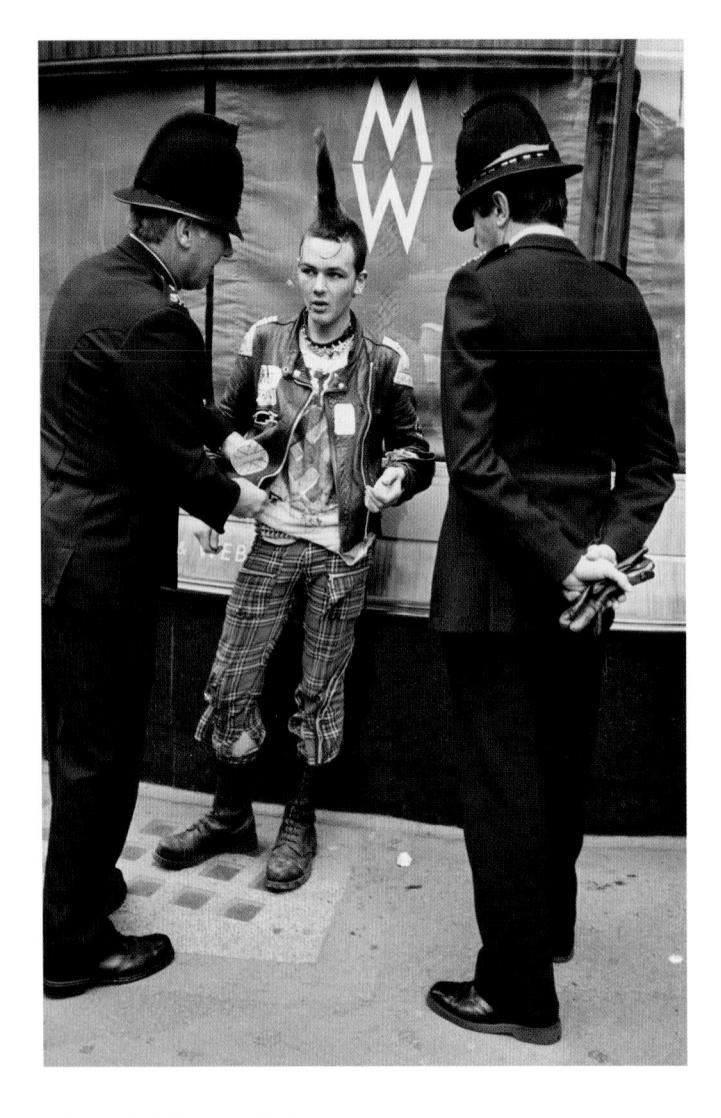

Policemen search a youth near the Stock Exchange during the second Stop The City protest.

27 September 1984

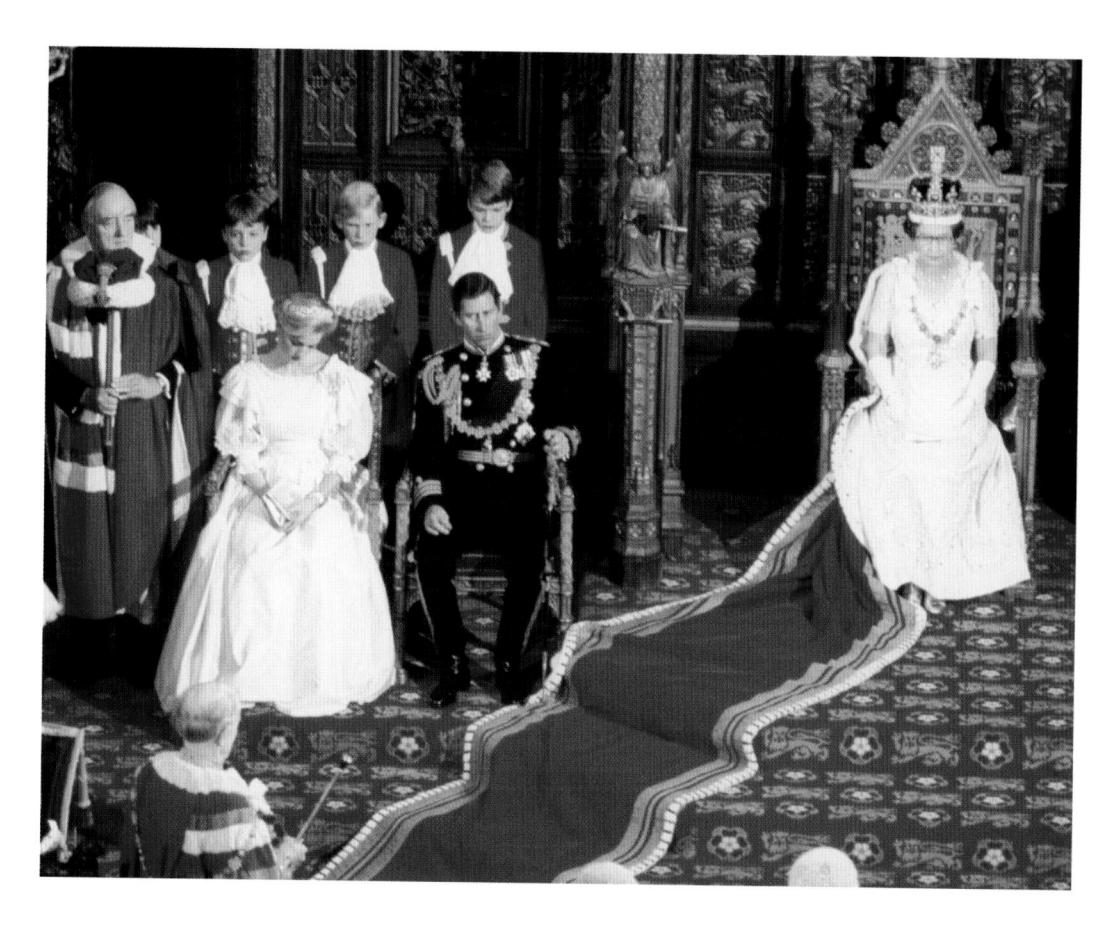

The State Opening of Parliament. 6 November 1984

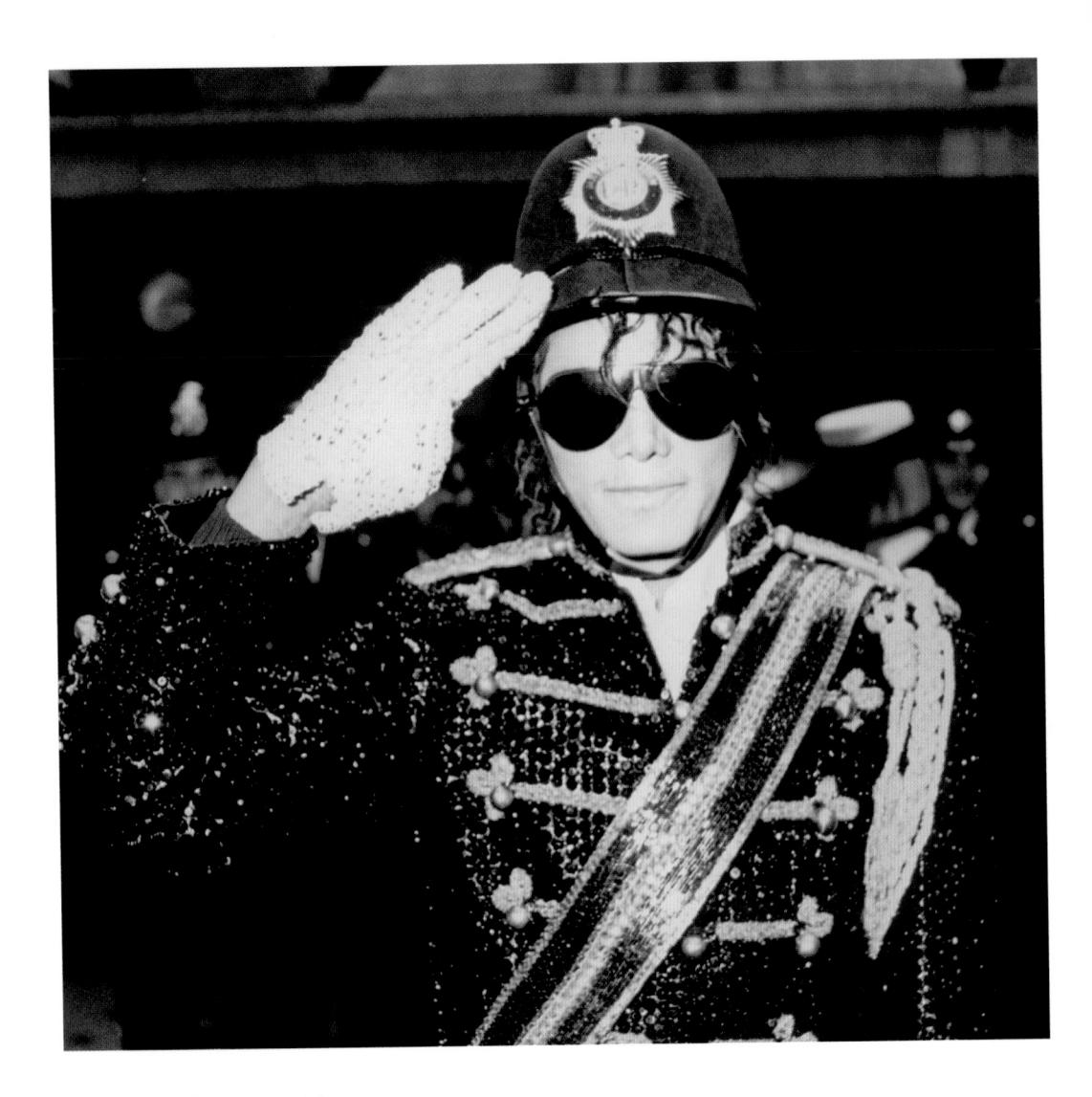

Facing page: Michael Jackson at Marylebone police station, the base for the Metropolitan Police team responsible for his safety.

30 March 1985

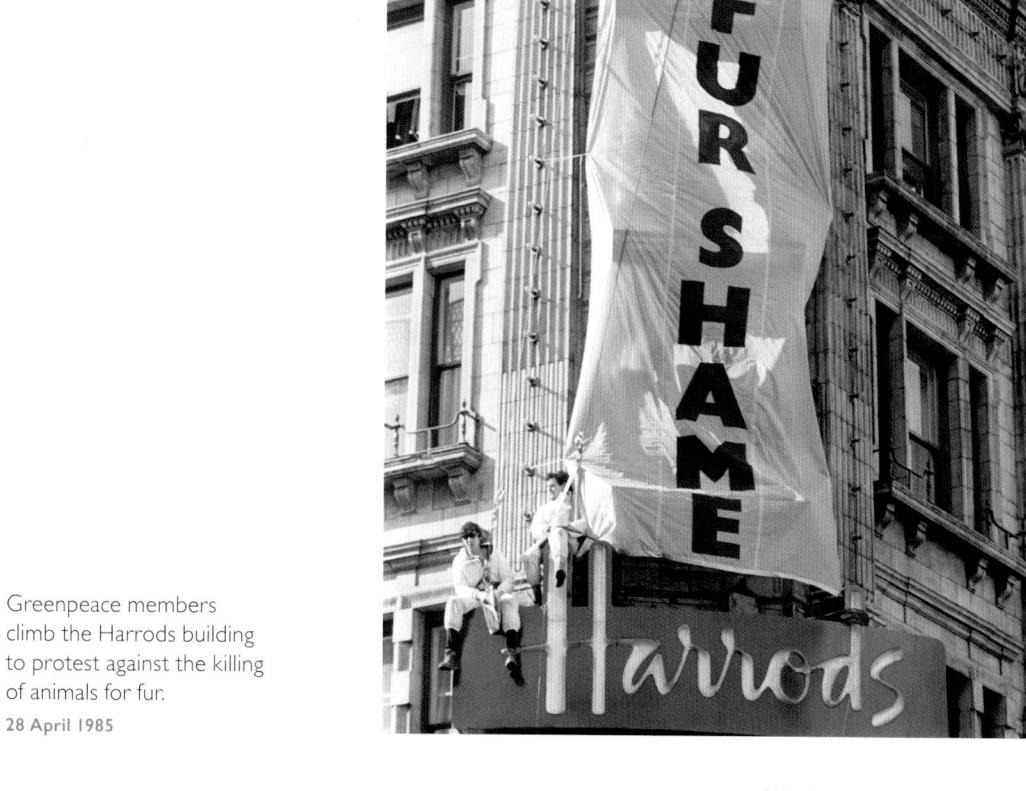

Greenpeace members climb the Harrods building to protest against the killing of animals for fur.

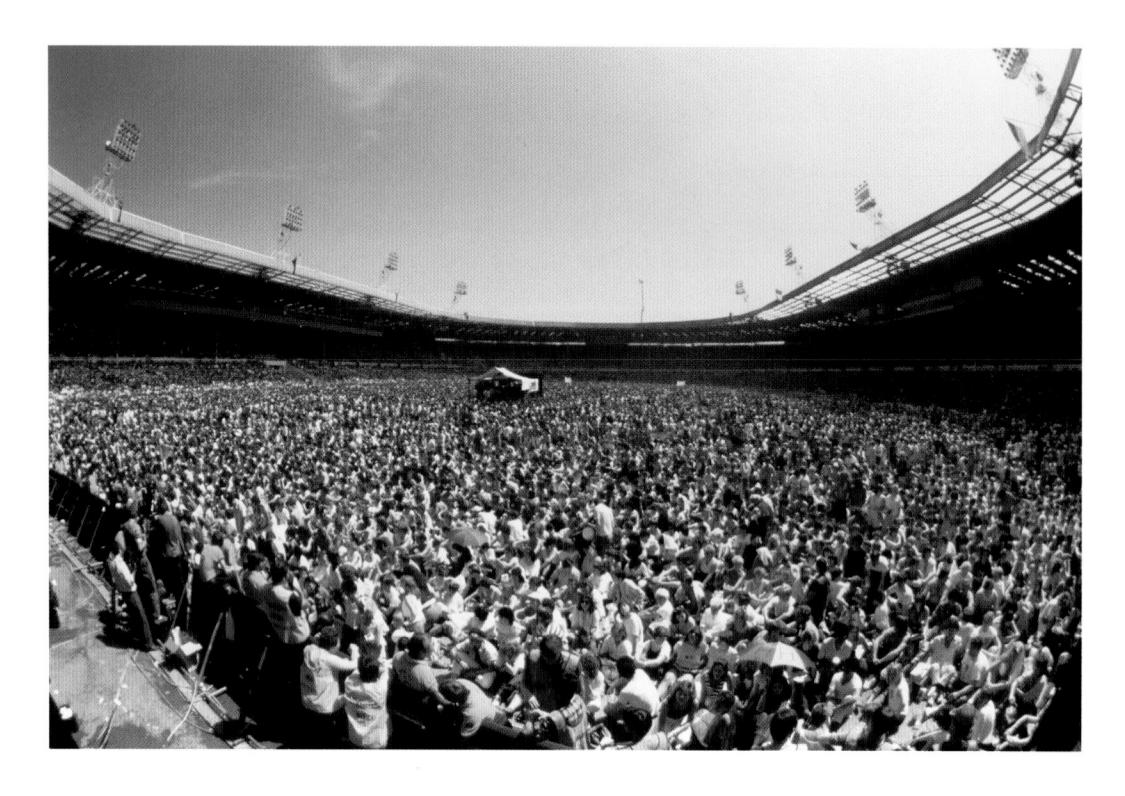

Wembley Stadium during the Live Aid concert.

13 July 1985

Facing page: ANC President Oliver Tambo (bottom left), US Democrat and civil rights campaigner Reverend Jesse Jackson (bottom centre) and GLC leader Ken Livingstone (bottom right), on the plinth of Nelson's Column in Trafalgar Square, during an anti-apartheid rally.

2 November 1985

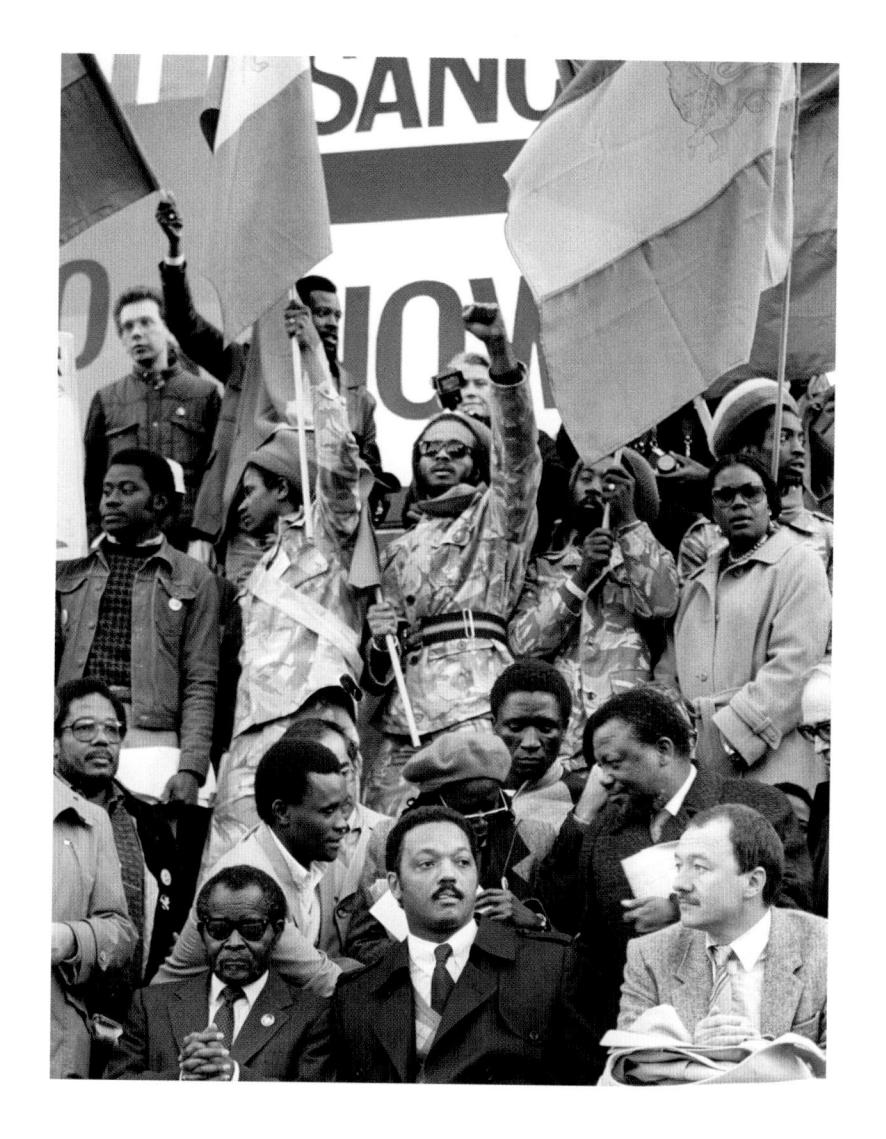

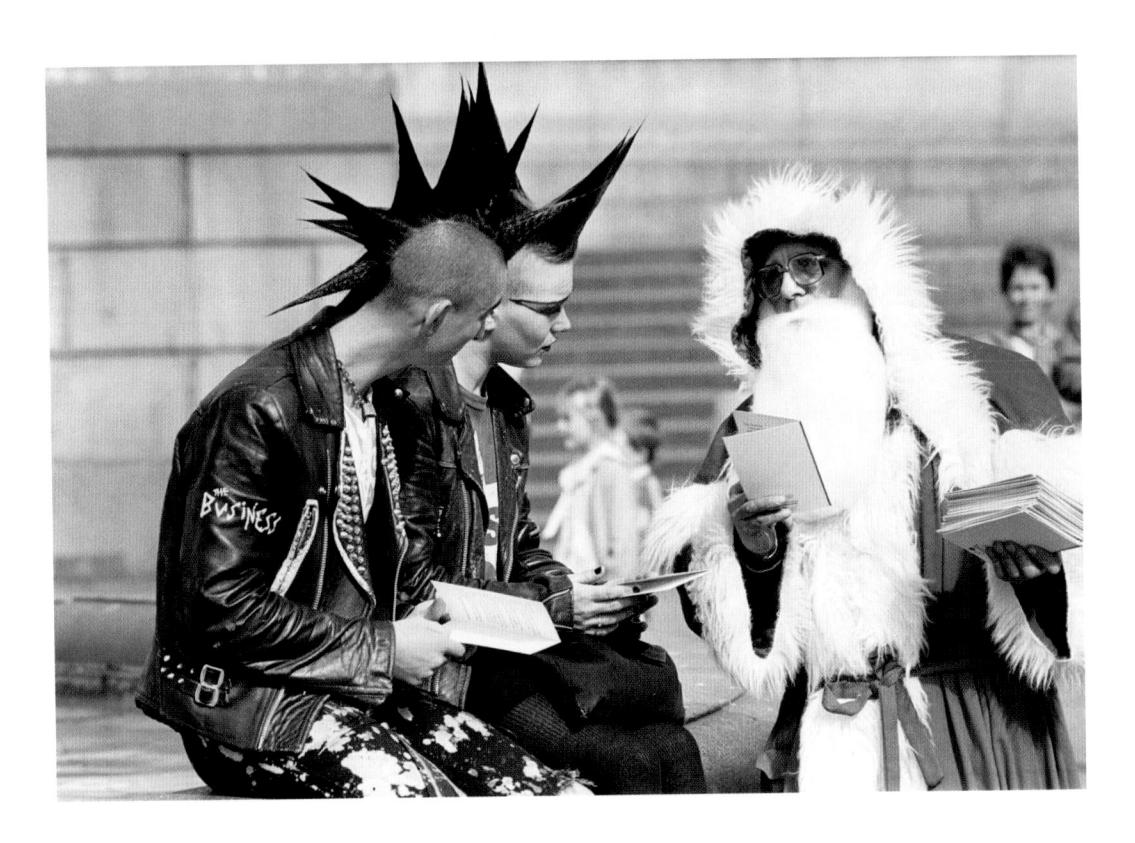

Santa Claus hands out early Christmas cards to punk rockers in Trafalgar Square to promote a charity campaign.

18 September 1986

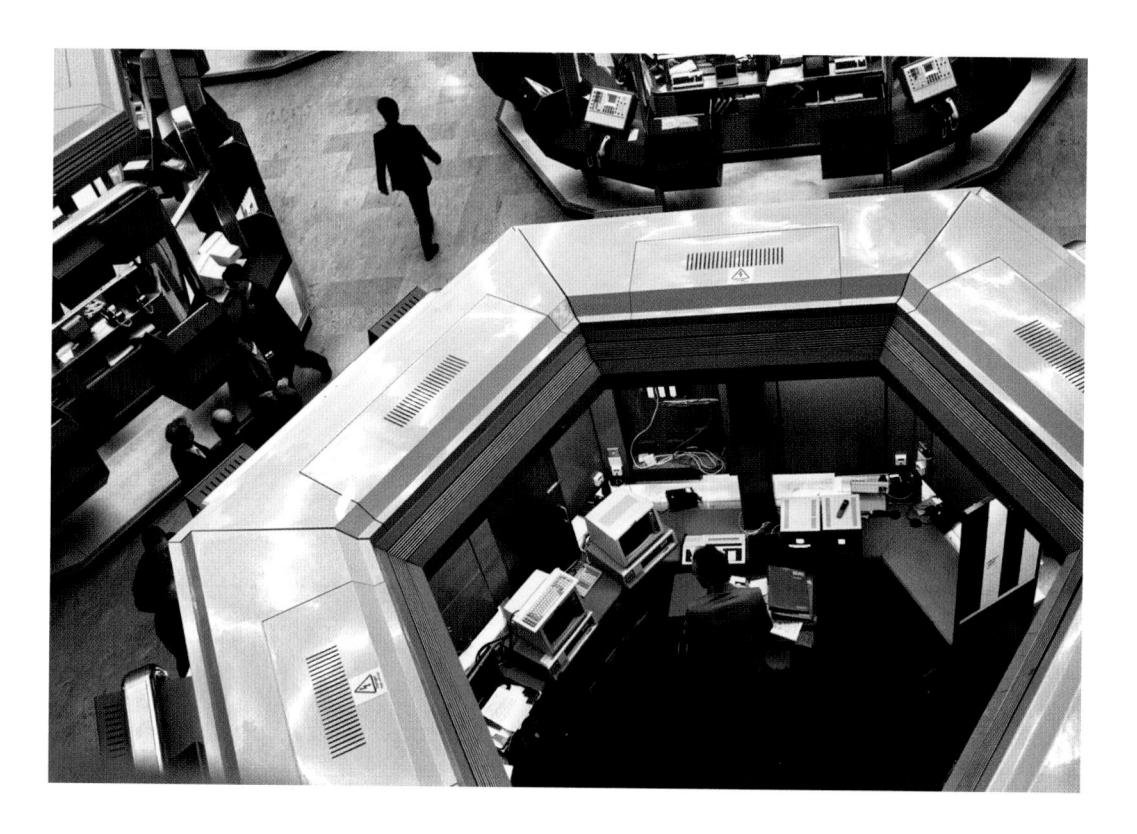

Dealing on the new high technology computer systems begins on the floor of the London Stock Exchange as the City's 'Big Bang' shake-up takes off.

27 October 1986

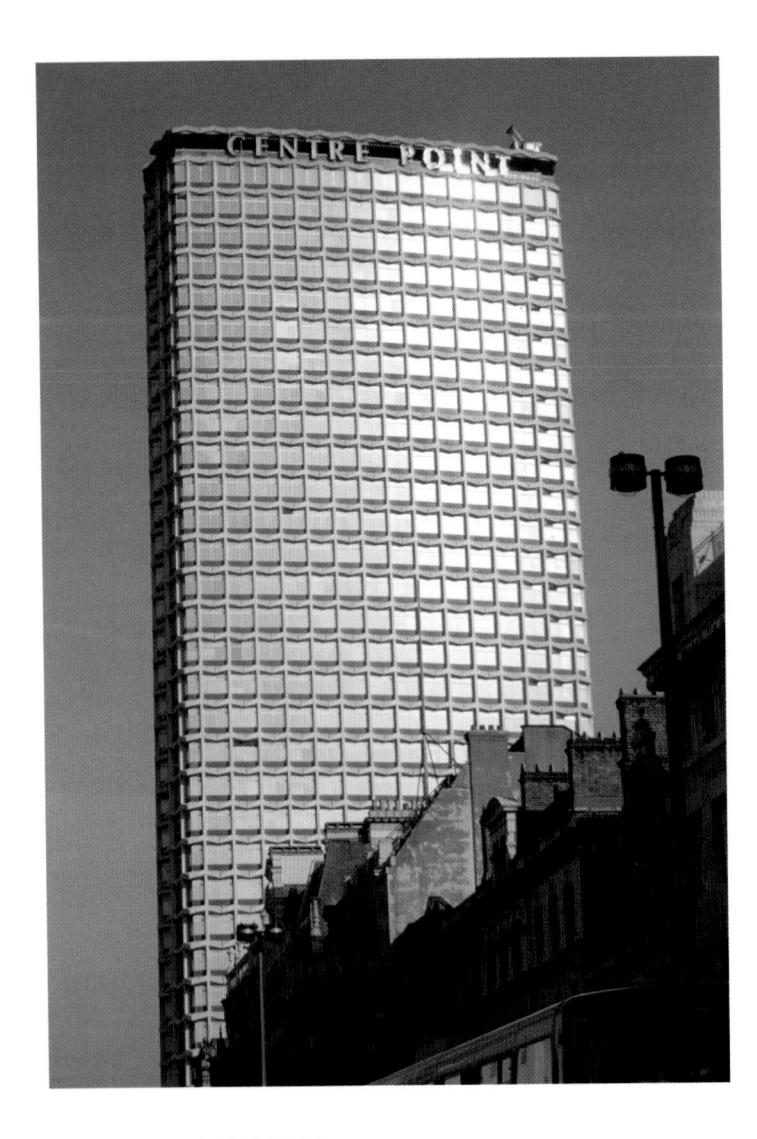

Centre Point. March 1990
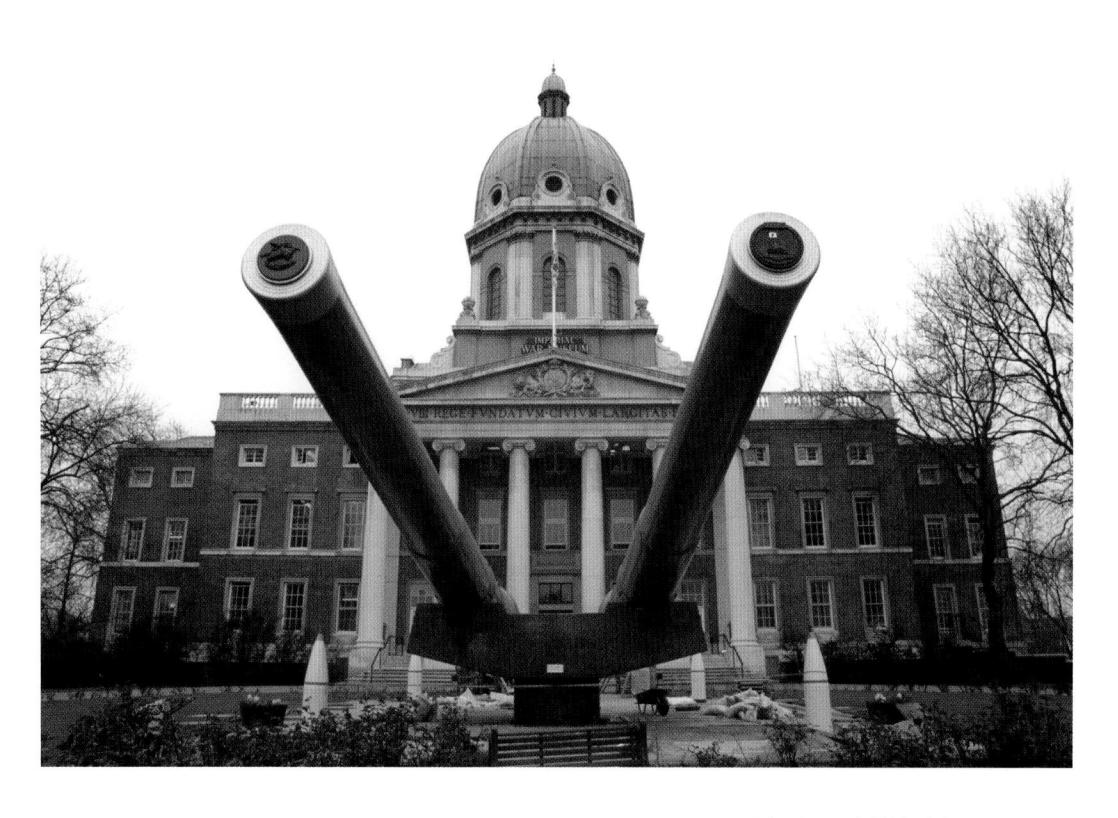

The Imperial War Museum. March 1990

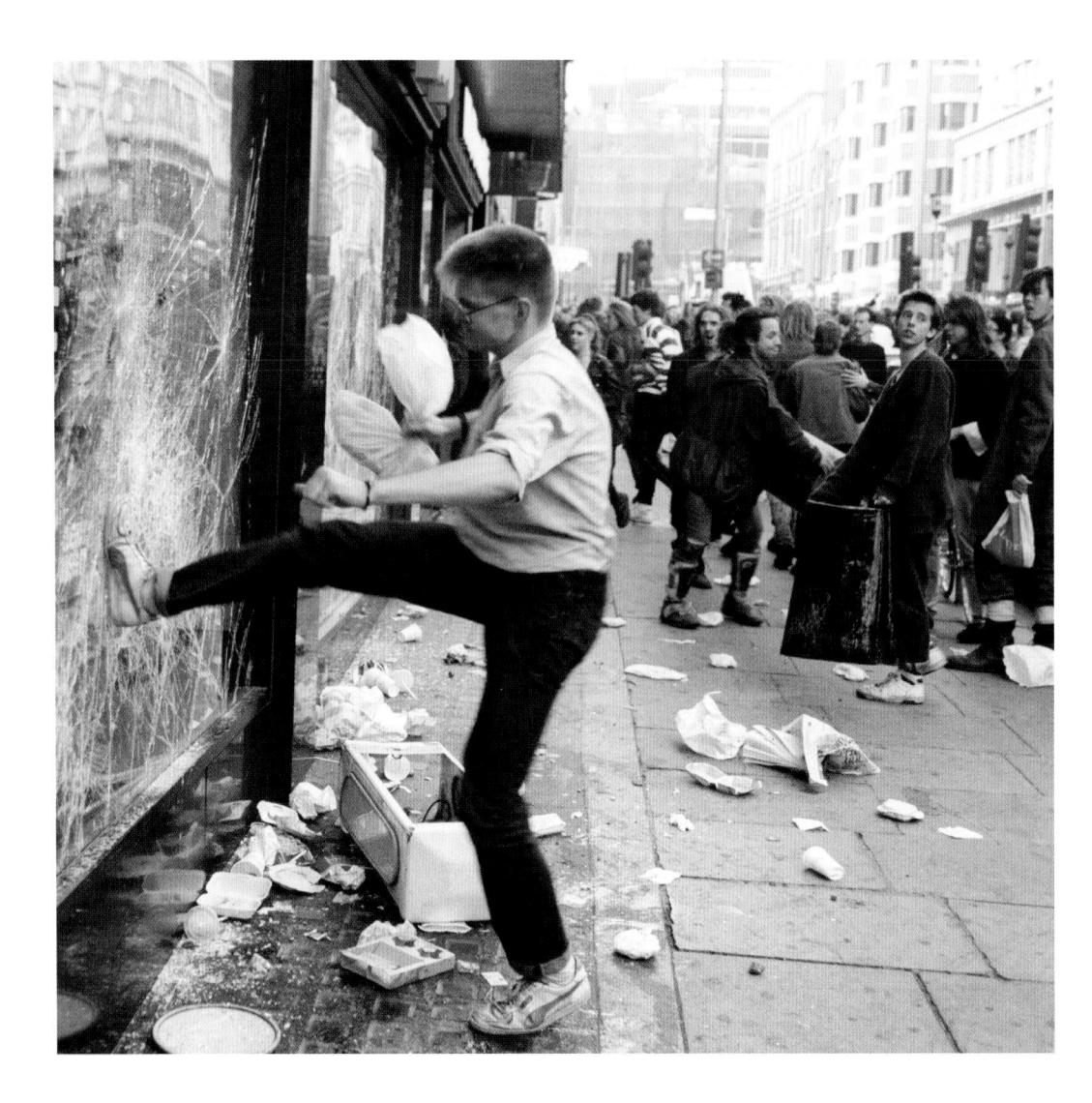

Facing page: A protester kicks the window of McDonalds in Lower Regent Street as poll tax demonstrations descend into rioting.

31 March 1990

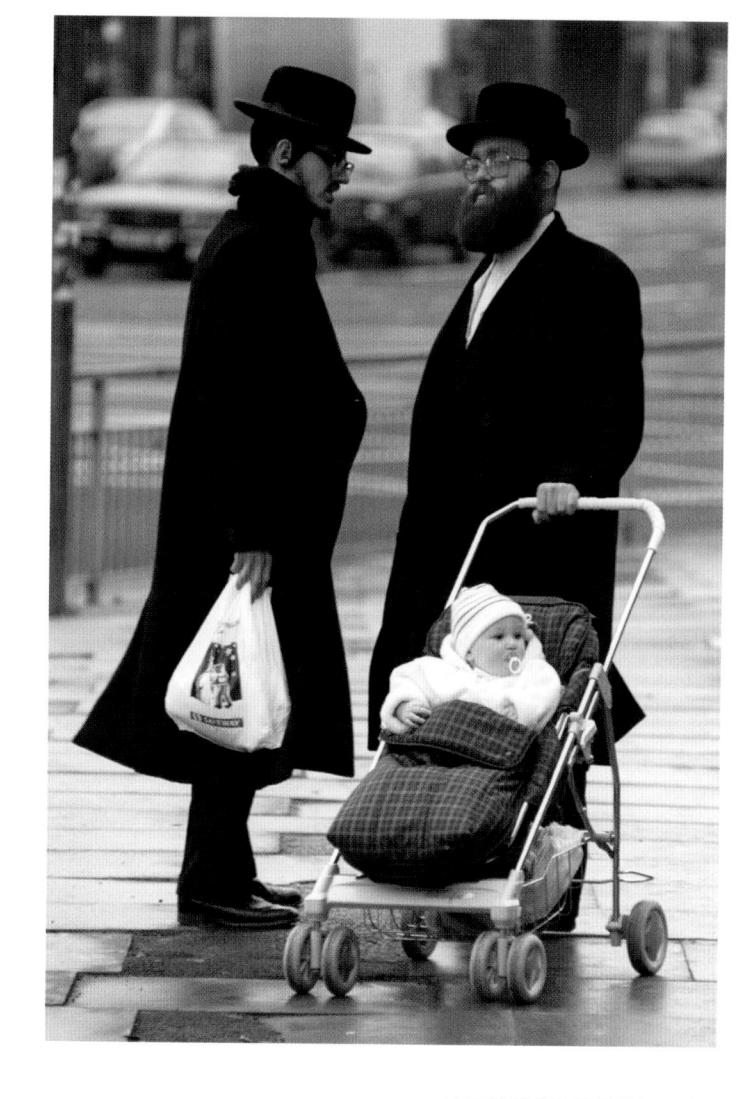

Members of the Hasidic Jewish community in Stamford Hill.

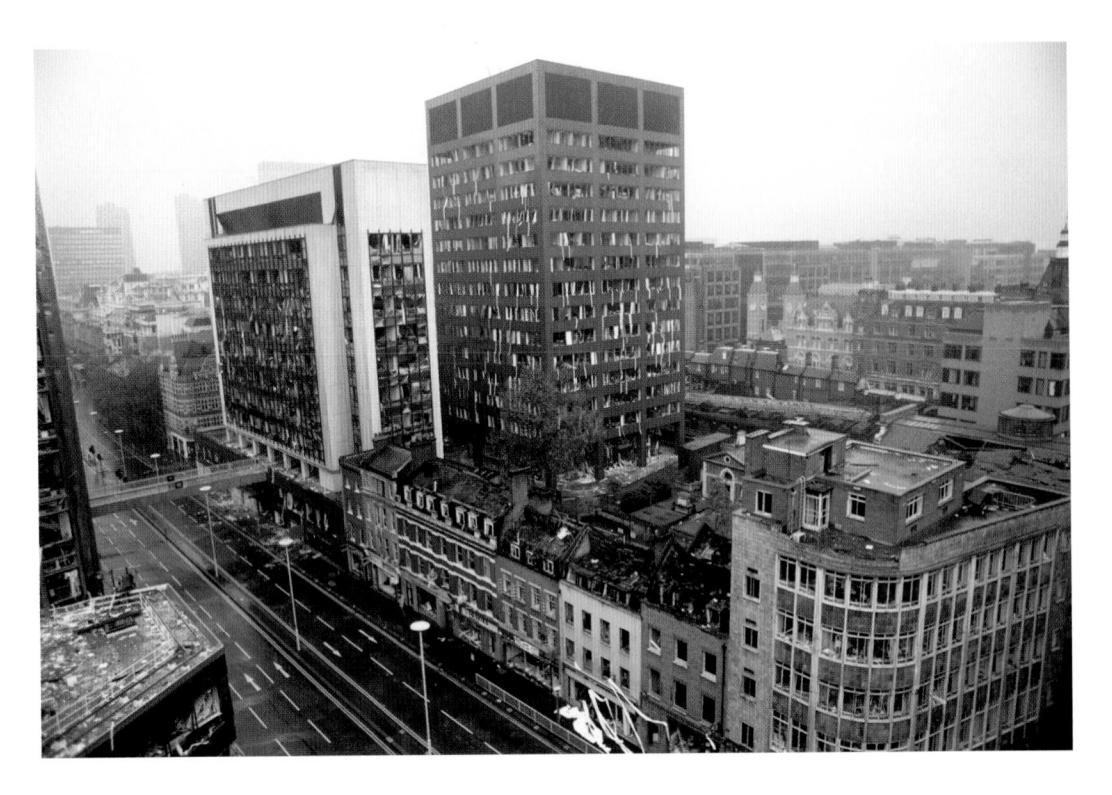

On Bishopsgate, a massive IRA bomb outside the HSBC building killed one and injured more than 40 people.

26 April 1993

Facing page: Covent Garden market has long since departed, leaving a space for shops and buskers.
8 July 1993

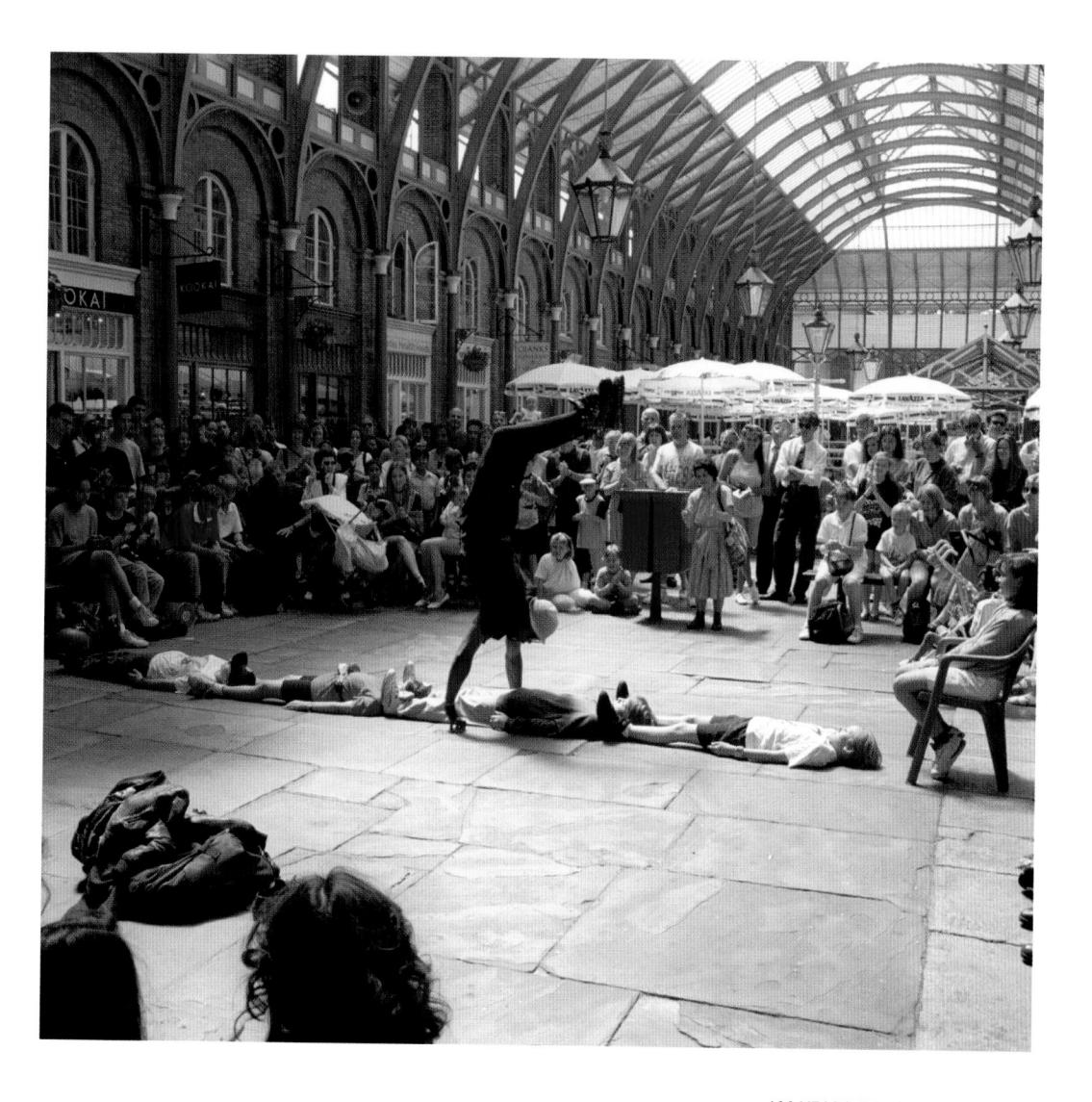

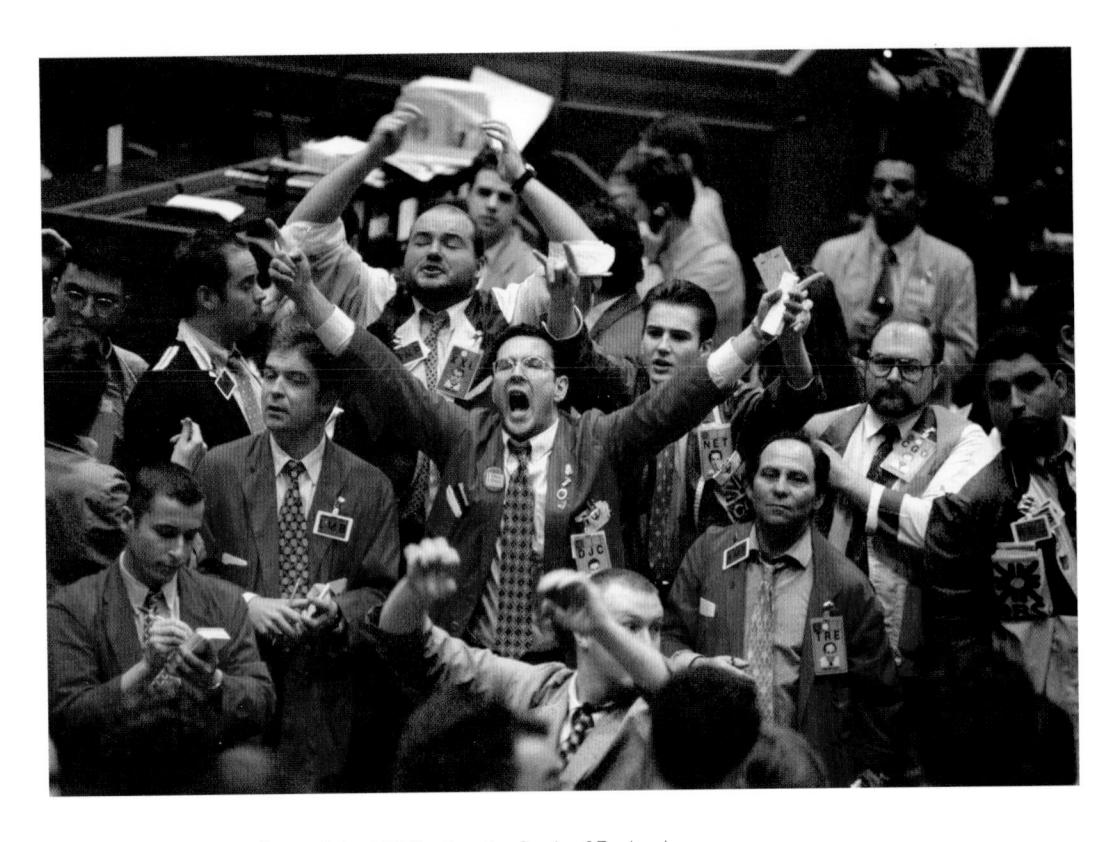

Frantic bidding on the floor of the LIFFE, after the Bank of England raises interest rates in a bid to cool the economy.

2 February 1995

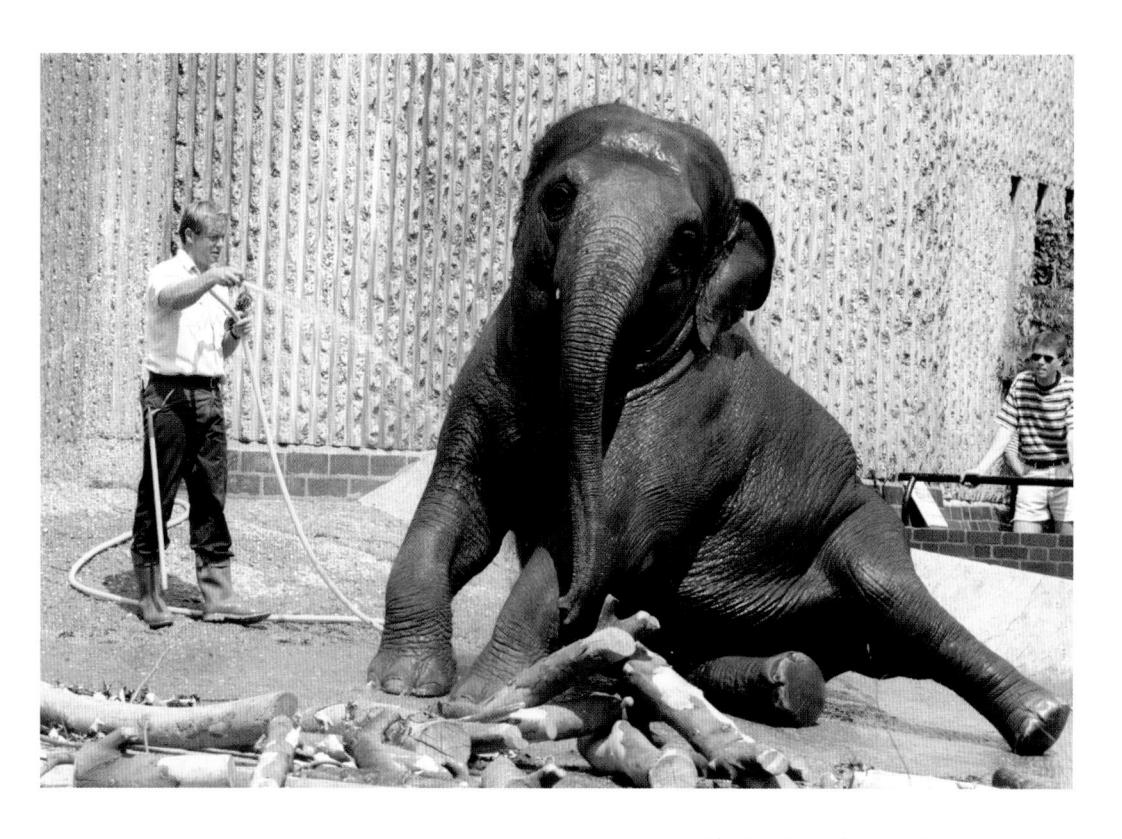

Hosing down London Zoo's elephants on the hottest day of the year.

I August 1995

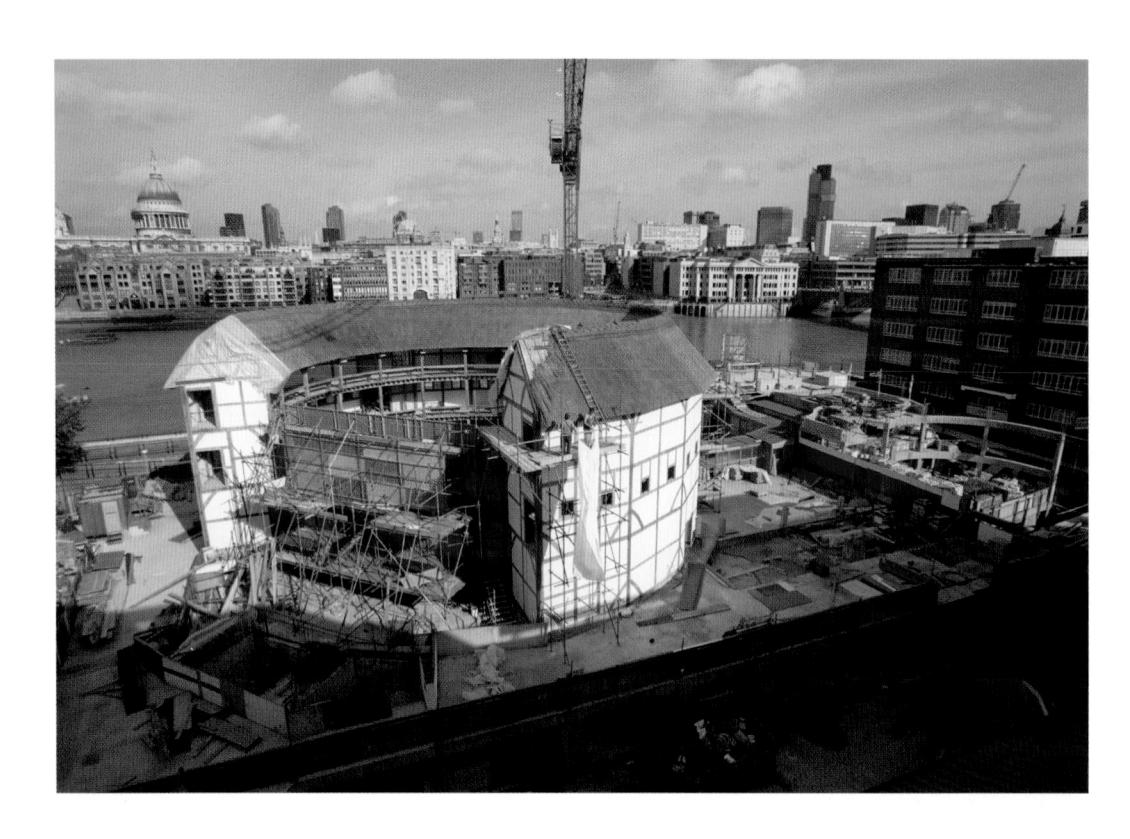

Work on the Globe theatre, being constructed on the original historic site on the South Bank.

16 October 1995

Facing page: Prime Minister John Major waves goodbye to Baroness Thatcher as she leaves Conservative Central Office in London. Prospects for the following General Election looked bleak for the Tories.

6 April 1997

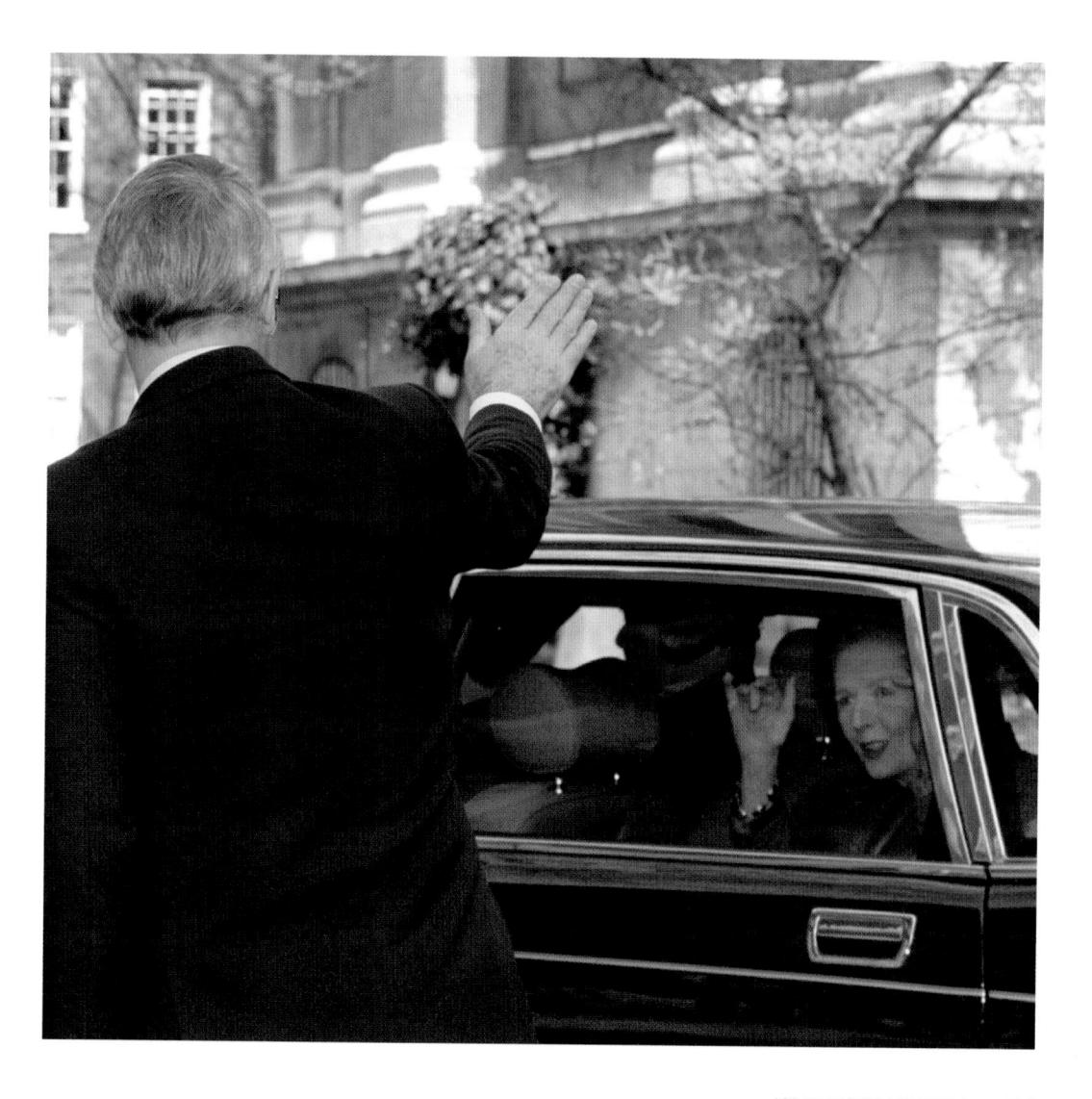

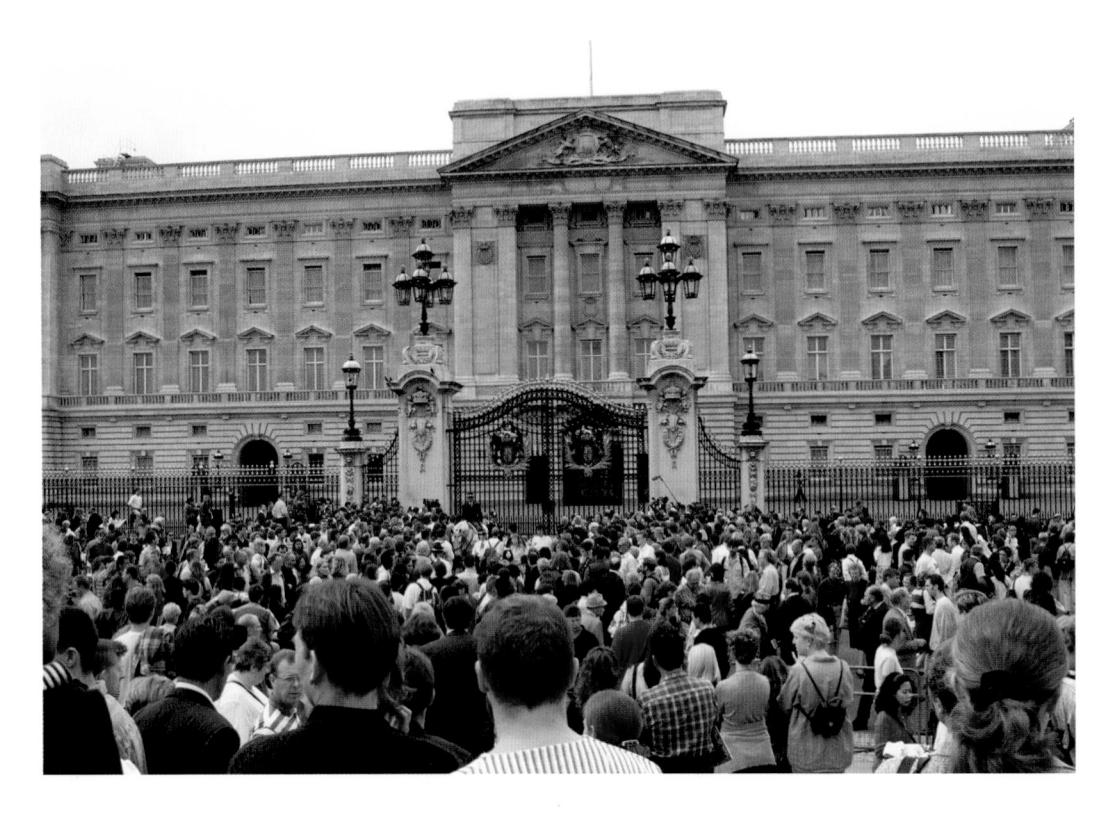

Crowds outside Buckingham Palace following the death of Diana, Princess of Wales.

31 August 1997

Facing page: (L-R) The Earl Spencer, Princes William and Harry, and The Prince of Wales wait as the hearse carrying the coffin of Diana, Princess of Wales, prepares to leave Westminster Abbey.

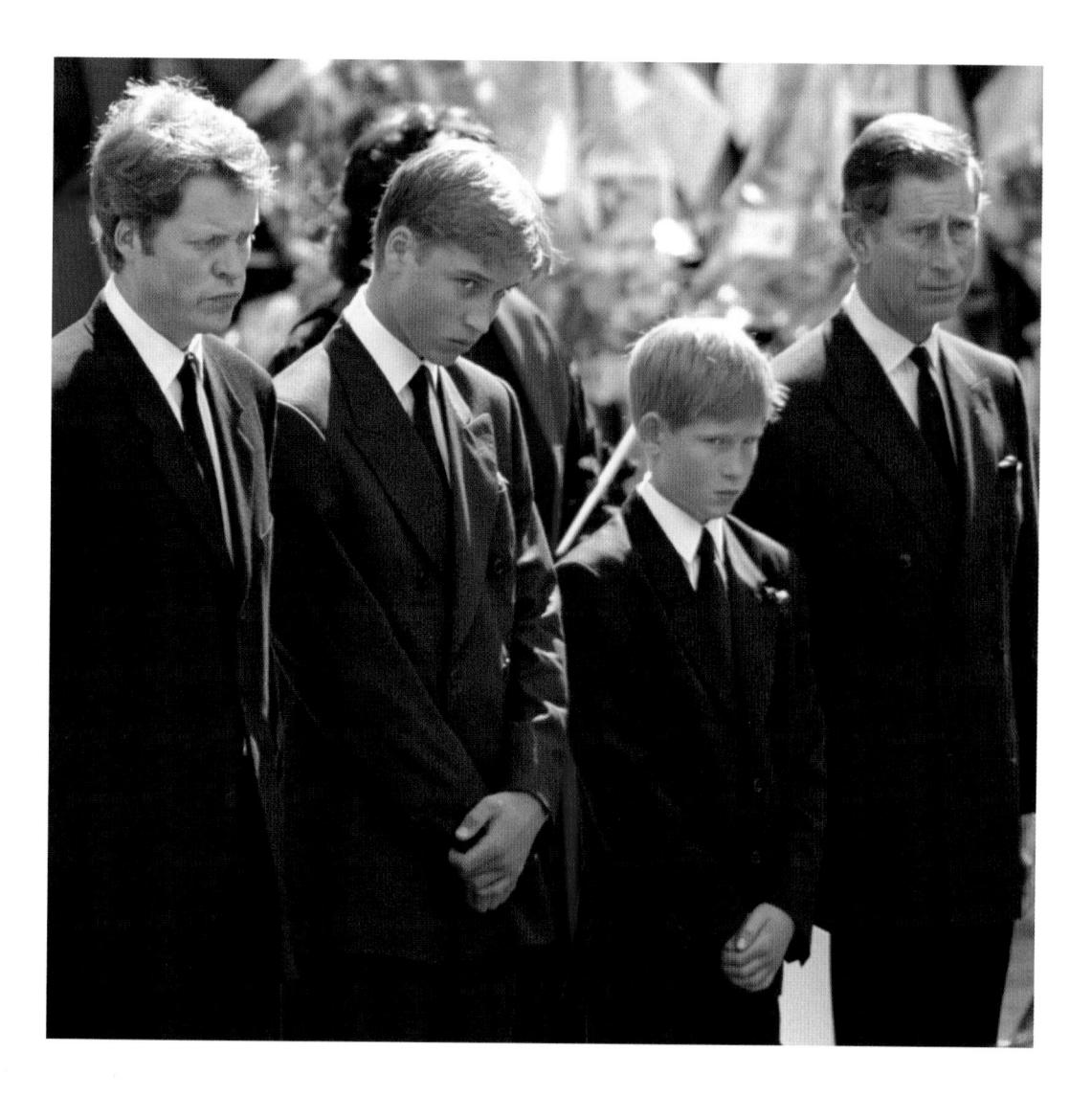

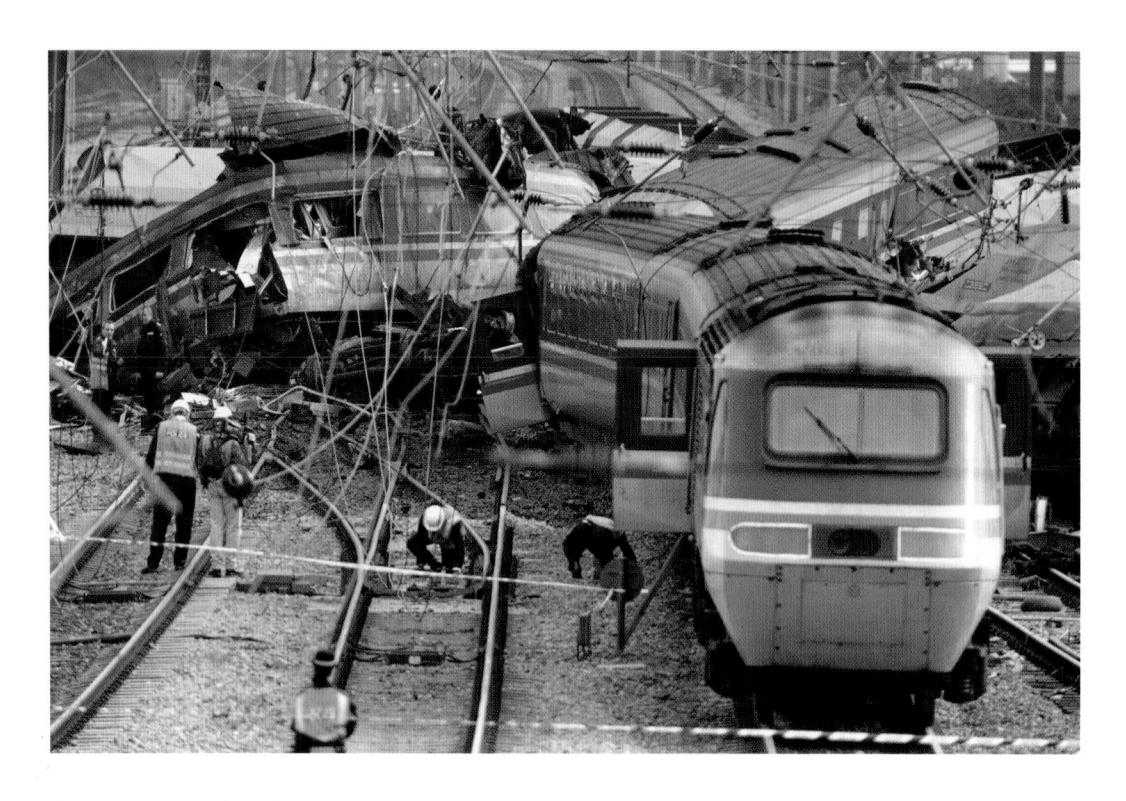

Clearing the site of the Southall rail crash after a Great Western express train ploughed into a goods train, leaving seven dead and more than 130 injured.

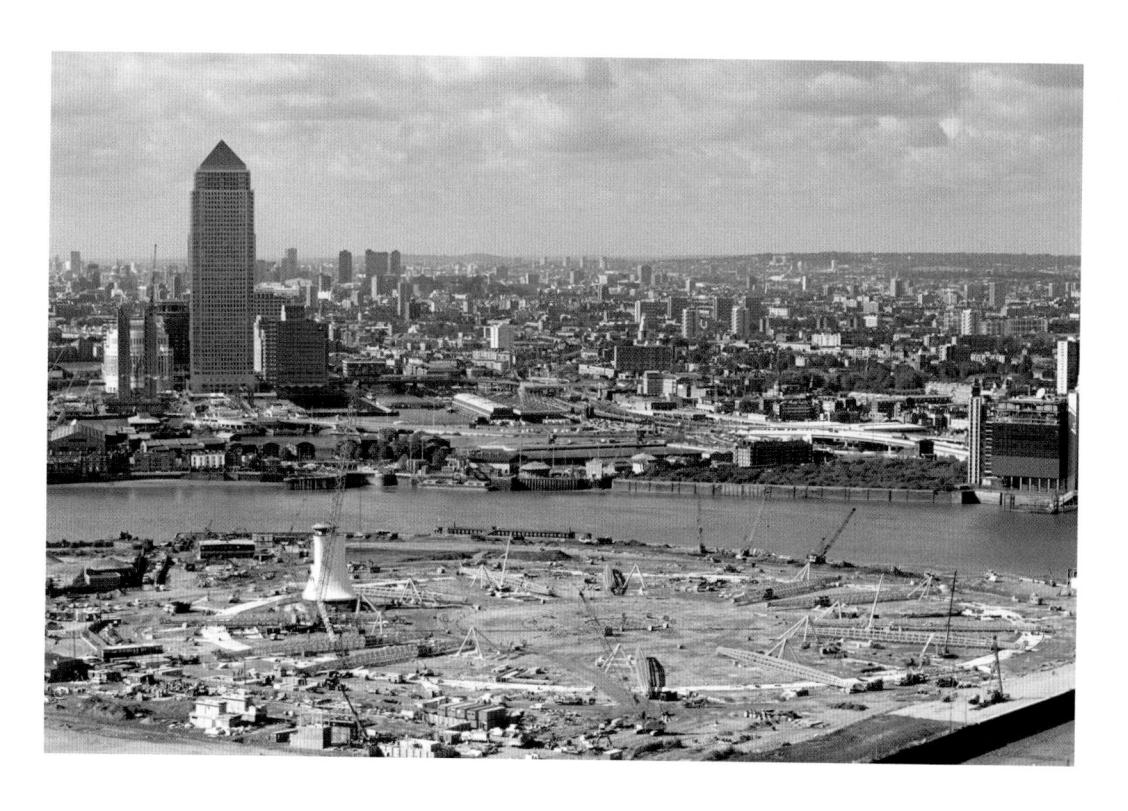

London's Docklands. Construction work begins on the Millennium Dome.

10 October 1997

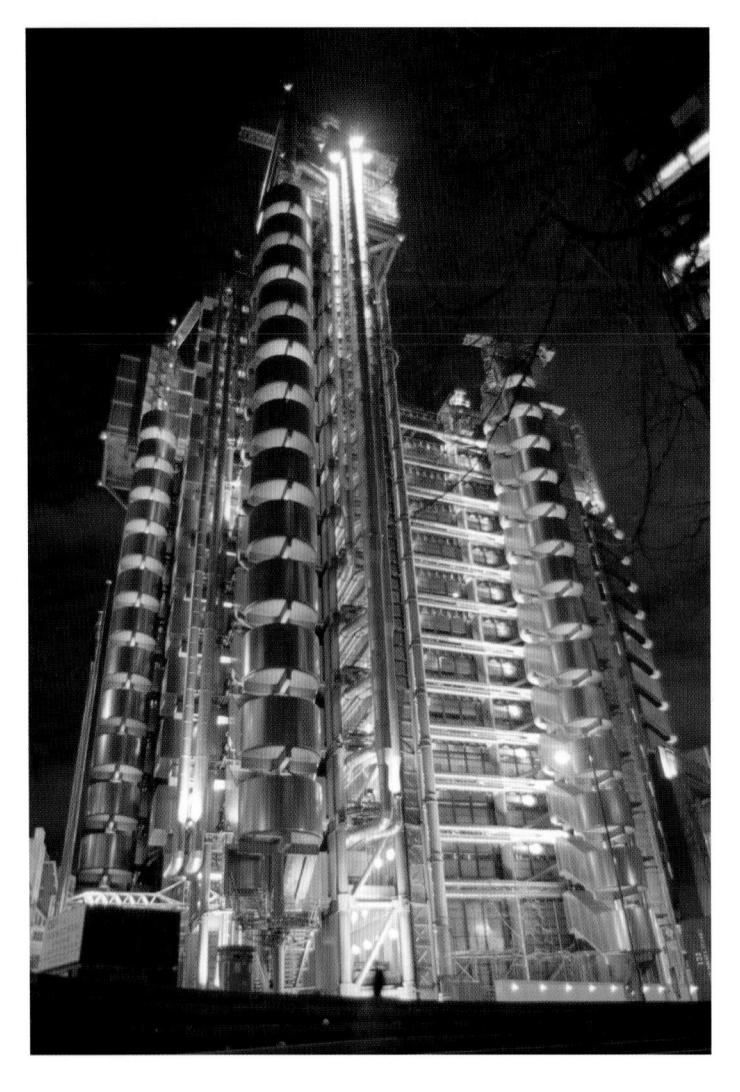

The Lloyds building, designed by architect Richard Rogers.

12 February 1999

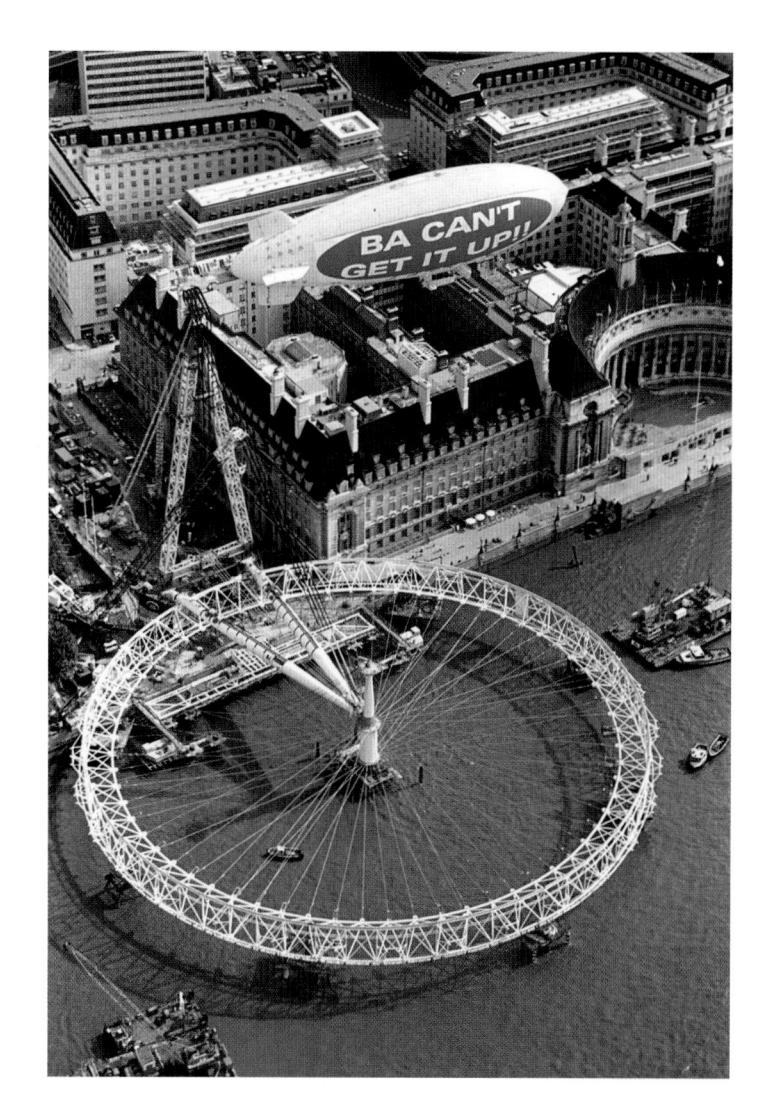

A Virgin light airship floats over the horizontal Millennium Wheel (the London Eye). The Wheel, sponsored by British Airways, was supposed to be lifted to its full height – three times taller than Tower Bridge – that month but when anchor clips holding its support cables started to buckle under the weight, the operation was aborted.

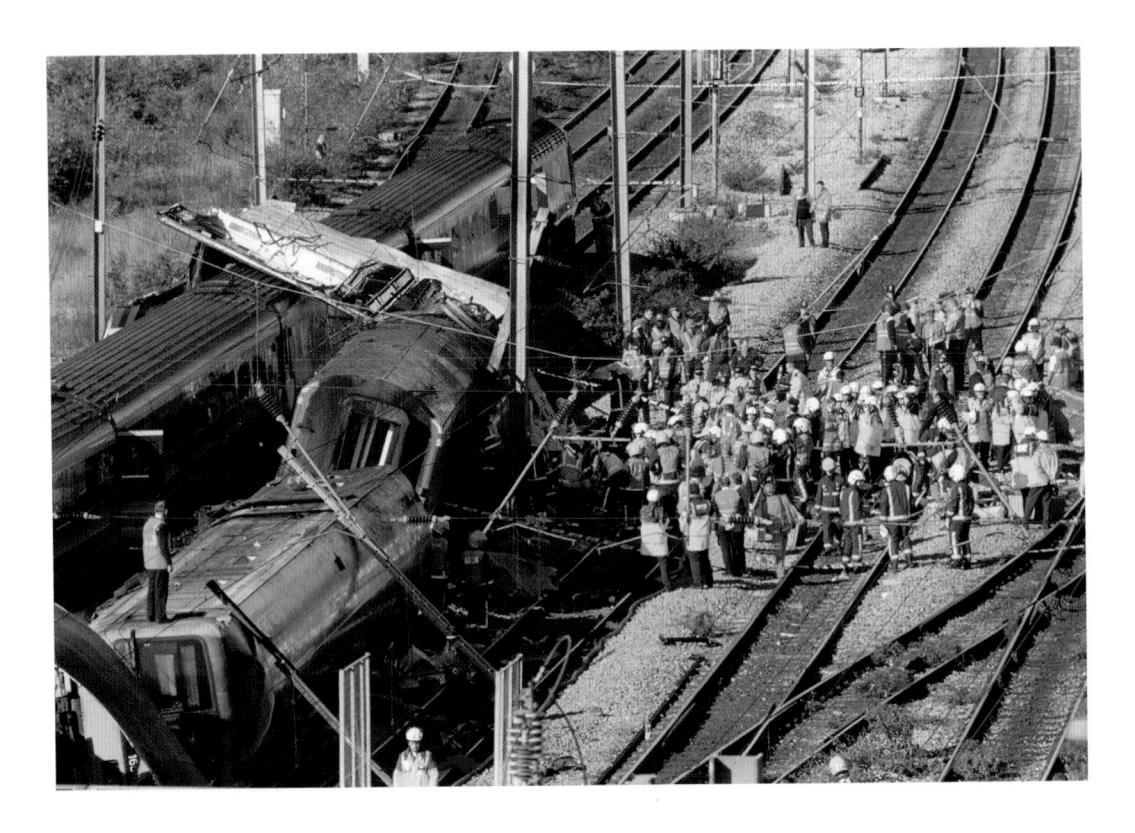

The aftermath of the Paddington rail crash. Two mainline trains collided and caught fire in the morning rush hour outside Paddington station. The disaster, which killed 31 people and injured over 500, was an echo of 1997's Southall crash that occurred close by on the same line.

5 October 1999

Facing page: Prime Minister
Tony Blair on the newly built
Jubilee Line extension, on his
way to the Millennium Dome.
14 December 1999

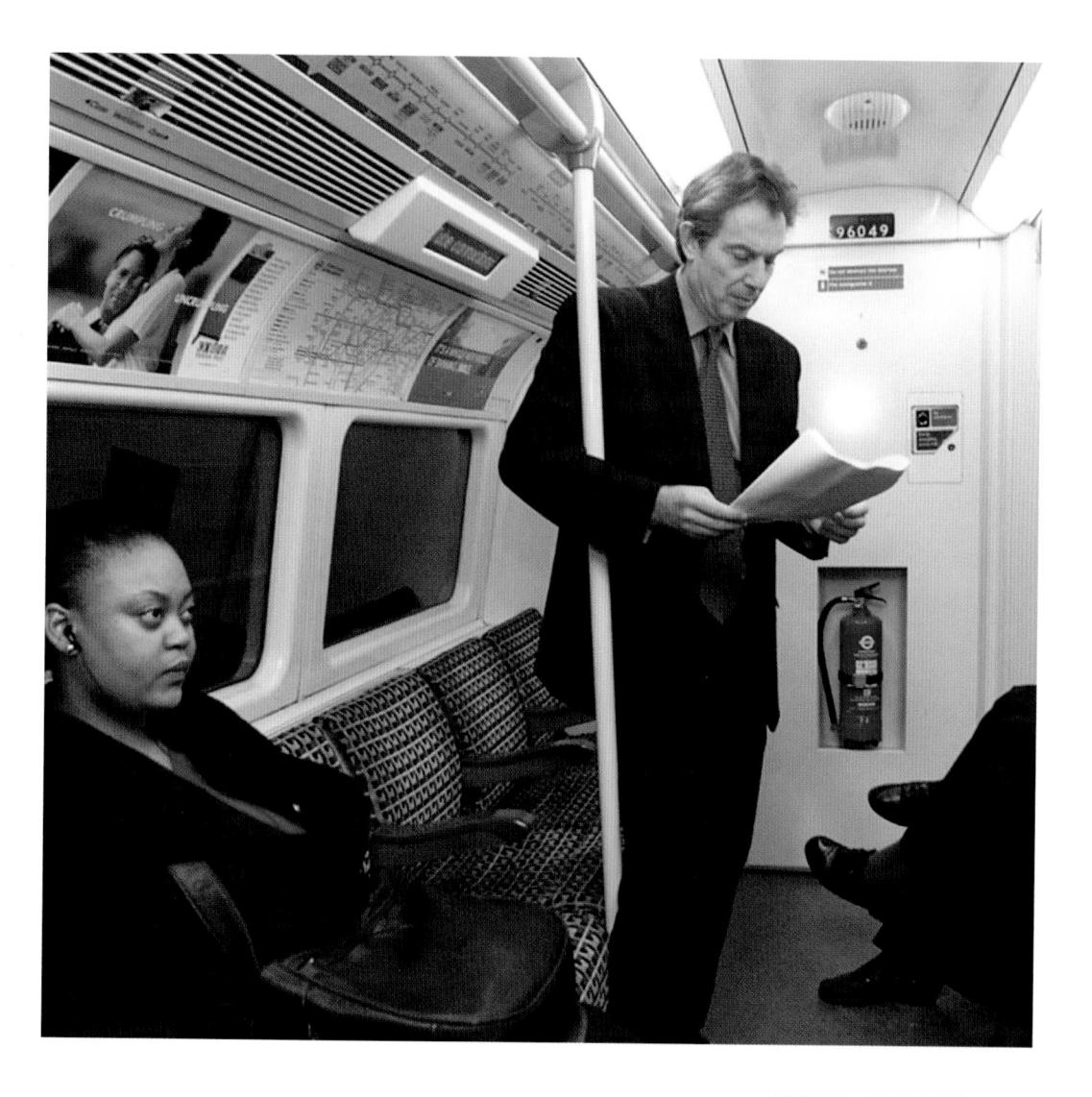

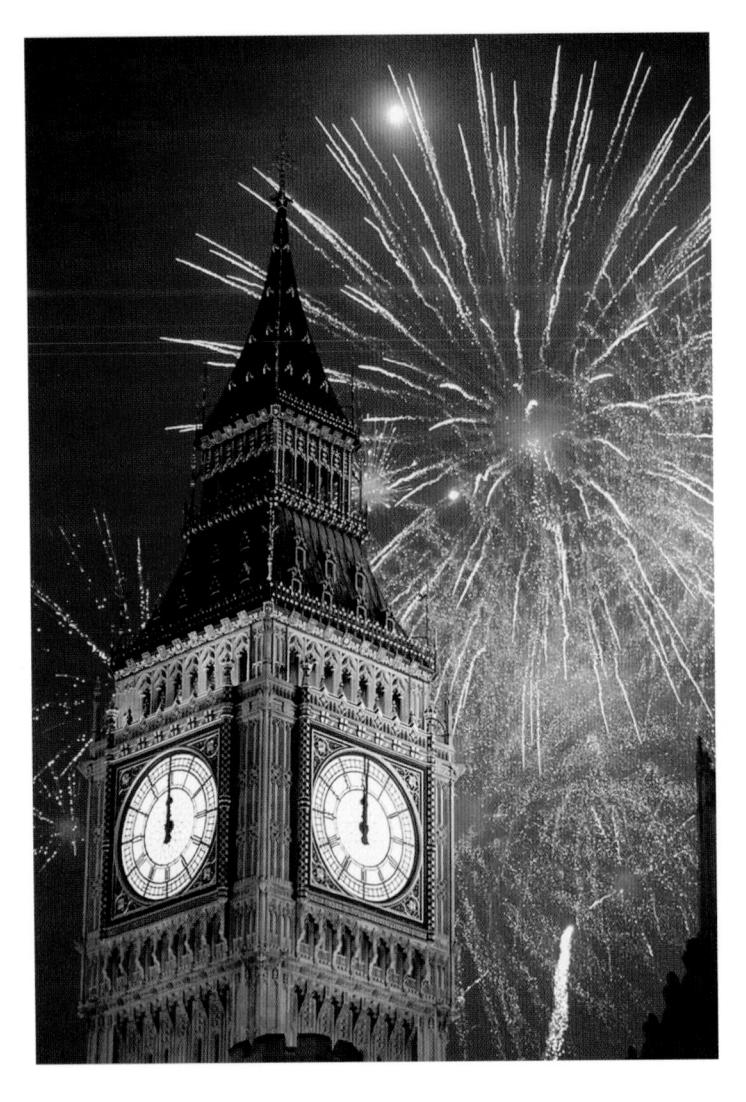

Fireworks usher in the new millennium.

I January 2000

Facing page: Abseilers clean one of the faces of Big Ben. 20 August 2001

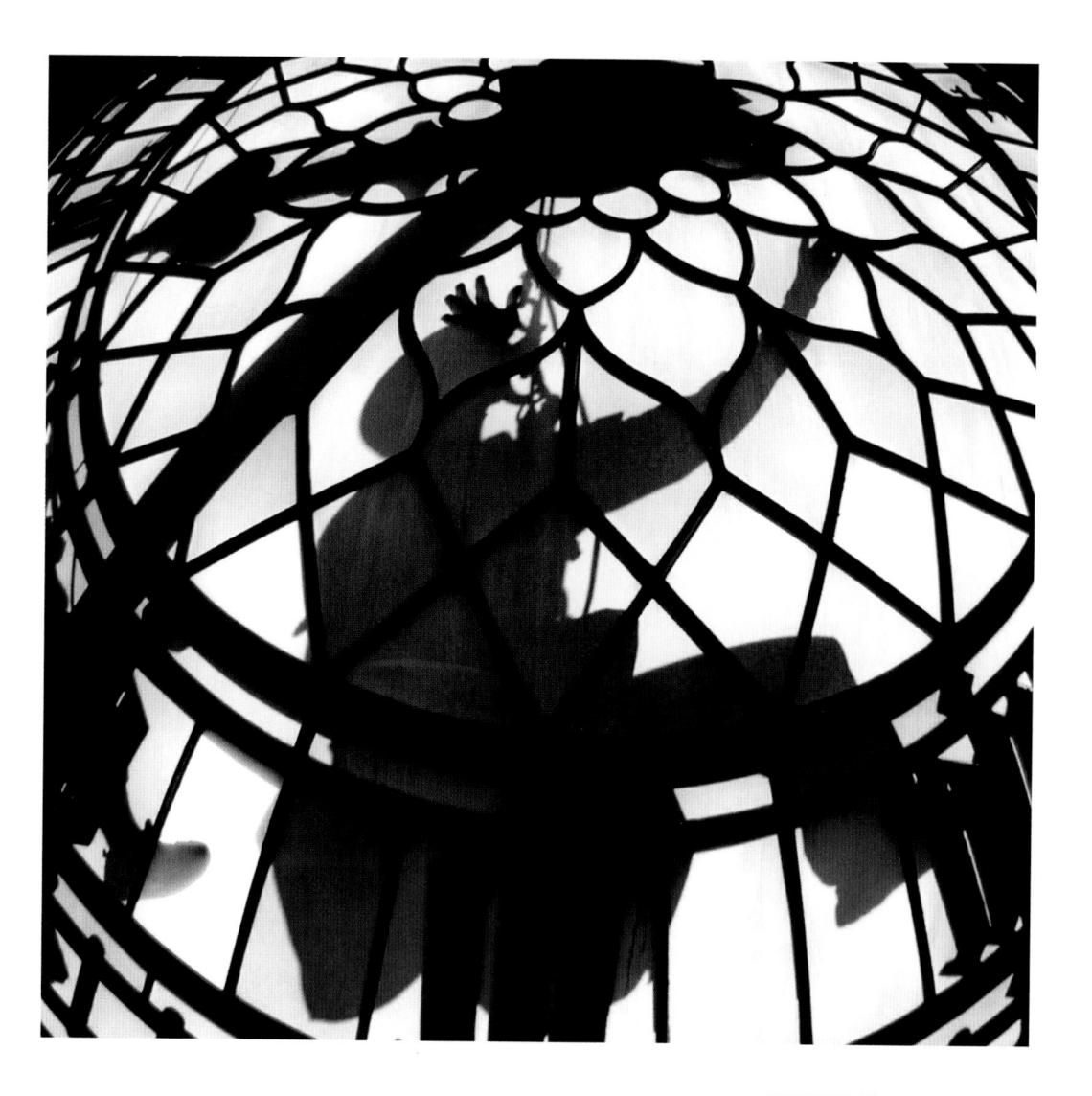

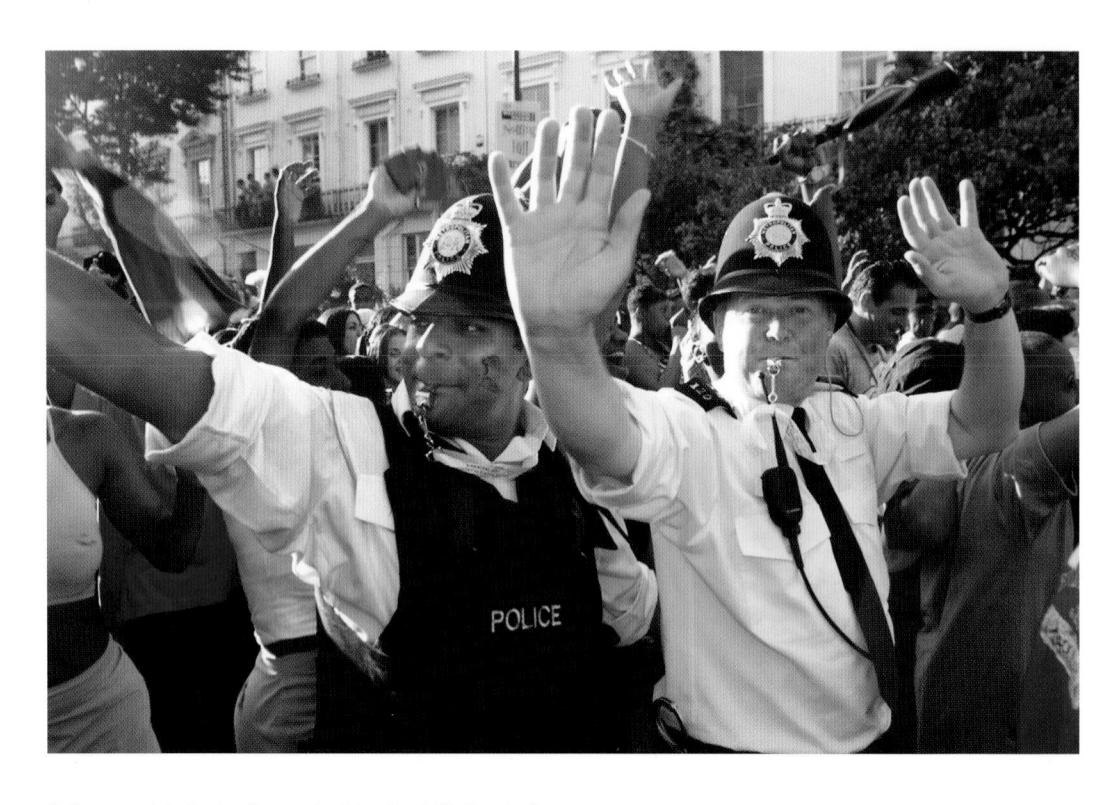

Policemen join in the fun at the Notting Hill Carnival. 27 August 2001

The Stock Exchange closes early after terrorist attacks destroy the World Trade Center in New York.

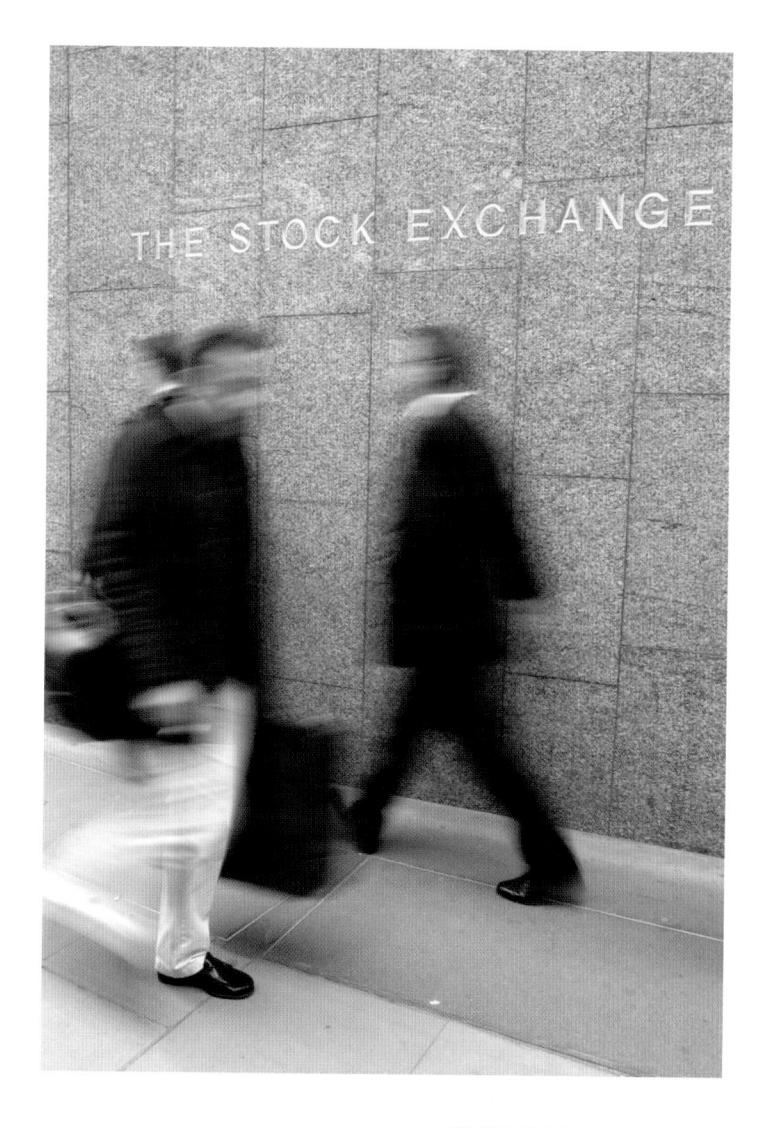

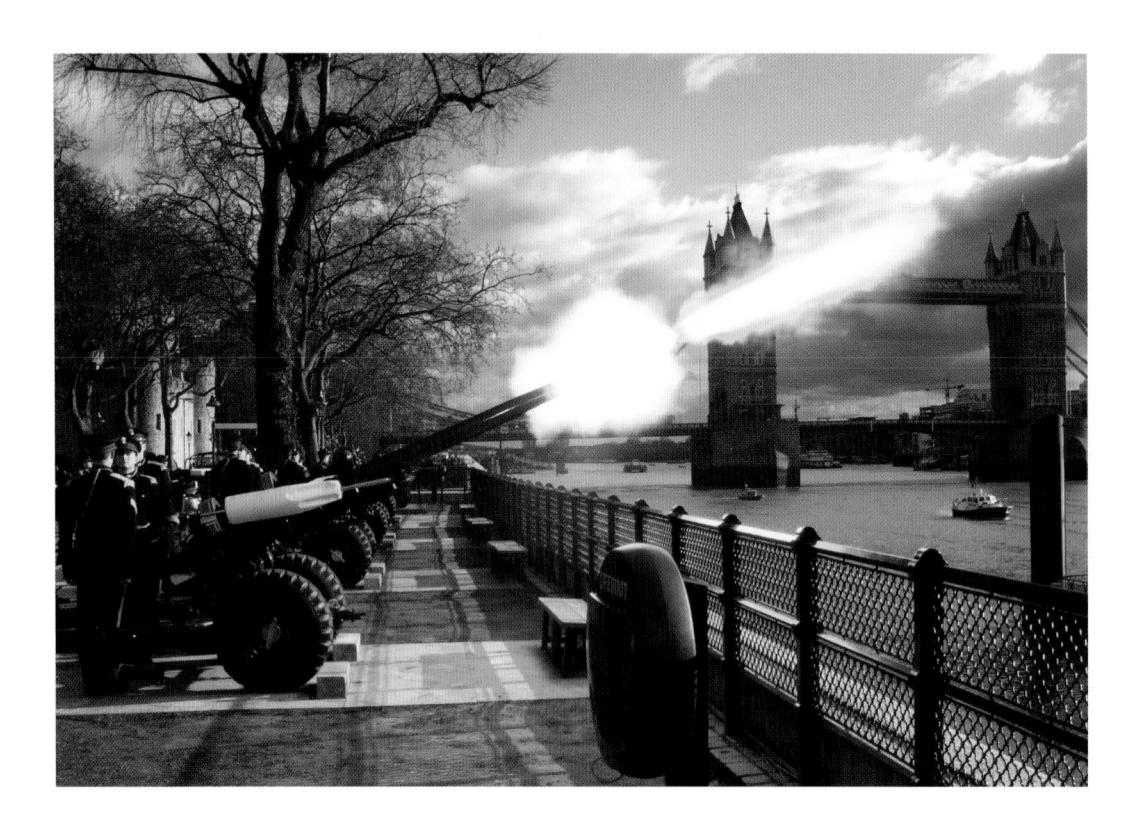

The Honourable Artillery Company marks the 50th anniversary of the Queen's accession to the throne with a 62-gun salute at The Tower of London.

6 February 2002

London Fashion Week, at Porchester Hall, Paddington. 20 February 2002

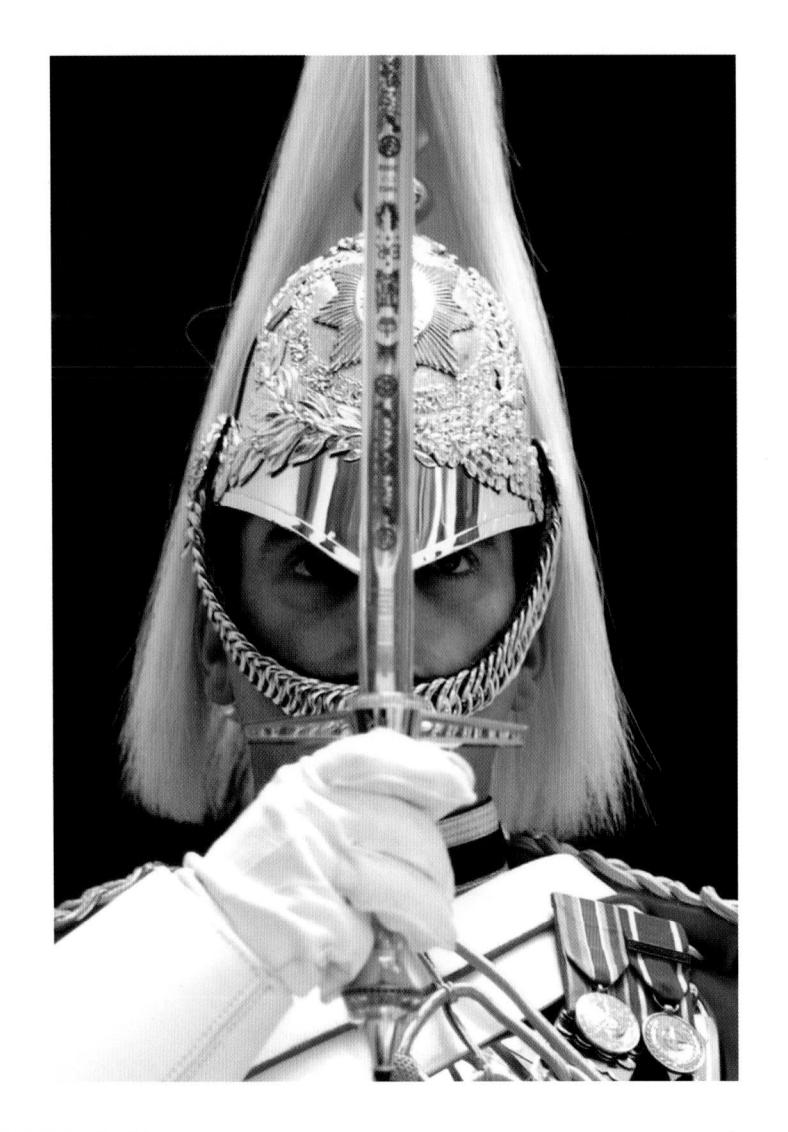

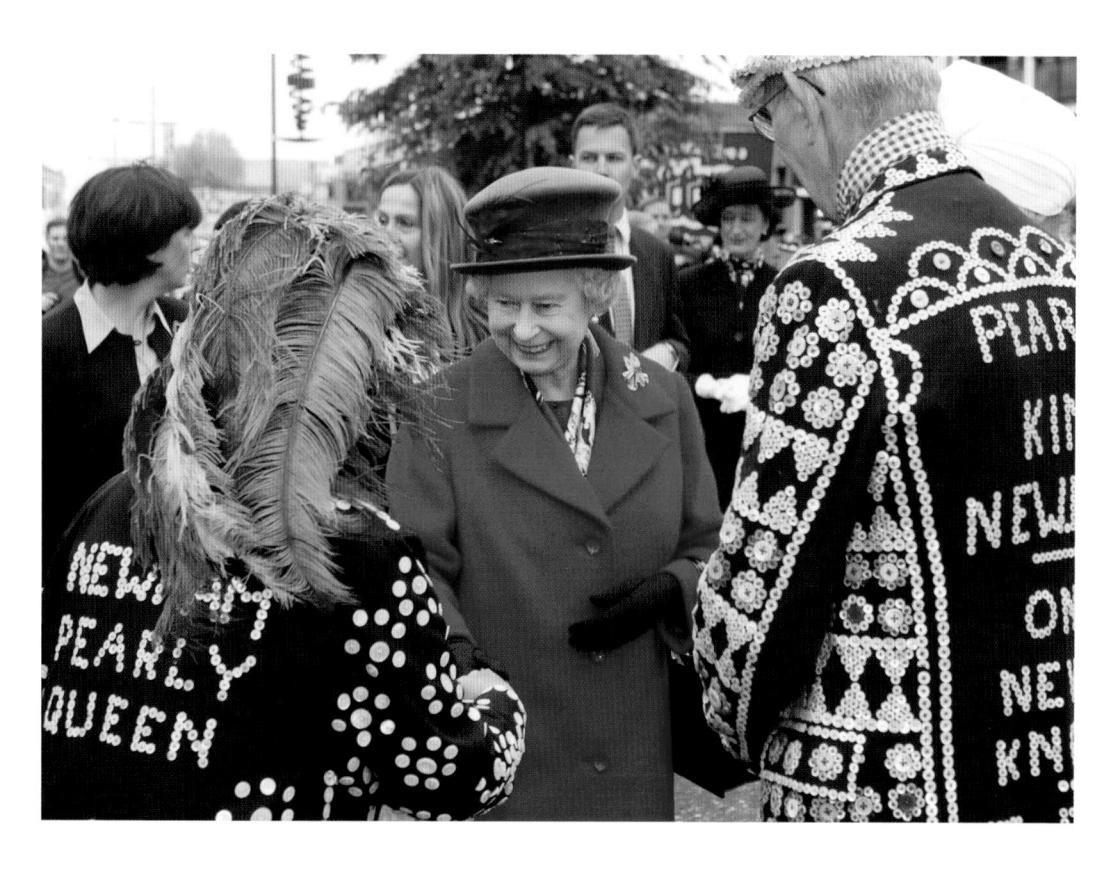

Facing page: Lance Corporal of Horse, Nick Hunt, of the Life Guards from the Household Cavalry, with a commemorative sword, commissioned to celebrate the Queen's Golden Jubilee.

20 March 2002

Queen Elizabeth II meets the pearly King and Queen of Newham during her Golden Jubilee tour of the UK.

9 May 2002

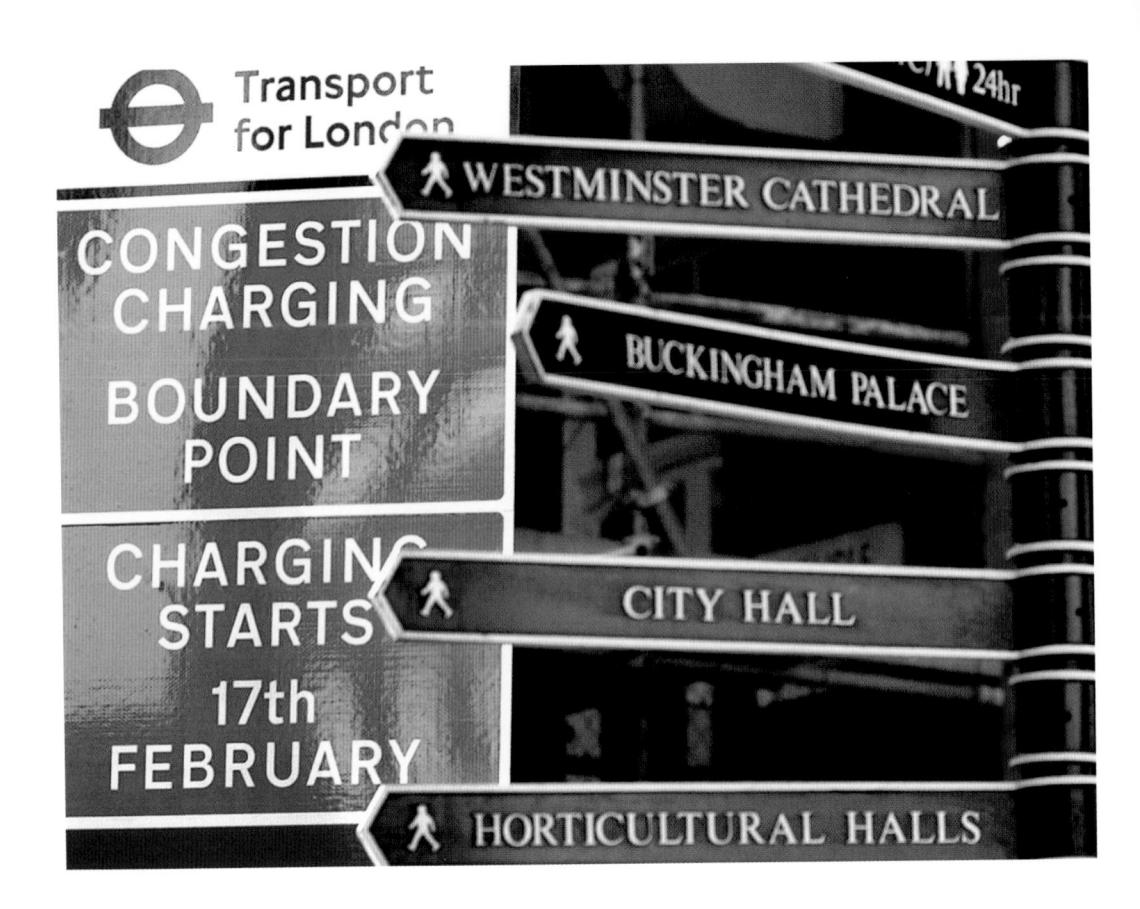

A sign on Victoria Street warns motorists of the London congestion charge.

5 February 2003

Anti-war demonstrators head down Piccadilly in central London on their way to a rally in Hyde Park. Over a million people turned out to register their opposition.

15 February 2003

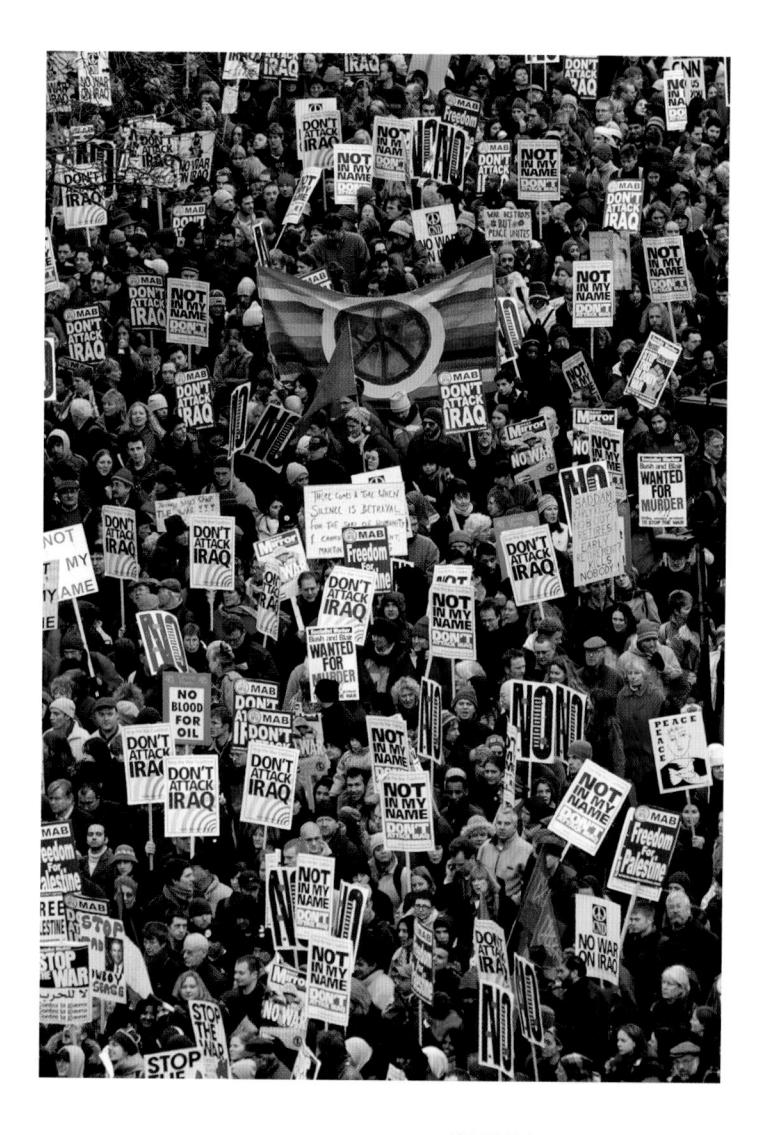

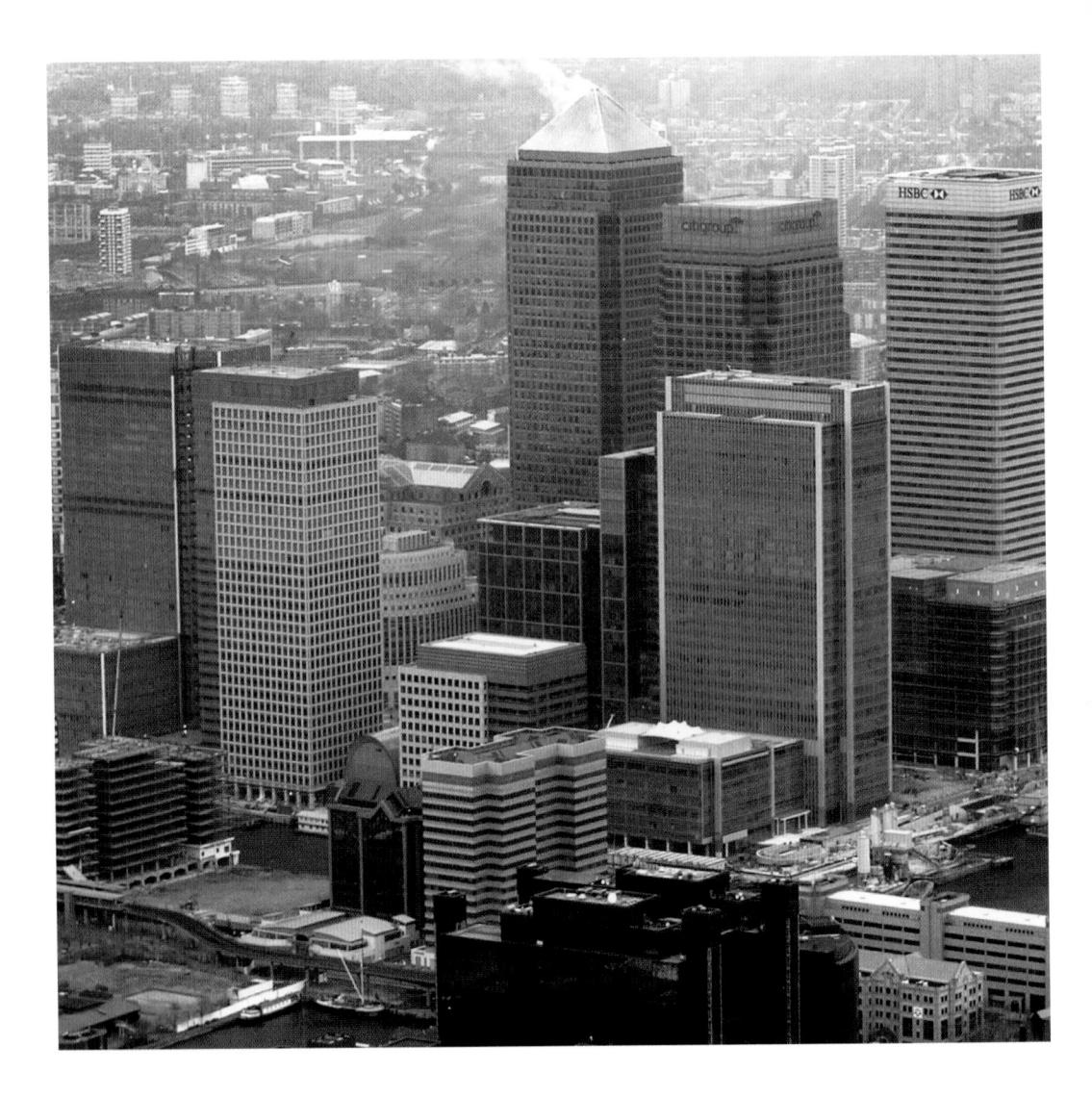

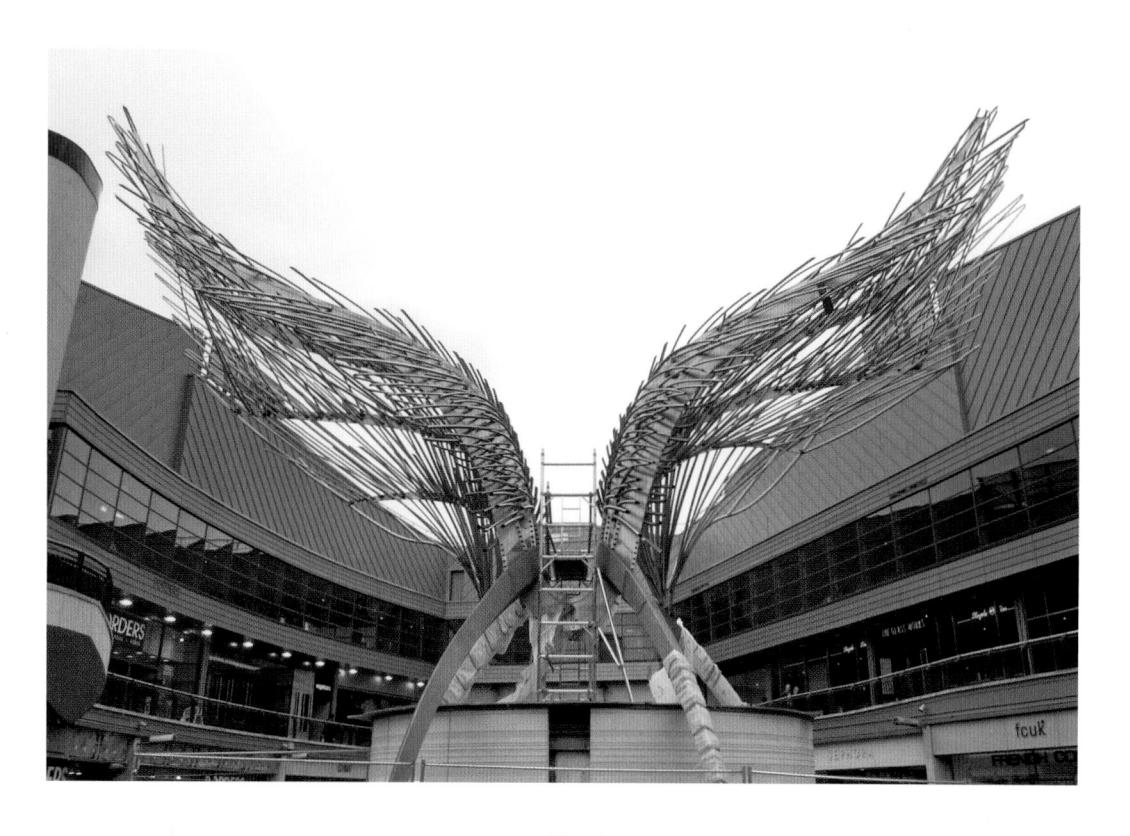

The Angel Wings sculpture being installed in the Angel Shopping Centre in Islington. It was designed by sculptor Wolfgang Buttress.

4 March 2003

Facing page: Canary Wharf.

21 February 2003

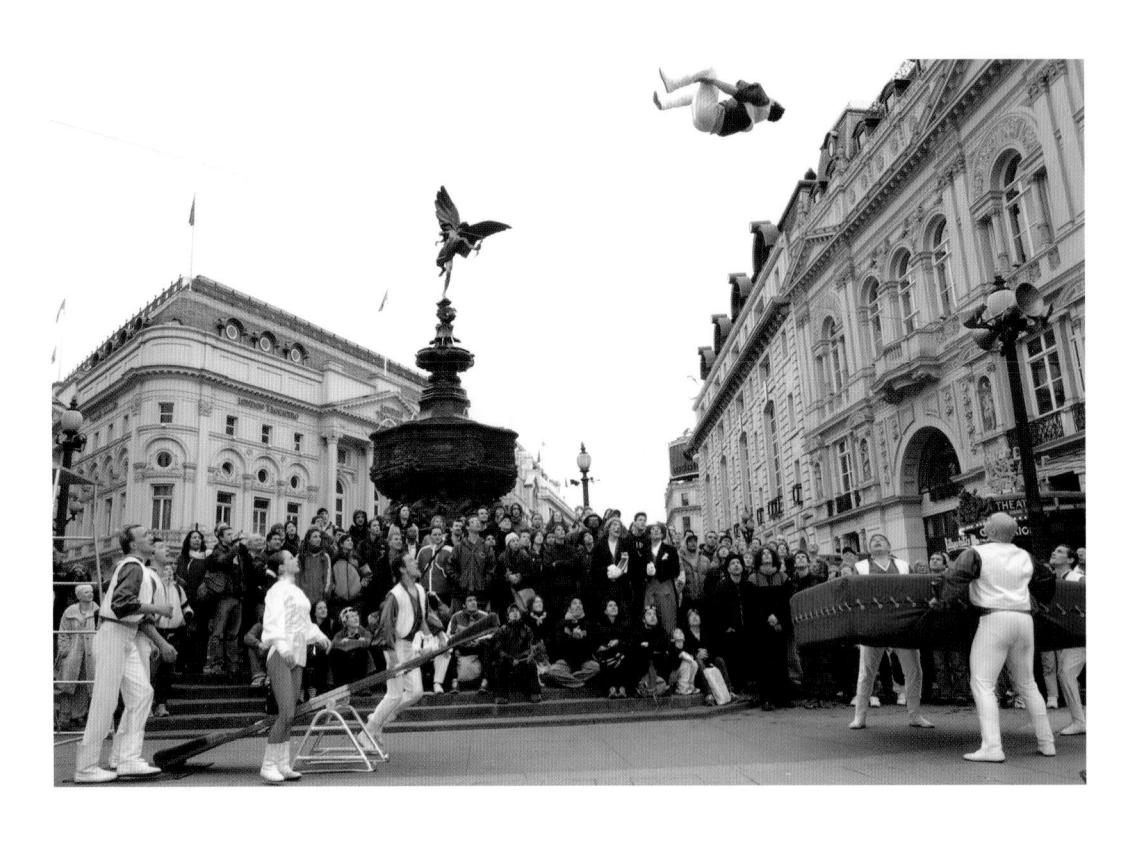

Acrobats from Arnett & Paulo's Circus perform in Piccadilly Circus to mark the first National Circus Day.

8 April 2003

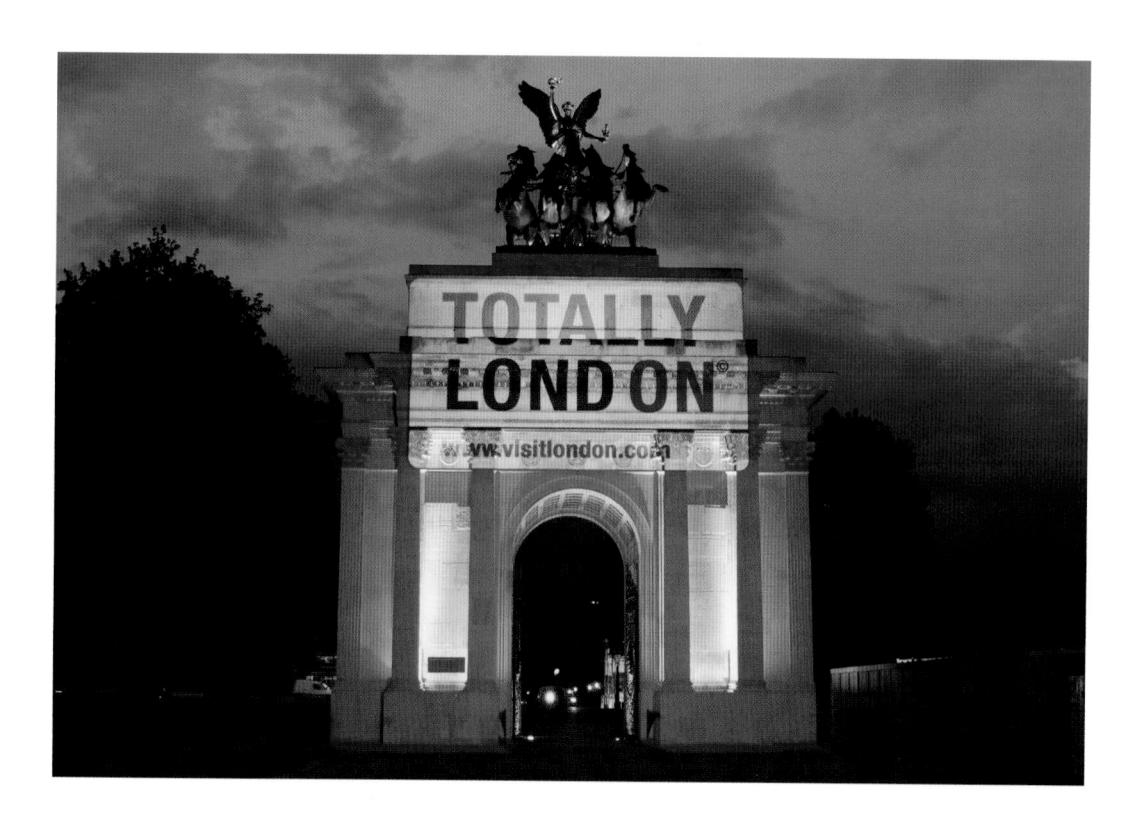

The Wellington Arch displays the Totally London logo to promote the capital as a tourist destination.

24 May 2003

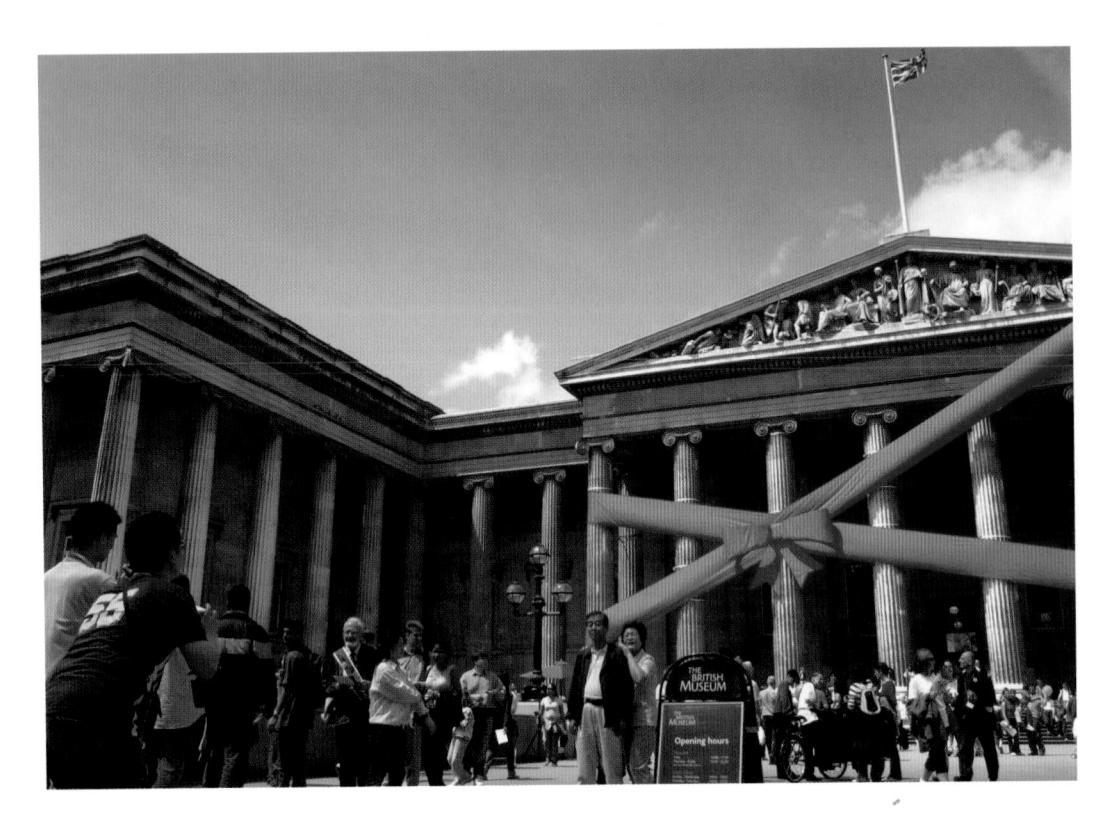

The British Museum's 250th anniversary celebrations. 7 June 2003

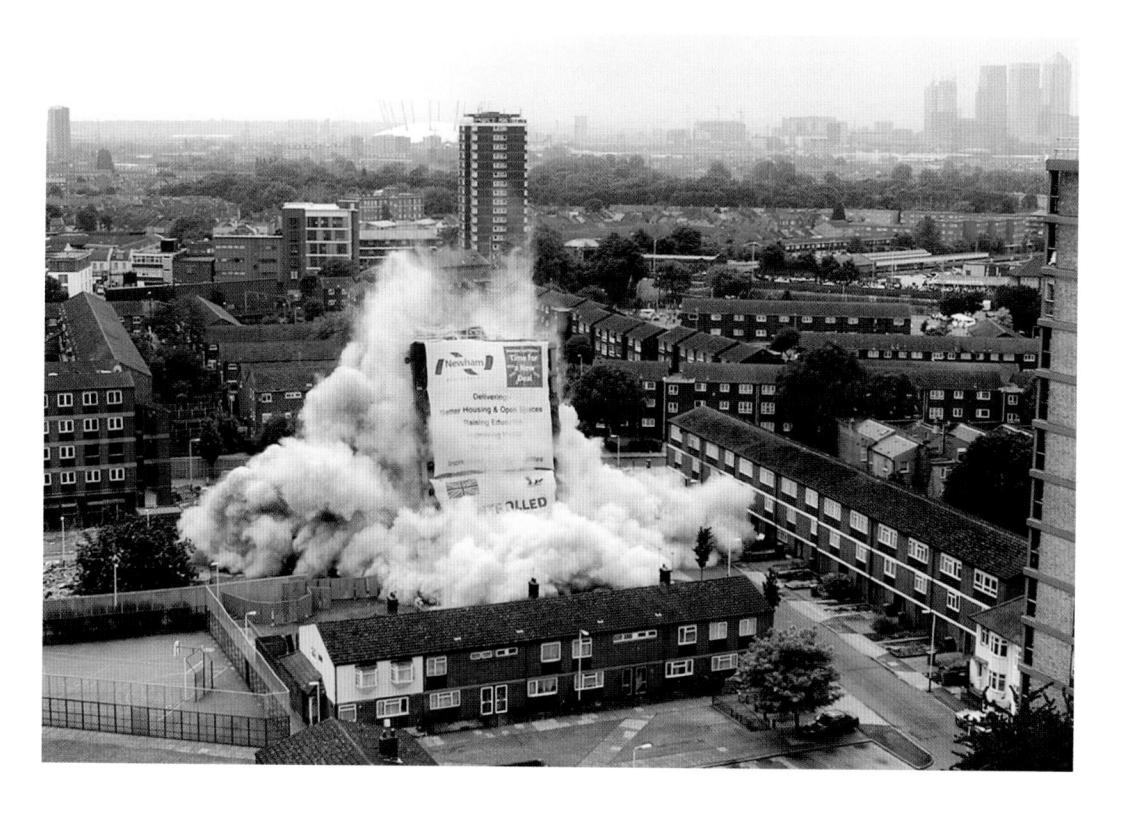

A tower block on the Brookes Estate in Plaistow is blown to the ground by controlled explosion. The demolition is part of a five-year regeneration project.

8 June 2003

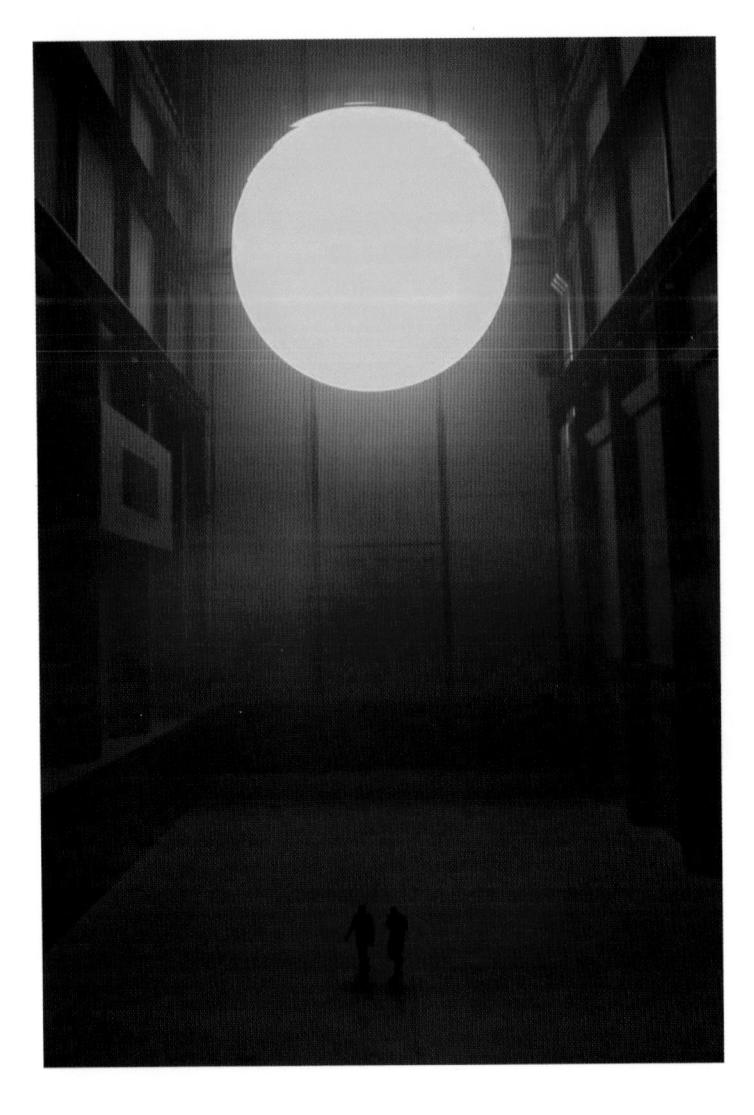

Olafur Eliasson's installation entitled *The Weather Project* in The Turbine Hall at the Tate Modern.

15 October 2003

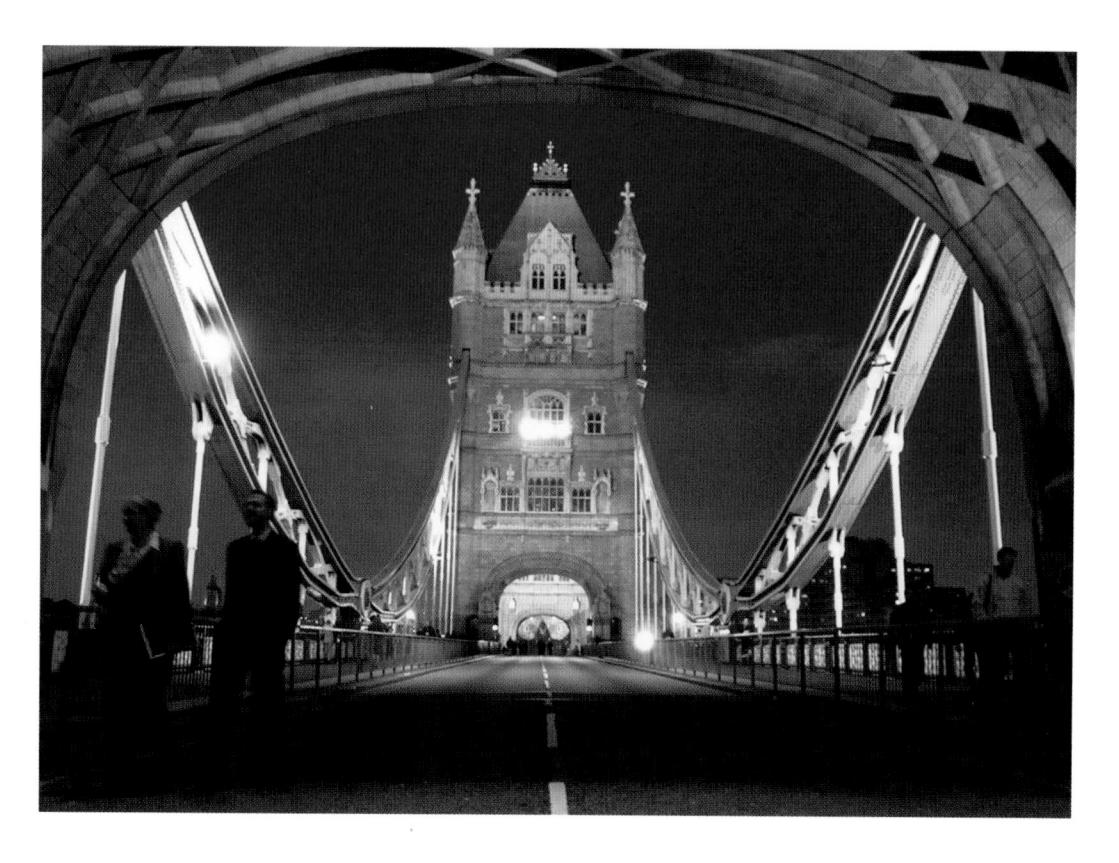

Tower Bridge is closed by a Fathers 4 Justice protestor, dressed as Spiderman, occupying a crane over the roadway.

4 November 2003

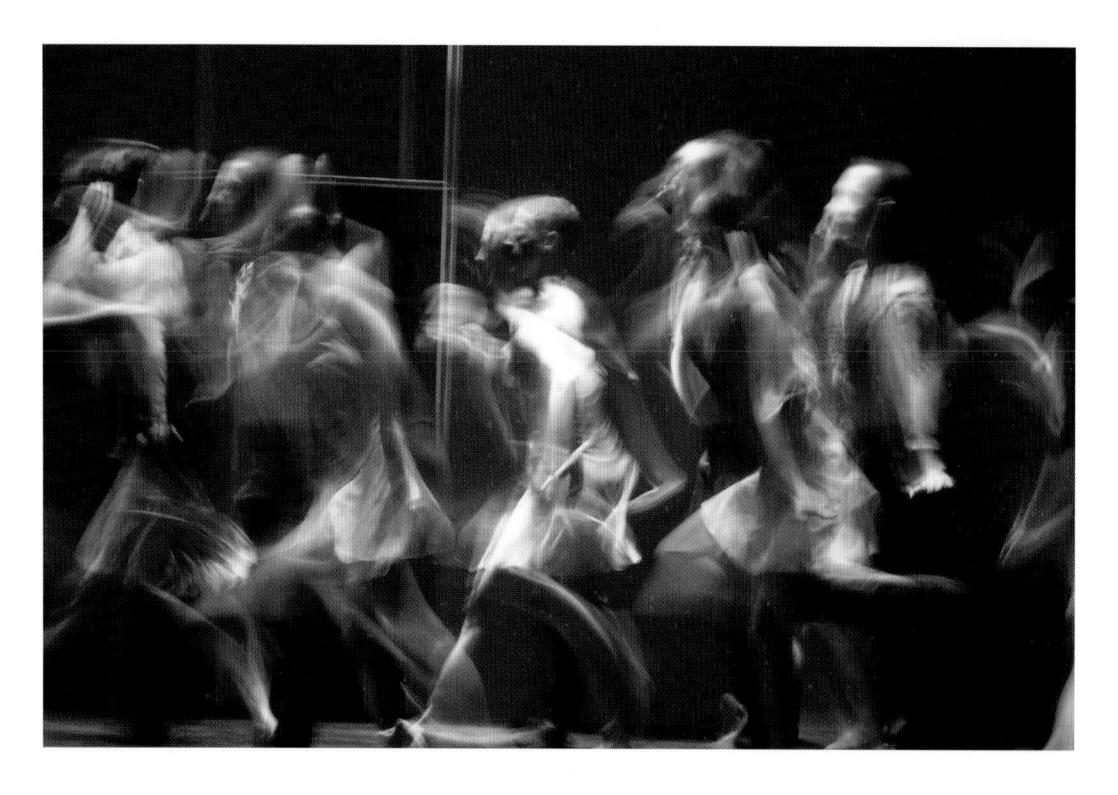

Dancers from the Rambert Dance Company rehearse at Sadler's Wells.

25 November 2003
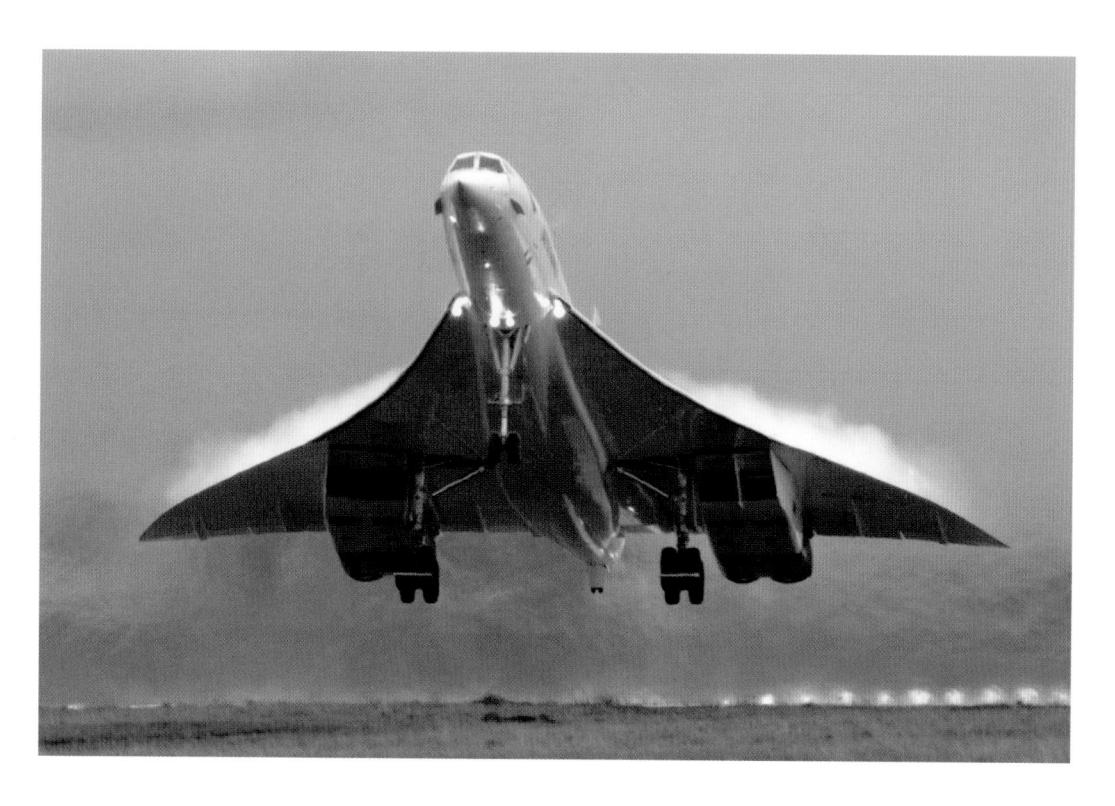

A British Airways Concorde takes off for the last time from Heathrow Airport.

26 November 2003

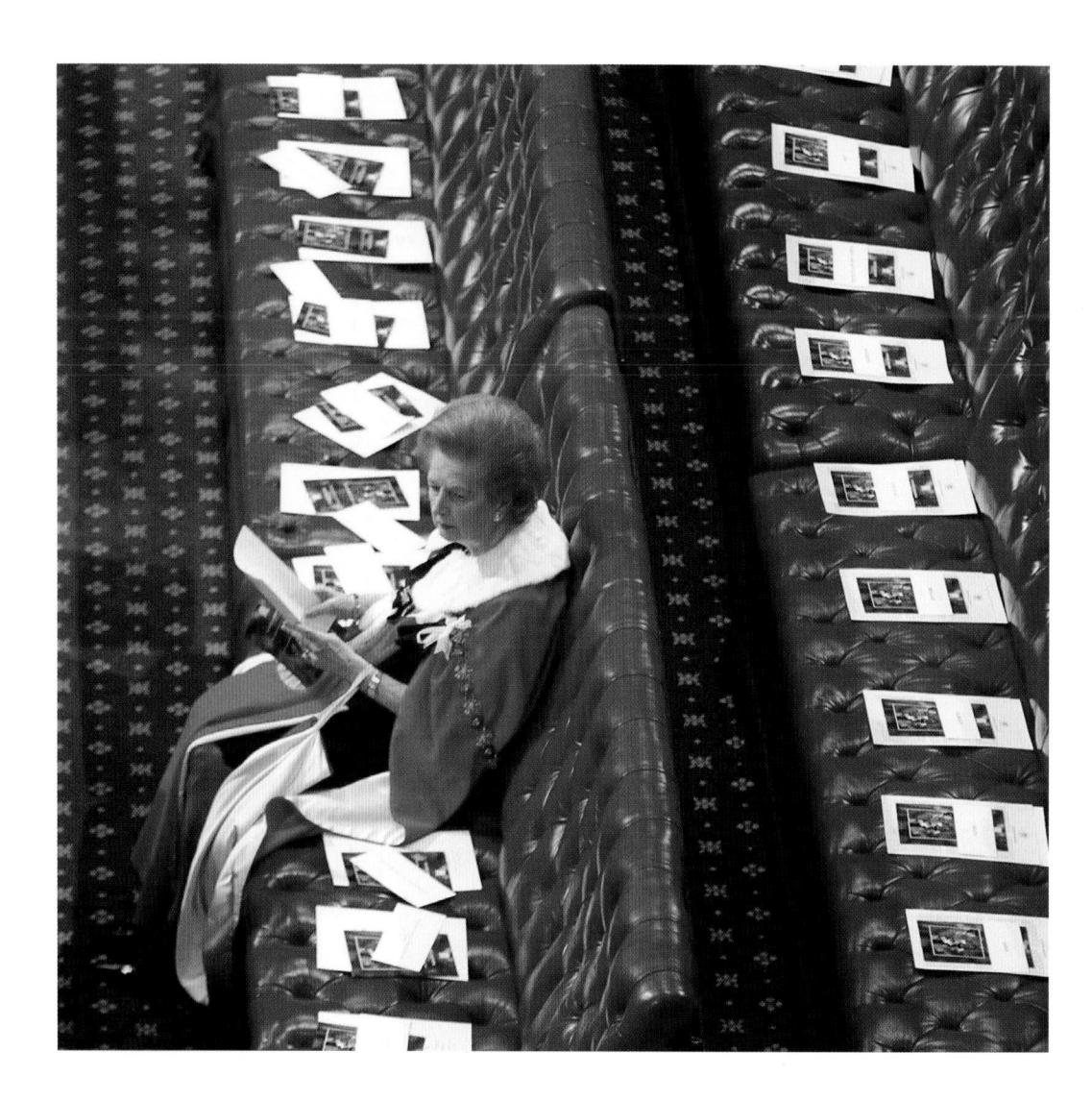

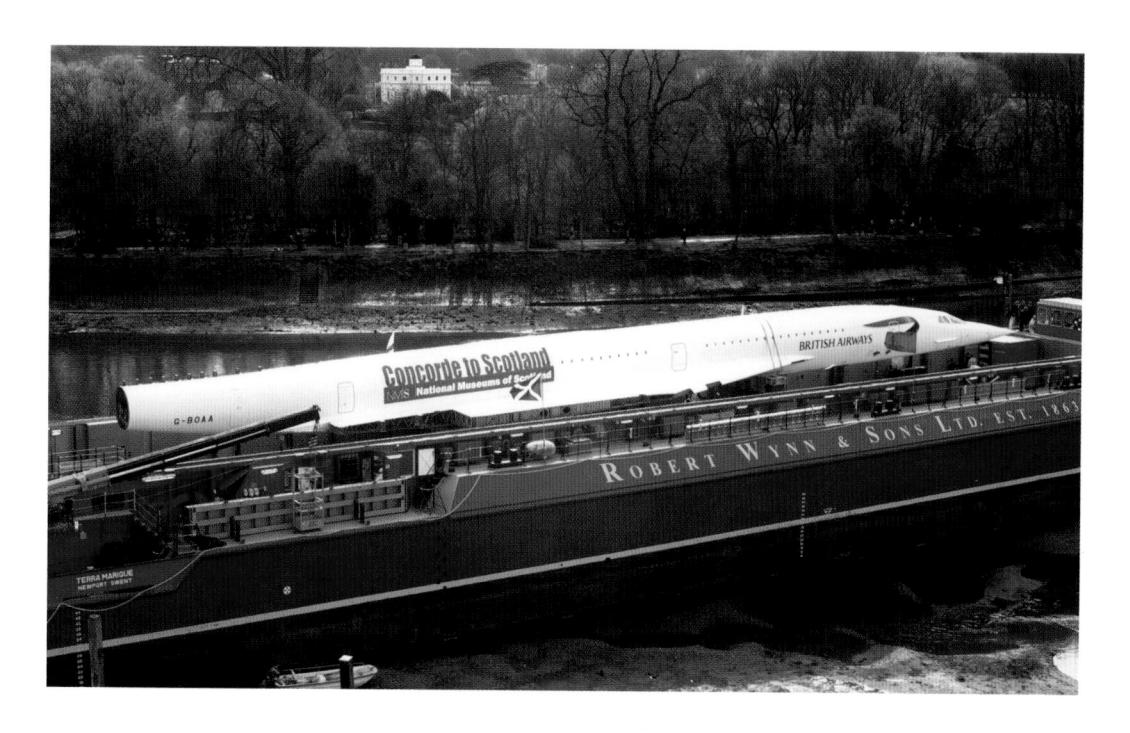

Facing page: Former Prime Minister Baroness Thatcher arrives early for the State Opening of Parliament at the Palace of Westminster.

26 November 2003

The last British Concorde begins its final journey, by barge from Isleworth to the Museum of Flight near Edinburgh.

4 April 2004

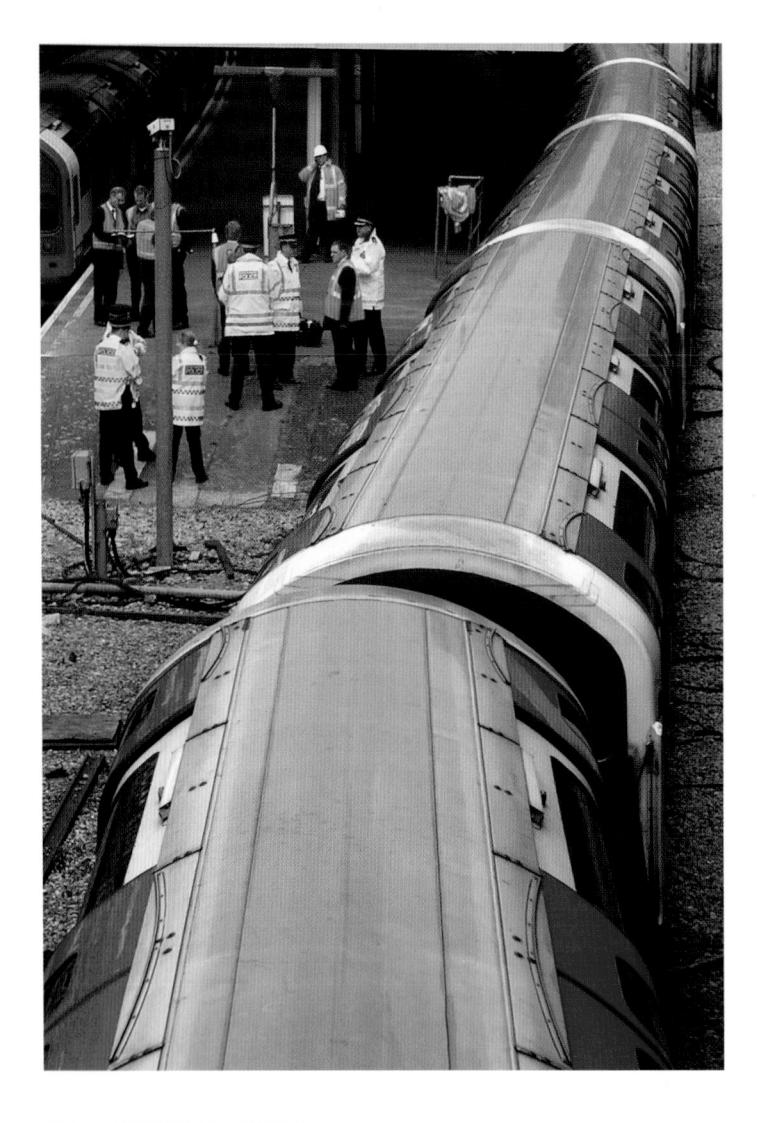

A derailed tube train at White City. None of the 150 passengers were hurt in the incident, which was the fourth derailment on the network in less than 16 months.

11 April 2004

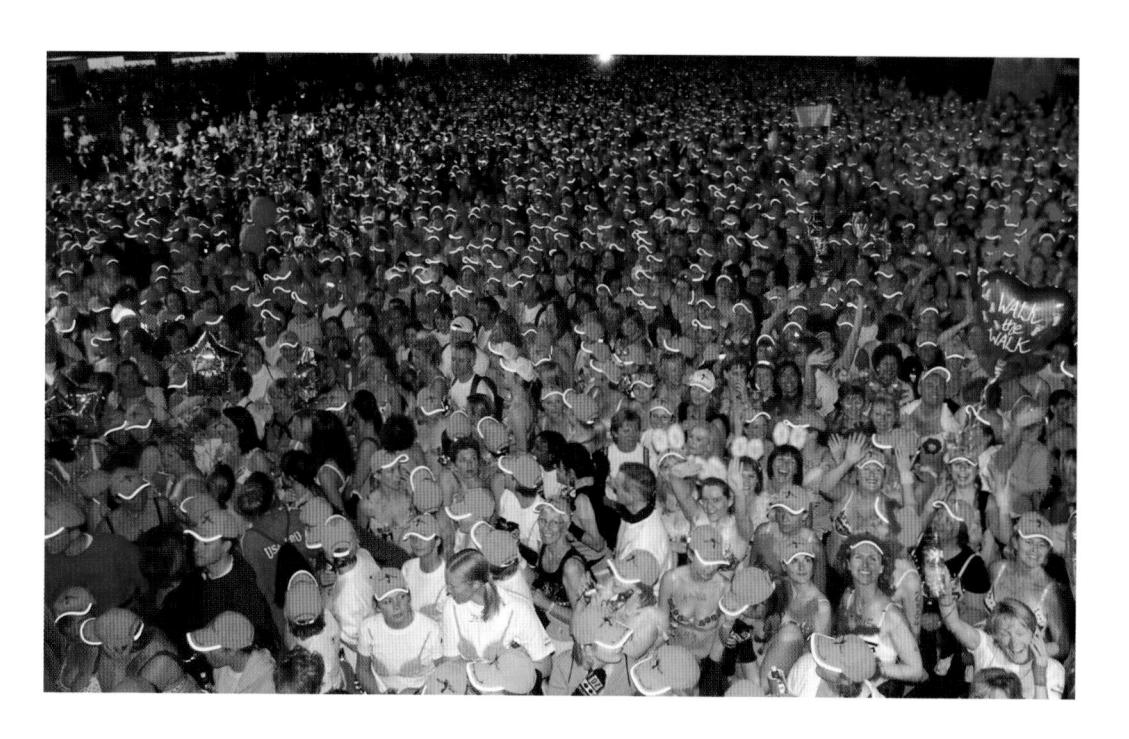

15,000 people take part in the Moonwalk night-time charity walk in aid of Breast Cancer Research, at Hyde Park. 16 May 2004

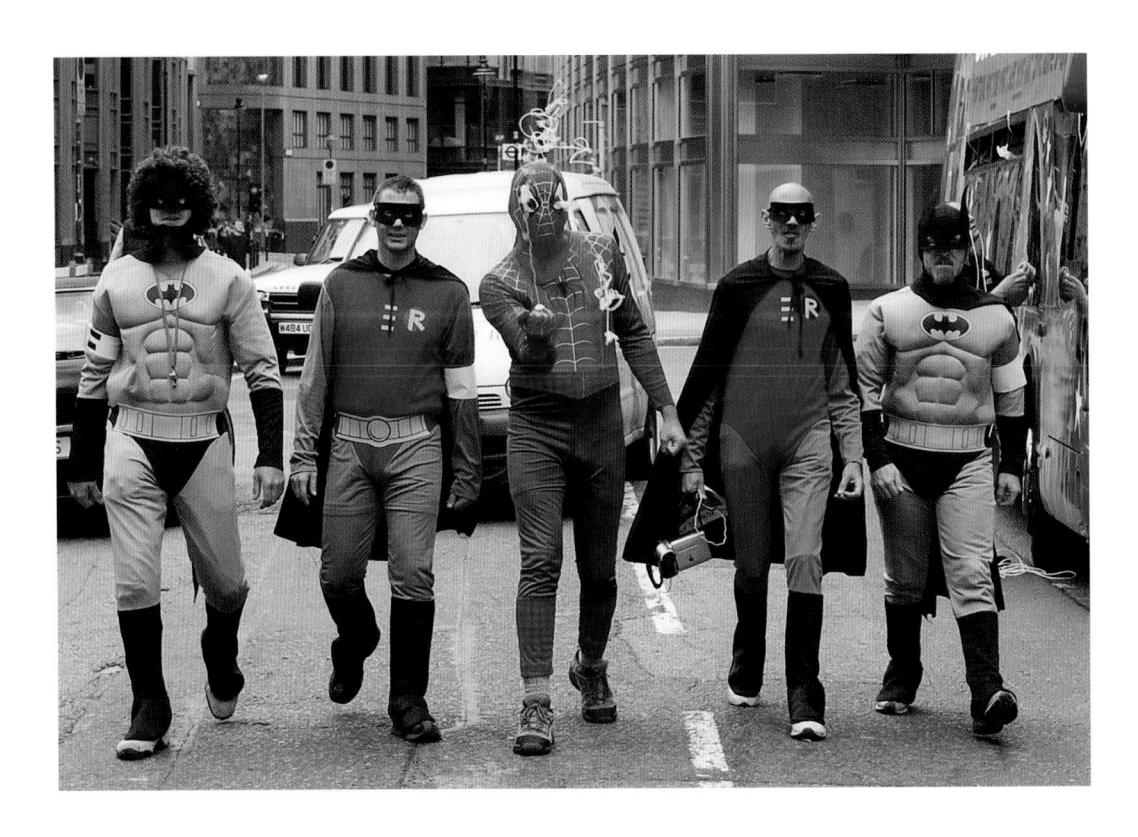

Members of Fathers 4 Justice prepare for Father's Day. 18 June 2004

Facing page: The Pride Parade travels through Piccadilly. The event is thought to be Europe's biggest gay festival.

3 July 2004

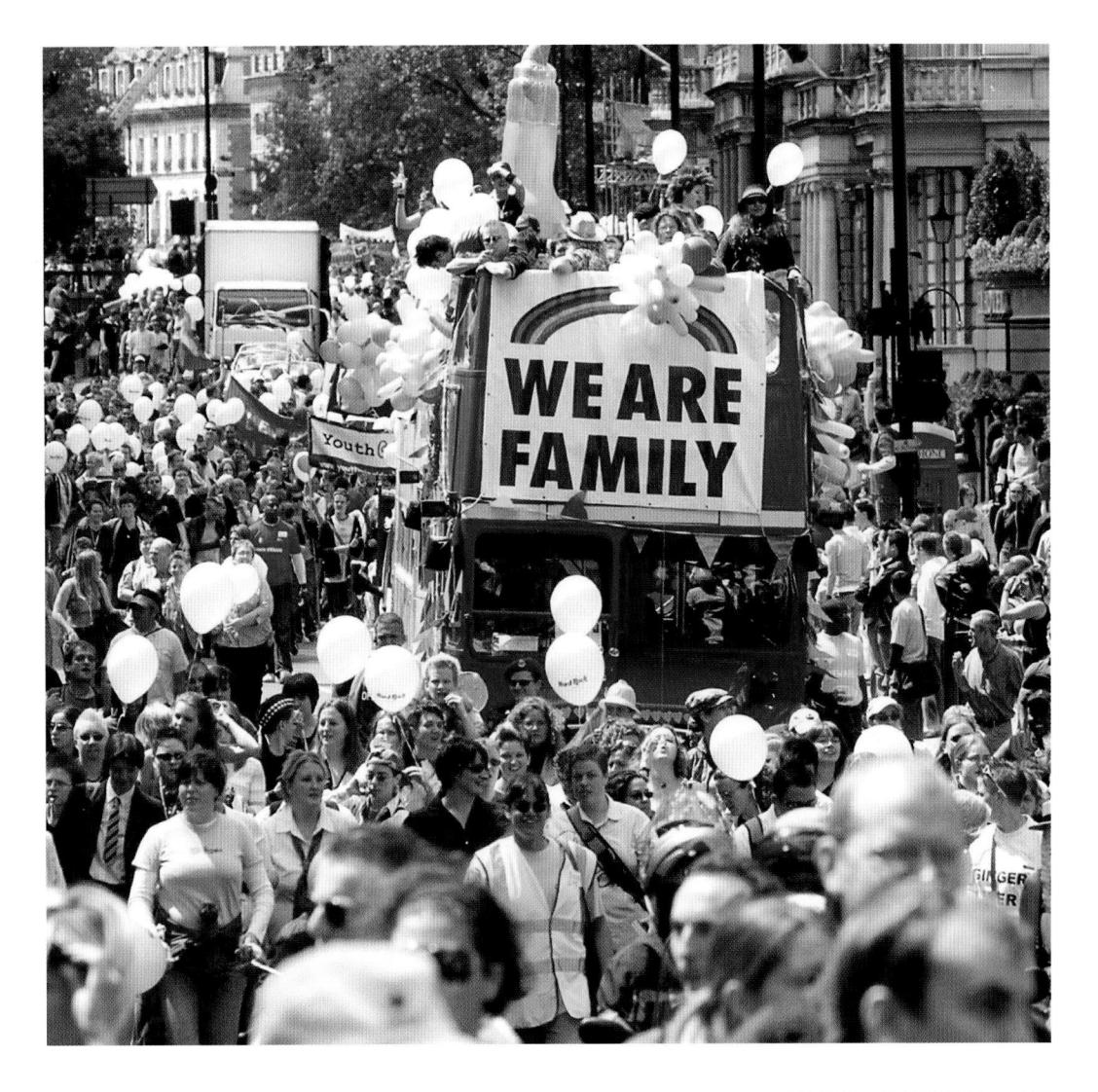

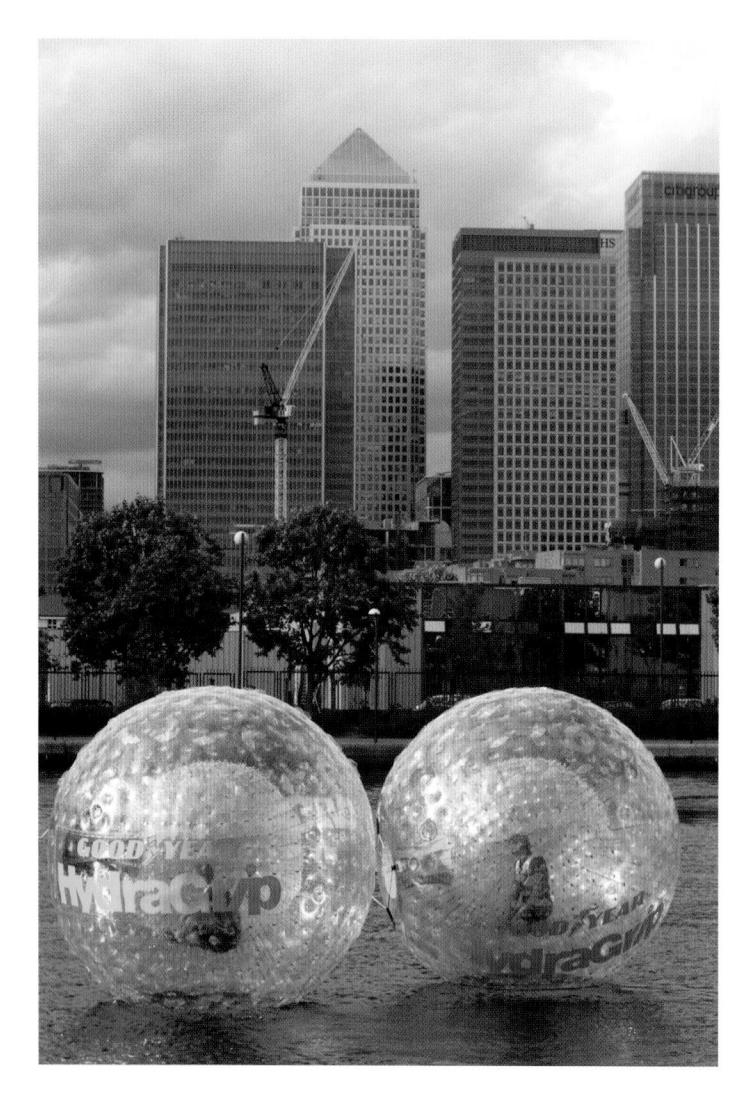

The new sport of Hydrazorbing takes to the water at Docklands Sailing and Watersports Centre on the Isle of Dogs.

15 July 2004

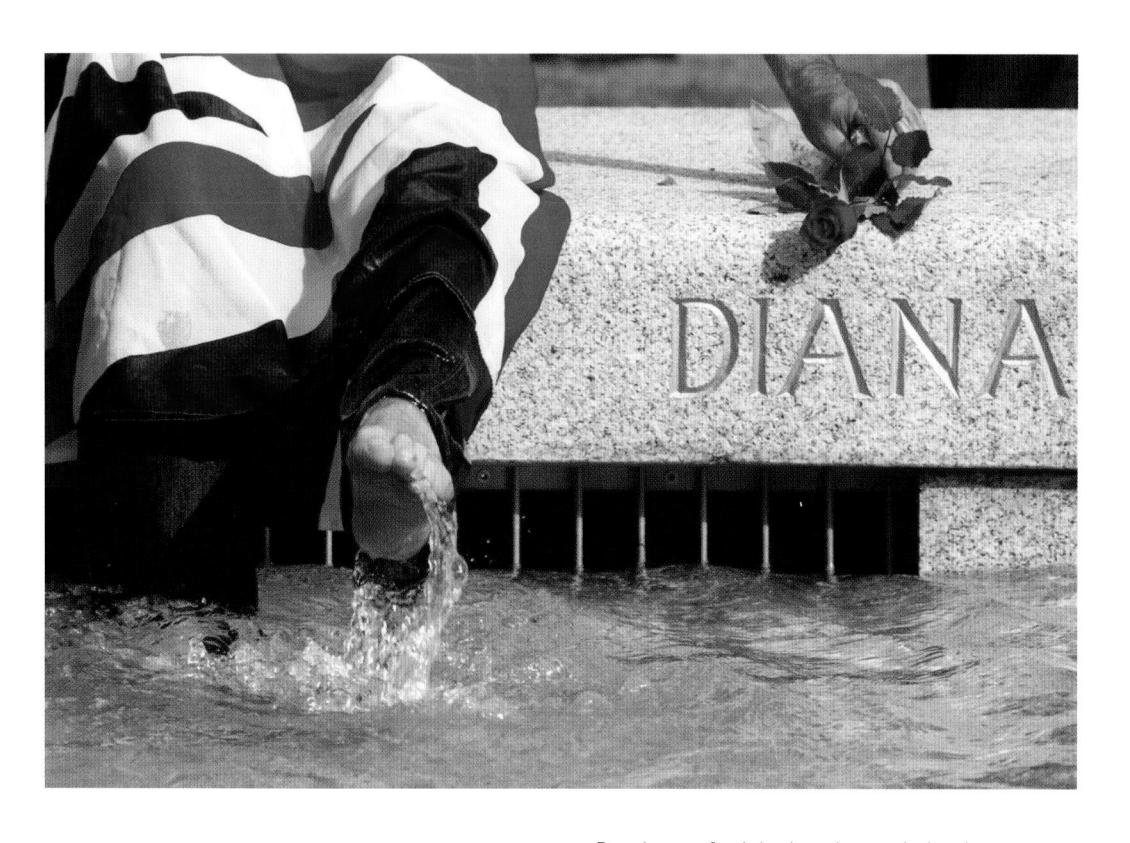

Royal superfan John Loughrey splashes in the Diana Fountain as it reopens to the public following safety modifications.

20 August 2004

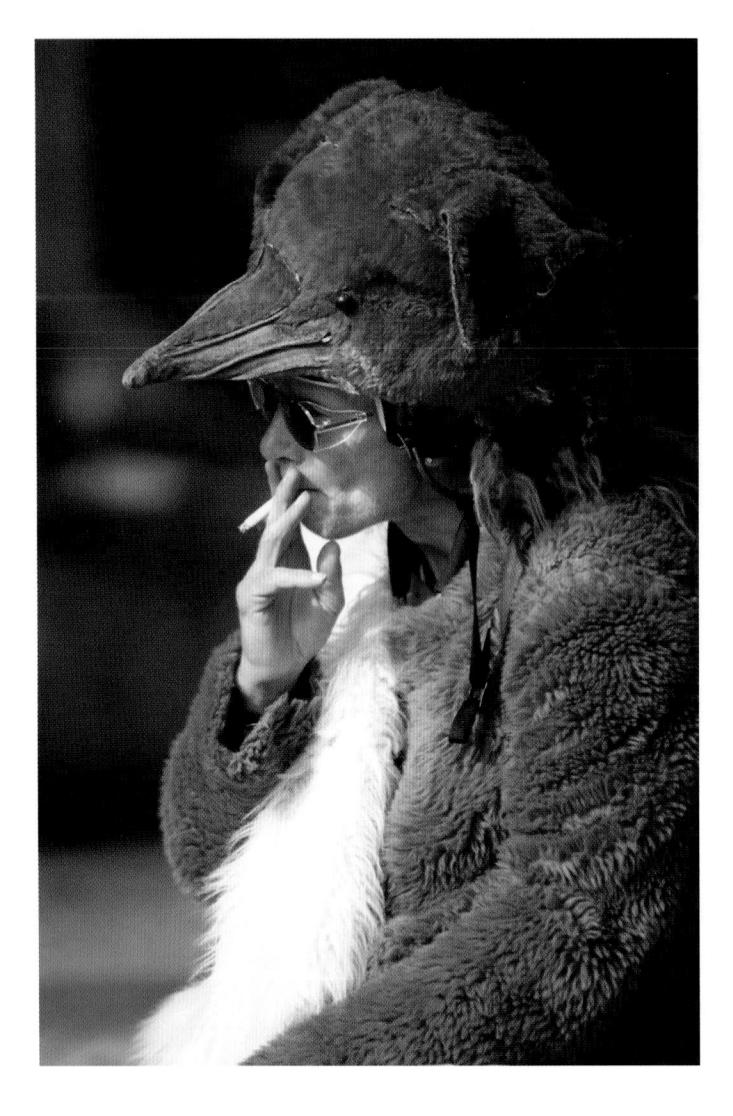

A pro-hunting demonstrator in Parliament Square.

15 September 2004

Facing page: A floral tribute at the National Service of Remembrance at the Cenotaph.

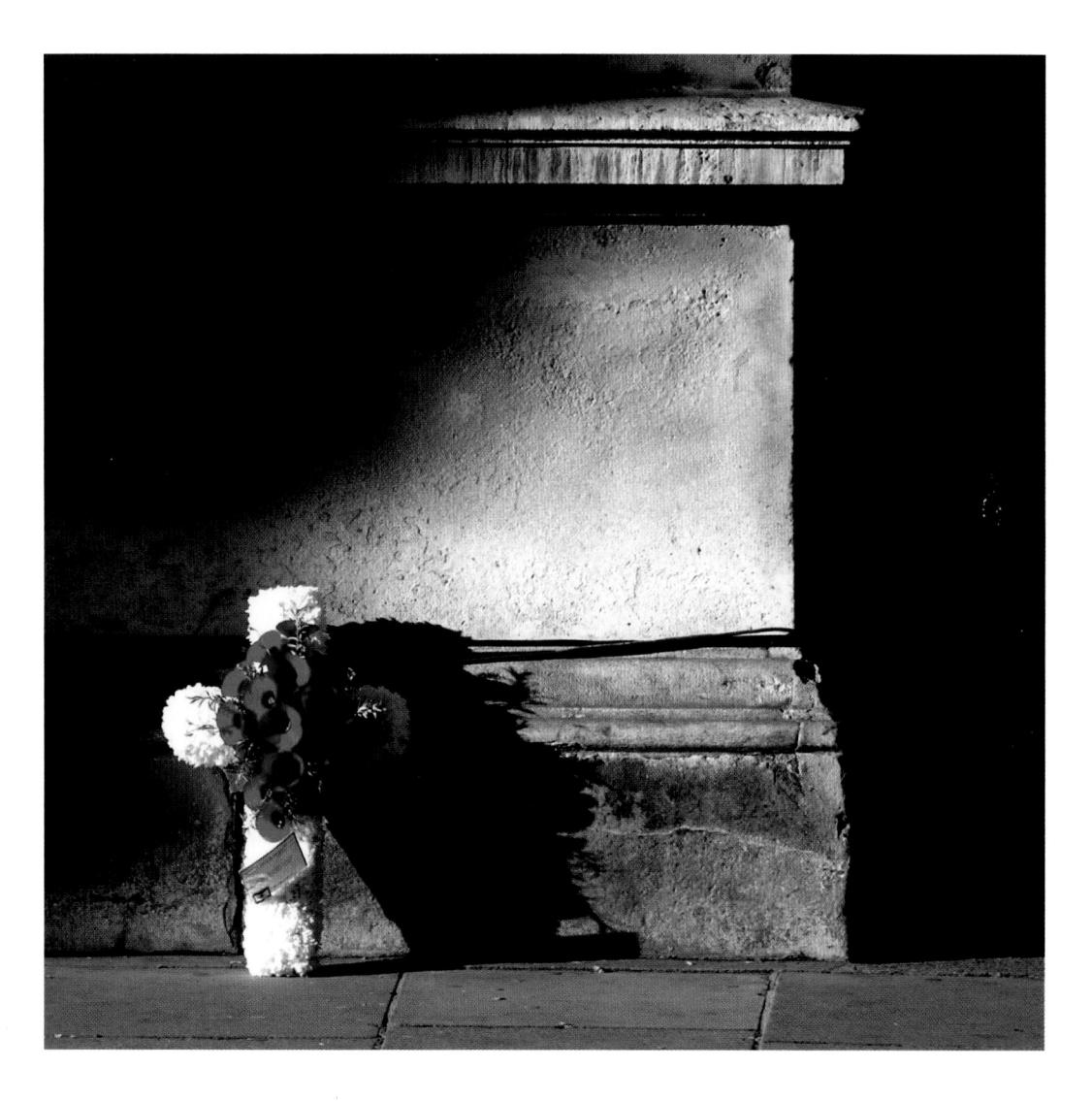

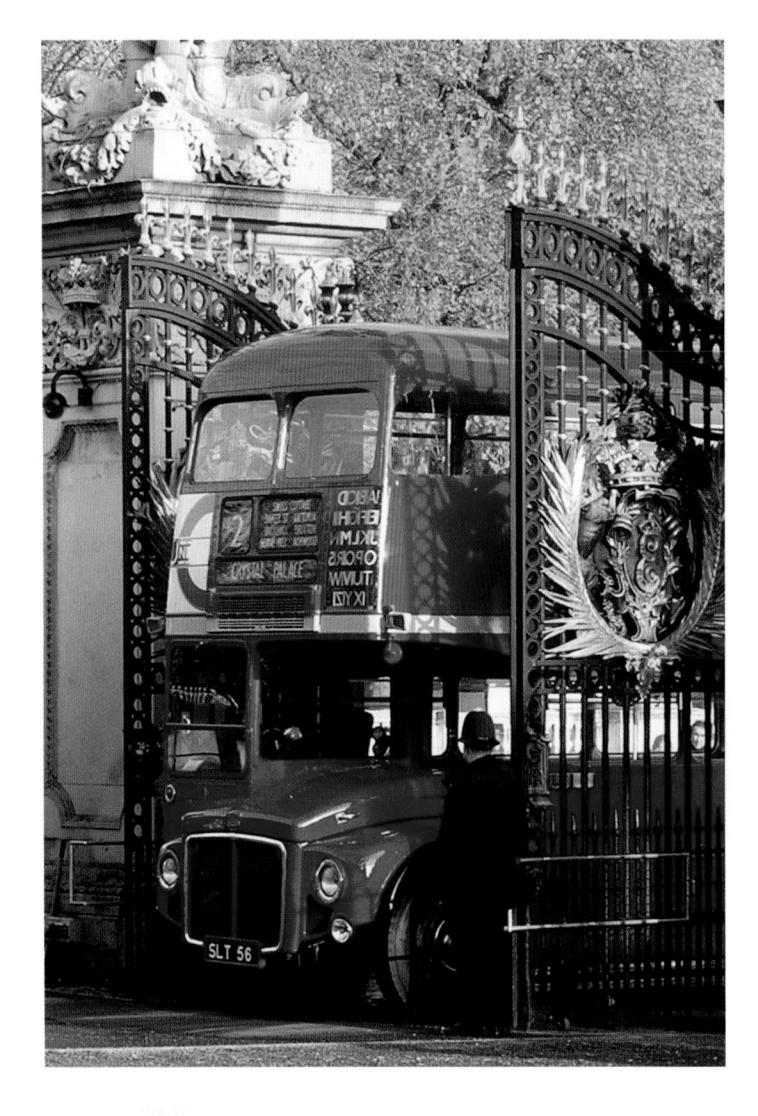

A Routemaster bus arrives at Buckingham Palace, to join other design classics including a Mini and the nose cone from a Concorde for an exhibition showcasing British excellence entitled the Avenue of Design.

22 November 2004

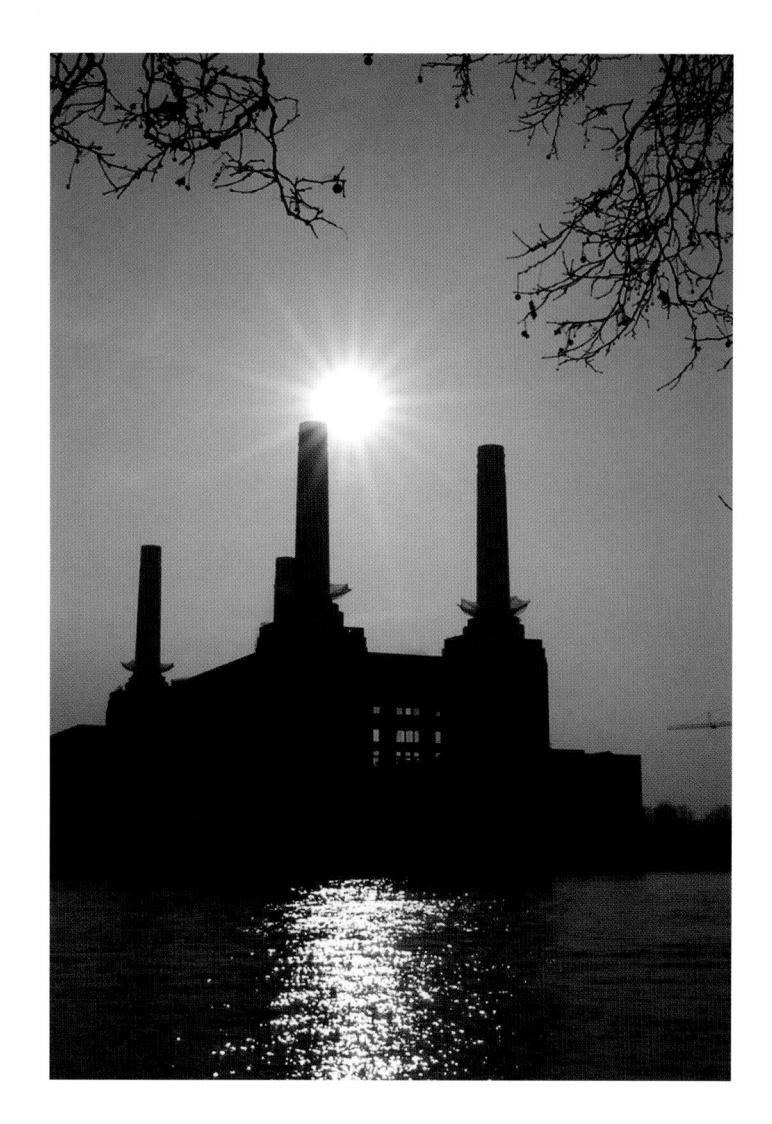

Battered but unbowed. In spite of its listed building status and being a much loved landmark, Battersea Power Station has been derelict for decades. It is now being renovated and developed into a modern living space and cultural hub.

8 February 2005

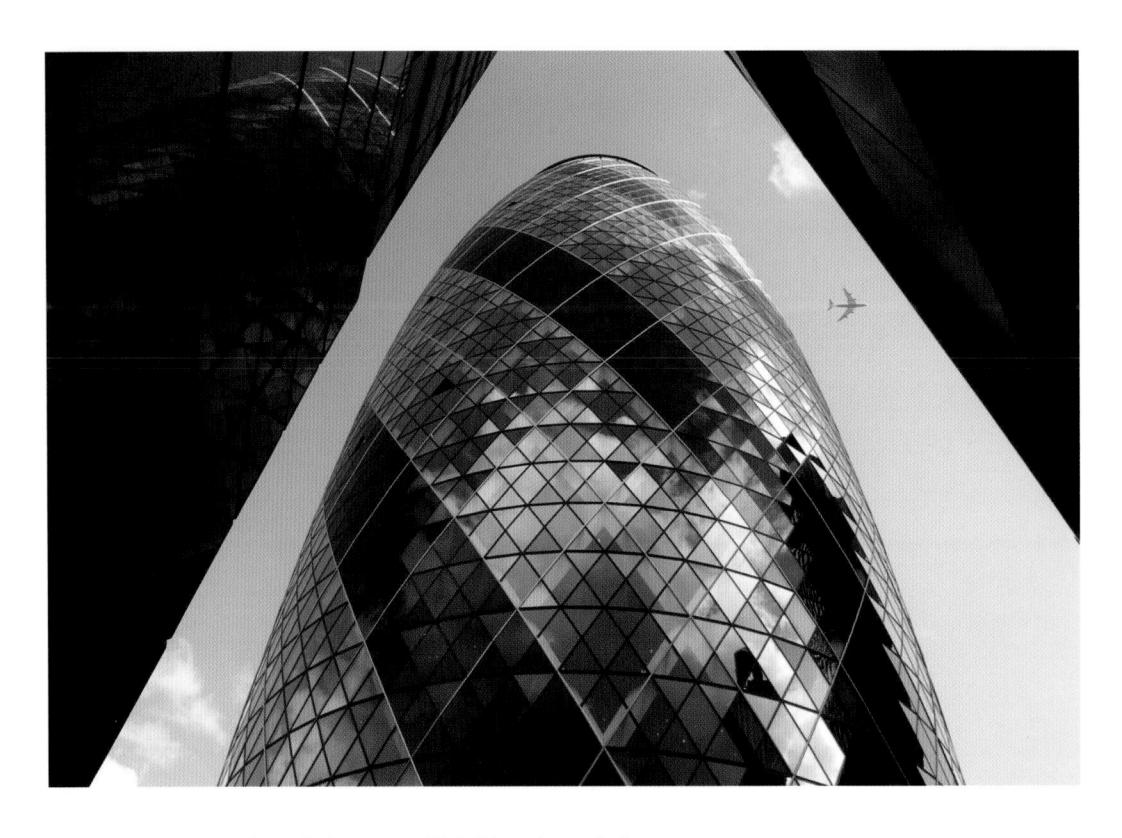

The Gherkin – more formally known as 30 St Mary Axe – built on the site of the old Baltic Exchange building, which was demolished after being structurally ruined by a terrorist bomb in 1992.

6 April 2005

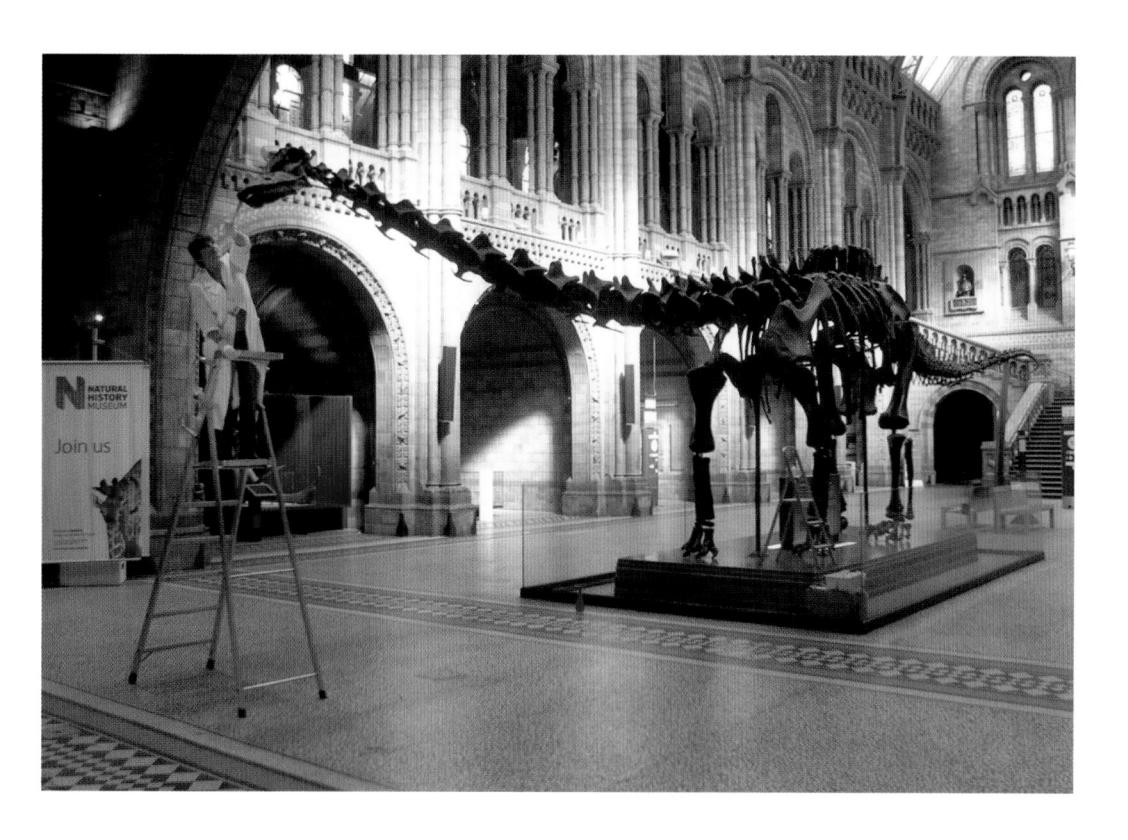

Museum conservator Lorraine Cornish cleaning the skeletal cast of Dippy the diplodocus for its 100th birthday in the Central Hall of the Natural History Museum, South Kensington. Dippy was the star of the museum until 2017, when the skeleton of Hope the blue whale took his place.

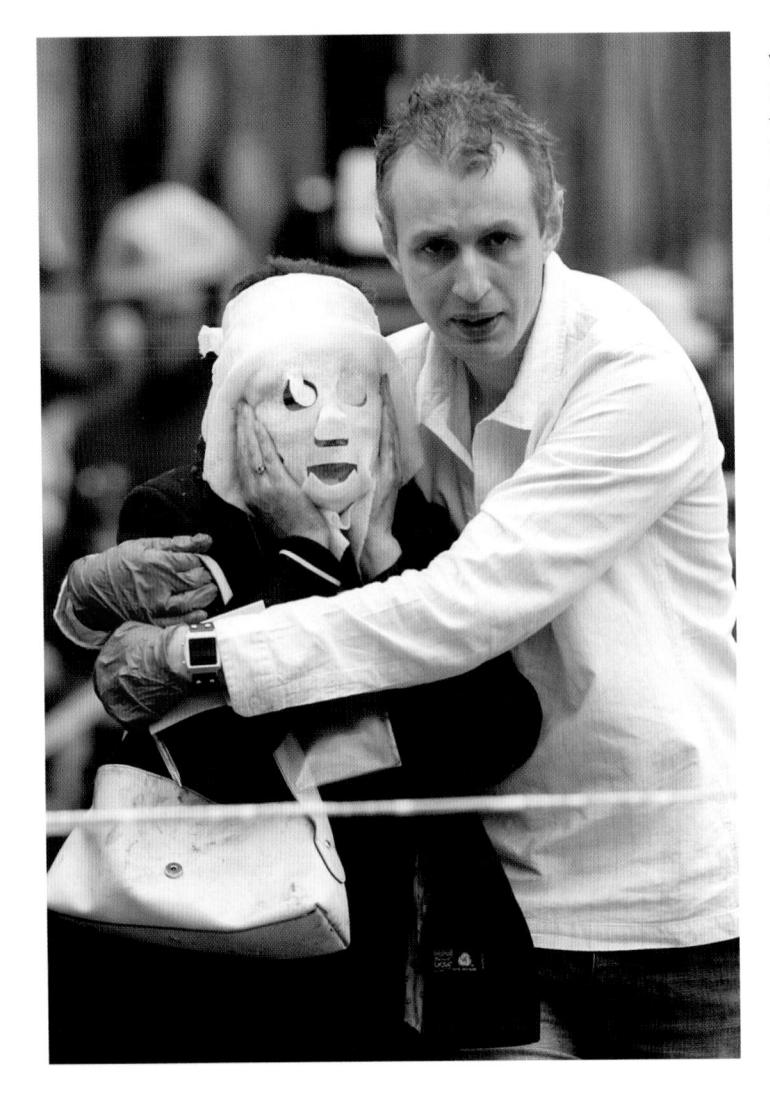

Walking wounded leaving Edgware Road tube station to be treated at the London Hilton Metropole Hotel after explosions ripped through central London.

7 July 2005

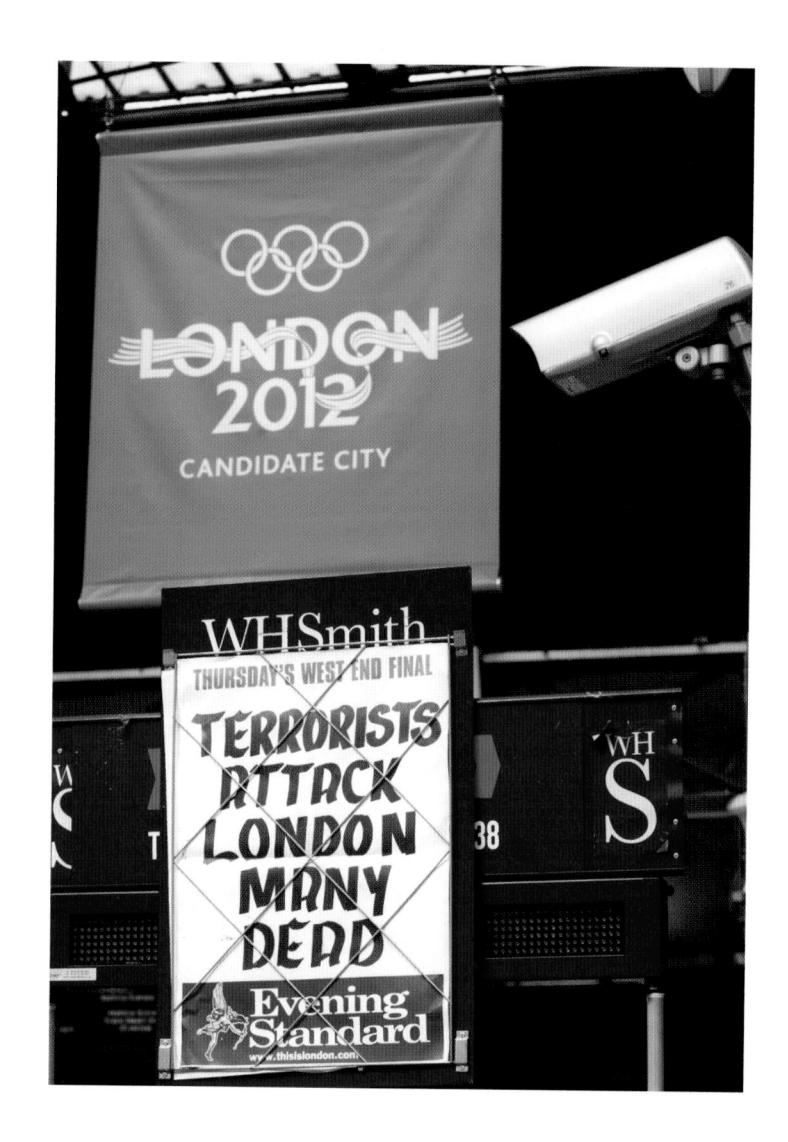

Suicide bombers struck as London prepared to celebrate being awarded the 2012 Olympics. 7 July 2005

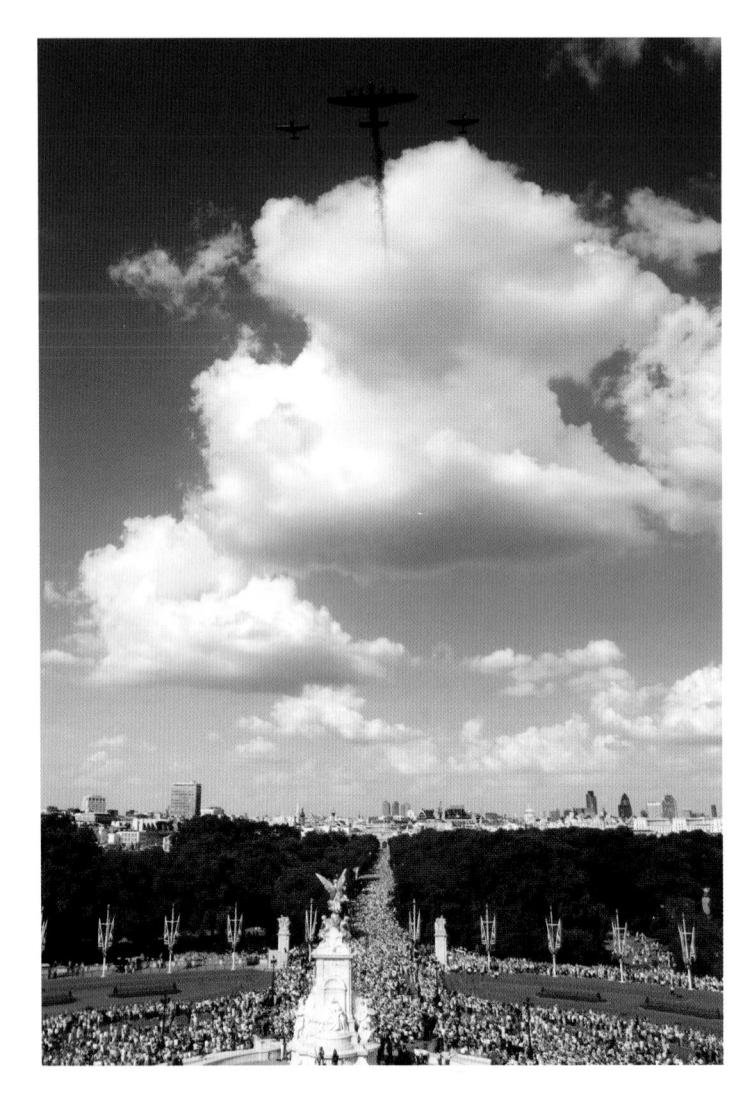

A Lancaster bomber from the RAF Battle of Britain Memorial Flight, flanked by a Hurricane and a Spitfire, drops one million poppies over The Mall to commemorate 60 years since the end of the Second World War. 20 July 2005

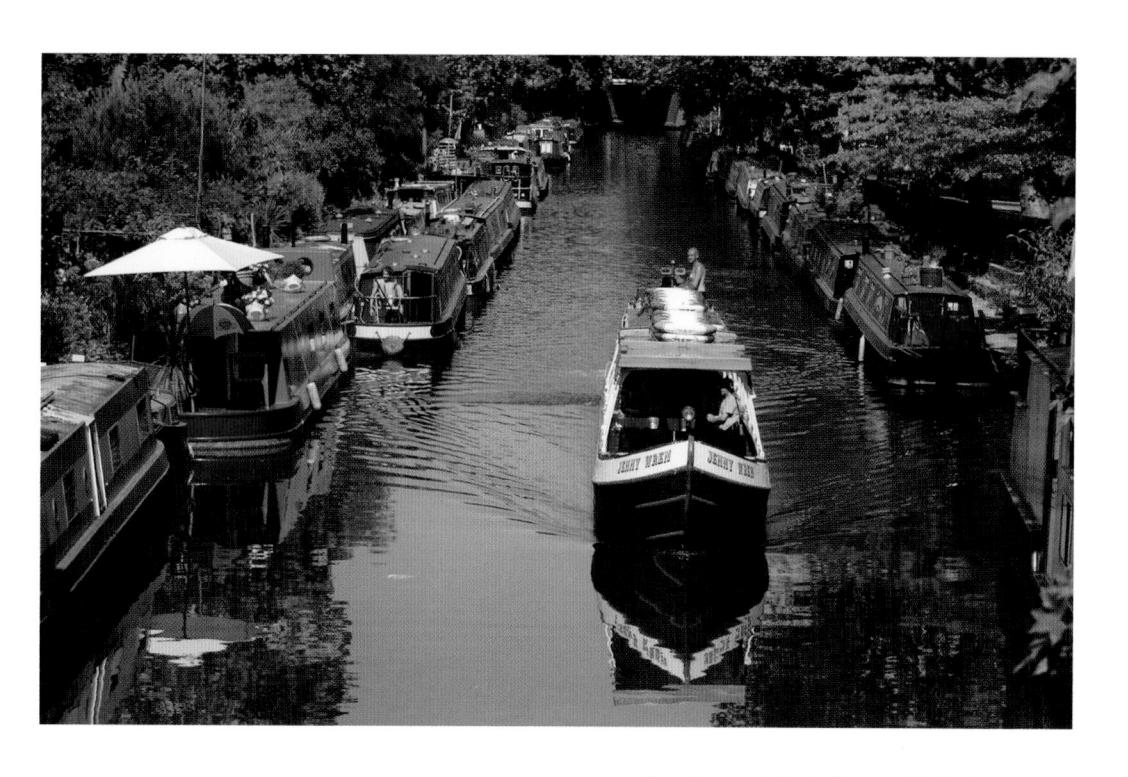

Canal boats in Little Venice, Maida Vale. 17 July 2006

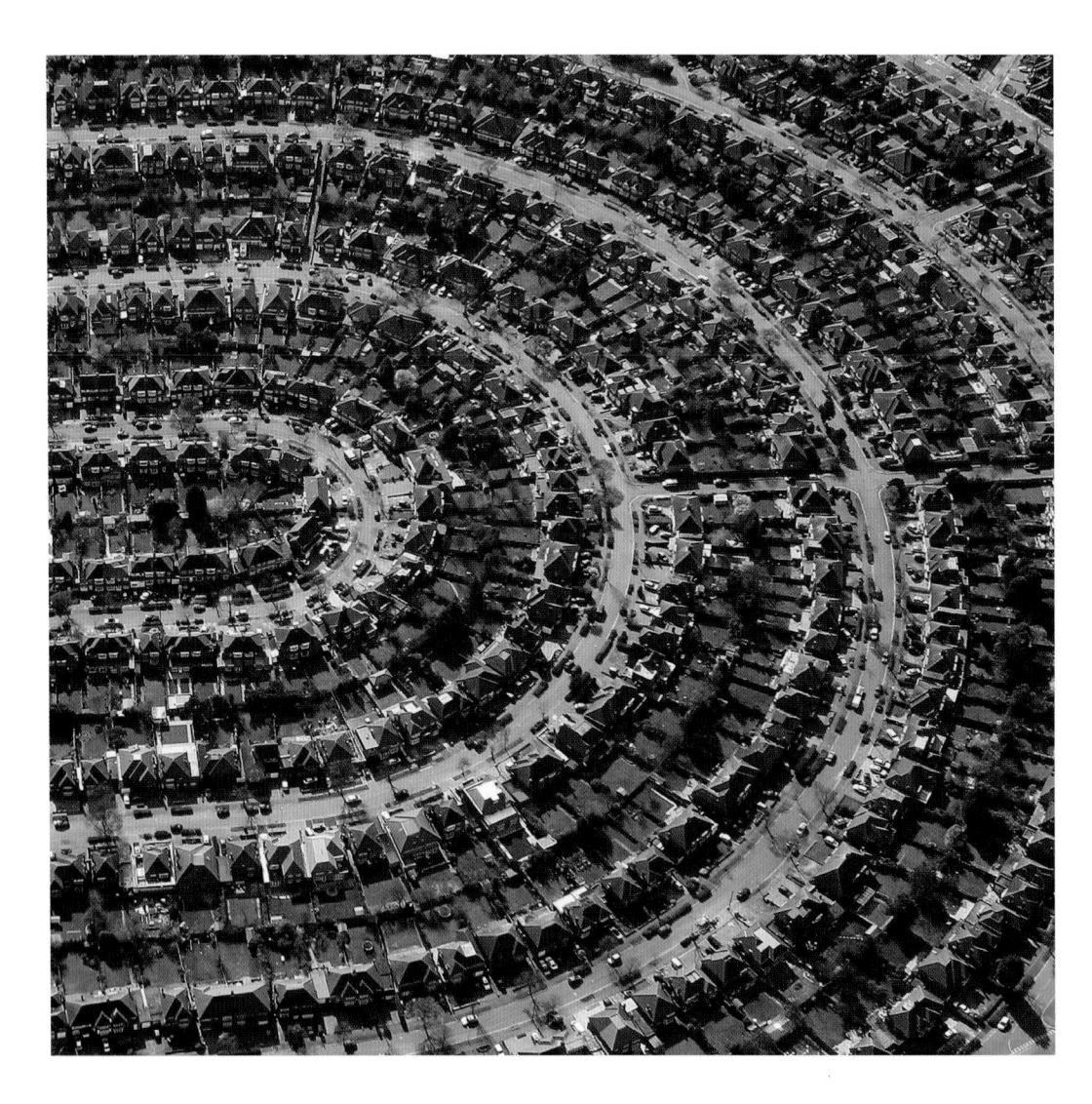

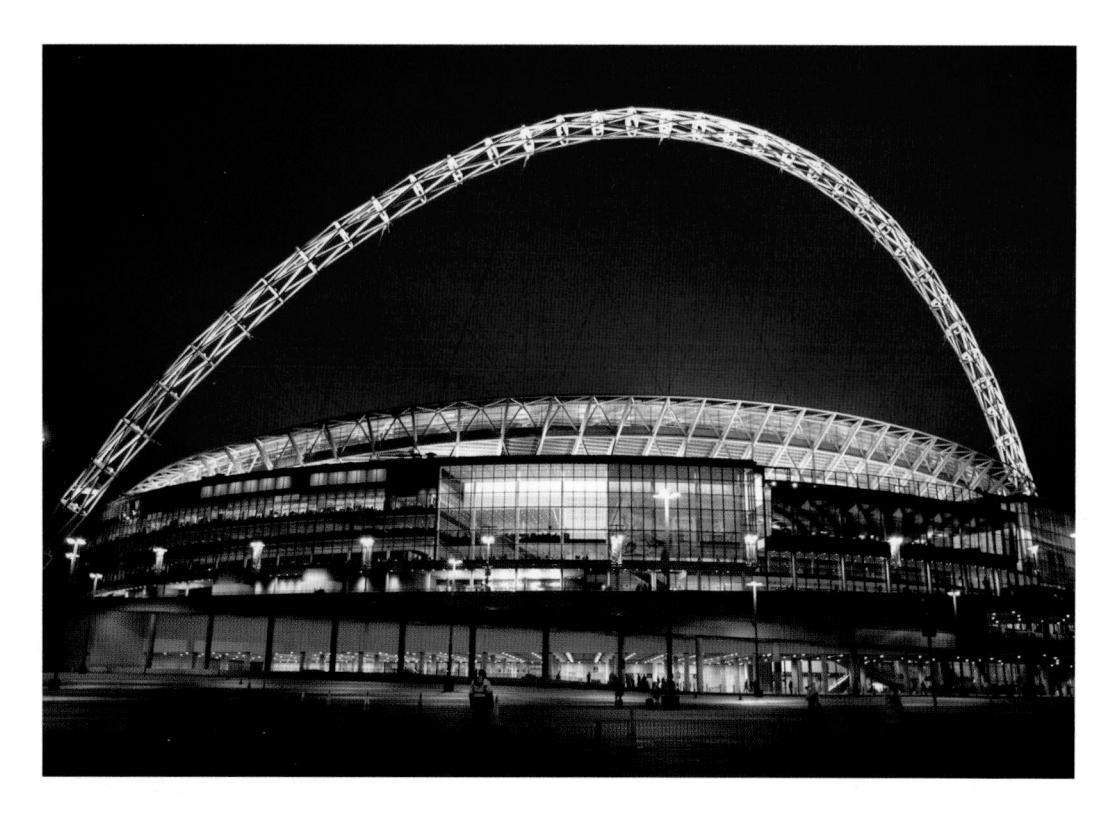

The new Wembley Stadium.
21 November 2007

Facing page: Edgware from the air.

II March 2007

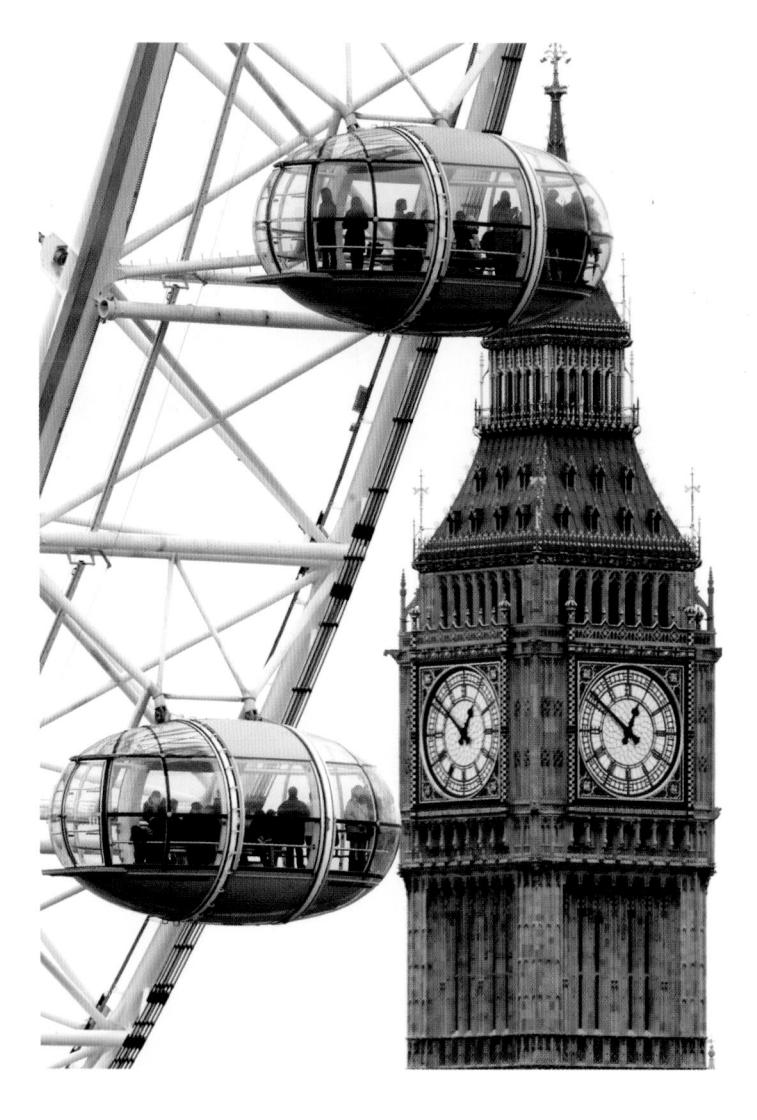

By 2015, more than 60 million people had visited the London Eye. The wheel can carry 800 people at a time in its 32 capsules.

5 June 2008

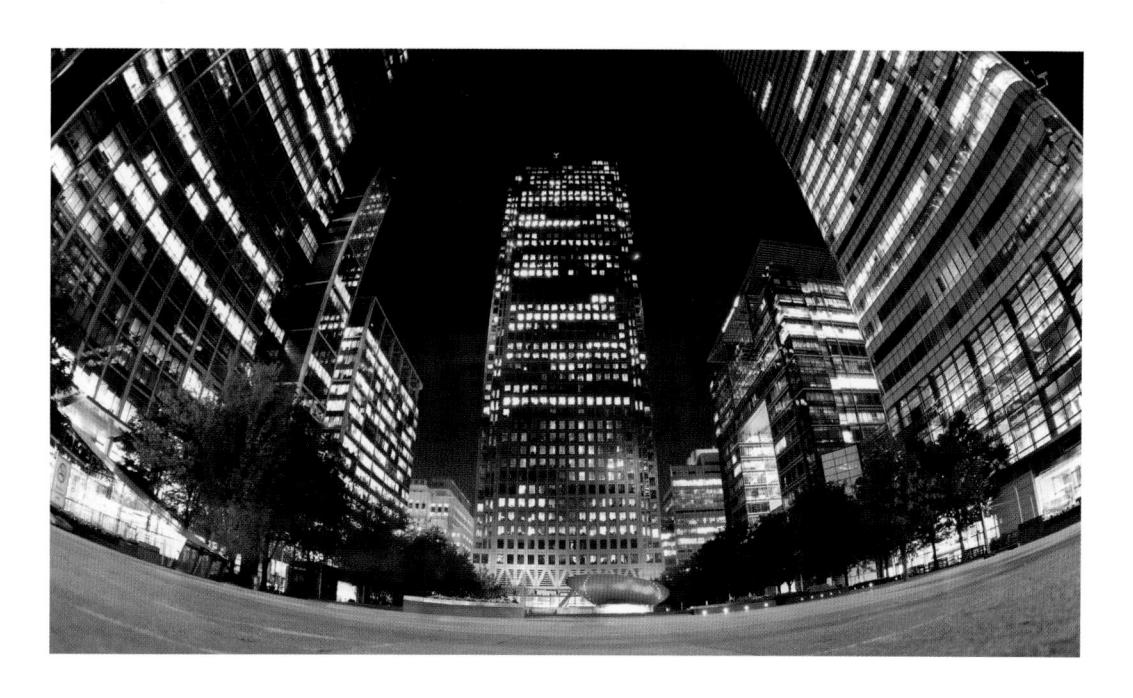

Canary Wharf by night. 28 September 2008

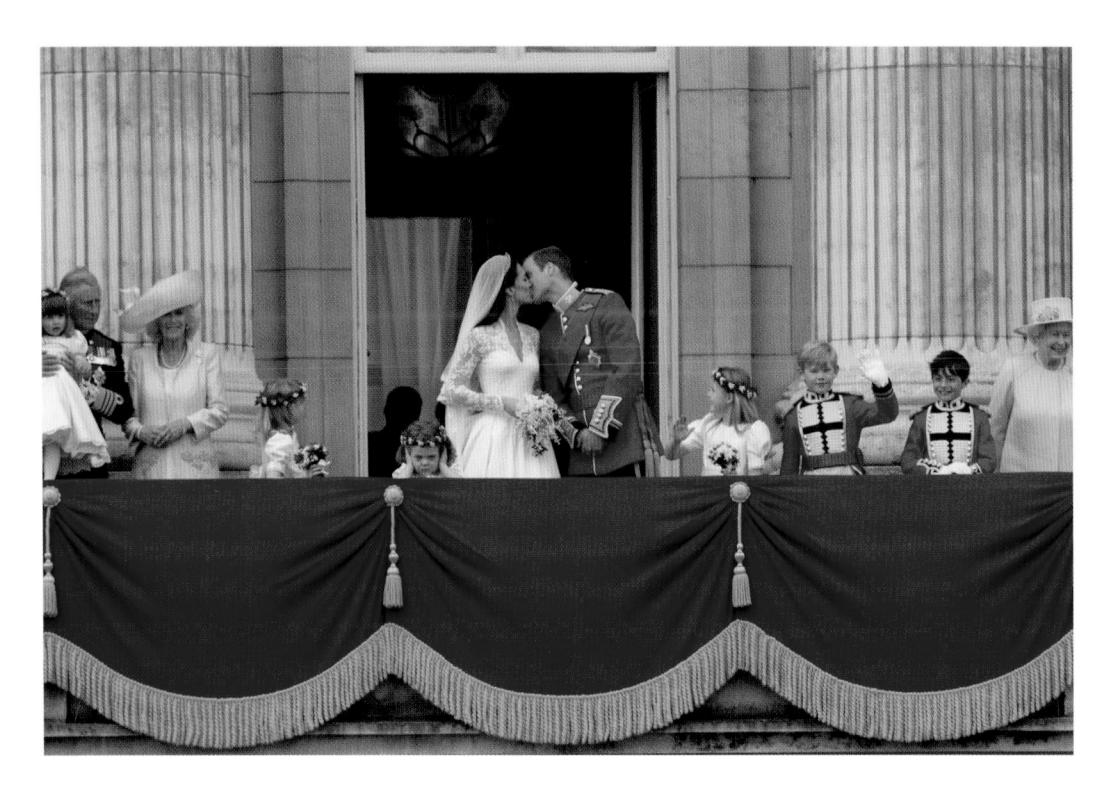

After their wedding at Westminster Abbey, Prince William and Kate Middleton, the new Duchess of Cambridge, share a kiss on the balcony of Buckingham Palace.

29 April 2011

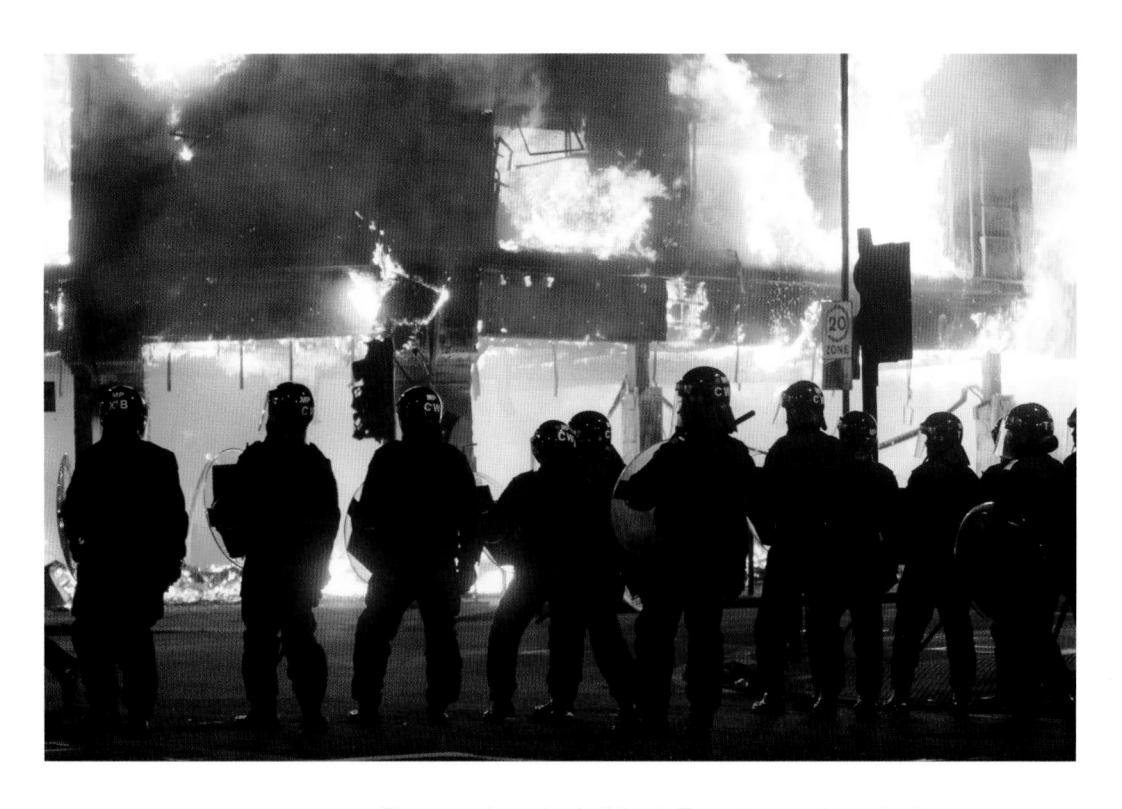

Fire rages through a building in Tottenham as riot police line across a street. There was unrest across the capital and in other English cities after the killing by police of Mark Duggan in Tottenham three days earlier.

7 August 2011

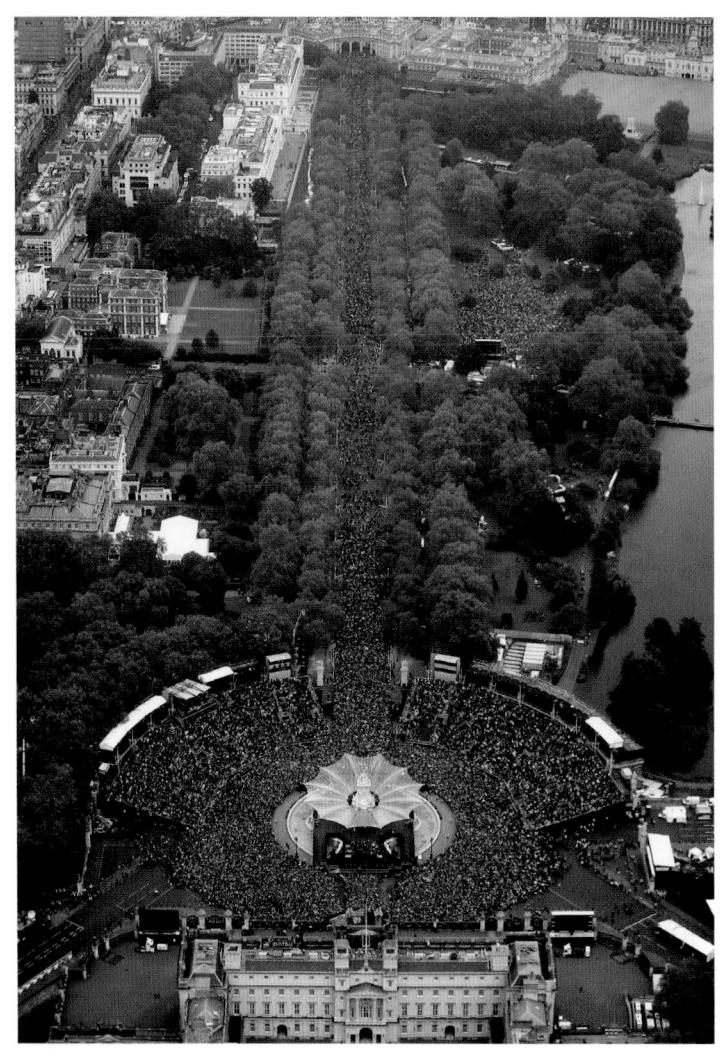

The Mall is filled with crowds celebrating the Queen's Diamond Jubilee. As the Queen appeared on the balcony of Buckingham Palace, the RAF Battle of Britain Memorial Flight formation flew past.

5 June 2012

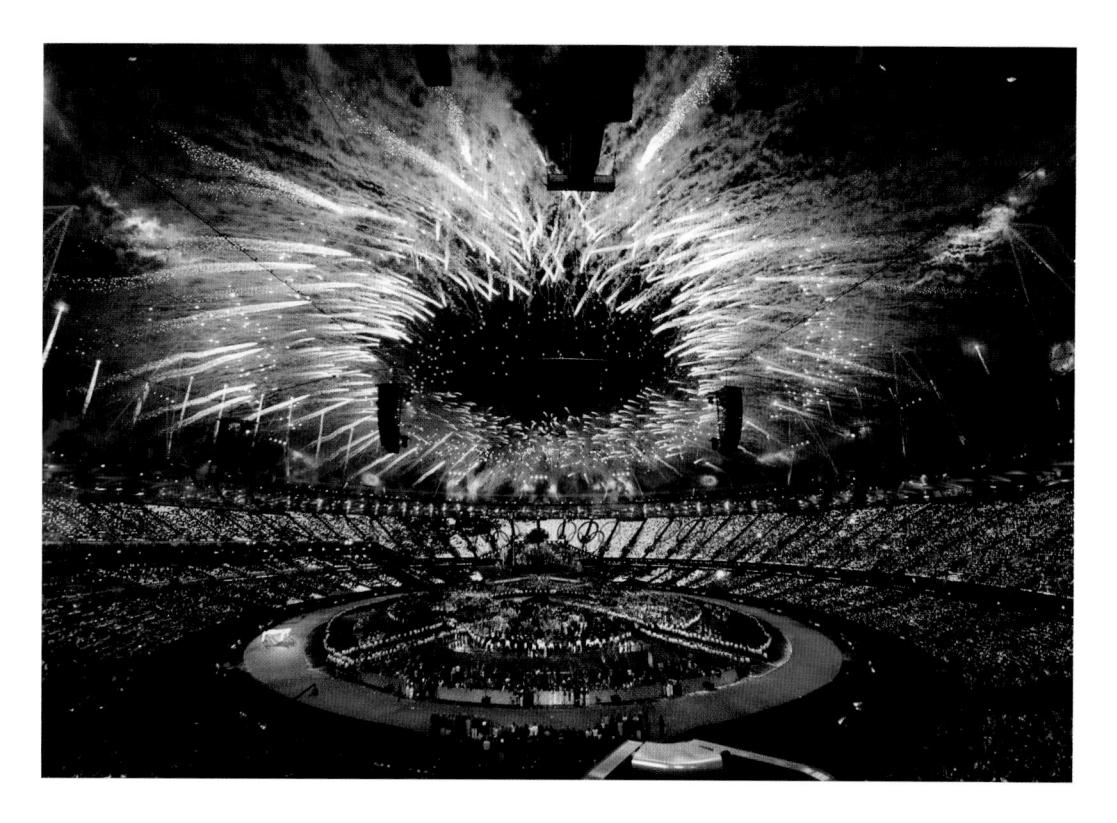

The opening ceremony of the 2012 Olympics was a spectacular showcase of Great Britain. The centrepiece of the new Olympic Park in East London was the stadium, which is now home to West Ham United and UK Athletics.

27 July 2012

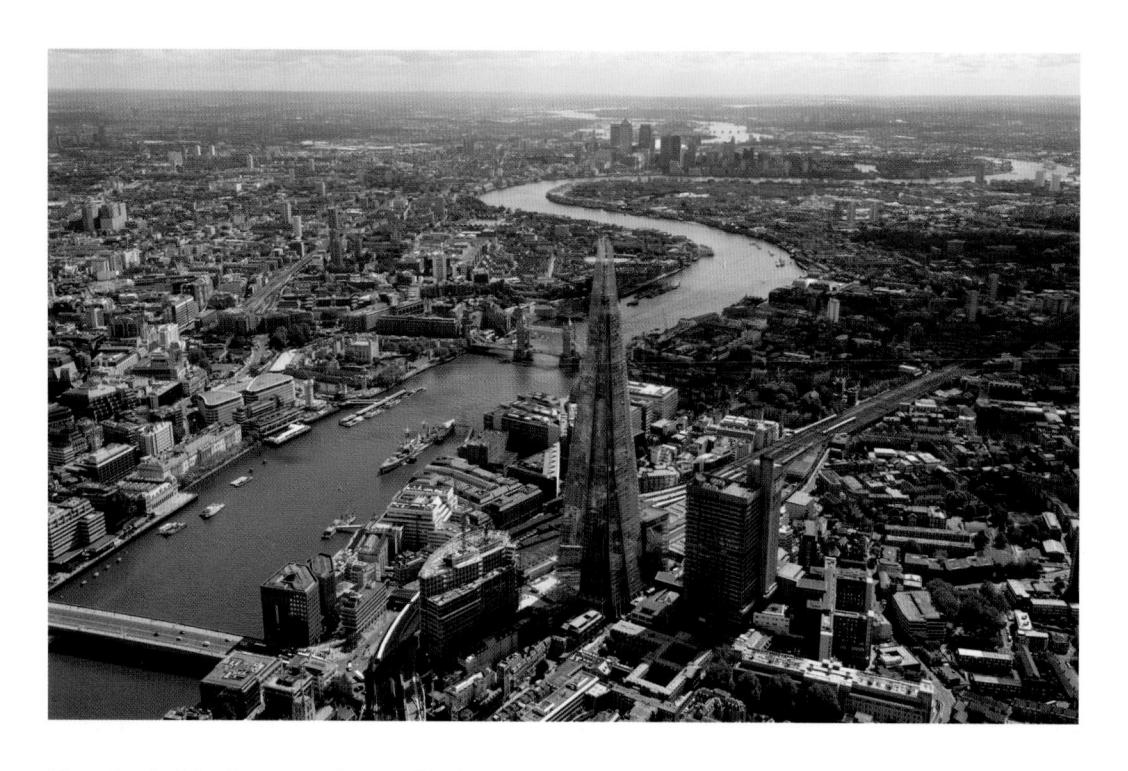

The tallest building in western Europe, The Shard's glassy exterior was completed in 2012. A viewing platform on the 72nd floor was opened to the public the following year, giving views across London of up to $65 \, \text{km}$. July 2012

Great Britain's Andy Murray beats Serbia's Novak Djokovic to win Wimbledon, the first British male singles champion in 77 years. 7 July 2013

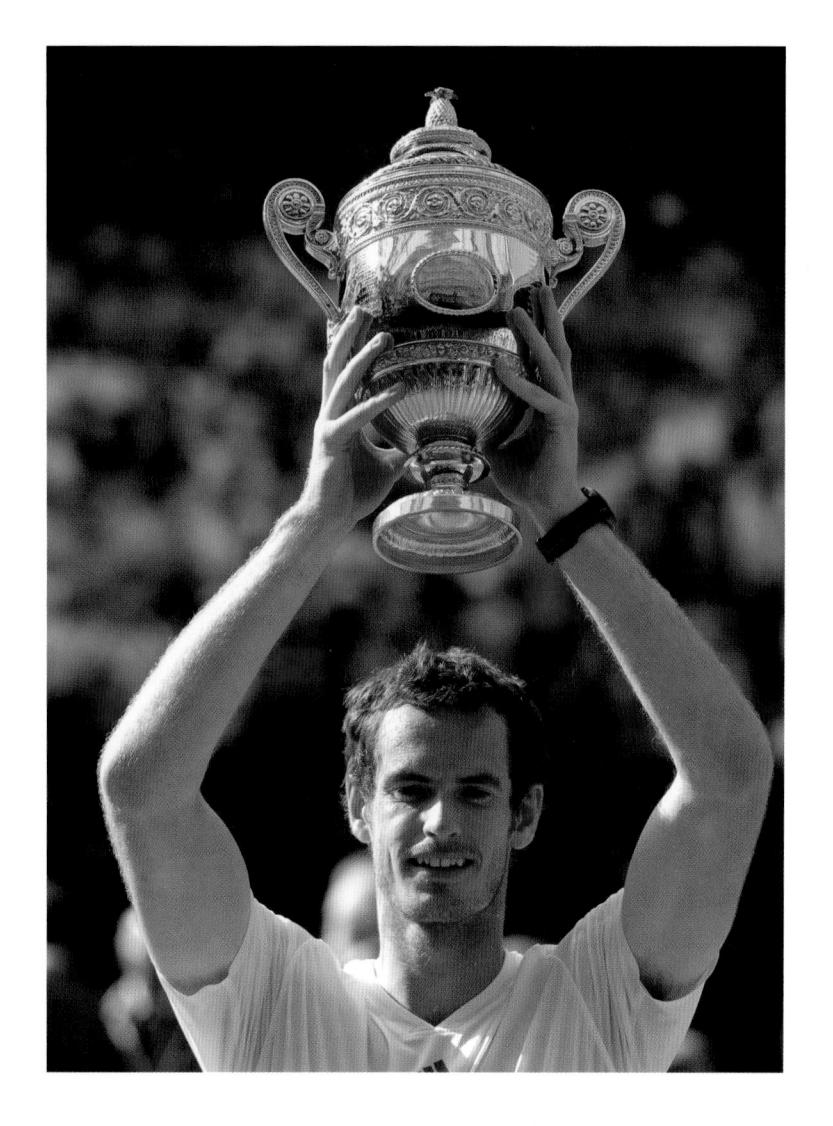

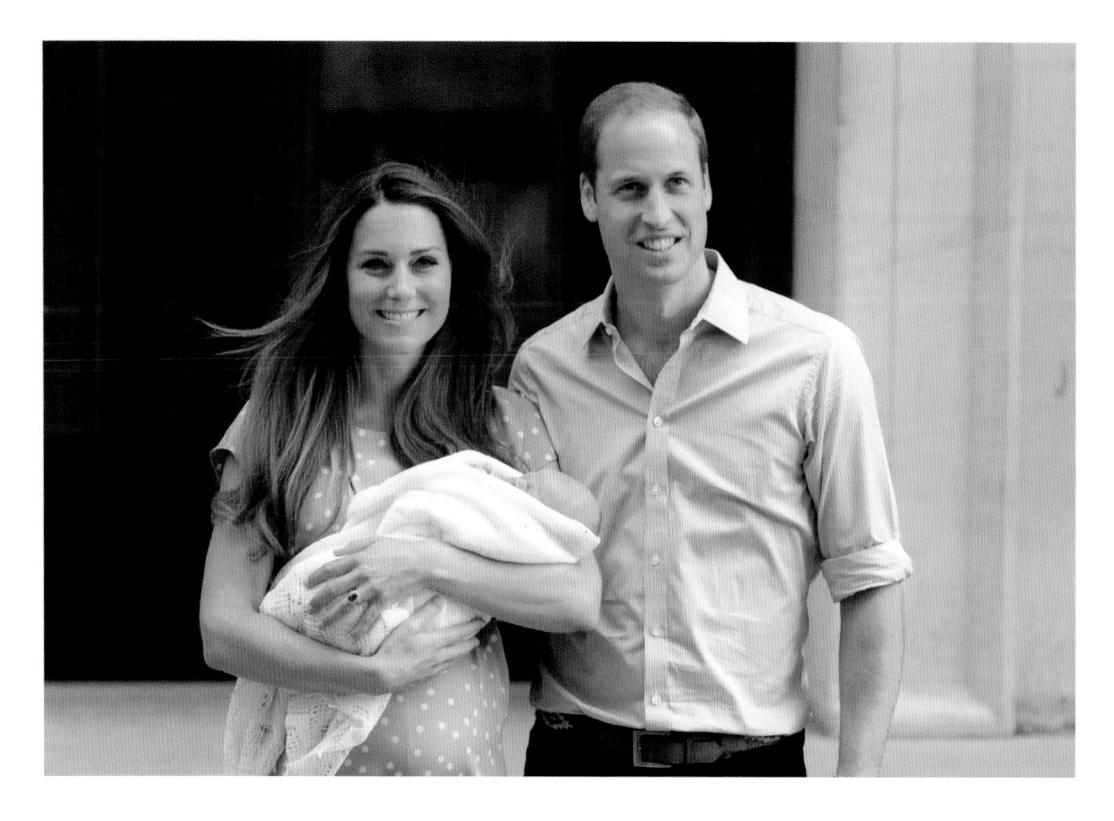

The Duke and Duchess of Cambridge outside St Mary's Hospital with their one-day-old son, Prince George. 23 July 2013

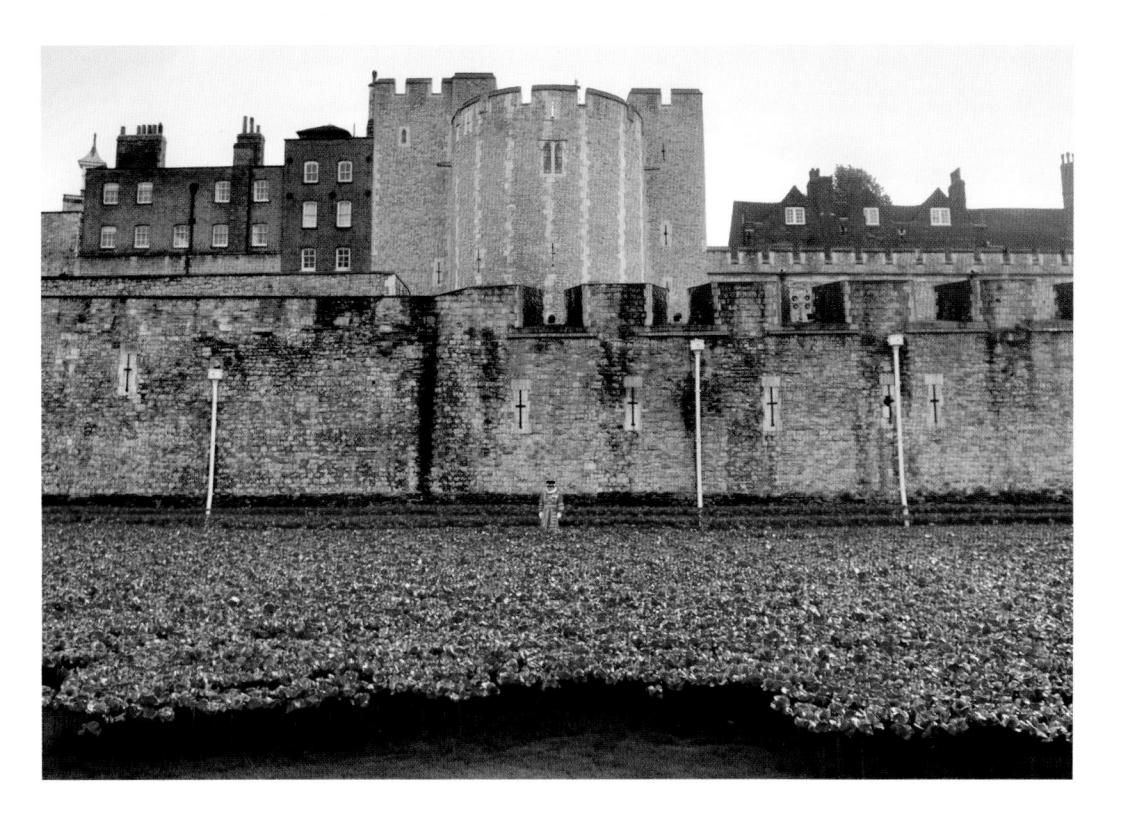

A Beefeater surveys some of the 888,246 ceramic poppies on display at the Tower of London. The installation marks 100 years of Britain's involvement in the First World War, with each poppy representing a British or Commonwealth death during the conflict.

16 October 2014

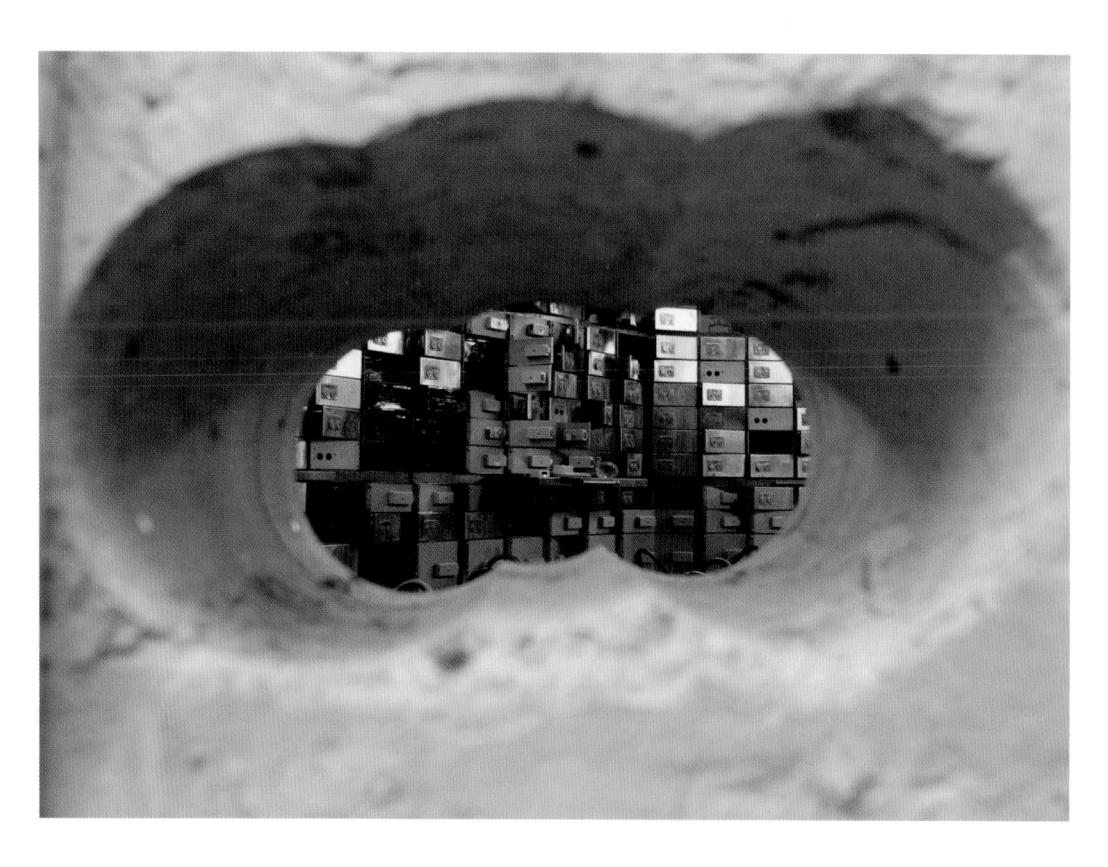

A hole drilled in the wall of a bank vault at the Hatton Garden Safe Deposit. Burglars stole £13.7 million of gold, cash and gems from 73 boxes in the raid.

April 2015

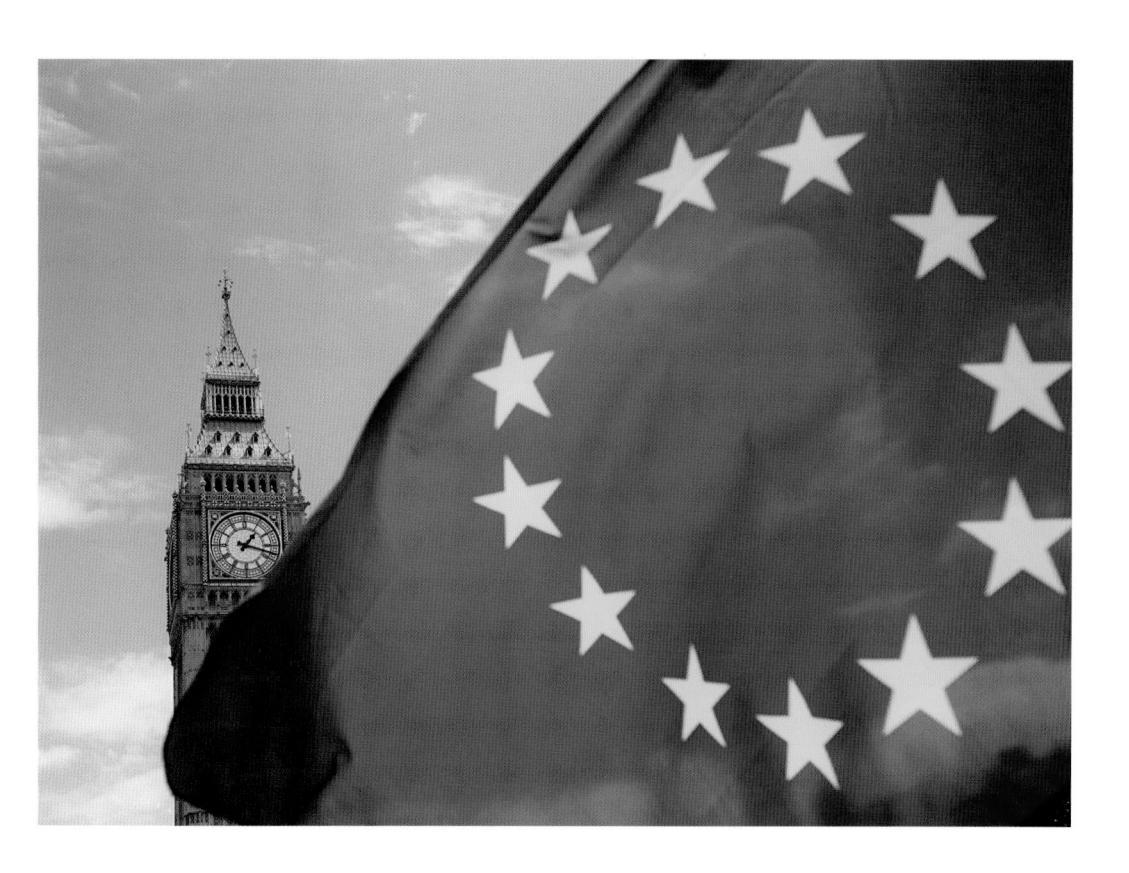

A referendum to gauge support for the country either remaining a member of, or leaving, the European Union was won by 'Vote Leave', paving the way for Britain to leave the European Union.

23 June 2016

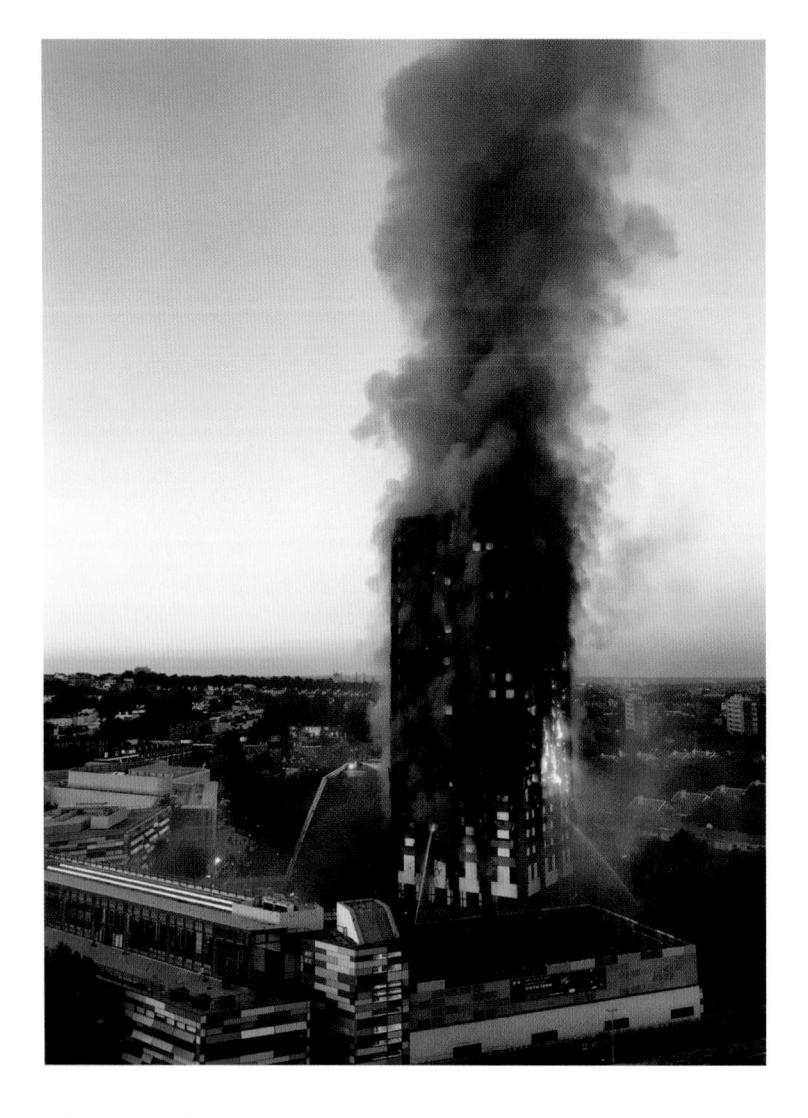

The 24-storey Grenfell Tower in West London, containing 120 flats, is consumed by fire and smoke. The devastating blaze claimed 72 lives.

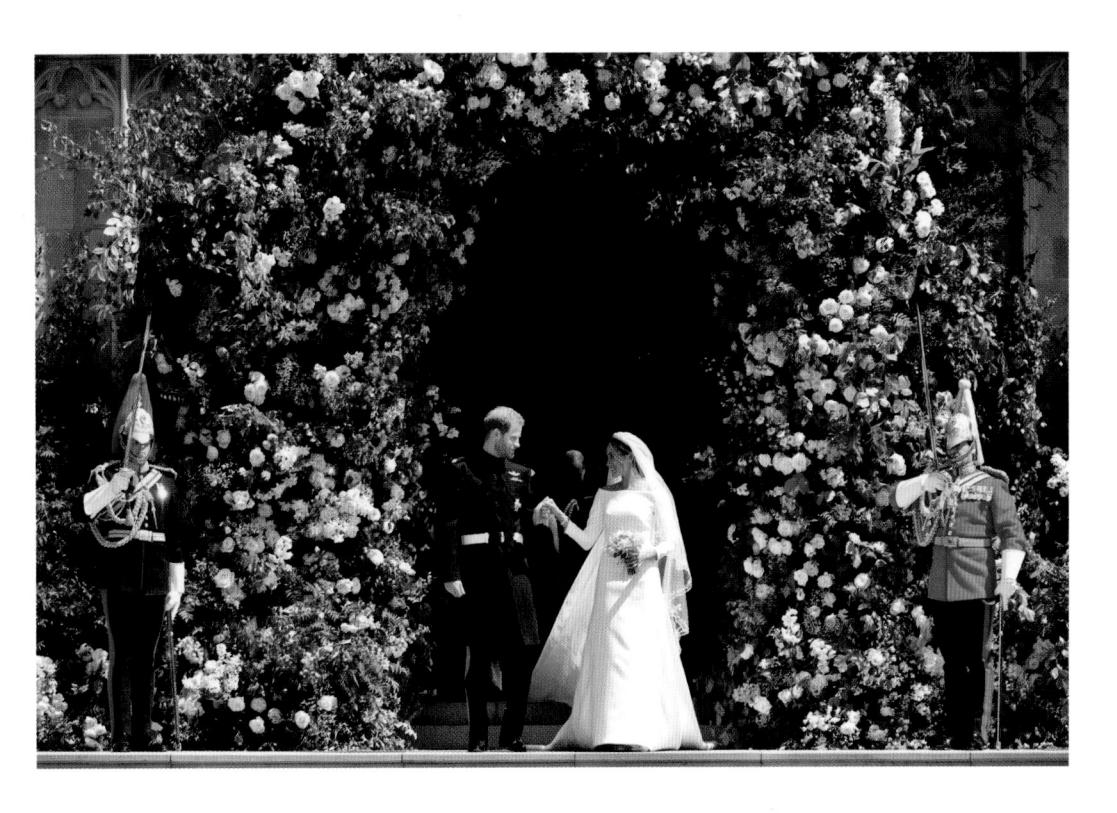

Prince Harry and Meghan Markle, Duke and Duchess of Sussex, leaving St. George's Chapel in Windsor Castle after their wedding ceremony. 19 May 2018

The Publishers gratefully acknowledge Press Association Images, from whose extensive archive the photographs in this book have been selected. Personal copies of the photographs in this book, and many others, may be ordered online at www.prints.paphotos.com

www.ammonitepress.com